THE SCULPTURE AND SCULPTORS OF THE GREEKS

THE METROPOLITAN MUSEUM OF ART

THE
SCULPTURE AND SCULPTORS
OF THE GREEKS

by Gisela M. A. Richter

FOURTH EDITION, NEWLY REVISED

New Haven and London, Yale University Press

1970

Library of Congress catalog card number: 70–99838
International standard book number: 0–300–01281–0

Designed by John O. C. McCrillis,
set in Bodoni Book type,
and printed in the United States of America by
Connecticut Printers, Inc., Hartford, Connecticut.

Distributed in Great Britain, Europe, Asia, and
Africa by Yale University Press Ltd., London; in
Canada by McGill-Queen's University Press, Montreal;
in Mexico by Centro Interamericano de Libros
Académicos, Mexico City; in Australasia by Australia
and New Zealand Book Co., Pty., Artarmon, New South
Wales; in India by UBS Publishers' Distributors Pvt., Ltd.,
Delhi; in Japan by John Weatherhill, Inc., Tokyo.

Ῥητὸν γὰρ οὐδαμῶς ἐστιν ὡς ἄλλα μαθήματα, ἀλλ᾽ ἐκ
πολλῆς συνουσίας γιγνομένης περὶ τὸ πρᾶγμα αὐτὸ καὶ
τοῦ συζῆν ἐξαίφνης οἷον ἀπὸ πυρὸς πηδήσαντος ἐξαφ-
θὲν φῶς ἐν τῇ ψυχῇ γενόμενον αὐτὸ ἑαυτὸ ἤδη τρέφει.

PLATO, EPISTLES VII. 341 C.

"There is no way of putting it into words like
other studies, but after much communion and
constant intercourse with the thing itself sud-
denly, like a light kindled from a leaping fire, it
is born within the soul and henceforth nourishes
itself."

CONTENTS

TEXT ILLUSTRATIONS

Page

PREFACE TO THE FOURTH EDITION[1]

In this new edition I have been able to make additions and corrections in the text regardless of the old pagination, and also to improve some of the illustrations and add to their number (many are by Miss Alison Frantz). I have therefore, I hope, been able to bring the book properly up to date. The most important changes are in the chapters on forgeries (pp. 141–48), on Pheidias (pp. 167–78), and on Lysippos (pp. 224–31), and in the concluding section, which now consists of two parts: Chapter 5 on the third and second centuries, and Chapter 6 on the first century B.C. I have added a number of the important newly discovered Greek sculptures from Asia Minor, Macedonia, Olympia, the Piraeus, Selinus, Gela, Baia, Sperlonga, Castelgandolfo, Vix, etc., as well as some new acquisitions by various museums. And I have now also included a number of reconstructions of buildings showing the sculptures in place (chiefly taken from Dinsmoor's *Architecture of Ancient Greece*), since for our appreciation of these architectural sculptures it is essential to visualize them in their original positions.

In the running text, references to publications of the objects discussed are added in footnotes; they are generally confined to the catalogues and handbooks where the objects now are, occasionally supplemented by the early accounts of their discovery. In Part Two, on the sculptors, I have added as a reference for each artist two recent studies: Lippold's "Griechische Plastik," in the *Handbuch der Archäologie* (1950), and the various articles on sculptors in the *Enciclopedia dell'Arte Antica Classica e Orientale*, I–VII (1958–66), in both of which references to previous publications will be found—especially to such detailed, indispensable works as C. Picard's *Manuel de l'archéologie grecque, La Sculpture*, I–IV (1935–54), with its many illustrations; Pauly-Wissowa's *Real-Encyclopädie*; and Thieme-Becker's *Künstlerlexikon* (many entries by M. Bieber), as well as to more modern publications.

I am greatly indebted to many colleagues for help in obtaining the necessary photographs and for discussions of problems—especially to Dott. G. Scichilone, who has also prepared the Index to the Illustrations. In presenting my own opinions on moot questions I have tried to give the supporting evidence as fairly as possible, and have added references to contrary opinions in the footnotes. Long polemical discussions seemed out of place in a book of this kind. The bibliography has again been brought up to date, though of course it could only include a selection of the many new studies that have recently been added in this field. Throughout I have tried to bear in mind that this book is intended to serve both the general reader and the serious student.

1. It should be pointed out that this edition is the only one that has appeared since the third edition of 1950. All the others—sometimes cited as new editions, of 1962, etc.—have been reprintings.

Finally I want to thank the Yale University Press for undertaking this new edition with its many new illustrations and Mrs. Anne Wilde, the editor, for her efficient help.

<div align="right">G. M. A. R.</div>

Rome
February, 1970

PREFACE TO THE FIRST EDITION

The immediate incentive for writing this book was the preparation of a course of lectures on Greek sculpture given under the auspices of The Metropolitan Museum of Art, Columbia University, and New York University in 1925 and 1926. It was a welcome opportunity to try a somewhat novel scheme for the presentation of this subject: the concentration first on the study of the sculpture itself and then on that of the sculptors who produced it. The abiding interest of Greek sculpture lies in the objects themselves. Their proper appreciation and understanding are a source of unending interest and enjoyment. It seemed desirable not to confuse this study with constant digressions concerning possible attributions to known artists; and it was likewise easier to give a consecutive picture of the great personalities who determined the development of Greek sculpture without continually interrupting the narrative by the consideration of other material. The opportunity thus afforded of giving our undivided attention to the sculpture as a purely artistic manifestation has suggested the consideration of a number of new aspects not usually treated in our histories of Greek art. In addition to making a consecutive, chronological study of the various types of the human figure I have tried to trace the development of drapery, of composition, and of the treatment of relief; and have added a chapter on animals and one on forgeries.

In the second part of my subject—"Greek Sculptors"—I have endeavored to give the evidence pure and simple, carefully sifted to the best of my ability; for the time seemed ripe to present the foundation we now have to build on without questionable superstructures. When we consider the large number of sculptors known to us practically only by their names[1] the pastime of assigning the extant sculptures to a small group of familiar masters appears precarious. And I have omitted the absorbing question of "schools" as equally unprofitable in a book of this kind. In spite of certain diversities of style in various localities (cf. p. 6) the common characteristics are by far the more distinct. And especially is this true from the beginning of the fifth century when communication among the Greek states became more constant. Artists traveled from place to place and local traditions became merged in an international Greek style. This homogeneity of Greek art is convincingly brought out by a study of the coin types of the various Greek cities, where we should expect such diversities but where local characteristics of style are seldom observable—except in the broad divi-

1. E.g. Amphion, Diodoros, Skymnos, Askaros, Arkesilaos, Kleoitas (first half of fifth century B.C.); Pison, Kolotes, Theokosmos, Styppax, Demetrios, Pyrrhos, Pyromachos, Kleiton, Nikodamos, Kallikles, Telephanes (second half of fifth century); Apellas, Xenophon, Polykles, Sthennis, Polykrates, Kalliades, Telesias, Ktesikles, Exekestos, Strabax, Nikomachos, Demetrios (fourth century); Telephanes, Telesias, Ktesikles (dates uncertain); etc., cf. Overbeck, *Schriftquellen*, passim.

sions of Peloponnesian, Athenian, and Ionic. Although our archaeological literature abounds in discussions regarding the geographical origins of extant sculptures the varying theories held by different archaeologists have shown how difficult it is to draw the dividing line. I have therefore spared my reader such attributions and concentrated my attention on the salient characteristics common to Greek sculpture.

For the convenience of the student I have added a chronological table, rendering myself thereby particularly vulnerable to attack, since many dates are disputed.

The translations of the Greek and Latin texts are taken mostly from the Loeb editions and H. Stuart Jones's *Select Passages from Ancient Writers Illustrative of Greek Sculpture,* with occasional slight variations.

The large number of illustrations in proportion to the text will, I know, be acceptable; for reproductions are more eloquent than words and make, in fact, many words unnecessary. Photographs of casts have been used in preference to those of originals only when the casts could be photographed in a better light or from a more convenient angle than was possible with the originals.

My debts for help rendered are so numerous that I can acknowledge them only in a general way. Throughout the years that I have been at work on this book I have invariably found a ready response from my fellow archaeologists in the giving of desired information, in the opportunities of study afforded, and in the supplying of needed photographs. I gratefully acknowledge herewith this friendly assistance. I am under special obligation to Mr. E. T. Newell, who has generously helped me with information regarding coins; to Mr. J. D. Beazley for many important suggestions particularly in the chronological table; to Mr. M. N. Tod for help in inscriptions; and above all to my sister, Irma Richter, an artist by profession, who has revised the whole first part of my manuscript and made innumerable suggestions and corrections in my text; I owe to her also the advice that I take up modeling and stone-cutting, an experience which proved invaluable.

Greek sculpture is a theme so much vaster than the interpretation of it by any one individual that it can never be a closed subject. Every fresh mind can make a new contribution by approaching it from a different angle and devoting to its analysis his own individual faculties. No apology is therefore needed for adding yet another volume to our histories of Greek sculpture. The mine on which we are working is inexhaustible; for its ore is not gold but the highest aspirations of a gifted people.

G. M. A. R.

New York
October 1928

PREFACE TO THE SECOND EDITION

The smaller format of this second edition has necessitated the repaging of the text. The figure numbers of the halftone and line illustrations are, however, the same as before. The colored plates have been omitted. A few alterations in the illustrations have been made: figures 77, 213, 505, 601, and 689 are I hope now clearer; 451 and 736 have been corrected; and in 613 and 615 the statue (Harmodios) has been made to lean slightly further forward. In the text I have been able to profit by some criticism and have tried to correct various mistakes and misprints. It is hoped that having the illustrations all at the end and a reference for each figure to the page where it is discussed will facilitate the use of the book. For the same purpose an index to the illustrations has been supplied and additions have been made to the index to the text.

New York G. M. A. R.
May 1930

PREFACE TO THE THIRD EDITION

Twenty years have passed since the second edition of this book appeared. In the two reprintings of 1941 and 1946 no changes were made. In this third edition I have been allowed to make alterations that seemed essential if they could be fitted into the old pagination. These changes, however, proved extensive, for much has happened in archaeology in the last two decades. I have tried to embody the most important new discoveries, to correct antiquated theories, and have largely rewritten the portions dealing with the archaic and the Hellenistic periods. The chronological table and the bibliography have been revised, and about forty-five substitutions have been made in the illustrations. In the footnotes I could only insert recent publications where space allowed; they are supplemented, however, by the new bibliography.

I have not tried to change the style of the text, since this would have necessitated rewriting most of the book; for one's style changes with the years—for better or for worse. I hope, however, that the improvements that I have been able to make will give the book a new lease on life.

I am indebted to many colleagues for help in various ways, especially to Professor Alfred Bellinger for drawing my attention to additional dated coins; to Dr. Margarete Bieber for improving the section on Greek dress; to my sister for many suggestions; and to several members of the Metropolitan Museum staff for timely assistance and several photographs. Above all, I am grateful to the Yale University Press for making this new edition possible. G. M. A. R.

New York
November 1949

ABBREVIATIONS

Periodicals

A.J.A.	*American Journal of Archaeology*
Annuario	*Annuario della Scuola Archeologica di Atene e delle Missioni Italiani in Oriente*
Arch. Anz.	*Archäologischer Anzeiger (Beiblatt zum Jahrbuch)*
Arch. Ztg.	*Archäologische Zeitung*
Ath. Mitt.	*Mitteilungen des deutschen archäologischen Instituts, Athenische Abteilung*
B.C.H.	*Bulletin de correspondance hellénique*
B.S.A.	*Annual of the British School at Athens*
Delt. arch.	Δελτίον Ἀρχαιολογικόν
Eph. arch.	Ἐφημερὶς Ἀρχαιολογική
J.d.I.	*Jahrbuch des deutschen archäologischen Instituts*
J.H.S.	*Journal of Hellenic Studies*
J.R.S.	*Journal of Roman Studies*
Mem. (or Rend.) Pont. Acc. Rom.	*Memorie (or Rendiconti) della Pontificia Accademia Romana di Archeologia*
Mon. Piot	*Monuments et Mémoires publiés par l'Académie des Inscriptions et Belles Lettres (Fondation Eugene Piot)*
Not.d.Scavi	*Notizie degli Scavi di antichità, comunicate all'Accademia dei Lincei*
Oest. Jahr.	*Jahreshefte des Oesterreichischen Archäologischen Instituts*
Rev. arch.	*Revue archéologique*
Röm. Mitt.	*Mitteilungen des deutschen archäologischen Instituts, Römische Abteilung*

Books

Beazley, *A.B.V.*	J. D. Beazley, *Attic Black-Figure Vase-Painters*
Beazley, *A.R.V.*[2]	J. D. Beazley, *Attic Red-Figure Vase-Painters*, 2d ed.
B.M.C.	*British Museum Catalogue of Coins*
Dinsmoor, *Architecture*	W. B. Dinsmoor, *The Architecture of Ancient Greece* (1950)
Head, *H.N.*[2]	B. V. Head, *Historia Numorum*, 2d ed.
Helbig-Speier, *Führer*[4]	Helbig, *Führer durch die öffentlichen Sammlungen klassischer Altertümer in Rom*, 4th ed., rev. by H. Speier (with collaborators)
I.G.	*Inscriptiones Grecae*
M.M.A.	Metropolitan Museum of Art, New York (*Bulletin*, handbooks, catalogues, etc.)
R.E.	Pauly-Wissowa, *Real-encyclopädie der classischen Altertumswissenschaft*

Note: Other abbreviated titles should be easily understood; full titles will be found in the bibliography.

PART I

GREEK SCULPTURE

THE HISTORICAL BACKGROUND OF
GREEK SCULPTURE

Like every art, Greek sculpture was largely conditioned by the history of its time; and the four chief phases in its development clearly reflect the outlook and conditions of the four outstanding periods in Greek history. The geometric, archaic, classical, and Hellenistic periods in Greek sculpture may be elucidated by contemporary events. It is essential, therefore, to view Greek art against its historical background.

Geometric and Archaic Periods (ca. 1000–500 B.C.)

AFTER the fall of the "Minoan" and "Mycenaean" civilizations there followed everywhere in Greece an obscure period during which the brilliant monarchies of the Aegean chieftains were replaced by "feudal" aristocracies. It is during these "dark ages" of the tenth, ninth, and eighth centuries that the Greek nation—that is, the Aegean people reinforced by successive invasions from the North and East—slowly prepared for the phenomenal rise of the classical Greek civilization. Its earliest manifestation was a widespread colonial movement. The expansion was first westward. As early as the eighth century colonies were founded all over Sicily and Southern Italy—at Cumae, Naxos, Syracuse, Katane, Megara, Rhegion, Sybaris, Kroton, Tarentum, Poseidonia, Ischia, etc. The movement continued during the whole of the seventh century, reaching in 600 as far as Marseilles and Spain and spreading also northeastward to Thasos, Chalkidike, Thrace, and the cities of the Bosphorus. At the end of this period of discovery and adventure we find Greece consisting of a number of powerful city-states each with its colonies and dependencies, ranging from Asia Minor to Italy and Spain. All these cities were independent units, knit together by a common religion, similar institutions and customs, and the consciousness of the same origin. To symbolize this unity there had arisen religious centers in various localities—Dodona, Delphi, Olympia, Delos, Cape Mykale—to which all Greeks journeyed to worship or consult the oracles. And, periodically, great religious festivals were celebrated—at Olympia, Corinth, Nemea, and Delphi—and hither Greeks from all parts of the world came to compete in athletic and musical contests while "barbarian" outsiders were strictly excluded. And thus were fostered the two dominating loyalties of the ancient Greeks—an intense local patriotism for the individual city-state and the consciousness of a common Hellenism amid a "barbarian" world. Throughout Greek history we are

aware of these two important factors which intermittently combined and separated the Greek city-states.

Another element which constituted a bond between the Greeks was the creation of new forms of political institutions unknown in the powerful East—of democracies in the place of the old aristocracies and monarchies. The first stage in this transformation was the appearance of tyrannies. In one Greek state after another we note in the later seventh century and during the sixth century the downfall of the powerful families and clans which had held the power for several centuries, and the substitution of the rule of one powerful man risen generally as champion of the people. This change began in Sikyon, Corinth, Megara, and in the Ionian cities, and spread from city to city. Kypselos and Periander of Corinth, Orthagoras of Sikyon, Thrasyboulos of Miletos, Polykrates of Samos, Peisistratos of Athens are names which stand out with many others as the founders of the greatness of their respective cities. Under the rule of most of these tyrants, as well as of some of the early aristocrats, the arts flourished. It was then that Greek monumental sculpture began.

After centuries of modest production in small bronzes, terracottas, and ivories there suddenly appears all over the Greek world an enthusiastic activity of temple building with sculpture in relief and in the round. We can catch a faint reflection of this brilliant dawn of Greek sculpture in the remains which have survived to this day. In Corfu, the ancient Korkyra, a temple has come to light with an amazingly impressive pediment, dominated by a central Medusa (figs. 81, 401, and I). In northern Thermos has been found another early temple with painted metopes (figs. 430, 431, and M). The head of Hera at Olympia (fig. 147) is perhaps part of the cult group of Zeus and Hera of the old Heraion. At Delphi the metopes of the "Treasury of Sikyon" (cf. figs. 383, 433) and the splendid dedicatory statues of Kleobis and Biton by [Poly]medes (cf. figs. 19, 151) bear witness to the growing wealth of the Greek states and the increasing importance of the common sanctuary of Apollo. On the Akropolis in Athens there arose a number of early temples, large and small, of which the gaily painted limestone pedimental sculptures are now in the Akropolis Museum—the "Achilles and Troilos" group (p. 94, n. 12), the Herakles and Hydra (fig. 403), the introduction of Herakles to Olympos (fig. 407), the splendid bull attacked by lions (fig. 403), and above all the "Bluebeard" or three-headed Typhon, and the Herakles fighting Triton (figs. 405, 406). We do not even know where some of the respective temples were situated, but we can visualize nevertheless the splendid effect of the whole. Furthermore, impressive single statues, like the colossal kouroi of Sounion (cf. fig. 18) and the calf bearer dedicated by Rhombos (figs. 5, 6), show the boldness and skill of these early sculptors.

Farther east in the Islands and Asia Minor there is the same activity. At Ephesos a temple is built to Artemis with the help of Kroisos, king of Lydia (560–546 or 555–541). The row of seated statues which lined the Sacred Way at Didyma (figs. 67,

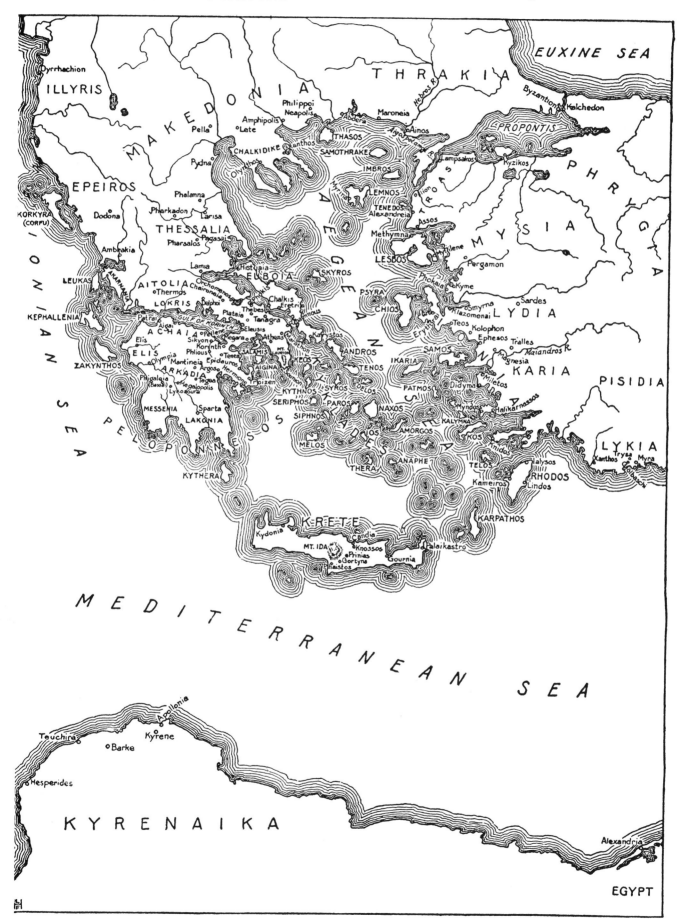

Dyrrhachion

ILLYRIS

MAKEDONIA

THRAKIA

EUXINE SEA

Byzantion

Kalchedon

Philippoi
Neapolis

Pella

Amphipolis
Lete

Abdera

Maroneia

Hebros R.

Ainos

PROPONTIS

PHRYGIA

CHALKIDIKE

Akanthos

THASOS

Olynthos

SAMOTHRAKE

IMBROS

Lampsakos

Kyzikos

Pydna

Phalanna

EPEIROS

Phtharkadon

Larisa

THESSALIA

Pharsalos

Pagasai

LEMNOS

Myrina

TENEDOS
Alexandreia

TROAS

Ilion

Assos

MYSIA

Methymna

Mytilene

Pergamon

LESBOS

KORKYRA
(CORFU)

Dodona

Ambrakia

Lamia

Histiaia

EUBOIA

SKYROS

Phokaia

Kyme

LEUKAS

AKARNANIA

AITOLIA

Orchomenos

Chaironeia

Thermos

LOKRIS

Delphi

Plataia

Thebes

Chalkis

Eretria

PSYRA

CHIOS

Smyrna

Klazomenai

LYDIA

Sardes

KEPHALLENIA

Patrai

Aigion

GULF OF KORINTH

Pellene

Megara

Tanagra

Eleusis

Athens

Euripos

Karystos

ANDROS

Erythrai

Teos

Kolophon

Ephesos

Tralles

Maiandros R.

ACHAIA

Sikyon

Korintho

Phlious

Tenea

SALAMIS

MT.
LAURION

Sunion

KEOS

TENOS

IKARIA

SAMOS

Magnesia

KARIA

PISIDIA

ELIS

Elis

Olympia

Mantineia

Epidauros

AIGINA

Hermione

Troizen

DELOS

Miletos

Didyma

ZAKYNTHOS

ARKADIA

Tegea

Phigaleia
(Bassai)

Megalopolis

Lykosoura

Argos

KYTHNOS

SYROS

SERIPHOS

PAROS

NAXOS

Myndos

Halikarnassos

KALYMNA

LYKIA

MESSENIA

Sparta

LAKONIA

SIPHNOS

AMORGOS

KOS

Knidos

Xanthos

Trysa

Myra

MELOS

THERA

ANAPHE

TELOS

Ialysos

RHODOS

Lindos

KYTHERA

Kameiros

KARPATHOS

IONIAN SEA

PELOPONNESOS

KRETE

Kydonia

Candia

MT. IDA

Knossos

Prinias

Gortyna

Phaistos

Gournia

Palaikastro

MEDITERRANEAN SEA

Teuchira

Apollonia

Kyrene

Barke

Hesperides

KYRENAIKA

Alexandria

EGYPT

278), the statues from the early temple of Hera at Samos, and the reliefs from Xanthos and Assos (cf. fig. 432) are typical east Greek products of the first half and third quarter of the sixth century. The flying Nike from Delos (figs. 82, 83) and the Naxian sphinx at Delphi (fig. 495) are two distinguished island products. In the west the metopes from the temples of Selinus (figs. 283, 434, 435) and the terracotta Gorgon from the temple of Athena at Syracuse (fig. 84) show that Sicily kept pace in this artistic production.

This widespread prosperity and interest in art reach their acme in the second half of the sixth century, which forms indeed the climax in the first act of the drama of Greek civilization—the period when Greece was as yet undisturbed either in the east or the west and could work out her novel experiments unhampered. Athens under Solon (594–93) and Peisistratos (ca. 561–27) had risen to a powerful state. The marble pedimental sculptures representing the battle of gods and giants (figs. 119, 412), the fine array of marble maidens erected as dedicatory offerings on the Akropolis (figs. 284–87), the statues of the later Apollos and kouroi (figs. 21–25, 26, 27), the large number of splendid tomb monuments (figs. 459 ff.) reflect this prosperity and show a high degree of refinement. But Athens was only one of many art-loving, prosperous states. The temple of Apollo at Delphi was rebuilt after a fire at an enormous expense in which the whole of Greece took part. The Treasury of the little island of Siphnos at Delphi (ca. 525–520) with its pediment (fig. 409) and magnificent frieze (figs. 451, 452, 526) and caryatids (fig. K) bears eloquent testimony to the widespread wealth of the time and the fine achievements of its artists. The Treasury of the Megarians at Olympia (fig. 410), the other great common sanctuary of the Greeks, is another example. Boeotia appears to have been particularly active, to judge from the imposing series of kouroi (figs. 32, 33) found in the Ptoan sanctuary and elsewhere. Even Sparta has presented us with a fine series of reliefs of the period (fig. 507).

In comparing these sculptures from so many localities with one another we note certain distinctions—a sturdiness, for instance, in the Peloponnesian products (cf. the Argive athlete, fig. 19) and a softness and elaboration in the Ionian works (cf. the Didyma and Samos statues, figs. 67, 117, 277). Nevertheless, it is the common characteristics that stand out—their buoyancy and freshness, their dignity and decorative quality. They present us indeed with a spirited picture of this early civilization and help us to visualize it as a time of eager quest—when philosophers were trying to understand the physical structure of the universe, when political experiments were everywhere being tried, when new forms of literature were being evolved; and also as a time with a strictly local outlook. The Greek states were self-contained, actively content in their respective spheres, with a brilliant and yet limited activity. Their sculpture, however, with its sense for volume and design, and its progressive development toward the representation of nature has a universal quality shared by them all.

Fifth Century

IN the fifth century a new direction is given to the history of Greece. Her expansion had already stopped a century before. Now, at the end of the sixth century, she is herself threatened. The danger of Persia, the irresistible conqueror, looms in the east; in the west, Carthage and Etruria have risen as powerful rivals. Meanwhile the political aspect of the Greek states has again changed. The descendants of the beneficent tyrants, having abused their power, have in many places been overthrown and in their stead aristocracies and democracies have been established—the latter a novel form of government in the ancient world and one which we now regard as typically Greek. It fostered that sense of individualism and independence, which was the essence of a Greek city-state, and thereby made more apparent both its weakness and its strength. Its weakness was shown when the danger of invasion threatened and its inability to present a united front became almost fatal to the common cause. On the other hand, it doubtless made possible the rapid rise to power of men of obscure origin like Themistokles, whose remarkable foresight turned the scale at a critical hour. The whole early part of the fifth century is taken up with the Persian danger. The attack on the Greek Islands began in 499. By 493 most of the east was subdued. The expedition against Greece proper was started in 492. Then came Marathon (490), Salamis (480), Plataia (479), the three great victories which decided the fate of Greece; in the west, Himera (480), which disposed of the Carthaginian danger in Sicily; and in the east the battles of Mykale (479) and the Eurymedon (467 or 466), which freed Miletos and the eastern cities.

These were strenuous days in which all energies were devoted to the safeguarding of the state. Naturally it was not the time for the erection of many important buildings and monuments. We have a few precious examples just preceding the cataclysm, for instance, the sculptures of the temple of Apollo Daphnephoros at Eretria (figs. 294, 298), which probably still belong before the turn of the century; and a few private dedications on the Akropolis (figs. 168, 284). The pediments of the temple of Aphaia at Aigina (figs. 415, 416, 108, 120, 121), begun perhaps about 500, were brought to their completion about 480, an eloquent testimony to the prosperity of the island at that period (shortly before her subjugation by Athens in 456), and also to the protection from the Persian danger which her outlying position afforded her. But otherwise there is little artistic activity to record during the actual years of the war and for a decade or so after, except a few memorials by which Greece showed her gratitude to the gods for her delivery: a platform with trophies erected by the Athenians in front of the Athenian Treasury at Delphi as a dedicatory offering after Marathon (p. 102, n. 42); a snake tripod in the same precinct, dedicated as a joint offering of the Greek states to commemorate the victory of Plataia; and a new group of the Tyrannicides (figs. 609, 610) set up in the Athenian marketplace (477) to take the place of that

carried off to Persia by Xerxes. All more ambitious undertakings had to bide their time. Athens could not be expected to restore her temples when she was straining every nerve to fortify her city and to strengthen her navy.

In the second quarter of the fifth century we find the Greek world recovering. The great temple of Zeus was begun at Olympia (ca. 468); Sicily under her tyrants (who retained their power there longer than elsewhere) was becoming more and more prosperous. Temple E was built at Selinus (figs. 440–43). A fine bronze chariot group (of which a charioteer [fig. 299] and other fragments have survived) was dedicated at Delphi by a Syracusan prince. Athens, too, was bestirring herself and was finding time at last to erect her important war monuments. The colossal Athena Promachos (fig. 635) by Pheidias was set up on the Akropolis, "an offering from the spoils of the Persians who landed at Marathon," and at Delphi was dedicated a group of deities and heroes "with one human figure, that of Miltiades, the general," another work of Pheidias and it, too, in memory of Marathon.

Not only is there in this period a general revival of artistic production, but a new element has entered Greek sculpture. The Greek horizon has been enlarged, the long struggles with representational problems have borne their fruit, and Greek sculpture now assumes an idealistic, spiritual character which gives it a new grandeur. In literature we perceive it best in the works of Aischylos; in sculpture perhaps in the pediments and metopes of the temple of Zeus at Olympia (figs. 71, 336, 380, 417–20, 444). And inevitably there arose now artists of the first rank, able to perpetuate in their work the new outlook. Of Pythagoras and Kalamis we have only the enthusiastic comments of those who had the good fortune to know their works (pp. 156 ff.); of the rhythmical sculptures of Myron we can form some conception by a few Roman copies which have survived (figs. 616, 621).

The second half of the fifth century is the climax of the second period in Greek sculpture, as the second half of the sixth was of the first period. At first, it was a time of comparative peace and material prosperity. In 454–453 the treasury of the confederacy of Delos was transferred from Delos to Athens; that is, the funds contributed by the members of the League for the upkeep of a strong navy as a protection against Persia were virtually at the disposal of Athens. In 446–445 a thirty-years' peace was signed between Athens and the Peloponnesians. The outward circumstances were thus favorable for artistic activity. Moreover, the elimination of the Persian danger, which had for a long time threatened annihilation, brought as a reaction a certain exaltation and a new dignity and importance to Greece. Athens, under the guidance of Perikles, seized her opportunity and spent her large resources for the beautification of her city. And thus arose the Parthenon (447–432; cf. figs. 96, 138, 305, 306, 374, 382, 421–23, 445, 447, 525, 527, 528, and N) with the chryselephantine Athena by Pheidias (438; figs. 633, 634, 636–44), the Propylaia as a palatial entrance to the Akropolis (437), the new Hall of Mysteries at Eleusis (ca. 430), the temple by the Ilissos (ca. 450; fig. 454), the temple at Rhamnous with a cult statue by Agorakritos (ca. 435–

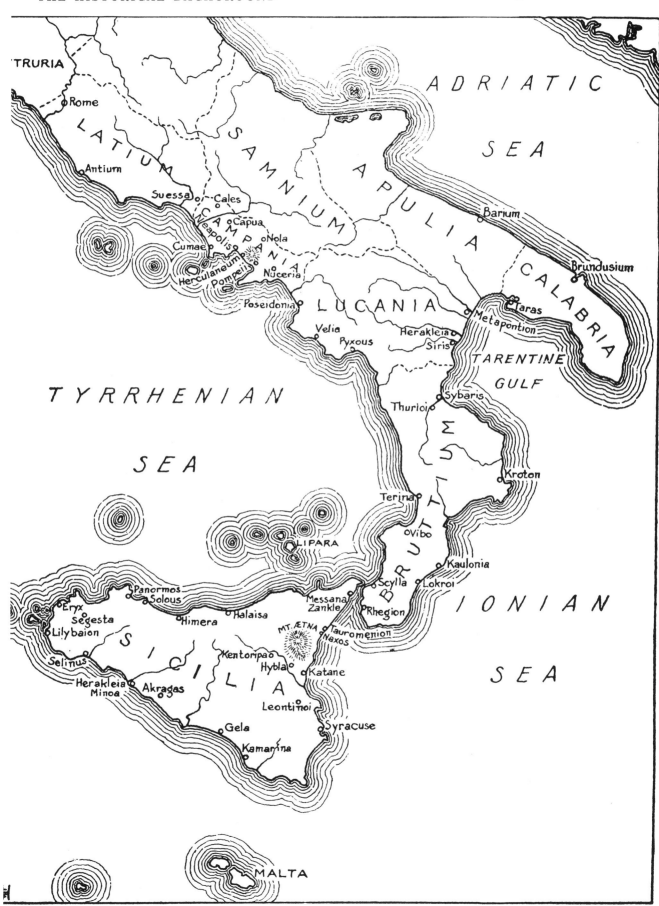

421; figs. 678, 679), and many other memorials, large and small. The leading sculptor in Athens was Pheidias. The idealism and majesty of his works, especially his chryselephantine Zeus at Olympia (figs. 647–50), left an abiding impression on Greek art and determined its character thenceforth. Greek art now assumes a universality consistent with its broadened horizon. Pheidias had many distinguished associates and followers—Alkamenes (pp. 181 ff.), Agorakritos (pp. 184 f.), Kresilas (pp. 178 ff.), etc., whose works in Athens and elsewhere gained wide renown. His greatest contemporary was Polykleitos of Argos (pp. 189 ff.), whose sense for harmonious composition we can appreciate even in the Roman copies which have survived of his Doryphoros (figs. 690–94) and Diadoumenos (figs. 695–97). Besides works which can be connected with prominent sculptors, there are others to which we can attach no names but which are among the finest that have survived. The Niobid in Rome (fig. 4) and the two figures in Copenhagen (figs. 97, 125) perhaps come from a pedimental composition shortly after 450.

If Athens had been allowed to carry out her imperialistic policy, if she had succeeded in subjugating completely, first the tributaries to the Delian League and then the Peloponnese, the history of Greece might have been that of Italy, with Athens in the role of Rome. But Athens was stopped in mid-career. After she had safely established her sea empire the trial of strength between herself and the Peloponnese began (431). It lasted first for ten years until the peace of Nikias (421) and then again from 419 to almost the end of the century. For a long time the result remained in question, but the disaster which overtook the Athenian expedition to Sicily (415–413) had much to do with the ultimate downfall of Athens. The decisive battle was won by the Spartan Lysander at Aigospotamoi in 405. The dream of empire which had come to Athens, as it has to many nations, was over. She was merely a small city-state once more.

The immediate influence on art of the Peloponnesian War was a stoppage of various building activities such as the Propylaia on the Akropolis. But as the war dragged on in a sometimes rather desultory fashion, normal life asserted itself and art regained a place. We have many fine monuments by which to judge this art of the last third of the fifth century—at Athens the Hephaisteion (figs. 201, 307), the Erechtheion (ca. 421–413; fig. 541, and ca. 409–406; figs. 316, 780), and the temple of Athena Nike (ca. 426; figs. 315, 313) with its balustrade (ca. 410; figs. 543, 545); at Sounion the temple of Poseidon (ca. 423); at Argos the temple of Hera (ca. 420; fig. 174); and farther afield the temple of Apollo at Phigaleia in mountainous Arkadia (figs. 197, 207–09, 211–14, 314–17, and O); the flying Nike of Paionios at Olympia (figs. 493, 494, 682, 687) and in the east the Heroön of Gjölbaschi (figs. 343, 455, 456). And besides this architectural sculpture, single statues like the Idolino (figs. 47, 48), and grave reliefs like those of Hegeso (fig. 466), Glykylla (fig. 322) and Ampharete (fig. 467), testify to the beauty of private memorials of the period.

The delicate character and refinement of these monuments hardly suggest that they

were created against a background of bitter warfare (we may except the tumultuous Phigaleia frieze). They are rather the logical development of the art of the preceding period, showing the continuance of artistic appreciation and well-being. As so often in history, the events of the time influence not contemporary but subsequent art. Indeed the soft, transparent draperies of many of the sculptures, evidently reproducing some fine and precious material (cf. p. 67), suggest an era of luxury. The same impression is gained by the continued output of chryselephantine temple statues (e.g. the Hera of Argos by Polykleitos [fig. 699]), the expensive dedications, the splendid character of the festivals and processions, and the defrayal by private citizens of costly state duties. The mental outlook may be gauged by the fact that this is the time of Euripides, Thucydides, Sokrates, and Aristophanes, following upon that of Herodotus and Sophokles. The old acceptance of traditional religion and customs is waning and there appears in its stead a new spirit of inquiry and scepticism, no longer confined as it had been in the sixth century to investigations of physical phenomena, but active now in the moral sphere. A time of individualism has begun.

Fourth Century (400–323 B.C.)

THE end of the Peloponnesian War was not followed—as had been that of the Persian wars—by an era of peace. Sparta's domination was even more distasteful to the Greeks than had been that of Athens; and when, after the battle of Leuktra (371), Thebes assumed the leadership, hostilities continued until her leader, Epameinondas, was killed at Mantineia (362), and therewith her power ended. It was clear that no one Greek city was able to impose her will on the others. Local independence was too deep-rooted. In the meantime a new experiment was being tried. The old idea of the city-state was being enlarged and various confederations and leagues gradually formed round the most prominent states—for instance, the Athenian, Boeotian, Arkadian, Achaean, and Thessalian. Unfortunately this proved no solution. Local jealousies and bickerings continued until Macedonia under Philip (359–336) and Alexander (336–323) at last subjugated the whole of Greece.

As we review the art of the fourth century we realize how these long-drawn-out hostilities gradually impoverished Greece. Compared with the great periods of public building in the sixth and fifth centuries the output of the fourth century appears modest. In the first quarter of the century we can cite the temple of Asklepios at Epidauros with its small pedimental groups (figs. 763–65) and its delicate akroteria (figs. 757–60). The temple of Tegea with sculptures perhaps by Skopas (figs. 737–40, 743) was a magnificent undertaking, presumably built to celebrate the overthrow of the Spartan yoke soon after 371. The temple of Apollo at Delphi, which had been destroyed in 373, was rebuilt shortly afterward by an international subscription. But the majority of artistic enterprises at this time were either private dedications and grave monuments (cf. figs. 334, 464, 465)—for private fortunes do not always decline with public ones—or were undertaken outside of Greece proper by the princes of Asia Minor.

The Nereid Monument at Xanthos (figs. 318–20, P), the Mausoleum at Halikarnassos (figs. 240, 330, 765–69, 776, 777, 784), the temple of Artemis at Sardes, the later temple of Artemis at Ephesos (figs. 345, 698, 751), even such single masterpieces as the Aphrodite of Knidos by Praxiteles (fig. 715) were all commissioned in Asiatic Greece. And the prominent sculptors of the time had to go eastward to find important work. But that Greece was still capable of great things is proved by the appearance of three such geniuses as Praxiteles, Skopas, and Lysippos in the sculptural field and of thinkers like Plato and Aristotle. Prose became a high art with such writers as Lysias and Demosthenes, and drama took a new lease on life at the end of this period with the comedies of Menander. We are clearly still in a creative period. The individualism initiated by such men as Euripides and Sokrates is reflected in the personal note of fourth-century sculpture. The impersonal grandeur of fifth-century art gives place to a gracious charm and delicacy. And portraiture assumes a more individualistic character.

Hellenistic Period (323–100 B.C.)

With Alexander we have reached the so-called Hellenistic age. By a series of brilliant campaigns he conquered the old kingdoms of Asia Minor, then marched victoriously farther and farther east until he reached distant India. It was a remarkable achievement, the more so as it was consummated in the brief thirteen years of Alexander's reign (336–323). If he had lived he would doubtless have consolidated his empire and the consequences of this Greek penetration would have been even more far-reaching. But his premature death was the signal for revolts and disaffections everywhere and Alexander's vast structure crumbled immediately. But not entirely. After more than twenty years of continuous warfare and intrigues there emerged in 301 four large monarchies under Macedonian generals—Macedonia and Greece under Kassandros; Thrace and Asia Minor under Lysimachos; the Oriental provinces under Seleukos; and Egypt under Ptolemy. These four kingdoms, with some independent states like Pergamon and Rhodes, continued in existence for two or three centuries, marked by great undertakings but also by constant warfare. The Greek inability to form powerful political units again showed itself in these altered circumstances. Endless quarrels and hostilities characterize the history of these kingdoms, until all-conquering Rome annexed one territory after another and finally in 30 B.C. included them all in her great empire, and thereby initiated a long era of peace.

The art of this Hellenistic period (323–100 B.C.) is a remarkable phenomenon. Though politically Greece has become a mere adjunct of Macedonia, from the point of view of culture she is still paramount. The small Hellenic city-states have been enlarged to embrace the "Hellenistic" world; artistic activity has shifted to new centers—to Pergamon, Ephesos, Rhodes, Tralles, Alexandria; but the artists are still Greek and their products continue in the Greek tradition, modified both in scope and in spirit to correspond to the new outlook. In contrast to the earlier periods the ma-

jority of Hellenistic sculpture is not architectural. Commemorative single statues and groups predominate, and a new importance is given to portraiture (pp. 55 f.). Though in this long epoch of two or three centuries production was constant and extended over a wide area, it is difficult to trace any consecutive development. There are obvious borrowings and adaptations from the past side by side with important original creations. It is also difficult to distribute the material among local schools, e.g. of Pergamon, Rhodes, and Alexandria, though the attempt is constantly made. We note, to be sure, various tendencies, but they appear in different localities,[1] and inscriptions teach us that artists from all over Greece and Asia were at work at the same place (e.g. in Pergamon and Rhodes).[2] Individual styles apply to certain monuments, but not to localities.[3] In other words, Hellenistic art is truly international. For a general survey it is better therefore simply to enumerate some conspicuous datable works of this period.

The so-called Alexander sarcophagus from the royal burial place at Sidon (figs. 184, 801) is a product of the last quarter of the fourth century. The Tyche of Antioch by Eutychides, a pupil of Lysippos, made after the foundation of Antioch in 300, is preserved in Roman copies (figs. 818–20). The portrait of Demosthenes by Polyeuktos (fig. 816) was erected ca. 280. All three are characteristic products of the early Hellenistic age.

Pergamon supplies us with valuable material for the succeeding period. Attalos I, king of Pergamon, won a momentous victory over the invading hordes of Galatians or Gauls who had long constituted a danger comparable to that of Persia more than two centuries ago. This achievement was commemorated in two splendid dedications. One was a group of statues erected either after the decisive victory in 241 or after the end of the war in 228. Marble copies of this group are preserved in the famous dying Gaul in the Capitoline Museum (fig. 130), and the Gaul killing himself and his wife, in the National Museum in Rome (figs. 114, 186). The other memorial consisted of a group of statues, two-thirds life-size, of Gauls, Amazons, Persians, giants. They were set up on the Akropolis in Athens probably on the occasion of Attalos' visit there in 200 B.C., and were seen by Pausanias in the second century A.D.[4] From his description, copies of these originals have been recognized in several small statues in Naples, Rome, Venice, and the Louvre (cf. fig. 127). Eumenes II, son of Attalos, enriched his city with a series of splendid buildings, one of which probably was the great altar of Zeus with its famous frieze representing the battle of gods and giants (cf. figs. 185,

1. E.g. the "Alexandrian morbidezza" is found not only in sculptures from Alexandria but in a considerable number from other sites (Priene, Chios, Athens, etc.).

2. Cf. Loewy, *Inschriften*, nos. 170 ff. Artists at work in Rhodes, for instance, hailed from Crete, Halikarnassos, Antioch, Laodikeia, Soloi, Miletos, etc.

3. The vigorous "Pergamene" style is characteristic of the Galatian groups (see below), but is conspicuously absent from such statues as the Hermaphrodite from Pergamon in Istanbul (fig. 58) or the relief in Istanbul, No. 90. Furthermore, many sculptures in the vigorous "Pergamene" style have been found elsewhere than in Pergamon (e.g. the giant's head, no. 2506 in the British Museum, in Trebizond, etc.).

4. I. 25. 2.

351, 352) and the smaller one with the adventures of Telephos. These three sets of sculptures give us a vivid picture of Pergamene activities during the second half of the third and the first half of the second century B.C. We know that for their production artists were employed not only from Pergamon, but from Athens, Ephesos, and Rhodes,[5] so that we must beware of claiming as Pergamene qualities which may be characteristic of their time rather than of one place.

As examples of second-century work from other localities we may mention the sculptures of the temple at Lykosoura by Damophon (figs. 816–20), the statues from Priene,[6] and the reliefs from Magnesia in the Louvre[7] (figs. 457a, b) and from Lagina in Istanbul (figs. 458a, b[8]). A series of portrait statues found at Delos (published in *Délos, 13*) dates from the middle of the second century to about 88 B.C., the year of the sack of Delos (cf. fig. 257). The first century B.C. was an age chiefly of copying and adapting former creations. The Borghese warrior (fig. 113) signed by Agasias of Ephesos and the Belvedere torso (fig. 836) signed by Apollonios of Athens, evidently reproduce second-century works by able copyists.

It is difficult during this Hellenistic period to trace a consecutive development. On the whole we may say that the earlier traditions are still strong in the late fourth and the early third century, while the later Hellenistic age is characterized both by a baroque realism and a rococo style with genre subjects. But there is also a constant harking back to earlier types, so that we get classicist and realistic work side by side. Taken as a whole the Hellenistic period presents a singularly varied spectacle compared with the steady trend of the earlier epochs. Fortunately, a great impetus was given to art by the activities of the Hellenistic princes in Pergamon, Alexandria, Rhodes, and elsewhere. In these products we observe an enlargement of sympathy and so of scope. Allegorical subjects, rustic scenes, figures in violent movement, languid women, old men, and children are favorite themes, and they are moreover treated with a new realism. The art of portraiture is developed (cf. supra) and an interest is taken in the representation of landscape. It was not until Rome conquered the Greek states one by one that creative Greek art practically stopped.

The Greek View of Life

IN conclusion, before we pass to our next chapter and to the consideration of the sculpture itself, let us pause a moment to consider what was the view of life that was evolved by this Greek civilization. What was the background of ideals against which Greek sculpture was created?

CIVIC IDEAL The civic ideal of Athens at the height of her power (431 B.C.) is admirably brought out in the famous funeral speech of Perikles as recounted by Thucydides[9] in his succinct, pregnant style. Briefly and with restraint Perikles enumerates the things

5. Fraenkel, *Inschriften von Pergamon*, pp. 70–84; Pliny, *N.H.* XXXIV. 8 a.
6. Wiegand and Schrader, *Priene*, pp. 366 ff. 7. *Catalogue sommaire des marbres antiques*, no. 2881.
8. Mendel, *Catalogue des Sculptures*, nos. 204, 205, 229. 9. II. 35 ff.

that Athens values, that make up her creed of life. They are, first, a democratic form of government where "the administration is in the hands of the many and not of the few," where "the law secures equal justice to all alike," and where "the claim of excellence is recognized," so that "when a citizen is in any way distinguished, he receives public advancement, not as a matter of privilege, but as the reward of merit"; in short where "a man may benefit his country whatever be the obscurity of his condition." It is not a blatant democracy: "A spirit of reverence pervades our public acts; we are prevented from doing wrong by respect for the authorities and for the laws, having an especial regard for those which are ordained for the protection of the injured as well as for those unwritten laws which bring upon the transgressor of them the reprobation of the general sentiment." And in this democracy it is individual responsibility that is fostered: "We regard a man who takes no interest in public affairs, not as harmless, but as a useless character; and if few of us are originators we are all sound judges of a policy." Courage and skill in warfare are encouraged, not, as at Sparta, by intensive military training but by an all-around education: "Whereas they [the Spartans] from early youth are always undergoing laborious exercises which are to make them brave, we live at ease, and yet are equally ready to face the perils which they face." "And thus our city is equally admirable in peace and in war. For we are lovers of the beautiful, yet simple in our tastes, and we cultivate the mind without loss of manliness. Wealth we employ, not for talk and ostentation, but because of the opportunities for action which it affords." (And let us here remember that the wealthy were called upon to bear heavy expenses for the state, such as the defrayal of trierarchies [i.e. the maintenance of warships], of the *choregia* [the equipment of the costly choruses of tragedies, etc.], and of embassies to Delphi, etc., which the patriotism of the city demanded to be in a fitting style.) The brilliant festivals with their colorful processions, the contests of athletic prowess, music, and literature, the unsurpassed art of the Periklean age are thus simply described: "We have provided for our minds very many relaxations from toil; we have regular games and sacrifices throughout the year;[10] our personal establishments are handsome; and the delight which we daily feel in these things banishes vexations." An amazingly concise and eloquent description by someone who does not believe in long speeches; for he proceeds with this appeal: "Instead of listening [to a discourse on a brave defense] I would have you day by day fix your eyes on the greatness of Athens, until you become filled with love of her."

As a preparation for this civic life the young Athenian was trained in athletics and in music (cf. p. 21). We know that athletic prowess was encouraged by the games at Olympia and elsewhere and that to the victor was given great honor. But even in our days of sport enthusiasm some of Pindar's odes in praise of these young ath-

ATHLETICS

10. There were about seventy feast days in the year. The great Panathenaia took place once every four years and lasted six to nine days. It consisted of musical and athletic contests, warlike exercises, torch and boat races (at the Peiraieus), and an impressive procession immortalized for us on the Parthenon frieze.

letes seem almost excessive in tone. But we must remember that to the Greeks, at least to the enlightened ones, a perfect body was also a means to a higher end: "In keeping the harmony of his body in tune, his constant aim is to preserve the symphony which resides in the soul."[11]

MUSIC

This "symphony" was fostered by music: "The music master makes rhythm and harmony familiar to the souls of boys, and they become gentler and more refined and having more rhythm and harmony in them they become more efficient in speech and in action. The whole life of man stands in need of good harmony and good rhythm."[12]

Greek literature is full of this ideal of harmony and temperance: "A day can prostrate and a day upraise all that is mortal; but the gods approve sobriety and forwardness abhor."[13] "God has everywhere assigned superiority to the mean, though the ways of his administration vary."[14] The underlying theme indeed of most Greek tragedies is the punishment of ὕβρις (insolence). The procession of maidens in the Parthenon frieze (fig. 305), and such figures as the Idolino (figs. 47, 48) and the Farnese Diadoumenos (fig. 665) show us this ideal of reverence and temperance embodied in art.

LOVE OF
KNOWLEDGE

But what the Greeks considered most characteristic of themselves was love of knowledge: "The spirited element . . . is attributed . . . to the natives of Thrace, and Scythia, and generally speaking of the northern countries; the love of knowledge would be chiefly attributed to our own country; and the love of riches people would especially connect with the Phoenicians and the Egyptians."[15] This "knowledge" comprised, for the elementary education, reading and writing (included in music, μουσική), mathematics, and the study of the poets, especially Homer (the average Greek seems to have known his *Iliad* and *Odyssey* by heart). A promising youth would proceed to natural science, rhetoric, grammar, and above all philosophy; for his nimble mind was ever ready for speculation. Plato in the Academy, Aristotle in the Lyceum, and the prominent Sophists supplied this need for higher education. The quality of this speculation is shown by the saying which Plato had put over the Academy: "Let no man ignorant of geometry enter here." And the wide range of knowledge covered by the educated Greek is suggested by the variety of subjects on which he wrote. Not many learned men of today would write authoritatively on law, kingship, piety, and the origin of the universe,[16] or combine the professions of an astronomer, a geometer, a physician, and a legislator.[17] In Greece this was the rule rather than the exception.

FESTIVALS

And then the Greek loved spectacles and sights. It was part of his joy of life and of his aesthetic sense: "Does he [the tyrant] not bury himself in his house and live for the most part the life of a woman, while he positively envies all other citizens who

11. Plato, *Republic* IX. 591.
13. Sophokles, *Ajax* 131 ff.
15. Plato, *Republic* IV. 435.
17. Like, e.g., Eudoxos of Knidos, cf. Diog. Laertios VIII. 86.

12. Plato, *Protagoras* 326 B.
14. Aischylos, *Eumenides* 520.
16. Like, e.g., Akellos, cf. Diogenes Laertios VIII. 80.

travel abroad and see grand sights?"[18] It is to satisfy this love of "grand sights" that the many processions and festivals were instituted in Greek life.

It has often been noted that the Greeks rarely speak of art. Compared with us, indeed, they are strangely inarticulate on the subject. But then they were an extraordinarily artistic nation in whom art was evidently taken for granted. Even so their power of analysis enabled them here, too, to judge clearly. Art to them was an end in itself, not a means to teach something else. "Have the arts severally any other interest to pursue than their own highest perfection?"[19]

Interwoven into each one of these Greek ideals was religion. There was the religion of certain prescribed rites and sacrifices in the worship of the various gods and goddesses, a merely formal observance day by day, and yet one which continually connected life with immaterial values; and there was the religion which transcended current beliefs and found its popular expression in the Eleusinian mysteries or produced a mystic like Plato to whom the objective world was merely a symbol of reality. But however deep or shallow, however analytical or unquestioning, this religion stirred the Greek soul to aspiration and creation.

RELIGION

Public life, then, service to the state in time of peace and war, the cultivation of the body and the mind by athletics, music, poetry, mathematics, and philosophy, relaxation in games, the theater and processions, and a reverent worship of the supernatural —these made up the chief activities of an Athenian citizen. It is a radiant picture which Athens presents to us of a full and rounded life, one of the sanest that man has evolved; but in fairness we must remember that this life was only for the select—the male Athenian citizens—and that women, metics (resident aliens), and slaves were excluded from much of it. It has been computed[20] that in Perikles' time there were in Athens 150,000 to 170,000 citizens, 35,000 to 40,000 metics, and perhaps 80,000 to 100,000 slaves (the totals comprise men, women, and children). The metics were not allowed to vote or hold political office. The slaves, though from all accounts generally well treated and allowed considerable independence of action, had not, of course, the same privileges as the citizens. And the women mostly led a quiet life indoors, apart from the intellectual and athletic life of the men. This exclusion of part of the population from what was most valuable in Greek life we must remember in our estimate of it.

18. Plato, *Republic* ix. 579. 19. Ibid., i. 341.

20. No actual statistics are available; cf. Tod, *Cambridge Ancient History*, v, p. 11; Gomme, *Population of Athens*, pp. 21 f.; Westermann, *Harvard Classical Studies*, Special Vol. (1941), p. 469.

THE GENERAL CHARACTERISTICS OF GREEK SCULPTURE

Before studying Greek sculpture in detail we must view it as a whole and analyze its general characteristics. Perhaps nothing could bring home to us better the difference in horizons between the Greeks and ourselves than the comparison of a work such as Bourdelle's Beethoven (fig. 1) with, let us say, the head of Kladeos from Olympia (fig. 2). Both are great works of art. In each the sculptor has been able to sum up the spirit of his age, and to lift it to a spiritual plane. But what a contrast between the fresh, forward-looking purity of the one and the brooding comprehension of the other! The life that was simple and joyous has become infinitely complex. For we must remember that when the Greeks of classical times began their career civilization was still young. Everything that has happened in the last three thousand years was to them nonexistent. It is difficult to realize at once what this implies. It means that their artistic background was confined to the products of Egypt, Western Asia, and, in part, Crete; and even of these their knowledge was limited, especially in literature, for what existed of Eastern writings was not easily accessible. Their own past was dimly remembered in the form of myths and legends. So practically the only literature they knew were the poems of Homer and Hesiod; the only history they were cognizant of was the Trojan War. In religion they had come in contact in the East with beliefs in heterogeneous gods and monsters, and from this they had developed the anthropomorphic religion found in Homer and Hesiod. In other words, most of the influences —artistic, intellectual, and religious—which act upon the modern man were as yet unformed. The background was simpler and the human mind had the freshness of youth.

In the centuries in which the classical Greek civilization was developed great changes occurred. From its primitive beginning it passed through many stages to a more complicated outlook, and during this time it created a large part of what constitutes our Western culture. Nevertheless, it is possible to view the Greek mind as a whole. We will endeavor to do so and to see how its quality determined the character of Greek sculpture.

THE GREEK
MENTALITY

The three outstanding characteristics which strike us when we analyze the Greek mentality applied to art are directness, agility, and a feeling for beauty.

The directness was no doubt largely the result of a simpler outlook. It is a quality which we with our more complicated natures have lost; and when we come in contact with it, it affects us like a fresh breeze on a sultry day. It enabled the Greeks to keep their eyes on the essentials without the distraction of superfluous details. In literature this shows itself in their vivid similes, their keen observation, and also in a bald sincerity in stating facts.[1] Take such a description as Aischylos': . . . ταχύπτεροι πνοαί, . . . ποντίων τε κυμάτων ἀνήριθμον γέλασμα, παμμῆτόρ τε γῆ[2] (Swift-winged winds . . . , and numberless laughter of waves, and earth the mother of all). Could there be a truer and more beautiful description of the much-besung wind and sea and earth? It reaches out to the chief quality of each, transforms it into poetry, and creates thereby something fundamental and permanent. Or take Klytaimnestra's analysis of her emotions (in Sophokles' *Elektra*[3]) when she hears of the death of her son Orestes, whose vengeance she dreaded: "Are these glad tidings? Rather would I say sad but of profit." It is a simple statement of the case, without pretense or blinking of facts; and perfectly concise. Greek literature is full of these pregnant, clear-eyed sayings. The much-quoted epitaph, "His father Philip laid here to rest his twelve-year-old son Nikoteles, his high hope,"[4] is another example of this combination of sincerity and conciseness. What could be added to the essential facts conveyed in "laid to rest," "twelve-year-old," and "high hope" which would not be a superfluity? And let us remember Aristotle's definition of superfluities. "That which makes no perceptible difference by its presence or its absence is no real part of the whole."[5]

It is this feeling for the whole unencumbered by superfluities which gives Greek art its peculiar greatness. At the very beginning of his career the Greek sculptor went straight to the essentials. In the early statues of Kouroi (cf. figs. 17 ff.) why is it that in spite of their stiffness and faulty construction they are full of life? Because the important functional parts of the body are properly accented, the details are omitted, and each and every part passes into and connects with the adjoining part. In the kouros of Melos, for instance (fig. 21), what a clear realization we obtain of the anatomical structure—the chest, the abdominal region, the pelvis, the kneecap, and ankle; the arms are not suspended, but seem to grow, from the shoulders, the legs from the trunk, the head from the neck; and so on with every member. Moreover, the rendering is simplified; the important parts are made to stand out and there are no incidents, no superfluities. The result is that we have the impression of an organic whole which can function and live. And this is true of all Greek sculpture during its several periods.

The second outstanding characteristic of the Greeks we may take to be their agility. It was stimulated doubtless by the geography of the country. For the combination of

1. For an illuminating discussion of this subject, cf. Livingstone, *The Greek Genius and Its Meaning to Us.*
2. *Prometheus Bound* 88 ff. 3. 766.
4. Kallimachos *Epigr.* 19. 5. *Poetics* 8. 4.

mountains and sea tended both to separate the Greek peoples from one another and to stimulate emigration. The mountains acted as barriers and the sea invited adventures. Hence the formation of a number of separate communities distributed over a large area including Greece, western Asia Minor, the Aegean Islands, southern Italy, and a few outlying places in Spain and France. This double circumstance ensured on the one hand compact community life in small city-states, on the other the variety of stimulus derived from heterogeneous peoples; all of which made for lively activity, because individual responsibility in a small state and rivalry with other states are apt to invite energy. This striving for adventure and for knowledge led the Greeks into many untried paths. It is responsible for the amazing number of their discoveries in almost every field of intellectual activity. "To be learning something is the greatest of pleasures, not only to the philosopher but also to the rest of mankind, however small their capacity for it," is Aristotle's definition of happiness[6] of which Plato's more imaginative rendering is, "He whose heart has been set on the love of learning and on true wisdom and has chiefly exercised this part of himself, this man must without fail have thoughts that are immortal and divine."[7]

In sculpture this agility of mind and this love of knowledge are likewise responsible for a great deal. They meant progress and development. Without them Greek sculpture might have remained stationary, never surpassing the attainments of Oriental artists. The Egyptian sculptor, for instance, with all his wonderful feeling for the value of essentials, practiced his art for thousands of years without solving some of its difficulties. He followed throughout the old law of frontality, his knowledge of anatomy remained primitive, and in his reliefs proper perspective was never attained. The agile mind of the Greek determined to wrestle with these problems. Not content with what had been accomplished before him, he was eager to solve new problems, and so he started out on his adventure of representing a human body in all manner of postures, constructed according to nature, with its parts in proper relation and perspective, both in the round and in relief. To a pioneer in the field it was a formidable task. But with remarkable perseverance the Greek artist accomplished it, and his solution of these problems was like the removal of shackles which had hampered the free development of art for generations. The human figure, by its movements and gestures, could henceforth express action and emotion. In a century or two we pass from the Apollo of Tenea (fig. 24) to the Idolino (figs. 47, 48), from the Nike of Delos (figs. 82, 83) to the Nike of Paionios (figs. 687, 692), from the Spartan ancestor relief (fig. 468) to the stelai of Hegeso and Ampharete (figs. 466, 467).

Feeling for Beauty A love of truth and of knowledge could easily have made realists of the Greeks; but their realism was transformed into idealism by their third great characteristic—their feeling for beauty. Beauty to them was not something apart from daily life but interwoven into every phase of it. The beauty of their own landscape undoubtedly quickened their sensibilities in this direction. Its grandeur and suavity, its rich colors and

6. *Poetics* IV. 4. 7. *Timaios* 90 A.

fine contours, its elusive, subtle quality would inevitably influence a young, impressionable people. It would incline them to regard beauty as an integral part of their lives and to find their happiness in the loveliness of their immediate surroundings. Their sense for beauty grew so strong that it became the underlying principle in their lives. For they made a great discovery—that goodness and beauty are identical, not only figuratively but actually. "Virtue it appears will be a kind of health and beauty and good habit of the soul; and vice will be a disease and deformity and sickness of it," says Plato in his *Republic*;[8] and with the Greeks it was a generally accepted principle. "Then good language and good harmony and grace and good rhythm all depend upon a good nature, by which I mean a mind that is really well and nobly constituted in its moral character," Plato says again in his *Republic*;[9] and in his *Symposion*:[10] "From the love of the beautiful has sprung every good in heaven and earth." Most eloquent of all is the current Greek expression for a gentleman—καλὸς κἀγαθός, "beautiful and good." As we have seen (pp. 15 f.), Greek and especially Athenian education was planned directly with this end in view; and athletics and music were given the most prominent places, one to foster the beauty of the body, the other of the mind. That exercise develops the body is easily accepted by us today; but that art and music make men good is not so generally believed. Yet the Athenians practiced this creed with good results; at least they won a reputation, Plato tells us, "throughout Europe and Asia" "for the beauties of their bodies and the various virtues of their souls."[11] Let us learn from Plato how this can be accomplished. In dealing with the education of his guardians in his *Republic*,[12] he gives us a specific account. Sokrates asks: "Ought we not to seek out artists who by the power of genius can trace out the nature of the fair and the graceful, that our young men, dwelling as it were in a healthful region, may drink in good from every quarter, whence any emanation from noble works may strike upon their eye or their ear, like a gale wafting health from salubrious lands, and win them imperceptibly from their earliest childhood into resemblance, love, and harmony with the true beauty of reason?" And when Glaukon assents Sokrates continues: "Is it then on these accounts that we attach such supreme importance to a musical education, because rhythm and harmony sink most deeply into the recesses of the soul, and take most powerful hold of it, bringing gracefulness in their train, and making a man graceful if he be rightly nurtured?" And finally he sums up, "There can be no fairer spectacle than that of a man who combines the possession of moral beauty in his soul with outward beauty of form, corresponding and harmonizing with the former, because the same great pattern enters into both." Translated into conduct this aesthetic ideal became a reverence for sobriety and temperance. As an imaginative, southern people the Greeks no doubt had strong feelings difficult to control; but they recognized that temperance was a kind

8. IV. 444.

9. III. 400.

10. 197.

11. *Timaios* 21 A–25 D.

12. III. 401–402.

of harmony, and therefore desirable. So μηδὲν ἄγαν, "nothing too much," became their motto, and ὕβρις, "insolence," their abomination.

Naturally in the art of sculpture the Greek sense of beauty found a fruitful field. It is directly responsible for the most characteristic quality, idealism. The creation of beauty was the sculptor's chief interest and his types are selected with this end in view. "But when you want to represent beautiful figures," says Sokrates to the artist Parrhasios, "since it is not easy to find everything without a flaw in a single human being, do you not then collect from a number what is beautiful in each, so that the whole body may appear beautiful?"[13] And Parrhasios admits that such is their practice. This sums up very simply the Greek point of view. It is not realism and truth to nature but perfection of form that the Greeks consciously strove for. And this beauty of form was further enhanced by their feeling for design, which gave to their work a highly decorative quality. It is particularly strong in the archaic period when stylization took the place of correctness of modeling, but it was not lost even in the more naturalistic periods, and always gives style to the whole—the style which distinguishes art from nature. Indeed it is this sense of composition which the Greek regarded as perhaps the most important element in a work of art. It is clearly brought out in the definition of beauty quoted by Plotinus (as the opinion of some):[14]

> What is it that impresses you when you look at something, attracts you, captivates you, and fills you with joy?
>
> The general opinion, I may say, is that it is the interrelation of parts toward one another and toward the whole, with the added element of good color, which constitutes beauty as perceived by the eye; in other words, that beauty in visible things as in everything else consists of symmetry and proportion. In their eyes, nothing simple and devoid of parts can be beautiful, only a composite.

This joy in "symmetry and proportion" can be clearly detected in all Greek art.

Another important factor in the "idealism" of Greek sculpture is its simplification. The Greek sculptor felt that to translate the human body into a work of art he must harmonize the multiformity and restlessness of nature and create a unity. We have spoken of his subordination of parts to the whole, his elimination of superfluous details, his restriction to the essentials. Equally important was his simplification of the design. His statue was contained in a unified space,[15] that is, a space with restricted depth. For instance, if the kouros of Melos (fig. 21) were placed between two sheets of glass the space occupied by the statue would be uniform; no part would unduly protrude; the whole figure is designed as a compact whole. This becomes specially noteworthy in groups or in figures in motion. In the Rhombos statue (figs. 5, 6) a

13. Xenophon, *Memorab.*, III, 7 ff.

14. *Ennead* I. vi. i. Though Plotinus lived in the third century A.D. his teachings are often borrowed from Plato and other philosophers of the fifth and fourth centuries B.C.

15. Cf. on this subject Hildebrand's remarks in his illuminating book, *Das Problem der Form*.

sheet of glass applied to the front would strike the calf's head, the man's head, and the forearms. One applied to the back would touch the calf's body and the man's body. In the fifth-century Niobid in the National Museum in Rome (fig. 4), the farther arm and leg are in one plane, the nearer arm and leg are in another; the volume is conceived as a relief. That such compactness is not true to nature we realize when we think of how a man carrying a calf would look in reality—how his arms, the calf's legs and head would extend in different directions, considerably beyond the plane of his head and body. Or if a living human being were to take the pose of the Niobid sinking down on one knee and lifting one arm to extract an arrow from her back, her legs would probably be in one direction, her arms in another. We should get an effect similar to the Falling Gladiator by Rimmer (fig. 7), where the arms and legs are designed in opposite planes; so that if we should apply our imaginary sheets of glass the depth occupied would be considerable. For this real air space the Greek sculptor substituted an ideal space unity. It is important to understand and realize this characteristic of Greek sculpture; for it is very largely through this conception of space that a Greek statue acquires its dignity and grandeur. A figure thus carved can be taken in by the human eye without distraction, and thereby attains that sense of quiet and detachment which makes art a refreshment to the spirit.

This "relief conception," as it has been called by Hildebrand, was inherited by the Greeks from the Egyptians; it was stimulated by the universal practice of stone carving, in which both the figure and the space surrounding it were potentially enclosed in the block, by the demand for architectural sculpture with its uniform depths of pediments and metopes. That the Greeks recognized its importance from an artistic point of view is shown by their practice of it even when working in bronze or with figures in which no background had to be considered. It is not until the very latest period, in such creations as the Dirke monument (fig. 837), that this conception is given up, and the result is, we feel immediately, a certain restlessness.

Still another determining element in the idealistic impression of Greek sculpture is beauty of contour. So much of Greek sculpture was out in the open to be viewed from a distance that the outline counted for much; and it is the lovely undulating outline of a Greek statue which impresses us from the first. Indeed this feeling for contour was so strong in the Greek artist that it shows itself in all his work, not only in the design of the whole figure, but in every part of it—the oval of the face, the swing of the eyelids, the curve of the lips, the drawing of the muscles and of the folds of the drapery. It is an extraordinarily strong sensitivity for rhythmic line—which found expression also in the shapes of vases and in vase painting.

It is, then, sense of structure, simplification of form and design, harmonious proportion, and rhythmic contour that stand out as the salient features of Greek sculpture. By them it acquires the grandeur which we feel in its presence. They give it its spiritual quality. And since art is a spiritualization of nature it is this spiritualizing quality which is fundamental, and without which representation is not art.

From our analysis of the Greek mind and its influence on Greek sculpture we must pass to the chief uses of sculpture in Greece; for the nature of the demand of course affects the character of the supply.

Sculpture in Greece was largely religious. Its chief use was for the decoration of temples either as pediment groups, friezes, or akroteria, for the cult statues of deities placed in the cella, and for votive statues and reliefs dedicated in sanctuaries. A large proportion of the sculpture that has survived is therefore architectural. This demand early developed the technique fo relief as well as the composition of large groups (pp. 90 ff.). We should never have had the superb creations of the western pediment of the Olympia temple (fig. 391) or of the Parthenon frieze but for the long history which preceded them and which gave the sculptor ample opportunities of development. But these pediments and friezes could not vie in importance with the cult statues placed in the interiors of temples. It was around them that the popular worship centered and it was by them that the people obtained a concrete realization of their gods. And so to embody his vision of the deity in a great temple statue was the highest task of a Greek sculptor. Unfortunately hardly any of these statues have survived. We have only descriptions and small reproductions by which to visualize the colossal chryselephantine statues by Pheidias, Polykleitos, and Alkamenes. In every estimate of Greek sculpture, therefore, we must remember that its finest creations have been irretrievably lost.

Another important demand for sculpture in Greek times was created by the custom of erecting statues of the victors in the athletic contests given in honor of Zeus, Poseidon, Hera, etc. The statues stood in the public places and in the sacred enclosures in which the games had taken place, and the young athletes were mostly represented nude, for that is how they had engaged in their contests. This practice and the athletic ideal which prompted it led to the development of the nude male type as a favorite form. Not only athletes but gods and heroes were so represented. In this series of nude male figures the ideal human form was gradually worked out and became one of the greatest achievements of Greek sculpture.

Commemorative sculptures which are so popular today also played an important part in Greece. A significant victory would be celebrated by the erection of a statue or group, like the Nike of Paionios at Olympia (fig. 682), or the bronze Athena of Pheidias on the Akropolis (fig. 635) which was an offering "from the spoils of the Persians who landed at Marathon." The group of the Tyrannicides (figs. 609 f.) set up on the marketplace would remind Athenians every day of their liberation from the tyrants and of the value of their democratic institutions. We hear also of large groups of several figures, e.g. statues of Athena, Apollo, Miltiades, Erechtheus, Kekrops, Pandion, Aigeus, and five other heroes, another offering "from the spoils of Marathon" by Pheidias. Such groups in the round must have been remarkable achievements, and it is a grievous loss that they have disappeared. The erection of portraits of distinguished men became increasingly popular as time went on.

Besides these more or less public uses of sculpture there was a large private de-
mand for grave monuments. The chief forms adopted in Athens were slabs with re-
liefs representing the departed, either alone or with sorrowing relatives, statues in
the round, slabs crowned by finials, and vases decorated with reliefs. They supply us
with some of the most touching and most "personal" representations we have in Greek
art. These sculptured grave monuments remained in vogue until the end of the fourth
century B.C. when the "anti-luxury" decree of Demetrios put a sudden stop to this
artistic expression (p. 113). Their constant use during three centuries greatly fur-
thered the development of relief technique.

It is important to become familiar also with the subjects represented in Greek
sculpture; for the Greek artist had an entirely different repertoire from our own.
Early Christian, medieval, and Renaissance art are from this point of view much
nearer to us, since they need little explanation; but when we enter the Greek field we
are stepping into an unknown land; and we must be careful to leave behind us any
preconceptions we may have.

SUBJECTS

We have seen how the athletic ideal helped to concentrate interest in the human
figure. It accustomed people to seeing the human body in all manner of postures and
to appreciating its beauty. Moreover, the Greek with his love of the normal had a
tendency to humanize everything. His gods and goddesses are no longer monsters, as
often in Eastern art, but assume human form; so do the nymphs, satyrs, centaurs,
Tritons, and the other personifications of nature. Even when these start with hybrid
shapes they soon lose their animal characteristics and gradually become more and
more human. And so Greek sculpture consists largely of figures of human beings rep-
resenting divinities, heroes, and athletes. Animals and decorative motives find a place
and an important one, but they are nevertheless secondary. The human figure is the
theme par excellence.

Joined to this humanizing tendency the Greeks had a love for storytelling. Much
of Greek religion consists of stories about gods and goddesses and heroes; and these
manifold imaginative tales would naturally make a great appeal to the artist. They
supplied him with the most varied material, which he used so constantly that definite
standardized types soon emerged. Plato's words about literature apply also to sculp-
ture and painting—that art must eschew novelty and be framed after the pattern of
those foundation myths which the poets have made familiar. So we must become con-
versant with these foundation myths. And a delightful process it is; for these stories
have the freshness and imaginative quality of a poetic people. In entering this world
of Greek fiction with its contests of Lapiths and centaurs and Amazons, its wonderful
deeds of heroes, and its manifold adventures of gods and goddesses, we feel very near
the beginning of civilization. We sense the vivaciousness and naïveté of youth. No
doubt some of the myths have a historical background; some are certainly rooted in
actual experience; but the poet when he took his material transformed fact into fancy
and then the artist translated this fancy into a beautiful picture. And so in our inter-

Mythological

pretation of Greek mythology in Greek art let us endeavor to catch the lovely simplicity of these spirited stories directly and concretely told. It is easy for us with our modern, complicated minds to read our own thoughts into these representations and endow them with farfetched symbolic significance. But thereby we lose the early Greek flavor and become more like the late Latin commentators. Take, for instance, the tale of the birth of the goddess Athena from the brain of Zeus. To a later artist it would inevitably have suggested the coming of the spirit of wisdom from the thought of the mightiest god, and he would have tried to convey the idea with appropriate grandeur. The Greek instead adopted a version of almost childlike literalness (fig. 3). We have Zeus in the center, Hephaistos splitting his head open with his axe, a little Athena emerging fully armed, and the goddesses of childbirth ministering on either side; no symbolism, only a refreshing fairy tale. Or take Theseus and Herakles in their many contests with monsters. How close to us the thought of the knight purging the world of evil, how dear the wish to see this moral conveyed! But to the Greek artist the hero was always Herakles with his lion's skin and club or Theseus with his little chiton and his sword (fig. 11) or Perseus with his distinctive paraphernalia, tackling in various ways these dangerous creatures. The whole interest lies in the contest, in the story, and in its artistic rendering.

In this connection we may again quote Plato;[16] for in his analytical time a few learned people were beginning to lose the childlikeness of earlier days and search for farfetched interpretations. When Sokrates is asked by young Phaidros whether he believes in the story that Boreas carried off Oreithyia he gives an illuminating answer, which it may be well to quote at length, for it states the case admirably: "If I disbelieved," Sokrates says,

> as the wise men do, I should not be extraordinary; then I might give a rational explanation, that a blast of Boreas, the north wind, pushed her off the neighboring rocks as she was playing with Pharmakeia, and that when she had died in this manner she was said to have been carried off by Boreas. I think, however, such explanations are very pretty in general, but are the inventions of a very clever and laborious and not altogether enviable man, for no other reason than because after this he must explain the forms of the Centaurs, and then that of the Chimaira, and there presses in upon him a whole crowd of such creatures, Gorgons, Pegasoi, and multitudes of strange, inconceivable, portentous natures. If anyone disbelieves in these, and with a rustic sort of wisdom, undertakes to explain each in accordance with probability, he will need a great deal of leisure. Now I have no leisure for them at all. . . . And so I dismiss these matters and accept the customary belief about them.

Surely our interest also lies in these customary beliefs of the people who produced and enjoyed the art which we are endeavoring to understand. So we cannot do better

16. *Phaidros* 229 D.

than follow Sokrates' advice and not spoil a fairy tale with a laborious mind. We must remember, then, that the only symbolism we shall find in Greek art is the concrete one by which pebbles suggest the beach (cf. fig. 12), a fish the sea, a growing plant the meadow (cf. fig. 9), a pine tree the mountain (cf. fig. 10), a reed the river bank (cf. fig. 8), and a column the house. This practical symbolism was freely used, for such shorthand methods were useful and easily understood, and were thoroughly in line with the Greek tendency to simplification.

The large number of architectural sculptures—the pediments of the temples, the continuous friezes, the metopes—have almost invariably mythological representations—either legends directly associated with the deity to whom the temple was dedicated (e.g. the birth of Athena and her strife with Poseidon in the pediments of the Parthenon), or the familiar contest scenes of Herakles, Theseus, Lapiths, etc. The almost total absence of historical representations is striking. Even in single sculptures erected to celebrate a specific victory such subjects are rare; when Miltiades is introduced in Pheidias' group commemorative of the battle of Marathon[17] he is associated with Athena, Apollo, and various heroes; the representation of Greeks and Persians on the frieze of the temple of Athena Nike is exceptional. We have not a single representation of the battles of Thermopylai or Salamis, of the Peloponnesian War, of the great plague, of the Sicilian expedition; in short, of the outstanding events which formed the chief preoccupation of the Greeks of the fifth century. How different the Romans or the Egyptians and Assyrians with their many friezes recording their triumphs over their enemies; how different we ourselves with some of our war monuments and realistic pictures of contemporary battles! The Greeks, in order to convey the strife and stress of their time, had recourse to mythological contests, or to the semilegendary events of the Trojan War.[18] These were far enough removed to admit of safe treatment, which with the constantly changing alignment of the Greek states was probably an important point. In any event, the Greeks knew that history with the strong partisan and bitter feeling it arouses is not an appropriate subject for sculpture. The same is true of contemporary political events. The Greek was distinctly a "political animal." Of all his contributions to mankind he prided himself most on his civic ideal. Every Athenian citizen was a representative in Congress and a legislator in the law courts. But that part of his life was passed over by the artist, and probably for the same reason for which contemporary wars were omitted—that controversial subjects do not belong to the realm of art.

There were some other aspects of daily life, however, which found a place in Greek *Daily Life* sculpture. Not only single statues of athletes but chariot groups were popular dedications; and occasionally even in the fifth century we hear of such genre subjects as

17. Pausanias x. 10. 1. In Mikon's famous painting of the battle of Marathon, Athena and some popular heroes (Theseus, Herakles, and Echetlos) are likewise introduced (Pausanias 1. 16).

18. We have a few exceptions to this general rule in Greek paintings, for instance in the representation of the battle of Oinoe in the Poikile (Pausanias 1. 15).

the statue by Styppax of "a slave roasting entrails and kindling a fire with a blast from his swollen cheeks";[19] and in the Hellenistic period such themes greatly gained in vogue, especially in bronze and terracotta statuettes (cf. p. 171). But the most frequent representations of daily life—except of course in vase-paintings—occur on the grave monuments of the fifth and fourth centuries where the departed were shown in their favorite occupations, as their families liked to remember them. To us these pictures of Greek life are singularly precious; for they are contemporary illustrations of familiar happenings and as such eloquent and trustworthy. We see here men represented as warriors or athletes; women busy with their spinning or putting on their jewelry; children playing ball or caressing their pet animals; and in the family groups we gain a realization of a happy and affectionate family life. And, always, these renderings are simple and direct—with no trace of sentimentality or exaggeration, but with the Greek note of serenity which makes of them something typical and permanent. We are reminded of Nietzsche's famous saying: "Die Griechen sind, wie das Genie, einfach: deshalb sind sie die unsterblichen Lehrer."

19. Pliny, *N.H.* xxxiv. 81.

CHAPTER 3

THE HUMAN FIGURE

Greek monumental sculpture in stone apparently began about the middle of the seventh century B.C. We have no reliable evidence as yet of large stone statues or reliefs from the geometric period. Though excavations have brought to light temples of that epoch in various localities the cult images in these sanctuaries were evidently small or perhaps of wood. In any event, the earliest rather large Greek sculptures now extant—in stone as well as in bronze or terracotta—may be dated late in the second quarter of the seventh century.

The Greek sculptor of that time had a long heritage that determined his start. He had before him on the one hand what had survived of the arts of his predecessors in his own land—the Minoans and the Mycenaeans, now considered the earliest known Greeks—and on the other hand those of his Oriental neighbors, the inhabitants of western Asia and of Egypt. The influence of Asia (Mesopotamia, Phoenicia, Syria) is evident in the bronze, terracotta, and ivory statuettes that have come to light all over the Greek world. It is seen especially in the early draped figures (cf. e.g. fig. 276), and in certain conventions, such as the spiral curls arranged symmetrically to right and left. The influence of Egypt is particularly marked in the early standing youths, the archaic kouroi (cf. figs. 16 ff.). The opening up of Egypt to the Greeks during the time of Psammetichos I, who gave the "Ionians and Carians" "places to dwell in on either side of the Nile" in recognition of the help given him in the conquest of Egypt, i.e., about 660 B.C.,[1] and the foundation of the Greek colony of Naukratis, probably about 650 B.C., doubtless played their part. We can imagine the sensitive Greeks beholding for the first time the impressive Egyptian sculpture and having their whole outlook changed thereby. How great this Eastern influence was we can see when we compare the "geometrized" products of the ninth and eighth centuries (fig. 13) with those of the two succeeding centuries.

In the seventh and sixth centuries, then, we find a series of primitive figures bearing a certain relation to the products of other nations, but nevertheless highly individual. Change from this beginning was slow and deliberate. At first only a few types were attempted for single statues and used again and again with slight variations: a standing, seated, striding, flying, or reclining figure was represented according to an accepted scheme adhered to by sculptors from every part of Greece. But within this scheme each could make his individual contribution. And gradually by concentrating

1. Cf. Herodotos, II. 154.

on his few themes, not distracted by constantly creating new compositions, he was able to solve the difficulties which beset him. Each new conquest became common property and formed a new starting point. And so the forward march continued, not only in the larger statues, but in small bronze and terracotta statuettes, and along parallel lines in vase-painting, engraving, and goldwork. It is an amazing feat of concentration, and could only have been obtained by that rare combination found in the Greeks of progressiveness and conservatism; eager for novelty, they nevertheless grafted the new on the old. Let us watch the story unfold itself, for to follow it step by step is an artistic education and pleasure of the first order. Our plan will be to pursue the principal types adopted for the human figure through the various centuries, restricting ourselves more or less to the undraped examples, since we shall deal with drapery in a separate chapter.

The Standing Figure

SEVENTH AND SIXTH CENTURIES

IN the opening chapter we find the standing figure in strictly frontal position, with the left foot generally a little advanced, the arms held close to the sides, occasionally bent at the elbow, the hands usually clenched.[2] It shows the Egyptian scheme of broad shoulders, narrow waist, and small flanks. We may take for the beginning of our story two marble torsos from Delos[3] (cf. fig. 16) and a bronze statuette from Dreros[4] (fig. 15) of the mid-seventh century B.C. The former are stiff and flat, almost like a four-sided plank. In the bronze statuette there are attempts at anatomical construction, but there is little modeling. From these beginnings we note a continuous progression toward a better realization of both the general shape and the details of the human figure; and throughout there are retained a fine unity and decorative sense. Indeed the simplification in the rendering of form imparts a grandeur to these early figures. The kouroi from Sounion[5] (cf. fig. 18), from the Dipylon[6] (fig. 144), and in New York[7] (fig. 20), Kleobis and Biton[8] (cf. fig. 19), of the late seventh to the early sixth century show us the sculptural conception of that time. The shape displays the four separate faces of the rectangular block from which it was carved and natural forms are translated into interrelated patterns (for comparison, see the anatomical statue by Houdon, fig. 14). Thus the torso is four-sided, the head cubic. The vertebral column is practically straight. The greatest protrusion of the back, seen in profile, is higher than that of the chest. The forearm is turned forward, while the clenched hand is twisted toward the body. The skull is undeveloped. Anatomical details are indicated on the surfaces of the block by grooves, ridges, and knobs. The clavicles are generally

2. In the following account the references are to the third edition of my *Kouroi* (1970), where copious illustrations and other references will be found.

3. *Kouroi*[3], figs. 20–24, p. 27. 4. Ibid., figs. 12, 13, p. 26.

5. National Museum, Athens, nos. 2720 and 3645. Papaspiridi, *Guide*, pp. 25 f., and S. Karouzou, *Cat.*, pp. 5 f., 7; Richter, *Kouroi*[2], nos. 2, 3.

6. National Museum, Athens, no. 3372 (head), no. 3965 (hand); *Kouroi*[3], no. 6; S. Karouzou, *Cat.*, p. 5.

7. Acc. no. 32.11.1., *Kouroi*[3], no. 1.

8. Homolle, *Fouilles de Delphes*, IV, pls. I, II; *Kouroi*[3], nos. 12 A and B.

marked as flat ridges. The lower boundary of the thorax is indicated by grooves form-
ing an obtuse angle or a narrow arch. In the rectus abdominis three or more transverse
divisions are marked above the navel, instead of the two visible in nature, and they
are merely incised in a flat pattern. The lower region is pointed obliquely, like the
upper, and is too short. The protrusion at the flanks is not indicated. The knees re-
produce more or less the symmetrical arrangement current in Egypt, with the vastus
externus and the vastus internus both reaching equally down to and bulging over the
patella, whereas in nature the arrangement is asymmetrical, with the muscular part
of the vastus externus considerably higher than the other. The kneecap takes the shape
of an approximately rectangular block and there is no indication of the pads of fat
on which it rests. The shins are more or less vertical. The feet stand squarely on the
ground with long toes, more or less parallel to one another and with ends receding
along one continuous line. The malleoli are level.

The kouroi probably from Boeotia[9] (fig. 17), from Tenea[10] (fig. 24), and from
Volomandra[11] (fig. 22), of the second quarter of the sixth century, and the kouros
from Melos[12] (fig. 21) of the mid-sixth century show a great development. The forms
have become more rounded and more modeled. Instead of linear patterns volumes are
coordinated, and the artist is more alive to anatomical construction. The vertebral
column assumes a slight curve; the skull is more domed; there is a slight protrusion
at the flanks; the inner vastus descends lower than the outer; the shin is curved; the
inner malleolus is higher than the outer.

By the third quarter of the century further advance in anatomical knowledge has
been made. The kouroi in Munich[13] (fig. 25) and from Anavysos[14] (fig. 23) and
Keos[15] are excellent examples. The stance is now less rigid. The curve of the thorax is
indicated. Its greatest protrusion front and back is level. The vertebral column as-
sumes its characteristic s-shaped curve. The abdominal region retains its early ren-
dering but is more modeled. The flanks are made more lifelike by the indication of
the iliac crest, with the muscle bulging over it. The transition of the flanks to the rec-
tus abdominis is marked by a groove. The arrangement of the vasti muscles over the
patella is asymmetrical. The toes no longer recede along one line; the second toe
projects further than the big toe and the small toe is short and turned inward. The
lovely contours in these figures and the gently undulating surfaces kept strictly within
the symmetrical scheme make an impression at once of quiet poise and extraordinary
vitality. The various parts appear proportionally interrelated and one form passes
naturally and inevitably into the next.

Since the standing female type during the archaic period was regularly draped we
shall study it in our chapter on drapery; but nude female figures occur occasionally

9. *Kouroi*[3], no. 39. 10. Ibid., no. 73.
11. Ibid., no. 63. 12. Ibid., no. 86.
13. Ibid., no. 135. 14. Ibid., no. 134.
15. Ibid., no. 144.

in bronze statuettes even in the sixth century. We may give as an example the girl from Cyprus in New York (fig. 31).

The climax of these early struggles is reached in the later sixth century. Outstanding examples are the bronze statue from the Piraeus[16] (fig. 26), about 525–520 B.C.; the Strangford[17] and Ptoon 20[18] kouroi (figs. 33, 32) of about 510–500 B.C., the bronze statuettes in New York[19] (figs. 28, 29) and Athens[20] (fig. 30), and the well-preserved statue of Aristodikos[21] (fig. 27). They retain many of the characteristics of the earlier figures. They are still in a symmetrical, frontal pose and are conceived as four-sided, with only four principal views considered—the front, the back, and the two sides—and the modeling is still somewhat flat. But much has been changed. The clavicles have their characteristic s-shaped curve. The swelling of the trapezium on the shoulder is indicated. The chest and back now curve out considerably, sufficiently at least to make us feel that the figure can breathe. The rectus abdominis at last assumes a more natural shape. The upper boundary instead of being pointed forms a semicircular arch and the transverse divisions are indicated, as in nature, with two above and one below the navel; the lower boundary takes the shape of a semicircle as well as its proportion. The flanks are rounded. The interlacement of the serratus magnus with the ribs is modeled beneath the arms. In the knee the vastus internus extends below the vastus externus and forms the distinctive swelling above the kneecap. The small pads of fat below the kneecap are observed. But in spite of this attention to anatomical construction the simplicity and decorative quality of the earlier statues are not lost.

Herewith the general shape of the Greek torso was achieved. It persists through later generations, merely perfected in the direction of greater amplitude of form and harmony of proportion.

FIFTH
CENTURY The first half of the fifth century proved epoch-making in another sphere. A revolutionary change took place through the uneven distribution of the weight of the body and the consequent abandonment of the symmetrical pose. The figure is made to rest more on one leg than on the other, whereby the two sides become different and the median line of the body forms a curve instead of a straight line. It is interesting to mark the various steps in the progression. The turn of the pelvis is at first accompanied by frontal shoulders and with only a slight difference between the two sides of the body, as in the Akropolis youth[22] (fig. 34) and the disk thrower in New York[23] (figs. 35, 36), both datable around 480. Presently one hip is placed markedly higher than the other, as in the Apollo of Olympia[24] (figs. 172, 419) of about 460 and the New York Adorans[25] (figs. 37–39).

16. Ibid., no. 159 bis. 17. Ibid., no. 159.
18. Ibid., no. 155. 19. *M.M.A. Catalogue of Bronzes*, no. 17.
20. In the National Museum, Athens, no. 6445; *Kouroi*³, no. 162.
21. *Kouroi*³, no. 165; Karouzos, *Aristodikos* (1961); S. Karouzou, *Catalogue*, no. 3938, p. 28.
22. Akropolis Museum, no. 698. *Kouroi*³, no. 190. 23. *M.M.A. Catalogue of Bronzes*, no. 78.
24. Treu, *Olympia*, III, pl. 22; Ashmole and Yalouris, *Olympia*, figs. 101, 105.
25. *M.M.A. Catalogue of Bronzes*, no. 79.

The variety and interest gained by this innovation are amazing. The figure suddenly acquires elasticity; it can walk and move about and is no longer confined to one place. And this change also put an end to the old four-sided conception, so that the figure becomes more rounded and natural. The Omphalos Apollo[26] (figs. 40, 41), the Tiber Apollo[27] (fig. 42), and the Boston Herakles[28] (fig. 43), Roman copies of Greek statues of about 470–50 B.C., show a further gain in freedom and mobility. An interplay of planes is achieved by turning the head, the shoulders, the pelvis, the knees in different directions counterbalancing one another. The lines of the eyes, shoulders, and hips are no longer horizontal but incline upward and downward in alternating rhythm. There is a constant interplay of surfaces, and yet the effect is not too variegated, for the whole is kept in a definite scheme. We have evolved from a patterned shape into a moving body. Nevertheless these statues are not a spontaneous expression, but arise from the long evolution of a type. The background of the pattern period gives them grandeur.

Even in these figures, however, the attitude has a lingering stiffness and the shoulders are too broad compared with the rest of the body. The problem remains to give greater ease to the pose, more harmony to the composition. This was accomplished during the second half of the fifth century B.C. It was achieved by further developing the scheme of counterpoise. The counterbalancing movements are accentuated. The median curve is emphasized and the weight is borne entirely by one leg. The figure thereby acquires swing and ease of attitude. Each form is modeled no longer in the dry, hard manner of archaic times, but with more amplitude. The four-sided conception has given way to perfect modeling in the round. Each part appears to point at the spectator as he looks at it, the adjoining portions retreating to the background; in other words, the sculptor no longer restricts himself to a few principal views of his figure but is able to combine a large number into a unified whole. The interrelated patterns of earlier days have given way to a balanced whole with the various parts of the body in proportional relation to one another.

FIG. A. River God Selinos, on a coin
(enlarged)
W. H. Woodward Collection

As conspicuous examples of this developed type we may take the Polykleitan figures of the Doryphoros (fig. 690) and Diadoumenos (fig. 695); the Idolino in Flor-

26. National Museum, Athens, no. 45; Papaspiridi, *Guide*, p. 54, and S. Karouzou, *Cat.*, p. 44; *Kouroi*[3], no. 197.

27. In the Museo Nazionale delle Terme. Helbig-Speier, *Führer*[4], III, no. 2253.

28. Caskey, *Cat. of Greek and Roman Sculpture*, no. 64.

ence[29] (figs. 47, 48); the bronze statuettes in the Louvre[30] (fig. 46) and New York[31] (fig. 44); and the figure of the river god Selinos on the coin of Selinus[32] (fig. A, supra). And for the female type we may cite the bronze statuette of a girl in Munich[33] (fig. 45). How much more natural are now the attitudes; what expressive contours the figures have assumed! What subtle variety is introduced by the action of the arms and how harmonious is the whole composition! But we are still conscious that the figure is an interrelated scheme comparable to a carefully planned architectural design.

At this period, when the problems of construction had been fully mastered, Greek sculpture might easily have become realistic. Instead, it shows in increasing manner a quality of aloofness, of universality. The modeling is more naturalistic, but the statues have a grandeur and idealism which remove them from nature. How did the Greek sculptor accomplish this? Such things are difficult to put into words; but one of the many reasons is that in spite of his new knowledge he kept his eye on the essentials. Though he had by now a thorough knowledge of the complicated anatomy of the human body, he was not distracted by the manysidedness of nature, but kept his modeling simple, his planes few, his volume unified; and he consciously harmonized his composition. The canon of proportion which we feel underlying the early statues has been developed into a subtler scheme. And so, instead of copying closely one particular human body, merely translating nature into stone, he created something typical. This quality of Greek sculpture has often been interpreted merely as physical beauty. But much more than the loveliness, it is the impersonality of fifth-century sculpture that makes it great. Plato gives us an explanation when he speaks of painters as "fixing their eyes on perfect truth as a perpetual standard of reference, to be contemplated with the minutest care, before they proceed to deal with earthly canons about things beautiful."[34] It is this recourse to the perfect pattern for inspiration which produces the typical as against the individual, the general instead of the particular. Fifth-century sculpture gives us a peculiar sense of exhilaration because it can translate us from the narrow personal plane to an impersonal one.

FOURTH
CENTURY
Naturally so lofty a standard could not be maintained forever. By the fourth century a softening makes itself felt. The curves are further accentuated, creating a still greater contrast of direction; and in the modeling the number of planes has greatly multiplied, more nearly approximating nature. All these changes are admirably shown in the Hermes by Praxiteles (fig. 711). There is a new grace in the attitude, and in the modeling all hard divisions have disappeared. One part now passes imperceptibly into the adjoining, everything is gentle and soft with infinite variations.

29. Amelung, *Antiken in Florenz*, no. 268.

30. De Ridder, *Bronzes antiques du Louvre*, *1*, no. 183; by some thought to reproduce the Diskophoros by Polykleitos.

31. *M.M.A. Catalogue of Bronzes*, no. 87. 32. Hill, *Select Greek Coins*, pl. XLI, 5.

33. Sieveking, *Münchner Jahrbuch der bildenden Kunst*, V (1910), pp. 1 ff.

34. Plato, *Republic* VI. 484.

The play of light and shade on this delicately carved surface suggests the luminous quality of flesh and we feel the envelope of skin over muscles and bones as we never have before; and yet there is something godlike in the quiet serenity and detachment. Nevertheless the lofty quality of fifth-century sculpture is gone. The pattern scheme out of which Greek sculpture grew and which gave it volume and grandeur is disappearing. We feel we are on a different plane, more personal, less spiritual, and so less invigorating. The same is true of all fourth-century sculpture. The Praxitelean Apollo Sauroktonos (figs. 720, 722 f.) and satyrs (figs. 56, 729 f.), the Skopaic Hermes of the Ephesos column (fig. 751), the bronze youths from the Bay of Marathon[35] (figs. 49–51), and from the Antikythera shipwreck[36] (fig. 52) show a lovely composition and modeling, but an absence of the former vigor and decorative quality.

The new taste for grace and softness naturally awakened interest in the female body. While in the sixth and fifth centuries undraped female figures appear only occasionally, they now become a favorite subject. The delicate modulations of the female form were rendered with fine appreciation, and a new realm of beauty was thereby added to the artistic stock. We can obtain only a faint glimmer of these fourth-century creations from the Roman copies of such famous works as the Knidian Aphrodite (fig. 715) and the Aphrodite Anadyomene (e.g. the Aphrodite from Kyrene,[37] fig. 54) or by bronze statuettes like the Aphrodites in the British Museum[38] (fig. 53) and from the Haviland Collection in New York[39] (fig. 55); for no first-class full-sized Greek originals have survived. But even so we can form an impression of the sensuous charm of the curves and subtly contrasting planes. And the potency of this charm can be gauged by the influence these works have exercised on all subsequent art.

Toward the later part of the fourth century the sculptor Lysippos introduced novelty into the design by imparting a slight torsion and "making the body more slender and the head smaller, thus giving his figures the appearance of greater height."[40] We see this new canon illustrated in the Apoxyomenos of the Vatican (fig. 791) with its slender proportions, in the praying boy in Berlin[41] (fig. 59), and in the bronze statuette of Alexander in Paris[42] (fig. 57). A new elasticity and realism are introduced by this change.

During the Hellenistic period these tendencies are still further accentuated. The graceful fourth-century poses either become even softer and more effeminate, as in

HELLENISTIC
PERIOD

35. National Museum, Athens, no. 15118; Rhomaios, in *Delt. arch.*, 1924–25, pp. 145 ff.; Papaspiridi, *Guide*, p. 216.

36. National Museum, Athens, no. 13396; Svoronos, *Das Athener Nationalmuseum*, pls. I, II, and in *Eph. arch.*, 1902, pls. 7–12; Papaspiridi, *Guide*, pp. 218 f.; and S. Karouzou, *Cat.*, pp. 160 f.

37. E. Paribeni, *Le Terme di Diocleziano e il Museo Nazionale Romano*, p. 160, no. 372.

38. Walters, *Select Bronzes*, pl. 45.

39. *A.J.A.* XXXVII (1933), pp. 48 ff.; *M.M.A. Handbook* (1953), p. 110, pl. 88a.

40. Pliny *N.H.* XXXIV, 65.

41. *Beschreibung der antiken Skulpturen in Berlin*, no. 2. Both arms are restored.

42. De Ridder, *Bronzes antiques du Louvre*, pl. 31, no. 370.

the Hermaphrodite in Istanbul[43] (fig. 58), sometimes with an added element of picturesqueness; or they are completely abandoned and a new sense of movement is imparted to the figure by "crossing the action." That is, the various parts of the body—the head, the trunk, the legs—are placed at completely different angles from one another, thus imparting a decided twist to the figure. A similar change takes place in the modeling. The planes hitherto kept fairly uniform with only subtle variations now show violent contrasts. The original pattern scheme has been discarded for a completely realistic rendering. The commanding statue of Poseidon in Athens[44] (fig. 60), the bronze portrait statue in Rome[45] (fig. 62) and the bronze satyr in New York[46] (fig. 61), all later Hellenistic, are typical examples. Compared with the lofty types of earlier days they make on us a restless, slightly theatrical impression; but their vitality and strength are undeniable. And by this new realism sculpture now becomes more human, less remote, and so more easily understood. Therewith a new world of ideas opened up to the sculptor, and he attempted many subjects hitherto neglected (cf. p. 50). Instead of the portrayal of beautiful types he turned to that of individual human beings and produced such sensitive renderings as the young negro musician in Paris (figs. 63–65). The simple standing figure now naturally became less common, and more intimate or complex poses prevailed.

Much that has been said regarding the development of the standing type applies also to the other types, for the modeling of the human figure is naturally similar in all. In our survey of these types, therefore, we shall confine ourselves largely to a study of the development in the attitudes.

The Seated Figure

THE seated figure enjoyed a great and continuous popularity in Greek sculpture. Besides the problem of representing the human figure in a relaxed, quiet pose, we have here the further task of making it appear separate and distinct from the seat. In early archaic renderings, like the goddess from Prinias,[47] the Branchidai statue[48] (fig. 67), and the example on the Corfu pediment[49] (fig. 66), this has not yet been achieved. The figure appears as part and parcel of the throne, and the attitudes are stiff and constrained, though grandly conceived. The statues are in strictly frontal position with both sides similar and no turn in either direction. In the examples of the later sixth century, such as the Athena by Endoios (?) from the Akropolis[50] (fig. 69) and the terracotta statuettes of this period (cf. fig. 68), there is a considerable advance in the elasticity of the pose, which has now a quiet dignity and charm. In the

43. Mendel, *Catalogue des sculptures*, no. 624.

44. National Museum, no. 235; Papaspiridi, *Guide*, p. 87, and S. Karouzou, *Cat.*, p. 184.

45. Helbig-Speier, *Führer*[4], III, no. 2273. 46. *M.M.A. Bulletin*, XXV (1930), pp. 40 ff.

47. Pernier, in *Bolletino d'arte*, 1908, p. 459; *Annuario*, 1914, p. 90, fig. 46.

48. Pryce, *Catalogue of Sculpture in the British Museum*, I, 1, B 271.

49. Rodenwaldt, *Korkyra*, II, pl. 25. 50. Dickins, *Catalogue*, no. 625.

Berlin goddess[51] (fig. 70) of about 480, there is a new grandeur, heralding a new era. In the transitional, i.e. early classical, period (480–450) the frontal pose is abandoned and the figure begins to move and turn, just as it does in the standing type. Interesting examples are the Penelope of the Vatican[52] (fig. 73), the beautiful Athena of the Olympia metope in the Louvre[53] (fig. 71), and the bronze lyre player in the Hermitage[54] (fig. 72); in the marble figures, which are really worked in high relief, the upper and lower parts of the body are placed in contrasting planes, while in the bronze statuette a pleasing variety is attained by less drastic means.

The seated figures of the Parthenon pediment[55] (figs. 74–76) show complete freedom. The poses are easy and relaxed, with a slight, not too obvious, change of direction in the upper and lower parts and the seats are entirely separate so that we feel that the body can rise at will; yet the former sense for design is still strong, imparting to these statues an imposing majesty.

The reliefs of the fourth-century gravestones show many seated figures in quiet and completely naturalistic poses (cf. figs. 466, 467). As examples in the round we may mention the Demeter from Knidos[56] (fig. 331) and some Tanagra statuettes[57] (cf. fig. 78), in which the gentle charm of fourth-century art finds expression. A comparison between the girl in figure 78 with the Penelope (fig. 73) will bring home to us better than many words the naturalistic development of the type. In the bronze Hermes from Herculaneum[58] (fig. 77) the problem of representing a seated figure in a momentary pose is ably solved. This statue—a Roman copy of an original of the Lysippian circle —foreshadows the new sense of movement which became so popular in Hellenistic times. In the bronze boxer[59] (fig. 847) and the Belvedere torso[60] (fig. 848), both Roman copies of statues of the late Hellenistic period, we find the same qualities we noted in the standing types of the period—superbly realistic modeling and dramatic action conveyed by a decided twist of the body and the placing of the head at a completely different angle from the trunk. The drunken woman hugging her bottle[61] (fig. 79) and the boy extracting a thorn from his foot[62] (fig. 80) give us an idea of the many-sidedness of the new outlook. But how far we have traveled from the stately Branchidai figures!

The Flying or Running Figure

FROM the beginning the Greek sculptor was interested in motion. To represent a flying or running or striding figure, what fascinating problems it entailed, how necessary

51. Wiegand, *Antike Denkmäler*, III, pp. 45 ff., pls. 37 ff.
52. Helbig-Speier, *Führer*[4], I, no. 123. 53. Ashmole and Yalouris, *Olympia*, fig. 153.
54. Waldhauer, *Pythagoras of Rhegium*, pp. 69 ff., figs. 13–15.
55. Smith, *The Sculptures of the Parthenon*, pls. 3, 5.
56. Smith, *Catalogue of Greek Sculpture in the British Museum*, II, no. 1300.
57. *M.M.A. Bulletin*, VI (1911), pp. 214 f., fig. 8; *M.M.A. Handbook*, 1953, p. 108, pl. 87g.
58. Ruesch, *Guida*, no. 841. 59. Helbig-Speier, *Führer*[4], III, no. 2272.
60. Ibid., I, no. 265. 61. Furtwängler, *Beschreibung der Glyptothek*, no. 437.
62. Smith, *Catalogue*, III, no. 1755.

for his metope or pedimental compositions, how difficult of solution with the limited powers at the command of the archaic artist! His method of coping with the difficulties is characteristic. He invented a scheme, a convention for these poses, highly decorative, far from naturalistic, but adequately serving his purpose. And the scheme once adopted was adhered to as a formula until by a greater knowledge of anatomy he achieved a more naturalistic interpretation. Thus, to show the motion of running or flying he represented the figure kneeling on one knee, with arms stretched upward, downward, or sidewise; the upper part of the body in full front, the legs in profile, with no proper interconnection between these two portions. As examples of the earlier archaic period we may cite the amazing Gorgon from the Corfu pediment[63] (fig. 81; ca. 600–580 B.C.), the Gorgon in Syracuse[64] (fig. 84), the Nike from Delos[65] (figs. 82, 83; ca. 560–550), and the bronze statuettes of a Nike in Athens[66] (fig. 85) and of a runner in New York[67] (figs. 86, 87). These figures, though they do not actually represent the motion correctly, certainly suggest it, and decoratively are effective. So the scheme—adequate for the time being—continued throughout most of the sixth century, developing gradually in the direction of naturalism by a less abrupt connection of the upper and lower parts. Attractive examples of later archaic renderings are the bronze statuette of Nike in London[68] (fig. 88) and a marble relief in Athens (fig. 89).[69] In spite of the adherence to the old scheme there is now more freedom and swing to the movement.

Side by side with this conventional scheme there appear during the sixth century more realistic representations in which the legs and arms are in more natural positions; for instance the bronze statuettes in Athens[70] (fig. 90), Berlin,[71] and London[72] (fig. 91). But they are only sporadic. Not until the early fifth century with the casting off of archaic conventions was the decorative motif of the early artist finally given up (surviving only in some representations on coins, where archaizing tendencies were always strong, since for practical reasons the continuity of a standard type was desirable).[73] In the small statue of a running maiden of about 480 found at Eleusis[74] (fig. 92) the body has the right forward direction, the knees are bent at the proper angle, and at last the upper and lower parts of the body coordinate. The only archa-

63. Bersakes, in *Praktika*, 1911, pp. 172 ff.; Rodenwaldt, *Korkyra*, II, pl. 4.

64. Orsi, in *Monumenti antichi*, XXV (1918), pl. 16; S. Benton, *Papers Br. Sch. at Rome*, XXII, 1954, pp. 132 ff., ("second half of the 7th century B.C.").

65. National Museum, Athens, no. 21; Papaspiridi, *Guide*, p. 24, and S. Karouzou, *Catalogue*, p. 9.

66. National Museum, no. 6483; Papaspiridi, *Guide*, p. 200.

67. *M.M.A. Catalogue of Bronzes*, no. 16. 68. Walters, *Select Bronzes*, pl. 4, fig. 1.

69. National Museum, Athens, no. 1959; Papaspiridi, *Guide*, p. 30, and S. Karouzou, *Catalogue*, pp. 22 ff.

70. National Museum, *Karapanos Collection*, no. 24; Papaspiridi, *Guide*, p. 209.

71. Kekulé, *Bronzen aus Dodona*, p. 32.

72. Walters, *Catalogue of Bronzes in the British Museum*, no. 208.

73. Thus on the coins of Kilikia a running winged female figure is shown in the conventional archaic attitude from the sixth century to the late fifth; cf. *B.M.C.*, XVII, Cilicia (Mallus?), pls. XV, XVI.

74. Walter, *Arch. Anz.*, 1925, p. 315.

isms are a lingering stiffness in the attitude and that charming, decorative quality which is gradually lost with the conquering naturalism. We still feel these two traits, though in a slightly less degree, in the Leto of the Conservatori Palace[75] (fig. 95), and the statue from Marmaria at Delphi[76] (fig. 94) of about 460–450. Even in the figure of the Ilissos frieze[77] (fig. 93) of about the middle of the century the upper part of the body is a little too perpendicular for the motion of the lower part. But a few years later complete freedom is attained. It is difficult to imagine more adequate representations of running figures than the Copenhagen Niobid[78] (ca. 450–440; fig. 97) or the Iris from the Parthenon pediment[79] (438–432; fig. 96), at once swiftly moving and majestic; or of a flying figure than the Nike of Paionios[80] (ca. 425–420; fig. 682), gently floating through the air. There is now no longer any need of formulas or conventions to suggest the idea of motion; the actual movement is successfully rendered in a naturalistic and yet artistic manner. It is a far cry from the Parthenon Iris to the schematized figures of the sixth century; but part of its greatness lies in the fact of its immediate succession from them. In spite of the consummate naturalistic modeling we are still conscious of the pattern scheme which is its background. The Epidauros Nike (fig. 760) is a graceful version of gliding motion characteristic of the early fourth century; and the forward-rushing female figure in Budapest[81] (fig. 98) is a Roman copy of a Greek work of the middle of that century. As examples of the Hellenistic period we may cite the famous Nike of Samothrake[82] (fig. 100), one of the most powerful renderings in the history of art; and the graceful bronze Eros (fig. 99) of the Morgan Collection[83] typical of the new outlook of the time. The former is conceived as alighting after flight, on a speeding ship, with wings still outspread, the latter as running in a torch race.

The Striding Figure

THE striding figure, that is, one in forward though not rapid motion, likewise absorbed the Greek sculptor from very early times. It was naturally an easier action to represent than that of rapid flight, and we find a fair measure of success even in the earliest attempts: for instance in the Zeus of the Corfu pediment[84] (fig. 101), where the action of the legs and of the whole forward-leaning body is already convincing, though the modeling is still primitive, with the upper part in full front, the legs in profile. The same general attitude with legs wide apart and one arm raised holding

75. Stuart Jones, *The Sculptures of the Palazzo dei Conservatori*, p. 227, no. 31, pl. 85.

76. Homolle, *Fouilles de Delphes*, IV, pl. LVI.

77. Studniczka, *Antike Denkmäler*, III, pl. 36; and in *J.d.I.*, XXXI, 1916, pp. 169 ff.

78. Arndt, *La Glyptothèque Ny Carlsberg*, pl. 38; Brunn-Bruckmann, *Denkmäler*, pls. 712–14; F. Poulsen, *Cat.* no. 398.

79. Smith, *Sculptures of the Parthenon*, pl. 3, right. 80. Treu, *Olympia*, III, pls. XLVI–XLVII.

81. Hekler, in Brunn-Bruckmann, *Denkmäler*, pl. 640.

82. Conze, Hauser, and Benndorf, *Untersuchungen auf Samothrake*, II, pl. LXIV; Lippold, *Griech. Plastik*, p. 360.

83. *M.M.A. Catalogue of Bronzes*, no. 131 (included when the statuette was there on loan).

84. Bersakes, in *Praktika*, 1911, p. 167; Rodenwaldt, *Korkyra*, II, pl. 28.

a spear, thunderbolt, or other weapon is found again and again during the sixth century. It is a favorite one for small bronze statuettes;[85] it occurs on the coins of Poseidonia[86] from 550 to 510 (fig. B on p. 00), and it is that of the Herakles in the pediment of the Siphnian Treasury[87] (fig. 409) and of many of the warriors on the Siphnian frieze (ca. 530–525; fig. 102). In all these renderings, just as in the contemporary flying figures, the upper and lower parts of the body do not coordinate; moreover, the body is often too perpendicular; and little attempt is made to show the contraction of the muscles under the strain of the action. All this is gradually corrected during the late sixth and the first half of the fifth century. We may mention as distinguished examples the bronze statuette of Herakles from Mantineia[88] (fig. 103), the bronze statue recently come to light in Ugento and now in the Taranto Museum[89] (ca. 75 cm.), the bronze statuettes of a warrior[90] (cf. fig. 104) and of Zeus[91] from Dodona (fig. 105), the warriors from west and east pediments of Aigina[92] (figs. 108, 415, 416), the Herakles of the Selinus metope[93] (fig. 442), and the splendid Poseidon from off Cape Artemision[94] (figs. 106, 107). In the warrior from Sparta[95] (fig. 109) and the Zeus in the terracotta group of Zeus and Ganymede from Olympia[96] (fig. 110) the upper part of the body is inclined farther forward, a device which accentuates the action. An effective variation is introduced by Kritios and Nesiotes in the Harmodios (figs. 613–15) of the Tyrannicide group in which the right arm is brought over the head.

All traces of archaism and stiffness disappear in the following period; and the type

FIG. B. Poseidon, on a coin of Poseidonia
(enlarged)
American Numismatic Society, New York

85. Cf. e.g. Neugebauer, *Antike Bronzestatuetten*, no. 27. 86. Gardner, *Types of Greek Coins*, pl. I, no. 2.

87. Homolle, *Fouilles de Delphes*, IV, pls. XLVI, XLVII, fig. 1a.

88. *M.M.A. Bulletin*, XXIII, 1928, pp. 266 ff., figs. 1–3; *M.M.A. Handbook* (1953), pp. 66 f., pl. 48, a.

89. N. Degrassi, *Bollettino d'arte*, XLIX (1964), p. 392, fig. 1; Trendall, *Archaeological Reports for 1966–67*, pp. 36 f., fig. 13. N. Degrassi's definitive publication will presently appear.

90. Kekulé, *Bronzen aus Dodona*, pl. II, p. 13. Daux, Chronique, in *B.C.H.*, 91 (1967), p. 684, fig. 10.

91. Kekulé, op. cit., pl. I, p. 6.

92. Furtwängler, *Aegina*, pl. 96, nos. 22, 14 (Glyptothek 76, 80); ibid., pl. 95, no. 72 (Glyptothek 86).

93. Benndorf, *Metopen von Selinunt*, pl. VII.

94. Karouzos, in *Delt. arch.*, 1930–31, pp. 41 ff.; S. Karouzou, *Cat.*, pp. 41 f., no. 15161.

95. National Museum, Athens, no. 3613. Woodward, in *B.S.A.*, XXVI (1923–25), pls. XVIII–XX, p. 253; Papaspiridi, *Guide*, p. 340.

96. Kunze, v. *Olympiabericht*, 1956, pp. 103 ff., pls. 54–63.

reaches its complete development in the striding Lapiths of the Parthenon metopes[97] of about 447–443 and in the Herakles of the Phigaleia frieze[98] of about 420 (fig. 111). The action is now perfectly convincing, the figures have an amazing force and freedom and are correctly constructed throughout. In the Herakles particularly the contraction of the muscles of the arms and of the serratus magnus are realistically rendered. The difference between these later, finished representations and the early attempts on the Corfu pediment is far-reaching; and yet the kinship is close. Again we feel the tradition behind the freer figures, which helps to give them restraint and stability. In the fourth century, though there is a lessening of vigor, we have fine renderings, like the warriors of the Mausoleum frieze (fig. 745). As examples of what happened to the striding figure in Hellenistic times we may cite the impetuous bronze Poseidon in the Louvre[99] (fig. 112; third century B.C.), the Borghese Warrior in the Louvre[100] (fig. 113), the Gaul killing himself in the Terme Museum[101] (fig. 114), and the bronze satyr from the Mahdia shipwreck[102] (fig. 115, second century B.C.). Here the tradition is fading. The realism of the action and of the modeling indicates a novel outlook. The Borghese warrior, indeed, might serve as a model in an anatomy class. And yet even here we note the observance of the unified volume, of the relief conception, one of the fundamental characteristics of earlier Greek sculpture (cf. pp. 22 f.); and they impart a certain stability and harmony to these animated figures.

The Reclining Figure

THE history of the reclining figure is one of the most interesting in Greek sculpture. A figure in a merely horizontal position was of course comparatively easy to represent, but the reclining posture in which the upper part of the torso faced the spectator and the legs were in profile presented many difficulties; and yet this attitude was the most desirable for scenes of banquets and combats or for fitting the figure into pediment angles. The twist of the body entailed a strong torsion, the rendering of which required more knowledge of anatomy than the archaic sculptor had. It is instructive to see how the Greek sculptor tackled these difficulties. At first he simply avoided them. He either took refuge in the completely horizontal attitude, as, for instance, in the angle figure of the Corfu pediment[103] (fig. 116) and in the fallen warriors on the Siphnian frieze,[104] or he covered the body with armor or drapery, as in the reclining figure of the Geneleos group from Samos[105] (fig. 117); or again he represented only

97. Smith, *Sculptures of the Parthenon*, pl. 19, 1.

98. Smith, *Catalogue of Greek Sculpture in the British Museum*, I, no. 541.

99. Charbonneaux, *Les bronzes grecs*, p. 105, pl. XXVIII, 3.

100. Brunn-Bruckmann, *Denkmäler*, pl. 75. 101. Helbig-Speier, *Führer*[4], III, no. 2337.

102. In the Alaoui Museum, Tunis; Fuchs, *Der Schiffsfund von Mahdia*, p. 19, pl. 19.

103. Bersakes, in *Praktika*, 1911, p. 185; Rodenwaldt, *Korkyra*, II, pl. 31.

104. Homolle, *Fouilles de Delphes,* IV, pls. XXI–XXIII.

105. Buschor, *Altsamische Standbilder*, I, figs. 99, 100. Inscribed ". . . oche who dedicated it to Hera."

the upper part nude and covered the lower with drapery, as in the Amazon from the corner of a pediment in the Thebes Museum[106] and in the bronze statuette of a banqueter in the British Museum[107] (ca. 520 B.C.; fig. 118). But we see the sculptor at grips with the problem in the fallen giant from the marble pediment of the Hekatompedon[108] (ca. 520; fig. 119). Here the chest is in full front view, while the hips and abdomen are abruptly turned. Beneath the sternum where the torsion takes place confusion reigns; the various divisions of the rectus abdominis are placed in strange positions and the median line forms several sharp angles in an impossible manner.

In the figures of the west[109] (fig. 120) and the east pediments[110] (fig. 121) of the Aigina temple (ca. 500–480) the problem is not yet solved; the various parts of the abdominal muscle are not rightly related and the median line is still angular.[111] The reclining satyr by the Brygos painter[112] (fig. 124), datable about 490–480, shows the same stage of development as the statues from Aigina. The rectus abdominis is rendered by adjacent ovals, the serratus magnus by a single row of curves, and the median line is omitted. But twenty years later we find the beautiful figures of Kladeos (fig. 122) and Alpheios (fig. 123) of the Olympia pediments,[113] both shown in reclining poses with correct construction. The action of the muscles is convincing and the necessary curve is attained; the undulating contours of the figures admirably suggest the slow stream of rivers, and their detachment fits them well for their role of spectators; the only archaism left is a lingering angularity. In the Ilissos of the Parthenon pediment[114] of about 438–432 (fig. 126) and the Niobid in Copenhagen[115] (fig. 125) the last vestige of stiffness is conquered; each part connects naturally with the succeeding, and together they form a harmonious whole. The Hellenistic period has given us some splendid representations of reclining figures, perfectly relaxed, in highly naturalistic renderings. We may cite as typical examples the dead Gaul in Venice[116] (fig. 127), the bronze statue of a sleeping Eros in the Metropolitan Museum[117] (fig. 128), the marble statue of a sleeping satyr in the Lateran Collection[118] (fig. 129), the famous dying Gaul in the Capitoline Museum[119] (fig. 130). The sculp-

106. From Topolia; cf. *Ath. Mitt.* xxx (1905), pl. 13.

107. Haynes, *British Museum Quarterly*, xx, no. 2 (1955), pp. 36 f., pl. 12.

108. Dickins, *Catalogue of the Acropolis Museum, 1*, no. 631 A. Though the navel itself and the portion below it are restored, the upper portion is fortunately intact.

109. Furtwängler, *Aegina*, pl. 96, nos. 1, 33 (Glyptothek 83, 79).

110. Ibid., pl. 95, no. 41 (Glyptothek 85).

111. Cf. on this subject Lange, *Darstellung des Menschen*, pp. 69 ff.

112. In the Metropolitan Museum, no. 12.234.5; cf. Richter and Hall, *Red-figured Athenian Vases*, no. 43, pl. 43, center; Beazley, *A.R.V.*², p. 382, no. 183.

113. Treu, *Olympia*, iii, pl. xv, 2, 3; Ashmole and Yalouris, *Olympia*, p. 13, figs. 1–12.

114. Smith, *Sculptures of the Parthenon*, pl. 7.

115. Arndt, *La Glyptothèque Ny Carlsberg*, pl. 51; F. Poulsen, *Cat.*, no. 399.

116. Dütschke, *Antike Bildwerke in Oberitalien*, v, no. 209; Bienkowski, *Die Darstellung der Gallier*, pp. 38 ff., fig. 50.

117. Richter, in *A.J.A.*, xlvii (1943), pp. 365 ff.; *M.M.A. Handbook* (1953), p. 123, pl. 102.

118. Helbig-Speier, *Führer*⁴, i, no. 1042. 119. Ibid., ii, no. 1436.

tor has not only rendered the pose naturalistically, with the various parts of the body placed in different directions, but has suggested the mood of each figure.

The Falling Figure

THE falling figure has an interesting career. At first the motif of a body falling backward was too difficult of achievement and a compromise was effected by representing the figure as partly kneeling—just as in the flying figure. We find this device in the giant opposing Zeus in the Corfu pediment[120] of the early sixth century (fig. 101) and in more developed form on the Siphnian frieze[121] (ca. 530–525; fig. 131). In the sculptures of the Athenian Treasury (ca. 510–500), however, the actual falling motion is at last attempted in the metope of Herakles and Kyknos[122] (fig. 132). In the east pediment of Aigina (ca. 480), as restored by Furtwängler[123] (cf. fig. 416), and in a metope of temple E at Selinus[124] (ca. 470) warriors and a giant are shown falling backward at precarious angles (fig. 443). The problem was also attempted in single compositions, as we know from the mention of a Volneratus deficiens by Kresilas (cf. p. 179 f.) and from the bronze statuettes of Ajax in Florence [125] (figs. 133, 134) and of the warriors in Modena[126] (fig. 136) and in St. Germain-en-Laye[127] (fig. 135). These bold attempts are characteristic of the adventurous early classical period and are found also in contemporary vase-paintings (cf. figs. C, 137[128]).

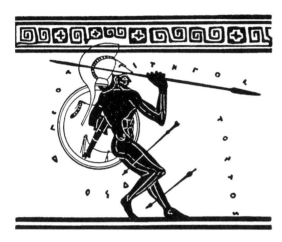

FIG. C. Wounded warrior, from a lekythos
Bibliothèque Nationale, Paris

The calm serenity of later fifth- and fourth-century sculpture hardly admitted of such restless creations of momentary poses. When utilized in contest scenes in pediments, metopes, and friezes the half-kneeling attitude is again adopted, but now with correct inclinations of the body and in beautiful postures. The metopes of the Parthenon, and the Phigaleia and Mausoleum friezes supply several examples (cf. fig. 138).[129] The striving for realism and variety in Hellenistic times made the adoption of the falling attitude again possible. A good example is the bronze statuette in New York of a drunken Herakles reeling backward[130] (fig. 139). The backward inclina-

120. Bersakes, in *Praktika*, 1911, p. 167; Rodenwaldt, *Korkyra*, II, pl. 28.

121. Homolle, in *Fouilles de Delphes*, IV, pls. XII–XIV. 122. Ibid., pl. XLII.

123. *Aegina*, pl. 106. 124. Benndorf, *Metopen von Selinunt*, pl. X.

125. Milani, in *Bolletino d'arte*, 2 (1908), pp. 361 ff. 126. Bulle, *Der schöne Mensch*, pl. 94.

127. S. Reinach, in *Gazette des Beaux-Arts*, XXXIII (1905), pp. 193 ff.

128. Metropolitan Museum, Acc. No. 08.258.21. By the Nekyia Painter. Richter and Hall, *Red-figured Athenian Vases*, no. 135; Beazley, *A.R.V.²*, p. 1086, no. 1.

129. Smith, *Sculptures of the Parthenon*, pl. 17, 2. 130. *M.M.A. Handbook* (1953), p. 125, pl. 104, d.

tion is not nearly so marked as in the examples of the transitional period, so that we have a better sense of equilibrium; and the modeling is completely naturalistic.

The Crouching Figure

THE crouching figures in the many combat scenes on pediments, metopes, and friezes necessarily vary largely in postures, leaning more or less forward according to the action and composition. The favorite attitude is the half-kneeling one, with one knee on the ground, the other bent at an angle. We can watch its development in the pediment groups from the Siphnian and Megarian (fig. 410) Treasuries to those of the temples of Aigina (figs. 415, 416) and Olympia[131] (figs. 140, 141). The crouching Lapiths of the Parthenon (fig. 138)[132] metopes show us the harmonious renderings of the second half of the fifth century; and as a typical example of later times we may cite the Aphrodite by Doidalses, which has been recognized in a number of Roman copies (cf. p. 234 and figs. 142, 822, 823).[133]

Such is the development of the chief types in Greek sculpture. Naturally other poses occur, at least occasionally, but they are surprisingly few; except of course in Hellenistic times, and during one other period—that of the end of the archaic epoch —when the Greek sculptor suddenly found himself able to represent the human body in all manner of postures. It was the first time in his career and he was naturally tempted to try out his powers in this new world of form. So we find him attempting such complicated poses as that of the Diskobolos (fig. 616) and the Marsyas (fig. 621), the bronze jumper in New York (fig. 143) and the Niobid in Rome (fig. 4). But this indulgence was only temporary. His taste for quiet and restraint soon brought him back to his simple attitudes for standing and seated figures, with the accepted types of figures in motion for his groups of contests. And we have seen what this concentration and sculptural feeling led him to achieve.

131. Treu, *Olympia*, III, pl. XIV; Ashmole and Yalouris, *Olympia*, pp. 15 ff., figs. 22–28, 41–43.
132. Smith, op. cit., pls. 19, 2 and 23, 2.
133. In Ostia; cf. R. Calza, *Museo Ostiense*, no. 123.

CHAPTER 4

THE HEAD

The Rendering of the Features

THE human figure with its manifold, intricate problems was so absorbing to the Greek sculptor during his early period that he could not give the head primary consideration. He struggled with its representation, as he did with that of the rest of the body, but to him the human face was only part of a physical organism, not the chief medium for the conveyance of human emotion. Moreover, emotion per se seemed at the time of secondary interest; for the emphasis was laid on the fundamental principles of sculptural representation. So the archaic Greek sculptor, starting as he did with a primitive conception of form, had to concentrate first and foremost on an adequate rendering of the human features (cf. fig. 145). Throughout the archaic period we find him absorbed in this task. At first, just as in his rendering of the torso, he was too timid to carve deeply into his block, so that the face was comparatively flat, with forehead, eyes, cheeks, mouth, and chin all more or less in one plane, the nose only protruding; the head, like the body, still retained the cubic shape of the block into which it was carved. Only gradually, in a slow and groping manner, he gave up his superficial carving and found the right relation of the different planes to one another.

It is interesting to watch him at work. The Dipylon head[1] (fig. 144) and the ivory youth from Samos[2] (fig. 146), both late seventh century, the Olympia Hera[3] (fig. 147; ca. 600), the Delphi Youth[4] (fig. 151), the Chrysaor from Corfu[5] (fig. 150), the kouros from Thera[6] (fig. 163), and the Berlin standing goddess[7] (figs. 148, 149), all of the first half of the sixth century, illustrate an early stage. Everything is flat and near the surface. The eyelids are merely curved ridges, the eyeballs are apt to be flat and prominent, and there is as yet no indication of the recess (canthus) or the tear-duct at the inner corner—except occasionally by a groove. The two lips are sharply cut and generally horizontal, with a triangular depression at the corners. The ear is often too high or too low and lies flat against the head, with a knob-like tragus and no indication of the antitragus; it has often a schematized form combining with the ear-ring into an effective pattern.

SEVENTH TO SIXTH CENTURY

1. Richter, *Kouroi*[3], no. 6. 2. Buschor, *Altsamische Standbilder*, IV, pp. 63 ff., figs. 238–48.
3. Treu, *Olympia*, III, pl. I, pp. 1 ff. 4. Homolle, *Fouilles de Delphes*, IV, pls. I, II; *Kouroi*[3], no. 12.
5. Bersakes, in *Praktika*, 1911, pp. 187 ff.; Rodenwaldt, *Korkyra*, II, pls. 10–17, pp. 43 ff.
6. *Kouroi*[3], no. 49.
7. Wiegand, in *Berliner Museen*, XLVII (1926), 2, p. 18; Blümel, *Die archaisch griechischen Skulpturen*, 1963, no. 1, figs. 1–8; Richter, *Korai*, no. 42.

In other words the forms of the features are conditioned by the fact that they are carved, so to speak, in relief on the flat sides of a cube instead of being modeled in the round; the front, back, and two profile views are the only ones considered. That these early heads, with all their primitiveness, often have power and splendor is due to the feeling for design and volume. The outline of the head, the lines formed by the eyebrows, the eyelids, and the lips have a fine swing; and the general effect is highly decorative. Moreover, they retain the connection with the block into which they were carved and thus compare favorably with some later work where this feeling for volume is lost.

By the second half of the sixth century much has been learned. There is now a greater difference of planes and many details hitherto neglected are observed. In the Akropolis kore no. 679[8] (fig. 152; ca. 540–530) and the kouros Ptoon 20[9] (fig. 32; late sixth century), for instance, the eye is sunk more deeply beneath the brow, the eyelids are no longer mere ridges, and the upper one has considerably more width than before; the ball itself recedes downward, so that the lower lid is in a distinctly different plane from the upper; and the inner corner is carved to indicate the canthus. The eye as a whole is not yet sufficiently sunk and the ball is not felt as a separate member, but the change from the primitive·rendering of fifty years before is great. The same applies to the mouth. The upper and lower lips are no longer practically identical ridges, but are differentiated, and are more deeply sunk, often with a sharp point at the corners producing the so-called archaic smile.[10] The ear is assuming its natural shape and the antitragus is indicated. Moreover, the whole head is becoming rounded instead of cubic. Nevertheless, the decorative quality is retained in the simplification of the form and the sharply defined contour of each feature. A mysterious charm pervades the whole.

The decorative instinct of the early Greek sculptor enabled him also to deal with another great problem which confronted him, the rendering of the hair. Since it seemed impossible with the knowledge at his command to represent in any way approaching reality the luminous, infinitely variegated surface of human hair, he frankly had recourse to a conventional treatment and utilized various designs, often with highly pleasing results. His commonest device at first was a series of long, vertical ridges starting from the forehead, brought down the back, and divided by horizontal grooves or ridges to form a checker pattern (New York head,[11] fig. 157). The ridges themselves are sometimes further diversified by smaller ripples (Sounion kouros,[12] fig. 155, and Delphi youth,[13] fig. 154); or the scheme is simplified by the

8. *Korai*, no. 113. 9. *Kouroi*³, no. 155.

10. In other words, this smile is, it would seem, merely the fortuitous result of the carving and has not the esoteric meaning sometimes claimed; for when later the transition between the corners of the mouth and the cheeks is made more gradual, the smile disappears (cf. p. 48).

11. *M.M.A. Bulletin*, xvii (1922), pp. 148 ff.; *Kouroi*³, no. 64.

12. National Museum, Athens, no. 2720. Papaspiridi, *Guide*, p. 25, and S. Karouzou, *Cat.*, pp. 25 f.; *Kouroi*³, no. 2. 13. Homolle, *Fouilles de Delphes*, iv, pls. i, ii; *Kouroi*³, no. 12.

use of horizontal or vertical ridges only (Tenea kouros,[14] fig. 156). Later, with greater truth to nature, wavy ridges are made to radiate from the center of the cranium (Akropolis kore,[15] fig. 159). In the first half of the sixth century the hair is generally long (cf. figs. 155, 163). A few separate strands or locks are brought over to hang down the shoulder in front, regularly in female statues and occasionally also in the male ones (e.g. in the Delphi Kleobis, fig. 19), and the charioteer on the recently discovered metope from Selinus[16] (fig. 166). From about 550 B.C. the hair is sometimes fairly short in male statues, descending only to the nape of the neck (cf. the Munich kouros,[17] fig. 160). In the late sixth century it is short or rolled or looped up behind (cf. fig. 158).[18] To frame the brow we often find—especially in male heads—highly stylized spiral curls, in one or more rows arranged symmetrically to right and left of the center (Thera kouros,[19] fig. 163; the Chrysaor from Corfu,[20] fig. 161; the Rampin head in the Louvre,[21] fig. 162; and the kouros in Kansas City, fig. 158); or merely a wavy outline (Tenea Apollo, fig. 156). In the female heads the hair is mostly represented waved in front, sometimes parted in the middle, with side coils on the temples (figs. 152, 153). In some of the earliest heads, it bulges forward over shoulders and back, and is arranged in braids coiled horizontally in layers on either side, in the so-called Daedalid fashion (fig. 165).[22] In both male and female heads a fillet—either forming a closed circle or tied, with ends hanging down—generally holds the hair in place, adding greatly to the ornamental effect of the coiffure. It is sometimes decorated with rosettes and other motifs. Occasionally we also find a second fillet, cords and rings, or bags for tying the hair at the back (figs. 149, 280, 281). The mass of the hair over the skull was generally only slightly variegated, or even kept quite plain (New York head;[23] fig. 167), showing plainly how little the sculptor felt the necessity of depth, the lack of which is indeed the outstanding feature in his sculptured representations of hair; here, as in the figure and the face, the carving is flat. An interesting device which can be observed on a head in Berlin is a punctured surface (fig. 164), preparatory—it has been suggested—for the addition of stucco.[24]

In the first half of the fifth century the advance toward naturalism continues along every line. The features become more convincing. The eye is farther sunk beneath the brow; and the form and position of the eyeball are better understood; the eyelids, though still heavy, are rendered more correctly with a good understanding of the

FIFTH
CENTURY

14. Furtwängler, *Beschreibung der Glyptothek*, no. 47; *Kouroi³*, no. 73.

15. Dickins, *Cat.*, no. 680, p. 226; Richter, *Korai*, no. 122. 16. Tusa, *Arch. Classica* (forthcoming).

17. Brunn-Bruckmann, *Denkmäler*, pl. 662; *Kouroi³*, no. 135.

18. *Guide of the William Rockhill Nelson Collection*, p. 18. 19. *Kouroi³*, no. 49.

20. Rodenwaldt, *Korkyra*, II, 2, pp. 43 ff., pls. 10–17.

21. Payne and Young, *Archaic Marble Sculptures from the Acropolis*, pls. 11a–11c; Charbonneaux, *Sculpture grecque au Musée du Louvre*, p. 6, no. 3104.

22. *M.M.A. Bulletin* (1925), p. 14, fig. 1.

23. *M.M.A. Bulletin*, XVI (1921), p. 9, fig. 1; *Cat. of Greek Sculptures*, no. 3.

24. *Beschreibung der Skulpturen in Berlin*, no. 308; Blümel, *Die archaisch griechischen Skulpturen*, no. 6; on the addition of stucco on marble cf. now Blümel, in *Rev. arch.*, 1968, pp. 11 ff.

canthus. The lips glide gradually into the cheeks. But there are still continuous contours round the eye and mouth, which add to the decorative feeling and detract from their realism. The ear assumes its right place, size, and form and stands out from the skull. We can watch the progressive development in the New York head (ca. 500; fig. 167), the Boudeuse in Athens[25] (ca. 485; fig. 168), the seated goddess in Berlin[26] (ca. 480; fig. 170), the Demarete coin of Syracuse[27] (ca. 479–478; fig. 169), the Delphi charioteer[28] (ca. 470; fig. 171), the Olympia Apollo[29] (ca. 460; fig. 172), and the Chatsworth head, now in the British Museum[30] (fig. 451). The hair is looped up (Olympia Apollo, fig. 172) or arranged in tresses tied round the head (Akropolis head,[31] fig. 177) or simply worn short (Delphi charioteer, fig. 171, and Brescia head,[32] fig. 175). It is either rendered by wavy ridges, now regularly radiating from the center of the head, as in the Barracco head[33] (fig. 173), or when worn short, by neat little ringlets lying close to the skull (Delphi charioteer, fig. 171). There is still no depth, the surface being practically continuous, with nothing obtruding. The fine spherical contour of the head is left unbroken.

We arrive then by the middle of the fifth century at an approximately naturalistic rendering of the human features, but still accompanied by a strong feeling for design and volume—a combination which gives to the products of this period a monumental quality. The general shape evolved has certain salient characteristics which have come to be regarded as typically Greek: in profile the forehead and the nose form an almost straight line; the eye is placed high up in its socket and closely approaches the eyebrow; the mouth is small with the curve of the lips accentuated; the chin is strong and the ear small; the face forms a regular oval.

The sculptors of the succeeding periods continued on the road toward naturalism. In the second half of the fifth century, the sharpness of outline gradually disappears. Attention is devoted to the study of transitional planes. In the Idolino[34] (fig. 176) and the head from Argos[35] (fig. 174) the contours of the features are softened, the upper eyelid is made to pass gently over the lower at the outer corner, the lips no longer converge to form sharp angles. Moreover, a decided rounding of the form as a whole has taken place so that every part passes naturally into the adjoining one.

In the hair too there is a marked advance toward realism. The separate strands begin to show greater variation and at last a slight feeling for depth is introduced. But the whole is still a strictly formalized design.

25. Dickins, *Cat.*, no. 686; Richter, *Korai*, no. 180.
26. *Antike Denkmäler*, III, pls. 37 ff.; Blümel, *Die archaisch griechischen Skulpturen* (1963), no. 21.
27. Regling, *Die antike Münze als Kunstwerk*, pl. XVIII, no. 403.
28. Homolle, *Fouilles de Delphes*, IV, pls. XLIX f.; Chamoux, in *Fouilles de Delphes*, IV, 5 (1955).
29. Treu, *Olympia*, III, pls. XXII f.; Ashmole and Yalouris, *Olympia*, p. 17, figs. 106–09.
30. Wace, in *J.H.S.*, LVIII (1938), pp. 90 ff.; cf. Haynes, *Revue archéolog.*, 1968, pp. 101 ff.
31. Dickins, *Cat.*, no. 689; *Kouroi*³, no. 191.
32. Furtwängler, *Masterpieces*, p. 175, fig. 72. Dütsche, *Antike Bildwerke in Oberitalien*, IV, no. 336.
33. Barracco and Helbig, *Collection Barracco*, pl. 29; *Kouroi*³, no. 188; Helbig-Speier, *Führer*⁴, II, no. 1859.
34. Amelung, *Antiken in Florenz*, no. 268. 35. Waldstein, *Argive Heraeum*, pl. XXXVI.

In the fourth century further great changes happen. We may take as representative examples the Hermes of Praxiteles[36] (fig. 178), the Marathon boy in Athens[37] (figs. 180, 181), the Bartlett head in the Boston Museum[38] (fig. 183), the head of Athena from the Piraeus,[39] and the head of a youth from a relief in the Metropolitan Museum[40] (fig. 179). The sculptor now realized that in order to convey the impression of natural form he must change it in many particulars, that is, he must translate natural form into impressional form. So he gives the appearance of sinking the eye much farther into the head by widening the bridge of the nose and by accentuating the brow; moreover, he greatly reduces the thickness of the eyelids, particularly of the lower one (carefully modeling, however, the transitional planes), so that both now appear as members which can cover an eyeball; and he hollows out the eyeball, making it sometimes actually concave instead of convex. The mouth, too, is changed. It becomes rounder and more fleshy, with the lower lip often shorter than the upper. The lips are generally slightly parted with a ridge below the upper lip giving the impression of teeth. The forehead is often triangular in female heads. The modeling creates a subtly variegated surface. The head from Chios[41] (fig. 182) shows the continuation of the Praxitelean style in the direction of even greater softness. One plane now passes imperceptibly into the next.

In the rendering of hair the lesson of impressional form is also learned. After the fifth century the surface becomes more and more variegated; at last a feeling of depth is introduced. In the hair of the Bartlett Aphrodite[42] (fig. 183), the Praxiteles Hermes (fig. 178), and the heads of the Alexander sarcophagus[43] (fig. 184) instead of flat locks and strands there are irregular tufts of considerable depth creating manifold shadows. Individually these masses are less like locks of hair than their predecessors, but collectively they convey the general impression more successfully.

All these tendencies are stressed and often exaggerated in the Hellenistic period. In the heads of a giant from the Pergamene altar[44] (fig. 185), of the Gauls in Rome[45] (figs. 186, 187), and of Zeus on a cameo in Venice[46] (fig. 188) the deep sinking of the eyes, the furrowed brow, the open mouth create deep shadows and produce a dramatic effect. In the hair the depth of the separate masses further increases, the contour plane now becoming entirely broken up and uneven. The conception is naturalistic, and the execution often shows great power; but here too, as in the rendering of the human figure, the feeling for volume is impaired and the former compactness disappears.

36. Treu, *Olympia*, III, pls. XLIX–LIII.

37. National Museum, Athens, no. 15118; Rhomaios, in *Delt. arch.*, 1924–25, pp. 145 ff.; Papaspiridi, *Guide*, p. 216.

38. Caskey, *Catalogue of Greek and Roman Sculpture*, no. 28.

39. *M.M.A. Bulletin*, VI (1911), pp. 210–11; *Catalogue of Greek Sculptures*, no. 118.

40. Schrader, in *Corolla L. Curtius*, pp. 81 ff., pls. 17 ff.

41. Caskey, *Catalogue*, no. 29. 42. Ibid., no. 28.

43. Mendel, *Catalogue des sculptures*, no. 68. 44. Museen zu Berlin, *Skulpturen aus Pergamon*, I, p. 27.

45. Helbig-Speier, *Führer*⁴, III, no. 2337. 46. Furtwängler, *Antike Gemmen*, pl. 59, 8.

The Head as a Medium of Expression

WE have pursued the history of the development of the human head from the point of view of the rendering of its features. We will now turn to the subject of how the Greek sculptor used it as a medium for the expression of emotion. Naturally, until an adequate knowledge of carving was attained it was futile to try to depict any range of feeling; instead, the artist had to convey his meaning by attitude and gesture. We have attempts, if attempts they be, in early Medusa heads[47] (cf. fig. 189) where presumably an expression evoking horror is intended. The so-called archaic smile which conveys happy alertness, is probably the fortuitous result of primitive carving (cf. p. 46, n. 10). In any event it was not until the late archaic and transitional (early classical) periods of the first half of the fifth century when the sculptor had attained

an approximately naturalistic rendering, that the means were adequate for this problem. Then indeed we find a great interest in the expression of human emotion—of joy, of sorrow, of pain, of surprise, of radiance. It resembles the sudden attention given to the representation of violent action; as if the sculptor, conscious of his new powers, wanted to try them out in all directions. An early example is the graphic rendering of pain in the falling giant of temple F of Selinus (end of sixth century),[48] who is represented with wide-open mouth, his teeth showing (fig. 190). A little later there are several excellent examples, such as the mourning woman on the Boston relief[49] (ca. 480–470), where sorrow is conveyed by the lowered upper eyelids and the short, drooping mouth (fig. 192); and her companion on the same relief (fig. 191), where joy is expressed by a swing of the upper lid and an upward curve of the mouth. In the Aphrodite of the Ludovisi relief[50] (fig. 193) we have a beautiful expression of radiance due likewise to the upward curve of the mouth and strongly curving upper lid. Another fine example of a radiant expression is the Zeus from the metope of temple E at Selinus[51] (ca. 475; fig. 195), where the lips are not only curved but parted and the eyes wide open. For the representation of physical pain we may cite the fallen warrior from the east pediment of Aigina[52] (ca. 480; fig. 564) with his contracted lips showing the teeth between them and the deep line from the nose downward; and the head of a dying warrior from the same pediment[53] (fig. 194) in which the gradual closing of the eyes is shown in a remarkably naturalistic manner. Even more realistic renderings of pain appear in some of the centaurs and Lapiths of the Olympia pediment[54] (ca. 465–460; figs. 196, 199) where deep lines are added on the brow and around the nostrils, and the contraction of the mouth is very marked. Myron's Marsyas[55] (ca. 450; fig. 198) gives us an example of the expression of surprise, indicated by the long

47. Dickins, *Catalogue*, no. 701.

48. Benndorf, *Metopen von Selinunt*, pl. 5; Collignon, *Histoire de la sculpture grecque*, I, p. 331.

49. Caskey, *Catalogue*, no. 17. On its authenticity cf. my pp. 146 f.

50. Helbig-Speier, *Führer*⁴, III, no. 2340. 51. Benndorf, op. cit., pl. VIII, p. 54.

52. Furtwängler, *Aegina*, pl. 95, no. 41 (Glyptothek, 85), text, p. 288.

53. Furtwängler, *Aegina*, pl. 97, no. 93 (Glyptothek 92), text, p. 253.

54. Treu, *Olympia*, III, pl. XXIX, 2 and 3 and pl. XXXI, 2. 55. Walters, *Select Bronzes*, pl. XVI.

upward curve of the eyebrows, the corresponding grooves on the forehead, and the oblique setting of the eyes.

Besides emotion, age can contract the features and bring furrows to the face. This too began to interest the Greek sculptor and we have, in the transitional period, representations of old age such as the old woman on the Boston relief[56] (fig. 197). The effect is obtained by the wrinkles on the forehead and on the lower part of the face, the deep furrows from the nose downward, and the series of ridges below the chin; the hooked nose adds to the realistic expression.

It is noteworthy that we have in contemporary vase-painting a parallel interest in these variants from the prevalent types of serene and youthful beauty. On a krater in the Metropolitan Museum, for instance, there is a realistic rendering of an old man[57] (fig. 202); on a vase in Schwerin is one of an old woman[58] (fig. 203); and on several vases are beautiful renderings of musical exaltation.[59]

But neither in sculpture nor in vase-painting did the practice of depicting emotion become general at this period. As a rule the faces have a lofty, impersonal character. The realistic touches occur only occasionally; and in the succeeding period—the second half of the fifth century—they become, if anything, less frequent. For the sculptor had by now tried out his new powers; his interest in what he considered wayside experiments quickly subsided, and he put his whole effort into his great task of using the human figure, body and head alike, as an expression of lofty idealism. Representative heads of this time are therefore such examples as the female head from Argos (fig. 174), the Lemnian Athena[60] (fig. 654), the Cassel Apollo[61] (cf. fig. 204), or the New York athlete[62] (fig. 205), which are distinguished for their detachment and serenity; or the Niobid in Rome[63] (fig. 206), whose composed features do not suggest in any way (except in the droop of the mouth) the physical agony she is in.

Nevertheless it is a mistake to think that the expression of emotion in the face is unknown in the second half of the fifth century. Instances occur particularly outside Attica, in regions which were far from the influence of Pheidian idealism. The Phigaleia frieze (last quarter of the fifth century) is an excellent example. In the collapsing Greek[64] (fig. 207), for instance, the suffering is indicated by the contraction of the eyebrows, which form upward loops with the bridge of the nose, and by the bringing of the eyelids closer together. In the dying Amazon[65] (fig. 208) this bringing together

56. Caskey, *Catalogue*, no. 17; on the authenticity of this monument see my pp. 146 f.

57. Acc. no. 07.286.81; Richter and Hall, no. 118; Beazley, *A.R.V.*², p. 991, no. 61.

58. Maybaum, in *J.d.I.*, xxvii (1912), pp. 24 ff., pl. 6. By the Pistoxenos painter; cf. Beazley, *A.R.V.*², p. 862, no. 30.

59. E.g. *J.H.S.*, xlii (1922), pl. ii, 1; Buschor, *Griechische Vasenmalerei*², 1925, p. 79, fig. 129; *A.J.A.*, xxvii (1923), p. 278, fig. 15.

60. Furtwängler, *Masterpieces*, pp. 4 ff. 61. Bieber, *Die Antiken Skulpturen in Cassel*, pls. i–viii.

62. *M.M.A.*, *Bulletin*, vii (1912), pp. 47 ff.; *Catalogue of Greek Sculptures*, no. 45.

63. Della Seta, in *Ausonia*, 2 (1907), pp. 3 ff., pls. 1–3; R. Paribeni, *Le Terme di Diocleziano e il Museo Nazionale Romano* (1922), no. 369.

64. Smith, *Catalogue of Greek Sculpture in the British Museum*, 1, no. 542. 65. Ibid.

of the eyelids and the pronounced curve of the lower lid admirably convey the feeling of faintness. A centaur whom a Lapith has seized by the hair[66] (fig. 209) plainly shows his physical suffering in his contracted eyebrows and open mouth. In two of the crouching women of the west pediment at Olympia[67] (cf. fig. 210), which are clearly later restorations, but presumably somewhat approximating the style of the originals, the contraction of the eyes and of the mouth, the deep line from the nose downward, and the furrowed forehead effectively indicate sorrow. Even in Attica there are examples. In some of the centaur heads of the Parthenon metopes (fig. 201) the wrinkles caused by pain are indicated in an almost exaggerated manner. In the head of Eurystheus from a metope of the Hephaisteion[68] datable soon after 450 B.C. horror is vividly portrayed (fig. 201). These may be explained as late examples of the transition period, which, as we saw, was distinguished by its experiments in the representation of momentary action and emotion.

The commonest way for the Greek sculptor to convey emotion, however, remained the attitude of the figure, which would moreover be equally telling nearby and at the long distance at which most of the architectural sculpture was seen.

In the rendering of feeling by gesture the Greek artist was undoubtedly helped by the emotional quality of his own people, whose vivid gesticulations could take the place of facial expression. We find him at all periods studying and making use of this means of representation. How suggestive, for instance, of entreaty is the fine group from the Phigaleia frieze of an Amazon asking a Greek warrior for mercy[69] (fig. 211). The raised arm, the upward inclination of the head are as eloquent as any play of features could be. And how effective a rendering of defense is the group, also from the Phigaleia frieze, of an Amazon warding off a Greek warrior[70] (fig. 212). How vividly the feeling of collapse is conveyed in the fallen centaur[71] (fig. 213) and the sinking Amazon[72] (fig. 214), both from the Phigaleia frieze. There is no need of agonized expressions in the faces, the positions of heads and arms and legs are sufficient in themselves to indicate the sculptor's meaning. And in quieter poses we get the same effects. The mourning Athena[73] (fig. 216) has been so called chiefly on account of the impression conveyed by the pose. In the woman on the Boston relief sorrow is suggested even more eloquently in her bowed attitude than in the expression of her face. It was in fact the accepted attitude for sorrow and is repeated in other mourners, for instance, in the bronze statuette in Berlin[74] (fig. 221), the marble statue

66. Ibid., no. 526.

67. Treu, *Olympia*, III, pl. xxxiv, 1–3; Ashmole and Yalouris, *Olympia*, pp. 22, 179, figs. 67–69 (where a date in the first century B.C. is tentatively proposed).

68. Dinsmoor, in *Hesperia*, Supplement v (1941), p. 117, fig. 44.

69. Smith, *Catalogue of Greek Sculpture in the British Museum*, I, no. 537.

70. Ibid., no. 538. 71. Ibid., no. 527.

72. Ibid., no. 542. 73. Dickins, *Catalogue*, no. 695.

74. Neugebauer, *Antike Bronzestatuetten*, no. 64.

in Berlin[75] (fig. 222), the Penelope in the Vatican (fig. 73), the figures on the acro-
terion in Berlin[76] (fig. 220), and the Penelope on the scyphus in Chiusi.[77] In the New
York stele[78] (figs. 215, 462) the love of the little girl for her pigeons and her sadness
are depicted entirely in the action and the inclination of the head, not in the expression
of the face.

In the fourth century, as we have already seen in our study of the human figure, FOURTH
there is a marked change toward individualism. A soft graciousness now takes the CENTURY
place of the former impersonal ideal. And this is naturally reflected also in the face.
In the Hermes of Praxiteles (fig. 178), for instance, there is an expression of dreami-
ness, of gentleness which though not in itself emotional has a distinctly emotional
appeal. The god has become more human, less remote, though still perfectly serene.
And this same evanescent charm appears in many heads of the later fourth and the
early third century, for instance, in the athlete in New York[79] (fig. 218), the Chios
and Bartlett heads in Boston (figs. 182, 183), and the Goldman head in Toledo[80] (fig.
217). Feminine grace and delicacy could not find a more perfect expression.

Skopas is generally regarded as the great emotional sculptor of the fourth century;
and certainly the heads from Tegea (figs. 737–40) attributed to him convey more
ardent feelings than we find in the Praxitelean faces. But we have seen from our pre-
vious study that this was not an innovation; only the means of conveying it is new—
by a marked projection of the lower part of the forehead, the oblique brows, and the
deep-set, upturned eyes creating strong shadows. And though the expression is more
intense than in most other contemporary works we can use the term "strong emotion"
only relatively. According to more modern conceptions most of the Skopasian works
(pp. 207 ff.) still have the Greek serenity and aloofness. We need only place them
beside truly emotional sculptures of German Gothic, Italian Renaissance, and later
times to realize the difference. Even compared with earlier works some of the sculp-
tures attributable to Skopas can hardly be called emotional. The dying Amazon on
the Mausoleum frieze[81] (fig. 219) shows less pain in her face than do her Phigaleian
sisters. It is the attitude rather than the facial expression which conveys the sculptor's
intention; and this is true of the majority of fourth-century sculpture, just as was the
case in the preceding period.

The sculptured gravestones might have been natural outlets for the representation
of human feeling; but even here, both during the fifth and the fourth century, grief
itself is seldom represented. We find instead an expression of dreamy detachment.

75. Berlin Museum, *Beschreibung der antiken Skulpturen*, nos. 498, 499.
76. Ibid., no. 1707; *Amtliche Berichte*, XXXII, 1910, pp. 1 ff.
77. Furtwängler and Reichhold, *Die griechische Vasenmalerei*, III, pl. 142.
78. *M.M.A., Bulletin*, XXII, 1927, pp. 101–05, figs. 1, 2; *Cat. of Greek Sculptures*, no. 73.
79. *M.M.A., Bulletin*, XI, 1916, pp. 82 ff.; *Cat. of Greek Sculptures*, no. 110.
80. Formerly in the collection of H. Goldman; Richter, *Art in America*, V, 1917, pp. 130–34.
81. Smith, *Catalogue of Greek Sculpture in the British Museum*, II, no. 1014.

The departed are shown as they were while alive, the men as athletes or warriors or horsemen[82] (cf. fig. 225) or students (cf. fig. 223[83]), with their sorrowing families and attendants; the women spinning (cf. fig. 224[84]) or engaged with their toilet or waited on by their handmaids or fondling their children; and the children with their playthings and pet animals—lovely, serene figures, their sorrow merely suggested by a quiet pathos, by the handshakes indicating farewell, and by the occasional mourning attitudes (cf. figs. 464,[85] 534[86]). Sometimes an inscription amplifies our knowledge, giving the names and relationships of the people represented, as in the stele of Ampharete holding her grandchild, in the Kerameikos Museum[87] (fig. 467). Only very rarely is death itself represented, as in the stele of Plangon, shown fainting on a couch[88] (fig. 227); or actual grief expressed, as in the weeping siren in Boston[89] (fig. 226, once a finial of a Greek stele), in which the contracted eyebrows and uplifted eyes, the hands tearing the hair and beating the breasts convey acute sorrow. We see how ably the Greek sculptor could, when he wished, express such emotion; and we know also how harassing a whole graveyard of such scenes would have been. The mystery and separation of death cannot adequately or artistically be expressed by such means.

HELLENISTIC
PERIOD

In the Hellenistic period, with the general trend toward realism, it was natural that interest in individual feelings should increase. The complexity of human nature offered a subject full of new possibilities in an age when pure beauty was no longer the aim of the artist; and it became the legitimate, almost exclusive interest of the sculptor to represent the individual human being in the manifold surroundings of his daily life in a direct and realistic manner. We now find representations of an Eros or a satyr in the abandonment of sleep[90] (figs. 128, 129, 228); a boy concentrating his whole attention on extracting a thorn from his foot (fig. 80); an old woman going to market with her wares[91] (fig. 229); a drunken old woman hugging her bottle (fig. 79); a little negro child huddled up and asleep beside his wine jar[92] (fig. 230); an old nurse carrying a child[93] (fig. 232); a young negro musician with mobile body and sad, sensitive face (fig. 63); a mischievous Eros[94] (fig. 231); a caricature with

82. Conze, *Attische Grabreliefs*, no. 1158; Brückner, *Der Friedhof am Eridanos*, pp. 24, 194.

83. Conze, op. cit., no. 622, pl. CXXI. 84. In Berlin. Conze, op. cit., no. 88, pl. XVII.

85. National Museum, Athens, no. 869. Papaspiridi, *Guide*, p. 153, pl. X; and S. Karouzou, *Cat.*, p. 110.

86. *M.M.A., Bulletin*, VIII, 1913, pp. 173 f.; *Catalogue of Greek Sculptures*, no. 89.

87. Cf. p. 113, n. 76. The unusually long inscription reads: "I hold here the dear child of my daughter. When we were alive and saw the rays of the sun with our eyes I held it on my knees. Now, dead myself, I hold it, also dead."

88. National Museum, Athens, no. 749. Papaspiridi, *Guide*, p. 133, no. 745, and S. Karouzou, *Cat.*, p. 115, no. 749.

89. Caskey, *Catalogue*, no. 44.

90. Furtwängler, *Beschreibung der Glyptothek*, no. 218. *M.M.A. Handbook* (1953), p. 123, pl. 102.

91. *M.M.A. Bulletin*, IV, 1909, pp. 201, 204–06, and *Handbook*, 1953, p. 143, pl. 124, c.

92. Ashmolean Museum. A. S. Murray, *J.H.S.*, VII, 1886, pl. LXIV, p. 37, no. 9.

93. *M.M.A.*, acc. no. 06.1066. 94. *M.M.A.*, acc. no. 06.1130.

all the pathos inherent in a clown[95] (fig. 233) ; a dying Persian[96] (fig. 234) ; Laokoon in agony of physical pain[97] (fig. 832) ; Ge making supplication for the life of her son.[98] It is a wonderfully varied world of human moods and feelings of which the Greek sculptor now avails himself; and he does it with remarkable understanding, using both the attitudes and the facial expressions to convey his meaning. It is as if, by coming down from his altitude, his sympathies had become enlarged and he could enter more deeply into the life around him. In our estimate of Greek art it is well to remember this wider region which the Greek sculptor explored at the end of his career, when realism in modeling and conception made him try every theme and represent it in a thoroughly naturalistic manner.

There is another important field in which the Greek artist distinguished himself— the art of portraiture. The archaic sculptor had aimed at the representation of the human figure with no attempt at individual personification. This applies to the rendering of the head as well as of the body. On account of their strong idealizing bent the sculptors of the fifth and early fourth centuries had produced portraits with a marked generalizing tendency. The aim had been, in the words of Aristotle,[99] "to reproduce the distinctive features of a man, and at the same time, without losing the likeness, to make him handsomer than he is"; that is, to dispense with minor, personal traits and create a type rather than an individual. And works like the Homer in Munich[100] (fig. 236; middle of the fifth century), the Perikles in the Vatican and British Museum (figs. 664, 668; ca. 440), and the bearded head by the gem-engraver Dexamenos in Boston[101] (fig. 235; third quarter of fifth century) had been the result—splendid conceptions of the general personalities of these men but without a strongly personal element.

This long tradition of generalization is still evident in the portraits of the fourth century—in the head of Thucydides[102] (second quarter; fig. 237) ; in those of Plato[103] (fig. 238), of Sokrates type A[104] (fig. 239), and of Maussolos[105] (fig. 240), all of the middle of the fourth century B.C.; and even in the finely characterized Euripides[106] (figs. 241, 242), Sophokles (fig. 243),[107] and Sokrates type B[108] (fig. 244; third quarter). But now the time had come for a more individualistic treatment; for interest in human nature per se had arisen. And so the Hellenistic period becomes the great age of realistic portraiture. Fortunately there are a goodly number of examples preserved

95. *M.M.A. Cat. of Bronzes*, no. 127. 96. Helbig-Speier, *Führer*⁴, III, no. 2240.

97. Amelung, *Die Skulpturen des Vatikanischen Museums*, II, no. 74, pl. 20; Helbig-Speier, *Führer*⁴, I, no. 219.

98. *Altertümer von Pergamon*, III, 2, pl. XII, p. 53. 99. *Poetics*, XV, 11.

100. Furtwängler, *Beschreibung der Glyptothek*, no. 273; Richter, *The Portraits of the Greeks*, I, p. 47, no. 5.

101. Beazley, *The Lewes House Gems*, no. 50; Richter, *Engraved Gems*, I, no. 326.

102. Richter, *Portraits of the Greeks*, I, p. 148, no. 2. 103. Ibid., II, p. 167, no. 15.

104. Schefold, *Bildnisse*, pp. 74 ff.; Richter, op. cit., I, p. 111, no. 12. 105. Richter, op. cit., II, pp. 161 f.

106. Ibid., *I*, p. 135, no. 12. 107. Ibid., *I*, p. 127, no. 18.

108. Ibid., *I*, p. 112, no. 1.

from which we can form a fair idea of Hellenistic achievements, and not merely Roman copies, as are most of the earlier Greek portraits, but actual originals. Perhaps their greatness lies in the combination of old idealism and new realism. The statues of Demosthenes[109] (fig. 815) and of Chrysippos,[110] (figs. 247, 826), the head in Lord Melchett's collection (fig. 248), the bronze statuette of a philosopher[111] (figs. 245, 246), the astounding head of Euthydemos I of Bactria[112] (fig. 254), and the heads on the coins (figs. 249–53[113]) and gems[114] of the Hellenistic period are not only typical portraits of Greek thinkers and poets and statesmen, but they have become at the same time vivid character studies of individual human beings. The sculptor gives us a faithful and detailed transcription of the features of a particular man; but like a true artist he also goes beyond the external appearance and conveys a penetrating picture of his sitter's character. In the late Hellenistic period the realism becomes even more marked. We can assign to it such powerful works as a head of Homer of which more than twenty examples have survived (e.g. fig. 255[115]), its counterpart the so-called Pseudo-Seneca, of which almost forty examples are extant (e.g. fig. 256[116]), so evidently representing another famous person (Hesiod has been suggested[117]), and the bronze head from Delos in Athens[118] (fig. 257). They form the immediate precursors of the Roman Republican portraits, which must have been executed by Greek artists; only the physiognomies of the two are different, the Greek portraits being mostly of intellectual persons, the Roman ones of practical men of affairs.

There is another circumstance which adds considerable interest to Greek portraiture—that the sculptor did not confine his characterization to the head but included the whole figure, and so was able to reveal his sitter's personality not merely in his features but in the attitude of the body. And this he was able to do with peculiar understanding. The Sophokles in the Lateran (fig. 264), the bronze statuette in the Metropolitan Museum[119] (fig. 258), the Demosthenes (fig. 817), and the Poseidippos[120] (fig. 259) in the Vatican are eloquent witnesses of Greek achievements along these lines. The manner in which the figures hold and carry themselves is so consistent with their physiognomies that it must be due to the penetrating observation of the sculptor. Unfortunately quite often the statues are fragmentary and we have many separate heads and bodies; even then, however, the pieces retain in a mysterious way the quality of the whole, so that even in a headless statue we can get some realization of the character of the man.

109. Ibid., II, pp. 216, 219, nos. 1, 32. 110. Ibid., II, p. 193.

111. Ibid., II, p. 199. 112. Ibid., III, p. 278, figs. 1970, 1971.

113. In the American Numismatic Society; from the collection of E. T. Newell.

114. Furtwängler, *Antike Gemmen*, pls. XXXII, XXXIII.

115. In the Museum of Fine Arts, Boston; Caskey, *Cat.*, no. 55.

116. In Naples. Ruesch, *Guida*, no. 879, Richter, op. cit., I, p. 59, no. 13. 117. Cf. Richter, op. cit., I, p. 65.

118. National Museum, no. 14612; Papaspiridi, *Guide*, p. 220; S. Karouzou, *Cat.*, pp. 187 f.

119. *Catalogue of Bronzes*, no. 120.

120. Amelung, *Die Skulpturen des vaticanischen Museums*, II, pl. 54, no. 271; Helbig-Speier, *Führer*[4], I, no. 129.

CHAPTER 5

DRAPERY

Equally with the beauty of the human form, the Greek felt the beauty of drapery; of large and small folds, of the differences of texture, of the composition of surfaces. To its artistic interpretation he devoted the same ability and concentration which he lavished on the study of the human body. In these studies he had a great advantage. The fashions of the day with the loosely hanging instead of closely fitting garments enabled him to watch the rich and varied play of folds of different materials. He did not have to create his opportunities artificially; he had them continuously before him. And not only did the free-hanging dresses assume expressive folds while the figure was at rest, but they were directly influenced by the action of the body. Every motion, every mood almost, of the person was reflected in the drapery. The Greek sculptor realized these possibilities fully, and after many arduous labors succeeded in making the drapery an eloquent means of expression. It is interesting to observe the various phases through which the Greek artist passed in his efforts at artistic representation, corresponding closely to the different stages of development in the modeling of the human figure.

Greek Dress

BEFORE studying the Greek sculptor's rendering of these draperies it may help to review briefly the chief garments in use among the Greeks,[1] so that we may recognize them when we see them and understand their structure.

The chief garments of the man were the chiton, the himation, and the chlamys.

The chiton was a tunic of soft linen or of wool. It was made either of one oblong cloth, at first rather narrow, later considerably wider, folded on one side and sewn on the other; or of two rectangular pieces sewn on both sides. At the top it was either pinned or sewn over the shoulders to form the sleeves. In the archaic period the openings for the arms were regularly on the sides (fig. D), in classical times generally along the upper edge[2] (fig. E on p. 59, a change which made for a more effective fall

1. This account is not meant to be exhaustive but merely a brief statement. For a study of Greek dress the reader is referred to Heuzey, *Histoire du costume antique*, Paris, 1922; Bieber, *Griechische Kleidung*, 1928, and *Entwicklungsgeschichte der griechischen Tracht*, 1934, 2nd ed. 1967; Studniczka, *Beiträge zur Geschichte der altgriechischen Tracht*; Bieber, "Der Chiton der ephesischen Amazonen," in *J.d.I.*, XXXIII, 1918, pp. 49 ff.; Kalkmann, "Zur Tracht archaischer Gewandfiguren," in *J.d.I.*, XI, 1896, pp. 19 ff.; Barker, "Domestic Costumes of the Athenian Woman in the Fifth and Fourth Centuries B.C.," *A.J.A.*, XXVI, 1922, pp. 410 ff.; Daremberg and Saglio, *Dictionnaire*, under *Tunica, Peplos, Pallium*; Pauly-Wissowa, *R.E.*, under χιτών, ἱμάτιον; Th. Hope, *Costumes of the Greeks and Romans*, 1962.

2. This important point is clearly brought out by Bieber, "Der Chiton der ephesischen Amazonen," pp. 49 ff.

of folds. The chiton could be worn short (fig. 260) or long (fig. 299). It generally appears with a belt[3] (fig. 261) over which the garment was pulled to form a pouch

(*kolpos*); and sometimes an overfold (*diploidion*) was introduced at the top; and now and then a second belt was worn over the pouch. Cords were occasionally placed across the back and the shoulders to keep the garment in place, especially when it was long (fig. 299). Belts, pins, cords, overfold, all helped to create variety.

A variant of this tunic is the so-called χιτὼν ἐξωμίς (*exomis*) fastened with a brooch on one shoulder only, worn likewise with a belt, but consisting merely of a rectangular cloth, not sewn, or only rarely so. As an example we may cite a rider from the Parthenon frieze in the British Museum[4] (fig. 262).

FIG. D. Archaic chiton with sleeve openings on sides

The himation, or the mantle, was a large rectangular piece of cloth (fig. 263[5]) about seven or eight feet long and in width about equal to the wearer's height. It was wrapped around the body in every conceivable way to suit the needs and fancy of the wearer. The artistic arrangement of its folds thus became a great opportunity and delight to the artist.

How much the many beautiful compositions in Greek sculpture are due to the interpretation of the artist rather than to direct copying of nature can be seen when we compare the statue of Sophokles in the Lateran Collection[6] (fig. 264) with a living model similarly draped (fig. 265). The drapery of the Sophokles is a harmonious composition, with the plain and the bunched surfaces consciously correlated. The actual model, in spite of every effort to imitate the happy effect of the statue, has no artistic appeal. How clumsy, for instance, are the folds below the right knee, interrupting the long sweep of the outline of the leg; and how dull the large expanse of smooth surface on the lower portion, relieved in the original by contrasting shadows; how much difference it makes when the lower edge of the drapery forms a strongly oblique instead of a quasi-horizontal line!

The chlamys was the short cloak worn as a wrap when the large himation would be in the way, for instance while hunting or riding (fig. 266). It too was probably rectangular, and it was fastened round the neck by a brooch or button, the loose ends falling down to form zigzag edges (fig. F, on p. 60); the dimensions were probably

3. Cf. the amphora in the M.M.A.; Richter and Hall, no. 119.
4. Smith, *Sculptures of the Parthenon*, pl. 66.
5. From a kylix in Berlin. 6. Helbig-Speier, *Führer*[4], I, no. 1066.

about six to seven feet long by three and one-half feet wide. Weights were often attached at the corners to keep the garment in place, as was the case also with the himation. Again, simple though the arrangement is, we can see by comparing a Greek drawing (fig. 266) with a draped model (fig. 267) how much the artist contributed to the aesthetic effect. A slight change in the zigzag edge and the different position of the left arm have made all the difference.

FIG. E. Classical chiton with sleeve openings
on upper edge

The women's dresses were similar to those of the men; that is, they were also rectangular pieces of cloth, loosely worn and effectively draped. The favorite forms were the chiton and the himation; rarely we find an additional short cloak.

Of the chiton there were two varieties. The Ionic, the chiton par excellence, was of linen imported from Egypt or the East and was generally made in two rectangular pieces sewn together on both sides and buttoned or pinned with brooches along the upper arm to form sleeves[7] (fig. 268). The Doric, known as the peplos, was made of wool spun and woven by Greek women in their houses, all in one piece; it was often worn open on one side and was regularly fastened over each shoulder with a brooch, button, or long pin[8] (fig. 269). The width of an Ionic chiton is given by Plato[9] as three meters (seven Attic cubits). The peplos was about as wide, twice the width of the outstretched arms to the finger tips, or a little less. The length naturally depended on the wearer's height. The former being of linen created a large number of crinkly folds,[10] the other, being of wool, fewer, massive ones. The wearing of the belts, pins, and overfolds again helped to introduce diversity.

The himation was similar to that worn by the men and ʷas used as an outside wrap over the chiton. It was often pulled up to cover the head to take the place of a hat (fig. 270[11]) in the manner that an Italian or Greek woman of today might use her shawl when going out of doors. Occasionally it was fastened on the shoulder with a pin.[12] A more complicated variant of this simple garment is the short Ionic himation[13] worn

7. For the openings of the sleeves, cf. pp. 57 f. (under the man's chiton).

8. Langlotz, *Fruehgriechische Bildhauerschulen*, pl. 16, a. 9. *Letters* XIII. 363a.

10. Whether these crinkly folds were at least partially due to an artificial pleating of the material, such as our accordion pleating, or were wholly the result of the stylization of the artist is still a moot question.

11. Terracotta statuette in the M.M.A., acc. no. 23.73.3.

12. E.g. on the fragment of a red-figured krater in the British Museum, no. E493, and on the François vase in Florence, Richter, *Korai*, pl. XII, a, b.

13. On this garment and the *epiblema* cf. my *Korai*, pp. 6 ff., and the references there cited.

by the Akropolis Maidens of about 550–480 B.C. (cf. figs. 285, 286, 287). This too seems to have been a rectangular piece of material, but it was regularly worn under the left arm and over the right shoulder where it was fastened by brooches or buttons, the spare material hanging loosely down. Its vertical pleats were apparently kept in place by a border, over which the himation was pulled up a little. It was worn over the chiton, which was generally pulled tightly to one side and was decorated with a vertical stripe.

The short cloak was not nearly so common with women as with men; probably because they did not indulge so much in violent exercise, like hunting or riding, when the long coat would be an encumbrance. It occurs occasionally as an extra wrap worn over the chiton and himation like a shawl or stole (cf. fig. 271). Its Greek name was *epiblema*.[13]

FIG. F. Chlamys

In addition to these loosely hanging garments we sometimes encounter sewn dresses of a similar appearance to our own; for instance, the embroidered sleeveless jacket on an onochoe by the Meidias painter in New York[14] (fig. 326) and the sleeved coat on a relief in Broom Hall[15] (fig. 272). In these, tube-like sleeves are sewn to the openings on the sides of the garment.[16] But such cases are few, except for Amazons, Persians, and other "barbarians" whose apparel consisted of sleeved and trousered garments (fig. 273[17]).

We must imagine these garments dyed in various colors, brilliant reds, browns, blues, yellows, greens, purples,[18] or plain white; occasionally with little ornaments all over the surface; and generally decorated with colored or embroidered bands. These bands—which add greatly to the artistic effect of the whole, as any practical experiment will show—generally appear only on the short sides, sometimes on one of the long sides also; not on all four sides, for the obvious reason that the composition would have lost by this excess.

The two chief materials used by the Greeks were linen and wool.[19] There is no men-

14. Richter and Hall, *Red-Figured Athenian Vases*, pl. 158, no. 159; Beazley, *A.R.V.*², p. 1313, no. 11.

15. Conze, *Att. Grabreliefs*, pl. CLVI, no. 819. Cf. also the instances figured by Bieber, *Griech. Kleidung*, fig. 8a and pls. XIV, 1–2, XXI, 1. 16. Bieber, op. cit., p. 16.

17. M.M.A., acc. no. 06.1021.189. Richter and Hall, no. 108, pl. 108; Beazley, *A.R.V.*², p. 1066, no. 10.

18. That Greek garments were brilliantly colored is attested by their appearing so in terracotta statuettes and marble sculptures of all periods, and on the white lekythoi of the fifth century B.C.

19. Blümner, *Gewerbe und Künste*, I, 106 ff., 191 ff.

tion of silk before the time of Aristotle,[20] but there is some evidence that it was adopted by the Greeks during the fifth century B.C. (cf. p. 00). It was known in China long before that (ca. 3000 B.C.). Cotton garments were worn in India and Egypt[21] but there is no evidence of their use in Greece before Roman times.

The Rendering of Drapery

WE have seen how much the Greek artist with his instinct for composition improved on the arrangement of drapery in nature. Besides his sense for harmonious design he had the realization of two other essential requirements: that in art drapery must not wholly hide the body beneath it; and that the folds must always clearly interconnect, so that the construction of the whole may be convincing. The female statue from Herculaneum[22] (fig. 274), wearing a thick Doric peplos with overfold, well illustrates the first quality. In the similarly draped living model (fig. 275) the outlines of the legs and breasts are completely concealed by the heavy material; and we quickly realize how much of the artistic effect is lost thereby.

The clear construction of the drapery in Greek sculpture is another source of genuine artistic enjoyment. In the many compositions of Greek drapery there is never any confusion; we do not wonder where one fold comes from or what becomes of another; the whole is convincing and logical. In nature that is not always so; one part of the garment often hides another in such a way that the interconnection is not apparent. How much more clearly, for instance, do we feel in the Sophokles statue (fig. 264) that the drapery enveloping the arms is part and parcel of the himation than we do in the corresponding living model (fig. 265). In the model we know that the upper shawl-like effect belongs to the himation and the cascade from the left arm is one end of it; but if it were an unfamiliar garment we might think that the lower part was a separate tight skirt and that a towel was hanging over the left arm. In the statue such doubts are impossible; each part of the mantle passes so unmistakably into the adjoining portion and connects with it that we feel the drapery as a whole, as a unit.

With these general characteristics of Greek drapery in mind let us now watch the course of its development.

An early stage is shown in the Nikandre in Athens[23] (fig. 277) and the Auxerre statue in the Louvre[24] (fig. 276), both still of the seventh century B.C. None of the essential requirements are as yet met. The treatment is flat, there is no attempt to render folds, only decorative borders; and there is practically no feeling for the body

SEVENTH TO SIXTH CENTURY

20. Aristotle, *Hist. anim.* v. 19; Pliny, *N.H.*, xi, 26–28. On the origin and use of silk, cf. Besnier, in Daremberg and Saglio, *Dictionnaire*, under "Sericum"; Blümner, op. cit., p. 201; Richter, "Silk in Greece," in *A.J.A.*, xxxiii (1929), pp. 27 ff.

21. Herodotos iii. 47, 106; Pollux vii. 75; Theophrastus *Historia Plantarum* iv. 7. 7. Cf. on this subject Blümner, op. cit., pp. 199–200. 22. Comparetti and de Petra, *La Villa ercolanese*, pl. xiv, 3.

23. National Museum, no. 1; Papaspiridi, *Guide*, p. 19, and S. Karouzou, *Cat.*, p. 3; Richter, *Korai*, no. 1.

24. *Korai*, no. 18.

beneath. Drapery merely acts as a covering and has no independent life. The superb standing maiden in Berlin[25] (figs. 279–81), the Chares statue from Miletos[26] (fig. 278), the maidens on the newly discovered metope from Selinus[27] (fig. 283), and the Philippe by Geneleos from Samos[28] (fig. 282), all of the second quarter of the sixth century, mark a step in advance. The surface begins to be broken up by a tentative, strictly stylized indication of folds. They have as yet little depth, for the sculptor is still too timid to cut deeply into his stone; but the essentials of the construction of the long chiton and of the himation are understood and clearly rendered. And in each case the decorative feeling of the artist has produced a beautiful design. The inter-relation of volumes, the different directions of ridges and grooves, the linear patterns for the edges of stacked folds all play their part in the composition.

The decorative treatment of drapery reached its climax during the second half of the sixth century. Conventions were multiplied, the scheme was enriched and en-larged. The figures on the friezes of the Siphnian Treasury (figs. 451, 452) and, above all, the Maidens from the Athenian Akropolis (figs. 285–87[29]) and from the Islands (fig. 288[30]) are instructive examples. The soft crinkly material of the linen chiton was rendered by a series of straight, or, more commonly, wavy ridges or in-cisions, running vertically if the drapery hung down loosely, obliquely and curving if directed sidewise. The heavier folds of the short Ionic himation were indicated by straight, deep grooves or ridges rather more widely spaced, often with zigzag edges. By these means the archaic artist was able to cope with the difficult problem of repre-senting the complicated garments of his time. The short mantles with overfolds, bor-ders, and little ornaments, worn over one shoulder and under the other, and the chitons generally so long that they had to be held up on one side, constituted such a mass of folds going in different directions that it was hard to simplify and to keep to the important elements. The Greek sculptor succeeded, in spite of his comparative inexperience, by his decorative sense, which enabled him to create a highly artistic design, as well as by his feeling for structure, which enabled him to connect every fold with its neighbor so that each had a meaning, a start and a finish, and helped to form a correlated whole.

Toward the end of the century a great change takes place. The drapery, though lying as before close against the body, begins to acquire a separate entity. We now feel that it is completely separate, that it can be taken on and off at will, and moreover that it has a life and swing of its own. We notice it best in reliefs where action is por-trayed, for instance in the mounting charioteer[31] (fig. 289) and the Hermes[32] (fig.

25. Wiegand, in *Berliner Museen* (1926), pp. 17 ff.; and in *Die Antike*, II, pp. 30 ff.; Blümel, *Die archaisch griechischen Skulpturen*, no. 1; *Korai*, no. 42. 26. In the British Museum. Pryce, *Cat.*, I, 1, no. B278.

27. Tusa, *Arch. classica* (forthcoming). 28. *Korai*, no. 67.

29. In the Akropolis Museum, Athens, nos. 679, 680, 674, 681; *Korai*, nos. 113, 122, 127.

30. *M.M.A., Bulletin* (1908), pp. 4 ff.; *Catalogue of Greek Sculptures*, no. 5; *Korai*, no. 151.

31. Dickins, *Catalogue*, no. 1342. 32. Ibid., no. 1343.

290) in the Akropolis Museum, and in the metopes from the Athenian Treasury in Delphi[33] (cf. figs. 437, 438). The old conventions of zigzag, radiating, and wavy grooves are still adhered to; but the direction of the folds is carefully studied in regard to the function they perform, so that they become more expressive of the action of the body. How convincingly, for instance, the mantle of the charioteer (fig. 289) clings to the back, is bunched over the upper arms, and where it hangs down is influenced partly by its own weight and partly by the movement of the body! The bronze statuette of Nike in London (fig. 88) is another beautiful instance of drapery expressive of the movement of the figure.

For the archaic conventions adopted by the Greek sculptor in his rendering of drapery we find interesting parallels on contemporary vases; they follow the development step by step, and are therefore often useful evidence for dating.[34] On the vase-paintings of the late seventh to the middle of the sixth century (cf. fig. 291[35]) the garment more or less hides the figure, as it does in the early sculpture, for the artist has not learned to differentiate between body and drapery or to give each its significance; individual folds are either not indicated or only a few of the most important are shown, and they are composed in an effective way. In other words, these vases show the same stage of development as the Auxerre and Miletos statues (figs. 276, 278). In the later black-figured and earliest red-figured vases (cf. fig. 292[36]) a conventional treatment has been developed similar to that in the more advanced maidens: fine, wavy lines for the chiton folds and straight, more widely spaced lines for those of the himation; a wavy line for the bottom edge of the chiton; zigzag lines for the edges of the himation; and small, wavy, radiating lines for the folds caused by the brooches or buttons in the sleeves. At the end of the sixth and the beginning of the fifth century the draperies on the vase paintings show the same life and individuality that we noted in the sculpture. We may compare, for instance, the relief of the mounting charioteer (fig. 289) with the vase by the Pasiades painter (510–500) in the British Museum[37] (fig. 294). The mantles worn like shawls over the shoulder have similar bunched folds, and there is the same suggestive treatment of drapery in motion by means of closely spaced oblique lines with zigzag edges. Sometimes there are similar individualistic renderings in sculpture and vase paintings; for instance, the peculiar wavy line for the folds of the mantles in one of the statue bases found in Athens[38] (fig. 297), which occurs in identical fashion on the paintings by Euthymides (fig. 293[39]); and the radiating folds of the chiton sleeves in the Amazon of the Athenian Treasury,[40]

33. Homolle, *Fouilles de Delphes*, IV, pls. XXXVII–XL.

34. On this subject, cf. Langlotz, *Zur Zeitbestimmung der strengrotfigurigen Vasenmalerei und Plastik*, and von Lücken, "Archaische griechische Vasenmalerei und Plastik," *Ath. Mitt.*, XLIV (1919), pp. 47 ff., pls. I–VI.

35. M.M.A., acc. no. 17.230.14; Beazley, *A.B.V.*, p. 144, no. 3.

36. M.M.A., acc. no. 06.1021.47; Beazley, *A.B.V.*, p. 667.

37. No. B 668; Hoppin, *Handbook*, II, p. 331; Beazley, *A.R.V.*², p. 98, no. 1.

38. Papaspiridi, *Guide*, p. 38, no. 3476; S. Karouzou, *Catalogue*, p. 31.

39. Hoppin, *Handbook*, I, p. 435; Beazley, *A.R.V.*², p. 26, no. 2. 40. *Fouilles de Delphes*, IV, pl. XL.

the Athena of the Eretria pediment[41] (fig. 295), and the draperies by Peithinos (fig. 296),[42] Sosias, and others.[43]

The first half of the fifth century is a period of great development in drapery as it is in every phase of Greek art. There is a gradual increase in naturalism, but always joined to the old decorative sense. The folds no longer descend according to an accepted scheme; they vary their direction just as they do in nature, but underlying their arrangement is the conscious composition of the artist. This combination produces singularly happy results. The mantle of Theseus in the Eretria pediment[44] (fig. 298), with its studied and yet natural arrangement, the similar mantle on the Aristogeiton in Naples[45] (fig. 611), the draperies of the Berlin seated goddess[46] (fig. 70), all show in a happy way this combination of the old decorative tendency with the new feeling for naturalism. The union of these two elements produces also the "architectural" draperies of this period—those of the Delphi charioteer[47] (fig. 299), of the Herculaneum Dancers (figs. 274, 536), of the Athena of the Olympia metope[48] (fig. 336) and of the terracotta fragment in New York[49] (fig. 300). In these the fine simplicity of the folds, hanging down like flutings of a column, gives the whole a feeling of stability; but the simplicity is never monotonous, for the scheme is infinitely varied; only the variety is concealed by not being accentuated. At first sight the vertical folds of the chiton of the Delphi Charioteer (fig. 299) or the horizontal folds on the sleeves all look alike, but if we look more closely we shall find every one different; the under edge appears at first horizontal; but in reality it makes a distinct curve. This quality of creating an appearance of simplicity but enlivening it with an undercurrent of richness and variety is one that underlies all Greek art. It is the product of a mind that can combine simplicity with subtlety.

The vases of the period reflect the same progress in knowledge and conception. The draperies of Makron, of the Brygos painter, of the Pan painter show a new life, a new stir and swish in the garments, tempered by a strong stylistic quality. How expressive are the turbulent chitons in the maenad dance by Makron in the Berlin Museum[50] (fig. 301), how much they help to convey the ecstasy of the wild maidens, and yet how restrained and harmonious is the design as a whole. And in the Makron cup in the Metropolitan Museum[51] (fig. 302) how convincingly the folds of the girl's chiton follow the action of the knee and then hang loosely and quietly down; and how much they contribute to the harmonious composition. Again in the krater by the Pan painter

41. Kuruniotes, in *Antike Denkmäler*, III, pl. 29.

42. Berlin Museum, no. 2279. Hoppin, op. cit., II, p. 335; Beazley, *A.R.V.*², p. 115, no. 2.

43. Cf. Langlotz, *Zeitbestimmung*, pp. 72, 73. 44. Kuruniotis, in *Antike Denkmäler*, III, pls. 27, 28.

45. Ruesch, *Guida*, no. 104.

46. *Antike Denkmäler*, III, pls. 37 ff.; Blümel, *Die archaisch griechischen Skulpturen*, no. 21.

47. *Fouilles de Delphes*, IV, pls. XLIX–L.

48. Treu, *Olympia*, III, pl. XLIII, 12; Ashmole and Yalouris, *Olympia*, p. 29, figs. 202–206.

49. *M.M.A. Handbook* (1930), p. 111, fig. 73.

50. Berlin Museum, no. 2290; Beazley, *A.R.V.*², p. 462, no. 48.

51. Acc. no. 12.231.1; Richter and Hall, no. 52; Beazley, *A.R.V.*², p. 468, no. 146.

in Boston[52] (fig. 303) what a splendid design is formed by the chlamys of Aktaion and how we feel the lower part of Artemis' chiton waving to and fro as she steps back to send her deadly arrow! Drapery has indeed become by now as eloquent a means of expressing the action and emotion of a scene as the human figure. And examination shows many parallels in details of renderings in sculpture and vase-painting; for instance, the similar designs for the mantles on the Theseus of Eretria (fig. 298) and on the Douris vases (cf. fig. G, infra) with their widely spaced folds stacked in two directions; or the beautiful transparent folds of the chitons of the Ludovisi Hora[53] (fig. 304) and the Makron hetaira (fig. 302).

The treatment of the drapery in the second half of the fifth century is the logical sequence of that in the first half. But changes are now rapid. The trend toward naturalism gains ground quickly and the design quality, though still strong, becomes less

SECOND HALF
OF FIFTH
CENTURY

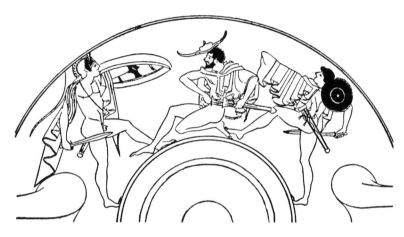

FIG. G. Detail of a kylix
Museum of Fine Arts, Boston

obvious. In the figures of the Parthenon frieze (ca. 442–438) though there is a marked retention of the old severity, the new spirit begins clearly to show itself. Folds have multiplied and they go in many different directions. Nevertheless we feel throughout the conscious composition of the artist in the distribution of light and shade, caused by the variety of volume in the folds. Thus in the "herald" of the slab in the Louvre (fig. 305) we have first the bare chest, then the deep folds on the left shoulder and round the waist, then the relieving flat surface of the right leg contrasting with the folds hanging down his left side. In the maidens marching in procession[54] (fig. 305) we note the same love for contrasting surfaces and the same device of puting one leg slightly forward and drawing the drapery tightly over it with only a few ridges to show the presence of the garments. This distribution of light and shade bebelt; then again a comparative rest where the chiton lies close over the body below

52. Furtwängler and Reichhold, *Die griechische Vasenmalerei*, pl. 115; Beazley, *A.R.V.*², p. 550, no. 1.
53. Helbig-Speier, *Führer*⁴, III, no. 2340.
54. Smith, *Sculptures of the Parthenon*, pls. 39, 55.

sides forming a pleasing design supplies the chief structural accents at a distance, and greatly helps the understanding of the whole.

In the Parthenon pediment figures (ca. 437–432; cf. figs. 74, 96, 306) the development toward naturalism has made distinct strides and we note another important change. The sculptor finally has courage to hew deeply into his marble; the adherence to flat surfaces dear to the archaic artist is entirely given up, and folds, even those of the chiton, once shown by incised wavy lines, are often an inch or two deep; while the heavy folds of the mantles have a volume of four inches or more. In the Iris (fig. 96) the direction of the folds conveys not only the rapid flight of the figure but the action of the wind blowing through it. But in spite of the increased realism the feeling for design is still strong and shows itself in the composition of the drapery. In the reclining "Fate"[55] (fig. 306), for instance, we begin with the bare neck and right shoulder, then comes the variegated surface of the chiton lying on the breast, then the strong shadows of the folds formed by the double thickness of the chiton bunched over the the waist; then the dramatic effect of the heavy himation with its many folds of great volume placed over the upper part of the legs; and finally the smoother part of the himation lying more or less foldless over the knees and lower part of the legs. The effect of the whole is suggestive of the rhythmic movement of waves. This conscious arrangement is a translation of the confusion of nature into an artistic composition.

Another characteristic of the drapery of this period is the increase in its transparency. The forms of the body beneath it show through much more clearly than before, though the garment always retains its separate entity.

We note the same qualities in the drapery of contemporary monuments—the group of watching deities of the Hephaisteion[56] (fig. 307) so reminiscent of the seated figures in the Parthenon pediment; in the stele of a seated woman in New York[57] (fig. 308); and in the statue recently acquired by the Museum of Basle,[58] to which is thought to belong a head of the Lysistrate type[59] (figs. 309, 310). We have here the same naturalistic effect combined with conscious composition, the same pleasant interrelation of contrasting lights and shadows, the same treatment of the drapery as a separate entity in spite of the increased softness.

It should be noted that the edges of draperies of the second half of the fifth century sometimes show a border of short transverse grooves (cf. figs. 4, 381), apparently to represent the selvage of the fabric, since this treatment occurs always on opposite, not adjoining edges.

By the last quarter of the fifth century another characteristic style is developed—that of making the drapery, particularly the chiton, very transparent, of minimizing its presence and letting the body appear clearly through it. It is an accentuation of

55. Smith, *Sculptures of the Parthenon*, pl. 5.

56. Sauer, *Das sogenannte Theseion*, pl. III; Dinsmoor, in *Hesperia*, Suppl. V (1941).

57. *M.M.A. Cat. of Greek Sculptures*, no. 75.

58. Berger, in *Antike Kunst*, XI (1968), pp. 67 ff., pl. 31, 1, pl. 33. If the combination is correct, it should indicate a date in the later fifth century B.C. for the head, rather than in the Hellenistic period or the first century B.C., as thought by some. 59. Richter, *The Portraits of the Greeks*, I, pp. 155 f., figs. 877–81.

a tendency which we noted in the period immediately preceding this one, and which now attains its climax. It is of course possible, indeed probable, that these transparent garments are intended to reproduce very thin materials which may have come into use at this time, that they represent in fact the διαφανῆ χιτώνια referred to in Aristophanes' *Lysistrata*, line 48, and the χιτώνια ἀμόργινα which "make women appear naked" (l. 150). Possibly they were of silk,[60] for this material is mentioned in Greek literature not long afterwards (Aristotle, *Hist. anim.* V. 19), and silk garments are often described as transparent in Roman literature. That the beautiful folds created by silk should have appealed to the Greek artist and have suggested the clinging draperies of this period would be only natural. But though temporary fashion may have influenced the rendering of drapery at this period the sculptor clearly did not merely copy nature. In the Nike adjusting her sandal[61] (fig. 543) the legs could never in reality show so clearly through two layers of material—the chiton and the himation. As in archaic art it is not realism that is aimed at, but artistic effect.

Joined to this transparency we note another characteristic feature in the drapery of this period: the decorative use of sweeping folds—generally of the himations—blown around the figure. The deep, broad channels creating dark shadows contrast with the smoother modeling of body and limbs and play an effective part in the design.

The combination of these two styles is characteristic of practically all the monuments of the late fifth century. The balustrade of the Nike temple, datable about 410, furnishes striking examples. We have already cited the Nike adjusting her sandal (fig. 543), where the contrast between the practically nude body and the deep shadows of the surrounding drapery is very striking. The Nike with the bull[62] (cf. fig. 545) shows this transparency combined with turbulent, highly decorative effects. Folds of great volume running in different directions are massed between the legs and form a variegated, dramatic background. It is a combination of stateliness and turmoil. The Karyatids of the Erechtheion[63] (fig. 541), dated between 421 and 413, show the same transparent drapery where it is laid against the left leg or over the breasts; at first sight we are not sure whether the upper part of the left leg is not bare—a doubt which would be impossible in the Parthenon figures. Moreover, in the breasts of the Karyatids the contours are distinctly visible through the drapery while in the Parthenon only their general shape is recognizable. The scanty fragments of the frieze of the Erechtheion[64] (409–406) are similar in style. In the group of the woman and child[65] (fig. 312) the folds of the drapery are practically confined to the surfaces surrounding the legs, whereas the legs appear almost nude. The Nike of Paionios in Olympia[66] (fig. 682) was dedicated, according to the inscription, by the Messenians and Naupaktians to Zeus with a tithe of the spoils taken from their enemies. The campaign re-

60. On this subject cf. Richter, *A.J.A.*, xxxiii (1929), pp. 27 ff.

61. Casson, *Catalogue of the Acropolis Museum*, ii, pp. 156 f., no. 12. 62. Ibid., p. 155, no. 11.

63. Smith, *Catalogue of Greek Sculpture in the British Museum*, i, no. 407; Paton et al., *The Erechtheum*, pls. xxxviii, xxxix, pp. 232 ff.

64. Ibid., pls. 40 ff., pp. 239 ff. 65. Casson, *Catalogue of the Acropolis Museum*, ii, p. 181, no. 1075.

66. Treu, *Olympia*, iii, pls. 46, 48.

ferred to is most easily identified as that of Sphakteria, 425, which would place the statue around 420. It brings out strikingly the characteristics we are analyzing. The transparency of the drapery over the portions of the body which it covers is so great that it does not affect the forms at all. The draped right leg is modeled as carefully as the bare left one and its contours show as distinctly. The presence of the drapery is only recognizable by the occasional ridges introduced to indicate the folds. By way of contrast the drapery is shown blowing behind in deep, restless folds creating strong shadows.

In the frieze of the Athena Nike temple—built "probably between 427 and 424"[67] —we have on the one hand quiet standing figures[68] (fig. 313) in which one leg though completely draped is carefully modeled with both contours showing—very different from the Parthenon treatment, where only the outer outline shows and the inner is lost through the covering drapery, and very similar to the Erechtheion caryatids (fig. 541) ; we have on the other hand a violent battle scene[68a] (fig. 311) in which the draperies of the contestants are blown right and left in turbulent masses of considerable volume, a device which greatly adds to the stir and tumult of the contest. The fragmentary sculptures of the Argive Heraion[69] (ca. 420) contain several beautiful examples of transparent, clinging drapery.

We learn from Pausanias[70] that the Phigaleia temple[71] was built by Iktinos, the architect of the Parthenon, and dedicated to Apollo Epikourios, "the Succorer" "for the help he gave in time of plague . . . at the time of the war between the Peloponnesians and Athenians." The style of the sculptures, both of the frieze (cf. figs. 314,[72] 315[73]) and the metopes (figs. 316,[74] 317[75]) points to a date about 420. The drapery in particular shows the characteristics we have noted in the sculptures of this period —the peculiar transparent quality with the contours of the bodies clearly shown and only occasional ridges to indicate the presence of the garments, and the decorative splashes against the background. Moreover, some figures bear a striking similarity to other late fifth-century reliefs; for instance, the Lapith woman on figure 315 to the Nike and bull from the balustrade (fig. 545). Taken as a whole, however, the composition in the Phigaleia frieze is wilder, more turbulent than that in the other monuments, reflecting the wildness of the Arkadian mountains in the tumult and agitation of the draperies.[76]

67. Cf. Dinsmoor, *Architecture*, pp. 185 ff.

68. In situ in Athens; cf. Blümel, *Fries des Tempels der Athena Nike*, pls. 1–3, 10–12; Carpenter, *The Sculpture of the Nike Temple Parapet*.

68a. Smith, *Catalogue of Greek Sculpture in the British Museum*, II, no. 422.

69. Waldstein, *The Argive Heraeum*, I, pls. XXXV, XXXVII.

70. VIII. 41. 50. 71. On this temple cf. Dinsmoor, *Architecture*, pp. 154 ff.

72. Smith, op. cit., I, no. 531. 73. Ibid., no. 530.

74. Ibid., no. 512. 75. Ibid., no. 517.

76. Attempts have been made to identify the Niobids in Rome (fig. 4) and Copenhagen (figs. 92, 118) and two figures in Paris as pedimental sculptures and akroteria, respectively, from this temple (cf. Dinsmoor, in *A.J.A.*, XLIV (1939), pp. 27 ff., and Picard, in *Monuments Piot*, 39 (1943), 49 ff.) ; but the evidence is not decisive.

The Nereids of the Nereid monument[77] (cf. figs. 318–20) show the same charac-
teristics we have been discussing, in an advanced form. The thin chiton of one Nereid
is indicated by a few ridges only, and interferes little with the modeling of the body,
and even the heavy, woolen peplos of the other Nereid shows the forms distinctly; as
soon as the draperies are separate from the figures they become deep, restless folds,
while the mantles held up behind (fig. 319) form sweeping masses. The treatment is
a tour de force in the art of sculpture and forms the climax of this style. Stylistically,
therefore, this monument is best dated at the very end of the fifth or the beginning of
the fourth century, that is ca. 400–390 B.C.

The seated figure on a didrachm of Terina of about 420–400[78] (fig. 327) has a
chiton and mantle through which the whole contour of the leg is visible. The reliefs
from Eleusis[79] and in the Louvre[80] (fig. 323), dated by their inscriptions in 420 and
410 respectively, show similar renderings. The Palatine Nike[81] (fig. 321), the grave
reliefs of Hegeso[82] (fig. 466) and Glykylla[83] (fig. 322), and the Medea relief in the
Lateran Collection[84] (fig. 324) are all stylistically related to the monuments we have
discussed.

The difference in the treatment of drapery between the third and the last quarter of
the fifth century is apparent also in vase painting. We need only compare the works
of the Phiale painter or the Achilles painter (contemporary with the sculptures of the
Parthenon) with those of Meidias and Aristophanes (allied to the artists of the Nike
balustrade and the Nereid monument) to appreciate the change. In the earlier works
the drapery still has a monumental quality, and retains its separate entity and inde-
pendence; cf. e.g. the Amymone by the Boston Phiale painter in the Metropolitan
Museum of Art[85] (fig. 325), who bears a marked resemblance to the Iris of the Par-
thenon (fig. 96). In the later paintings the drapery clings closely to the body with
multitudinous little folds clearly revealing the forms beneath it, as in the figures of
the scene of women perfuming clothes by the Meidias painter in the Metropolitan
Museum[86] (fig. 326).

The late fifth-century treatment of transparent garments lingers on through the
early fourth century. The Aphrodite on the silver stater of Aphrodisias (?), Kilikia,
dated about 379–74, wears a diaphanous garment[87] (fig. 328); and this is still true
to some extent of the Kerkyra on the treaty relief dated 375.[88] Several of the Epi-

FOURTH
CENTURY

77. Smith, op. cit., II, no. 909.

78. Regling, "Terina," in *Sechsundsechzigstes Winckelmannsprogramm* (1906), pp. 21, 50, pl. II, θθ.

79. Philios, *Ath. Mitt.* XIX, 1894, pl. VII, pp. 163 ff. 80. Ibid., XXXV, 1910, pl. IV, 2.

81. Found on the Palatine and formerly in the Museum there, now in the National Museum of the Terme;
Aurigemma, *Le Terme di Diocleziano e Il Museo Nazionale Romano*, p. 63, no. 159.

82. Conze, *Attische Grabreliefs*, no. 68, pl. XXX.

83. Smith, *Catalogue of Greek Sculpture in the British Museum*, III, no. 2231.

84. Helbig-Speier, *Führer*⁴, I, no. 1060.

85. Acc. no. 17.230.35. Richter and Hall, no. 122; Beazley, *A.R.V.*², p. 1020, no. 100.

86. Acc. no. 75.2.11 (G.R.1243). Richter and Hall, no. 159; Beazley, *A.R.V.*², p. 1313, no. 11.

87. Hill, *Select Greek Coins*, pl. XLII, 2.

88. National Museum, Athens, no. 1467. Dumont, *B.C.H.*, II (1878), pl. 12.

dauros sculptures[89] (ca. 400–375; cf. figs. 757 ff.) have the transparent fluttering draperies of former times, though the folds have now more variety of direction. The Delphian caryatids[90] (fig. 329) with their diaphanous garments and faces in which we can note the transition from the more severe fifth-century type to the softer fourth-century one (with triangular forehead) are best placed in this period of the early fourth century.[91]

By the second quarter and the middle of the fourth century a great change in the rendering of drapery has taken place. The naturalistic treatment finally wins over the former decorative one. The Maussollos[92] and Artemisia in the British Museum (fig. 330) show the new tendency clearly. The conscious arrangement of the earlier monuments where every fold had its distinct value in the design has given place to a more complicated, more naturalistic treatment. The smooth parts no longer alternate with bunched folds in a harmonious composition; the folds run in every direction as they would in reality, with a heavy mass of material gathered round the waist.

In the majority of the fourth-century grave stelai (cf. fig. 334) the new style is firmly established; likewise in such monuments as the Demeter of Knidos in the British Museum[93] (fig. 331), the figures on the Ephesos drums[94] (fig. 751), the mourning women on the Sidon sarcophagus[95] (fig. 332), and the bronze statue recently fished out of the sea and now in the Smyrna Museum[96] (fig. 333), all of the middle of the century; likewise in the Asklepios relief in Copenhagen,[97] dated by its inscription in 329. The draperies now have the right values, the mantles are heavy and cumbrous, they perform their proper function of covering the bodies, but their artistic effect is not on the same level as before. Even in such attractive creations as the Muses on the Mantineia base (figs. 727, 728) and the terracotta statuettes from Tanagra (cf. fig. 270) the draperies have the characteristic fourth-century denseness. Though they are consciously composed for artistic effect the general impression lacks the grandeur of the earlier creations.

The progressive development in Greek drapery from the fifth to the fourth century can be clearly visualized in a series of female figures standing in similar attitudes and each wearing a peplos. A statue in Copenhagen[98] (figs. 337, 338) and the Athena on the Olympia metope (fig. 336) illustrate the architectural style of the transition (early classical) period, with stiff, almost perpendicular folds, and few diversions on

89. Defrasse and Lechat, *Epidaure*, pl. 177. 90. *Fouilles de Delphes*, IV, pls. LX–LXII.

91. For a probable dating on historical grounds at about 400 B.C. cf. Pomtow, in *J.d.I.*, XXXV (1920), p. 114.

92. Smith, *Catalogue*, II, nos. 1000, 1001; Riemann, in *R.E.*, XXIV (1963), s.v. Pytheos, cols. 439 ff., where persuasive arguments are given for the position of the chariot and the two figures on top of the building—which had been doubted by some.

93. Smith, *Catalogue*, II, no. 1300. 94. Smith, op. cit., II, no. 1206.

95. Mendel, *Catalogue des sculptures*, no. 10.

96. G. E. Bean, *Ill. London News* (Nov. 1953), pp. 747 ff., fig. 2; Arias, in *Enc. Arte Antica*, III, 1960, p. 65, s.v. "Demetra"; Ridgway, in *A.J.A.*, 71 (1967), pp. 329 ff.

97. *Ny Carlsberg Glyptotek, Billedtavler*, no. 231; F. Poulsen, *Catalogue*, no. 231.

98. Arndt, *La Glyptothèque Ny Carlsberg*, pls. 7–8.

the overfold. A bronze statuette in the Bibliothèque Nationale,[99] a Roman copy of a work of about 450–40 (fig. 335), retains the quiet majesty of the Olympia sculptures, with a distinct lessening, however, of the tension. The Athena Parthenos (figs. 639, 640), the Athena Medici[100] (fig. 339), and a torso in Venice[101] (fig. 340), of about 440–435, show the grandiose, Pheidian style with considerable life and variation. More folds are now introduced in both the upper and lower parts, and the leg is placed considerably more sidewise, which takes away from the perpendicular effect. Another torso in Venice[102] (fig. 341) illustrates the stage contemporary with the Parthenon pediments. The drapery is becoming softer and more transparent and the leg which does not carry the weight is sharply bent, giving greater ease to the attitude. The style of the last quarter of the fifth century is seen in the torso at Eleusis[103] (fig. 342), the Erechtheion Karyatids[104] (fig. 541), and the figure from the Gjölbaschi monument[105] (fig. 343). The drapery shows a further increase in softness and variation and has assumed a completely transparent quality in certain portions, for instance over the breasts and the bent leg. But the old feeling for design is still apparent. A torso in Venice[106] (fig. 344) of this period is in the same soft, transparent style, with a lively variegation in the folds of the kolpos, which gives it the same dramatic quality we note in the Phigaleia frieze (p. 68). A figure on the Ephesos drum in the British Museum[107] (fig. 345) and another statue in Venice[108] (fig. 346) illustrate the fourth-century style. The garment has lost its former fluidity and transparency and has become more naturalistic. The vertical folds over the supporting leg no longer fall in uninterrupted vertical lines, as before, but the channels show variations; the tightly drawn portion between the vertical folds and the flexed leg has disappeared and a heavy fold falls from the right knee—as it would in nature. In other words the right value is now given to each portion but the former sense for composition is impaired.

In the succeeding Hellenistic period we have many fine renderings, but it is not easy to trace a continued development; for since complete naturalism has now been reached it is merely a question of introducing variations on a given theme. Moreover, art is now sometimes eclectic and reverts to and combines earlier creations. Among such adaptations of former styles we may mention as particularly successful the splendid Victory of Samothrake (fig. 100) which shows on the one hand the transparency of the late fifth-century style as well as its dramatic effect of sweeping folds, on

HELLENISTIC PERIOD

99. Babelon and Blanchet, *Catalogue des bronzes antiques de la Bibliothèque Nationale*, no. 1045.

100. Furtwängler, *Masterpieces*, fig. 6, pp. 27 ff.; Brunn-Bruckmann, *Denkmäler*, pl. 171.

101. Furtwängler, *Griechische Originalstatuen in Venedig* (in *Abh. d. I. Cl. d. R. Ak. d. Wiss.*, XXI, II Abth.), pl. VII, 2. Since Furtwängler's publication of this interesting series of draped female figures—all less than life-size—they have been freed from their restorations and are exhibited in the Archaeological Museum on the Piazza S. Marco. 102. Furtwängler, op. cit., pl. VI, 2.

103. Herrmann in Brunn-Bruckmann, *Denkmäler*, pl. 536.

104. Stevens et al., *The Erechtheum*, pls. XXXVIII f.

105. Benndorf, *Das Heroön von Gjölbaschi-Trysa*, pl. VII.

106. Furtwängler, *Griechische Originalstatuen in Venedig*, pl. IV, 2.

107. Smith, *Catalogue*, II, no. 1206. 108. Furtwängler, op. cit., pl. V.

the other the concentration of heavy masses characteristic of the middle of the fourth; but the whole further complicated by a greater variation of direction. The Nike of Brescia[109] (fig. 347) shows the same combination of late fifth- and fourth-century styles—a transparent chiton covering the upper part of the body and a dense, heavy himation wrapped round the lower; only here the complication of the folds is more marked. A Hellenistic torso of a woman in Boston[110] (fig. 349) has the diaphanous garment of the late fifth century, treated, however, with greater elaboration. How closely earlier styles are sometimes adhered to can be seen by comparing the Themis of Chairestratos[111] (fig. 348; first half of the third century) with the Artemisia from the Mausoleum (fig. 330). The Themis is a more formalized treatment of the earlier, naturalistic rendering.

Besides these eclectic copies and adaptations we have important new contributions. Just as in the representation of the human figure, there is introduced in the Hellenistic period a love of movement and of violent contrasts, so in the drapery we find a tendency toward dramatic and turbulent effects. The Pergamene frieze[112] (cf. e.g. fig. 351) and the statue of the Gaul killing himself (fig. 114) supply us with excellent examples. The sweep and swirl of the draperies caused by the violent motion and the strong shadows of the deep channels between the folds make on us an impression of power and restlessness. An interesting detail which may be observed on some of the Pergamene figures and which appears from the fourth century onward[113] is the indication of horizontal and vertical stripes crossing one another, generally referred to as "Liegefalten," the idea being that they represent creases caused by the folding of the garment while not in use. Characteristic of this period is the rendering of the chiton by multitudinous folds placed close together and nowhere transparent—suggesting a considerable thickness of material. We may mention as good examples some of the figures on the Pergamene frieze (cf. fig. 352) and the Anzio Girl in Rome[114] (fig. 353).

Another new style, prevalent during the second century, is that of transparent drapery, not as heretofore to show the body beneath it, but to display other drapery. It was a tour de force, for it implied the showing of one set of folds beneath another, the two going in different directions, and crossing one another. The problem is ably solved in such statues as the figure from Magnesia in Istanbul,[115] the Muse in Berlin[116] (fig. 354), and the statue from the Giustiniani Collection in the Metropolitan Museum[117] (fig. 355).

109. Dütschke, *Antike Bildwerke in Oberitalien*, IV, p. 153.

110. Caskey, *Catalogue of Greek and Roman Sculpture*, no. 51.

111. National Museum, Athens, no. 231; Papaspiridi, *Guide*, p. 79, pl. V; S. Karouzou, *Catalogue*, p. 167.

112. Museen zu Berlin, *Altertümer von Pergamon*, III, 2.

113. Cf. list of sculptures given in my *Catalogue of Bronzes in the Metropolitan Museum*, p. 150, and *A.J.A.*, XLVIII, 1944, p. 238.

114. Helbig-Speier, *Führer*⁴, III, no. 2270. 115. Mendel, *Catalogue des sculptures*, no. 549.

116. *Beschreibung der Skulpturen in Berlin*, no. 221.

117. *Galleria Giustiniani, 1*, pl. 33; *M.M.A. Catalogue of Greek Sculptures*, no. 200.

An important contribution of Hellenistic times is found in standing and seated portrait statues wearing himatia, such as the bronze philosopher (fig. 258) and the seated statue signed by Zeuxis[118] (fig. 356) in the Metropolitan Museum, the bronze seated figure in the British Museum[119] (fig. 350), and the Sophokles in the Lateran Collection (fig. 264). The mantle is arranged in comparatively few, significant folds, composed with reference to a general design and yet bringing out in an admirable manner both the chief forms of the body and the heavy quality of the material. The former sense of design and the later naturalism are here combined in happy fashion.

118. *M.M.A. Catalogue of Greek Sculptures*, no. 190. 119. Walters, *Select Bronzes*, no. LXV.

CHAPTER 6

ANIMALS

It has sometimes been said that the study of the human figure formed the sole interest of the Greek sculptor and that he attempted little else. But this is not strictly true. Being a lover of form, and of form in motion, he could not but be attracted by the various animals surrounding him and attempt their portrayal. We find him indeed at work on this study throughout his career. Several great sculptors attained renown for their representations: Kalamis, for instance, for his horses,[1] Myron for his famous cow set up on the Akropolis,[2] and Strongylion for his horses and oxen.[3] Furthermore, Nikias is called by Pausanias[4] "the greatest painter of animals of his time" (i.e. fourth century B.C.).

As we pass in review the animal sculpture of the Greeks we realize that it had the same course of development as that of the human figure. Beginning with conventionalization and stylization it became gradually more and more naturalistic, passing through a period in the fifth century when the blending of the two conceptions brought about some remarkably fine renderings, and finally emerging in the Hellenistic period with realistic representations comparable to our own nineteenth-century art—comparable and yet distinct; for, just as in the human figure the long period of stylization left its imprint even on the later Greek conceptions, so in the naturalistic animals of Hellenistic times there is always a generalization which gives them a certain grandeur and stamps them as "classical." And throughout this long history the Greek sculptor showed his wonted ability to seize the essentials, to mark each animal with its characteristic traits, and thus bring out its individual nature.

We can mention here only a few of the outstanding representations which have survived.[5]

LION The decorative feeling of the archaic artist is clearly apparent in such works as the limestone lion from Perachora in the Boston Museum[6] (figs. 357, 358; second quarter of the sixth century). We find here the same rectangular conception, the strictly symmetrical scheme that we observe in the contemporary human figure. The body is represented in full profile, the head in full front, without any of the twists and turnings natural to a living animal. The mane is indicated by ornamental rows of flame-like

1. Cf. p. 159. 2. Cf. p. 164.
3. Cf. pp. 188 f. 4. 1.29.15.

5. For fuller treatments cf. Keller, *Die antike Tierwelt*, 1909; Richter, *Animals in Greek Sculpture*, 1930; Blümel, *Tierplastik, Bildwerke aus fünf Jahrtausenden*, 1939; S. D. Markman, *The Horse in Greek Art*, 1943; J. K. Anderson, *Ancient Greek Horsemanship*, 1961.

6. Caskey, *Cat.*, no. 10; Brunn-Bruckmann, *Denkmäler*, pl. 641.

locks; but there is also a distinct attempt at representing the swelling muscles of the legs and trunk as well as the ribs; so that—as always in Greek art—the stylization is grounded on nature and is not purely abstract.

Among the finest Greek representations of lions we have are the reclining lion in Berlin[7] (fig. 359, second half of the sixth century) and the dead lion of the Olympia metope[8] (fig. 360; ca. 465–460). The lion in Berlin is fortunately in a good state of preservation. We could have no better example of the happy combination of stylization and increasing naturalism current at the time. The forms of the body are correctly indicated in a generalized manner; the planes are simple, the effective stylization of the mane is retained. But there has entered into the representation a better understanding of the essential nature of the animal. We note it in the relaxed body with both hind legs brought over to one side and head resting on one paw, in the indication of the loose skin over the right hind leg, and more especially in the expressive face with its small, watchful eye and soft parts round the mouth. The Olympia animal is more advanced in naturalism, but retains a monumental quality. The head is modeled with more detail, but the mane is in the old conventionalized manner. The helpless, relaxed body, one paw placed under the head, the other doubled up on the side, is wonderfully convincing.

In the second half of the fifth century the lion is not nearly so popular as in the earlier art. Moreover, in these increasingly realistic renderings it becomes apparent that the artist had no opportunity to study from life.[9] We may take as examples the lions of the Nereid monument[10] of circa 500–490 B.C. and the related example in the Metropolitan Museum[11] (figs. 361, 362). Here the pose, the slender body, the elongated skull, the short hair on the neck resemble those of a dog rather than of a lion; only in the wide-open mouth has the artist successfully conveyed the impression of a fierce animal of prey. The lion from the Mausoleum[12] (fig. 363) is a typical example of the fourth century (ca. 350). Again the sculptor has given it the build of a dog with straight legs placed wide apart and he has in no way conveyed that strange restlessness of a lion's body which suggests motion even when in repose, or the quality of his skin as it glides to and fro over the powerful muscles. And the detailed modeling makes us the more conscious of the misunderstanding of such salient features.

We have a wealth of beautiful representations of the horse in Greek art. Effective early examples are those from Prinias[13] (fig. 364, second half of the seventh century), on the Siphnian frieze[14] (fig. 526; before 525 B.C.), and on the bronze krater from

HORSE

7. Wiegand in *Berliner Museen*, XLVIII, 3 (1927), pp. 1 f.; Blümel, *Die archaisch griech. Skulpturen*, no. 62.
8. Treu, *Olympia*, III, pl. 35, 1; Ashmole and Yalouris, *Olympia*, p. 25, figs. 143, 150 f.
9. The lion was extinct in Greece proper in historic times; cf. Herodotos, VII, 125 f., and Aristotle, *Historia animalium*, VI, 31, and VIII, 28, who both say that lions occur in Europe only in the extreme north of Greece between the rivers Acheloos and Nestos.
10. Smith, *Cat. of Greek Sculpture in the British Museum*, II, nos. 929, 930.
11. *M.M.A. Bulletin*, 1910, pp. 40 f.; *Cat. of Greek Sculptures*, no. 72.
12. Smith, op. cit., II, nos. 1075 ff. 13. Pernier, *Bolletino d'Arte*, 1908, p. 458.
14. *Fouilles de Delphes*, IV, pls. 4, 5.

Vix[15] (fig. 368; ca. 510 B.C.), all highly decorative. From the first half of the fifth century we may select the marble horses in the Akropolis Museum, with their fine aristocratic bearing[16] (figs. 365, 366, ca. 500–480 B.C.), and shortly afterwards the bronze statuette of a rider in Princeton[17] (fig. 367), the large bronze statuettes in New York[18] (figs. 369, 370) and Olympia[19] (figs. 371, 372), and the terracotta horses from Gela which served as akroteria[20] (cf. fig. 373)—all placed together for convenient comparison.

The second half of the fifth century produced the horses of the Parthenon frieze (fig. 525; ca. 442–438) and pediment (cf. fig. 374; ca. 438–431). Naturalism has made great strides. As we study the surface of the marble we shall note infinite modulations, closely observed from nature. The complicated muscles and veins of a horse's head, its fleshy and bony parts, are carefully rendered with a wealth of light and shade; and yet there is no confusion, because the transitions are clear and gradual, so that an impression of simplicity is retained; the greater complexity only adds richness and variety to the quiet majesty of former times. There are few artistic enjoyments comparable to that of watching the cavalcade of riders on the southern frieze of the Parthenon (fig. 525), so lively and yet so clear-cut, or the horse of Selene from the eastern pediment (fig. 374), one of the grandest conceptions of a horse known.

In the fourth century comes a gradual change to another conception. The horse, perhaps by Skopas, on the Mausoleum frieze (fig. 744; ca. 350) has still much of the fire and simplicity of its predecessors, but its companions on the same frieze (figs. 767, 768, 776) and in the chariot group[21] (cf. fig. 375) show it in less degree. And gradually with the increasing realism the difference in the various planes is accentuated and the whole becomes more elaborate. The horses on the Alexander sarcophagus[22] (fig. 800, last quarter of fourth century), on the contemporary relief in New York[23] (fig. 376), and on the relief recently found in Athens of a Negro boy holding a restive horse[24] (fig. 377) are good examples of such naturalistic renderings. This elaboration becomes more marked in the later Hellenistic period. Nevertheless the former sense of design is never completely lost sight of. It lends distinction to the bronze head in the Museo Archeologico in Florence[25] (fig. 378), which may be re-

15. First published by Joffroy, in *Bulletin de la Société Archéologique et Historique du Châtillonais*, series 3 (1953), no. 5. 16. Dickins, *Catalogue*, nos. 697, 700.

17. *Master Bronzes from the Classical World* (1967), no. 58.

18. *M.M.A. Bull.*, 1923, pp. 89 ff.; *M.M.A. Handbook*, 1953, p. 65, pl. 46. On the recent controversy regarding its authenticity cf. my p. 148.

19. Kunze in III. *Olympiabericht* (1941), pp. 133 ff., pls. 59–64.

20. Orlandini, *Scritti in onore di G. Libertini*, 1957, pp. 117 ff., pls. I–III; Griffo and von Matt, *Gela*, fig. 71.

21. Smith, *Catalogue of Greek Sculpture in the British Museum*, II, no. 1002.

22. Mendel, *Catalogue des sculptures*, no. 68. 23. *M.M.A. Cat. of Greek Sculptures*, no. 142.

24. National Museum, Athens, no. 4464; Kotzas, in *Polemon*, 4 (1951), pp. 5 f.; Daux, *B.C.H.*, 74 (1950), p. 291; S. Karouzou, *Catalogue*, p. 127, pl. 49 ("it probably formed the embellishment of the base of a statue of some officer [Macedonian?]."). Cf. also my note in *J.R.S.* (1958), pls. 3, 8, p. 12; there reproduced, with Karouzos' kind permission, from the illustration in *Polemon*—as also here.

25. Amelung, *Antiken in Florenz*, no. 270.

garded as a forerunner of the distinguished creations of the Renaissance (e.g. the horse of Colleoni by Verrocchio).

There are many excellent renderings of the bull and the cow in a variety of attitudes both in the round and in relief. The bronze statuette from Delphi[26] (fig. 379; late archaic) shows a walking cow with simplified modeling, the chief bones of the legs and head well accentuated, the loose skin of the neck rendered by a series of delicately incised lines.

BULL AND COW

The high-water mark in the rendering of the bull and the cow is reached in the metope of the Zeus temple at Olympia with Herakles and the Cretan bull[27] (fig. 380; ca. 465–460), and a little later in the cows of the Parthenon frieze[28] (fig. 381; ca. 442–438) and the bronze statuette of a cow in the Cabinet des Médailles in Paris[29] (fig. 382). In the Olympia bull how successfully the turn of the head is conveyed, how decorative and yet how natural is the raised swinging tail, and above all how convincing the powerful body. The Parthenon cows and the bronze cow are rather quieter specimens, modeled with a beautiful, restrained naturalism. The ponderous motion, the sleek body and stiff legs, the powerful bones, are faithfully rendered, and yet with the same generalizing tendency that we note in the contemporary human figures. It is this combination of advanced naturalism and simplification that must have distinguished the famous cow of Myron (cf. p. 164).

The contrast between the early simplified rendering and the later realistic one is well brought out in a comparison of the boar of the "Sikyonian" Treasury at Delphi[30] (fig. 383) and the statue in the Uffizi[31] (fig. 384). The former shows the animal as a fierce creature, its forefeet set forward, the head lowered ready for attack; only the important functional parts are indicated so that the outline stands out clearly. In the Uffizi statue it is represented—with a wealth of detail—sitting in characteristic, lazy attitude.

BOAR

We have a delightful series of bronze statuettes of goats belonging to the late archaic period. The animal is shown in a variety of postures. We may mention as conspicuous examples a goat lying down with head to one side in the British Museum[32] (fig. 385) and a leaping goat in the Metropolitan Museum[33] (fig. 386). The forms of the goat—its elastic body and strong slender legs, its eager, long-nosed face, and little turned-up tail are well observed and rendered in the simplified manner of the period, while the shaggy hair of the beard and brow and along the ridge of the back is indicated by delicately incised lines. In each case the contours form pleasant curves and the composition has the decorative quality of a carefully planned design. In the bronze

GOAT

26. *Fouilles de Delphes*, v, pl. XVI, 5.

27. Treu, *Olympia*, III, pl. XXXVI, 4; Ashmole and Yalouris, *Olympia*, p. 26, figs. 162, 165, 166.

28. Smith, *Sculptures of the Parthenon*, pls. 40, 88–91.

29. Babelon and Blanchet, *Catalogue des bronzes antiques de la Bibliothèque Nationale*, no. 1157.

30. *Fouilles de Delphes*, IV, pl. III, and p. 22. 31. Amelung, *Antiken in Florenz*, no. 9.

32. Walters, *Catalogue of Bronzes in the British Museum*, no. 233.

33. *M.M.A. Bulletin*, 1921, p. 36; *M.M.A. Handbook* (1953), p. 51, pl. 36, h.

statuette of a standing goat in Geneva[34] (fig. 387; second half of fifth century) the hair is stylized but the modeling of the shaggy legs and of the head is naturalistic. As fourth-century examples we may cite the butting goats in Athens[35] (fig. 388) which served as a finial of a gravestone and which, though realistically rendered, are decoratively composed for the purpose they served.

DOG The dog appears frequently in Greek sculpture and is observed in many characteristic postures—of expectant listening, running, attacking its prey, sniffing the ground, sleeping, licking its body, in a cat-and-dog fight, and patiently submitting to a child's caresses. The dog in the cat-and-dog fight on the statue base in Athens (fig. 297; end of sixth century) is an excellent early characterization of the eager yet hesitant way in which the dog attacks its arch enemy. The thin, agile body with the strong hind legs and finely curved, sensitive tail are well observed. A large hound standing quietly with its head uplifted as a dwarf pats it on the neck is engraved on a carnelian of late fifth-century style in the Metropolitan Museum[36] (fig. 389). Though on a small scale it is one of the finest representations we have of the period. All essentials in the lithe body are indicated, and yet simply modeled in a large style; and the dog's mingled enjoyment and patient endurance of the caress are vividly conveyed. The seated hound of serpentine in the Conservatori Palace in Rome[37] (fig. 392) is another well-characterized rendering, probably a Roman copy of a fourth-century work. Like the greyhound in the Glyptothek, Munich,[38] and the famous example still in situ in the Kerameikos, Athens,[39] the original probably came from a grave monument, the dog being conceived as a guardian of the tomb. In the Barracco Museum is a dog lying down with its head turned back to lick a wound on its leg[40] (fig. 390). It is perhaps a Roman copy of a Greek original described by Pliny[41] as a dedication in the temple of Juno on the Capitol. The Barracco dog is extraordinarily lifelike with its lanky body and the pose and face suggestive of suffering. We have clearly here reached the naturalistic stage of the late Greek period, in which the sculptor is in full sympathy with his subject and renders it directly as he sees it.

 There is a series of seated dogs in the Vatican,[42] the Uffizi[43] (fig. 391), and elsewhere,[44] evidently Roman copies of what must have been a famous original. The animal is represented with head lifted to one side, mouth open, forelegs spread apart

34. Deonna, *Catalogue des bronzes figurés antiques*, no. 105.

35. National Museum, no. 805; cf. also nos. 781, 783, 786, 806; Conze, *Attische Grabreliefs*, pls. CCCLVII–CCCLVIII, nos. 1685–1688.

36. Richter, *Catalogue of Engraved Gems* (1950), no. 96. It is about one-half inch long.

37. Stuart Jones, *The Sculptures of the Palazzo dei Conservatori*, p. 145, no. 27a, pl. 96.

38. Wolters, *Führer* (1923), no. 497. 39. Collignon, *Les Statues funéraires*, pp. 240 f.

40. Barracco and Helbig, *La Collection Barracco*, pl. 58; Helbig-Speier, *Führer*⁴, II, no. 1913.

41. *N.H.* xxxiv. 38.

42. Amelung, *Die Skulpturen des vaticanischen Museums*, II, no. 65.

43. Amelung, *Führer durch die Antiken in Florenz*, nos. 10, 11.

44. Cf. the list given by Amelung, *Die Skulpturen des vaticanischen Museums*, II, p. 164. All of them are extensively restored.

in a momentary posture; he is in that breathless state of expectancy preceding violent action which we know so well in the dog. The transitory pose and the masterly realism with which it is conveyed place the sculptor in the Hellenistic age. The breed of these dogs is said to be the pseudo-Molossian, the same as the dog in the Kerameikos (see above). It is differentiated from the true mastiff or the Molossian by the more pointed muzzle, manelike hair on the neck, and bushy tail.[45]

There are many notable representations of birds in Greek sculpture. They occur both as attributes in statues and statuettes of various deities and as single representations on coins and gems. We can list here only a few distinguished examples.

BIRDS

The majestic eagle appears on the coins of Elis, Akragas, and other cities during the fifth and fourth centuries—as quietly sitting, beating its wings, or devouring its prey.[46] Its striking beauty evidently appealed to these die engravers and they have reproduced in masterly fashion the grand curves of its neck as it bends down on its prey (fig. 393[47]) or lifts its head, the handsome design of its wings, and its shapely head with the hooked beak and deep-set eyes (fig. 394[48]). The swans on the coins of Klazomenai[49] are equally successful. The bird is represented walking, beating its wings, or turning its head to preen its wings (fig. 395)—all naturalistic and yet highly decorative postures in which the curves of the long neck and the lines of the wings are effectively utilized.

On Greek gems of the later fifth century birds are favorite representations and among them are several masterly renderings. We may select for illustration the famous flying heron signed by Dexamenos[50] (fig. 397) and the heron standing on one leg[51] (fig. 396). The salient characteristics of the bird are brought out, while the whole is simplified into a beautiful design adapted to fill the given space.

There are several fine representations of minor animals on Greek coins and gems; of these we will select the crab on the coins of Akragas of about 472–450[52] (fig. 398) with delicately modeled claws and denticles, the bee on the fourth-century coins of Ephesos[53] (fig. 399), and the wasp on an engraved gem in Berlin[54] (fig. 400), of which the slender body and delicate wings are sensitively reproduced.

**MISCEL-
LANEOUS
ANIMALS**

45. Cf. Keller, *Die antike Tierwelt*, I, p. 112.
46. Imhoof-Blumer and Keller, *Tier- und Pflanzenbilder*, pls. IV and V.
47. Coins of Akragas, ca. 413–406 B.C.
48. Coin of Elis, about 421–400 B.C. 49. *B.M.C., Ionia*, pp. 19 f.
50. Furtwängler, *Antike Gemmen*, pl. XIV, 4; Richter, *Engraved Gems*, I (1968), no. 467.
51. Beazley, *The Lewes House Gems*, no. 66; Richter, op. cit., I, no. 466.
52. Imhoof-Blumer and Keller, *Tier- und Pflanzenbilder*, pl. VIII, 1 ff.; Hill, *Select Greek Coins*, pl. LIX, 2.
53. Imhoof-Blumer and Keller, op. cit., pl. VII, 19 ff. 54. Richter, op. cit., I, no. 477.

CHAPTER 7

RELIEF

Relief stands midway, so to speak, between sculpture in the round and drawing, and so partakes of the qualities of both. It resembles drawing in that it has to suggest volume on a flat or comparatively flat surface; and it resembles sculpture in the round in that it has a variety of planes. The consideration of these two properties is therefore essential in relief technique. To practice it successfully a sculptor has to have a knowledge of foreshortening and a knowledge of the treatment of planes. Together they will give him the means by which to translate form as it is in nature into artistic form, giving a general impression of nature. The latter we shall call for convenience "impressional form."[1]

Both in Egyptian and Assyrian art, reliefs formed a significant part and were produced for thousands of years; but the important problem of foreshortening was not mastered by either. The garden scene on the relief from Nineveh in the British Museum[2] (fig. 501), a product of the seventh century B.C., sums up both the achievements and the limitations of Oriental art, and shows us what knowledge the Greek sculptor inherited from his predecessors in the craft. We see at once that the important law is realized that there must be a continuous front plane with nothing obtruding unduly from it, a device which gives the whole its unified effect. This is a law governing impressional form as contrasted with natural form. In nature form is of course not so organized and more or less isolated shapes may protrude in all directions. It is the work of the artist to combine these into a harmonious design.

Besides the two chief planes, the front plane and the background plane, Oriental art recognized practically no others. Objects clearly meant to be in the middle and far distance, like one of the two servants fanning the king and the tree behind them (in fig. 501), are placed in the same plane with the objects nearest the eye. The farther arms of the king and queen are in the same plane as the nearer arms; the table in front of the couch is level with the couch; and so on. There is consequently no feeling of space; the eye is not led from plane to plane to a distance beyond, and so the forms do not appear to have their proper depths. Furthermore, no foreshortening is used in the rendering of figures and other objects. The upper part of the king's body is shown in full front when in reality it should be in three-quarter view, for he is turning from a profile to a front position, while the head reverts to the profile—an unnatural ren-

1. For excellent analyses of "impressional form" (*Wirkungsform*) and "natural form" (*Daseinsform*) cf. Hildebrand, *Das Problem der Form*, pp. 16 ff.
2. Jastrow, *The Civilization of Babylonia and Assyria*, pl. 62.

dering, due to the difficulty the sculptor experienced in representing the torsion of the body. On this account the other figures are all kept in strictly profile views. In Egyptian art the same conventions hold from the time of the Old Kingdom (ca. 3000–2500 B.C.) to the later dynasties. Even in the Ptolemaic period the three-quarter view is incorrectly shown (fig. 502).[3]

The Greeks began where the Egyptians and Assyrians had left off, in relief technique as in other branches of art. But they realized, as their predecessors apparently never had, the importance of foreshortening and of the feeling for space in relief; and they set themselves to this task with wonted initiative and concentration. Within a century or two they succeeded in introducing them in their work. In the Hegeso relief of the end of the fifth century (fig. 466) there is a uniform front plane for the heads, the nearer arms, the nearer legs, and the chair; from this the eye is led to the background by several planes gradually succeeding one another; and in the farthest plane are placed the left arm of the attendant, the lid of the open chest, and part of the drapery of Hegeso. Moreover, the bodies are represented in correct three-quarter view, the farther portions in less high relief than the nearer portions. Thereby everything takes its right place, and we obtain the impression of depth and distance.

Let us see how this was accomplished; for it was only by gradual stages that the Greek artist arrived at this perfect solution.

An unfinished archaic relief from Naukratis[4] (fig. 503) and an unfinished portion of the frieze of the Nereid monument[5] (fig. 506), both in the British Museum, show clearly how the Greek sculptor proceeded. He did not work from the background up, but from the front backward. That is, he did not—as many sculptors do nowadays—begin with a smooth clay background and gradually add his figures to it, and when it was finished translate his clay creation into stone through the intermediary of a plaster cast. He started with his marble block, smoothed it out, thus producing his outer plane, drew his figure on it, and then cut away the surrounding portions to obtain his background. Automatically he has created thereby his two chief planes, and he has kept the front plane uniform. Any details of modeling added later were kept within these two planes. This method of work, doubtless practiced also by the Egyptians and Assyrians, sufficiently explains the flatness, the unified planes, and the lack of foreshortening in early reliefs. It was much more difficult to experiment in different planes while carving into stone than while adding malleable clay to a background; and it was in the nature of such work to obtain a uniform front plane. The only shadows in these early reliefs are those cast by the contours of the figures, which thereby are made to stand out clearly against the background plane. The relief gives an impression of two-dimensional design.

In the relief of the dancing women from Branchidai, now in the British Museum[6] (fig. 505; ca. 540), the principle of the uniform front plane is observed, but there is SIXTH CENTURY

3. Limestone relief in the Metropolitan Museum. 4. Pryce, *Catalogue*, I, 1, no. B 437.
5. Smith, *Catalogue*, II, no. 908. 6. Pryce, *Catalogue*, I, 1, no. B 285.

an absence of intermediate planes. The arms are all in the same plane regardless of their positions, and we find it difficult in consequence to apportion them to their respective figures; for we obtain no clear impression of which parts are behind which. The same is true of the man stabbing a lion on the sepulchral chest from Xanthos, also in the British Museum;[7] of the horsemen and deer from Sardes;[8] in fact, universally of archaic Greek reliefs.

Occasionally we find intermediate planes introduced; for instance in the Orestes relief from Sparta[9] (fig. 504; early sixth century), where the farther arm of the man is in lower relief than the rest of the composition; but there is not yet a gradual leading down to it by intervening planes. The use of a series of planes was rendered especially desirable where the relative position of the figures demanded it—for instance in the relief from the "Sikyonian" Treasury (fig. 433) where three oxen are represented alongside one another. A distinct attempt is made here to place the legs, the chests and the heads of the oxen in a series of receding planes. Thereby a certain impression of depth is obtained, so that there is no question in our minds which figure is behind which. But the transition from one plane to the next is abrupt and angular; there is no graduated recession. The same is true of the relief from Sparta in the Berlin Museum[10] (fig. 507).

In the Siphnian frieze (530–525) we find the same partial knowledge. Where one figure is definitely placed in front of another, as in the Apollo and Artemis group (fig. 451, left), the farther one is appropriately sunk; but in the fighting warrior in front the two striding legs are placed more or less in the same plane, though one is behind the other. And the transition from one plane to the next is sudden.

This tentative use of different planes continues in works of the end of the sixth century. In the monument known as the Harpy tomb[11] the farther arms and legs are sometimes appropriately sunk, at other times they are not. For instance, the farther arm of the figure holding a pomegranate (fig. 512), on the south side, is too prominent, while the farther arm of the figure standing before him is properly sunk. One takes its place in relation to the other parts, the other does not. In the group of a seated figure receiving a helmet (fig. 511), on the north side, the planes of the farther arms and legs are fairly successful, except for the left leg of the warrior and the right hand of the seated figure which are too prominent. In the Aristion stele (fig. 460) the calf of the far leg protrudes unduly, while the far arm is shown correctly as in the farthest distance. It is interesting to observe in this connection how difficult the archaic artist found the placing of one foot behind the other. Since he could not get his effect by a variety of planes we often have the impression that one foot is on top of the other, and that the staff held in the hand rests on the toe of the foot (cf. fig. 509[12]). In these

7. Ibid., B 286. 8. Ibid., B 269, B 270.

9. Tod and Wace, *Catalogue of the Sparta Museum*, p. 132, no. 1.

10. *Beschreibung der antiken Skulpturen*, no. 731; Blümel, *Die archaisch griechischen Skulpturen*, no. 42.

11. Pryce, op. cit., I, 1, no. B 287; Tritsch, in *J.H.S.*, LXII (1942), pp. 39 ff.

12. In the Metropolitan Museum, acc. no. 12.158. *M.M.A. Catalogue of Greek Sculptures*, no. 13.

cases of superimposed forms the right impression is sometimes achieved by sinking the parts immediately adjoining; as is the case in the feet of the Aristion stele (fig. 460). This stele also shows in a convincing way how careful the Greek sculptor was to keep his outer plane uniform. The nearer arm does not stand out from the body, but is carved into the figure, so that it is on a level with the highest plane of the body. Natural form would demand more volume for the arm; but from the point of view of impressional form the rendering is successful, for the arm takes its proper place in the composition.

In the charioteer relief in Athens[13] (fig. 289; ca. 510–500) the disposition of the planes is beautifully managed. We obtain an impression of depth and motion from the way the eye is led farther and farther into the background by the gradually receding planes; and yet the numbers of planes is restricted so as to insure a harmonious impression. In these later archaic reliefs the interplay of light and shade on the surface of the figure begins to suggest a certain roundness, but the projections are so slight that they do not interfere with the more accentuated shadows of the contours. The design is still conceived as two-dimensional.

A device conspicuous in the Siphnian frieze, and general in Greek reliefs of all periods, is the irregularity of the background plane. For instance, when the inside of a shield is represented it is hollowed out so as to penetrate deeper than the general background (fig. 451, center). This cutting into the background plane was useful not only for obtaining the farthest distance but also in giving life and variety by creating deeper shadows and providing accents where needed. We note it in the cock and hen reliefs from Xanthos,[14] in the "Harpy tomb"[15] (figs. 511, 512), and in many contemporary and later works where the grouping of the figures did not necessarily demand it—showing clearly the artistic preference for a variegated rather than a uniform background.

The question of distance planes is intimately connected with the representation of the three-quarter view,[16] for to convey this correctly the height of the relief must gradually diminish in the farther portions. Naturally, before the Greek sculptor learned to distinguish between a middle and a far distance he was unable to represent it convincingly; moreover, the torsion of the body involved in it was more than his knowledge of anatomy could cope with. So the best plan seemed to be to avoid the three-quarter view and to restrict himself as far as possible to the profile and full front. And this is what the early sculptor tried to do. When he did attempt the three-quarter view he dealt with it very simply—by putting a front upper body on a profile lower one, as the Egyptians had before him; cf. the Perseus and Medusa group on the Selinus metope (fig. 434) and the central warrior on the Siphnian frieze (fig. 451).

13. Dickins, *Cat.*, no. 1342.

14. Pryce, *British Museum Catalogue*, I, 1, B 299–306. 15. Ibid., B 287.

16. For the sake of convenience I am taking this to mean any view intermediate between the profile and the full front.

The difficult problem of representing the junction was generally avoided by the wearing of a garment or the placing of some concealing object at the critical place.

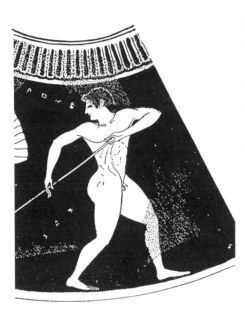

Fig. H. Javelin thrower, from a psykter by Oltos; drawing by Lindsley F. Hall
Metropolitan Museum of Art, New York

At the end of the sixth and beginning of the fifth century interest in the representation of the three-quarter view gradually increased, and we note constant attempts at dealing with it. The same device of a front upper body and a profile lower one with a concealing garment at the juncture is still adopted in the youth holding a cat on the statue base in Athens[17] (fig. 297; ca. 510–500). In other figures on the same relief the whole trunk is shown in front or back view while one leg and the head are in profile. But the problem begins to be squarely faced in two of the ball players on this base (cf. fig. 508) and in the runner from Athens[18] (fig. 89), where, though the chest is frontal, the rectus abdominis is shifted to one side. In the Alxenor relief[18a] (fig. 461) the torsion is suggested by placing one leg in front view, the other in profile, with the toes protruding beyond the front plane and carved on the lower molding of the frame.

Similar renderings of the three-quarter view occur in the black-figured and early red-figured Athenian vases. At first the upper part of the body is in complete front, the lower in profile, and garments generally hide the juncture. Presently, however, here also the rectus abdominis is shifted to one side[19] (cf. fig. H).

The prevalent interest in depicting the three-quarter view is graphically indicated on an amphora in Munich[20] (fig. 510) where three figures are fairly successfully drawn in these poses and where Euthymides has added the proud boast: "Euphronios never did anything like this." Euthymides was evidently a pioneer in this difficult field.

TRANSI-
TIONAL
PERIOD

During the early classical or transitional period of 480–450 the problem is further studied and the right solution gradually found. How convincingly, e.g., in the "Birth of Aphrodite" on the three-sided relief in Rome[21] (figs. 513–15) the arms of the three women are shown one behind the other, and how harmoniously one plane glides into the next! And in the mourning woman on the companion piece in Boston[22] (figs.

17. National Museum, no. 3476; Papaspiridi, *Guide*, p. 38, and S. Karouzou, *Cat.*, pp. 31 f.

18. National Museum, no. 1959; Papaspiridi, *Guide*, p. 30, and S. Karouzou, *Cat.*, pp. 22 f.

18a. National Museum, no. 139. Papaspiridi, *Guide*, p. 31, and S. Karouzou, *Cat.*, p. 36.

19. Richter and Hall, *Red-figured Athenian Vases*, pl. 4, no. 3; Beazley, *A.R.V.*², p. 54, no. 7.

20. No. 1307; Richter, *Attic Red-figured Vases, A Survey*, p. 55; Beazley, *A.R.V.*², p. 26, no. 1.

21. Helbig-Speier, *Führer*⁴, III, no. 2340. 22. Caskey, *Cat. of Sculpture*, no. 17.

516–18) we are led gently from one plane to another until we reach the farthest distance in the wings of Eros. The three-quarter view attempted in both women on this slab also marks a great advance on former times. The upper portion of the body is shown in gradually retreating depth, and the farthest portion is distinctly flatter than the nearest part. The only archaizing trait left is that the breasts do not take their proper place. The nearer seems too close to the arm, the farther is not sufficiently sunk. The same is true of the stele of a youth from Sounion[23] (fig. 533; ca. 470–460); the farther portion is too prominent. In the Zeus of the Selinus metope (fig. 440) the three-quarter view is almost correct. The farther part of the chest protrudes a little too much, and the same is true of the Hera. But we are coming close to a perfect solution.

This lingering hesitancy to decrease sufficiently the depth of the farther parts is general in the works just before the middle of the fifth century, for instance the "Mourning Athena" (fig. 216) and the grave relief of an athlete in the Vatican[24] (fig. 519). Even in the Eleusinian relief[25] (fig. 520) of about 440 B.C. there are a few traces of this archaism. The left shoulder and back of the Demeter are not convincingly foreshortened, though in other respects the relief shows a consummate refinement in the treatment of planes. There is now more variety in the use of shadows, which are no longer confined to outline but give the impression of modeled shapes. The strands of the hair and the folds of the drapery are carved in varying planes and add color and life to the scheme. Though this use of shadows is still discreet and the design is still essentially two-dimensional, a feeling of depth is thereby introduced.

In the vase-paintings of the period the general interest in the problem is seen in the increasing use of the three-quarter view. Achievements vary. Sometimes the rendering is just the same as in early times, with the upper part in complete front, the lower in profile, and no indication of the muscles where the torsion takes place; as for instance in a satyr by the Pan painter in New York[26] (fig. 521). At other times though the chest is still in front view the torsion is shown in the rectus abdominis which is placed obliquely, ending apparently on the farther hip; as in a satyr by the Brygos painter in the Metropolitan Museum[27] (fig. 124). Gradually it was understood that the farther side of the chest must be contracted and the median line no longer placed in the center. A quite successful effort is seen in the engaging boy by the Berlin painter on an oinochoe in the Metropolitan Museum[28] (fig. 523). The vases of about 475–460 show still more advanced renderings (fig. 524), almost completely successful, with occasional lapses (cf. figs. 137, 522), just as in the contemporary sculptures.

23. National Museum, Athens, no. 3344; Papaspiridi, *Guide*, p. 32, and S. Karouzou, *Cat.*, p. 3.

24. Helbig-Spèier, *Führer*[4], I, no. 875; Magi, in *Studies presented to D. M. Robinson*, I, pp. 615 ff., pls. 58–60 (with the recently discovered lower part added).

25. National Museum, Athens, no. 126; Papaspiridi, *Guide*, p. 45, and S. Karouzou, *Cat.*, p. 38.

26. In the Metropolitan Museum, acc. no. 16.72; Richter and Hall, no. 64; Beazley, *A.R.V.*[2], p. 561, no. 6.

27. Acc. no. 12.234.5; Richter and Hall, no. 43; Beazley, *A.R.V.*[2], p. 182, no. 183.

28. Acc. no. 22.139.32; Richter and Hall, no. 15; Beazley, *A.R.V.*[2], p. 210, no. 186.

SECOND
HALF OF
FIFTH
CENTURY

By the second half of the fifth century complete knowledge of relief technique has been attained. The Parthenon frieze (ca. 442–438) is a supreme example (figs. 527, 528). The three-quarter view is now rendered without difficulty and becomes in fact the prevailing pose. We have a uniform front plane and a number of others leading us gradually to the background, suggesting space and distance. Moreover, the sculptor now understands thoroughly the requirements of impressional form. Thereby he is able to accomplish astounding things. In the cavalry procession,[29] for instance, he represents as many as eight horsemen abreast in a relief of only about two inches in depth, and the effect is convincing (fig. 525).

Let us see how he accomplished this feat. In the early frieze from Prinias (fig. 363; ca. 650–625) the horses are simply placed behind one another in a row and all difficulties are thereby avoided. In the metope of the "Sikyonian" Treasury (fig. 433; ca. 570–550), in order to represent several animals alongside one another a series of planes was resorted to, one behind the other in steplike formation, and the various heads and legs were all made alike, except that the three heads in the front plane were shown full front, whereas the others are in profile. By the time of the Siphnian Treasury (somewhat before 525) the sculptor has learned that impressional form is better served not by trying to put each animal immediately behind the next but by stringing them along. In one of the friezes[30] (cf. fig. 526) four horses are placed each a little in front of the other, and the crossings of the lines thereby produced give the desired effect. In the Parthenon frieze the lesson has been finally learned (cf. fig. 525). The whole fore part of every horse is represented, as well as a considerable part of every rider, and they are placed one next to the other, occupying a considerable area. The effect that one rider moves alongside another is attained by an ingenious variation of planes where the different shapes cut across one another. Keeping to the important principle of a uniform front plane, the riders' and horses' heads and much of their bodies, irrespective of the positions they occupy, are placed in the front plane; but where one figure cuts against its neighbor—be it the leg of a rider against a horse's body, or the front legs of a horse against the body of an adjacent horse, or a horse's head against the next rider's body—in these areas the recession of planes is always clearly marked—often by sinking the receding surfaces considerably. This is best seen when a single figure appears against a horse's body or—in the procession of cattle—against a cow's body (fig. 381). Here the figures of the men are carved on the same level as the animals behind them, but they appear convincingly in front of them because the animals' bodies cave in where the lines cross. There could be no better instance of impressional form as against natural form in relief technique.

This principle of crossing lines and the sinking of the surface of the adjoining parts is used throughout the frieze with good effect. In the assembly of deities[31] the impression of one god sitting behind another is successfully conveyed by the simple device

29. Smith, *Sculptures of the Parthenon*, pls. 53 ff. 30. *Fouilles de Delphes*, IV, pls. IX–X.
31. Smith, *Sculptures of the Parthenon*, pls. 33, 34, 36.

of making the rails of the farther chairs oblique, and by placing the legs of the adjoining figure so that they cross the rail. Poseidon (fig. 527) evidently sits on the outside, for his chair rail is horizontal. And that is why he is shown in profile (with his right arm flattened so as to be in the uniform front plane); while Apollo and Artemis, who sit next to him, have oblique chair rails and the upper parts of their bodies are in three-quarter views. The same is true of the groups of Athena and Hephaistos and of Hera and Zeus; not, however, of the group of Hermes, Dionysos, Demeter, and Ares (fig. 528)—where the chair rails are horizontal and only once a leg crosses the adjoining stool. These gods are clearly conceived as sitting next to one another in a horizontal row.

An excellent example of the effect of crossing lines can be observed in the frieze of the Gjölbaschi monument. Here we have a row of armed soldiers in a fortress (figs. 455, 456). They are closely massed; the height of the relief in each is about uniform, but we get the distinct impression that one is behind the other by the crossing lines of the shields and the depression of each farther shield where it is cut by the rim of the nearer one. It is a clever device which only long experience in relief work could teach.

The Phigaleia frieze is likewise able, experienced work from the point of view of relief technique. The depth here is considerably greater than in the Parthenon frieze, and portions of the figures are actually modeled in the round and detached from the background (cf. figs. 314, 315); while in other places, for instance when the insides of shields are represented, the carving sinks beneath the background plane (fig. 315). The drapery sometimes stands out in deep folds (fig. 314); at other times it is in very low relief (fig. 315) or is actually sunk into the background, like the mantle of the centaur in slab 527 (fig. 213). By this variety of planes we obtain the impression of depth and distance. The background itself is also uneven. It bulges in and out, sinking with the draperies and shields, protruding with other portions, as occasion demands, so that sometimes there is a difference of several inches in its depth; and this variation adds to the life and movement of the whole. Effective also is the use of crossing lines. In the scenes of combats where one figure is locked with another, this device enables the sculptor to show their relative positions clearly without any sense of confusion. But in spite of the tumult, the high relief, the uneven background, and the frequent crossing lines, the unity of the whole is preserved by the strict adherence to the uniform front plane. Nothing obtrudes beyond it; even when a shield is held out from the body (e.g. in slabs 535 and 527) it is in the same plane with the body; and by gradual and slow stages the eye is led to a middle and farther distance which gives depth and solidity to the figures. Naturally in this treatment shadows are no longer confined to outline but accompany the movement of every figure, modeling it in the round, and helping to give it a three-dimensional aspect. It must be remembered that the frieze was intended to be seen at a considerable height and the high relief would make it more visible and effective from below.

The frieze of the Erechtheion is an interesting experiment in relief technique. The

figures are worked singly without background and were fastened in situ against the frieze wall of black Eleusinian stone; in other words, it was appliqué relief. Unfortunately we cannot obtain the original effect.

The parallelism we have noted of achievements in sculpture and in vase-painting is apparent also during the second half of the fifth century. On the vases likewise the three-quarter view now presents no further difficulty and is correctly rendered throughout. For the period of the Parthenon, good examples are the Poseidon and Amymone by the Phiale painter on a lekythos in the Metropolitan Museum[32] (fig. 325), and, for the end of the century, the woman on the oenochoe by the Meidias painter in the same museum[33] (fig. 326). By this new knowledge of foreshortening Greek vase paintings gained in spaciousness, and at last convey the impression of the third dimension. Thereby they come nearer to a painting in the modern sense of the word than they did before.

FOURTH
CENTURY

Fourth-century reliefs carry on the traditions of their predecessors, and show able handling of relief technique.

In the Mausoleum frieze of the middle of the century (cf. figs. 744–46) the figures are much less crowded than in the Parthenon and Phigaleia friezes. Each combatant stands out practically singly against the background. To accentuate the contours a deep groove runs along them. Care is taken that the figures should interconnect by crossing lines. Sometimes it is just the tail of the horse crossing the adjoining figure's head, or two feet crossing, or a foot crossing a hoof. Though slight it is enough to prevent the contestants from being isolated. The background is quite uneven; indeed since so much of it is unoccupied, variation was necessary to prevent monotony.

How important some use of crossing lines is in the grouping of widely spaced figures can be appreciated in portions of the friezes of the Nereid monument[34] and of the Lysikrates monument,[35] where the figures are entirely unconnected (figs. 529, 530). A curious staccato effect is the result. The figures appear isolated and the sense of unified action is impaired. Even a slight employment of such crossing lines in the hunting scene of the Nereid frieze[36] (fig. 531), where some of the horses' feet cross the bodies in front of them, obviates this isolation.

In the grave reliefs of the fourth century (cf. fig. 334) the problem is encountered of compressing a group of people into a comparatively small space. There is now no trace of the two-dimensional design of the earlier stelai with its strongly marked contours. The figures no longer seem attached to the background, but stand out in varying depths, modeled in light and shade. Large expanses of shadows break up the uniformity, and the silhouette no longer counts.

HELLENISTIC
PERIOD

In Hellenistic reliefs the three-dimensional conception and the strong contrasts be-

32. Acc. no. 17.230.35; Richter and Hall, no. 122; Beazley, *A.R.V.*², p. 1020, no. 100.
33. Acc. no. 75.2.11 (GR.1243); Richter and Hall, no. 159; Beazley, *A.R.V.*², p. 1313, no. 11.
34. Smith, *Catalogue of Greek Sculpture in the British Museum*, II, no. 886.
35. De Cou, in *Papers of the American School of Classical Studies, Athens*, VI, pp. 316 ff.
36. Smith, op. cit., II, no. 888.

tween light and shade are still further accentuated, the figures often being modeled practically in the round. Furthermore, the composition of the friezes again becomes crowded; for instance, in the Alexander sarcophagus (fig. 800) and the Pergamon frieze (fig. S).

Relief work on a rounded surface, though it appears occasionally in the sixth[37] and fifth centuries (cf. fig. 535[38]), became popular only during the fourth century and the Hellenistic period. We find it on the Ephesos drums (cf. fig. 751) and the Lysikrates monument[39] (figs. 530, R), and commonly on marble tomb vases (cf. fig. 534[40]). On the last the relief is often very low; the rounded surface of the vase was then a distinct advantage, for it enabled the sculptor to obtain a feeling of depth and perspective without constantly having to vary the height of the relief. The curved surface of the vase supplied the necessary variation, and the sculptor could keep to a fairly uniform shallow depth.

37. Cf. e.g. the polos of the two Delphian karyatids; Richter, *Korai*, figs. 274, 310.
38. *M.M.A. Bulletin*, 1947, pp. 179 ff.; *M.M.A. Cat. of Greek Sculptures*, no. 87.
39. De Cou, op. cit., 6, 316 ff.
40. *M.M.A. Bulletin*, 1913, pp. 173 f.; *M.M.A. Cat. of Greek Sculptures*, no. 89.

CHAPTER 8

COMPOSITION

We have examined the Greek sculptor's work as it appears in his single figures—his rendering of the human body, the head, the drapery, his representations of animals, and his relief technique. There is another important aspect of his work, the grouping of his figures in relation to one another, in other words, their composition. That the Greeks were intensely interested in design we know from their studies in proportion and interrelations.[1] It is indeed likely that a definite system of proportion, probably geometrical rather than arithmetical, underlay Greek design[2] and that it is this subtle symmetry based on an interplay of its parts with one another and with the whole which creates in us the singular satisfaction we derive from a Greek temple, an Athenian vase, and a pediment composition. Greek interest in geometric proportion is attested by the definite assertions of ancient writers.[3]

The Greeks had, moreover, extensive opportunities of practicing design, so that they developed it to an extraordinary degree. Both in their architectural sculptures and in their minor arts they were confronted with problems the solution of which they attacked with wonted application. The fitting of a large number of figures into the triangular space of a pediment, the composition of groups to occupy the rectangular space of a metope, of a grave relief, or of a long frieze, or the fitting of a design into the circular space of a coin or a sealstone; all these were problems of great difficulty

1. Besides Polykleitos (cf. pp. 189 ff.) many other ancient artists wrote books on proportion: "Praeterea minus nobiles multi praecepta symmetriarum conscripserunt uti Nexaris, Theocydes, Demophilos, Pollis, Leonides, Silanion, Melampus (Melanthius), Sarnacus, Euphranor" (Vitruvius VII, Preface 14). Of these the sculptor Pollis can be dated at least before 480, probably in the later part of the sixth century (Robert, in *J.d.I.*, *30* [1915], p. 241).

2. Cf. on this subject:

J. Hambidge, *The Greek Vase* (1920), *The Parthenon* (1924), and *The Elements of Dynamic Symmetry* (1948; reprinted 1968).

L. D. Caskey, *The Geometry of Greek Vases*, 1922.

G. M. A. Richter, "Dynamic Symmetry from the Designer's Point of View," in *A.J.A.*, XXVI (1922), pp. 59 ff., and "Dynamic Symmetry as applied to Pottery," in *Journal of the American Ceramic Society*, VIII, 3, 1925, pp. 131 ff.

E. Mössel, *Die Proportion in Antike und Mittelalter* (1926); *Urformen des Raumes als Grundlagen der Formgestaltung* (1931).

I. A. Richter, *Rhythmic Form in Art* (1932).

All of these writers find "the golden section" employed in Greek design—as it was in the Renaissance.

3. Plotinus, *Ennead* I. VI. 1 (cited on p. 26); Plato, *Timaios* 31. Plato, *Republic* VII. 529: ". . . just as we might employ diagrams which fell in our way, curiously drawn and elaborated by Daidalos or some other craftsman or painter. For, I imagine, a person acquainted with geometry, on seeing such diagrams, would think them most beautifully finished, but . . ." This shows definitely that artists used geometrical proportion. Cf. also p. 191.

and were satisfactorily solved only after many experiments. Since the Greeks ulti-
mately achieved such splendid results, it will be of interest to study the road they
traveled.

A large part of early Greek sculpture is architectural, that is, it served to decorate
the temples and treasuries of the period. Its composition therefore became of special
importance, for it had not only to form a pleasing design in itself, but to play a part
in the larger composition. Unfortunately it is impossible for us to see these sculptures
in their original setting, as a part of the larger scheme. It is difficult enough in most
cases to reconstruct the composition of the individual group so battered and disjointed
are the fragments. To view them upon the pediment or in the friezes of a well-pre-
served Greek temple—harmonizing with it and making their own contribution—has
not been vouchsafed us in a single instance. We must try to bridge this gap with our
imagination, supplying it first with all the evidence available.

The lines of a Greek temple are largely vertical and horizontal (cf. fig. 402). There
are the horizontal steps, the vertical columns with vertical flutings, the horizontal epi-
style, the vertical triglyphs, the horizontal cornice. This design in straight lines needed
diversity, which was furnished by the sculptural decorations—the metopes between
the triglyphs, the continuous friezes, the pedimental groups crowning each end, the
akroteria at each angle of the pediment standing free against the sky, the antefixes
and waterspouts ranged along the cornice on the sides, and the moldings introduced
here and there. These decorations by their variety of line saved the buildings from
any impression of monotony. This important function we must keep in mind in our
study of the composition of Greek architectural sculptures. I have, therefore, added
illustrations of several reconstructions of buildings with their sculptures in place (cf.
figs. I–T). Though not necessarily accurate in all details, they will help, I think, to
visualize how these sculptures were originally intended to be seen.

Pediments

THE pediment groups presented peculiar difficulties. The chief requirements were: to
place in the center a prominent figure or group, since here comes the chief accent; to
fill the awkward space of the angles; and to compose figures for the intervening parts
of constantly diminishing heights. And the composition as a whole had to produce the
needed variety of line and create a harmonious effect. The gradual evolution from
primitive renderings to the solutions of the Parthenon are fascinating to watch.

One of the earliest Greek pediments so far known is that of the temple of Artemis
at Corfu,[4] worked in local limestone (figs. 401, I, J; ca. 600–580). The great achieve-
ment here is the effective centerpiece. The Medusa stands out in all her grandeur and
importance. The other figures—the little Chrysaor on the right, the Pegasos on the
left, the lions or panthers[5] on each side, and the diminutive figures right and left—

4. Βερσάκης, Πρακτικά, 1911, pp. 164 ff.; Rodenwaldt, *Korkyra* II, pls. I ff.; Dinsmoor, *Architecture*, pp. 73 ff.
5. The spots point to panthers, the mane to lions.

are secondary as far as the impression of the whole is concerned; they are completely overshadowed by the great Gorgon. The problem of filling the angle is solved by a reclining figure (fig. 116); not one with feet in the corner and head raised, as later at Olympia and in the Parthenon; but a curious person lying in a completely horizontal position, his head in the angle, quite unconnected with the rest of the group. The intervening figures consist of two panthers or lions (effective in that they keep up the scale of the Medusa and supply desirable horizontal and oblique lines) and smaller figures of a seated figure (fig. 66), attacked by an enemy of whom only the lance head is preserved, and of a group with Zeus brandishing his thunderbolt against

FIG. I. Pediment of the temple of Artemis at Korkyra (Corfu)

a giant (fig. 101). The combat groups furnish a pleasing variety of direction, while the seated figure reduces the height of the human figure without making it too diminutive; here this device is not yet adequately carried out, but it is successfully utilized later in the eastern pediment of the Parthenon. The weak points in the composition are the lack of concerted action and, so, of unity, as well as the exaggeratedly small scale of the side figures compared with the central Gorgon and the lions.

The chief difficulty experienced by the early sculptor was evidently the adaptation of his figures to the slope of the pediment. It is not surprising therefore that he avoided compositions with only human figures. Animals and monsters were more adaptable than the human frame, and their wriggly tails and claws fitted nicely into the nar-

Fɪɢ. J. Angle of the pediment of the temple of Artemis at Korkyra

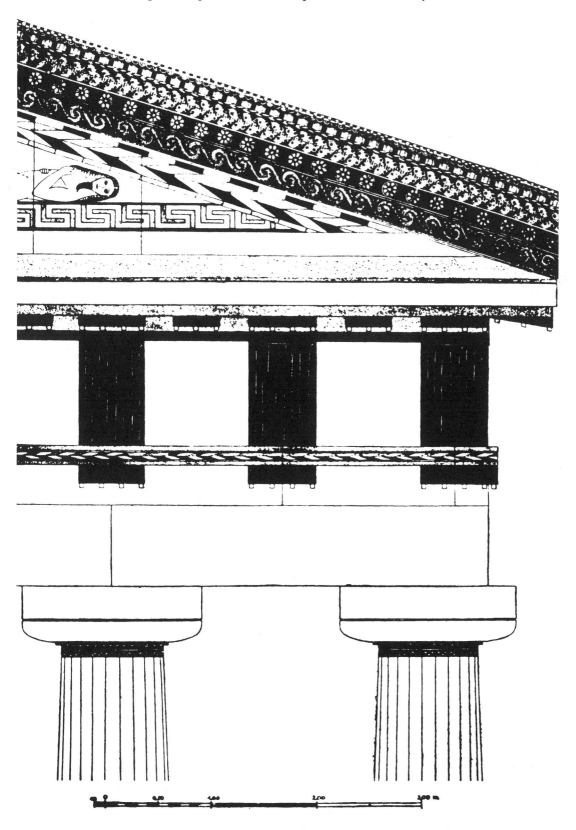

rowing space; and moreover they could expand conveniently toward the middle. This scheme appears in several of the poros pediments found on the Akropolis of Athens.

In the small Hydra pediment[6] (fig. 403; ca. 590) Herakles is the great central fig- ure. The Hydra with her manifold heads and curling tails occupies the whole right side, supplying an admirable variety of line and filling the space in a convenient manner. Iolaos, Herakles' companion, is ready with his chariot on the left. He had to be made distinctly smaller than Herakles; but he is still of acceptable size, being fairly near the center. The horses with heads down form a good lengthwise group toward the left; but they do not quite reach the angle, so the large crab which is said to have been sent by Hera to harass Herakles was provided as a filler.

Similar solutions are offered in the Bluebeard and Triton pediment also from the Akropolis[7] (figs. 405, 406), where a huge monster occupies each sloping side; in one case a three-headed being, in the other a fish-tailed Triton strangled by Herakles, whose body is shown in appropriate scale crouching beside it. The central group be- tween these two sloping compositions may have been supplied by a bull attacked on each side by a lion[8] (cf. fig. 404), in the scheme current in early archaic art;[9] while portions of still other pediments show a lioness devouring a bull, Herakles and Triton, and curling snakes.[10]

Fairly successful though these devices were in decorating the allotted space, they did not satisfy the Greek sculptor for long. Monsters were being rapidly ousted from Greek art, and it was desirable to develop more satisfactorily a composition with only human figures. Such a group had been tried as early as about 570–550 in the poros pediment of the introduction of Herakles into Olympos[11] (fig. 407). Here large seated figures of Zeus and Hera occupy the center; and a little Herakles, and a still smaller figure with a fawn skin are placed further down the slope. Between Hera and Herakles must have been an Athena, escorting the hero; and on the other side of the pediment was probably an assembly of deities. The sculptor has succeeded here in providing an effective centerpiece, as well as a unified subject; but for the problem of the slopes he frankly knew no way out except the awkward diminutive figures.

Another early pediment with a unified subject appears to have been the one with the little water carrier, perhaps to be identified as representing Troilos, Polyxena, and Achilles by the well house.[12]

In the pediment of the Siphnian Treasury (fig. 409) at Delphi[13] (525) the com- position with human figures is more successfully carried out. The subject is the con-

6. Dickins, *Catalogue of the Acropolis Museum*, no. 1, p. 57.

7. Dickins, op. cit., nos. 35, 36, pp. 78 ff.; Buschor, in *Ath. Mitt.* XLVII (1922), pp. 53 ff., 106 ff.; Dinsmoor, *Architecture*, pp. 71 ff. 8. Dickins, op. cit., no. 3. Cf. n. 16.

9. Cf. the parallels on black-figured vases given by Buschor, op. cit., pls. 13, 14.

10. Cf. Dickins, op. cit., pp. 74 ff. 11. Cf. Dickins, op. cit., pp. 62 ff.

12. Buschor, op. cit., pp. 81 ff., pl. VI; Zanotti-Bianco, *Rendiconti della Pont. Acc. rom. di Arch.*, XIX, 1942– 43, pp. 371 ff.; Dinsmoor, *Architecture*, p. 71.

13. *Fouilles de Delphes*, IV, pl. XVI–XVII, 1 and 1a; Dinsmoor, *Architecture*, pp. 136 f.

test of Herakles and Apollo for the Delphian tripod. In the center is Athena[14] towering over everyone else. Apollo and Herakles, the contestants for the tripod, and Artemis, Apollo's helpmate, come next in scale. Then appear slightly smaller figures, the convenient groups of chariots and horses familiar from the Herakles and Hydra pediment; and other persons decreasing in height toward the corners, among them a crouching charioteer and a reclining man. Of the latter only a small part is preserved, but enough to show that the head is no longer resting in the corner like that of his predecessor on the Corfu pediment, but is slightly raised and placed toward the central group, foreshadowing in fact the Kladeos of Olympia and the Ilissos of the Parthenon (figs. 122, 126). To represent a figure crouching behind a chariot is likewise an important step in advance. It forecasts the use of kneeling, crouching, falling figures which could be adapted to the diminishing space without unduly reducing the scale. There is no apparent relation between the sparse subsidiary figures and the crowded central group; the sculptor has not yet learned to produce an interrelated composition. Together with the frieze and the Karyatids, however, the composition served the purpose of adding variety to the design as a whole (cf. fig. K).

The group of Athena and a giant (fig. 119), and the crouching giants[15] (fig. 412) in the Akropolis Museum (datable early in the last quarter of the sixth century) must have belonged to an important Peisistratid building.[16] The center of the pediment was occupied either by this one group of Athena and her giant, or perhaps by Zeus (or Poseidon) and Athena, each with an opposing giant. For there are preserved a left foot larger than Athena's (which must have belonged to an important personage placed near the center) and several other feet presumably belonging to giants. The splendid crouching giants helped to fill the slopes. The composition must have been one of great power.

The pediments of the temple of Apollo at Delphi[17] (ca. 510) are unfortunately also very fragmentary. Enough remains of the eastern one[18] (figs. 408, 411, 413), however, to show that the center was occupied by Apollo's four-horse chariot seen in full front, flanked on either side by standing figures, and with groups of lions attacking animals in the corners (cf. fig. 411). The sculptor has avoided the strongly diminishing scale, but the many vertical lines in the middle are isolated and the animal groups frankly a subterfuge. The western pediment is still more fragmentary; from the remains (cf. fig. 414) we can only judge that its subject was one of action—apparently a combat of gods and giants.

14. For a suggestion that the central figure is Zeus, not Athena, cf. Ridgway, in *A.J.A.*, LXIX (1965), pp. 1 ff.

15. Dickins, *Catalogue of the Acropolis Museum*, nos. 631 A, B, C; Schrader, *Akropolis*, pp. 345 ff., pls. 185 ff.

16. The building used to be identified as the peristyle added by Peisistratos to the "old temple of Athena," and the Bluebeard and Triton pediments were thought to have belonged to the older structure. Recently various theories have been advanced regarding this temple; cf. Schuchhardt, *Ath. Mitt.* (1935–36), pp. 1 ff.; Dinsmoor, in *A.J.A.*, LI (1947), pp. 109 ff.; and *Architecture*, p. 90; also a forthcoming study by Miliades.

17. Dinsmoor, *Architecture*, pp. 91 f. 18. *Fouilles de Delphes*, IV, pls. XXXII–XXXVI.

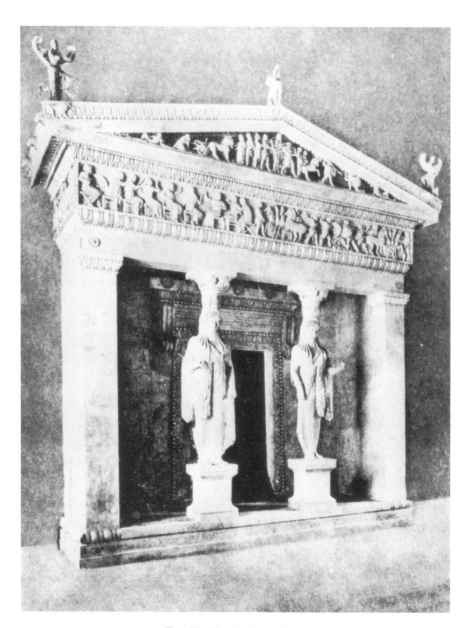

FIG. K. The Siphnian Treasury at Delphi

A marked development is seen in the pediment of the Megarian Treasury at Olym-pia[19] (fig. 410), with its battle of gods and giants (ca. 520–510). Here we have at last a unified composition. Zeus and his opponent form the middle group; then comes a striding deity on either side with a falling opponent; then a crouching deity with a fallen enemy; and in the extreme corners animals. It is a harmonious, animated com-position of figures of about the same scale, knit together by unity of action. And there

19. Treu, *Olympia*, III, pls. II, III; Dinsmoor, op. cit., p. 116.

is no longer any monotony of lines; they flow in every direction, thus performing their function of supplying variety of movement in the composition of a Greek temple. Unfortunately the preservation is very poor. The soft limestone is so battered and broken that it was only with great difficulty that a reconstruction of the group proved possible.

The same theme of an animated contest appears in the pediments of the temple of Aphaia (figs. 415, 416) at Aigina[20] (ca. 500–480); for once discovered it naturally found favor, since it seemed to supply the chief desiderata—unified action, variety of direction, and an occasion for placing figures in all sorts of postures, thereby reducing their heights and not too much their scale. In both the west and east pediments[21] the center is occupied by an Athena, slightly larger than the contestants. She no longer takes part in the struggle as she did in the Siphnian pediment; she is detached, and by her quiet, stately presence dominates the scene of turmoil.[22] In the west pediment the contestants on each side are divided into two distinct groups of three (in the Megarian pediment there were two groups of two) separate and independent of each other. The reclining figure in the angle (cf. fig. 120) is being stabbed and shot at by his opponents and thus becomes part of the fighting scene. For that purpose he faces toward the center, just as did the early reclining figure in the Corfu pediment; but his head is now partly raised, and he has therefore been pushed a little away from the angle which is occupied by helmets. The two groups of three do not interconnect, which gives the whole a staccato appearance.

This weakness is rectified in the later, eastern pediment. Here each side is occupied by one interconnected group of four warriors, one striding, one falling, one crouching, one kneeling; and then, in the corner, a wounded warrior (cf. fig. 121), his back to the others, but turning toward them, and therefore of them; his feet very neatly fitting into the angle. This interrelation of the various figures greatly helps the unity of the whole. We see it accomplished here for the first time in the history of Greek pediments.

Twenty years later comes the temple of Zeus at Olympia[23] (ca. 465–460). In the west pediment (figs. 418, 419) there is again a central dominating figure, calm amid the restless confusion of battle. The bodies of centaurs, of young Lapiths, and of Lapith women intermingle in the violence of the struggle, as they seize one another by the head, by the arm, by the waist. We can make out three separate groups on each side, with perhaps two reclining women at each corner; but the figures are so closely

20. Furtwängler, *Aegina*, pls. 104–06; Dinsmoor, op. cit., pp. 105 ff. The sculptures were acquired by the crown prince of Bavaria in 1903, and restored by Thorvaldsen. These restorations have been largely removed. Cf. a forthcoming publication by D. Ohly.

21. I follow here the reconstructions by Furtwängler, op. cit., pls. 104–06. On the composition of these pediments cf. now E. Schmidt, in VI. *Int. Kongress* (Berlin, 1939), pp. 374 f., pl. 35a.

22. The Athena of the Eretria pediment (fig. 246) was, as far as one can tell, a similarly detached central figure. Not enough remains of the pedimental statues to allow a reconstruction of the composition. On the recent resumption of the excavation of this site cf. Schefold, in *Antike Kunst*, IX (1966), pp. 106 ff.

23. Treu, *Olympia*, III, pls. XVIII–XXI; Dinsmoor, *Architecture*, pp. 151 ff.; Ashmole and Yalouris, *Olympia* (1967).

intertwined that we have none of the staccato feeling of the western pediment of Aigina. And miraculously, in spite of the violence of action, the effect of the whole is beautifully rhythmical. As so often in Greek art, the splendor of the composition transcends the subject, makes us forget it, and fills us with pleasure in its harmonious design.

On the eastern pediment[24] (figs. 417, 419) are represented the preparations for the race of Pelops. It is a quiet, restful scene, a presiding Zeus in the center, two standing figures on each side, then chariots with crouching figures, and seated and reclining spectators in the angles (cf. figs. 122, 123, L). The scheme with its vertical central figures followed by horizontal chariots and crouching people is more old-fashioned than that of the western pediment; strongly reminiscent, in fact, of the Siphnian pediment, only of course less harsh, more subtly interconnected. As a design it does not reach the height of the western pediment.

In the Parthenon pediments (ca. 438–432) we reach the climax of Greek pedimental composition.[25] Here are no violent battles, no falling, crouching, striding warriors; and yet the scenes are full of life and action, as well as of rest and composure. The design of the west pediment[26] (figs. 421, 422) is happily preserved to us in a drawing made in 1674, a few years before its destruction. In the middle are Athena and Poseidon, moving diagonally away from the center and by their size and position dominating the scene. Then come the familiar chariot groups, but now with splendid rearing horses and with full-sized charioteers; then sitting figures in a great variety of attitudes, no longer parallel to the background, but in various oblique postures, thus leading gradually and naturally to the reclining figures at the corners (cf. fig. 126).

The middle portion of the east pediment is irretrievably lost. We have not even a drawing, for it was already gone in 1674. We only know, from Pausanias,[27] that the subject was the birth of the goddess Athena. The preserved ends (fig. 423) are not dissimilar from those of the west pediment, consisting chiefly of seated and half-reclining figures, subtly interconnected by their attitudes, by a slight turn to the right or the left. The early device of the Corfu pediment of a seated figure for adaptation to the slope is here perfected. For the filling of the corners the sculptor has used a novel and bold device—Helios rising with his horses from the sea at one end (fig. 424), Selene disappearing into it at the other (figs. 374, 425). Throughout we feel that the designer here at work had reached his full stature. After a century or two of

24. The position of some of the figures in both pediments is debated; cf. the articles on the subject by Winter, in *Ath. Mitt.* (1925), pp. 1 ff.; Bulle, in *J.d.I.*, LIV, 1939, pp. 137 ff.; and now Ashmole and Yalouris, op. cit., figs. 14–17. As the suggested changes are slight I have retained the reconstructions by Studniczka and Treu for my figs. 417, 418, since they include the effective framework of the pediments. The angle figures in the west pediment have been recognized as later replacements (in Pentelic instead of Parian marble), of which the suggested date has ranged from the fifth to the first century B.C.; cf. the references given by Dinsmoor, in *A.J.A.*, XLV (1941), p. 401, notes 13–18, and by Lippold, *Handbuch*, p. 121, note 5.

25. Smith, *Sculptures of the Parthenon*, fig. 27; Dinsmoor, *Architecture*, pp. 159 ff.

26. Smith, op. cit., figs. 8, 9. 27. I. 24. 5.

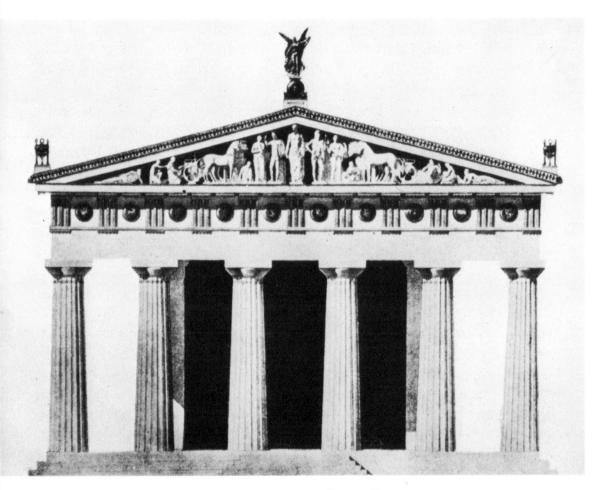

FIG. L. The eastern façade of the temple of Zeus at Olympia

continued struggle he has emerged from all preparatory stages, and, building on the results of former trials and gropings, is able to fashion his composition into a magnificent, harmonious whole.

After the Parthenon there is no outstanding pedimental composition, at least now known.[28] The east pediment of the Nereid monument[29] (fig. 426) is a somewhat awkward composition, reverting to the timid solutions of archaic times: two groups in the center followed by figures of strongly diminishing heights, and animals in the corners. What is preserved of the west pediment[30] shows a combat scene. But the sumptuous general effect of the sculptural decoration of that building—pediment, numerous friezes, and statues of Nereids—may be seen in Niemann's reconstruction (fig. P).

28. The pediment(?) which included the Niobids in Rome and Copenhagen (cf. figs. 92, 118) must have been an outstanding composition a decade or so previous to that of the Parthenon.
29. Smith, *Cat. of Greek Sculpture in the British Museum*, II, no. 924; Dinsmoor, *Architecture*, pp. 256 f.
30. Smith, op. cit., no. 925; Brunn-Bruckmann, *Denkmäler*, pl. 219.

The remains of the pediments of the temples of Athena Alea at Tegea[31] (ca. 360; cf. pp. 208 f.) and Asklepios at Epidauros[32] (first quarter of the fourth century; cf. pp. 213 ff.) are too scanty to be judged. Other small pediments of the fourth century, for instance, those from an Attic tombstone[33] and from the Sidon sarcophagus of mourning women[34] (fig. 427; middle of fourth century) show inadequately filled spaces, the corners left vacant. The pediments of the Alexander sarcophagus[35] (cf. figs. 428, 429; last quarter of the fourth century) revert to the old contest scenes with crouching and striding warriors, with the innovation, however, that the central figure consists of a rider on a rearing horse. They are able compositions, but in no way noteworthy developments of what has gone before.

Metopes

A LESS complicated task than the designing of a pedimental group was the composition of a metope, that is, the fitting of one or more figures into a rectangular space. Here too the requirement was a harmonious filling of the space itself, as well as the introduction of variety in the vertical and horizontal design of a Doric temple. We can trace an interesting development from the primitive efforts of the seventh and early sixth centuries to the finished productions of the fifth.

In the painted metopes of the temple of Thermos[36] (figs. 430, 431; perhaps ca. 640–620) the composition is still somewhat stilted. In the single figure of Perseus the legs and arms are simply spread out in the attitude of running to occupy the broad space; and the three seated goddesses fill it too compactly, without the interplay of crossing lines. But their effectiveness in the whole composition may be seen in fig. M.

The same angularity is found in the metopes of the "Sikyonian" Treasury in Delphi[37] (ca. 570–550). A single animal with a subsidiary figure is a favorite motive (fig. 383). More ambitious compositions are attempted in the Dioskouroi and the sons of Aphareus[38] bringing back the cattle (fig. 433) and in the Dioskouroi with Orpheus in the Argo.[39] But there is still a sameness of posture and a strict adherence to the vertical line. In the metopes of the temple of Athena at Assos[40] (third quarter of the sixth century), nothing intricate in the way of a composition is attempted (cf. fig. 432). We find confronting sphinxes, single centaurs, single animals; and when there is a group of two figures they are merely placed side by side, not interconnected. The

31. Dugas et al., *Le Sanctuaire d'Aléa Athéna à Tégée*, pls. xcvi ff.; Dinsmoor, op. cit., p. 218.

32. Defrasse and Lechat, *Epidaure*, p. 55; Dinsmoor, op. cit., pp. 218 f. On the recent addition of several fragments by Yalouris, cf. Daux, Chronique, in *B.C.H.*, xc (1966), pp. 783 ff.

33. Furtwängler, *Aegina*, p. 333, fig. 268. 34. Mendel, *Catalogue des sculptures*, I, no. 10.

35. Mendel, op. cit., I, no. 68; Dinsmoor, op. cit., p. 262.

36. Soteriades and Kawerau, *Antike Denkmäler*, II, pp. 1 ff., pls. 51 ff.; Dinsmoor, op. cit., p. 51, pl. 17.

37. *Fouilles de Delphes*, IV, pl. IV; Poulsen, *Delphi*, pp. 73 ff.; Dinsmoor, op. cit., pp. 116 f.

38. Only Idas is preserved. The names are identified by the painted inscriptions.

39. *Fouilles de Delphes*, IV, pl. IV, top.

40. Bacon et al., *Investigations at Assos*, pp. 145, 147, 151; Dinsmoor, op. cit., p. 88.

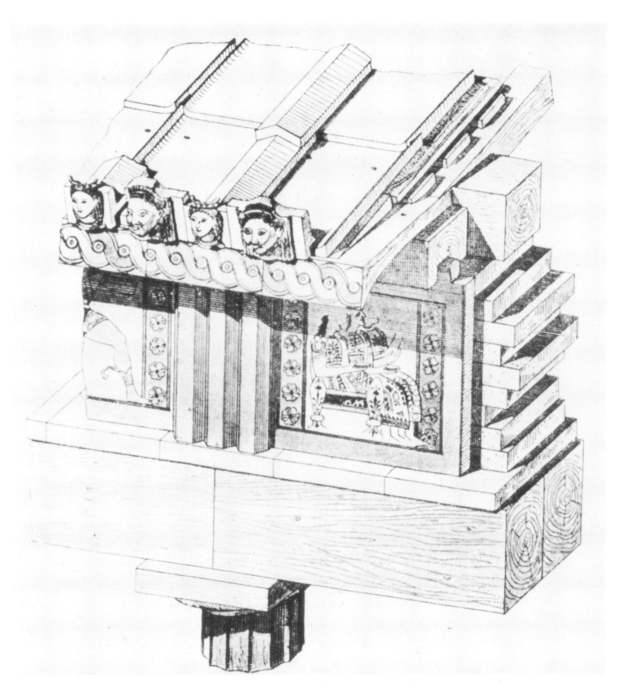

Fɪɢ. M. Entablature of the temple of Thermon (as restored by Kawerau)

metopes of temple C of Selinus[41] (ca. 550–540) show the same tendency to accentuate the vertical line, the same lack of interrelation between the component parts. The Athena, Perseus, and Medusa (fig. 434) are, for instance, simply placed side by side; so are the Herakles and the Kerkopes (fig. 435). The only oblique direction is given in the striding legs of the heroes.

In the metopes of the Athenian Treasury[42] (ca. 510–500) we at last get a more varied design. The oblique line is now boldly introduced by placing Herakles on top of the hind, which breaks up entirely the old monotonous arrangement and introduces a refreshing element of diversity and interrelation (fig. 436). It is not yet an entirely successful design, however, for it is rather top-heavy; even when the hind was whole it was too slender compared to the Herakles above. In the Herakles and Kyknos metope (fig. 132) the two figures are both placed in markedly oblique positions. They fill the space admirably and present an interesting variation. There are many other novel compositions among the metopes of this Treasury and we regret the more the fragmentary condition of most of them. In the group of Theseus and the Minotaur (fig. 437) the hero steps forward in a strongly slanting position and clutches the Minotaur, whose trunk is vertical but whose legs and head form oblique lines. In another metope (fig. 438a) is a warrior in the same oblique attitude as Theseus, holding out a large shield, while his opponent is collapsing diagonally in front of him. The metope with Athena and Theseus (fig. 438) shows the earlier arrangement of two figures standing side by side, but with a new spaciousness. The figures are not so close together, and the arms they extend toward each other create diversity. The metopes of the later temple of Hera from Foce del Sele (ca. 510–500 B.C.)[43] likewise show harmoniously composed running women adequately filling the allotted space (fig. 439).

The metopes of temple E at Selinus[44] (second quarter of fifth century) are among the finest remains of late archaic art. We note two schemes in their design. In the group of Herakles and an Amazon (fig. 442) and in that of Athena and a giant (fig. 443) we have two strongly oblique figures, similar to the Herakles and Kyknos of the Athenian Treasury (fig. 132). In the Zeus and Hera (fig. 440) and in the Artemis and Aktaion groups (fig. 441), one figure is vertical and occupies a relatively small portion of the relief while the other is placed obliquely across the remaining portion. There is a harmony in these compositions—in the interrelation of the two figures and in the pleasing empty spaces. In spite of the violent movement and the agonizing subject of the Aktaion metope, it charms and rests us by the beauty of its design. Just as in the Lapith and centaur contest of the western pediment of Olympia, the rhythmical quality of the composition transcends the theme.

41. Benndorf, *Metopen von Selinunt*, pls. 1, 2; Dinsmoor, op. cit., pp. 80 ff.

42. *Fouilles de Delphes*, IV, pls. XXXVIII ff.; Dinsmoor, op. cit., p. 117. The date of this Treasury has been disputed. For varying theories cf. Dinsmoor, *A.J.A.*, L, 1946, pp. 86 ff., and *Architecture*, p. 117; Picard, *Manuel*, II, pp. 24 ff.; Richter, *Archaic Greek Art Against Its Historical Background*, pp. 144 f.; Schefold, *Museum Helveticum*, III (1946), fasc. 2, pp. 72 ff.; Kähler, *Gr. Metopenbild*, pp. 80 ff., 102 f.; Richter, *Korai*, pp. 64 ff.

43. Zancani Montuoro and Zanotti-Bianco, *Heraion alla Foce del Sele*, I, pp. 123 ff.

44. Benndorf, *Metopen von Selinunt*, pls. 7–10; Dinsmoor, *Architecture*, p. 109.

This sense of harmony is characteristic also of the metopes of the Olympia temple[45] (ca. 460). Many of them are scenes of violent movement—Herakles fighting the Cretan bull (fig. 380), Herakles cleaning out the Augean stables. But this feeling of struggle is largely mitigated by the interplay of lines and surfaces, and by the restful empty spaces against which the contours of the figures stand out effectively. Moreover, each fourth metope when in place on the temple had a quiet design—on the east side Herakles and Atlas (fig. 445), on the west side Herakles and the Stymphalian birds. Without question this arrangement was intentional. It was intended for relief and variety, just as in a Greek drama there is the juxtaposition of violent scenes with quiet choruses. And it makes us feel poignantly how much we miss in not seeing these architectural compositions in their original setting. An extract from a Greek play is still beautiful out of its context, but it has lost much of its dramatic quality. Similarly a piece of architectural sculpture when removed from the place it occupied in the building may be lovely in itself, but we miss the part it played in the composition of the whole.

In the metopes of the Parthenon[46] the Greek sculptor reaches his highest level. Horizontal, oblique, and vertical movement, curves, and empty spaces are now used with the greatest freedom and effectiveness; and there is infinite variety in the compositions (cf. fig. N). Unfortunately many of the metopes are fragmentary; and just because they are so carefully composed we miss the lost portions more acutely. A few, however, are sufficiently well preserved for an adequate appreciation of the composition. What a splendidly bold design is the centaur rushing in triumph over the dead body of a Lapith (fig. 447)! How beautifully the space is occupied, how well the contours stand out, what a pleasing variety the lines must have created in their original setting. Two other centaur and Lapith groups (figs. 445, 446) are likewise fine examples of interrelated designs. The beauty of line and of composition again makes us forget the violence of the struggle, for it gives these fighting Lapiths and centaurs a regal grandeur quite independent of their action.

Occasionally in the Parthenon metopes the figures are not kept strictly within the rectangular frame but project over it. This cutting into the horizontal lines of the temple architecture was doubtless made for variation and occurs also elsewhere; for instance, on the Athenian Treasury (in the metope with Athena and Theseus), and at Olympia (in the metope with the Augean stables).

The metopes of the Hephaisteion[47] also show bold compositions (cf. fig. 448), but they are mostly not well enough preserved to be judged. Of the Phigaleia metopes[48] (cf. figs. 315, 316) only a few fragments are preserved, executed with rather more finish than the frieze.

After the fifth century there are few metopes of importance to record; for the Doric

45. Treu, *Olympia*, III, pls. XXXV–XLV; Ashmole and Yalouris, *Olympia*, pp. 22 ff., pls. 143–211.

46. Smith, *Sculptures of the Parthenon*, pls. 16 ff.

47. Sauer, *Das sogenannte Theseion*, pls. V and VI; Dinsmoor, *Architecture*, pp. 179 ff.

48. Smith, *Catalogue of Greek Sculpture in the British Museum*, I, nos. 510–19; Dinsmoor, op. cit., pp. 154 ff.

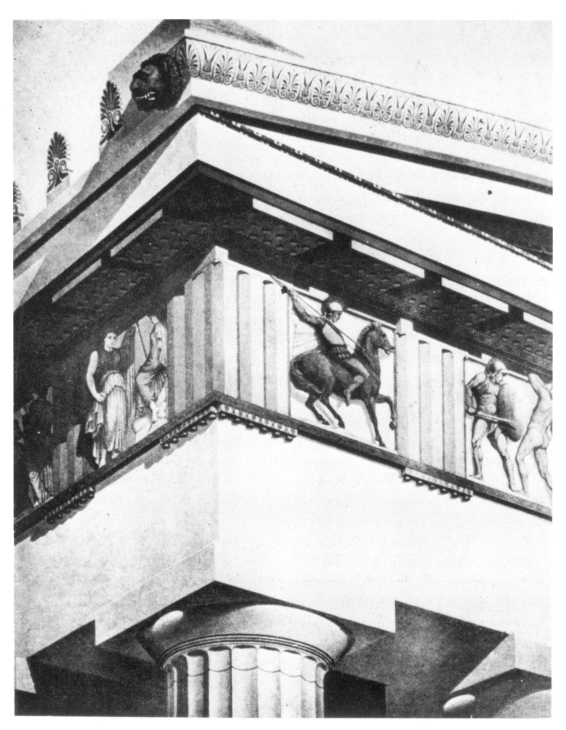

FIG. N. Northwest corner of the Parthenon (as restored by Fenger)

style fell more and more into disuse, giving place to the Ionic and Corinthian, and so
metopes were little needed. As fine examples of the early third century we may, how-
ever, cite the metopes of the temple of Athena at Ilion, erected by Lysimachos,[49] of
which the best preserved (now in the Museum der Vorgeschichte, Berlin) represents
the regal Helios driving his four-horse chariot (fig. 449). And I can also illustrate
here another outstanding example of the Hellenistic period, found with a number of
other metopes in the dromos of a funerary chamber at Taranto (fig. 450). It repre-
sents one of those lively combat scenes so popular in this period between a victorious
horseman and a fallen enemy, and has been dated in the third century B.C.[50]

Continuous Friezes

A STUDY of the continuous friezes of Greek temples and treasuries from the point of
view of their composition brings out the same interesting development in the spacing
and interrelation of figures which we have noted in the pediments and metopes. Only
here our material is more scanty, for we have not so many examples of the earlier
periods well enough preserved to admit a safe judgment of their design. In the reliefs
of the temple of Assos[51] (third quarter of sixth century; cf. fig. 432) there is the
same staccato feeling, the same confusing juxtaposition of figures of completely dif-
ferent scale that we noted in the early pediments (cf. fig. 401). In the frieze of the
Siphnian Treasury[52] (figs. 451, 452; somewhat before 525) great progress has been
made in the interrelation of the figures by the introduction of oblique lines and inter-
locked groups; but the effect of the whole is still somewhat harsh. The late archaic
relief of cocks and hens and the procession of chariots[53] (cf. fig. 453; ca. 470) from
Xanthos are widely spaced compositions in which each figure stands out effectively.
In the frieze of the Ilissos temple[54] (ca. 450) several interrelated groups are success-
fully introduced, but there is still a lack of harmony (fig. 454).

And this brings us to the great achievement of the Parthenon frieze[55] (ca. 442–
438). It was clearly conceived as a unified whole. From the start of the action (in the
southwest corner) with the mounting of the riders, through the lively cavalcades of
horsemen (fig. 525) and charioteers (along the western ends of the north and south
sides), and the slowing down of speed in the men with sacrificial animals and vessels
(at the eastern ends of these sides) and the solemn advance of the maidens (fig. 305)
to the magnificent climax of the seated deities (figs. 527, 528)—throughout this long
composition of over five hundred feet in length the sculptor has created a harmonious,

49. Cf. Lippold, *Handbuch*, pl. 110, 1, p. 307, and the references there cited.

50. The whole ensemble will presently be published by Mr. Joseph Carter, by whose generous permission
I am able to mention and illustrate here the best preserved example.

51. Bacon et al., *Investigations at Assos*, pp. 145 ff.; Dinsmoor, *Architecture*, p. 88, fig. 33.

52. Picard and Coste-Messelières, *Fouilles de Delphes*, IV, 2, pp. 72 ff.; Poulsen, *Delphi*, pp. 101 ff.; Dins-
moor, op. cit., pp. 138 f.

53. Pryce, *Cat. of Sculpture in the British Museum*, I, 1, B 299 ff., B 311–13.

54. *Antike Denkmäler*, III, pl. 36; Studniczka, *J.d.I.*, XXXI, 1916, pp. 169 ff.

55. Smith, *Sculptures of the Parthenon*, pls. 30 ff., pp. 50 ff.

interrelated design. And the effect is never monotonous, for lively action and quiet poses are intermingled, producing the needed contrast in composition and interest. To appreciate it fully we must try in our imagination to see it in position, running along the inside of the epistyle, with the metopes—also in a continuous series—on the outer side (cf. fig. N), and the pediments rising at each end.

The Phigaleia frieze[56] (ca. 420) is a more tempestuous, vivacious composition (figs. 314, 315), full of boldly designed groups and flying draperies with deep shadows forming a highly decorative background. It has not the restraint and majesty of the Attic Parthenon, but its life and tumult are exhilarating. Exceptionally it was placed inside the cella, creating a novel, highly original design (cf. fig. O).

In the friezes of the Gjölbaschi[57] and Nereid monuments[58] (cf. fig. P; end of fifth century) we find an important innovation. Hitherto the Greek sculptor had confined his representation to limited groups of figures of which the beginning and end were clearly visible. In other words the many scenes of battle and contests and banquets resolve themselves into a limited number of participants, variously grouped. Even in the Parthenon frieze the impression is never conveyed that this is a section of a procession which continues beyond the actual representation. On the contrary the procession is complete in itself—it begins where the sculptor starts it and ends where he leaves it off. But that the Greeks forestalled later artists in the suggestion of continuance over and beyond the actual representation is shown in the renderings on the Gjölbaschi (figs. 455, 456) and the Nereid friezes.[59] Here in the massed formations of soldiers we obtain for the first time the sense that this is merely a section of a larger whole; just as in the reliefs of the arch of Titus we feel that this is only part of a long procession.

The friezes of the Mausoleum of Halikarnassos[60] (middle of the fourth century; cf. figs. 744–46, 767, 768, 776, 777, 798, Q) show a less compact, more spacious composition, the contour of each figure standing out effectively against the background and the whole making a quieter impression than the closely interlocked figures of the earlier reliefs. But the interconnection of the figures is brought out not only in the crossing lines but also in the wavelike pattern which runs through the design. The same spaciousness marks the friezes of the Lysikrates monument[61] (figs. 530, R) and the sarcophagus of Mourning Women from Sidon[62] (fig. 332) of the middle of the fourth century. With the advent of the Hellenistic period there is a reversion to crowded compositions and closely interlocked groups, as shown in the friezes of the "Alexander sarcophagus"[63] (end of the fourth century; fig. 800) and the Pergamon

56. Smith, *Cat. of Sculpture in the British Museum*, I, nos. 520–42. For the recent addition of a head to one of the warriors cf. Dörig, in *Antike Kunst*, x (1967), pp. 101 ff.

57. Benndorf, *Das Heroön von Gjölbaschi-Trysa*; Körte, in *J.d.I.*, xxxi (1916), pp. 257 ff.

58. Smith, *Catalogue of Greek Sculpture in the British Museum*, II, nos. 850 ff.; Dinsmoor, op. cit., pp. 237 ff.

59. *Monumenti dell'Instituto*, x, pls. xv, xvi.

60. Smith, op. cit., II, nos. 1006 ff.; Ashmole, *J.H.S.*, LXXXIX, 1969, pp. 22 f., pl. I.

61. Ibid., I, no. 430 (description of cast); the original is in situ in Athens: Dinsmoor, op. cit., p. 257.

62. Mendel, *Catalogue des sculptures*, I, no. 10. 63. Ibid., no. 68.

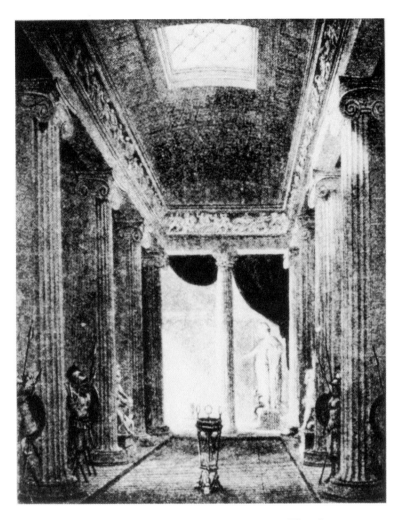

FIG. O. Interior of the temple of Apollo at Phigaleia
(as restored by Cockerell)

altar[64] (first half of the second century; figs. 351, 352, S). In the latter the relief is very high and effective use is made of strong shadows which add to the feeling of restlessness and turmoil. In it we have reached the climax of Hellenistic art.

For the later second century B.C. we may select the friezes of two important monuments in Asia Minor: the altar and temple of Artemis Leukophryene at Magnesia on the Meander,[65] (figs. 457a, b) and the temple of Hekate at Lagina[66] (figs. 458a, b). The altar and temple has been dated (on what seems convincing evidence, both epi-

64. Berlin, Pergamon Museum, cf. Winnefeld, "Die Friese des grossen Altars," in *Altertümer von Pergamon*, III (2): Kähler, *Der grosse Fries von Pergamon*; Dinsmoor, op. cit., pp. 287 ff., pl. 47.

65. The sculptural remains are mostly in Istanbul, and in part in Paris and Berlin. Cf. Mendel, op. cit., I, pp. 365 ff., nos. 148–187; *Catalogue sommaire des marbres antiques du Musée du Louvre* (1922), pp. 162 f.; Lippold, *Handbuch*, pp. 373 f., with other references.

66. Mendel, op. cit., I, pp. 428 ff., nos. 198–232; Schober, "Der Fries des Hekateions von Lagina," in *Istanbuler Forschungen*, II (1933), pp. 96 ff.; Lippold, op. cit., p. 375, with other references.

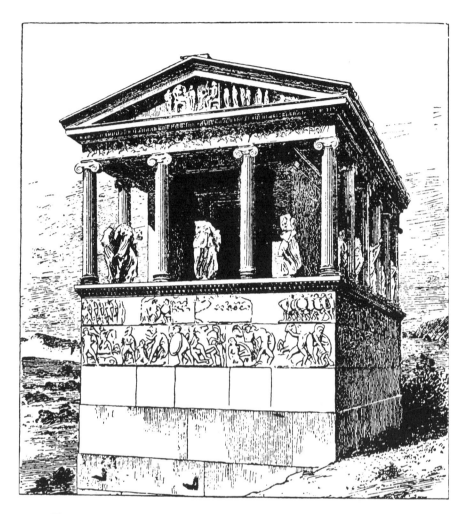

FIG. P. The Nereid monument at Xanthos (as restored by Niemann)

graphical and historical) respectively to "150 B.C. or later," and to "140–129 B.C."[67]
The temple of Hekate has been assigned to the late second century. We find in both
compositions quietly standing figures reminiscent of fourth-century types and lively
combat scenes recalling the Pergamene creations of the first half of the century, but
tamer. They, as well as some other sculptures from various sites, indicate that we have
reached a period when original inspiration was beginning to wane, and artists were
more or less copying and adapting the creations of their great past (cf. p. 243). The
Roman conquests of the Greek world and the consequent loss of freedom evidently
had their inevitable consequences.[68]

67. Cf. von Gerkan, in *Arch. Anz., 38–39* (1923–24), cols. 344 ff.; Lippold, op. cit., pp. 375 f.
68. On this period of free reproductions cf. Lippold, op. cit., pp. 364 ff., and my p. 243.

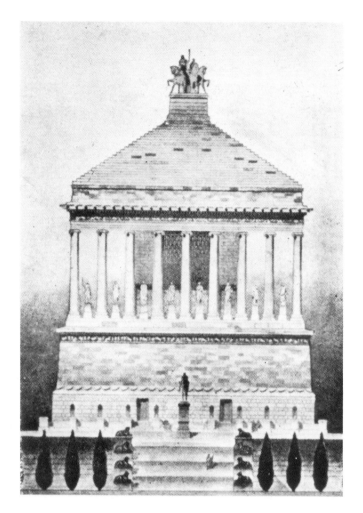

FIG. Q. Mausoleum at Halikarnassos (as restored
by Dinsmoor)

Grave Stelai

BESIDES these architectural sculptures there is another type of relief, like the metopes
rectangular in form, which is interesting to study for the development of its composi-
tion, viz., the grave stele. We can note definite stages in its evolution.

The early grave stele is high and narrow and generally contains only one figure,
which takes up the entire available field. The stele of Aristion by Aristokles[69] (ca.
510) is a typical example (fig. 460). Occasionally two figures are compressed into

69. National Museum, Athens, no. 29; Papaspiridi, *Guide*, p. 37, and S. Karouzou, *Cat.*, p. 17.

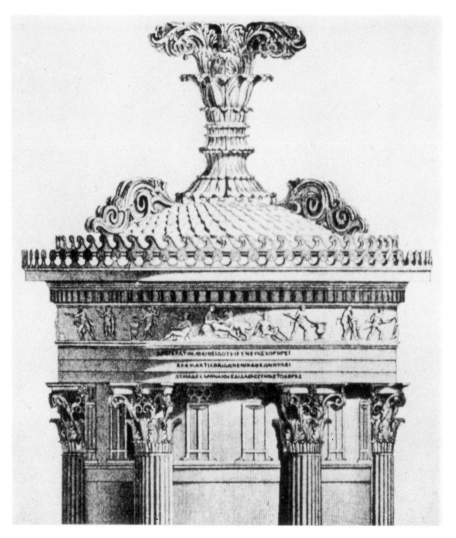

FIG.R. Top of the Choragic monument of Lysikrates at Athens
(as restored by Stuart and Revett)

the same narrow space, as in the gravestone of a youth and his sister[70] (fig. 459) in
the Metropolitan Museum (ca. 550–530) crowned by a handsome capital of lyre de-
sign and surmounted by a sphinx. The stele by Alxenor[71] (fig. 461) and that of a girl
from the Esquiline—both of the early fifth century—are a little wider in proportion
to their height, so that the sense of crowding is less marked; but even the man on the
gravestone in Naples[72] (second quarter of the fifth century) still completely fills the

70. Richter, *The Archaic Gravestones of Attica*, no. 37, and *Korai*, no. 137, figs. 439, 440. The original of
the head of the girl is in Berlin. The fragment containing the lower right arm and buttock of the youth (*Korai*,
fig. 439) is in the reserve collection of the National Museum, Athens, and was discovered there in 1966 by S.
Karouzou, who will soon publish it in detail. Still another fragment (the chest of the youth) was discovered in
1967 by Despinis, also in the reserve collection of the National Museum.

71. National Museum, Athens, no. 39. Papaspiridi, *Guide*, p. 31, and S. Karouzou, *Cat.*, p. 36.

72. Ruesch, *Guida*, no. 98 (6556).

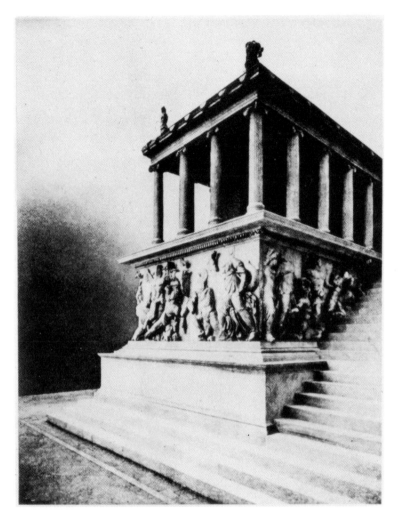

Fɪɢ. S. Detail from the Great Altar at Pergamon; in Berlin

available space. By the middle of the century the slab has become distinctly wider, so that the sculptor could afford more space around the figure and create a more harmonious composition with interesting interrelated surfaces. And naturally the contours of the figure now become more effective. It could either be placed in approximately the middle of the slab, as in the girl with the pigeons now in the Metropolitan Museum[73] (fig. 462) or to the extreme left, which gave room for the action in front, as in the stele of the girl with a casket in Berlin[74] (fig. 463). In the latter the palmette finial which crowned the slab is still preserved, adding greatly to the effect of the whole.

During the second half of the fifth century we have a further increase of the width in relation to the height; and this allows room for an additional figure and yet a re-

73. *Antike Denkmäler*, ɪ, pl. 54; *M.M.A. Bulletin*, 1927, pp. 101 ff.
74. Berlin Museum, no. 1482; von Schneider, in *Antike Denkmäler*, ɪ, pl. 33, 2.

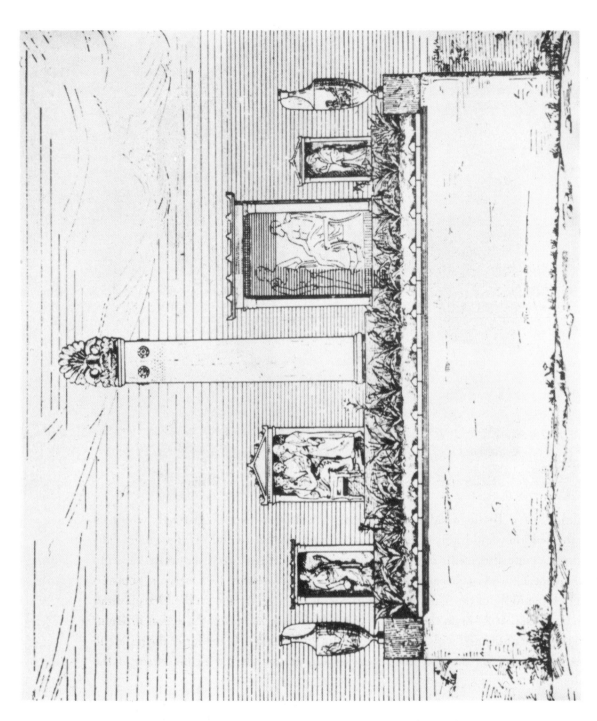

FIG. T. Group of gravestones in a family plot; in the Kerameikos, Athens

tention of the restful empty spaces. The stelai of Hegeso[75] (fig. 466), Ampharete[76] (fig. 467), and Glykylla[77] (fig. 322) are masterpieces in design: harmonious groupings with an effective prominence of the chief figures. The slabs are now regularly crowned with pediments, and engaged pillars are generally added at the sides.

In the fourth century we have approximately the same proportions, but the compositions now become more crowded, there are fewer empty spaces, the contours become less important, and there is no longer the pleasant interrelation of the figures and of the spaces in the background (cf. fig. 334[78]). Occasionally, however, there are more spacious groupings of two figures, as in the moving representation of a sorrowing father with his young son[79] (fig. 464). Furthermore, the depth of the relief increases. Sometimes it is so great that parts of the figures are actually in the round and the framework of a pediment resting on the side pillars becomes so deep as to give the appearance of a shrine (ναΐσκος); cf. the gravestone of Aristonautes[80] (fig. 465). Sometimes a group of such gravestones—together with high shafts, surmounted by akroteria, and marble lekythoi decorated with reliefs—were assembled in a family plot on a high platform, forming a variegated architectural whole (cf. fig. T).

And here the consecutive story ends. The antiluxury decree of Demetrios of Phaleron (ca. 307 B.C.) forbade the erection of sculptured gravestones in Athens; and for some time there appear only insignificant pillars, bowls, and slabs in the graveyards. The new law killed one of the most beautiful forms of artistic expression in Attica.

75. Conze, *Att. Grabreliefs*, pl. xxx, 68; Diepolder, *Att. Grabreliefs*, p. 27, pl. 20. In the National Museum, Athens, no. 3624. S. Karouzou, *Cat.*, p. 77.

76. In the Kerameikos Museum. Kübler, *Ath. Mitt.*, 59, 1934, pp. 25 ff.; Karo, *An Attic Cemetery*, p. 28, pl. 28.

77. In the British Museum. Smith, *Cat.*, III, no. 2231.

78. In the Metropolitan Museum, New York. *M.M.A., Catalogue of Greek Sculptures*, no. 86.

79. National Museum, Athens, no. 869. Conze, op. cit., pl. ccxi, no. 1059. Papaspiridi, *Guide*, p. 153, pl. x, and S. Karouzou, *Cat.*, p. 110.

80. In the National Museum, Athens, no. 738. Conze, op. cit., pl. ccxii, 1058; Diepolder, op. cit., pl. 50; Papaspiridi, *Guide*, pp. 129 f., and S. Karouzou, pp. 125 f., *Cat.*, p. 125.

TECHNIQUE

In the preceding chapters we have treated Greek sculpture solely from the artistic point of view—which forms indeed our chief interest today. But we cannot thoroughly understand even the artistic quality of Greek sculpture without some knowledge·of its technique; for any art is necessarily conditioned by the methods employed in producing it.

WOOD Regarding the technical processes of Greek sculpture[1] we know practically only what the monuments themselves can teach us, though we get a little help from a few statements of ancient writers, from inscriptions, and from representations of sculptors at work. And of course a study of the methods employed in the making of sculpture today is also helpful.

Materials

THE materials used by Greek sculptors were wood, bronze, soft limestone, marble, terracotta, silver, gold, ivory, lead, wax, iron, and amber. That wood was employed, especially in early archaic times, we know by the frequent references in ancient literature to various figures in that material. Pausanias in his travels through Greece in the second century A.D. still saw a good many of the primitive xoana that owed their survival among the later products to their religious sanctity. That wooden figures were produced later also, we know from specific instances; e.g. in the third century at Delos[2] and in Roman times.[3] Only a few examples are preserved today. The damp climate of Greece has destroyed practically all.

BRONZE Bronze was probably the commonest material of Greek sculpture and certain distinguished sculptors, like Polykleitos and Lysippos, worked almost exclusively in that material. It is largely due to this circumstance that so few original works by the greatest Greek artists have survived; for the intrinsic value of bronze caused it to be melted down in later times; and this brought about the destruction of a large output of Greek art. A Greek bronze statue today is a rarity, though bronze statuettes and

1. Cf. on this subject especially Dugas, in Daremberg and Saglio, *Dictionnaire*, IV, s.v., "Sculptura," pp. 1136 ff.; Blümel, *Griechische Bildhauer an der Arbeit*, 1940, 4th ed. 1953, English ed. 1955; and in *Staatliche Museen, Berlin, Forschungen und Berichte*, X, 1968, pp. 95 ff.; S. Casson, *The Technique of Early Greek Sculpture*, 1933; S. Adam, *The Technique of Greek Sculpture in the Archaic and Classical Periods*, 1966; J. Etienne, *The Chisel in Greek Sculpture*, 1968. For the technique of copying by the pointing process cf. Richter, The Technique of Roman Copies, in *The Portraits of the Greeks*, I, 1965, pp. 24 ff., and references there cited; also in *Röm. Mitt.*, LXIX, 1962, pp. 52 ff.; and in *Studi in onore di Luisa Banti*, 1965, pp. 289 ff.

2. Homolle, *B.C.H.* XXIII (1899), p. 502. 3. Contoleon, in *Ath. Mitt.* XIV (1889), p. 91.

various kinds of small reliefs have been preserved in graves and sanctuaries in large numbers.

The earliest bronze statues were plated, that is, made of hammered sheets of bronze, riveted together.[4] A number of statuettes in that technique have survived (cf. fig. 15). Bronze casting is said to have been an invention by Rhoikos and Theodoros of Samos[5] (sixth century B.C.); as a matter of fact Greek examples of even hollow casting are known from the seventh century. Statuettes are mostly cast solid; but in full-sized statues both the weight and the cost were against such a practice, and hollow casting was resorted to. Both in solid and in hollow casting the Greeks mostly used the so-called cire perdue process, which is still employed in a modified form at the present day, but casting from sandbox molds was also practiced to a limited extent.[6] Solid casting was comparatively simple. The object to be cast was first modeled in wax and then surrounded with a mixture of clay and sand which formed a kind of mantle. When this was thoroughly dry, an opening was made at an appropriate place and the whole heated until all the wax melted away. The molten metal was then poured in, a few ventholes having previously been made in the mantle to allow for the escape of the air. After cooling, the mantle was broken up and the bronze was ready for the finishing touches.

The process of hollow casting by the cire perdue process was apparently as follows: A core of clay or plaster was surrounded with a layer of wax, which was modeled in the shape of the required statue and made of the same thickness that the bronze was to be. Before the application of the outer mantle, wax rods, to act as future gates and vents, were probably attached to the figure, in the same way that they are nowadays; for one of the difficulties of bronze casting is that the metal cools quickly and therefore has to be conveyed to the various cavities through several channels at the same time. Moreover, in order to keep the interior core from becoming displaced on the disappearance of the wax, metal rods were inserted, which pierced through the wax, joining the core to the mantle. When the outer mantle had been added, the whole was treated as in solid casting, that is, it was heated in a furnace until the wax all disappeared, whereupon the liquid bronze was poured in, which now occupied only the spaces left vacant by the molten wax instead of the whole interior. When the mantle was broken up there emerged the bronze, from which had to be removed the inside core, the rods which had been inserted to keep the core in place, and the gates and vents, which were now of bronze. Also, any defects of casting caused by air bubbles and other accidents had to be repaired, generally by means of small patches (still visible on many ancient bronzes).

4. Plates of bronze riveted on a wooden body are found also in Gothic sculpture, e.g., in the funerary statue of Blanche de Champagne in the Louvre, no. 167.

5. Pausanias VIII. 14. 8: "The first to cast statues in molten bronze were the Samians Rhoikos, the son of Phileas, and Theodoros, the son of Telekles."

6. Cf. Kluge and Lehmann-Hartleben, *Die Antiken Grossbronzen*, I, pp. 82 ff.; Blümel, in *Weltkunst*, XXXVIII, 1968, pp. 568 ff.

That bronze statues were worked in parts is shown in an attractive picture of a Greek foundry on a kylix in Berlin[7] (fig. 473) ; and can be noted on extant figures, for instance on the Delphi charioteer.[8] After the figure was completed the surface was first cleaned (cf. fig. 430b, where workmen are shown scraping the surface with strigils), and then treated to preserve the golden color of the bronze, but not artificially patinated as is done today. Occasionally it was gilt or silvered.[9]

SOFT LIMESTONE Local limestones were employed by Greek sculptors, especially in early times. The pediment figures of the early temples on the Akropolis were made of local Piraeus stone, the λίθος πώρινος of the ancients, and are hence often referred to as poros sculptures. The softness and lightness of these stones made them easy to cut and handle, and the unattractive surface could be hidden by paint. The sculptors of Cyprus used their own coarse limestone throughout their career. But elsewhere this material was mostly given up in the course of time in favor of marble.

IRON Iron was used at all periods as we know from ancient writers; but through corrosion little has survived.[10]

MARBLE The general employment of marble[11] in Greek sculpture begins in the seventh century B.C., and becomes firmly established during the sixth. At first it was the island marbles, especially the coarse-grained Naxian and the finer-grained Parian which were in demand. Early in the fifth century[12] Athens developed the quarries of her own Mount Pentelikon, and henceforth much of her sculpture is in this close-grained, milky white marble;[13] though the crystalline, transparent Parian was often preferred for single statues.[14] Occasionally the bluish gray marble of Mount Hymettos[15] was employed, also, and elsewhere local marbles occur; for instance the Thasian marble for sculptures from that vicinity, and the Doliana variety in some of the sculptures of Tegea. The quarries of Carrara and Luna of Italy were not worked till Roman times.[16] Their untransparent denseness is singularly unattractive compared to the luminous quality of the Greek stones.

7. Furtwängler and Reichhold, *Die Griechische Vasenmalerei*, III, pl. 135; Beazley, *A.R.V.*[2], p. 400, no. 1, and *Acc. Nazion. dei Lincei, Celebrazioni Lincee*, 16 (1968), pp. 35 ff. By the Foundry Painter.

8. Cf. Chamoux, *Fouilles de Delphes*, IX, fasc. 5 (1955), pp. 58 ff.

9. Cf. my *M.M.A. Catalogue of Bronzes*, pp. XXXVI ff., and the references there cited to Plutarch, Pliny, and to various papyri; also Pernice, *Oest. Jahr.*, XIII, 1910, pp. 102 ff.

10. Cf. Picard, *Manuel*, I, pp. 171 f.

11. Cf. the list of marbles used by the Greeks given by Lafaye in Daremberg and Saglio, *Dictionnaire*, s.v. Marmor, pp. 1601 ff.; also Lepsius, *Griechische Marmorstudien*, in *Abh. d. Akad. d. Wissensch. zu Berlin*, 1890. Henry Washington has pointed out that all quarries vary, and that identical marbles are sometimes found in very different localities (cf. *A.J.A.* II (1898), pp. 1 ff.). For a careful analysis of the many sources of seemingly identical marbles cf. now C. Renfrew and J. Springer, in *B.S.A.*, LXIII (1968), pp. 45 ff.

12. Pentelic marble occurs occasionally also in sixth-century monuments.

13. Exposure gradually turns it a golden brown by the oxidation of the iron which it contains. On these marbles, cf. Lepsius, *Griechische Marmorstudien*, pp. 11 ff.

14. The Hermes of Praxiteles is of Parian marble. This marble was called λυχνίτης or λιχνεὺς λίθος in ancient times, according to Pliny, *N.H.* XXXVI. 5, because it was worked by lamplight (λύχνος).

15. The Moschophoros is in that material.

16. Pliny, *N.H.* XXXVI. 14, 49, 135; see below, note 19.

All the Greek marbles are white or whitish. Colored stones, so popular in Egypt and in imperial Rome, were not favored in Greece. Only occasionally do we find black Eleusinian stone introduced as the background of a frieze or as a color note in architecture.[17]

Terracotta was commonly used for statuettes at all periods, but only occasionally in Greece for large statues. In Italy, on the other hand, and also in Cyprus, it was a favorite material[18] (cf. figs. 84, 499). The difference is explained by the source of supplies, Greece having abundant provision of marble, Italy hardly any, at least until the opening of the Carrara quarries.[19] Greek terracotta statues were built up in coils and wads of clay with thick walls. To prevent distortion and diminish shrinkage during the firing the clay was mixed with sand and grog (particles of fired clay). Statuettes though occasionally modeled are usually molded and hollow. This process was briefly as follows: A mold of clay was first made and baked to considerable hardness. Its surface was then covered with layers of moist clay until the required thickness was reached. The shrinkage of the clay in drying allowed the figure to be easily removed from the mold. The back was made separately (either in another mold, or, if summarily worked, by hand) with a venthole for evaporation. The two parts were carefully joined with slip (liquid clay), the necessary retouching done in the more careful examples, the surface covered with white engobe, and the whole then fired; finally the entire surface was painted in tempera colors (cf. p. 126). The same mold could be used again and again, but to insure the desired diversity the head and arms were often molded separately and different molds variously combined. The many hundred Tanagra statuettes in spite of their obvious similarity include few duplicates.

TERRACOTTA

The use of such precious materials as gold and silver was naturally not common for full-sized statues. Silver indeed seems only to have been employed for statuettes and small reliefs. Gold, however, in conjunction with ivory was in general use for the so-called chryselephantine statues. The Athena Parthenos and the Olympian Zeus by Pheidias are the most famous examples known, but we hear of a number of other temple statues of the kind;[20] moreover a number of gold and ivory fragments of such statues, of the archaic period, have been found at Delphi,[21] and a few other ivory pieces are also known.[22] Moreover, at Olympia have recently been found some terracotta piece molds, on which the gold drapery of the Pheidian Zeus had been ham-

SILVER
GOLD AND
IVORY

17. E.g., in the Erechtheion, the Parthenon and the Propylaia, in the Zeus temple at Olympia, and at Eleusis.

18. Cf. especially the terracotta sculptures in the Syracuse Museum (Orsi, in *Monumenti antichi*, xxv, pls. 16, 17) and those from Veii in the Villa Giulia Museum.

19. The Etruscans used Carrara marble to a slight extent (Müller, *Die Etrusker*, I, 2, p. 226), more generally that of Pisa (Strabo V. C223; Müller, op. cit., I, 2, p. 227).

20. Cf. pp. 169–73.

21. Cf. Amandry, in *B.C.H.*, LXIII (1939), pp. 86 ff.

22. Cf., e.g., Albizzati, in *J.H.S.*, xxxv (1916), pp. 373 ff., pls. VIII, IX; Lethaby, in *J.H.S.*, xxxvII (1917), pp. 17 f.; Amandry, in *J.H.S.*, LXIV (1944), pl. XI.

mered.[23] The nude parts—the head, arms, and feet—were made of plates of ivory, the drapery of sheets of gold. The glitter of the gold was, at least sometimes, neutralized by the addition of painted patterns, as we know in the case of the Olympian Zeus.[24] That the effect was exceedingly impressive is attested by the universal admiration of the two great Pheidian masterpieces. The Zeus was in fact considered to have "added something to traditional religion, so adequate to the divine nature was the majesty of the work."[25]

Occasionally we hear of gilded statues, not only of bronze but of marble. The Eros of Thespiai by Praxiteles, for instance, had gilt wings.[26] Phryne is said to have dedicated a gilt[27] (or gold?[28]) statue of herself at Delphi, executed by Praxiteles. In Roman times it became a practice to gild Greek statues[29] to cater to the taste for gaudiness.

COMBINATION OF WOOD WITH MARBLE AND IVORY

The so-called akrolithic[30] statues (literally "with extremities of stone") were made of wood, often gilded, with face, hands, and feet of marble;[31] and single ivory feet or hands have also been found (fig. 471) provided with holes for fastening, probably to wooden bodies. In localities where marble was scarce stucco or plaster was sometimes used to piece out the marble. This practice is commonly found in Egypt;[32] cf. also the recent finds (of the later periods) at Kalydon.[33]

STUCCO AND PLASTER

AMBER WAX LEAD

Amber was in occasional use for statuettes and small reliefs, especially in Etruria;[34] likewise wax and lead.

Only marble sculptures have survived in any large quantity up to our time; for their weight and the lack of intrinsic value of their material made them less desirable for transportation. It is only their use in limekilns that worked for their destruction. In our account of technical processes, therefore, we shall have the marble remains mostly in mind.

Methods of Work

DIFFERENT APPROACH BY THE ANCIENT AND LATER ARTISTS

THERE is an important difference between the methods of Greek and some modern sculptors in marble. Nowadays we might start by making a full-sized model in clay on a lead armature, then make a plaster cast of this model, and finally translate the

23. Kunze, in *Gnomon*, XXVII (1955), pp. 222 f., XXVIII (1956), pp. 318 ff., and in *Neue Deutsche Ausgrabungen im Mittelmeer* . . . (1954), pp. 278 ff.

24. Strabo, VIII, 353. 25. Quintilian, *Inst. orat.*, XII, 10, 9.

26. Julian. Imperat., *Orat.*, II, 54B (unless the gilding was added later).

27. Pausanias, x.15.1 (ἐπίχρυσον).

28. Athen., XIII.591B (χρύσεον); cf. also Plutarch, *De pyth. orac.* 15, etc.

29. Cf. eg., Pliny, *N.H.*, XXXIV.63. 30. Pausanias IX. 4. 1.

31. Ibid., x. 2 tells of such a statue of Athena by Pheidias, and Vitruvius II. 8. 11 of one by Leochares.

32. Dickins, *Hellenistic Sculpture*, p. 22.

33. Poulsen and Rhomaios, "Erster vorläufiger Bericht über die dänisch-griechischen Ausgrabungen von Kalydon," in *Historisk-filologiske Meddelelserudgivne af det kgl. Danske Videnskabernes Selskab, 14* (3), p. 67, and passim.

34. On amber cf. now Strong, British Museum, *Catalogue of Carved Amber*.

cast into marble by the process of pointing.[35] Since both the cast and the marble copy are produced by mechanical means it follows that the clay model is the only original creation of the modern artist. The Greek method was different. The making of plaster casts of statues was said to have been invented by Lysistratos, the brother of Lysippos, at the end of the fourth century B.C.[36] And for the employment of pointing we have ample evidence from the early first century B.C. on[37] (cf. fig. 475), when it was extensively used. The thousands of Roman copies of Greek works we have today were doubtless produced in this way (see pp. 243 ff.).

The first mention by ancient writers[38] of models for statues is that concerning Arkesilaos and Pasiteles, sculptors of the first century B.C.: "[Marcus Varro] also praises Arkesilaos . . . , for whose models [*proplasmata*] artists would pay more than was given for the finished works of others. . . . Varro further praises Pasiteles who said that molding (*plastice*) was the mother of chasing, statuary, and sculpture, and who, though he excelled in all these arts, never executed any work without first making a "model"[39] (cf. pp. 244 f.); he was possibly the first to introduce the practice of copying a full-sized model exactly.[40] In any event the specific mention of Pasiteles as never executing a work without making a "model" suggests that he was a pioneer in mechanical copying. It would seem therefore that the Greek sculptor during his best periods cut into his marble block freehand. That is, while later artists created their figures by the successive addition of lumps of clay on an armature that admits of bending in any direction (fig. 473), the Greek artist worked by cutting layer after layer from his rigid block of stone. The Greek worked from the outside in,[41] the later

USE OF A
MODEL

35. That is, a number of points are marked on the cast, transferred by means of a pointing machine to the stone block, and then drilled in to the required depth; whereupon the superfluous marble is cut away until the points are reached. Cf. e.g. Richter, in *Röm. Mitt.*, LXIX (1962), pp. 52 ff.

36. *N.H.*, XXXV. 153: Idem et de signis effigies exprimere invenit, crevitque res in tantum, ut nulla signa statuaeve sine argilla fierent ("He also discovered how to take casts from statues, a practice which was extended to such a degree that no figure or statue was made without a clay model"). The passage has been much discussed, some authorities referring "idem" to (the previously mentioned) Boutades, on account of the next statement: "Hence it is clear that the art of clay modeling is older than that of bronze casting." Actual plaster molds of the Hellenistic period have been found from time to time; cf. Rubensohn, *Hellenistisches Silbergerät in antiken Gipsabgüssen*, and the references there cited on pp. 3–5. The use of plaster casts doubtless facilitated the making of free copies like those found at Pergamon.

37. Furtwängler, *Statuenkopieen im Altertum*, p. 21, note 4, gives a list of statues in which puntelli are still visible, none of them earlier than the first century B.C. Cf. also E. A. Gardner, *J.H.S.*, XI (1890), p. 142, note 1; and Blümel, *Griechische Bildhauerarbeit*, pls. 33, 34a, b, d, 35a, b. Blümel (pp. 30 ff.) points out that the ancient method of pointing was not nearly so thorough as it is today; only a few salient points were obtained while today three or four hundred points may be placed on one head.

38. The τύποι of Timotheos, by some interpreted as models, were more probably reliefs; cf. p. 000. The horse modeled by Athena (fig. 469; cf. also Furtwängler and Reichhold, *Griechische Vasenmalerei*, pl. 162, 3) on an Athenian red-figured vase in Berlin was probably for a bronze statue.

39. Pliny, *N.H.* XXXV. 156.

40. Cf. Kekulé, *Die Gruppe des Künstlers Menelaos*, pp. 19 ff.; Furtwängler, *Statuenkopieen*, p. 21; and my pp. 244 f.

41. This applies of course only to stone (and wood) sculpture; in bronze and terracotta statues the techniques require the reverse process.

artists from the inside out.[42] To this different approach is largely due the difference in conception. Greek marble sculpture, especially during the early period, is compact and unified, the mass being conditioned by the block of stone. Later sculptures having no such restrictions are often composed in a variety of directions, and so are more elastic, but lack the unified depth of the earlier days.

That the Greek sculptor did not mechanically translate models into stone does not of course mean that he made no use at all of preliminary models and sketches.[43] The Greek artist was essentially painstaking. He loved precision, interplay of proportion, harmonious composition. Polykleitos wrote a book on proportion and embodied his theories in a statue.[44] And other sculptors were engrossed in the same subject.[45] Even vase-painters made preliminary sketches of their designs with many corrections. How can we imagine, then, Greek sculptors taking blocks of stone and hewing into them without a carefully worked out scheme? Especially in the creative periods of the fifth and early fourth centuries B.C. such preparatory experimentation would seem essential. And if probable in the production of single statues it is even more likely in that of architectural sculpture, the great pediments and metopes and continuous friezes which together had to form a harmonious whole. In the building accounts of the Erechtheion are entries of wages paid to a number of sculptors who executed single figures in the continuous frieze.[46] In the building accounts of the Parthenon are recorded the wages paid to "the sculptors" (perhaps ten) of the pediments in the year 434–433.[47] Surely such sculptors, however able, must have worked from a design created by a single artist. That no such sketches and models have survived is natural, for they would have been executed in wax[48] or perishable clay[49] (as is customary now-

42. Many sculptors of today have reverted to the old method of stonecutting; e.g. R. Laurent of New York and Eric Gill and Frank Dobson of England. Hildebrand in his *Problem der Form* recommends it to his fellow artists.

43. On this subject, cf. Johansen, in *Arch. Anz.*, 1923–24, pp. 141 ff. (he assumes life-size clay models); and Blümel, *Griechische Bildhauerarbeit*, pp. 24 ff. (he proposes models about half life-size for the Parthenon pediments [p. 33] and large drawings for the Parthenon frieze [p. 34]). Personally I hesitate to assume large, carefully worked clay models for the reason admirably stated by the English sculptor, Eric Gill, in his *Sculpture, An Essay on Stone Cutting*, pp. 26 f.: "It is not desirable to make exact models in clay, because the sort of thing which can be easily and suitably constructed in clay may not be, and generally is not suitable for carving in stone. . . . Modeling is a process of addition; whereas carving is a process of subtraction. The proper modeling of clay results in a certain spareness and tenseness of form and any desired amount of "freedom" or detachment of parts. The proper carving of stone results in a certain roundness and solidity of form with no detachment of parts. Consequently a model made to be full size of the proposed carving would be, if modeled in a manner natural to clay, more of an hindrance than a help to the carver, and would be labour, and long labour in vain. . . . The finished work is not a piece of carving but a stone imitation of a clay model." Greek sculptures all seem thought out in stone.

44. Cf. my p. 190. 45. Cf. my p. 90, n. 1.

46. *I. G.*, I, 324 c, d; Loewy, *Inschriften*, no. 526; Stuart Jones, *Select Passages*, no. 159; Paton et al., *The Erechtheum*, p. 389. The average price paid for a single figure is sixty drachmas. We must remember that the frieze is small in scale, about two feet high.

47. Cf. p. 177, note 114.

48. We know definitely that the models of rosettes for the Erechtheion were made in wax; cf. Paton et al., op. cit., p. 395.

49. The little terracotta reliefs, thought by Waldstein (*Essays on the Art of Pheidias*, pp. 212 ff., pls. IX, XI, XIII) to have served as models for the frieze, have now been shown to be modern forgeries.

adays [cf. fig. 474] and was in the Renaissance[50]), or drawn on equally perishable papyrus.

The use of a living model was not the rule with Greek sculptors; at least there is little mention of it. Only occasionally in a later period is the opinion expressed that a certain woman served as a model for a particular statue; for instance, Athenaios[51] says that Phryne was the model for the Aphrodite of Knidos while Clement of Alexandria[52] states it was Kratine. During the earlier period when naturalism was a secondary object sculptors studied the systems evolved by previous artists rather than nature directly. Quintilian[53] states that sculptors took the Doryphoros of Polykleitos as a model; and Pliny[54] tells us how much impressed Lysippos was with an answer by Eupompos: "That artist, when asked which of his predecessors he followed, pointed to a crowd of men and replied that Nature herself and no artist was the true model"—evidently an unusual attitude before that time. On the other hand, the custom of athletes' stripping for their exercises gave the sculptor plentiful opportunities of studying the human figure; and his great interest in it is attested by the whole history of Greek sculpture and its constant development toward greater naturalism. In the Hellenistic period when the study of anatomy became absorbing, the use of the living model by artists must have become inevitable.

USE OF A
LIVING
MODEL

The tools used by the Greek sculptor[55] in the carving of his blocks seem to have been much the same as those employed today: viz., chisels of various shapes and sizes worked by the help of a mallet (cf. figs. 478–80). The procedure of modern stonecutters[56] is as follows: the pointed chisels (the punch or point) are first used for the trimming of the stone into the general shape of the statue, then the claw chisels (with dentated edge) for the removal of the outer layers of the stone; and as one approaches nearer and nearer to the final surface the finer ones are required—the gouge and the more delicate claw chisels; lastly, for smoothing the surface, the flat chisel, files, rasps, and soft stones.[57] A polish can be added by rubbing with sand. Greek practice was similar. Several unfinished statues in Athens and elsewhere show the marks of these tools[58] (cf. figs. 472, 475, 476) and throw interesting light on the processes employed. Apparently in the earlier periods the use of the flat chisel and the gouge was limited, while the pointed and claw chisels[59] were extensively used. From the later

TOOLS

50. Cf. Vasari's *Life of Garofolo* (Sansoni, Milanesi), VI, p. 464: "Fece modelli di terra per veder meglio l'ombre ed i lumi."

51. Δειπνοσοφισταί XIII. 59. 52. Προτρεπτικὸς πρὸς Ἕλληνας IV. 47.

53. V. 12. 21. 54. *N.H.* XXXIV. 61.

55. Cf. on this subject Blümner, *Gewerbe und Künste*, II, p. 194 and III, p. 192; E. A. Gardner, in *J.H.S.* (1890), p. 137, fig. 3; Dugas, in Daremberg and Saglio, *Dictionnaire*, s.v. Sculptura, p. 1138; Blümel, *Griechische Bildhauerarbeit*, pp. 1 ff.; S. Adam, *The Technique of Greek Sculpture*.

56. I had the great advantage of joining a class in stonecutting under Mr. Robert Laurent at the Art Students' League in New York which gave me a new insight into this subject.

57. Plutarch, *Discr. adul. et amic.*, 34, 74E, refers to the smoothing and polishing of statues; cf. also Pliny, *N.H.*, XXXVI, 53 and 54.

58. E. Gardner, *J.H.S.*, XI (1890), pp. 129 ff.; Blümel, *Griechische Bildhauer an der Arbeit*, pp. 10 ff.

59. Marks of the claw chisel occur as early as the second quarter of the sixth century, for instance on the Akropolis kore 593, and on the head in Munich, Blümel, op. cit., figs. 20, 21.

fifth century onward the flat chisel was employed on the nude parts for the final smoothing. A comparison between the slightly rough surfaces of the earlier marbles and the smooth texture of later sculptures will bear this out.

For the smoothing of plane surfaces the archaic Greek stonecutter used the drove[60] —a very broad flat chisel in common use also today. Later this tool seems not to have been employed, at least the striations it produces have not been observed on extant postarchaic sculptures.

The simple drill (Stichbohrer) was known from early times, as we learn from the drill holes for the attachment of earrings and other ornaments in early archaic sculptures.[61] The running drill (laufender Bohrer)—probably in the form of a bow drill— must have been introduced at least as early as the second half of the fifth century,[62] for traces of the grooves it produces are visible on monuments of that period, for instance, on the Parthenon frieze and pediment.[63] The deeply carved folds of the latter could indeed hardly have been produced without it. In earlier times a makeshift method was used, viz. a number of holes were bored side by side and then connected.

It is interesting to observe the treatment by the Greek sculptor of the backs and other parts of his marble[64] figures when they did not show. As a general rule he seems to have carefully finished only those portions which were visible. When a marble statue was exposed to view where it could be seen from all sides it was equally finished all around. But when a statue was seen only from the front or the side, not from behind, as in the pediment figures, the back did not generally receive the same attention (fig. 481). The tool marks were often not removed and even the modeling is sometimes only cursory; but the composition of each figure as a whole was carried out. On the other hand there are instances when the backs are beautifully worked even when they did not show, as in the Aigina and the Parthenon pediments (cf. fig. 75). Single statues when intended to be placed against the wall or where the back was not seen are likewise often unfinished behind. We may mention as examples the Hermes of Praxiteles (fig. 483), the Zeus of Mylasa,[65] and the standing youth in Boston.[66] The backs of grave stelai in the Kerameikos in Athens are likewise left quite rough (fig. 477). In reliefs the receding planes are often superficially worked, especially in

60. On the use of the drove cf. Richter, in A.J.A. xlvii, 1943, pp. 188 ff.

61. Homer refers to such a tool, τέρετρον and τρύπανον, in the working of wood.

62. The bow drill was known in Egypt at least as early as 1200–1000; cf. the drill caps of diorite and bone from Lisht in the Metropolitan Museum.

63. I have been able to observe these both on the pediments (especially on the "Fates") and on the frieze (especially on the maidens and deities of the east side). Others deny the use of the running drill on the Parthenon figures; cf. Puchstein, in Arch. Anz. (1890), p. 110, and S. Adam, op. cit., pp. 64 ff.; but see my review in A.J.A., lxxii, 1968, p. 10. Cf. on the use of the drill also de Villefosse, in Daremberg and Saglio, Dictionnaire, s.v. "Terebra"; Blümel, Griechische Bildhauerarbeit, p. 15, and Griechische Bildhauer an der Arbeit, pp. 35 ff. For the tradition that Kallimachos "was the first to bore marble," see my p. 186.

64. A bronze figure was naturally finished throughout.

65. Caskey, Catalogue of Sculpture, no. 25. 66. Ibid., no. 41.

the grave monuments. In other words the attitude of the Greek sculptor was the same as that of the Greek potter—he did not waste labor where it profited nobody.[67]

Nowadays a sculptor generally makes his statue out of a single block. The Greeks PIECING —perhaps on account of the difficulty of transportation—used smaller blocks and pieced them. The parts were skillfully joined by means of marble tenons fitting into mortises, or two smooth surfaces were secured with metal dowels or, when the addition was small, merely with cement.[68] The archaic statues of the Akropolis are almost all made in several pieces, the arms and heads often separate from the bodies, and fastened to one another by means of large marble tenons and mortises secured with molten lead or lime (cf. figs. 284, 286); likewise parts of the drapery, locks of hair, etc. And this practice is general in Greek art at all periods.[69] Many statues show the original dowel holes—sometimes with the iron or bronze dowels still adhering—by which the arms, heads, etc., were originally attached. A good example is the statue in New York[70] signed by Zeuxis (figs. 356, 484) in which the attached parts have become separated. There is a large mortise for the insertion of the head and neck; the arms and the right foot were fastened by iron dowels; and part of the left foot was attached with cement or lime. Many heads which have become separated from their bodies were worked to fit into large hollows (cf. fig. 482[71]). The top of the head is sometimes separate from the rest, the two surfaces being smoothed to fit and kept in place by small dowels.[72] This accounts for such parts being often missing (cf. fig. 485).

Occasionally the piecing is not original but was done later as a repair. An excellent example of such an ancient repair is seen on the figure from Laurion in the Metropolitan Museum[73] (figs. 487, 488); here the head and left arm are worked in separate pieces in a style later than the rest of the figure; the outline of the hair of the original archaic head can still be seen at the back (fig. 487). The kore no. 670 in the Akropolis Museum—of Island marble—has the right sleeve repaired in Pentelic marble.[74]

Occasionally the piecing is in different materials. In the Selinus metopes the head, hands, and feet of the female figures are of marble, the rest of coarser limestone[75] (fig. 440). In the girl from Anzio,[76] (fig. 353) and the Demeter of Knidos[77] (fig. 331) the heads are of a finer marble than the rest of the figures.

67. The insides of amphorae and hydriae are left unturned, for they did not show; those of kylikes and kraters, which were exposed to view, are always carefully finished; on this subject, cf. my *Craft of Athenian Pottery*, p. 14. 68. Cf. Treu, in *J.d.I.*, x (1895), p. 8.

69. Cf. on this subject the list of references given by Dugas in his article, "Sculptura," in Daremberg and Saglio, *Dictionnaire*, p. 1144; my *Korai*, pp. 13, 16.

70. Richter, *M.M.A.*, *Catalogue of Greek Sculptures*, no. 190. 71. *Ibid.*, no. 141.

72. E.g. in the head of a girl from Priene, British Museum no. 1153, the Chios head in Boston, etc.; cf. also the instances in the Louvre cited by Héron de Villefosse, in *Monuments Piot*, I, p. 72, note.

73. *M.M.A.*, *Cat. of Greek Sculptures*, no. 4; my *Korai*, p. 85, figs. 441–44.

74. Dickins, *Cat.*, no. 670; Langlotz, in Schrader, *Marmorbildwerke*, no. 8; my *Korai*, no. 119.

75. Benndorf, *Metopen von Selinunt*, pp. 41 f.

76. Helbig-Speier, *Führer*⁴, III, no. 2270. To the extensive literature on this famous statue can now be added Mingazzini, *J.d.I.*, LXXXI (1966), pp. 173 ff., with new suggestions.

77. Smith, *Catalogue of Greek Sculpture in the British Museum*, II, no. 1300.

Another general practice was the addition of accessories in different materials. The eyeballs, though generally painted on a smoothed surface, were occasionally inset, probably in ivory, stone, or glass. Early examples are no. 682 of the Akropolis figures, the "Antenor" statue, no. 681 (fig. 287),[78] and a head from an archaic grave relief in the Metropolitan Museum[79] (fig. 486). A fragment of a head in the British Museum[80] has likewise hollow eye sockets. In bronze heads the inset eyeballs are occasionally still in place (cf. fig. 489).[81] Sometimes the eyelashes were worked separately in little bronze plates with dentated edges[82] (figs. U, 489). Locks of hair were occasionally made in bronze or lead (fig. 490);[83] necklaces and earrings and the ornaments of diadems, sometimes even the diadems or wreaths themselves, were added in bronze

FIG. U. Bronze plate
with eyelashes for
insertion in a statue
Delphi Museum

or gold.[84] In these cases they have of course generally disappeared, only the holes for their attachment remaining (cf. fig. 491); but occasionally they are still preserved.[85] The spears and swords, the reins and bridles of horses, and the scepters were often added in metal (wholly or in part) or painted on the background of the reliefs. The holes for their attachment show their former presence. The Siphnian, Parthenon, and Mausoleum friezes, the Aigina and Olympia sculptures, and the figures of the Alexander sarcophagus were so provided. The relief from Thasos in the Louvre[86] still have bronze pegs for the additions of the *kerykeion* of Hermes, the wreaths of the nymphs, and the strings of the lyre of Apollo (cf. fig. 492). The cheekpieces and other parts of helmets were often separately attached, as we learn from the Aigina sculptures.

Color

SUCH accessories in various materials are conceivable only in painted sculpture. And this brings us to what is probably the greatest difference between ancient and modern statues—the use of color. Nowadays the rule is to leave the marbles, limestones, and woods we use in their original finish; only occasionally of late have we taken to paint-

78. Cf. Lechat, *Au Musée de l'Acropole*, p. 242; Langlotz, op. cit., no. 4138; *Korai*, nos. 116, 110.

79. *M.M.A. Bulletin*, 1913, p. 174, and *Catalogue of Greek Sculptures*, no. 447.

80. Smith, op. cit., I, no. 328.

81. In Copenhagen. Cf. F. Poulsen, *Catalogue, Ny Carlsberg Glyptotek*, no. 460a.

82. Such separate plates belonging to bronze statues have been found at Delphi (*Fouilles de Delphes*, V, p. 43, no. 87, fig. 131). The Delphi charioteer has them still in place; so has the marble statue probably by Antenor (no. 681 in the Akropolis Museum).

83. Cf. Wace, in *J.H.S.*, LVIII (1938), pp. 90 ff.; Gjerstad, in *Erani*, XLIII (1945), pp. 236 ff.; Haynes, "The Technique of the Chatsworth Head," in *Rev. Arch.*, 1968, pp. 101 ff. Cf. also Amelung, *Oest. Jahresh.*, XI (1908), p. 179 (a head of Athena); and some of the Akropolis Maidens, Lechat, op. cit., p. 236, nos. 8, 9, and note 2; and a male head in the Akropolis Museum, no. 657; cf. Lange in *Ath. Mitt.*, VII, 1882, pl. IX, 1, p. 193; also my *Korai*, passim.

84. Cf. e.g. the examples of Akropolis Maidens cited by Lechat, op. cit., pp. 209, 212–13. The Agorakritos Nemesis has holes in the diadem for the attachment of figures (see my p. 185).

85. E.g. in the head from Delos in the National Museum, Athens, no. 23; cf. *B.C.H.*, III (1879), pl. VIII, 1.

86. *Catalogue sommaire des marbres antiques* (1922), no. 696, pl. XXVI.

ing the surface. But Greek sculpture throughout its career was painted,[1] irrespective of whether its material was limestone, terracotta, wood, or marble.[2] If this thought comes to us at first as somewhat of a surprise, let us remember that unpainted sculpture is a recent taste. The universal practice in olden times was to paint sculpture. The Egyptians had done it before the Greeks, the Etruscans and Romans copied it from their predecessors, and the Gothic sculptors carried on the tradition. It was only in the Renaissance when taste reverted to classical sculpture—which had in the meantime lost its color—that unpainted figures were produced.[3] And we have inherited this taste from our more immediate past.

So much of Greek sculpture is architectural—and we know that Greek architecture was painted—that it would indeed be inconceivable that the statues and reliefs should not have conformed to the general scheme. Moreover, in the brilliant Greek light and at the height from which they were seen the differentiation in color was essential. But since comparatively few Greek sculptures have their color preserved,[4] we must examine the evidence carefully to form a proper picture.

That wooden figures were entirely painted is likely since their surfaces needed protection from the atmosphere. An inscription from Delos of the third century B.C.[5] shows that the wooden statue offered annually to Dionysos was painted. ON WOOD

That the whole surface of limestone sculptures was painted we know sufficiently from the painted Akropolis groups (figs. 403–07) and the statues and reliefs from Cyprus.[6] The chief colors used[7] were blue and red; yellow, brown, black, and white ON LIME-STONE

1. On this subject see especially Collignon, "La Polychromie dans la sculpture grecque," in *Revue des Deux Mondes*, 1895, pp. 845–46; Girard, *La Peinture antique*, p. 282; Treu, *Sollen wir unsere Statuen bemalen?*, and *J.d.I.*, IV (1889), pp. 18 ff., X (1895), pp. 25 ff.; E. Robinson, "Did the Greeks Paint their Sculptures?" in the *Century Magazine*, XLIII, 1892, pp. 869 ff.; Museum of Fine Arts, Boston, *The Hermes of Praxiteles and the Venus Genetrix, Experiments in Restoring the Color of Greek Sculpture*, by Joseph Lindon Smith, described and explained by Edward Robinson (1892); Richter, in *A.J.A.*, XLVIII (1944), pp. 321 ff.; L. F. Hall, ibid., pp. 334 ff. On the technical side, cf. Berger, *Die Maltechnik des Altertums* (1904), pp. 49 ff.; Laurie, *Greek and Roman Painting*, pp. 104 ff., and *The Materials of the Painter's Craft* (1910); Solon, *Polychroney* (1924); Eibner, *Entwicklung und Werkstoffe der Wandmalerei* (1926), pp. 67 ff.; Reuterswärd, *Studien zur Polychromie der Plastik, Griechenland und Rom* (1960), with an extensive bibliography.

2. On the pigments used by the ancients, cf. especially A. Reinach, *Textes grecs et latins relatifs à l'histoire de la peinture ancienne*, pp. 8 ff., and Laurie, *Greek and Roman Painting*, pp. 9 ff. They knew the earth colors —the yellow and red ochres, terre verte, and probably the siennas and umber; also white earth, blue carbonate of copper, and artificial pigments. From a simple palette they proceeded to a more and more complicated one. "Painters had a very complete palette at their command, a palette which remained the same, with a few modifications right through the history of painting and up to the dawn of modern chemistry" (Laurie, op. cit.— judging apparently from Hellenistic and Roman paintings, not from earlier Greek).

3. Though many Renaissance figures, especially those in wood and terracotta, are of course also colored.

4. This loss is easily explained by the nature of the mediums used by the ancients (gum, glue, and white or yolk of egg). "Such mediums can all be dissolved and mixed with water, and while serving to attach the pigment do not really protect it from attack by air or moisture or prevent its easy removal" (Laurie, *Greek and Roman Painting*, p. 18). The quick disappearance of the colors after the discovery of the sculptures also indicates their temporary character. Fortunately now the colors can be protected chemically.

5. Homolle, *B.C.H.*, XIX (1890), pp. 396, 502. Color is preserved on some wooden statuettes.

6. Myres, *Handbook of the Cesnola Collection*, p. 131.

7. The same palette of colors is found in Egyptian sculpture.

occur in smaller washes; also green.[8] The coloring is conventional, bulls, horses, beards often appearing blue, merely for their general effect.

On the tufa metopes of the temple C of Selinus[9] numerous color traces could be distinguished, especially when they were first unearthed (1822–23). Again the predominant colors were red, blue, and yellow, with occasional green, and touches of black and white.

ON TERRA-
COTTA

Terracotta sculpture, like limestone, was wholly painted. Some of the archaic sculptures from the Athenaion in Syracuse give us a good idea of the brilliance of this coloring.[10] A fragment of a terracotta statue in New York[11] (fig. 499) has numerous traces of color left. The terracotta statuettes which have come down to us in such large numbers were all originally painted. They were first covered entirely with a white engobe and over this the colors were added. The garments show a variety of bright shades—blue, red, pink, yellow, brown, violet, and, rarely, green. The color of the flesh where preserved is generally reddish or pinkish, of the hair auburn brown, of the lips red, of the eyes blue. Gilt and black appear for details. Unfortunately the white coating has largely flaked off and with it the colors, leaving only the drab terracotta surface. Originally the impression was colorful and gay.

ON MARBLE

*Archaic
Period*

We can form some idea of the use of color in archaic marble statues from the Akropolis figures found in the "Persian debris."[12] Being safely hidden away not so long after their creation they have retained at least occasionally some of their colors in fair condition[13] (figs. 284–86). Only a portion of the surface is painted; that is, the color is confined to parts of the head (the hair, the eyes, the lips, and such accessories as earrings and diadems) and to the embroidered bands and ornaments of the drapery; and it is used as a solid wash on a garment generally only when a small part of it shows. The evidence available at present indicates that in archaic times women's flesh was left whitish and the flesh of men painted brownish, and that only in later times the flesh of women as well as of men was colored[14] (see below). The clear definition of archaic sculptures with their sharply marked boundaries made the use of color doubly effective. In fact it is possible that the employment of color in its turn influenced the precision of individual forms, for instance of the lips and eyes.[15]

Besides the Akropolis figures numerous other archaic marble figures show remains of color. In the metopes of the "Sikyonian" Treasury at Delphi (cf. fig. 433) color traces are preserved on the figures but not on the background: e.g. dark red on the

8. What today appears green is sometimes blue which has turned green. On some of the statues in the Akropolis Museum, however, we find both green and blue.

9. Benndorf, *Die Metopen von Selinunt*, pp. 42–43.

10. Cf. Orsi, in *Monumenti antichi*, XXV (1918), pls. XVI, XVII. 11. *M.M.A. Bulletin*, 1925, p. 15, fig. 3.

12. After the havoc wrought by the Persians the Athenians buried the old broken statues in convenient pockets on the hill.

13. The colors have faded somewhat since the figures were first found. The casts in the Metropolitan Museum have been colored by M. E. Gilliéron from the original sketches made by his father shortly after their discovery in 1880. 14. On this evidence cf. Richter, in *A.J.A.*, XLVIII, 1944, pp. 324 ff.

15. On this point, cf. Solon, *Polychromy*, pp. 122 f., 130.

draperies of Europa and the Dioskouroi.[16] On the standing maiden in Berlin (figs. 279–81) the color is still preserved in places—red on the chiton, yellow on the mantle, yellow on the hair, blue, red, and yellow on the meander border.[17] On a fragment of a head from Ephesos there are remains of red on the skin and black on the hair.[18] The frieze of the Siphnian Treasury in Delphi (cf. figs. 451, 452) retained much of its original color scheme when first found—blue on the background, blue, green, and red on the figures.[19] The statuette of the treasurer 144 in the Akropolis Museum, has traces of red on the flesh parts. Two sphinxes, finials of grave monuments in the Metropolitan Museum, have red, blue and black on the feathers and the hair.[20] The Naxian sphinx at Delphi (fig. 495) was likewise gaily colored.[21] A statue base in Athens[22] (fig. 297) has a good deal of red preserved on the background. On archaic grave reliefs we often see some color (generally red) still adhering to the background or the hair.

No fifth-[23] or fourth-century statue has survived with its colors at all well preserved. But traces have been observed, for instance, on the Aigina marbles[24] (cf. figs. 415, 416), on the seated goddess in Berlin[25] (fig. 70), on the Olympia pediments and metopes[26] (cf. figs. 417–20, 444), the gravestone of Philis in the Louvre,[27] the frieze of Hephaisteion[28] (cf. fig. 307), and the votive relief from Eleusis dating from about 400[29] (fig. 500). There is no certain evidence of color having been found on the sculptures of the Parthenon,[30] a fact which is not surprising considering the long period during which they were exposed. On the frieze[31] and statues[32] of the Mausoleum, however, the traces of color were unmistakable; likewise on the hair and sandals of *Fifth Century* *Fourth Century*

16. F. Poulsen, *Delphi*, pp. 81, 88. 17. Wiegand, *Berliner Museen*, 1926, 2, p. 18.
18. Pryce, *Catalogue of Sculpture in the British Museum*, I, 1, no. B 93. 19. Poulsen, op. cit., p. 141.
20. Richter, *M.M.A. Cat. of Greek Sculptures*, nos. 10, 15. 21. Poulsen, op. cit., p. 100.
22. National Museum, no. 3476. Papaspiridi, *Guide*, p. 40, and S. Karouzou, *Cat.*, pp. 31 f.
23. Except of course the early fifth-century figures from the Akropolis like the "Boudeuse" and the Blond Boy (nos. 686, 689).
24. Furtwängler, *Aegina*, pp. 300 ff., e.g. red on the whole of the mantle of Athena of the eastern pediment, blue and red on the scales of her aegis, blue on some of the helmets, red on the inside of the shields, etc.
25. Wiegand, *Antike Denkmäler*, III, p. 46; no actual colors are preserved, but incised decorations and weathering show their former presence.
26. Cf. Treu, in *J.d.I.*, x (1895), pp. 25 ff., e.g. red on the mantle of Apollo (the whole garment was evidently painted, forming an effective background for the nude figure) and on some of the horses' tails; red on various parts of the metope figures, blue on their background.
27. Prachov, *Annali dell'Instituto*, 1872, p. 186, e.g. a pinkish tone on the flesh, especially on the cheek.
28. Sauer, *Das sogenannte Theseion*, p. 187; slight remnants of green, blue, and red on the garments, and blue on the background.
29. Rodenwaldt, in *J.d.I.*, xxxvi (1921), pp. 4 ff., pl. I; blue on the background, reddish brown on the hair, yellow on the veil of Demeter, red on the eyes, eyebrows, and contours of the figures.
30. Michaelis, *Der Parthenon*, pp. 124 f. (metopes), 156 f. (pediments), 226 f. (frieze).
31. They were particularly vivid when first found. Newton (*Travels and Discoveries in the Levant*, 2, 131) writes soon after their discovery: "The whole frieze was colored. From the examination of a number of fragments on their first disinterment I ascertained that the ground of the relief, like that of the architectural ornaments was a blue, equal in intensity to ultra-marine, the flesh a dun-red, and the drapery and armor picked out with vermilion and perhaps other colors." Cf. also Smith, *Catalogue of Greek Sculpture in the British Museum*, II, p. 97. 32. Cf. Newton, *Halicarnassus*, II, 1, pp. 222, 232.

the Hermes by Praxiteles[33] (fig. 711). On a few fragments of the fourth-century sculptures of Ephesos there are remains of color including some on the skin.[34] Several fourth-century Athenian grave stelai show extensive remains of color.[35] For instance, the monument of Aristonautes[36] has red on the inside of the shield, green near the shoulder straps, and blue on the background; that of Prokleides[37] has traces of a red background and blue on the drapery. Finally the reliefs of the rock tomb at Myra in Lycia (probably fourth century) when found had their colors beautifully preserved.[38] One of these has a blue background, violet, red, and yellow draperies, and flesh-colored nude parts. Another has a red background, violet drapery, a yellow couch with blue and red ornaments, and again flesh-colored nude parts.

Hellenistic Period

Traces of color have likewise been found on Hellenistic and Roman sculpture. Of these the most important is the Alexander sarcophagus from Sidon in the Istanbul Museum[39] (fig. 801). On its reliefs representing battle and hunting scenes are the most varied hues of color—purple, violet, yellow, blue, and different shades of red and brown on the garments, not merely as borders but covering the whole surface; on the bodies some parts such as the hair and the iris are picked out in color. The flesh itself is covered with a light, transparent wash, light yellow for the Greek soldiers, a darker yellow for the Persians. On other examples there are more meagre traces. The old market woman in the Metropolitan Museum (fig. 229) once had some deep red preserved on her sandal strap and bright pink on her mantle.[40] On a head of a girl

Roman Period

from Priene[41] in the British Museum traces of red remain in the iris of the eye, the eyebrow, and the curls. The head of Athena in Berlin[42] (fig. 641), a Roman copy of the Athena Parthenos, has yellow on the helmet, red on hair and eyebrows, dark brown on the iris. A female head in Athens,[43] a copy of a fifth-century work, still shows color on the hair and the eyes. Another head from the Esquiline in the British Museum[44] (fig. 498)—a Roman copy of a fourth-century Greek original—has copious traces of red and yellow on the hair and, what is specially interesting, pink on the skin. The

33. Reddish brown on the hair and red and gilt on the sandal.

34. In the British Museum: the lower part of the head of a youth, inv. no. 74. 7–10.272 (gray on the flesh probably originally pink); the head of a girl, inv. no. 1927. 2–14.1 (on the hair traces of brown, eyebrows and pupils brown, flesh pinkish). The latter is from Ephesos, but not certainly from the temple and perhaps of later date—so F. N. Pryce informed me.

35. For a list of Greek stelai with color traces, cf. Brueckner, in Sachregister of Conze, *Attische Grabreliefs*, IV, p. 142; and Rodenwaldt, in *Arch. Anz.*, 1922, p. 170.

36. National Museum, Athens, no. 738. Papaspiridi, *Guide*, p. 129, and S. Karouzou, *Cat.*, pp. 125 f.; Conze, op. cit., pl. CCXLV, no. 1151.

37. National Museum, Athens, no. 737. Papaspiridi, *Guide*, p. 128, and S. Karouzou, *Cat.*, pp. 119 f.; Conze, op. cit., pl. CXLI, no. 718.

38. Fellows, *Discoveries in Lycia*, third plate after p. 198 (colored). Colored casts of these reliefs were once shown in the Mausoleum Room of the British Museum (Smith, *Cat.* II, no. 954).

39. Cf. Hamdy-Bey and Th. Reinach, *Une Nécropole royale*, text and plates (some colored); Winter, *Alexander-Sarkophag* (colored plates); Mendel, *Cat.*, no. 68. 40. Richter, *Cat. of Greek Sculptures*, no. 221.

41. Smith, *Catalogue*, II, no. 1153. 42. Fränkel in *Antike Denkmäler*, I, 1886, pl. III.

43. National Museum, no. 177. Wolters, in *J.d.I.*, XIV (1899), pp. 143 ff.; Papaspiridi, *Guide*, p. 48, and S. Karouzou, *Cat.*, pp. 67 f. 44. Treu, in *J.d.I.*, IV (1889), pp. 18 ff., and pl. 1.

statue of Augustus from Primaporta in the Vatican has remains of a richly variegated color scheme.[45] Finally we may mention a wall painting from Pompeii in which a woman is represented painting a piece of sculpture,[46] and a South Italian vase in New York[47] on which a man is shown painting a statue (fig. 470).

In addition to painting there is another process which we hear of in antiquity, that of γάνωσις or κόσμησις. Vitruvius[48] gives the following account of it:

GANOSIS

> Though it [red[49]] keeps its color perfectly when applied in the polished stucco finish of closed apartments, yet in open apartments, such as peristyles and exedrae or other places of the sort, where the bright rays of the sun and moon can penetrate, it is spoiled by contact with them, loses the strength of its color, and turns black. . . . But if anyone should be more particular and should wish the red finish to retain its color he must, when the wall is polished and dry, rub over it with a stiff brush Punic wax melted and mixed with a little oil; and afterwards melt the wax by warming it and the wall at close quarters with charcoal enclosed in an iron vessel; and finally smooth it off by rubbing it down with a candle and clean cloths, as nude marble statues are treated. This is termed γάνωσις in Greek. The protecting coat of Punic wax prevents the light of the moon and the rays of the sun from licking up and drawing the color out of such polished finishing.

Pliny[50] gives a similar description, again mentioning Punic wax, known for its purity,[51] and ends by saying: "as one treats marble figures to make them brilliant."

45. Amelung, *Die Skulpturen des vaticanischen Museums*, I, no. 14: "red and pink on the tunic and the mantel; the cuirass bordered with yellow and blue fringes; red, yellow, blue, pink, and brown on the ornamental relief; brown on the tree-trunk; reddish brown on the hair"; Helbig-Speier, *Führer*⁴, I, no. 411.

46. Mau, *Pompeii* (1904), p. 282, fig. 133; Museo Borbonico, VII, 3. Cf. also E. Robinson, *Century Magazine*, XLIII (1892), 883, where frescoes are mentioned with colored statues.

47. D. von Bothmer, in *M.M.A. Bull.*, February, 1951, pp. 156 ff.

48. *De arch.* VII. 9. 2–4: (Minium) cum est in expolitionibus conclavium tectoriis inductum: permanet, sine vitiis, suo colore. Apertis vero, id est peristyliis aut exhedris, aut ceteris ejusdem modi locis, quo sol et luna possit splendores et radios inmittere, cum ab his locus tangitur, vitiatur; et, amissa virtute coloris, denigratur, At, si qui subtilior fuerit, et voluerit expolitionem miniaceam suum colorem retinere, cum paries expolitus et aridus fuerit, ceram punicam igni liquefactam paulo oleo temperatam saeta inducat; deinde postea, carbonibus in ferreo vase compositis eam ceram a proximo cum pariete calefaciundo sudare cogat, itaque ut peraequetur; deinde tunc candela linteisque puris subigat uti signa marmorea nuda curantur. Haec autem γάνωσις graece dicitur. Ita, obstans cerae punicae lorica non patitur nec lunae splendorem, nec solis radios, lambendo eripere ex his politionibus colorem.

49. *Minium*, though often translated by vermilion, is really red lead, Pb_3O_4, while vermilion is cinnabar, HgS (mercury). This information I owe to Prentice Duell. See also Baldinucci, *Vocabulario toscano dell' arte del disegno* (1681), p. 98, under *minio*, who describes it as made of lead and white lead.

50. *N.H.* XXXIII. 122: Inlito solis atque lunae contactus inimicus. Remedium ut, parieti siccato, cera punica cum oleo liquefacta candens saetis inducatur iterumque admotis gallae carbonibus inuratur ad sudorem usque, postea candelis subigatur ac deinde linteis puris, sicut et marmora nitescunt.

51. Pliny, *N.H.* XXI. 83. Cf. Treu, in *J.d.I.*, IV (1889), p. 23.

Elsewhere Pliny[52] gives a receipt for Punic wax. Important is Plutarch's statement[53]: "The 'ganosis' of the statue is necessary, for the red ochre[54] with which the ancient statues are painted soon loses its color." Eloquent is also the derivation of γάνωσις: γανόω = to make bright, polish; γεγανωμένον = lacquered. In the inventories of Delian temples of the year 279 B.C. accounts appear for the articles used in the κόσμησις of statues which include sponges, nitre, oil, linen, wax, and perfume.[55] In some cases the oil is described as ἔλαιον λευκόν, white oil.[56] Clearly the object was to apply a colorless varnish over the whole surface for the preservation of the surface and especially of the colors. This is also borne out by the fact that in these same Delian inscriptions[57] salaries are paid for the κόσμησις of a figure in addition to those paid to the sculptor and the painter of the statue.

Frequent applications of this oil and wax mixture were apparently necessary, for we hear of specialists known as κοσμηταί[58] who commanded considerable salaries. It is natural therefore that no trace of it now remains.

It has been suggested that this application toned the marble sufficiently to make the addition of color to the nude parts unnecessary.[59] Practical experiments do not bear this out. An application of Punic wax does not affect the color of the white marble sufficiently to make it harmonize with the painted hair, eyes, and mouth.[60] We have also seen that in the Mausoleum frieze, the Sidon sarcophagus, the Myra reliefs, and a few other pieces, actual colors on the nude parts were and sometimes are still visible,[61] and the same is borne out by the literary evidence in which the faint flush of the cheeks and a body color "not too white but just suffused with red" is referred to (see below). And in the related case of terracotta statuettes, covered over their whole surface with a white engobe in imitation presumably of marble statues, the reddish or pinkish tone applied on the white for the flesh is often preserved; as also in the statues

52. *N.H.* XXI. 84: Punica fit hoc modo: ventilatur sub diu saepius cera fulva, dein fervet in aqua marina ex alto petita, addito nitro. Inde linpulis hauriunt florem, id est candidissima quaeque, transfunduntque in vas, quod exiguum frigidae habeat, et rursus marina decocunt separatim, dein vas ipsum aut aquam refrigerant. Et cum hoc ter fecere, juncea crate sub diu siccant sole lunaque. Haec enim candorem facit, sol siccat, et, ne liquefaciat, protegunt tenui linteo. "Punic wax is prepared in the following manner: the yellow [unbleached] wax is placed for a long time in the open air. Then it is boiled in sea water, obtained from the open sea, with *nitrum* added. Then the top, that is, the purest part, is skimmed off with a ladle and poured into a cool vessel. When this has been repeated three times, the wax is then dried on woven rushes in the sunlight and the moonlight. This process bleaches it. It is whiter still if it is boiled once more in the sunlight. The sun dries it without melting it and it is covered with a soft linen cloth."

53. *Quaest. Rom.* 287 D: ἡ δὲ γάνωσις τοῦ ἀγάλματος ἀναγκαία, ταχὺ γὰρ ἐξανθεῖ τὸ μίλτινον ᾧ τὰ παλαιὰ τῶν ἀγαλμάτων ἔχρωζον.

54. Τὸ μίλτινον or ἡ μίλτος should be translated by red ochre, "an earth colored by haematite (oxide of iron, Fe₂O₃)" (Duell). 55. Homolle, *B.C.H.*, XIV (1890), p. 498.

56. Ibid., p. 499. 57. Ibid., pp. 502–03.

58. Ibid., p. 500; VI (1882), p. 48. 59. Cf., e.g., Gardner, *Handbook of Greek Sculpture*, pp. 29 ff.

60. Richter, *Metropolitan Museum Studies*, I, pp. 25 ff.; and in *A.J.A.*, XLVIII, 1944, pp. 327 ff.

61. The fact that the hair and drapery have an uneven, often slightly roughened surface while the nude parts are smooth would help to account for the better preservation of the color on the former. This variety in finish definitely suggests the difference in texture between skin and hair or drapery.

which appear on Roman frescoes and mosaics.[62] Furthermore in Egyptian sculpture where the original paint is often well preserved the skin is regularly colored, that of men reddish brown, that of women yellow; in Gothic sculpture the flesh is likewise painted. There seems no reason therefore not to assume a similar practice in classical Greek times. We must then interpret γάνωσις as an application over the colors for their better preservation.

The literary evidence on the subject shows that great emphasis was placed on successful coloring. Pliny[63] tells us that when Praxiteles was asked which of his statues he valued most he replied, "those to which Nikias has put his hand. So much did he prize the *circumlitio*[64] of that artist." As Nikias was a famous painter[65] it is significant that he did not think it beneath him to paint statues. And this is borne out by an inscription from Delos of the third century B.C. which records equal sums paid to the sculptor of a statue and to its painter.[66] Furthermore Lucian[67] in his description of his ideally beautiful woman borrows not only various features from famous sculptors but apportions its painting among the most illustrious artists of antiquity. The passage is important, so we will quote it in full:

"What do you think, Polystratos? Will the figure be beautiful?"

"Yes, surely, when it has been completed to the uttermost detail: for there is still, despite your unexampled zeal, one beauty that you have left out of your statue in collecting and combining everything as you did."

"What is that?"

"Not the most unimportant, my friend, unless you will maintain that perfection of form is but little enhanced by color and appropriateness in each detail, so that just those parts will be black which should be black, and those white which should be, and the flush of life will glow upon the surface, and so forth. I fear we will stand in need of the most important features!"

"Where then can we get all that? Or shall we call in the painters of course, and particularly those who excelled in mixing their colors and in applying them judiciously? Come then, let us call in Polygnotos and Euphranor of old, and Apelles and Aëtion. Let them divide up the work, and let Euphranor color the hair as he painted Hera's; let Polygnotos do the becomingness of her brows and the faint flush of her cheeks, just as he did Kassandra in the Lesche at Delphi, and let him also do her clothing, which shall be of the most delicate texture, so that it not only clings close where it should, but a great deal of it floats in the air. The body Apelles shall represent after the manner of his Pakate, not too white but just suffused with red; and her lips shall be done by Aëtion like Roxana's. But stay! We have Homer, the best of all painters, even in the presence of

62. E. Robinson, in *Century Magazine*, XLIII, 1892, p. 883. 63. *N.H.* XXXV. 133.
64. *Circumlitio* = "the application of color," literally "the besmearing all around."
65. Cf. Overbeck, *Schriftquellen*, nos. 1811 ff. 66. Cf. Homolle, in *B.C.H.*, XIV (1890), p. 502.
67. Εἰχόνες 6. 27.

Euphranor and Apelles. Let her be throughout of a color like that which Homer gave to the thighs of Menelaos when he likened them to ivory tinged with crimson; and let him also paint the eyes and make her 'ox-eyed.' The Theban poet, too, shall lend him a hand in the work, to give her 'violet brows.' Yes, and Homer shall make her 'laughter-loving' and 'white-armed' and 'rosy-fingered,' and, in a word, shall liken her to golden Aphrodite far more fittingly than he did the daughter of Briseus."

Another important testimony is the famous passage of Plato:[68]

If we were to paint statues and someone were to come and object that we do not employ the most beautiful colors for the most beautiful parts of the body; that, for instance, we do not paint the eyes vermilion, but black, we should think that we had answered the censor very well by saying to him: "Do not think that we ought to paint eyes so beautifully that they cease to be eyes; and what I say of this part of the body must be understood of the others likewise."

A passage in Plutarch[69] is equally eloquent: "They (the actors in a drama) are like toilet-makers and chair-bearers of a luxurious woman; or rather like the encausters and gilders and colorers of statues (ἀγαλμάτων ἐγκαυσταὶ καὶ χρυσωταὶ καὶ βαφεῖς)."

We have abundant evidence, then, of every description—monumental, literary, and epigraphical—to show that coloring of sculptures in all materials was prevalent with Greek sculptors throughout their career. We cannot as yet trace its development stage by stage; but a few statements of ancient writers[70] inform us that the development was along naturalistic lines, i.e. by the gradual use of mixed instead of pure colors and the introduction of shadows and perspective. And a comparison between the sixth-century maidens and the fourth-century Alexander sarcophagus shows the changes made in the direction of a more extensive palette, a more delicate harmony of tone, and a more naturalistic rendering. Whatever prejudices one may have against colored sculpture in theory, the fact remains that what has been actually preserved—from the Akropolis Maidens to the Alexander sarcophagus—is so pleasing that it makes the white sculpture appear tame by comparison. And if we sense this in museums we can imagine that the contrast would be even greater in the glare of a Greek sun.

Mounting

WHEN a statue was completed it had to be set in place.[71] If it was a single statue or relief it was mounted on a base, which was sometimes of an inferior material such as limestone. The shape of the base is generally rectangular or round; occasionally tri-

68. *Republic* IV. 420 c. 69. *De glor. Athen.* 6.
70. Plutarch, *De gloria Ath.*, 346a; Hesychios, s.v. Σκιά; Pliny, *N.H.*, XXXV, 60. 61.
71. On the mounting of Greek statues cf. e.g. Raubitschek, in *Bulletin de l'Institut archéologique bulgare*, 12 (1938), pp. 132 ff., and his *Dedications*, passim.

angular (e.g. the Nike of Paionios), or in the shape of a column (e.g. the Naxian Sphinx at Delphi[72] (fig. 495) and several archaic korai in Athens[73]). It was regularly provided with a dedicatory inscription (cf. fig. 771) and occasionally with the signature of the artist. Now and then it was decorated with reliefs (cf. e.g. fig. 770). The fastening was generally done by metal dowels secured with molten lead (fig. 497),[74] or the plinth of the statue was inserted into a corresponding depression in the base and fastened with molten lead (fig. 496).[75]

The early pediment figures are in relief, either low (e.g. Corfu and Hydra pediments; figs. 401, 403) or high relief (e.g. "Bluebeard" pediment; fig. 405). The sculptures of the pediments of the Siphnian Treasury (fig. 409) and of the temple of Apollo at Delphi (figs. 408, 411, 413, 414) are partly in relief, partly in the round. The figures of the Eretria pediment were fastened with large dowels to the background (fig. 481). Later the figures stand free, e.g. in the Aigina and Olympia pediments and in the Parthenon (cf. fig. 75), and the plinths, with which they are now regularly[76] provided, are secured to the cornice with bronze clamps and leaden pegs.[77] The later pediment figures must have been carved before they were set up, since they are worked in the round. For such work, in so far as it had to be executed under cover, a temporary studio (ἐργαστήριον) near the temple was erected.[78] Certain changes had naturally often to be made after the figures were placed, and this was rendered easy by the practice of piecing.[79] The metopes were presumably also worked on the ground. With the continuous friezes the method varied. In the Parthenon the slabs seem to have been carved in situ, for they are of great depth and weight, and the risk to the reliefs in mounting would have been great; moreover the figures overlap from stone to stone. In the Phigaleia temple the slabs were clearly worked separately and then erected, for each has a complete composition, and occasionally when a piece protrudes the hollow into which it fitted is carved in the adjoining stone.

At least sometimes care was taken to calculate the effect of the sculptures at their proper height. The Parthenon frieze is carved in deeper relief at the top than at the bottom.[80] A comparison of the Nike of Paionios at the height she was intended for and when placed low down[81] (figs. 493, 494) gives us a realization of the importance of such a calculation. That some sculptors failed in this provision also in Greek times is brought out in the anecdote[82] of the contest of Pheidias and Alkamenes for a statue of Athena which was to be mounted on a high column; we are told that Alkamenes' statue was very delicate and greatly admired until it was set up, when the

72. F. Poulsen, *Delphi*, p. 98, fig. 29. 73. Akropolis Museum, nos. 686, 609.

74. Richter, *A.J.A.*, XLV (1941), p. 159, figs. 1, 2.

75. Cf. e.g. nos. 609, 681, 624, 596 in the Akropolis Museum.

76. The Epidauros figures are an exception. 77. Furtwängler, *Aegina*, pp. 203–04, 206.

78. We hear of such workrooms at Olympia, on the Akropolis, and at Epidauros.

79. Treu, in *J.d.I.*, x (1895), 20.

80. The depth of the Parthenon frieze is 5½ cm. top, 3½ cm. below (Dinsmoor). Such differences, however, are not observable in all architectural sculptures.

81. Cf. Treu, *Olympia*, III, 192, figs. 223–24. 82. Tzetzes, *Chiliades*, VIII, 353 ff.

effect was entirely lost; while Pheidias' work was properly calculated to be seen at the height intended.

The Status of Greek Sculptors

OUR study of the methods employed by the Greek sculptor has brought him very near to us, and has made us feel interested in his life. What do we know of the conditions under which Greek sculptors lived? Very little. They were regarded of course as hand-workers, like all artists in the old days; and this circumstance made their standing comparatively low in certain parts of Greece and in the estimate of some people. In the military state of Sparta no citizen was allowed to do any manual work[83]—and so Sparta has produced few artists. For the estimate of artists in the Roman period, Plutarch's statement[84] is revealing: "Labor with one's own hands on lowly tasks gives witness, in the toil thus expended on useless things, to one's own indifference to higher things. No generous youth, from seeing the Zeus at Pisa, or the Hera at Argos, longs to be Pheidias or Polykleitos; nor to be Anakreon or Philetas or Archilochos out of pleasure in their poems. For it does not of necessity follow that if the work delighted you with its grace, the one who wrought it is worthy of your esteem." But it is a mistake to generalize from a few sentiments; just as it would be misleading to generalize for the modern outlook from English nineteenth-century prejudices when the church, the army, and the navy were the only professions open to a gentleman. Solon passed a law against idleness in accordance with which every citizen had to declare his means of livelihood,[85] and he thereby set his seal on respect for work of all kinds. In Athens artists, at least the prominent ones, were certainly in high standing. Many of them belonged to the citizen class. They became intimate with the mighty. Pheidias and Perikles were close friends. The sister of Kephisodotos the Younger, the son of Praxiteles, married Phokion, a member of a distinguished old family.[86] The same Kephisodotos filled the functions of a trierarch,[87] which required considerable wealth. Nikias, the painter, was accorded a public funeral.[88] Moreover, the prices paid to sculptors were comparatively high—not a bad criterion of contemporary appreciation. Each small figure in the Erechtheion frieze cost about sixty drachmas[89] (at a time when the wage of a skilled workman was one drachma a day[90] and the value of silver was about seven or eight times what it is today[91]). For the three Epidauros akroteria, all executed in one year by one man, the payment amounted to 3,010 drachmas.[92] A little later (in the time of the philosopher Diogenes) we hear of three

83. Xenophon, *Lac. resp.* VII. 1–2. 84. *Perikles* II. 1.

85. Cf. Herodotos, II. 177; Plutarch, *Solon* 17. 1; cf. also 2. 3.

86. Plutarch, *Phokion* 19. 1. 87. Loewy, *Inschriften*, No. 555.

88. Pausanias I. 29. 15. 89. Paton, et al., *The Erechtheum*, p. 289.

90. Ibid., p. 381. The Athenian drachma was then equivalent to about 22½ American cents.

91. Foucart, *B.C.H.*, XIV (1890), p. 593, note 1.

92. Cf. my p. 214; since Epidauros used the Aiginetic drachma at this period, which was equivalent to about 33 cents, this would amount to about $993.30.

thousand drachmas being paid for a single statue.[93] Naturally in Roman times collectors paid huge prices—five hundred talents, for instance, for the colossal statue of Apollo by Kalamis;[94] but that was mostly for "antiques." That some of the artists were highly educated men we can surmise from the facts that they wrote books on symmetry and proportion,[95] and that many of them combined several artistic professions, being at one and the same time architect and sculptor,[96] or sculptor and painter,[97] or sculptor and silversmith,[98] etc., just as was customary in the Renaissance.[99] We can imagine, then, the Greek sculptor as leading a pleasurable existence; gifted as few human beings have ever been, absorbed in his work and its many problems, and honored by an appreciative public.[100]

93. Diogenes Laert. VI. 35. 94. Pliny, *N.H.* XXXIV. 39. It was thirty cubits in height.

95. E.g. Polykleitos and Euphranor, etc.; see pp. 190, 177, n. 114.

96. E.g. Skopas; cf. pp. 207 ff. 97. E.g. Pythagoras, Pheidias, Euphranor, and Kallimachos.

98. E.g. Myron; cf. pp. 160 ff.

99. E.g. Michelangelo, who was sculptor, painter, and architect, and Brunelleschi, who was architect, sculptor, and goldsmith (Vasari, ed., Sansoni-Milanesi, 2, 330).

100. On the appreciation of sculptors in ancient Greece cf. now the careful analysis by M. Guarducci in *Archeologia classica,* IX, 1957, pp. 1 ff., X, 1958, pp. 138 ff., XIV, 1962, pp. 236 ff.

GREEK SCULPTURE COMPARED WITH ROMAN COPIES AND MODERN FORGERIES

We have studied Greek sculpture from various points of view—its conception, its modeling, its composition, its technique, and the treatment of relief. In this chapter we shall study it from still another angle—an indirect one, but one that is particularly illuminating—its relation to Roman copies and modern forgeries; for it is often by comparison with other products that the inherent qualities of a work of art are realized. Moreover, the consideration is a practical one, since in our examination of ancient sculpture we are continually confronted with these questions of origin.

Roman Copies

IT is important to remember that much of what we have come to call Roman art was produced by Greek artists and other people of non-Roman origin.[1] When, therefore, we use the term Roman it is meant to signify a period rather than a nationality. The Roman Empire created an outlook that pervaded all communities and is manifest in the art produced in its wide domains.

As a consequence of the Roman conquest of Greece a multitude of Greek works of art had been transferred to Italy and had been exhibited in public places. By this direct contact the Romans had come to appreciate Greek art. By the first century B.C., the natural supply of originals through looting by the conquering generals had waned and so the public demand had to be supplied by a vast output of copies (cf. p. 243). These copies of earlier works were either made mechanically by the pointing process (cf. pp. 244 ff.), in which case a Greek work was produced as exactly as possible,[1a] or, they were adaptations with slight variations.

The direct copies have the greatest value for us today; for many a Greek work is

1. For recent discussions cf. Rizzo, I Romani e l'arte greca, in *L'Urbe*, x, 1947, pp. 3 ff.; Vessberg, *Studien zur Kunstgeschichte der römischen Republik*, pp. 26 ff., and passim; my *Three Critical Periods in Greek Sculpture*, 1951, and p. 139 of this book.

1a. In evaluating Roman copies of Greek sculptures it is, however, important to remember that the ancient pointing process differed from the modern in that not nearly as many subsidiary points were used as nowadays, with the result that more leeway was left to the sculptor for the making of minor changes—hence the differences observable in extant copies from the same Greek original. Cf. on this subject my *Portraits of the Greeks*, I, pp. 24 ff.

preserved only in such Roman reproductions. But in trying to visualize through them the lost Greek originals we must be aware of the differences and supply in our minds what the Roman copies do not give.

The most important thing a Roman copy reproduces is the composition of the original statue or group. There may be an occasional variation in detail, but a faithful copy, made by the pointing process, preserves the general scheme. From works like the Diadoumenos of Delos (fig. 695) we get a realization of the harmonious design of a Greek fifth-century original. In fact our whole knowledge of Polykleitos is based on such Roman copies. So are our understanding of the art of Myron with its important innovations in attitudes of movement, and our realization of the Athena Parthenos by Pheidias, one of the most famous works of antiquity.

DIRECT COPIES OF GREEK WORKS

The difference between such Roman reproductions and the Greek models shows itself therefore chiefly in the execution. The sculptors of Roman times, copying as they did earlier Greek creations by mechanical means, missed the imperceptible variety that gave them life. Instead of a delicately variegated surface with gradual, gentle transitions they show a harder, more summary treatment. Naturally the rendering varies. Some Roman copies are much better than others; some even approximate the Greek originals so closely that it is difficult to distinguish between them; but mostly they lack the sensitiveness that characterizes Greek work. A few examples will bear this out. For such comparison I have selected copies of average execution, since they are best suited to bring out the difference.

In spite of the apparent simplicity of the drapery of the transition period of 480–450 we shall find, when we study it, a great deal of variety and feeling for the texture of the material and the continuity of the folds. For instance, in the Sterope and Hippodameia of the East pediment at Olympia[2] (fig. 420) and the standing Athena of one of the metopes[3] (fig. 336), the folds, though apparently uniform, are as a matter of fact infinitely varied. No groove is parallel to another; the direction of each is slightly different, and one is a little wider, another a little narrower; and between the chief grooves are a number of shorter ones, all various lengths, that start at the waist but are not carried all the way down. Moreover, the construction of the garment is made perfectly apparent: a thick woolen tunic, belted, pulled up to form a short pouch, and worn with an overfold. The bunched folds just above the waist are convincing; we feel that there are two thicknesses of cloth, and laid above it the one thickness of the overfold. The few folds on this overfold sufficiently indicate the heaviness of the material and moreover add the necessary variety. After our enjoyment of this sensitive treatment, the contrast in the maidens from Herculaneum[4] (cf. fig. 536) or the Hestia Giustiniani[5] is immediately apparent. They are Roman copies of Greek works of about the same period as the Olympia sculptures and they reproduce their majestic

2. Treu, *Olympia*, III, pl. X; Ashmole and Yalouris, *Olympia*, figs. 19, 48.
3. Treu, op. cit., pls. XL and XLIII; Ashmole and Yalouris, op. cit., fig. 202.
4. Brunn-Bruckmann, *Denkmäler*, pls. 294–95. 5. Ibid., pl. 491.

compositions admirably. But how hard is the rendering of the folds! How relentless are these deep grooves running practically parallel to one another, all starting at the top and ending at the bottom, with only occasionally a little pretense at variation. The pouch looks like a second overfold, not two thicknesses of material. We have here no sense of the varied effects of nature treated in a decorative manner, as in the Olympia sculptures, but a mechanical copying of an artistic rendering inadequately understood.

And other styles of drapery are copied with the same lack of comprehension. If the mantle held by the Lapith on the Parthenon metope (fig. 446) gives us pleasure, if we enjoy the fine swing and consecutiveness of its curving folds, what do we feel before the mantle of a Roman copy with a similar composition[6] (fig. 538)? It is no longer an enjoyment to follow each fold and feel its lifelike and yet rhythmical effect. The stolid vertical folds on the sides and the hesitating curving folds in the middle have nothing in common with their prototypes except their general direction. Again, if we have any appreciation for the beauty of the drapery of the Erechtheion kore (fig. 541), for the variegation of its vertical folds, for the fine curve made by the overhanging pouch, for the little pleats on the overfold, each one of which appears inevitably occasioned by the fall of the garment and yet plays a part in the artistic whole, how hard will seem by contrast the Roman rendering in the Vatican (fig. 542) with its leaden, lifeless folds. An instructive comparison is the Nike adjusting her sandal from the Balustrade (fig. 543) with a copy of it on a Roman relief in Munich[7] (fig. 544). How stilted the oblique lines seem on the copy[8] compared to the fifth-century model; how monotonously regular are the zigzag lines along the edge of the mantle compared to the varied treatment on the earlier figure! How much of the effect of the original is lost in making the drapery less transparent! The same contrast is presented in the relief of the Nike and the bull from the Nike Balustrade (fig. 545) and the Roman version of it in the Vatican[9] (fig. 546).

We can multiply such contrasts and comparisons—the fine swing of the backward-flying drapery of the Paionios Nike (fig. 682), splendidly decorative and yet so naturalistic that we can feel the wind blowing against it, and the rigidity of the backward-flying drapery on the Chiaramonti Niobid[10] in the Vatican (fig. 537); the lifelike effect on the Parthenon "Fate"[11] (fig. 539), where with all the amazing variety there is a steady downward trend, and the ribbonlike folds of the Barberini "Suppliant"[12]

6. Amelung, *Die Skulpturen des vaticanischen Museums, 1*, no. 5; Helbig-Speier, *Führer*[4], I, no. 407. The same applies to the replicas found in the Villa Adriana; cf. Aurigemma, *Villa Adrianna*, figs. 95, 98, 104; Helbig-Speier, op. cit., III, no. 800.

7. Furtwängler, *Beschreibung der Skulpturen in der Glyptothek*, no. 264.

8. It must be remembered, however, that some of the folds are restored.

9. Amelung, *Die Skulpturen des Vatikanischen Museums*, II, p. 270, no. 94, pl. 7; Helbig-Speier, *Führer*[4], I, no. 227. 10. Amelung, op. cit., I, no. 176, pl. 44; Helbig-Speier, *Führer*[4], I, no. 598.

11. Smith, *Sculptures of the Parthenon*, pl. 5.

12. Helbig, *Führer*[3], II, no. 1820. For a recent interesting suggestion that the figure represents Iphigeneia cf. Mingazzini, in *Antike Kunst*, XI, 1968, 53 ff.

(fig. 540) now in the Louvre, which seem to be applied on the surface; the convincing and delicate treatment of the thin chiton with its multitudinous little folds showing beneath the thick mantle of the kore on the Eleusis relief in Athens[13] (fig. 520) and the more mechanical interpretation of this same effect on two Roman reliefs in the Metropolitan Museum—one a direct copy, the other an adaptation[14] (fig. 549).

In the body and the head there is the same difference. We need only pass from the Praxiteles Hermes[15] (fig. 711) to such good Roman copies of fourth-century statues as the Lansdowne Herakles[16] (fig. 754) with its hard grooves and ridges to realize the different sensitivity of the two sculptors; or from the Greek head from the southern slope of the Akropolis[17] (fig. 547) to a copy in Berlin[18] (fig. 548) to see how the melting eyes, the variegated hair, the sensitive lips have hardened. The softness of outline that constitutes the chief charm of the Greek original has disappeared.

But that the distinction between a Greek original and a Roman copy is not always obvious is shown by the recent suggestion that the head of "Eubouleus" (fig. 551)—which has for many years been considered to be Greek fourth-century work—is a Roman copy, like the other replicas of this type (cf. fig. 550).[18a]

We now know that the reliefs in Madrid[19] (fig. 554), New York[20] (fig. 683), and elsewhere, with representations of maenads, formerly thought to be adaptations of Greek works, are really direct copies of late fifth-century originals; for two of the reliefs, in Madrid and New York, are exactly alike in composition and size (see p. 186). Lovely and charming though these figures are, when we compare them with their predecessors on fifth-century vases (figs. 301 and 552) the difference becomes immediately apparent. The true zest for life so noticeable in their predecessors has somehow passed from them. Compared with the earlier figures they show all the difference between real ecstasy and its reflection. The frenzy of the Roman maenads seems mere make-believe. It is, in fact, the difference between an epoch of direct inspiration and one of imitation.

In addition to these mechanical copies we have adaptations of earlier works. For instance, the late fifth-century maenads that have survived in direct copies also occur on the marble vases, altars, and candelabra so popular in Roman times. They are there reduced in scale and shown in different groupings, with slight variations in the attitudes, gestures, and attributes, to adapt them to their new milieu. On a krater in New York[21] (fig. 553), for instance, are a number of figures, including maenads and

ADAPTATIONS
OF GREEK
WORKS

13. National Museum, no. 126. Papaspiridi, *Guide*, p. 45, and S. Karouzou, *Cat.*, p. 58.

14. *M.M.A. Cat. of Greek Sculptures*, nos. 34, 35.

15. It is in fact this sensitiveness in the modeling which should indicate that the statue must be a Greek original, not a Roman copy.

16. Now in the J. Paul Getty Museum, California; cf. S. Howard, *The Lansdowne Herakles*, 1966.

17. National Museum, Athens, no. 182. Papaspiridi, *Guide*, p. 51, and S. Karouzou, *Catalogue*, pp. 165 f.

18. Berlin Museum, *Beschreibung der antiken Skulpturen*, no. 610.

18a. Cf. on this question p. 203 and the references there cited.

19. Ricard, *Marbres du Musée de Prado*, nos. 178 ff.; cf. Rizzo, *Thiasos*.

20. *M.M.A. Cat. of Greek Sculptures*, no. 58. 21. Ibid., no. 60.

nymphs, which are known from other reliefs.[22] In these transformations some of the freshness of the original creations is of course lost. How charmingly natural are the folds in the Gjölbaschi dancer[23] (fig. 555), daintily holding up the edge of her garment, and how artificial, by comparison, the similar treatment on the Roman relief in the Vatican[24] (fig. 556) with its stiffly converging lines.

ECLECTIC WORKS

Sometimes figures in the round belonging to different periods are combined in one group. For instance, the statue of a youth by Stephanos[25] (fig. 857), the pupil of Pasiteles, is clearly derived from a work of the early classical epoch of the second quarter of the fifth century. The same youth appears in a group in Naples[26] with a woman of late fifth-century style, and in another group in the Louvre[27] with a youth also in a later style (cf. p. 245).

A style that became very popular in Roman times is the so-called archaistic, in imitation of the Greek archaic of the sixth century, with an inevitable admixture, however, of later elements.[28] A statue of Artemis of which there are several copies (cf. figs. 557,[29] 558,[30] 559[31]) is a characteristic example. The drapery with its zigzag folds and wavy lines is in the sixth-century manner (though the treatment does not show the lifelike variety or the subtle curves of genuine Greek work); the head is in the developed style, with the eye modeled in various planes and the forms rounded instead of angular. Similar discrepancies between the rendering of the face and the drapery are evident in such works as the "Borghese Altar"[32] and the figures on a candelabrum in Rome[33] (fig. 560). Sometimes the freshness of Greek archaic art is reproduced with more sensitive understanding, as in the archaistic bronze statuette in the British Museum[34] (fig. 562), where the folds are less stiff and mechanical; it is only when we compare it with a genuine archaic Greek work like the bronze statuette in the British Museum[35] (fig. 563) that we become conscious of such deficiencies as the multitude of parallel grooves in the folds hanging from the arm, the monotonous regularity of the zigzag lines, and the lack of feeling for the thinness of the chiton sleeve where it emerges from the himation. It is interesting to compare the London statuette with a similar one in the Bibliothèque Nationale[36] (fig. 561). The latter shows the same conception, but is inferior in workmanship.

22. Cf. Hauser, *Die neuattischen Reliefs,* passim. 23. Benndorf, *Das Heroön von Gjölbaschi-Trysa,* pl. xx.
24. Amelung, *Die Skulpturen des vaticanischen Museums,* I, no. 644.
25. In the Albani Collection; cf. Helbig, *Führer*³, II, no. 1846; Helbig-Speier, *Führer*⁴, IV (forthcoming).
26. Cf. Ruesch, *Guida,* no. 110. 27. Cf. Brunn-Bruckmann, *Denkmäler,* pl. 307.
28. Many of these archaistic works have now been recognized as copies of earlier creations; cf. the article by Becatti, in *Critica d'Arte,* 1941, pp. 32 ff. Direct copies of archaic works are comparatively rare. On these see now J. Dörig, in *Antike Kunst,* XIII, 1969, pp. 41 ff. 29. Ruesch, *Guida,* p. 31, no. 106, fig. 8.
30. Milani, *Il Museo archeologico di Firenze,* pl. CXLV, p. 261.
31. Dütschke, *Antike Bildwerke in Oberitalien,* v, p. 122, no. 309.
32. Froehner, *Notice de la sculpture antique du Louvre,* no. 1.
33. I owe the photograph to the kindness of Mr. Pietrangeli.
34. Walters, *Select Bronzes,* pl. II. 35. Walters, *Cat. of Bronzes,* no. 548.
36. Babelon and Blanchet, *Catalogue,* no. 265.

Modern Forgeries[37]

IN judging between ancient works and modern forgeries[38] we have to deal with an entirely different problem. However different the Greeks were from the Romans, they both had the horizon of the classical world. But so diverse is the Greek spirit from our own that it is rare that a modern mind can catch it sufficiently to reproduce it in a work of art. To distinguish therefore between Greek works and modern reproductions our best method is to be thoroughly familiar with Greek art, to become steeped in its conceptions, to appreciate the style of its modeling, to be acquainted with the paraphernalia it employs. And then our eyes will quickly detect the almost invariable inconsistencies in modern forgeries.

Let us take a few examples: A common device of the forger is to copy an extant statue or design, varying it a little in the process. For even he, or rather he of all people, realizes how hard it is for a modern mind to create an ancient work; so he prefers to have a starting point. Figure 565 is a head bought in Italy by an American collector and given to the Metropolitan Museum for purposes of study. The first things that strike us in it are the apparent correctness of the type and the flabbiness of the modeling. It is clearly in the style of the Aiginetan marbles. In fact, a closer examination shows that it is a copy of the fallen warrior from the east pediment (cf. fig. 564), broken and therefore seen upright, and so not too obviously reminiscent of its model. The heads are almost line for line the same, except that in the copy all the sharpnesses of the original are gone; the edge round the nosepiece is not there, the precise ridges for the beard have become blunt, the little sharp ridges on the eyelids and lips have disappeared, the teeth no longer show between the lips. And then there is another variation—one of those blunders that a forger is so apt to commit because he is working in an unfamiliar field, and that an archaeologist can easily detect by his familiarity with the ancient world; one of those clues, in fact, which are independent of style, which cannot, therefore, be called a subjective impression, and so form a tangible, incontrovertible argument. In the Aigina warrior the cheekpiece of the helmet is turned down, a large part of it has been broken away, but the hinge and a small portion of it are still there. The forger copied it very much as he found it, but in his general blurring process he made the hinge and the fracture rather indistinct; and then since he did not understand what was meant he added another (upturned) cheekpiece on top!

The bronze head shown in figures 568 and 569 exists in several replicas,[39] which make their appearance from time to time in the antique market. It evidently repro-

37. In the following discussion of forgeries I am presenting merely my own opinions as to the authenticity of certain "antiquities" and "in my opinion" must be understood throughout in any definite statements made.

38. Very little has been written on this absorbing but precarious subject. For an excellent analysis cf. Furtwängler, *Neuere Fälschungen von Antiken* (1899).

39. Cf. Furtwängler, *Neuere Fälschungen*, pp. 24 f., figs. 19, 20; Arndt, *Einzelaufnahmen*, no. 1059, and others there mentioned. Still another replica, obtained by a private collector in Germany, came to New York in 1910.

duces the familiar "Sappho" type of the fifth century. But when we compare it with the Greek originals of that period, or with Roman replicas of such originals, we are at once struck with its flabby appearance. The mouth appears weak and indistinct, the eyes too staring, the rendering of the whole face lacks firmness. The Greeks and the Romans—at least from the fifth century onward—had a thorough understanding of the human body. In their modeling we are made to feel not only the surface but the substance of bony structure beneath. This head has only a surface, not a core of muscles and bones. And inevitably we find the usual misconceptions. The forger apparently had in his mind a female head with her hair tied up with a long ribbon, like the "Sappho" in the Ny Carlsberg Glyptotek[40] (figs. 566, 567). In trying to reproduce this he made a fatal variation—the ribbon becomes a Renaissance cap at the back, and on the front portion appears a Renaissance ornament.

The same feeble, indistinct modeling condemns the head illustrated in figure 571, clearly copied from the fine original in Athens[41] (fig. 570). The sculptor could not reproduce the precision of archaic Greek art; he has succeeded only in obtaining a superficial resemblance. How greatly we appreciate the sense of structure, the decorative curves in the contours of the skull and of each feature in the Greek head, after looking at this modern imitation. And again there is a helpful giveaway. In the Greek head the locks which fall over the shoulders are all long and of about the same length. The forger has represented some of his locks rightly as if continuing beyond the break, but one he has modeled as a short complete curl.

Perhaps the most difficult forgeries to detect are those in the archaistic style; for they are imitations of imitations. A helpful comparison is that between the archaistic head of Athena of the Roman period in the Metropolitan Museum[42] (fig. 572) and a modern copy of it (fig. 573). It will make us appreciate the firm modeling of the Roman head, the fine contours of its eyelids and lips, the precision of the grooves of the hair and of the ornamental fillet, all features which we miss in the imitation. Moreover, a modern expression of alertness has crept into the latter which stamps it as not ancient. Incidentally the hair has been cut short and does not continue to the break as it does in the New York original.

The head illustrated in figure 575 is typical of a large output of forgeries. It is clearly copied from the Aphrodite of Melos (fig. 574); but the face has a modern, personal note totally alien to its serene prototype. It illustrates in a somewhat obvious manner how difficult it is for a man with a twentieth-century outlook to imitate works produced more than two thousand years ago. And this difference will assert itself even when an exact copy is attempted—by means of a plaster cast and the pointing process. Figure 576 is an ancient marble head in the Metropolitan Museum;[43] figure 577 is a plaster cast of this head evidently used to produce the modern marble imitation (with similar breaks!) shown in figure 578. In spite of the mechanical process involved,

40. Arndt, *La Glyptothèque Ny Carlsberg*, pl. 43. 41. National Museum, no. 17; S. Karouzou, *Cat.*, p. 27.
42. *M.M.A. Bulletin*, 1913, pp. 51–52. 43. *M.M.A. Cat. of Greek Sculptures*, no. 160.

which should ensure accuracy, the differences are palpable—e.g. in the modeling of the eyelids, of the ear, and especially of the hair. The hair in the original seems actually to grow out of the head, while in the copy it appears to be stuck on the surface. The living quality of the original work has not been reproduced in the modern copy.

Greek drapery is not easy to imitate. The Greek sculptor had such a strong feeling for structure that his drapery is always conceived as a logical whole; we can invariably see whence each fold comes and where it is going. This was of course difficult to attain by someone portraying a garment unfamiliar because not in contemporary use. A good instance is the would-be archaic or archaistic statue shown in figure 582.[44] The rendering of the drapery here shows several important misunderstandings. The scheme on the upper part of the body is correct, that is, the himation with its overfold passes from the right shoulder beneath the left arm; but in the lower portion the artist has continued this Ionic himation (which in reality is short) and has represented it as long, with the chiton, however, reappearing at the bottom.[45] We may contrast the archaic and archaistic renderings, figs. 285–87, 561, 562. How stiff, too, are the curving ridges in the lower part of the drapery, where it is pulled sideways by the left hand, compared with the sensitive archaic renderings (cf. figs. 285, 287, 288).

The forgeries of terracotta figurines are a good field for the study of drapery. Figure 584 is a statuette in the Metropolitan Museum, exhibited in a case of forgeries in the Study Collection, for comparison with the genuine Greek examples. The girl wears a long chiton and a himation loosely draped over the lower part of her body. The chiton appears to be girt below the breasts; but we know this only because there is a horizontal dividing line. There is no continuity between the folds of the upper part of the garment and the lower, no indication of the effect created by the drawing in of a belt, no interest in pursuing a fold from its beginning to its end. Contrast this with the treatment on a Greek statuette (fig. 583). How clearly the upper portion is conceived as part and parcel of the lower, how well the effect of the belt on the material is studied! We can see what happens to each fold above and below the depression, for there is everywhere a distinct feeling for continuity and structure. And besides this stylistic difference there is here too a tangible clue; for the forger has made an amusing mistake in the rendering of the garment. Below the mantle the chiton ·becomes again visible, as it so often does in the Greek statuettes. But so little did the artist understand what he was representing that he showed it with two edges, as if the woman wore two chitons, one a little shorter than the other.

Of course the mistakes are not always so obvious. Figure 586 shows a woman wearing a chiton and wrapped in her himation. There are no palpable misunderstandings, except the way the chiton is rendered at the bottom. Naturally where it falls over the feet the vertical folds are affected, and this is correctly indicated; but this oblique direction is retained also in the intervening portions where there is no reason for any

44. Richter, *M.M.A. Handbook of the Classical Collection*, 1930, p. 343. By Dossena.
45. On the structure of the short Ionic himation cf. now my *Korai*, pp. 6 ff., and the references there cited.

interference with the vertical hang—again a lack of structural sense on the part of the maker. Even more noticeable, however, is the hesitating way in which the folds of the himation are represented. There is not the firm swing in the required directions which we find invariably in similar Greek renderings, e.g. in figure 585. We see that a groping hand is at work, feeling its way in an unfamiliar field.

The most difficult quality of all for the modern forger to imitate is the Greek simplicity and aloofness; his figures are almost invariably affected and self-conscious. Extreme examples are the statuettes in New York of a young lady sitting on a rock, looking at herself in a mirror, her head a little on one side (fig. 587), and of a girl stretched out on the floor, her arm resting on a footstool, in quiet contemplation (fig. 589). The Greek figures do not assume such recherché, theatrical, self-conscious postures. If they contemplate, they make no outward show of it (cf. fig. 216). If they look into their mirrors, they do so quietly and unaffectedly (cf. fig. 588[46]). If they hold anything, they grasp it in the natural way. It is this poise, which constitutes the charm of the Greek figures, that is so difficult to imitate, and so the lack of it becomes the distinguishing element in a modern forgery.

The comparison of a modern gem engraving of Amymone[47] (fig. 591) with its ancient prototype[48] (fig. 590) brings out the same difference in conception. According to the legend Amymone was sent by her father to fetch water, and was helped in her quest by Poseidon. In the ancient representation she is stooping to fill her jug with water in a convincing, lifelike manner; in the modern rendering she sits upright in an uncomfortable position holding the jug as if it were a symbol like the trident.

The imitation of Greek grave reliefs is particularly difficult. The detached serenity of the Greek figures is so far removed from modern conceptions that it is almost impossible to reproduce. A relief from one of the storerooms of the Berlin Museum[49] (fig. 592) will bear this out. How different are the expressions of the man and woman from those of their prototypes! The scene has become a social incident; there is no trace of the former pathos and aloofness. And the finial on the top of the stele appears stilted, the leaves have not the living quality of growth so conspicuous in Greek akroteria (cf. fig. 463).

In another grave relief in Berlin (fig. 593), of fifth-century type, the modern sculptor has succeeded a little better. He has at least avoided sentimentality. But instead of the grace of fifth-century work the figures have a stiff, wooden quality. The filling of the space—with a central figure and a little boy placed on each side—immediately strikes us as unsatisfactory when we compare it with the harmonious compositions of even cursorily worked Greek stelai. And then there are other giveaways. The chair, a would-be *klismos*, is misunderstood and has no back.[50] The farther arm and hand

46. Caskey, *Cat. of Greek and Roman Sculpture in the Museum of Fine Arts*, Boston, no. 23.
47. *M.M.A. Catalogue of Engraved Gems* (1920), no. 419. 48. Furtwängler, *Antike Gemmen*, pl. xxx, 29.
49. I am greatly indebted to the authorities of the Berlin Museum for letting me have photographs of the two pieces illustrated in figs. 553, 554, both of which have long been recognized as forgeries by them.
50. On the *klismos* cf. my *Furniture²*, pp. 33 ff.

of the woman are in too high relief. A sculptor of the second half of the fifth century, with his knowledge of the rendering of planes in relief, would have made these parts less prominent so that they should appear to be in the far distance.

Sometimes a Greek work that is known only in Roman copies has been reproduced on a small scale, either entire or in part; for instance, the Ares Borghese (fig. 581) and the Mattei Amazon (fig. 580). These forgeries are not always obvious, for the composition is directly copied from an original work,[51] and therefore convincing; and the fact that they are copies of known originals is not in itself a source of suspicion, for reduced Roman replicas of famous Greek originals of course exist. In such cases the physical condition of the marble is the most helpful criterion (see below).

Occasionally there have come into the market important forgeries of a rather different caliber from those described—not copies or adaptations, but actual creations in the ancient style. The best known examples are the striding Athena, the youth carrying a girl, and the little maiden, all by the Italian sculptor Alceo Dossena[52] (figs. 581, 594–96). Though they are on the whole remarkably successful, their modern origin can be detected by the same criteria as those applied to the other forgeries. Analysis inevitably shows occasional inconsistencies in the rendering and a different outlook in the conception. The simplicity and vitality of the Greek works are apparently too difficult for us moderns to attain; and even when lively action is attempted, the effect of the whole lacks vitality. And here too we have one of those concrete clues which so often give away a forgery. The grooves in the hair and hands of Dossena's youth were evidently made by the running drill, which as we know (cf. p. 122) was not used by Greek sculptors until the second half of the fifth century, whereas the style of the group is late archaic.[53]

Besides the test of style there are the physical and chemical conditions of the material to help us in our examination. Ancient marbles, for instance, having been exposed to the air and the soil for long periods of time, generally show a disintegration of the surface due to attack by acids in the air and soil, an opening of the spaces between the crystals, and a certain amount of penetration of rust and other stains, whereas in a modern marble such discolorations are merely superficial. In other words, in an ancient marble we generally find a gradual transition in color or crystalline structure from the outermost layers to those underneath, due to an interaction of the soil matter and the marble (forming, for instance, calcium silicate); whereas in a modern marble a perfectly fresh layer can be exposed immediately below the surface. This becomes apparent by an examination under ultraviolet rays. When a fresh break is examined in an ancient marble piece a white contour shows; in a modern one

51. Compare e.g. our fig. 541 with our fig. 620, and our fig. 542 with fig. 19 in Charbonneaux, *La Sculpture grecque classique.*

52. Cf. Studniczka's article, "Neue archaische Marmorskulpturen, Falsches und Echtes," in *J.d.I.*, XLIII (1928), pp. 140 ff.; Richter, *M.M.A. Bulletin*, 1929, pp. 3 ff.; Ashmole, in *J.H.S.*, L, 1930, pp. 99 ff.

53. Cf. the excellent analysis by Ashmole, op. cit.

the whole surface appears violet.[54] Furthermore, the soil matter on the surface of a forgery is generally loosely adherent, whereas the incrustation on an ancient marble can often be soaked in water for weeks without being affected. Ancient root marks have generally become strongly embedded in the marble; those of more recent formation have not penetrated beneath the surface. In an ancient marble the "weathering" varies according to exposure to the elements, the sheltered parts, for instance, of pedimental figures being generally better preserved than the exposed ones; in a forgery, on the other hand, the "weathering" often covers the whole surface.

In bronzes similar conditions obtain to those in marbles. In ancient bronzes there is an opening up of the crystals and the penetration of the products of corrosion (malachite or cuprite) into the intervening spaces, whereas in modern bronzes there is no such penetration below the surface. An ancient bronze shows a lack of uniformity in the corrosion of the surface; certain areas are much more affected than others. A modern forgery is apt to have a uniform surface throughout. Furthermore, the color of ancient bronze is generally more reddish than that of modern imitations, which usually contain more of the cheaper zinc.[55]

But also in these physical analyses there are pitfalls; at least chemists and mineralogists have been known to pronounce as genuine works which later have been proved modern; and vice versa. And we must always remember that a forger can select an ancient piece of marble and rework it. Nevertheless the endorsement of a stylistic judgment by physical criteria is certainly helpful in doubtful cases.

If it is important to be able to detect a modern forgery, it is at least as important to recognize a Greek original. It requires the same faculty—an appreciation of the essential qualities of a Greek work of art. Since the Greeks have a tendency to confine their representations to a limited number of established types, the natural reaction in archaeological circles when something uncommon appears is to suspect it. It is unusual; therefore it cannot be right. But that is of course not a safe criterion. We cannot pretend to know all that was usual among the Greeks, for their output was much greater than what remains of it today; so that we must not expect to find an exact parallel for everything. A much saner method is to draw the dividing line between what is Greek in spirit and in general practice, and what is not. But the following instances show that this is not always easy.

One of the most interesting archaeological controversies of our time has been waged round the Boston counterpart of the Ludovisi throne[56] (figs. 516–18). Its authenticity has been suspected by one of the best-known English archaeologists, one of the best-known French archaeologists, and one of the best-known German archaeologists, the first and the last attacking it in print. The general trend of the protests was that the expression of emotion in the faces of the figures had no counterpart in contemporary

54. I learned much by being able to examine sculptures under the violet-ray lamp at the Metropolitan Museum together with James Rorimer, a pioneer in that field.

55. I am indebted to Dr. Colin G. Fink, of the department of electrochemistry at Columbia University, for help in the preparation of these statements. 56. Caskey, *Catalogue*, no. 17.

works, the conelike shape of the weights on the balance had no parallel, the band on the hair of the old woman was unusual, the position of the feet strange, etc., etc. In many cases, such as the expression of emotion, we can quote similar instances enough; with others it seems negligible whether we have parallels or not. In the things that stand out—the well-knit human bodies, the structural drapery, the harmony of the composition, the treatment of the relief—the figures seem to be essentially Greek. And there are helpful physical arguments in favor of authenticity. When the piece first came to Edward Warren at Lewes the surface was covered with a hard incrustation which took weeks to remove with the help of a razor.[57] But this laborious work was confined to the three sculptured faces; and when the under surface was recently examined it was found to retain strongly adhering incrustation and root marks.[58]

The early archaic kouros in New York[59] (fig. 20) is another important Greek work the authenticity of which was questioned when it was first published. The arguments advanced were that it deviated from the known archaic works in that the body leaned too far forward, that the head was too large, the neck too long, the forearms were turned forward in an unnatural manner, that moreover the scheme of grooves and ridges suggesting the anatomical construction of the lower legs was peculiar and that the neckband was not tied. A close study of these renderings showed that they deviated, it was true, from those current in late archaic sculpture, but that they could all be paralleled on—and were indeed typical of—early archaic figures. Especially convincing was the discovery of several fragments of the lower legs belonging to the Sounion group of kouroi[60] which had the same markings as the New York kouros. As these fragments were not known when the New York kouros was purchased they could not have been utilized by a forger.

The Standing Maiden in Berlin[61] (figs. 279–81) also passed through a period of suspicion. Her farouche character seemed strange when compared with the gracious charm of the late archaic maidens of the Akropolis (see figs. 284–86). Now it is realized that the apparently unusual features—the compactness of the figure, the broad forearms, the posture of the left arm, the rendering of the quasi-vertical folds, the form of the necklace, the manner in which the hair is worn in a bag—are all typical of works datable in the second quarter of the sixth century (cf. the Akropolis maiden 593, the Calf Bearer [fig. 5], the relief of the Diskophoros,[62] and some of the figures on the François vase).

57. So Mr. Gearing, who performed the work, reported (to me and others).

58. Ashmole, *Bull. of the Boston Museum*, LXIII (1965), 593; Jucker, *Museum Helveticum*, XXII, 2 (1965), pp. 117 ff., XXIV (1967), pp. 116 ff.; Ashmole and W. J. Young, in *Bulletin of the Boston Museum*, LXVI (1969), pp. 124 ff.; cf. also Nash, in *Röm. Mitt.*, LXVIII (1959), pp. 104 ff. (on what is known of the finding place); Becatti, in *Enc. Arte Antica*, VII, 1966, pp. 1018 ff., s.v. "Trono di Boston" (with an extensive bibliography of views pro and con the authenticity).

59. Richter, *Kouroi*³, no. 1, figs. 25–32; *M.M.A. Cat. of Greek Sculptures*, no. 1.

60. Richter, *Kouroi*³, figs. 42–46.

61. Blümel, *Die archaich griechischen Skulpturen* (1963), no. 1; Richter, *Korai*, no. 42.

62. Payne and Young, *Archaic Marble Sculpture from the Acropolis*, pl. 12.

The Seated Maiden in Berlin[63] seemed almost too good to be true. Soon, however, its finding place—near Taranto—was definitely established,[64] and the doubts had to subside.

The large bronze statuette of a horse in New York[65] (figs. 369, 370) has recently aroused an interesting controversy. After more than forty years of unquestioned acceptance as a distinguished Greek work of the second quarter of the fifth century B.C., its authenticity was questioned on technical grounds.[66] Presently there came an answer to these strictures by a well-known sculptor-archaeologist with the claim that on these same technical grounds the horse must be ancient.[67] The controversy still continues.

When experts disagree and leading critics can be found at variance regarding the authenticity of certain works, how can such questions be finally settled? Sometimes we are so fortunate as to be able to discover the actual forgers. But that is rare. In many cases the question remains open, and in these we can only say with Gaugin: "Criticism passes, good work remains."[68]

63. Blümel, op. cit., no. 21.

64. Zancani Montuoro, *La Persefone di Taranto*, pp. 7 ff.; published by the Società Magna Grecia, 1933.

65. First published by me in the *M.M.A. Bull.*, 1923, pp. 89 ff.

66. J. V. Noble, in *New York Times*, Dec. 7, 1967, p. 1; *M.M.A. Bull.*, Feb., 1968, pp. 253 ff.

67. Blümel, in *Die Welt* (1968), pp. 568 f.; S. Knox, in *New York Times* (Aug. 10, 1968), p. 25; Blümel, in *Arch. Anz.*, 1969, pp. 208 ff.

68. Quoted by E. Abbot on the title page of her book, *The Great Painters*.

PART II

GREEK SCULPTORS

CHAPTER 1

ARCHAIC PERIOD

We have tried in the foregoing chapters to study Greek sculpture purely as an artistic manifestation. Our endeavor has been to appreciate its manifold beauty and to follow the story of its achievements by a direct consideration of the products themselves. So as not to encumber our path we have given little attention to the sculptors who produced these works. Nevertheless, a study of Greek sculpture is not complete without a realization of the personalities who helped to determine its development. To recapture in our imagination the individualities of these great men, to gauge the separate contribution of each to the history of Greek sculpture is an inspiring but also a difficult task. For to arrive at a correct appreciation we must sift carefully the evidence at hand—literary, epigraphical, and stylistic—which has become somewhat confused by many conflicting theories. In our analysis of these artists we shall endeavor to admit only such data as appear unassailable, citing where possible the original sources of our knowledge. In this way only can we build our reconstructions on a solid foundation.

We know little about the individual sculptors of the early and middle archaic periods.[1] Ancient writers[2] give some general information about the beginnings of Greek sculpture, generally in connection with the legendary figure of **Daidalos.** They also mention a few sculptors by name and even assign specific works to them—for instance, **Smilis of Aegina** who is said to have made the wooden cult statue of Hera in Samos; **Rhoikos** and **Theodoros of Samos** (see p. 115); **Melas of Chios** and his descendants **Mikkiades** and **Archermos; Dipoinos** and **Skyllis of Crete** and their pupils; and **Cheirisophos,** also of Crete(?). Rarely, however, has it been possible to associate extant works with these names. A few names are known from signatures; but again only in a few instances can these signatures be connected with specific works. The inscription on the base of Kleobis and Biton (cf. fig. 19) informs us that the Argive **[Poly]medes** made them.[3] One of the seated statues from Branchidai in the British Museum (B 273) is inscribed "**Eudemos** made it."[4] **Geneleos** signed a group of statues erected in the Heraion of Samos[5] (cf. figs. 117, 282). The name **Phaidimos** is now known from three signatures—one on the base of a kore, of which, however, only

1. On these early artists cf. Lippold, *Handbuch,* pp. 6 ff., and the references there cited; also the pertinent articles in *Enc. Arte Antica,* i–vii (1958–66), with references.

2. Cf. Overbeck, *Schriftquellen,* nos. 74 ff., 314 ff.

3. Poulsen, *Delphi,* p. 95; von Premerstein, *Oest. Jahresh.,* xiii, 1910, pp. 41 ff.; Tod, *Greek Historical Inscriptions,* pp. 4 f.; Richter, *Kouroi³,* nos. 12A, B.

4. Pryce, *Cat.,* i, 1, B 273. 5. Buschor, *Altsamische Standbilder,* ii, pp. 26 ff., v, pp. 84 ff.

part of a sandaled foot is preserved; another on a base that may perhaps have belonged to the stele of a youth; and a third in which he is called σοφός, skillful, but which was found without any sculpture.[6] The names **Mikkiades** and **Archermos,** mentioned by Pliny,[7] appear on a base that may have belonged to the Nike of Delos[8] (fig. 82). And so on. Scanty though these records of individual Greek sculptors are, we can nevertheless appreciate what they collectively accomplished. They were the leaders in that phenomenal transition from the primitive, geometrized renderings of the eighth century to the archaic kouroi (cf. figs. 16 ff.). Diodorus (iv. 76) describes this change in picturesque language, ascribing the whole movement to Daidalos: "And in the sculptor's art he so far excelled all other men that in after times the fable was told of him that the statues which he made were like human beings; for they saw and walked, and, in a word, exercised every bodily function, so that his handiwork seemed to be a living being. And being the first to give them open eyes, and parted legs, and outstretched arms, he justly won the admiration of men: for before his time artists made statues with closed eyes and hands hanging down and cleaving to their sides." It is evident that the rapidity of this development was helped by the inspiration derived from Egypt (cf. p. 30). Later, when Greek sculpture had become more sophisticated, these early efforts were naturally not appreciated. According to Plato,[9] for instance, sculptors of his time held "that Daidalos, were he now to be born and to make statues such as those by which he won his fame, would be laughed to scorn." And yet it was admitted that "a kind of divinity rested upon his words."[10] We too when we view these early creations have the same mingled impression of primitiveness combined with grandeur.

In the later archaic period our knowledge becomes somewhat enlarged. We know now by name a number of sculptors who can be connected with specific works. Thus **Endoios** is probably the sculptor of the seated Athena in the Akropolis Museum[11] (fig. 69), for it was found at the northern slope of the Akropolis, that is, near the Erechtheion where Pausanias[12] saw a statue of Athena by Endoios; and Endoios can be dated in the period of the Akropolis statue by several inscriptions.[13] **Antenor** made the early group of the Tyrannicides[14] (cf. p. 155), and he signed his name on a base on which perhaps stood one of the most imposing of the Maidens in Athens[15] (fig. 287). **Ageladas of Argos,** the reputed teacher of Pheidias, of Myron, and of

6. Pezopoulos, in *Eph. arch.*, 1937, p. 538; Karouzos, *Epitymbion Chr. Tsounta*, pp. 542 f., 572; M. Guarducci, in Richter, *Archaic Gravestones of Attica* (1956), pp. 156 ff., nos. 34–36.

7. *N.H.* xxxv. 11. 8. Raubitschek, *Dedications*, p. 485.

9. *Hipp. maj.*, 282A. 10. Cf. Pausanias ii. 4. 5.

11. Dickins, *Catalogue*, no. 625. 12. i. 26. 4.

13. Cf. Loewy, *Inschriften*, no. 8, and one of the statue bases found in Athens; cf. *Arch. Anz.*, 1922, p. 59. On Endoios cf. Raubitschek, in *A.J.A.*, xlvi (1942), pp. 245 ff., and *Dedications*, pp. 491 ff.

14. Pausanias i. 8. 5.

15. Akropolis Museum, no. 681. Raubitschek, in *A.J.A.*, xliv (1940), p. 58, n. 2, and *Dedications*, pp. 481 ff.; Langlotz, in Schrader, *Marmorbildwerke*, no. 38; Lippold, *Handbuch*, pp. 80 f.; Richter, *Korai*, no. 110.

Polykleitos,[16] made a Zeus for the Messenians[17] the general composition of which appears to be reproduced on coins of Messene[18] (fig. 599). **Aristokles** has signed the famous stele of Aristion[19] (fig. 460) and **Alxenor of Naxos** one from Boeotia (fig. 461).[20] And so on.

16. Suidas, *Geladas;* Tzetzes, *Chil.,* VIII, 325; Schol. Aristophanes, *Frogs,* 504; Pliny, *N.H.* XXXIV, 55 and 57. On Ageladas cf. Lippold, *Handbuch,* pp. 88 ff., and the references there cited; Orlandini, in *Enc. Arte Antica,* III, 1960, pp. 1085 f., s.v. Hageladas, and the references there cited.

17. Pausanias IV. 33. 2; Lacroix, *Reproductions de statues sur les monnaies,* p. 228, pl. XIX, 3.

18. Imhoof-Blumer and Gardner, *Numismatic Commentary,* pl. P, iv and v. The date of Ageladas has given rise to much discussion.

19. Athens, National Museum, no. 29. Loewy, *Inschriften,* no. 10; Papaspiridi, *Guide,* p. 29, and S. Karouzou, *Cat.,* p. 17; Guarducci, op. cit., p. 170, no. 67.

20. National Museum, Athens, no. 39. Papaspiridi, *Guide,* p. 31, and S. Karouzou, *Cat.,* p. 36; Loewy, *Inschriften,* no. 7.

CHAPTER 2

TRANSITIONAL OR EARLY CLASSICAL PERIOD

When we reach the transitional period of 480–450 (now mostly called early classical) a new era dawns. Greek sculpture passes from archaism to freedom and experimentation, and naturally such an epoch produced and was probably largely conditioned by great leaders. Our study of Greek sculptors as individual artistic personalities properly begins now, for only from now on have we the material on which to base it. The outstanding names of this time are Kritios, with his collaborator Nesiotes, Pythagoras, Kalamis, and Myron.

Kritios and Nesiotes

ORIGIN KRITIOS[1] was probably an Athenian, for he is called Attic by Pausanias[2] and his recorded works were all produced in Athens. He signed his name with that of Nesiotes
DATE on six statue bases found on the Akropolis datable about 460 or earlier.[3] One of these inscriptions gives the name of the dedicator Epicharinos and therefore probably formed part of the work seen by Pausanias[4] and described in the words: "Among the portrait statues which stand next to the horse is that of Epicharinos, who practised the race in armor." But Kritios owes his fame, with posterity at least, to his statues of the Tyrannicides Harmodios and Aristogeiton with which he was commissioned after the original statues by Antenor had been carried off by Xerxes. The story is succinctly told by Pausanias:[5] "Not far off (in the marketplace) are the statues of Harmodios and Aristogeiton, who slew Hipparchos. The one pair are the work of Kritios while the older ones were made by Antenor. When Xerxes captured Athens after the Athenians had deserted the city, he carried them away as spoils, and Antiochos afterward restored them to the Athenians." (According to Arrian[6] and Pliny[7] it was Alexander the Great who restored them to Athens, and according to Valerius Maximus[8] it was Seleukos.) The statues are referred to also by a number of other writers. They evidently enjoyed a great reputation. We know moreover the exact date in which they were set up, viz., in the archonship of Adeimantos, i.e. Olympiad 75,4 = 477 B.C.[9] They were probably of bronze, as were those by Antenor. Though there is no detailed description of these statues it has been possible to identify copies of them (since

1. On Kritios cf. Lippold, *Handbuch*, pp. 106 ff., and the references there cited; Raubitschek, *Dedications*, pp. 513 ff.; W. Fuchs, in *Enc. Arte Antica*, IV, 1961, pp. 410 ff., s.v. Kritios and Nesiotes, and the references there cited. 2. VI. 3. 5.

3. Loewy, *Inschriften*, nos. 38–40; Raubitschek, *Dedications*, nos. 120–23, 160, 161, pp. 513 ff.

4. I. 23. 9. 5. I. 8. 5.

6. *Anabasis* III. 16. 7–8. 7. *N.H.* XXXIV. 70.

8. II. 10 ext. 1. 9. *Marm. Par. Epoch.*, I, 1, 1, 70 ff.

groups at this period are rare and the subject is uncommon) in two advancing men which occur on a number of monuments.[10] These consist of coins, vases, and marble reliefs as well as full-sized statues (cf. figs. 602 ff.), the latter of the style of the period in question. The most complete marble copies are those in the Naples Museum[11] (figs. 609, 610). Other replicas of the head of Harmodios are in the National Museum of the Terme in Rome[12] and in the Metropolitan Museum in New York[13] (figs. 602, 603); further copies of the head of Aristogeiton are the so-called Pherekydes in Madrid,[14] and one in the Vatican[15] (fig. 612); there is a torso of Aristogeiton in the Boboli Gardens[16] and a recently discovered one, in the Museo Nuovo in Rome,[17] which fits the Vatican head (fig. 611). Furthermore one of the plaster fragments found at Baiae (in what seems to have been a sculptor's workshop[18]) was evidently taken from a head of Aristogeiton (fig. 607[19]), which, to judge by its fine workmanship, may have been the Greek original in the Athenian Agora. And of the original group there has also now been found a fragment of the inscribed base.[20]

To appreciate the composition of this remarkable work we must remember that the STYLE Naples group has been extensively restored.[21] One can, however, obtain an adequate idea of its original appearance from the copies of the group on the minor monuments, with the help of which full-sized casts have been reconstructed, reproducing the original action (figs. 610–15). Their relative positions have given rise to much discussion;[22] but it seems clear that they stood side by side (as on the Kyzikos coin), not one behind the other. The group forms an amazingly vigorous composition, introducing a number of innovations which mark an advance over older striding figures (cf. pp. 39 ff.), such as the position of the right arm in the Harmodios, with the forearm brought over the head, which imparts a new energy to the whole figure. Lucian's[23] estimate of the style of the school of Kritios and Nesiotes as "closely knit and sinewy and stiff and severe in outline" is based on the conceptions of a later age. Compared with what went before them the Tyrannicides show an astonishing progress. On the strength of this work Kritios must be classed as a leader in the new era. His greatness

10. Cf. now Brunnsåker, *The Tyrant Slayers of Kritios and Nesiotes* (1955), and the references there cited.

11. Ruesch, *Guida*, nos. 103, 104. The former alien head of Aristogeiton has now been replaced by a cast of a head of Aristogeiton found in the magazzini of the Vatican.

12. Formerly in the Villa Mattei, cf. Arndt, *Einzelaufnahmen*, no. 115.

13. Richter, in *A.J.A.*, XXXII (1928), pp. 1 ff.; *M.M.A. Cat. of Greek Sculptures*, no. 25.

14. Hübner, *Antike Bildwerke in Madrid*, p. 110, no. 176.

15. Kaschnitz-Weinberg, *Sculture del Magazzino del Museo Vaticano*, no. 1.

16. Arndt, op. cit., no. 99.

17. Bocconi, *Collezioni Capitolini*, Supplement (issued in 1948), p. 12.

18. Cf. Napoli, in *Boll. d'Arte*, XXXIX (1954), p. 10; Richter, *The Portraits of the Greeks*, 1, p. 26; *A.J.A.*, 1970 (forthcoming).

19. Here reproduced with A. de Franciscis' kind permission.

20. Shear, in *A.J.A.*, XL (1936), p. 190, and in *Hesperia*, VI (1937), p. 352; Meritt, in *Hesperia*, V (1936), pp. 355 ff. 21. Cf. Ruesch, loc. cit.

22. For various suggestions cf. Schefold, in *J.d.I.*, LII (1937), pp. 33 ff.; Buschor, *Die Tyrannenmörder*, pp. 8 ff.; Bakalakis, *Oest. Jahr.*, XXXIII, 1941, p. 26; Langlotz, in *Gymnasium, 58* (1951), 20 ff.

23. *Rhet. Praecept.*, 9.

and the appreciation in which he was held are further indicated by the fact that he was the founder of a school and had several distinguished pupils.[24]

Other works have been tentatively attributed to Kritios on the strength of their general resemblance to the Tyrannicides, especially the Youth in the Akropolis Museum[25] (fig. 34). But even the latter has not quite the same clear demarcation of the muscles or the swing of the composition which characterize both the Harmodios and the Aristogeiton. It is better to build our estimate of Kritios solely on these two well-authenticated works.

Hegesias—Hegias(?)[26]

TOGETHER with Kritios and Nesiotes, Pliny[27] mentions Hegias and Lucian[28] Hegesias (so evidently the same person). Pliny[29] cites several of his works (e.g. the Dioskouroi, boys riding racehorses, an Athena, and "king Pyrrhus"), and Quintilian[30] describes them as "harsh." According to Dio Chrysostomos,[31] he (Hegias) was the teacher of Pheidias. On the Akropolis was found an inscription[32] with his signature, datable before 480 B.C. That is all we know about him.

Pythagoras

ORIGIN PYTHAGORAS[33] was a Samian by birth, for he signs himself Πυθαγόρας Σάμιος in the inscription on the base of a portrait of Euthymos the boxer;[34] and Pliny[35] and Pausanias[36] refer to him as "of Rhegion"; so that he probably was one of the emigrants who left Samos after its fall in 496 B.C. for Zankle and thereby became subject to Anaxilas of Rhegion.[37] He is said to have been the pupil of Klearchos of Rhegion.[38]

DATE His date can be determined by the facts that he made a statue of the runner Astylos,[39] in celebration of his first victory at Olympia (488), that his statue of the boxer Euthymos was set up after the latter's third victory in 472,[40] and that there were statues by him of the wrestler Leontiskos of Messene[41] (456), of the hoplite runner

24. Pausanias VI. 3, 5; Pliny, *N.H.* XXXIV. 85; Lucian, *Rhet. Praec.*, 9; Pfuhl, in *J.d.I.*, XLI (1926), p. 48.

25. Dickins, *Catalogue*, no. 698.

26. On Hegias, Hegesias cf. Pfuhl, in *R.E.* VII, 2, cols. 2615 ff.; Lippold, *Handbuch*, p. 108, and the references there cited; Orlandini, in *Enc. Arte Antica*, III, 1961, pp. 1128 ff., s.v. "Hegias," and the references there cited.

27. *N.H.* XXXIV. 49. 28. *Rhetor. praecept.*, 9.

29. *N.H.* XXXIV. 78. 30. *Inst. orat.*, XII. 10. 7.

31. *Orat.* 55. 1., p. 282. 32. *I.G.*, II, I, 526.

33. On Pythagoras cf. Lippold, *Handbuch*, pp. 124 ff., and the references there cited; Orlandini, in *Enc. Arte Antica*, VI (1965), pp. 573 ff., s.v. "Pythagoras," and the references there cited.

34. Loewy, *Inschriften*, no. 23.

35. E.g. *N.H.* XXXIV. 59. 36. E.g. VI. 18. 1.

37. This twofold origin is probably responsible for the confusion which led Pliny (*N.H.* XXXIV. 59) and Diogenes Laertios (VIII. 46) to distinguish two sculptors, one of Samos, the other of Rhegion.

38. Pausanias III. 17. 6. 39. Pliny, *N.H.* XXXIV. 59; Pausanias VI. 13. 1.

40. Loewy, *Inschriften*, no. 23; Pausanias VI. 6. 4–6; Grenfell and Hunt, *Oxyrhynchus Papyri*, II, p. 88, col. I, lines 12, 25.

41. Pausanias VI. 4. 3; Grenfell and Hunt, op. cit., II, p. 89, col. II, line 2.

Mnaseas of Kyrene[42] (456), and of Kratisthenes of Kyrene[43] (448). So his activity appears to lie in the period during and following the Persian wars. In his work he is said to have combined a certain advance in naturalism—Pliny[44] speaks of him as "the first to represent sinews and veins and to bestow attention on the treatment of hair"— with a new sense for harmonious composition: "He is thought to have been the first to aim at rhythm and proportion ($\rho\nu\theta\mu\sigma\hat{\nu}$ $\kappa\alpha\grave{\iota}$ $\sigma\nu\mu\mu\epsilon\tau\rho\acute{\iota}\alpha\varsigma$)."[45] In other words he recognized and dealt with the two great needs and tendencies of his time; and his achievements brought him great fame and recognition, for he is listed with the foremost Greek sculptors by Pliny[46] and was judged to have surpassed even Myron with a statue of a pankratiast dedicated at Delphi.[47] The subjects of his works enumerated by ancient writers include—in addition to the usual victorious athletes[48] and a four-horse chariot group of Kratisthenes the Kyrenean with himself and a Nike mounted on the car[49]— such individual creations as "a lame man at Syracuse the pain of whose wound seems to be felt by the spectator,"[50] "a magnificent bronze group at Tarentum of Europa carried away by the bull,"[51] "Apollo transfixing the serpent with his arrows,"[52] "Eteokles and Polyneikes killing each other,"[53] and a winged Perseus.[54] In his attempt at new compositions and his novel interest in emotion he was again a child of his time and doubtless a leader in this new movement.

STYLE

WORKS

With this somewhat general information it is not surprising that it has not been possible to identify with certainty any of his works with extant statues. There has of course been no lack of attributions. The Omphalos Apollo (figs. 40, 41) has been thought to reproduce his statue of the boxer Euthymos,[55] the Valentini torso in Rome his lame Philoktetes,[56] a bronze statuette of a kithara player in the Hermitage[57] (fig. 72) his lyre player,[58] and a group of Europa and the bull in the British Museum[59] his representation of this subject.[60] Several bronze statuettes have been attributed to him for their "rhythm and fine proportion."[61] But tempting though it be to connect some of the few statues we have of this period with one of its most prominent artists, we must admit that we are not adding to our knowledge thereby. We may make a few guesses and regard them as such; we may surmise that the influence of Pythagoras' creations was widespread and survived in many later representations: that, for instance, the

42. Pausanias VI. 13. 7 and 18. 1; Pliny, *N.H.* XXXIV. 59.

43. Pausanias VI. 18. 1.

44. *N.H.* XXXIV. 59.

45. Diogenes Laert. VIII. 47.

46. *N.H.* XXXIV. 49.

47. *N.H.* XXXIV. 59.

48. Besides the references quoted above, cf. Pausanias VI. 7. 10 (statue of Dromeus), Pausanias VI. 6. 1 (statue of Protolaos).

49. Pausanias VI. 18. 1.

50. Pliny, *N.H.* XXXIV. 59.

51. Varro, *L.L.* v. 31.

52. Pliny, *N.H.* XXXIV. 59.

53. Tatian, *c. Graec.* 54.

54. Dio Chrysost., *Orat.*, 37. 10. p. 106.

55. Waldstein, in *J.H.S.*, I, pp. 168 f.

56. Waldhauer, *Pythagoras of Rhegium*, pp. 73 ff., figs. 16–18.

57. Ibid., pp. 69 ff., figs. 13–15.

58. Pliny, *N.H.* XXXIV. 59.

59. Cf. Smith, *Catalogue*, III, pl. 1, no. 1535.

60. Waldhauer, op. cit., pp. 63 ff.

61. Langlotz, *Fruehgriechische Bildhauerschulen*, pp. 147 ff. Another attribution is an akrolithic statue of Apollo found at Cirò in South Italy (cf. Della Seta, in *Italia Antica* [1928], p. 157, fig. 156).

wounded Philoktetes on a later fifth- or early fourth-century gem in the Louvre[62] (fig. 601) is reminiscent of the sculptor's famous statue; or that the fifth-century terracotta statuettes of Europa[63] give us some idea of the harmonious composition of his group; or again, that the Apollo killing the serpent on the coins of Kroton[64] (fig. 600) is based in a general way on Pythagoras' design. But these are all conjectures, and unfortunately do not enable us actually to realize the personality of one of the greatest and most original of Greek sculptors.

Kalamis

ORIGIN EQUALLY tantalizing is our ignorance of Kalamis,[65] a slightly younger contemporary of Pythagoras. We do not even know his origin. His works were widely scattered, but he was active also in Athens, and had there some important commissions;[66] so it is

DATE sometimes assumed that he was an Athenian. His date may be deduced from the following recorded facts: He made "racehorses with boys seated on them for a chariot group commemorating the Olympic victories of Hieron, tyrant of Syracuse."[67] The victory was won in 468; but since Hieron died the following year, "the debt was paid to the god by Deinomenes, the son of Hieron,"[68] that is, the group must be after 467. He was employed by Pindar (ca. 522–ca. 442) for a statue of Zeus Ammon at Thebes.[69] In Quintilian's[70] Canon of Sculptors he is placed between Hegesias and Myron. Pausanias[71] states that he made a statue of Apollo the Averter of Ill (Alexikakos) and that this epithet was given to the god "because he put an end to the plague which afflicted them at the time of the Peloponnesian War by means of an oracle from Delphi." The great plague of the Peloponnesian War was so terrible an experience that it seems to have wiped out all memories of former visitations. We may infer therefore that Pausanias here makes this common error; for 430–429 would be an improbably late date for Kalamis. All the other evidence[72] points to 475–450 as his most flourishing period.

STYLE We have some valuable, though again rather general information regarding his style. Quintilian[73] and Cicero[74] both estimate his statues as less stiff and rigid than

62. Furtwängler, *Antike Gemmen*, pl. xxxi, 10; cf. also pl. xxi, 20–24.

63. Cf. *M.M.A. Handbook* (1930), p. 142, fig. 100.

64. Head, *Historia numorum*, p. 96, fig. 54; Lacroix, *Reproductions de statues sur les monnaies*, p. 250, pl. xx, 11.

65. On Kalamis cf. Lippold, *Handbuch*, pp. 110 ff., and the references there cited; Orlandini, in *Enc. Arte Antica*, iv, 1961, pp. 291 ff., s.v. "Kalamis," and the references there cited.

66. Cf. infra. 67. Pausanias vi. 12. 1.

68. Ibid. 69. Pausanias ix. 16. 1.

70. xii. 10. 7. 71. Pausanias i. 3. 4.

72. Pausanias' statement (x. 19. 4) that Praxias, a pupil of Kalamis, worked on the pediments of the temple of Apollo at Delphi presumably refers to a later Kalamis; for this temple, completed ca. 510, was not destroyed till ca. 373, and Praxias is named as son of Lysimachos in an inscription from Oropos datable a little before 338 B.C. (Loewy, *Inschriften*, no. 127a). On the younger Kalamis cf. Studniczka, *Kalamis*, pp. 5–14; Anti, "Calamide," *Atti di R. Istituto Veneto*, lxxxii, pp. 1105 ff.; Raubitschek, *Dedications*, p. 506.

73. *Inst. orat.* xii. 10. 7: Nam duriora et Tuscanicis proxima Callon atque Hegesias, iam minus rigida Calamis, molliora adhuc supra dictis Myron fecit. 74. *Brut.* 18. 70.

those of Kallon, Hegesias, and Kanachos, but not so supple as those of Myron. That is, his work retains only slight traces of archaism but has not yet reached the freedom of the compositions of Myron. Lucian[75] in his description of the Panthea, the ideal woman who is to combine the excellencies of all the best works of art, wants Kalamis and his Sosandra "to adorn her with reverence and supply the noble and unconscious smile of the goddess, and the simple and orderly arrangement of the drapery, except that she shall not have her head covered."[76] The refinement of his work is also brought out in the passage of Dionysios of Halikarnassos[77] in which he compares "the oratory of Isokrates to the art of Polykleitos and Pheidias with its grandeur and breadth of style and sublimity, and that of Lysias to the art of Kalamis and Kallimachos with its delicacy and grace." He was a great sculptor of horses and had indeed no equal in this field.[78] Praxiteles is said to have placed a charioteer of his own on a four-horse chariot of Kalamis "lest the artist who excelled in representing horses should be thought to have failed in his treatment of the human figure."[79]

The most famous of Kalamis' works seems to have been the Sosandra referred to WORKS with so much praise by Lucian. Since Lucian[80] speaks of her as "seen by all who ascended the Akropolis," it has been suggested that she was identical with another work by Kalamis—a statue of Aphrodite dedicated by Kallias[81] which Pausanias saw at the entrance of the Akropolis.[82] A fragment of a base which was found in the Agora with parts of the names Kallias and Kalamis may have belonged to this dedication.[83] Among his figures of deities were two statues of Apollo—the Apollo Alexikakos in the Kerameikos at Athens[84] and a colossal statue, thirty cubits in height, at Apollonia on the Black Sea,[85] perhaps reproduced on coins of that city[86] (fig. 597). Pausanias[87] mentions as a work of Kalamis a "Hermes carrying a ram on his shoulders" set up by the people of Tanagra. The statue commemorated the averting of a plague by the god's carrying a ram round the city wall; and a Hermes Kriophoros appears on Roman coins of that city[88] (fig. 598), evidently reproducing this composition: unfortunately the coins are too badly preserved to give us a clear idea. We also hear of a Dionysos

75. *Eikones* 6. Cf. also his *Dialogues of the Hetairai* III. 2.

76. ἡ Σώσανδρα δὲ καὶ Κάλαμις αἰδοῖ κοσμήσουσιν αὐτήν, καὶ τὸ μειδίαμα σεμνὸν καὶ λεληθὸς ὥσπερ τὸ ἐκείνης ἔσται, καὶ τὸ εὐσταλὲς δὲ καὶ κόσμιον τῆς ἀναβολῆς παρὰ τῆς Σώσανδρας πλὴν ὅτι ἀκατακάλυπτος ᾽αὔτη ἔσται τὴν κεφαλήν. 77. *De Isocrate* 542 R.

78. Pliny, *N.H.* XXXIV. 71; and Propertius III. 9 and 10.

79. Pliny, *N.H.* XXXIV. 71. To our taste such a combination of styles would be a doubtful improvement. The suggestion that the reference is to the elder Praxiteles is open to the objection that Kalamis was at least as able a sculptor of the human figure as that sculptor. 80. *Eikones* 4.

81. Kallias was a brother-in-law of Kimon and is said to have won his wife Elpinike by paying fifty talents to free Kimon from arrest for a debt incurred by his father. It is suggested that Kallias' Aphrodite was nicknamed Sosandra (Saviour of Men, instead of Soteira, her usual epithet) as a result of this incident (cf. Benndorf, *Das Cultusbild der Athena Nike*, p. 45). 82. Pausanias I. 23. 2.

83. Raubitschek, *Dedications*, no. 136 and p. 507. 84. Pausanias I. 3. 4.

85. Strabo VII. 319; Pliny, *N.H.* XXXIV. 39; Appian, *Illyr.* 30.

86. Pick, in *J.d.I.*, XIII (1898), pls. 10, 26–28; Reisch, in *Oest. Jahresh.*, IX (1906), p. 222, fig. 64; Lacroix, *Reproductions de statues sur les monnaies*, p. 248, pl. XX, 6, 7, 10. 87. IX. 22. 1.

88. Imhoof-Blumer and Gardner, *Numismatic Commentary*, pl. X, nos. XI, XII; Lacroix, op. cit., p. 249.

with a Triton at Tanagra,[89] a wingless Victory at Athens,[90] and a Zeus Ammon at
Thebes.[91] He was a precursor of Pheidias in the art of producing gold and ivory fig-
ures with an Asklepios at Sikyon[92] described as "beardless, holding a sceptre in one
hand and in the other a cone of the cultivated pine." A statue of Alkmene set up at
Delphi "showed him a master also in the art of representing human beings."[93] A
Hermione,[94] bronze boys extending their right hands in prayer,[95] an Erinys,[96] horses,[97]
and chariot groups[98] complete the list of his works.

Unfortunately none of these sculptures can be identified with extant statues. The
"Omphalos Apollo" (figs. 40, 41) has been thought to reproduce his Apollo Alexi-
kakos; the "Penelope" in the Vatican[99] (fig. 73) has been associated with his name;
and his Hermes Kriophoros has been recognized by some authorities in a statue at
Wilton House[100] and in a relief in Athens;[101] all, however, on slender evidence. Con-
temporary works such as the horse from Olympia[102] (figs. 371, 372) and the Poseidon
found off Cape Artemision[103] (figs. 106, 107) may give us some idea of the beauty of
his products in bronze; and such works as the girl with pigeons in New York (fig. 462)
may help us to picture the "simplicity and orderliness" ($\tau\grave{o}$ $\epsilon\grave{v}\sigma\tau\alpha\lambda\grave{\epsilon}\varsigma$ $\delta\grave{\epsilon}$ $\kappa\alpha\grave{\iota}$ $\kappa\acute{o}\sigma\mu\iota\upsilon\nu$)
of the drapery of the Sosandra. But so far we must be content to visualize Kalamis in
a general way as a celebrated artist of the transitional period, distinguished for his
grace and refinement rather than for the originality of his poses; capable, however, of
producing colossal works; working in bronze and marble, as well as in gold and ivory;
and a great sculptor of horses. It is a vague picture, but more definite assertions would
only blot out the faint traces we have.

Whether the Kalamis referred to as a distinguished "engraver" (caelator) by
Pliny[104] was identical with the sculptor is not certain, but he may very well have
been, for in Greece famous sculptors are known to have been proficient metal-
workers.[105]

Myron

ORIGIN THE greatest sculptor of the transitional period was Myron[1] of Eleutherai, a town on
the boundary of Boeotia and Attica.[2] According to Pliny[3] he was a pupil of Ageladas

89. Pausanias IX. 20. 4. By some identified with the figure on coins of Tanagra, Imhoof-Blumer and Gardner, *Numismatic Commentary*, pl. X, nos. VII and VIII. 90. Pausanias V. 26. 6.
91. Pausanias IX. 16. 1; commissioned by Pindar, see above.
92. Pausanias II. 10. 3. 93. Pliny, *N.H.* XXXIV. 71.
94. Pausanias X. 16. 4. 95. Pausanias V. 25. 5.
96. Schol. Aeschin. *Timarch.* 747 R. 97. Pausanias VI. 12. 1.
98. Pliny, *N.H.* XXXIV. 71. 99. Helbig-Speier, *Führer*⁴, I, no. 123.
100. Michaelis, *Marbles in Great Britain*, p. 702, no. 144; Clarac, IV, 658, 1545 B.
101. Collignon, *Histoire de la Sculpture grecque*, I, fig. 207.
102. Kunze, in III. *Bericht über die Ausgrabungen in Olympia*, 1941, pp. 133 ff., pls. 59–64.
103. Karouzos, in *Delt. arch.*, XIII, 1933, pp. 93 f. 104. *N.H.* XXXVI. 36; XXXIV. 47; XXXIII. 154.
105. Cf. Richter, in *A.J.A.*, XLV, 1941, p. 382, and the references there cited; also pp. 114, 226 of this book.
1. On Myron cf. Lippold, *Handbuch*, pp. 136 ff., and the references there cited; Arias, in *Enc. Arte Antica*, V, 1963, pp. 111 ff., s.v. Mirone, and the references there cited.
2. Pliny, *N.H.* XXXIV. 57. 3. Loc. cit.

and a rival of Pythagoras. He made a statue of Timanthes of Kleonai[4] who won an
Olympic victory in 456 B.C.[5] and two statues of Lykinos of Sparta[6] who won a chariot
race about 448.[7] An inscribed base[8] placed at the entrance of the Propylaia and dating
from about 446 bears the name of "Lykios of Eleutherai, the son of Myron" as the
author of the statues. So that the period of Myron's activity seems to lie between 480
and 445 B.C.

Fortunately we are not dependent for our appreciation of Myron on general state-
ments in ancient writings. It has been possible to recognize copies of two of his works
in extant statues, and we can thereby obtain a clear conception of his style.

The identification of the Diskobolos we owe to Lucian's[9] description: "Surely you
do not speak of the quoit-thrower who stoops in the attitude of one who is making his
cast, turning round toward the hand that holds the quoit, and bending the other knee
gently beneath him, like one who will rise erect as he hurls the quoit? No, for that
quoit-thrower of whom you speak is one of the works of Myron." By this detailed
account—so different from the brief, generalized statements in which ancient writers
mostly refer to Greek sculpture—we can identify a splendid composition existing in
several Roman copies as the work of Myron (fig. 616[10]). The marble statue, formerly
in the possession of the Lancelotti family, now in the Museo Nazionale delle Terme,
in Rome[11] (fig. 620), is the only example with the original head, turned round toward
the hand with the quoit, just as Lucian describes. Other good replicas are: a statue
from Tivoli in the British Museum;[12] a statue from the same locality in the Vatican;[13]
a fine torso from Castel Porziano in the National Museum of the Terme, Rome[14] (fig.
619); a torso, restored as a warrior, in the Capitoline Museum in Rome;[15] a bronze
statuette with the head worked in a later style in Munich[16] (figs. 617, 618); and rep-
resentations on gems[17] (cf. p. 162). If we remember that the pose of the Diskobolos[18]
has no antecedents, we shall realize what a courageous innovator Myron was. In his
representations of a violent action he chose not the striding or crouching or falling
types worked out in pedimental sculptures, as some of his contemporaries did,[19] but an

4. Pausanias VI. 8. 4. 5. Grenfell and Hunt, *Oxyrhynchus Papyri*, II, p. 89, col. II, line 4.
6. Pausanias VI. 2. 2. 7. Grenfell and Hunt, op. cit., II, p. 90, col. II, line 34.
8. *Delt. arch.*, 1889, p. 179; Stuart Jones, *Select Passages*, no. 147; Raubitschek, *Dedications*, no. 135 (cf.
also no. 138). 9. *Philopseud.* 18.
10. This illustration is taken from a composite cast of the Lancelotti head, the Vatican body, and some new
restorations, especially the left arm.
11. Cf. Brunn-Bruckmann, *Denkmäler*, pl. 256; E. Paribeni, *Cat.*, no. 20; Helbig-Speier, *Führer*[4], III, no.
2269. 12. Smith, *Catalogue*, I, no. 250.
13. Helbig-Speier, *Führer*[4], I, no. 503; cf. also the fragment, ibid., no. 788.
14. Helbig-Speier, *Führer*[4], III, no. 2269.
15. Stuart Jones, *Catalogue*, no. 50; Helbig-Speier, *Führer*[4], II, no. 1232.
16. Sieveking, in Brunn-Bruckmann, *Denkmäler*, pl. 681.
17. Furtwängler, *Antike Gemmen*, pls. XLIV, 26, 27 and XLVI, 8; Richter, *Engraved Gems*, II, no. 345.
18. For some polemics regarding the details of this pose, especially the position of the left foot, cf. Schröder,
Zum Diskobol des Myron; Sieveking, op. cit., text to pl. 681; and again Schröder, in *Arch. Anz.*, 1920, pp. 61 ff.
19. E.g. Kritios and Nesiotes, the striding type in the Tyrannicides; Pythagoras, the crouching type (?) in
his Apollo killing the serpent; and Kresilas, the falling type in his Volneratus deficiens (?).

FIG. V. Diskobolos, on an
engraved gem (enlarged)

entirely novel composition. And the effect of this twisted body in a momentary pose is not restless (at least if seen in full-front view as doubtless intended) but singularly harmonious. The criticism of Quintilian,[20] "What can be more strained and artificial in its attitude than the famous quoit-thrower of Myron?" only applies to the actual subject; and his defense of it on the ground of its "novelty and difficulty" is not necessary. The Diskobolos is an artistic creation of the first rank, quite independent of the period in which it was produced. The harmony which we note in the composition is also apparent in the modeling. Though it is much more naturalistic than in archaic sculpture, the pattern scheme is still marked, and each group of muscles forms a decorative design interrelated with the next group. The features are modeled in this same severe, harmonious style, while the hair is indicated by little ringlets lying close to the skull in the fashion of earlier days.

Marsyas The second identified work of Myron is the Marsyas. Pliny[21] describes it: Fecit et canem et discobolum et Perseum et pristas et satyrum admirantem tibias et Minervam (a satyr gazing in wonderment at the flutes and Athena—unless Minervam is the object of "fecit," in which case it might be a single statue, not part of a group with the satyr). The combination of the two in one composition, however, is made likely by Pausanias'[22] mention of such a group on the Akropolis of Athens: "Here Athena is represented in the act of striking[23] the Satyr Marsyas, because he took up the flutes when the goddess wished them to be thrown aside." Groups of Athena and Marsyas answering such descriptions occur on Roman coins of Athens[24] (fig. 626), on a red-figured oinochoe in the Berlin Museum[25] (fig. 625), and on a marble vase in Athens[26] (fig. 624). From the attitudes of the figures on these representations copies in the round have been recognized. The best example of the Marsyas is a statue in the Lateran Collection,[27] in fine preservation, except for the missing arms[28] (fig. 621). A bronze statuette in the British Museum[29] (fig. 630) appears to be a later version of this theme. The arms are preserved but do not correspond exactly to the attitude on the coin representations, for the right hand is brought to the head. A good Roman

20. *Inst. orat.* 2. 13. 8.

21. *N.H.* xxxiv. 57. 22. i. 24. 1.

23. παίουσα, perhaps "on the point of striking"; or the text may be corrupt for ἐπιοῦσα, "advancing upon," or ἀπιοῦσα, "just turning round before leaving" (P. Jacobsthal).

24. Cf. Imhoof-Blumer and Gardner, *Numismatic Commentary*, pl. Z, nos. xx, xxi; Lacroix, *Reproductions de statues sur les monnaies*, p. 253, pl. xxi, 1–4.

25. Hirschfeld, "Athena und Marsyas," in 32. *Berliner Winckelmannsprogramm*, 1872; Furtwängler, *Beschreibung der Vasensammlung*, no. 2418.

26. National Museum, no. 127; Heydemann, in *Arch. Ztg.*, 1873, p. 96; Kekulé, in *Arch. Ztg.*, 1875, pl. 8; Papaspiridi, *Guide*, p. 48. 27. Helbig-Speier, *Führer*⁴, i, no. 1065.

28. These used to be restored as playing the castanets; but were removed in 1925.

29. Walters, *Select Bronzes*, pl. xvi.

replica of the head is in the Barracco Museum[30] (fig. 622), and a fragmentary one, found in 1938 near S. Maria in Cosmedin, is in the Capitoline Museum, Rome, inv. 2993[31] (fig. 623). The Athena has been identified in a statue also preserved in several replicas, of which the best is in Frankfurt[32] (figs. 627–29). Another copy or adaptation is in the Boboli Gardens in Florence and copies of the head are in the Albertinum, Dresden, and in the Vatican.[33] The attitude is that of the goddess on the coins, with the left leg placed sidewise and backward and the head turned to the left. This unusual pose and the fact that the style is that of the period reinforce the identification.

The Marsyas, like the Diskobolos, is a splendid composition, full of action and yet beautifully harmonious. Its rhythmical movement and sturdy modeling mark it as the conception of a great artist. The attitude of starting back (not falling) is again a novel one in Greek art though not so bold an innovation as that of the Diskobolos. In the Marsyas Myron's originality is further shown in the individualistic treatment of the lean body with its restless modeling (note e.g. the accentuation of the muscles of the serratus magnus and the comparative absence of the "pattern scheme"), and above all in the expression of surprise in the wild face with its oblique ridges on the forehead and its shaggy hair and beard—in striking contrast to the quiet severity of the aristocratic Diskobolos. There have been attempts to combine the Marsyas and the Athena in a composition similar to that on the coins. Sieveking's reconstruction is perhaps the most satisfactory (fig. 631). The two figures with their contrasting attitudes make a harmonious design comparable to the rhythmical compositions in the vase paintings of the period. (The right hand of Marsyas was perhaps more extended, as in fig. 625.) The Athena, as she appears at least in the Roman copies we have, may seem tame compared to the Marsyas. But if she is not so grand in conception, she has the quiet dignity befitting a goddess; and the sideways turn of her body lends variety to the traditional pose.

Among the other works of Myron mentioned by ancient writers our interest is *Ladas* aroused particularly by the statue of Ladas, a victorious runner at Olympia. A vivid description of it appears in the *Anthology:*[34] "As once thou wast, instinct with life, when thou didst fly from Thymos swift as the wind, on tiptoe, with every muscle at full strain—even so did Myron fashion thee in bronze, and stamp on thy whole frame eager yearning for the crown that Pisa gives." "He is full of hope, and on his lips is seen the breath that comes from the hollow flanks; anon the bronze will leap to seize the crown, and the base will hold it no longer; see how art is swifter than the wind." Here again Myron attempted a momentary pose, full of action and life; and we must

30. Helbig-Speier, *Führer*[4], II, no. 1872.

31. Here illustrated with the kind permission of C. Pietrangeli.

32. Dragendorff, *Antike Denkmäler*, III (1909–1911), p. 8, pl. 9.

33. Arndt, in *Antike Plastik, Walther Amelung zum 60ᵗᵉⁿ Geburtstag*, pp. 11–12, fig. 9; Picard, *Manuel*, II, p. 240, fig. 108; Kaschnitz-Weinberg, *Sculture del Magazzino del Museo Vaticano*, no. 59, pl. xviii; Hermann, *Verzeichnis der antiken Originalwerke der Skulpturensammlung zu Dresden*, 1925, no. 48.

34. Anth. Plan. IV. 54.

regret exceedingly the apparently total loss of this work, comparable doubtless in boldness and vigor to the Diskobolos and the Marsyas.

Other Works　　　　The other works we hear of as by Myron—deities, heroes, and athletes—are most of them mere names to us now: a Hekate at Aigina;[35] a colossal group of Zeus, Athena, and Herakles in Samos;[36] two figures of Apollo, one at Ephesos,[37] another at Agrigentum;[38] a Dionysos at Orchomenos;[39] a statue of Herakles at Heius,[40] and one shown in the Circus Maximus in Rome;[41] a Perseus "after his exploit with Medusa" on the Akropolis at Athens;[42] an Erechtheus;[43] and a number of statues of victorious athletes.[44] But the work of Myron which made the greatest appeal in antiquity was his

Animals　　　　bronze cow which stood on the Akropolis at Athens[45] and of whose lifelike quality we have many testimonies.[46] Men and animals alike mistook her for real, the calves went up to her to be suckled, the lions to devour her. She appeared to have breath inside her (ἔμπνοος) and seemed about to bellow (μηκήσεται). We may be sure that her beauty was not due so much to realism as to that quality of design and vigor of conception which give life and distinction to Myron's work.

Besides the cow we hear of four bulls[47] and a dog[48] by Myron, so that he must have been greatly interested in animal sculpture. Moreover, several chased silver vases are ascribed to Myron,[49] showing the versatility of the man.[50]

STYLE　　　　Some critical estimates of Myron's art by ancient writers are of interest. Pliny[51] sums up his chief characteristics: "He is thought to have been the first to extend life-like representation in art. He was more versatile than Polykleitos, and more studious of symmetry.[52] Yet he too expended his care on the bodily frame, and did not repre-

35. Pausanias II. 30. 2.

36. Strabo XIV. 1, 14. On the possible identification of the base of this group with one found in Samos, and of Roman copies of the statues cf. Buschor, in *Ath. Mitt.*, LXVIII (1953), pp. 51 ff.; Berger, "Zum samischen Zeus des Myron" in *Röm. Mitt.* (forthcoming).

37. Pliny, *N.H.* XXXIV. 58.　　　　　　　　　38. Cicero, *In Verrem* IV. 43. 93.

39. Pausanias IX. 30. 1; *Anth. Gr.* IV. 173. 270 (*Plan.* IV. 257).

40. Cicero, op. cit., IV. 3. 5.　　　　　　　　41. Pliny, *N.H.* XXXIV. 57.

42. Pausanias I. 23. 7.

43. Pausanias IX. 30. 1. Perhaps part of the group of Erechtheus and Eumolpos fighting each other mentioned by Pausanias I. 27. 4, as on the Akropolis.

44. Pausanias VI. 2. 2, 8. 4, 8. 5, 13. 2.　　　　45. It was later removed to the Forum Pacis at Rome.

46. Cf. Overbeck, *Schriftquellen*, nos. 550–591. It is thought by some to be reproduced on the denarius of Augustus (Gabrici, *Studi e materiali di arch. e numismatica*, II, 1902, p. 168, fig. 20).

47. Propertius II. 31. 7.　　　　48. Pliny, *N.H.* XXXIV. 57: "canem"; Benndorf emends Ladam.

49. Martial IV. 39. 1; VI. 92; VIII. 51; Stat., *Silv.* I. 3. 50; Phaedr., *Fab.* V, prologue.

50. It has been thought that this Myron and the *caelator Kalamis* (see p. 160, n. 104) were later artists; but cf. *A.J.A.*, XLV (1941), p. 382. It is in line with ancient—as well as Renaissance—tradition for an artist to have several fields for his activities. The Myron who made the drunken old woman (Pliny, *N.H.* XXXVI. 32) is described as "qui in aere laudatur" (the celebrated bronze caster) and is perhaps of later date.

51. Pliny, *N.H.* XXXIV. 58: "Primus hic multiplicasse veritatem videtur, numerosior in arte quam Polyclitus (et) in symmetria diligentior, et ipse tamen corporum tenus curiosus animi sensus non expressisse, capillum quoque et pubem non emendatius fecisse quam rudis antiquitas instituisset."

52. Several emendations have been suggested to prevent Pliny from saying that Myron was more interested in symmetry than Polykleitos, the great student of proportion. But that Myron's work was also beautifully rhythmical we learn from his Diskobolos and his Marsyas.

sent the emotions of the mind. His treatment too of the hair of the head and body showed no advance on the rude attempts of early art." Petronius[53] refers to Myron as the one "who could almost catch the souls of men and beasts and enchain them in bronze." He is regularly mentioned with Polykleitos, Lysippos, Praxiteles, and Pheidias as among the most eminent sculptors of Greece.[54] His works are considered by Cicero[55] as not yet realistic but nevertheless beautiful, by Quintilian[56] as suppler and more advanced than those of Kalamis. He is said to have used the Delian composition of bronze as against the Aiginetan one employed by Polykleitos.[57]

In other words, ancient writers agree very much with our own estimate of Myron as a great innovator, who created lifelike yet rhythmical renderings, slightly touched with archaisms, and whose chief interest was the human body in a variety of postures. He is the great representative of the period of experimentation, and helped to determine the character of this important epoch.

Based on this definite knowledge of the works and character of Myron there have been many attributions of extant statues as copies of his works. Furtwängler lists nineteen such in his *Masterpieces*.[58] The most important are the heads identified as Perseus,[59] in the Museo Nuovo in Rome[60] and in the British Museum,[61] copies of a distinguished work of this period;[62] the Cassel Apollo[63] (fig. 204); the resting Herakles, of which reproductions are in the Boston and Ashmolean Museums[64] (fig. 43), and the boxer adjusting protective straps on his head (reconstructed by Amelung).[65] But we have no conclusive evidence to make any of these theories realities, and so we will not dim our clear picture of Myron with them. ATTRIBUTIONS

In addition to these outstanding personalities there were of course other prominent sculptors. A number are mentioned by ancient writers who ascribe various works to them; for instance, **Kanachos** and **Aristokles of Sikyon,** and **Kallon** and **Onatas of Aigina**.[66] They too worked in this epoch of experimentation and doubtless their sculptures showed interest in lively action and harmonious composition. We cannot with

53. *Satyr.* 88.

54. Cicero, *De oratore* III. 7. 26; Auctor ad Herenn. IV. 6; *Lucian, Somn.* 8; etc.

55. *Brut.* 18. 70. 56. *Inst. orat.* XII. 10. 7.

57. Pliny, *N.H.* XXXIV. 9. Chemical analyses have shown that there is a great variety in the alloys of ancient bronzes, so that it is quite possible that different compositions were favored by individual artists.

58. Pp. 165 ff. 59. Furtwängler, *Masterpieces*, pp. 197 ff.

60. Formerly in the Antiquario Comunale; Furtwängler, op. cit., p. 198, fig. 83.

61. Smith, *Catalogue*, III, no. 1743.

62. For its reconstruction and possible attribution to Myron (or Pythagoras) cf. now Langlotz, in *Heidelberger Akad. d. Wiss.* (philosoph.-hist. Kl., 1951), pp. 7 ff.

63. Furtwängler, *Masterpieces*, pp. 190 ff.

64. Cf. Caskey, *Catalogue*, no. 64; Lippold, *Antike Plastik, Walther Amelung zum 60ten Geburtstag*, pp. 127 ff.; Ashmolean Museum, *Guide*, p. 93.

65. Bieber, in *J.d.I.*, XLII, 1927, pp. 153 ff. For further attributions cf. V. H. Poulsen, in *Acta Archaeologica*, 8, 1937, pp. 136 ff.

66. Cf. Overbeck, *Schriftquellen*, nos. 403–428; Lippold, *Handbuch*, pp. 86 f. (Kanachos and Aristokles), pp. 97 f. (Onatas); Carettoni, in *Enc. Arte Antica*, IV, 1961, pp. 308 ff., s.v. Kanachos; De Marinis, in *Enc. Arte Antica*, V, 1963, pp. 691 f., s.v. Onatas.

certainty connect their names with any extant sculptures,[67] but at least the signatures of Kallon (Kalon) and Onatas have survived on bases found on the Akropolis.[68]

67. For a tentative identification of a torso in the Antiquario of the Roman Forum as a Roman copy of Kanachos' Apollo Philesios cf. Bielefeld, in *Antike Plastik*, VIII (1968), pp. 13 ff., pls. 5, 6, and the references there cited.

68. Loewy, *Inschriften*, no. 27; Kirchner, *Imagines*, no. 16; Raubitschek, *Dedications*, nos. 85, 236, pp. 508 f., 520 ff.

SECOND HALF OF FIFTH CENTURY B.C.

Pheidias

WE know the origin of Pheidias[1] from his own signature on the statue of Zeus at Olympia: "Pheidias, the son of Charmides, the Athenian, made me."[2] He is said to have been the pupil of Hegias[3] and Ageladas.[4] Pliny[5] gives as his chief date the 83d Olympiad, that is 448–444 B.C., a natural period to select, since during it was begun the work on the Parthenon. He made a gold and ivory statue of Athena at Pellene in Achaia[6] before his statue of Athena Parthenos on the Akropolis of Athens, and he was commissioned with several works to celebrate the victory over the Persians,[7] showing that in the second quarter of the fifth century B.C. he was already a recognized artist. His great opportunity came soon after the middle of the fifth century when Perikles, in 449, assumed power in Athens and gave him control over his artistic undertakings.[8] The next fifteen years were a time of ceaseless activity on the little hill of the Akropolis. On the southern slope arose the Odeion founded by Perikles; the Parthenon was begun in 447–446 and in 438 the colossal temple statue of Athena by Pheidias was dedicated; by 432 the pediment sculptures were in place and the whole temple complete;[9] Mnesikles built the Propylaia in five years (437–432). Plutarch gives us a graphic description:[10] "As the buildings rose stately in size and unsurpassed in form and grace, the workmen vied with each other that the quality of their work might be enhanced by its artistic beauty. Most wonderful of all was the rapidity of construction. Each one of them, men thought, would require many successive generations to complete it, but all of them were fully completed in the heyday of a single administration." After the work on the Parthenon our evidence becomes confused. Pheidias' suc-

ORIGIN

DATE AND
LIFE

1. On Pheidias in general cf. especially V. H. Poulsen, *From the Collections*, III, 1942, pp. 33 ff.; Langlotz, *Phidiasprobleme*, 1948; Buschor, *Phidias der Mensch*, 1948; Lippold, *Handbuch*, 1950, pp. 141 ff., and the references there cited; Becatti, *Problemi fidiaci*, 1951, and in *Enc. Arte Antica*, III, 1960, pp. 649 ff., s.v. "Fidia," and the references there cited; M. Santangelo, *Fidia: Il Maestro del Partenone* (forthcoming).

2. Pausanias v. 10.2. 3. Dion Chrysost., *Orat.* 55. 1. 282 (as emended). Cf. my p. 156.

4. Schol. Aristoph., *Frogs* 504; Tzetzes, *Chil.* VII. 929.

5. *N.H.* XXXIV. 49. Floruit autem (Pheidias) olympiade LXXXIII, circiter CCC nostrae urbis anno.

6. Pausanias VII. 27. 2.

7. A bronze Athena at Athens (Pausanias I. 28. 2), a group at Delphi (Pausanias X. 10. 1), and an Athena at Plataia (Pausanias IX. 4. 1).

8. Plutarch, *Perikles* XIII. 4: "His [Perikles'] general manager and general overseer was Pheidias, although the several works had great architects and artists besides." And XIII. 9: "Everything almost was under his [Pheidias'] charge, and all the artists and artisans, as I have said, were under his superintendence, owing to his friendship with Perikles."

9. Cf. p. 177. 10. XIII. 1.

cess was too phenomenal not to bring on him the envy of the less fortunate. In the frank words of Plutarch:[11] "And being a friend of Perikles with considerable influence over him he became an object of jealousy and acquired many enemies." Ancient writers give contradictory accounts as to what happened. On the one hand it is said that he was put in prison (shortly after 438) and died there;[12] on the other hand that he went to Olympia (in 438 or 432) to execute the statue of Zeus, and died there.[13] The opinions of archaeologists were accordingly divided as to whether the Olympian Zeus was executed before or after the Athena Parthenos. This controversy has now been settled in favor of the priority of the Athena through the evidence that has recently come to light at Olympia, i.e. the discovery of material used for the making of the Zeus (in a fill next to Pheidias' workroom) consisting of terracotta molds into which the gold sheathing of the mantle was hammered, stylistically datable in the time of the Parthenon pediments, and a fragment of a vase by the Kleophon painter (ca. 430 B.C.); cf. my p. 173, n. 69.

WORKS

We have little by which to form a conception of Pheidias' great creations. Ancient writers give long descriptions of some of them in terms of the highest praise, and it has been possible thereby to identify small-scale representations of Roman date as copies of three of his chief works—the Athena Promachos, the Athena Parthenos, and the Olympian Zeus. Though they cannot make us visualize the precious gold and ivory or bronze originals several times life-size, we must try to obtain from them what help we can.

Athena Promachos or the Bronze Athena

The Bronze Athena, nowadays generally referred to as the Athena Promachos,[14] is said by Pausanias[15] to have been an offering "from the spoils of the Persians who landed at Marathon"; but the statue was probably not erected until about 456, as we learn from an inscription.[16] She was of bronze and rose to a great height. The point of her spear and the crest of her helmet are said to have been visible even to mariners approaching from Sounion. The general attitude and imposing nature of this statue can be gathered from representations of it on Athenian coins of the Roman Imperial period, where it appears as a tall statue standing on the Akropolis, between the Parthenon and the Propylaia, that is, seen from the north, as indicated by the presence

11. *Perikles* XXXI. 2.

12. Plutarch, *Perikles* XXXI. 2: "Formal prosecution of Pheidias was made in the assembly. Embezzlement indeed was not proven, but . . . Pheidias accordingly was led away to prison and died there."

13. Scholiast on Aristophanes, *Peace* 605 ff., quoting Philochoros (historian of the fourth to third century B.C.): "The artist Pheidias was thought to have been guilty of peculation . . . and was put to trial. He fled to Elis, where he is said to have accepted the contract for the statue of Zeus at Olympia."

14. In ancient literature she is generally called "the Bronze Athena." The epithet of Athena Promachos is directly applied to her by the Scholiast on Dem., *Androt.* 597 R, and in *I.G.*, III. 1. 638 (ca. A.D. 410). It has made its way into modern archeological literature, though hardly appropriate to the quiet attitude of the statue.

15. I. 28. 2.

16. Meritt, *Hesperia*, V, 1936, p. 373; Raubitschek and Stevens, in *Hesperia*, XV, 1946, pp. 107 ff.

of the grotto of Pan[17] (fig. 635). As far as one can make out from these minute representations, Athena is shown standing, with the right hand extended and holding a Nike or an owl, a spear in her left hand, a shield by her side. (But in some of the representations the attitudes of the arms seem to vary.) The former identification of the figure on Roman coins[18] where she is shown holding a spear in her right hand and a shield in her left has accordingly become doubtful[19] (fig. 632).

The chryselephantine statues of the Athena Parthenos and the Olympian Zeus are cited as Pheidias' outstanding works.[20] Their precious material[21] and great size naturally made them conspicuous attainments, but apart from their intrinsic value they were great artistic achievements, for Pheidias' genius appears to have embodied in them a nobility and grandeur which left an abiding impression on the beholder. Pausanias[22] gives a detailed description of the Athena Parthenos: "On the middle of the helmet rests the figure of a sphinx and on either side of the helmet griffins are represented. The statue of Athena stands erect and wears a tunic reaching to the feet. On its breast is represented in ivory the head of Medusa, and a Victory about four cubits in height stands on one of its hands, while in the other it holds a spear; at its feet rests a shield, and close to the shield is a serpent which no doubt represents Erichthonios; on the base of the statue the birth of Pandora is wrought in relief." Pliny[23] supplies the further information that "on the shield was wrought in relief the battle of the Amazons on the convex surface, and the combats of gods and giants on the concave side, while on the sandals was represented those of the Lapiths and Centaurs."[24] And from Plutarch[25] we learn that in the battle of Amazons on the shield "Pheidias introduced a figure of himself as a bald old man lifting up a stone in both hands, and a very fine portrait of Perikles fighting with an Amazon," his arm across his face.[26] From these descriptions several statuettes, heads, and reliefs—all of Roman date—have been identified as copied from Pheidias' work.[27] By their combined

Athena Parthenos

17. The site has been tentatively identified as one of two large leveled surfaces about thirty yards east of the Propylaia; cf. D'Ooge, *The Acropolis of Athens*, p. 299. Moreover a piece of the pedestal is preserved in a capping course with colossal bead-and-reel and egg-and-dart moldings (Dinsmoor, in *A.J.A.*, xxv (1921), p. 128, fig. 1, and *Architecture*, p. 211; Raubitschek and Stevens, op. cit., pp. 107 ff.).

18. Imhoof-Blumer and Gardner, *Numismatic Commentary*, pl. 10, nos. 3–7; Shear, in *Hesperia*, 5 (1936), 316 ff., pl. 7, 1–21; Lacroix, *Reproductions de statues sur les monnaies*, pl. 24, 7–10, pl. 25.

19. Cf. Chamoux, in *B.C.H.*, 68–69 (1944–45), pp. 206 ff.; Lacroix, op. cit., pp. 283 ff.; also Langlotz, *Phidiasprobleme*, pp. 73 ff.; *Herdejüngen, Antike Kunst*, XII, 1969, pp. 102 ff. Nor can the statue be the same as that described by Niketas (*Chron. Isaac. Ang. et Alex. F.*, p. 738B.) as standing in later times in the forum of Constantine, for his description does not tally.

20. Cf. e.g. Quintilian, *Inst. orat.* XII. 10. 9.

21. The Athena Parthenos is supposed to have borne forty talents' weight of refined gold (Thucydides II. 13).

22. I. 24. 5. 23. *N.H.* XXXVI. 18.

24. According to Aristotle, *De Mundo* 6. 399b, the shield contained a hidden mechanism by which if the head were removed the whole statue would fall to pieces. 25. *Perikles* XXXI. 4.

26. This feature brought on Pheidias the charge of sacrilege.

27. Cf. the lists given by Schreiber, *Athena Parthenos*; Puchstein, in *J.d.I.*, v, 1890, p. 83, note 16; Robinson, in *A.J.A.*, xv, 1911, pp. 499 ff.; Picard, *Manuel, 2*, pp. 378 ff.; Schuchhardt, in *Antike Plastik*, II, 1963, pp. 31 ff.

evidence we can reconstruct the entire figure. The so-called Varvakeion Athena[28] (figs. 638, 639) shows the sphinx and griffins on the head, the aegis, the shield with the serpent, and the Nike. The statuettes from Monastir and in Patras[29] (fig. 642) resemble the Varvakeion statuette but are of rather better execution. The Lenormant Athena[30] (fig. 640) gives the reliefs on the outside of the shield and on the base. On the Strangford shield[31] (fig. 645) the relief decoration is seen in greater detail.[32] The reliefs found in the sea at the Piraieus[33] give us excerpts from the Amazonomachy (cf. fig. 646). The Princeton statuette[34] (fig. 643), the polychrome head in Berlin[35] (fig. 641), the Aspasios gem[36] (fig. 636), the Koul Oba medallion,[37] and the head on the coins[38] (cf. fig. 637) show details of helmet and aegis. The whole figure on the late Athenian coins[39] (fig. 633) and on engraved gems[40] (fig. 633)—minute though it is— supplies two important additional points of evidence; the spear in the left hand and no supporting pillar for the hand with the Victory, showing that its addition in the Varvakeion statuette may be a later feature.[41]

Our imagination has to work hard to reconstruct from these faint reflections the vision of the great temple statue about forty feet high (with its base), which the worshiper beheld when he entered the cella of the Parthenon. But from a few of them— notably the Lenormant statuette, the Berlin head, and the Aspasios gem—we may catch a faint glimmer of the majesty, the *amplitudo*,[42] which made it one of the most famous statues of the world. And the great impression it made in the artistic world may be gauged by the many adaptations, contemporary and later, especially by the fine statue from distant Pergamon[43] (fig. 644)—produced in the Hellenistic period when an entirely different taste prevailed.

28. National Museum, Athens, no. 129. Papaspiridi, *Guide*, pp. 46 f., and S. Karouzou, *Cat.*, pp. 68 f.

29. *Arch. Anz.*, 1932, cols. 89 ff.; *B.S.A.*, III, pl. 9.

30. National Museum, Athens, no. 128. Papaspiridi, *Guide*, pp. 47 f., and S. Karouzou, *Cat.*, p. 67.

31. Smith, *Catalogue of Greek Sculpture in the British Museum*, I, no. 302.

32. E. Harrison, in *Hesperia*, XXXV, 1966, pp. 107 ff., pls. 36–41, now cites all the other fragments of the shield, of which several have recently been found in the Athenian Agora.

33. Schrader, in *Corolla L. Curtius*, pp. 81 ff.; Ras, in *B.C.H.*, LVIII–LIX (1944–45), pp. 200 ff. (he discusses the composition, on which see now E. Harrison, op. cit.); Lippold, *Handbuch*, p. 147, and the references there cited; Strocka, *Piräusreliefs und Parthenosschild der Amazonomachie des Phidias* (1967).

34. Shear, in *A.J.A.*, XXVIII (1924), pp. 117 f., pls. II–IV.

35. Berlin Museum, *Beschreibung der antiken Skulpturen*, no. 76A.

36. Furtwängler, *Antike Gemmen*, pl. XLIX, 12; Richter, *Engraved Gems*, II, no. 64.

37. Kieseritzky, in *Ath. Mitt.*, VIII (1883), pp. 291 ff., pl. XV.

38. Imhoof-Blumer and Gardner, *Numismatic Commentary*, pl. Y, no. XXIII; Lacroix, *Reproductions de statues sur les monnaies*, pp. 271 ff.

39. Imhoof-Blumer and Gardner, op. cit., pl. Y, nos. XVIII ff.

40. Richter, *Engraved Gems*, II, nos. 93 ff.

41. On varying views on this subject cf. Stevens, in *Hesperia*, XXIV, 1955, pp. 263 ff., XXX, 1961, pp. 2 ff.; Richter, in *Studi in onore di A. Calderini e R. Paribeni*, III, 1956, pp. 147 ff.; Schuchhardt, in *Antike Plastik*, II (1963), pp. 31 ff. It should be noted that on coins of Priene of the time of Alexander Severus and Valerian a tree appears below Athena's right hand (cf. Lacroix, op. cit., pl. XXIV, 5), which was explained by Babelon (*Rois de Syrie*, p. 9) as a later addition, by Lacroix as indicating a support in the original. Since it is a tree and not a pillar could it perhaps be an attribute?

42. Pliny, *N.H.* XXXVI. 18. 43. *Altertümer von Pergamon*, VII, pl. VIII.

The statue had a long subsequent history.[44] We hear of repairs made at different times (the first was ten years after its dedication); and a number of thefts of the precious material are recorded (e.g. in the fourth century Philourgos removed the gorgoneion from the aegis and in 296 B.C. Lachares absconded with the gold parts of the statue). In A.D. 375 it still stood inside the cella.[45] According to one report it was removed from there toward the end of the fifth century A.D.[46] There is some evidence that it perished in a fire between A.D. 429 and 485,[47] and still another account mentions it at Constantinople[48] in the tenth century. But its ultimate fate is not definitely known.

The greatest fruit of Pheidias' genius appears to have been the Olympian Zeus. He was even more celebrated than the Athena Parthenos. Pliny[49] says: "No one doubts that Pheidias' renown extends through all lands where the fame of his Olympian Zeus is heard"; and elsewhere refers to it as the "unrivaled statue."[50] Dio Chrysostomos[51] calls it the embodiment of peace, "the guardian of Hellas when she is of one mind and not distraught with faction," and concludes that when you stand before this statue, you forget every misfortune of our earthly life, even though you have been broken by adversities and grief and sleep shuns your eyes—so great is the splendor and beauty of the artist's creation.[52] Quintilian[53] tells us that "its beauty can be said to have added something to traditional religion, so adequate to the divine nature is the majesty of his work" (cuius pulchritudo adiecisse aliquid receptae religioni videtur; adeo maiestas operis deum aequauit). Pheidias himself when asked after what pattern he was going to fashion his Zeus is said to have quoted Homer's lines[54]: "So spake the son of Kronos and nodded his dark brow, and the ambrosial locks waved from the king's undying head; and he made Olympos quake." And this vision of the god of gods he succeeded in embodying in his Olympian Zeus, transcending all previous conceptions and creating thereby a great work of religious sculpture.

What have we by which to visualize this statue? Unfortunately little. Pausanias[55] gives a long description of it and all its accessories:

> The god is seated on his throne and is made of gold and ivory; on his head rests a garland which imitates sprays of olive. In his right hand he bears a Victory, also of ivory and gold, which holds a fillet and has a garland on its head; and in his left is a sceptre inlaid with every kind of metal; the bird which is perched on the sceptre is the eagle. The sandals of the god and likewise his robe are of gold.

Olympian Zeus

44. Koehler, in *Ath. Mitt.*, v, 1880, p. 89; Schreiber, *Athena Parthenos*, p. 628.

45. Zosimos, *Hist. nova*, IV, 18. 46. Marinus, *Life of Proclus*, 30.

47. Führer, in *Röm. Mitt.*, 1892, pp. 158 ff.

48. Schol. Aristid. *Orat.* 50. On the words "the ivory Athena": "It seems she is set up in the Forum of Constantine and in the Bouleuterion, or Senate as they call it" (by Arethas, archbishop of Caesarea).

49. *N.H.* XXXVI. 18.

50. *N.H.* XXXIV. 54. 51. *Orat.* XII. 51 f. (period of Domitian).

52. Ibid., 51. 53. *Inst. orat.* XII. 10. 9.

54. Strabo VIII. 353. 55. v. 11. 1 ff.

On the robe are wrought figures and flowers; these latter are lilies. The throne is diversified with gold and precious stones and ebony and ivory and there are figures upon it painted and sculptured.

Then follows a detailed account of the decorations[56] and the screens, the latter painted by Panainos, Pheidias' nephew.[57] The statue was about seven times life-size, the full height of the temple. Strabo[58] speaks of it as "almost touching the roof with his head, thus giving the impression that if Zeus arose and stood erect he would unroof the temple."

We must imagine this colossal figure, then, grandly conceived and carved in simple lines; gleaming with its gold and ivory, but the brightness tempered by the figures wrought in the drapery; the scepter sparkling with precious stones; and the throne elaborately decorated—a combination of grandeur and richness. How different would be our understanding today of Greek sculpture if one of these masterpieces had survived! Instead, all that has come down to us is the little reliefs on the reverse of some Roman coins[59] and engraved gems,[60] showing the head (figs. 647, 648) and the enthroned figure (figs. 649, 650[61]). Diminutive, late, and inadequate though they be, even they are imbued with something of the benign majesty of the original and give us a faint impression of the harmony of the composition. And they indicate a stylistic date around 435 B.C.—as suggested by the completely easy pose and the deep-set eyes (cf. fig. 647), i.e. the date indicated by recent discoveries at Olympia[61a] (cf. p. 168).

Though we have no direct copies of Pheidias' Zeus except the small reproductions on the coins and gems, many later works of art reflect its influence. The marble head in Boston[62] (fig. 652) and a painting from Eleusis (fig. 653),[63] evidently reproduce the general style, modified to suit a later age. It is natural that the creation of a type so universally acclaimed as fitting should exercise a strong and long-felt influence.

The temple of Zeus was burned down in the time of Theodosius II in the fifth cen-

56. They include a representation of "Apollo and Artemis shooting down the children of Niobe," which have been thought to have been reproduced in a number of copies harking back to a fifth-century original, among them the disk in the British Museum, Smith, *Cat.*, III, no. 2200, pl. XXVI. Cf. Furtwängler, *Masterpieces*, pp. 43 f., with references.

57. Cf. A. Reinach, *Recueil Milliet*, nos. 162 ff. Pliny and Pausanias call him a brother of Pheidias, but the usually well-informed Strabo a nephew. 58. VIII. 353.

59. Minted between A.D. 48 and 198, i.e. in the time of Hadrian, Commodus, Septimius Severus, Caracalla, and Geta. Cf. Imhoof-Blumer and Gardner, *Numismatic Commentary*, pl. P, nos. 20–23; Liegle, in *Kongressbericht* (1939), pp. 653 ff.; Seltman, in *Hesperia*, XVII (1948), pl. 28, 1.

60. On these cf. now Richter, "The Pheidian Zeus at Olympia," in *Hesperia*, XXXV, 1966, pp. 166 ff., and *Engraved Gems*, vol. II, nos. 55 ff.

61. A carnelian intaglio in the Cabinet des Médailles, no. 1421a, in which the head of the statue reaches way up to the apex of the roof, just as Strabo describes it. Thereby we have the confirmation that the figures on the coins of Elis really represent the Pheidian Zeus—which had been doubted by some.

61a. The interval of ca. 30 years between the completion of the temple with its sculptural decoration (cf. pp. 97 f.) can be explained by supposing there was an earlier cult statue—perhaps reproduced on coin of Elis (cf. *B.M.C.*, Peloponnesos, pl. XII; Head, *N.H.²*, p. 422, fig. 230; and my figs. 65a,b.

62. Caskey, *Catalogue*, no. 25. 63. *Eph. Arch.*, 1888, pl. 5, p. 77.

64. Schol. Lucian, *Rhetor. praecept.* 10, vol. 4, p. 221, ed. Jacobitz.

tury A.D. and Pheidias' statue may have perished at that time.[64] But according to the Byzantine historian Cedrenus[65] it was later at Constantinople in the Palace of Lausos; and this palace was destroyed by fire in A.D. 475.[66]

If the coins reproduce at all accurately the style of the Olympian Zeus—and as they are of Roman date that may be assumed—they point to a date in the second half of the fifth century. At least this is indicated by the deep-set eyes (particularly clear in the recently discovered, well-preserved coin in Berlin[67]) and the completely easy pose. We may add that the little Nike (if it reproduces the original creation and not a later substitution) is markedly naturalistic; considerably more so than that held by the Athena Parthenos. The slight archaism in the rendering of the hair of Zeus is not uncommon in heads of the later fifth century.[68] But if the Zeus on stylistic grounds suggests a date after rather than before 450, Pheidias must have gone to Elis after his work on the Parthenos in Athens (448–438), not before it[69] (cf. supra, p. 168).

To the question: "Which of the works of Pheidias do you praise most highly?" Lucian[70] gives the answer: "Which but the Goddess of Lemnos whereon Pheidias deigned to inscribe his name," and then proceeds to borrow certain features for his Panthea or perfect woman: "Pheidias and the Lemnian Goddess shall bestow on her the outline of her countenance, her delicate cheeks, and finely proportioned nose." Lucian does not stand alone in his admiration. Pausanias[71] is likewise carried away: "The most remarkable of the works of Pheidias, an image of Athena, called the Lemnian, after the dedicators." The statue stood on the Akropolis. The dedicators were doubtless the Athenian colonists sent to Lemnos between 451 and 448. In addition to these definite references there are others which may perhaps be applied to this statue: (1) Pliny's[72] statement that "Pheidias made an Athena of bronze of such outstanding beauty that she was called the Beautiful"; (2) a passage of Himerios[73] to the effect that Pheidias did not always represent Athena armed, but sometimes substituted beauty for the helmet; and (3) an epigram in the *Anthology* in which the statue of Athena in Athens is preferred to the Knidian Aphrodite.[74] If Lucian's and Pausanias' statements reflect a universally admitted preference, it is certainly probable that these references to the beautiful Athena apply to the Lemnian; and if so, we obtain from them the additional information that the statue was of bronze and did not wear a helmet.

What was this statue which could be called Pheidias' finest creation even by those who knew his two great chryselephantine figures? It must have been one which by

Athena Lemnia

65. *Comp. histor.* 322 B. 66. Ibid., 348 A.

67. Cf. Liegle, op. cit., pl. 76.

68. Cf., e.g. the examples cited by Pfuhl, in *J.d.I.*, XLII (1927), p. 133.

69. Since this question of chronology is now settled (by the recent finds at Olympia, cf. supra) I am omitting from this edition the account dealing with the various bits of external evidence for the late date given in the former editions. 70. *Eikones*, 4.

71. I. 28. 2. 72. *N.H.* XXXIV. 54.

73. *Orat.* 21. 4. 74. *Anthol. Gr.* I. 193; cf. also IV. 168, 248.

some exquisite quality of its own made one forget its more ambitious rivals. Furt-wängler's theory[75] that we possess marble copies of it in two marble statues in Dresden (cf. fig. 655) and in a head in Bologna (fig. 654) meets the evidence exceptionally well. The style corresponds in date to the Lemnian dedication (the forties of the fifth century) ; the sharp contours of the features, the treatment of the hair, and the hollow eyes point to a bronze original; and above all they suggest that the original was of surpassing beauty. There are indeed few heads preserved to us from antiquity of such pure and noble loveliness as the head in Bologna (Roman copy though it is) and few figures so grand in conception as this statue when we can visualize its composition holding a helmet in one hand and a lance in the other (fig. 656[76]). Our admiration goes out to her just as did Lucian's and Pausanias' of old. Moreover the point picked out by Lucian, the countenance with its delicate cheeks, is particularly striking here. It is its lovely oval face which adds so greatly to its attraction and distinguishes it from other "Pheidian" heads, such as the Athena Parthenos (figs. 638 ff.) and the Athena Medici. Furthermore, that the statue was admired also in Roman times is indicated by its appearance on engraved gems of that period (cf. fig. 658[77]). If only it were certain that by his beautiful helmetless Athena Himerios had meant the Lemnian, or even that Pliny's "bronze" Athena is the Lemnian, the case would be strong indeed. But neither of them actually says so. And so we cannot regard the identification as abso-lutely certain.

The Amazon Pliny[78] tells the following anecdote: "The most famous artists, though born at some distance of time from each other, still came into competition, since each had made a statue of an Amazon, to be dedicated in the temple of Artemis at Ephesos, when it was decided that the prize should be awarded to the one which the artists themselves who were on the spot declared to be the best. This proved to be the statue which each artist placed second to his own, namely that of Polykleitos; the statue of Pheidias was second, that of Kresilas third, Kydon's fourth, and Phradmon's fifth." Whatever may be the truth of the details of this story, it suggests that five statues by the artists named stood in the temple at Ephesos perhaps as a single offering. And this is borne out by other evidence. Three distinct types occur in many replicas (cf. figs. 662, 671, 700), indicating that they were derived from famous originals; and they are in the style of the required period, i.e. about 440, when Pheidias, Polykleitos, and Kresilas are all known to have been active; while a fourth and a fifth type evidently not so popular and presumably by lesser artists such Phradmon and Kydon, also exist (figs. 663,

75. *Masterpieces*, pp. 4 ff.; cf. now also Lippold, *Handbuch*, p. 145, and the references there cited.

76. From a restored cast in Budapest (Hekler, *Pheidias*, p. 21, figs. 9, 10) ; in that in Strassburg (Wolters-Springer, *Handbuch der Kunstgeschichte*[12], fig. 498) the helmet is held too high and the composition of the arms is thus less harmonious. A similar composition appears on a red-figured vase in Bologna (Pellegrini, *Catalogo dei vasi delle necropoli felsinee*, p. 191, fig. 115, no. 393 [cf. our fig. 657]).

77. In the British Museum, Walters, *Catalogue of Engraved Gems*, no. 1372; Furtwängler, *Antike Gemmen*, pl. XXXVIII, 35 (cf. also his *Masterpieces*, p. 14, note 4) ; Richter, *Engraved Gems*, II, no. 104.

78. *N.H.* XXXIV. 53.

664).[79] Furthermore a relief with an Amazon of one of the popular types has been found at Ephesos,[80] lending additional credence to the story. The question which type should be connected with what particular artist is naturally one of great interest and one that has absorbed archaeologists for some time. Furtwängler's[81] allocation of the Mattei type to Pheidias, the Berlin one to Polykleitos, and the Capitoline one to Kresilas has recently been challenged[82] and again endorsed.[83] Both on external and on stylistic evidence it still—to me at least—seems the most plausible (cf. p. 198).

The identification of the Mattei type[84] (fig. 661)—now best represented by the headless, but otherwise almost complete, statue found in the Villa Adriana (fig. 662)[85]—with that of Pheidias is rendered likely by its close correspondence to the representation of a (lost) gem[86] (fig. 660) showing an Amazon grasping a lance with both hands, the right high above the head, perhaps about to swing herself on to her horse,[87] and Lucian's testimony:[88] "Which of the works of Pheidias do you praise most highly? . . . The Amazon who is leaning on her spear." The missing parts of the Mattei statue (the head and both arms) can be partly reconstructed from the gem engraving and from the statue in Hadrian's villa.

Unfortunately none of the replicas of the Mattei type have the head preserved except the supporting figure from Loukou in Athens[89] (fig. 659)—a rather generalized rendering. The head corresponds in a general way to that on the gem, and clearly goes back to a fine original. Lucian[90] wants to borrow for his perfect woman "the setting of

79. It used to be thought that Kydon was a mistake for the ethnic of Kresilas, i.e. "of Kydonia". (though Κήδων nowhere else is used for this ethnic). But recently a fifth type of Amazon, also from Ephesos, has become known (cf. Eichler, in *Oest. Jahresh*, XLIII [1956–58], pp. 7 ff.; Richter, "Pliny's Five Amazons," *Archaeology*, 12 [1959], pp. 111 ff.). So it seems best to revert to Pliny's specific statement: "probatissimam apparuit iam esse quam omnes secundam a sua quisque iudicarent, hanc est Polycliti, proxima ab ea Phidiae, tertia Cresilae, quarta Cydonis, quinta Phradmonis." Since the implication is that the fourth and fifth types were by Phradmon and Kydon, so the least original statues would seem to be by them. The type represented in the statue in the Villa Doria Pamfili in Rome used to be connected with Phradmon; but this is now uncertain, since there are two candidates, and so which of these two types was the work by Phradmon, which by Kydon remains problematical. Each is represented by a single extant copy, and each approximates one of the evidently more famous types, i.e. that in the Villa Doria Pamfili is markedly like the Berlin-ex Lansdowne type, and the new type from Ephesos resembles the Capitoline statue.

80. *J.d.I.*, xx, 1915, pl. 6. 81. Furtwängler, *Masterpieces*, pp. 128 ff.

82. E.g. by Graef, in *J.d.I.*, xii, 1897, pp. 82 ff.; Noack, in *J.d.I.*, xxx, 1915, pp. 131 ff.; Bulle, *Der schöne Mensch*, p. 100; Anti, *Mon. ant.* xxvi (1930), pp. 600 ff.; Pfuhl, in *J.d.I.* (1926), pp. 23 f.; Lippold, *Handbuch*, pp. 171 f. Cf. also Johnson, *Lysippos*, p. 30, who reviews the chief arguments.

83. Bieber, in *J.d.I.*, xxxiii, 1918, pp. 49 ff.; Richter, *Handbook of Greek Art*, pp. 114 f., 6th ed. (1969), pp. 126 f.

84. Amelung, *Die Skulpturen des Vatikanischen Museums*, ii, no. 265; Helbig-Speier, *Führer*⁴, i, no. 126.

85. R. Vighi, *Villa Hadriana*, 1958, pp. 51 f.

86. Natter, *A Treatise on the Ancient Method of Engraving on Precious Stones*, London, 1754, pl. xxxi, opp. p. 48.

87. Furtwängler, *Masterpieces*, p. 137; this explanation has been doubted (cf. Amelung, op. cit., 2, no. 265), but the pose calls for a specific action of this kind, cf. Langlotz, *Phidiasprobleme*, pp. 59 f.

88. *Eikones* 4. 89. National Museum, no. 705. Cf. Amelung, loc. cit.; S. Karouzou, *Cat.*, p. 66.

90. *Eikones* 6.

the mouth and the neck" from the Amazon of Pheidias, so that they were evidently of special excellence.[91]

Fragmentary though our knowledge of this statue is, we can yet appreciate a certain elasticity and vigor which distinguish her from her rival sisters and give her the appearance almost of a goddess. The treatment of the soft, crinkly chiton with its many variegated folds foreshadows that of the Parthenon pediments.

Anadoumenos Pausanias[92] saw a statue in Olympia of a "boy binding a fillet on his head" "by the great sculptor Pheidias." We have no other mention or description of it; but on stylistic grounds the Farnese Diadoumenos in the British Museum[93] (fig. 665) has been thought to be a copy of this work. It shows indeed a marked resemblance to the youths on the Parthenon frieze in the structure of the body and in a certain "sublimity" ($\mu\epsilon\gamma\alpha\lambda\epsilon\iota\acute{o}\tau\eta\varsigma$) of conception, so that the identification is certainly possible. But we must remember that a youth binding on a fillet as a badge of victory was a popular subject, and that Pheidias had many pupils, and his influence was widespread, so that the identification can be regarded only as a probable theory.

Other Works Ancient writers mention a number of other works by Pheidias: as early works, a group at Delphi of Athena, Apollo, Miltiades, Erechtheus, Kekrops, and other heroes —a tithe offering after Marathon,[94] a chryselephantine Athena at Pellene,[95] an Athena of gilt wood with marble face, hands, and feet at Plataia;[96] during Perikles' administration, an Aphrodite Ourania of Parian marble at Melite;[97] in his later years, an Aphrodite Ourania of gold and ivory with one foot on a tortoise at Elis,[98] a bronze Apollo,[99] a marble Hermes at Thebes,[100] a bronze Athena,[101] a marble Aphrodite [102] "of great beauty," and so on. They are mere names to us now.

The diversity of Pheidias' genius is attested by the fact that he worked in marble,[103] bronze, and gold and ivory; and that he was also a painter,[104] an engraver,[105] and, in the words of Pliny, opened up new possibilities in embossed metal work (toreutice).[106]

ATTRIBU- Inevitably a considerable number of statues of the period have been brought into
TIONS connection with the magic name of Pheidias; e.g. the fine Apollo from the Tiber in the National Museum in Rome (fig. 42), the Eleusis relief in Athens (fig. 520), the statuesque Zeus in Dresden, the Demeter in Cherchel, the kore in the Villa Albani. They

91. There have been several tentative identifications for this missing head, e.g. Furtwängler, *Masterpieces*, p. 138, suggested the head in Naples, pendant to the Doryphoros signed by Apollonios—of which a replica has since been found in Tivoli—which, however, does not fit the Pheidian Amazon found there; and Langlotz, *Phidiasprobleme*, pp. 61 ff. suggested a head in Petworth.

92. VI. 4. 5. 93. Smith, *Cat.*, I, no. 501.
94. Pausanias X. 10. 1. Erected probably about 465 B.C. 95. Pausanias VII. 27. 2.
96. Pausanias IX. 4. 1; Plutarch, *Aristid.* 20.
97. Pausanias I. 14. 7. On this statue cf. now S. Settis, χsλώνη, *Saggio sull'Afrodite Urania di Fidia* (1966).
98. Pausanias VI. 25. 1.
99. Pausanias I. 24. 8. 100. Pausanias IX. 10. 2.
101. Pliny, *N.H.* XXXIV. 54. 102. Pliny, *N.H.* XXXVI. 15.
103. Cf. Lucian, *Zeus Tragoedus*, 7. 104. Pliny, *N.H.* XXXV. 54.
105. Martial III. 35; IV. 39. 1, 4; X. 87. 15 f.; Nicephor. Gregor., *Hist.* VIII. 7; Julianus Imperat., *Epist.* 8.
106. Cf. on this subject Richter, *A.J.A.*, XLV, 1941, pp. 377 ff.

all have the Pheidian grandeur, but they do not really help us to visualize his style, for their connection with the master is not certain.

Is this, then, all we know of the greatest of Greek sculptors—a few reproductions on Roman coins and in Roman statues of a handful of his works? Fortunately we have other material to help us in our search. Since Pheidias was placed in charge of the artistic undertakings during Perikles' administration[107] he must have been responsible for the greatest of these—the Parthenon.[108] Plutarch[109] tells us that under him worked many architects, artists, and artisans, but "everything was under his direct charge." It stands to reason then that though he cannot have executed the sculptures of the Parthenon himself—probably an army of workmen was employed on this great task to complete it in the phenomenally short period of its production—he nevertheless had a guiding hand in them. He must have sketched the designs, or at least initiated and revised them. In any event his genius presided over their creation and they certainly show—one and all—"the sublimity and precision" ($\check{\epsilon}\chi o \upsilon \sigma \acute{a} \ \tau \iota \ \kappa a \grave{\iota} \ \mu \epsilon \gamma a \lambda \epsilon \hat{\iota} o \nu$ $\kappa a \grave{\iota} \ \mathring{a} \kappa \rho \iota \beta \grave{\epsilon} s \ \mathring{a} \mu a$) which we are told were the chief characteristics of his style.[110] It was indeed a mighty task. The ninety-two metopes (of which only twenty are fairly well preserved now) were executed between 447 and 443[111] at the beginning of the building; for they had to be in place before the erection of the cornice. The frieze (524 feet, 1 inch,[112] about 160 meters long) was probably carved in situ between 442 and 438.[113] The two pediments come last in date, between 439 and 432,[114] after the dedication of the temple statue in 438. Together they show us the development of sculpture in Athens during the third quarter of the fifth century. And an astounding picture it is—from the grandiose, simple metopes (figs. 445, 447) to the quiet, rhythmical frieze (figs. 305, 381, 525, 527, 528), and ending with the rich and splendid

107. Plutarch, *Perikles* XIII. 4.

108. On the building cf. especially Dinsmoor, *Architecture*, pp. 159 ff. On the sculpture cf. Smith, *The Sculptures of the Parthenon*; Lippold, *Handbuch* (1950), and the references there cited; Brommer, *Die Skulpturen der Parthenongiebel* (1963), and *Die Metopen des Parthenon* (1967); E. Harrison and Brommer, in *Hesperia*, 24 (1955), pp. 85 ff.; E. Harrison, in *A.J.A.*, LXXI (1967), pp. 27 ff.

109. *Perikles* XIII. 4. 110. Demetrius, *De Eloct.* 14.

111. The building records of the Parthenon, fragments of which are preserved, help to establish the dates of the various parts of the building; cf. Dinsmoor, in *A.J.A.*, XVII, 1913, pp. 77 ff.; XXV, 1921, pp. 242 ff. The first entry is in the year 447–446.

112. Smith, *The Sculptures of the Parthenon*, p. 52.

113. We have a record in the building inscription for wood purchased in 444–443, probably for the scaffolding necessary for the erection of the frieze and the roof; and in 438 the wood from these scaffoldings is sold; see also my p. 66.

114. According to the building inscription, marble for this purpose was brought to the workshops in 439–438 and the work begun the following year. In 434–433 there is an entry of 16,392 drachmas given as yearly wages to the sculptors ([$\mathring{a} \gamma a \lambda$]$\mu a \tau o \pi o \iota o \iota s$), cf. Woodward, in *B.S.A.*, XVI (1909–10), p. 196. That Pheidias could not have executed the pediment sculptures himself is clearly indicated by the mention of sculptors instead of sculptor (probably about ten, for they receive about five times as much as the wage given to the sculptors of the Epidauros pediment and akroteria [see my pp. 214 f.] when wages were about 100 percent higher). On the other hand a design or model of the pediment figures must have preceded the beginning of their execution; and surely Pheidias would not neglect or leave entirely to others the most important feature in the decoration of the temple.

pediment figures (figs. 74–76, 96, 126, 421–23, 665). But different though they are in details of modeling and composition they are all imbued with the same spirit—that quality of Pheidias' genius which made him excel in creations of divinities.

Pheidias lived through a momentous epoch in Greek art. He was born toward the end of the archaic period, took part in the experiments of the transitional one, and helped to impart to Greek art the idealism which to many now is its distinctive quality.

Kresilas

KRESILAS[1] from Kydonia, Crete, may be ranked among Athenian sculptors, for his chief works seem to have been executed in Athens. Five bases of statues giving Kresilas as the name of the sculptor have been found, three on the Akropolis of Athens:[2] (1) Ἑρμόλυκος Διειτρέφους ἀπαρχήν. Κρησίλας ἐπόησεν[3] (Hermolykos, the son of Dieitrephes [set it up] as a first offering. Kresilas was the sculptor). (2) (a) Πείκον Ἀνδρο[κ]λ[έος καὶ]ικλεός; (b) ἀνεθέτεν Ἀθεναί[αι δεκάτεν Κρεσ]ίλας ἐποίε,[4] "Peikon, the son of Androkles, and . . . , of . . . ikles, dedicated [it] to Athena as a tithe. Kresilas made it." Here the two fragments have been tentatively combined, and (b) read ([A portrait] of [Per]ikles, [Kres]ilas was the sculptor) ca. 450, and connected with the statue of Perikles (see below). (3) [τόνδε Πύρες] ἀνέθεκε Πολυμνέστου φίλο[ς υἰὸς] εὐξάμενος δεκάτεν Παλλάδι Τριτογενεῖ Κυδονιέτας Κρεσίλας εἰργάσσατο,[5] "This Pyres, the dear son of Polymnestos, dedicated as a tithe to Athena the Tritoborn in fulfilment of a vow. Kresilas the Kydonian made it." (4) Ἀλεξίας Λύωνος ἀνέθη[κε] τᾷ Δάματρι τᾷ [Χ]θονία[ι] Ἑρμιονεύς. Κρησίλας ἐποίησε Κυδωνιάτ[ας][6] (Alexias, the son of Lyon, of Hermione, dedicated it to the Chthonian Demeter. Kresilas of Kydonia made it. Probably to be connected with another inscription, with the signature of Dorotheos from Argos. (5) Κρησίλας ἐποίη . . . ἐκ Κυδωνιάς, "Kresilas of Kydonia made it at Delphi.[7] One of his statues was evidently taken to Pergamon for a base with his signature was found there."[8] We learn from these that Kresilas was active during 450–425, though the period can of course have been more extensive.

Pliny[9] mentions as one of Kresilas' works "Perikles the Olympian," and describes it as worthy of his name, adding, "The marvel of this art is that it has made men of renown yet more renowned." Pausanias[10] saw a portrait of Perikles on the Akropolis.

1. On Kresilas cf. Lippold, *Handbuch*, pp. 172 ff., and the references there cited; Orlandini, in *Enc. Arte Antica*, IV, 1961, pp. 405 ff., s.v. "Kresilas," and the references there cited.
2. Raubitschek, *Dedications*, nos. 131, 132, 133, and pp. 510 ff.
3. Loewy, *Inschriften*, no. 46.
4. *Delt. arch.*, 1889, p. 36; *I.G.*², I, no. 528; Meritt, in *Hesperia*, V, 1936, pp. 51 ff. The combination of the two fragments was considered doubtful by Raubitschek, *Dedications*, no. 131 and p. 511.
5. Loewy, op. cit., no. 47; repeated in *Anth. Pal.*, XIII, 13.
6. Loewy, op. cit., no. 45; Peek, in *Ath. Mitt.*, LIX, 1934, pp. 45 ff., no. 8.
7. *B.C.H.*, 1899, p. 378.
8. Jacobsthal, in *Ath. Mitt.* XXXIII (1908), p. 418, no. 60; Raubitschek, *Dedications*, p. 512.
9. *N.H.* XXXIV. 74. 10. I. 25. 1.

Two herms inscribed with the name of Perikles, in the British Museum[11] (fig. 668) and in the Vatican[12] (fig. 667), are clearly Roman copies of a work of about 440. Other good replicas of the head, not inscribed, are in the Barracco Museum, Rome,[13] in the Staatliche Museen, Berlin,[14] and in the Glyptothek, Munich.[15] The original was evidently a famous work by a well-known sculptor and so might well have been the portrait by Kresilas extolled by Pliny. But we must remember that apparently many portraits of Perikles were erected. For instance, Plutarch[16] says that "the images of Perikles *almost all of them* wear helmets"; so we are still bound to regard the identification as only probable. However that may be, the herms in question certainly show us a fine conception of the great Athenian who guided the fortunes of his city at one of the most critical periods of her history and to whom—more than to any other single man, except to the creative artists Pheidias and Iktinos—the great achievement of the Parthenon was due. The sculptor has admirably caught the noble, somewhat haughty spirit, which was able to rise above criticism when occasion demanded it, and which combined this detachment with a devoted friendship for people like Pheidias, Anaxagoras, and Aspasia. It would not be too much to say that such a portrait "added yet more renown to Perikles' fame." The portrait though generalized in the style of the fifth century has some curiously individual details. Perikles' high skull—which earned him the nickname of squill head[17]—is shown in the Naples copy where the hair shows through the eyeholes of the helmet. The little tilt of the head in the British Museum example (which is unbroken) is evidently a characteristic pose and gives it a lifelike quality. The small oblique wrinkles at the birth of the eyebrows with the two little horizontal cuts[18] beneath it accentuate the serious, thoughtful character of the head, while the full, sensuous lips suggest his more emotional and artistic side.

Another famous work by Kresilas mentioned by Pliny[19] is "a man wounded and *Volneratus* dying [volneratus deficiens] in whom the spectator can feel how little life is left." Pausanias[20] in describing the Akropolis of Athens mentions "a bronze portrait of Dieitrephes shot with arrows." Ross conjectured that the inscription from the Akropolis on the base of the Dieitrephes by Kresilas[21] belonged to the statue mentioned by Pausanias and that this was identical with Pliny's wounded man. Pausanias[22] identifies Dieitrephes with the Athenian general mentioned in Thucydides VII. 29 (414 B.C.) and VIII. 64 (411 B.C.). But these dates have been considered to be too late for the

11. Smith, *Catalogue*, I, no. 549.

12. Helbig-Speier, *Führer*⁴, I, no. 71. 13. Arndt, *Katalog*, pls. 39, 39a.

14. Kekulé, Bildnis des Perikles, in 61. *Winckelmannsprogramm*, p. 16; Blümel, *Katalog*, IV, K127.

15. No. 157. Arndt-Bruckmann, *Griechische und Römische Porträts*, pls. 411–16. Cf. V. H. Poulsen, *Acta Arch.*, XI, 1940, p. 32; Furtwängler, *Beschreibung der Glyptotek*, no. 50. On all these portraits cf. now Richter, *The Portraits of the Greeks*, I, 102 ff., figs. 429–44, and the references there cited.

16. *Perikles* III. 2. 17. Plutarch, *Perikles* III. 2 and XIII. 6.

18. These do not appear in all the replicas. 19. *N.H.* XXXIV. 74.

20. I. 23. 3.

21. See above (Loewy, *Inschriften*, no. 46; Raubitschek, *Dedications*, no. 132). 22. I. 23. 3.

character of the letters on the inscription; Furtwängler[23] therefore suggested an elder Dieitrephes, the father of Nikostratos (Thucydides 3. 75; 4. 119, 129), about whom however nothing definite is known. It is quite possible of course that Kresilas made two statues—a volneratus deficiens and a Dieitrephes shot with arrows. The base with the Dieitrephes inscription[24] is square and the upper side is only about $27\frac{1}{2}$ by $29\frac{1}{2}$ inches (70 × 75 cm.), showing that the statue—if that of a volneratus—was not represented fallen, but apparently in the act of falling. The boldness of such a conception would be typical of the transitional epoch (cf. figs. 143, 616) and would show that Kresilas—at least during his youth—caught the spirit of the experimental period in which he lived and attempted the momentary poses popular at the time. We may obtain some visualization of such a statue from extant representations of falling figures of that period such as the warrior ("shot with arrows") on the lekythos in the Bibliothèque Nationale in Paris[25] (fig. C on p. 43), the bronze statuette in Modena[26] (fig. 136), and the bronze wounded warrior in St. Germain-en-Laye[27] (figs. 135, 669; later reconstructed as a lamp support). The last bears a certain similarity to the Capitoline Amazon (figs. 670, 671) and the Perikles (figs. 667, 668)—in the heavy eyelids, the strongly marked tear ducts, the full lips with depressed corners, and the oval face; its identification therefore as a copy of Kresilas' volneratus deficiens seems attractive.

Amazon

FIG. W. Amazon, on a gem (from a drawing, enlarged) *Bibliothèque Nationale, Paris*

Pliny[28] mentions Kresilas as one of the sculptors who made an Amazon in competition with Pheidias, Polykleitos, Kydon, and Phradmon (cf. p. 174) and calls it "volneratus." The Capitoline (fig. 671) and Berlin (fig. 700) types of Amazon have both been thought to reproduce Kresilas' work. The arguments in favor of assigning the Capitoline one to Kresilas[29] are its similarity to the Perikles (cf. figs. 668, 670), and the fact that the wound is here the dominant note.[30] The right arm is wrongly restored. It should be raised and leaning on a spear, as on the gem fig. W, an attitude more suggestive of her helplessness. Even so the composition is somewhat heavy and lacks the rhythmical quality we associate with Polykleitos; it seems hard to believe that this figure won the prize in competition

23. *Masterpieces*, p. 123.

24. Loewy, op. cit., no. 46. The two holes on the upper face of the base noted by Loewy are not deep enough to have served for the attachment of a statue and can therefore not be taken as evidence of its pose. See also Raubitschek, loc. cit. 25. Furtwängler, op. cit., fig. 48.

26. Bulle, *Der schöne Mensch*, pl. 94. Here the attitude of the legs is reversed.

27. S. Reinach, in *Gazette des Beaux-Arts*, 1905, p. 203. The genuineness of the statuette has been doubted. When I examined the original (in 1927) I could see no valid reasons for such doubts. See also Lippold, *Handbuch*, p. 173; and for some restorations Picard, *Manuel*, II, pp. 604 f.

28. *N.H.* XXXIV. 75; see also XXXIV. 53. 29. Cf. Furtwängler, *Masterpieces*, pp. 128 ff.

30. Cf. the analysis by Furtwängler, op. cit., p. 134. This has of course been disputed by the adherents of other theories; but see Bieber, in *J.d.I.*, XXXIII (1918), p. 72.

with the statues preserved in the Mattei and ex-Lansdowne-Berlin types (cf. figs. 661, 700). The argument that the inner vastus is pronounced in the Capitoline statue, as in Polykleitos' Doryphoros and Diadoumenos, loses weight when we remember that other fifth-century statues not associated with Polykleitos have that rendering. It seems best, therefore, to assign the Capitoline type to Kresilas. The number of copies preserved of this type, especially heads, speaks for its popularity in ancient times.[31]

Basing his study of Kresilas on the Perikles and the Amazon (both of which however we must remember are not certain assignations) Furtwängler attributed to him the originals of the Athena Velletri[32] (fig. 672), the Diomede,[33] the Medusa Rondanini,[34] and the head of an athlete[35] (cf. fig. 205). They have in common certain marked characteristics—the long, narrow eyes with heavy lids and strongly marked tear ducts, the vertical grooves above the nose (present in the Perikles and the Diomede), the full, finely modeled lips with a slight depression at the corners, and the rendering of the hair in a series of ringlets (somewhat freer in treatment in the Petworth Athlete). The heads are all noble, severe types with a touch of melancholy (specially noticeable in the Amazon and the Petworth head) which gives them an individual cast, imparting an interesting mingling of idealism and realism. ATTRIBU-TIONS

We have tried to peer through the darkness in which the personality of Kresilas is still hidden, and have obtained a certain realization of what his style perhaps was. But it is based only on guesses, and this we must bear in mind in any future reconstructions.

Alkamenes

ALKAMENES[36] seems to have been an Athenian; for he is referred to as such by Pliny[37] and most of his important works were made in Athens; moreover, in a competition with Agorakritos, a Parian, we are told that Alkamenes won, "not by the merit of his work, but by the votes of his city, whose people supported their townsman against an alien."[38] Besides this testimony Suidas'[39] statement that he was a Lemnian and Tzetzes'[40] that he was an islander can hardly be credited. ORIGIN

The fame of Alkamenes was widely recognized: Pliny[41] speaks of him as "an artist of the first rank, whose works are to be found in many temples at Athens," Lucian[42] borrows from him several points for his perfect woman, and he is classed with the

31. Cf. list given by Michaelis, in *J.d.I.*, v (1886), 17, supplemented by Furtwängler, op. cit., p. 132, note 1, and Anti, in *Monumenti Antichi*, xxvi, 1920, cols. 501 ff. 32. Furtwängler, op. cit., p. 141.

33. Ibid., p. 146. 34. Ibid., p. 156.

35. Ibid., p. 161; *M.M.A. Handbook* (1930), p. 253, fig. 177; *Cat. of Greek Sculptures*, no. 45.

36. On Alkamenes cf. Lippold, *Handbuch*, pp. 184 ff., and the references there cited; Becatti, in *Enc. Arte Antica*, i, 1958, 255 ff., s.v. "Alkamenes," and the references there cited.

37. *N.H.* xxxvi. 16. 38. Pliny, *N.H.* xxxvi. 17.

39. Under Ἀλκαμένης.

40. *Historiarum variarum Chiliades*, viii. 340. Unless, of course, they are referring to another Alkamenes (see pp. 183 f.).

41. *N.H.* xxxvi. 16. 42. Εἰκόνες. 6.

DATE great Pheidias and Polykleitos by Dionysios of Halikarnassos.[43] Most of the available evidence points to the second half of the fifth century as the period of his activity. He is referred to generally as the pupil,[44] occasionally as the rival and contemporary[45] of Pheidias, terms not mutually exclusive, for a pupil may later become a rival and even be called a contemporary. We have a definite date for a relief of Athena and Herakles "dedicated after the Tyranny of the Thirty"[46] (404–403 B.C.).

WORKS
Hermes
Propylaios

 A herm of a bearded head[47] found at Pergamon (fig. 673) is inscribed: "You will recognize Alkamenes' beautiful statue, the Hermes before the gates. Pergamios set it up."[48] A similar but not identical herm found at Ephesos is also attested to be the work of Alkamenes by an inscription.[49] Both are evidently Roman copies or adaptations of a work by Alkamenes, perhaps the Hermes of the Gateway (ὃν Προπύλαιον ὀνομάζουσι) which Pausanias[50] saw at the entrance of the Akropolis, but of which he does not name the sculptor. That it was a famous production is indicated by the large number of copies we have, large and small, preserved in many museums (cf. fig. 674[51]). The style of the herm is evidently archaistic, the formal treatment of the hair and beard being conditioned by its architectonic character, for the rendering of the eyes places it in the second half of the fifth century.

Seated
Dionysos

 Representations of a seated Dionysos on Roman coins of Athens[52] (fig. 677) appear to reproduce the temple statue by Alkamenes seen by Pausanias.[53] The stiffness of the pose suggests a date before the Pheidian creation. The head, however (fig. 676), in which the eyes are deep-set, places it in the second half of the fifth century.

Other Works

 Ancient writers speak of a Hephaistos "in whom, though he is standing upright and clothed, lameness is slightly indicated in a manner not unpleasing to the eyes."[54] Roman copies of this work have been credibly identified—notably in a marble head in the Vatican, reliefs on Roman lamps, and a number of marble torsos.[54a] And it has been thought that the original of this Hephaistos was the cult statue of the Hephaisteion of Athens, which stands above the Agora.

 We also are told of a Hera in a temple on the way from Phaleron to Athens,[55] an Ares,[56] an Asklepios,[57] and an athlete.[58] According to Pausanias[59] he was the first who

43. περὶ τῆς Δημοσθένους λέξεως, 50. 1108. 44. Pliny, N.H. XXXVI. 16 and 17, and XXXIV. 72.
45. Pliny N.H. XXXIV. 49 and Tzetzes, Historiarum variarum Chiliades VIII. 340.
46. Pausanias IX. 11. 6.
47. Now in the Istanbul Museum; cf. Mendel, Catalogue des sculptures, II, no. 527.
48. Εἰδήσεις Ἀλκαμένεος περικαλλὲς ἄγαλμα Ἑρμᾶν τὸν πρὸ πυλῶν. εἴσατο Περγάμιος.
49. Praschniker, Oest. Jahr., XXIX, 1934, pp. 23 ff.; Picard, Manuel, II, pp. 554 f.
50. I. 22. 8. 51. M.M.A. Catalogue of Bronzes, no. 235.
52. Imhoof-Blumer and Gardner, Numismatic Comm., pl. CC, nos. I–IV, p. 142.
53. I. 20. 3.
54. Cicero, De Natura Deorum 1. 30.
54a. Cf. on this identification especially Furtwängler, Masterpieces (1895), pp. 88 f.; Bieber, Antike Skulpturen und Bronzen in Kassel, 1915, p. 16, no. 15; S. Karouzou, Ath. Mitt. 69/70, 1954/55, pp. 67 ff., and Rev. arch. 1968, fasc. 1, pp. 131 ff.; W. Fuchs, in Helbig-Speier, Führer⁴, I (1963), no. 293; Pharaklas, Arch. Deltion, XXI, 1966, pp. 122 ff.; and a forthcoming study by F. Brommer. 55. Pausanias I. 1. 5.
56. Pausanias I. 8. 4. 57. Pausanias VIII. 9. 1.
58. Pliny, N.H. XXXIV. 72. 59. II. 30. 2.

made "three images of Hekate attached to each other"; and such a triple image by him called Hekate on the Tower stood in Athens beside the temple of Athena Nike. His masterpiece was evidently his Aphrodite in the Gardens, in which Lucian[60] admired especially "the cheeks and prominent parts of the face, and furthermore the hands and the symmetry of the wrists and the delicacy of the tapering fingers"; "Pheidias himself is said to have put the finishing touches to this statue."[61] None of these works have been satisfactorily identified[62] with extant statues, though many tentative attributions have been made. The Aphrodite of the Gardens was once thought to be reproduced in the Venus Genetrix type,[63] but except for its attractiveness and its evident popularity (there are many extant replicas[64]) we have unfortunately no convincing evidence. Among the other attributions is the group of Prokne and Itys in the Akropolis Museum[65] (fig. 675) which has been thought to be identical with the group mentioned by Pausanias[66] as dedicated by one Alkamenes—(ἀνέθηκεν Ἀλκαμένης). Since the name is not uncommon,[67] one cannot be sure that the dedicator was the famous sculptor, especially as the execution is not of the highest order.

It is difficult to form a proper estimate of the style of Alkamenes from the meagre STYLE
evidence at our disposal. We may gather at least from the descriptions of his works that his favorite subjects were deities, and that these must have suited his style best. This is borne out by Quintilian's[68] remark that Polykleitos' work lacked the majesty (pondus) which Pheidias and Alkamenes were both able to impart to their statues. The herm and the Dionysos certainly suggest this quality of lofty serenity. So we can visualize Alkamenes as a worthy successor of Pheidias in his great idealistic conceptions.

But there is a piece of evidence which does not fit into this picture. Pausanias[69] in his description of the pediments of Olympia says that the pediment sculptures on the western end are by Alkamenes, "a contemporary of Pheidias and second only to him in the sculptor's art." It seems unlikely that Alkamenes should have been a prominent enough sculptor in 465–460 to be commissioned with a pediment composition of one of the most important temples in Greece and still be active after 403. Moreover, the little that we learn of Alkamenes' style in the herm from Pergamon and the Dionysos on the coins is not in line with that of the Olympia pediments. We shall see later (see p. 187 f.) that Pausanias' ascription of the east pediment to Paionios is also open to doubt. We must therefore either reject Pausanias' statement and put it down as one

60. *Eikones* 6. 61. Pliny, *N.H.* xxxvi. 16.

62. For attributions made and some new suggestions, cf. Schröder, "Alkamenes-Studien" in *Winckelmannsprogramm*, 1921; cf. also Schrader, *Phidias*, pp. 184 ff.; Walston, *Alcamenes*, pp. 149 ff.; Picard, *Manuel*, II, pp. 551 ff.; Lippold, *Handbuch*, pp. 184 ff.; Eckstein, in *Antike Plastik*, IV, 1965, pls. 12–14 (on the Hekateion).

63. The best replica is in the Louvre; cf. Brunn-Bruckmann, *Denkmäler*, pl. 473. On the identification of this Aphrodite cf. now Langlotz, "Aphrodite in den Gärten," *Sitzungsberichte der Heidelberger Akad. d. Wiss.*, philos. u. hist. Klasse, 1953–1954, 2 Abh., pp. 7 ff. 64. Harcum, in *A.J.A.*, XXXI (1927), pp. 141 ff.

65. Casson, *Catalogue*, pp. 257–58, nos. 1358, 2789. 66. I. 24. 3.

67. E.g. Pape, *Griech. Eigennamen* (1911), s.v. Ἀλκαμένης, listed eight then known.

68. *Inst. orat.* XII. 10. 8 (7). 69. v. 10. 8.

of his occasional mistakes, or we must suppose that there was an elder Alkamenes
belonging to the first half of the fifth century. For the latter view some support may be
gained from the fact that Pliny[70] places Alkamenes with such early sculptors as Critias
(Kritios), Nesiotes, and Hegias. But since they are called contemporaries of Pheidias,
and a date about 448 (83d Olympiad) is assigned to them, not much comfort can be
derived therefrom.

Agorakritos

PLINY[71] gives the following account of Agorakritos:[72] "Agorakritos of Paros was also
a pupil of Pheidias, who was attracted by his youthful beauty, and so is said to have
allowed his name to appear on several of his own works. Both pupils, however, en-
tered into competition with representations of Aphrodite, and Alkamenes bore the
palm; Agorakritos accordingly sold his statue, as the story goes, on the condition that
it should not remain at Athens, and called it Nemesis; it was set up at Rhamnous, a
deme of Attica, and was preferred by Varro to all statues." By other writers[73] this
statue of Nemesis is assigned to Pheidias, in spite of the fact that on a fold of the
garment was the signature of Agorakritos: Ἀγοράκριτος Πάριος ἐποίησεν, "Agorakri-
tos of Paros made it"; the popular explanation given being that Pheidias let Ago-
rakritos do this as a special favor. But Pliny's account is very specific and the fact
that Photios,[74] who repeats the popular story, says that the statue was first made for
Aphrodite reinforces Pliny's testimony.[75] Perhaps in later times the statue was attrib-
uted to the more famous artist and the story of Pheidias' generosity to his favorite in
letting him attach his name to his own works was invented to support the claim.

We obtain further details regarding this statue from Pausanias.[76] "On the head of
the goddess rests a crown bearing stags and small images of Victory; in her left hand
she holds an apple branch, in her right a bowl on which Ethiopians are represented."
It was of Parian marble,[77] ten cubits in height,[78] and was mounted on a base decorated
with reliefs.[79] For its name, Nemesis, "of all deities the most implacable enemy of
insolent men," Pausanias[80] gives a different account from that by Pliny; namely, that
the Persians who landed at Marathon "incurred the wrath of the goddess for thinking
in their pride that Athens lay as a prize at their feet and bringing Parian marble for
the erection of a trophy as though they had accomplished their end." This marble was
later made into the statue of Nemesis.

These stories assume special interest since a fragment of this statue was actually

70. *N.H.* xxxiv. 49. 71. *N.H.* xxxvi. 17.

72. On Agorakritos cf. Lippold, *Handbuch*, pp. 187 ff., and the references there cited; Maribini-Moes, in
Enc. Arte Antica, i (1958), pp. 146 ff., s.v. "Agorakritos," and the references there cited.

73. Strabo, Zenobios, Suidas, Photios, Tzetzes, Hesychios, Pomponius, and Solinus; cf. Overbeck, *Schrift-
quellen*, pp. 835–43. 74. Ῥαμνουσία Νέμεσις.

75. Cf. on this subject Wilamowitz, "Antigonos von Karystos," in *Philologische Untersuchungen*, iv, 1881,
pp. 10 f. 76. i. 33. 2.

77. Pausanias i. 33. 2. 78. Zenob. v. 82.

79. Pausanias i. 33. 7–8. 80. i. 33. 2.

found during excavations in the temple of Nemesis at Rhamnous[81] (fig. 678). It is
the upper part of a marble head and could easily be identified as the work in question,
for it fits the evidence exactly. It is female, colossal, of Parian marble, of the style
of the second half of the fifth century, and it has traces of a *stephanos* with holes above
—to carry the crown described by Pausanias. So we may confidently take this little
fragment as coming from the hand of Pheidias' favorite pupil. Small and battered
though it is, its study teaches us that Agorakritos followed closely in the footsteps of
his great master. The flat, wavy hair, the accentuated lower eyelid, the simple model-
ing of the cheek are paralleled on the figures of the Parthenon frieze; and they pro-
duce the same general effect of serenity and grandeur. It has been suggested that we
may obtain a general idea of the statue from the representations on fourth-century
coins of Cyprus of a goddess holding a phiale and a branch[82] (fig. 679); but this is
problematical. There have also been found a number of fragments of the relief which
decorated its base,[83] including heads of women (cf. fig. 680) and youths, parts of
draped bodies, and a horse's head. The execution—in very high relief, about half
life-size—is delicate, though somewhat cursory, as would be natural in a decorative
composition, presumably designed by Agorakritos but executed by his assistants. We
learn from Pausanias that the subject was Leda bringing Helen to Nemesis in the
presence of Homeric heroes;[84] and we can obtain an idea of its composition by a Ro-
man copy of four of the figures in Stockholm.[85]

There are two other works by Agorakritos mentioned by ancient writers—a bronze
group of Athena Itonia and Zeus in the temple of Athena at Koroneia in Boeotia[86]
and a statue of the Mother of the Gods.[87] The latter is described as seated, holding a
cymbal in her hand, and with lions under her throne. We may therefore have repro-
ductions of it in a type which occurs in a number of replicas in many variations and
corresponds to this general description.[88]

From all this evidence we learn that Agorakritos was a worthy representative of the
idealistic school which Pheidias had inaugurated.

Kallimachos

OF Kallimachos[89] we know the following: he made a golden lamp for the Athena
Polias[90] (in the Erechtheion, which was completed in 408) and a seated image of

81. Rossbach, *Ath. Mitt.*, XV, 1890, pp. 64 ff. It is now in the British Museum, cf. Smith, *Catalogue*, I, no. 460.

82. Six, in *Numismatic Chronicle*, 3d series, vol. II, 1882, pl. V, pp. 89–102; Lacroix, *Reproductions de statues sur les monnaies*, pp. 287 ff., pl. XXVI, 1.

83. National Museum, Athens, nos. 203–14. Papaspiridi, *Guide*, p. 64, and S. Karouzou, *Cat.*, p. 54.

84. Pausanias I. 33. 7–8.

85. Kjellberg, *Nationalmusée Arsbok*, 1923, pp. 1 ff., fig. 1. Compare the reconstruction made previous to the identification of the Stockholm relief by Pallat, in *J.d.I.*, IX (1894), p. 9.

86. Pausanias IX. 34. 1.

87. Pliny, *N.H.* XXXVI. 17; attributed to Pheidias by Pausanias I. 3. 5, and Arrian, *Peripl. Pont. euxin.* 9.

88. von Salis, *J.d.I.* XXVIII (1913), pp. 1 ff.

89. On Kallimachos cf. Lippold, *Handbuch*, pp. 222 ff., and the references there cited; Guerrini, in *Enc. Arte Antica*, IV, 1961, pp. 298 ff., s.v. Kallimachos, and the references there cited.

90. Pausanias I. 26. 6.

Hera[91] for a temple at Plataia which was erected after 426. He is said to have invented the Corinthian capital,[92] and to have been the first[93] "to bore marble" ($\lambda\ell\theta ov\varsigma$ $\pi\rho\hat{\omega}\tau o\varsigma$ $\dot{\epsilon}\tau\rho\dot{v}\pi\eta\sigma\epsilon$), that is, to employ the drill. He was known for the finicky quality of his work. Pliny[94] says of him: "Of all the artists Kallimachos is the most remarkable for the epithet applied to him. He continually subjected his own work to the severest criticism and bestowed endless labor upon it, for which reason he was called *catatexitechnus,* 'the man who enfeebles his art'; a memorable warning that even diligence must have its limit. His dancing maidens of Sparta is a work of flawless precision, but one robbed of all its charm by the excessive labor spent on it." Vitruvius[95] and Dionysios of Halikarnassos[96] both speak of the elegance and grace of his work. It is ingenuity, then, and graceful elaboration that characterize this master. The relief in the Capitoline Museum[97] of Pan and the three Graces (fig. 681) on which is the inscription, "Kallimachos made it," apparently of late Hellenistic or Roman date, is either a later copy of one of his works[98] or merely signed by another Kallimachos.[99] The Spartan dancers (Pliny's *saltantes Lacaenae*) have been recognized in a number of reliefs of the Roman period, and the stylistically related dancing Maenads, of which copies exist in Madrid (cf. fig. 554), Rome, and New York (fig. 683), have also been connected with Kallimachos.[100] The almost exaggerated transparency of the garments would place their prototypes at the very end of the fifth or the beginning of the fourth century, which is the period in which Kallimachos appears to have been active; and their elaboration and elegance bear out the estimate in which Kallimachos was held. So the attribution is certainly a possible one. And it would make us agree with Pausanias'[101] statement that Kallimachos "fell short of the first rank in his art"; for his figures, charming though they are, lack the significance of the great works of this period.

Paionios

PAIONIOS of Mende,[1] in Thrace, is known to us by an original work found in Olympia in 1875.[2] It is a statue of a flying Victory with an eagle beneath her, the whole mounted on a high triangular base[3] (figs. 682, 687) on which is the following inscrip-

91. Pausanias IX. 2. 7. 92. Vitruvius IV. 1. 10.

93. Pausanias, I. 26. 7. This can hardly be correct, for both the simple drill and the running drill were in use at an earlier period, cf. p. 122. 94. *N.H.* XXXIV. 92.

95. IV. 1. 10. 96. *De Isocrate* 543R.

97. Loewy, *Inschriften,* no. 500; Helbig-Speier, *Führer*⁴, II, no. 1371 (with references).

98. Cf. Schmidt, *Archaistische Kunst,* pp. 62f.; Brunn-Bruckmann, *Denkmäler,* pl. 654, left.

99. So e.g. von Steuben in Helbig-Speier, *Führer*⁴, II, no. 1371.

100. Rizzo, *Thiasos;* Richter, in *A.J.A.,* XL, 1936, pp. 11 ff.; Caputo, *La Danza delle Menadi,* 1948.

101. I. 26. 6.

1. On Paionios cf. Lippold, *Handbuch,* p. 205 and the references there cited; Hofkes-Brukker, in *Enc. Arte Antica,* V (1963), pp. 844 ff., s.v. "Paionios," and the references there cited.

2. Treu, *Olympia,* III, pls. XLVI–XLVIII, text, pp. 182 f.; for the reconstruction by Grüttner, cf. Pomtow, in *J.d.I.,* XXXVII (1922), p. 62, fig. 5; on the fragment of the head (my fig. 687) cf. *Olympia* III, pp. 190 ff.

3. Nine blocks of the base have been found. It has been estimated that originally there were twelve blocks, which would bring the total height to nearly 30 feet.

tion:[4] "The Messenians and Naupaktians dedicated [it] to Olympian Zeus as a tithe of the spoil of their enemies. Paionios of Mende made the statue and was a successful competitor in the construction of the akroteria for the temple." To make our evidence complete the statue is described by Pausanias:[5]

> The Dorian Messenians who formerly received Naupaktos from the Athenians dedicated at Olympia a statue on a pillar. This was the work of Paionios of Mende, and was set up from spoils taken from the enemy when the Messenians were at war with the Akarnanians and the people of Oiniadai. Such at least is my view; but the Messenians themselves assert that the statue is a memorial of the engagement in the island of Sphakteria in which they fought beside the Athenians and that they did not inscribe the name of the enemy on the monument for fear of the Spartans, while they had no fear of the Akarnanians or the people of Oiniadai.

We can imagine Pausanias in the Altis puzzling over the inscriptions and wondering who the enemy referred to was! It is not likely, however, that his guess is right, for in the expedition against the Oiniadai (in 452 B.C.) the Messenians were anything but successful and had to beat a hasty retreat by night. There is no reason, therefore, to doubt the Messenian tradition that the engagement referred to was the battle of Sphakteria. This places the statue not long after 424, a date which accords well with its style; for the transparency of the drapery against the body and its sweeping folds where it is blown around the figure are characteristics of the last quarter of the fifth century.[6] Attempts made to date the statue earlier, about 450,[7] are supposed to derive support from the early style of the head, better preserved replicas of which are the Hertz head[8] in the Palazzo Venezia (figs. 684, 685) and the head from the Vatican Magazzini[9] (fig. 686). But the early appearance of the former is largely due to the rendering of the nose, which is restored, while a study of the eyes with the delicately modeled lower lids and of the rounded mouth point to a later date; and this is fully borne out by the Vatican head, in which the work is more delicate and variegated, thoroughly in line with later fifth-century work. The beautiful poise of the figure and the bold and yet restrained composition show us Paionios as a sculptor of individuality, strongly imbued with the great conceptions of his period.

The date of the Nike is important in our consideration of Pausanias' attribution to Paionios of the eastern pediment of the temple of Zeus at Olympia:[10] "The sculptures of the front pediment are the work of Paionios, a native of Mende in Thrace." Not only is the period of time which separates the pediment sculptures from the Nike con-

4. Loewy, *Inschriften*, no. 49.

5. v. 26. 1.　　　　　　　　　　　　　6. See p. 71.

7. Amelung, in *Röm. Mitt.*, IX, 1894, pp. 168 f.; but see the discussion by Furtwängler, *Olympia*, III, text, pp. 191 ff.; and Pfuhl, in *J.d.I.*, XLI (1926), p. 25.　　　　8. Amelung, op. cit., pp. 162 f.

9. Kaschnitz-Weinberg, *Sculture del Magazzino del Museo Vaticano*, no. 47, pp. 29 ff., pl. XV. Both show some variations from the Olympia example, e.g. in the rendering of the headband.

10. v. 10. 6.

siderable, but there is also the difference of style. How is it possible to attribute to the same master works stylistically so far removed from each other? It is best, therefore, to suppose either that Pausanias was mistaken, or that there was an earlier Paionios. Possibly Pausanias was misled by the statement in the inscription on the base that Paionios "made the akroteria of the temple" and confused them in his mind with the pediment. The akroteria are elsewhere described by Pausanias:[11] "A gilt kettle is set on each extremity of the roof of the temple at Olympia; and a Victory, also gilt, stands just at the middle of the gable."[12]

Strongylion[13]

PAUSANIAS[14] describes a bronze statue of the wooden horse which he saw on the Akropolis: "The story of the horse is that it contained the bravest of the Greeks, and the bronze horse is in accordance therewith, for Menestheus and Teukros are leaning out of it, and the sons of Theseus also." Part of the marble base of this ambitious composition was found on the Akropolis in 1840 (fig. 689) with the following inscription: "Chairedemos, the son of Euangelos of Koile, dedicated it. Strongylion made it."[15] Aristophanes refers to this horse in his *Birds*[16] and cites the first five words of the inscription. The lettering of the inscription also agrees with a date in the last quarter of the fifth century.

Pausanias and Pliny mention other works by Strongylion—an Amazon "with beautiful legs" greatly admired by Nero, who carried it with him from place to place;[17] a boy to whom Brutus became so attached that it went by the name of "Bruti puer";[18] Muses on Mount Helikon;[19] and an Artemis called "the Saviour" ($\Sigma\acute{\omega}\tau\epsilon\iota\rho\alpha$) at Megara.[20] The latter is represented on Roman coins of Megara and Pegai[21] (fig. 688), where the goddess appears in a short chiton, running, with a torch in each hand. Sometimes the figure is mounted on a base inside a temple. A figure in such rapid motion is unusual for a temple statue and like the bronze horse bears out the originality of the artist. From Pausanias[22] we learn also that Strongylion made "oxen[23] and horses of

11. v. 10. 4.

12. That this Victory was a reduced copy of the one on the triangular base is not suggested by our present knowledge of Greek sculpture. This applies also to Pomtow's theory (*J.d.I.*, XXXVII, 1922, pp. 55 ff.) that the statue erected on the Messenian triangular base in Delphi was the bronze original from which the Victory in Olympia was copied. The fifth century was an age of original creations, not of replicas.

13. On Strongylion cf. Lippold, *Handbuch*, pp. 189 f., and the references there cited; Moreno, in *Enc. Arte Antica*, VII (1966), 518 f., s.v. "Strongylion," and the references there cited.

14. I. 23. 8.

15. Loewy, *Inschriften*, no. 52; Stevens, in *Hesperia*, V, 1936, pp. 460 f.; Raubitschek, *Dedications*, no. 176, and p. 524. 16. 1128.

17. Pliny, *N.H.* XXXIV. 82. 18. Pliny, *N.H.* XXXIV. 32; Martial II. 77. 3f.

19. Pausanias IX. 30. 1. 20. Pausanias I. 40. 2.

21. Imhoof-Blumner and Gardner, *Numismatic Commentary*, pl. A, nos. I–II; Lacroix, *Reproductions de statues sur les monnaies*, pp. 293 f., pl. XXVII. 22. IX. 30. 1.

23. For one of his bulls cf. Stevens, in *Hesperia*, Supplement III, pp. 19 ff.

remarkable excellence." He was evidently, like Myron, a great animal sculptor; and he was akin to him also in his adventurous spirit.

Polykleitos

POLYKLEITOS[24] calls himself "an Argive" on the base of his statue of Pythokles[25] and he is referred to as such by Plato[26] and Pausanias.[27] Pliny's[28] statement that he came from Sikyon, the successor of Argos in civic and artistic importance, is an understandable anachronism. He is said to have been a pupil of the Argive Ageladas.[29] Plato calls Polykleitos a contemporary of Pheidias[30] and represents his sons as of an age[31] with those of Perikles. Pythokles, the young Elean, of whom he made a statue at Olympia[32] the base of which has been found (see above), was victorious in the pentathlon in 452 B.C.[33] The same year an Olympic victory was won by one Ariston,[34] probably identical with Aristion the boxer of Epidauros, whose statue Polykleitos made at Olympia[35] and the base of which was found there.[36] The apparently later date of the inscriptions,[37] especially in the case of that of Aristion, which led to the former assignment of the statues to the younger Polykleitos, can be explained by the supposition that the original ones became defaced and were later replaced. Polykleitos' statue of Kyniskos may be assigned by its inscription to 450–440.[38] The chryselephantine Hera of Argos must have been made shortly after the fire which destroyed the old Heraion in the 89th Olympiad (ca. 422);[39] hence Pliny's[40] date for Polykleitos as the 90th Olympiad (ca. 420). Pausanias[41] mentions Polykleitos as making an Aphrodite as a support of a tripod "dedicated from the spoils of the victory at Aigospotamoi" (405). If he (and not the younger Polykleitos) was really at work on this monument[42] it must have been one of his latest products; and his activity then ranges from 452 or earlier to the end of the century.

For our estimate of Polykleitos there is no original statue extant; but several of his famous works have been recognized in Roman copies and from them we can derive a glimpse of this great personality. Pliny[43] describes one of Polykleitos' works as "a boy of manly form bearing a lance, called 'the Canon' by artists, who draw from it the rudiments of art as from a code (so that Polykleitos is held to be the only man

ORIGIN

DATE

WORKS

The Doryphoros

24. On Polykleitos cf. Lippold, *Handbuch*, pp. 162 ff., and the references there cited; Bianchi Bandinelli, in *Enc. Arte Antica*, VI, 1965, pp. 266 ff., s.v. "Policleto," and the references there cited.

25. Loewy, *Inschriften*, no. 91. 26. *Protag.*, 311, C.

27. III. 18. 7, and VI. 6. 2. See also *Anthol. Gr.*, II. 185. 5. 28. *N.H.* XXXIV. 55.

29. Ibid. 30. *Protag.*, 311 C.

31. Op. cit., 328 C. 32. Pausanias VI. 7. 10.

33. Grenfell and Hunt, *Oxyrhynchus Papyri*, II, p. 90, col. II, line 14.

34. Ibid., p. 90, line 16. 35. Pausanias VI. 13. 6.

36. Loewy, *Inschriften*, no. 92. 37. Cf. ibid., nos. 91, 92.

38. Ibid., no. 50.

39. Thucydides IV. 133. The new building was started immediately by Eupolemos, cf. Pausanias II. 17. 3.

40. *N.H.* XXXIV. 49. 41. III. 18. 8.

42. Cf. Furtwängler, *Masterpieces*, p. 224. 43. *N.H.* XXXIV. 55; cf. Stuart Jones, ad. loc.

who has embodied art itself in a work of art)." This together with Pliny's statements[44] that a characteristic of Polykleitos' statues is "the way they step forward with one leg" and that Varro thought that "they are squarely built and seem almost to be made on a uniform pattern," have enabled archaeologists to identify a type preserved in several replicas as Polykleitos' famous statue. It is also significant that a fourth-century Greek stele found at Argos shows a youth in the attitude of the Doryphoros[45] (fig. 694). The best copy in the round was found in Pompeii and is now in the Naples Museum[46] (fig. 690). A broad-shouldered youth is represented in a walking attitude, his weight mostly on his right leg, his left placed sideways and backward; with the left hand he grasps a lance, the right arm is lowered. He has a flat, long skull with hair arranged in superimposed, flat ringlets, following closely the contour of the skull (figs. 691, 692,[47] 693[48]). In spite of the hardness and mechanical character of the Roman copies, we can sense from them some of the beauty of proportion for which the original was famous. There is a harmony of line, a poise and relaxation in the attitude never before attained in the history of Greek sculpture. This is largely due to the new scheme in which the arm which hangs loosely down is on the side of the supporting leg, while the arm which is bent and holds an attribute is on the side of the relaxed leg; it is a reversal of the older scheme and makes for greater harmony by distributing the muscular action between the two sides of the body.[49] Moreover, the modeling shows a complete understanding of the human body. Every detail is accurately rendered and even veins are indicated. In other words the long struggles in the representation of the standing human figure here find their consummation. Henceforth this subject could be treated differently but not more perfectly. The original seems to have played an important role. We are told that Lysippos regarded it as his master,[50] and that sculptors in general took it as their model.[51] It evidently not only marked an epoch when it was created but long held its own as a great achievement.

That Polykleitos wrote a book on proportion and embodied his system in this statue is of course of great interest—especially to us today who have begun to appreciate again the value of design. It confirms what we know from other sources, that the Greeks found the problems of composition absorbing. Unfortunately it is difficult to recover Polykleitos' original scheme from the Roman copies—which might so easily be inaccurate in detail. We know only that it was an interrelation of parts; since Galen[52] tells us that "Chrysippos holds beauty to consist in the proportions not of the

44. *N.H.* xxxiv. 56.

45. *Ath. Mitt.* iii (1878), pl. 13; in the National Museum, Athens, no. 3153; Papaspiridi, *Guide*, p. 266, and S. Karouzou, *Catalogue*, p. 86.

46. Ruesch, *Guida*, no. 146 (6011); for a list of the other replicas, cf. Furtwängler, op. cit., pp. 228–29; Neugebauer, in *Berliner Museen*, xlviii, 2 (1927), pp. 1 ff.; Anti, in *Monumenti antichi*, xxvi (1920), cols. 628 ff. 47. Shear, in *A.J.A.*, xxx (1926), p. 462.

48. Comparetti and de Petra, *La Villa ercolanese*, pl. viii, 3; Ruesch, *Guida*, no. 146 (6011).

49. Cf. Furtwängler, op. cit., pp. 226–27. 50. Cicero, *Brutus* 86. 296.

51. Quintilian, *Inst. orat.* 5. 12. 21. 52. Diels, *Die Fragmente der Vorsokratiker*⁴ i, no. 28, pp. 295 f.

elements but of the parts, that is to say, of finger to finger and of all the fingers to the palm and wrist, and of these to the forearm, and of the forearm to the upper arm, and of all the parts to each other, as they are set forth in the Canon of Polykleitos." And this interrelation can hardly have been purely arithmetical, as Vitruvius proposes, for that has been shown not to fit. It is more likely from what we know so far of Greek design that the scheme was geometrical[53] and that it is the subtle interrelation of volumes that gives us delight also now.

Pliny[54] lists as another work of Polykleitos "a youth of boyish form binding his *Diadoumenos* hair, famous for its price, 100 talents."[55] By a comparison with the Doryphoros it has been possible to identify a type preserved in a number of replicas as reproducing this statue (cf. figs. 695–97). A youth is represented raising his arm to bind a fillet round his head. The attitude of the body, the clear demarcation of the various planes formed by the muscles, the rather shallow pelvic curve, and the square, broad-shouldered build are the same as in the Doryphoros. But by certain, perhaps slight, modifications a feeling of greater freedom is produced. The raising of the arms, the marked inclination of the head to one side, introduce more variety in the upper part of the figure and give it added interest. Moreover, the left leg is placed more sideways and this increases the animation of the pose. The treatment of the head also shows considerable advance. There is more variation in the modeling of the face, the lower part is softer and the hair is more plastic. Clearly the Diadoumenos is a later work than the Doryphoros, dating probably from about 430, while the Doryphoros may be placed at about 450. We are fortunate in having several good copies which can more adequately reflect the qualities of the original than was possible in the case of the Doryphoros. The best full-size replica was found at Delos (fig. 695) and is now in the National Museum in Athens.[56] Another excellent copy is in Madrid.[57] The statue from Vaison in the British Museum,[58] is not of the same caliber; but fine heads are preserved in Dresden,[59] Cassel,[60] and New York[61] (fig. 697), a large terracotta statuette is in New York[62] (fig. 696), and there are a number of other copies.[63] The original evidently enjoyed great popularity. And small wonder. From the point of view of composition it is unquestionably one of the most rhythmical creations of antiquity, retaining the sturdiness of the earlier age but with an added harmony. That Polykleitos could advance from the Doryphoros to the Diadoumenos shows that he, like Pheidias, was

53. Cf. my p. 90. 54. *N.H.* xxxiv. 55.
55. Paid, of course, in Hellenistic or Roman times.
56. No. 1826; cf. *Monuments Piot,* iii (1896), pp. 137 f., pls. xiv, xv; Papaspiridi, *Guide,* p. 98; and S. Karouzou, *Catalogue,* p. 86. 57. Ricard, *Marbres antiques,* pp. 38 f.
58. Smith, *Catalogue of Greek Sculpture,* i, no. 500. 59. Furtwängler, *Masterpieces,* pls. x, xii.
60. Bieber, *Katalog,* p. 10.
61. Richter, in *A.J.A.,* xxxix (1935), pp. 46 ff.; *M.M.A. Catalogue of Greek Sculpture,* no. 38.
62. *M.M.A. Bulletin,* 1932, pp. 250 ff.
63. Cf. Anti, in *Monumenti antichi,* xxvi (1920), cols. 632–34; Picard, *Manuel,* ii, pp. 288 ff.; Lippold, *Handbuch,* p. 166, n. 6. To these can now be added e.g. a torso recently acquired in Baltimore; cf. Hill, *Bulletin of the Walters Art Gallery,* 20 (May 1968), pp. 1 f.

capable of great development. And that he improved in composition after he had produced his great "Canon" indicates his continued interest in and feeling for design. The other quality which we hear was characteristic of Polykleitos—his high finish— can also be appreciated in the best copies of the Diadoumenos. The treatment of the curls, especially, with their wealth of detail (and in the original bronze they would be of course much crisper) reminds us of Plutarch's[64] remark that "Polykleitos said that the work was most difficult when the clay came under the nail." It was evidently the last finishing touches in which Polykleitos delighted.

Hera Polykleitos' most important work was considered to be his temple statue of Hera in the Heraion near Argos. It is described by Pausanias:[65] "The image of Hera is colossal in size, seated upon a throne: it is made of gold and ivory, and is the work of Polykleitos; on her head is a crown adorned with Graces and Seasons; in one hand she holds the fruit of the pomegranate, in the other a scepter. They say that a cuckoo is perched on the scepter." The statue is compared by writers with the gold and ivory Zeus by Pheidias. Strabo[66] considers Polykleitos' work the more beautiful in workmanship ($\tau \acute{\epsilon} \chi \nu \eta$), but second in magnificence ($\pi o \lambda \upsilon \tau \acute{\epsilon} \lambda \epsilon \iota \alpha$) and size to the Zeus. When the Heraion was excavated in 1892 fragments of the metopes[67] and pediment sculptures were found (now in the National Museum of Athens);[68] but no piece of the statue appeared. Our only means of visualizing it now is by the head of Hera which makes its appearance on the coins of Argos (fig. 698) at about the period of the statue,[69] and by the representations of a seated goddess on Argive coins of the Roman period[70] (fig. 699) answering closely to Pausanias' description. Even in these little reliefs we can sense the harmony of the composition. It differs from the Zeus by Pheidias in several important features. In the Hera there are no side rails to the throne, the arms of the figure are extended more sidewise, the scepter is grasped higher, and the legs are placed farther forward than in the Zeus. By these changes a greater sense of freedom is obtained. All tension has disappeared and we have a rhythmical design comparable to that of the Diadoumenos. But at the same time— compared with the creation of Pheidias—there is an impairment of dignity. We can understand Quintilian's[71] criticism—that while Polykleitos' works excelled all others in finish (*diligentia*) and elegance (*decor*), they lacked the grandeur (*pondus*) of the products of Pheidias.

The Amazon In Pliny's story of the competition in statues of Amazons (see p. 174) the one by Polykleitos was placed first, while Pheidias' came second. Of the types of Amazons

64. *Quaest. Conv.* II. 3. 2. 65. II. 17. 4.
66. VIII. 372. 67. Waldstein, *Argive Heraeum.*
68. Cf. infra, n. 109.

69. Cf. Head, *Historia numorum*, p. 438, fig. 240. The stephanos has a decoration of palmettes and scrolls instead of the Graces and Seasons described by Pausanias—a natural simplification when the scale was so much reduced. However, Seltman (*Coins of Olympia*, 1921, pp. 75 ff.) and Lacroix (*Reproductions de statues sur les monnaies*, pp. 254 ff.) doubted the connection for various reasons.

70. Imhoof-Blumer and Gardner, *Numismatic Commentary*, pl. 1, nos. XII–XV, p. 34; Lacroix, op. cit., p. 258, pl. XXI, 13, 14. 71. *Inst. orat.* XII. 10 (7).

preserved to us in Roman copies we have seen that the "Mattei" one has on good grounds been assigned to Pheidias (see pp. 175 f.). That leaves the Berlin and Capitoline types to be divided between Polykleitos and Kresilas (cf. p. 180), and of these the former appears more distinctly Polykleitan[72] (fig. 700). An Amazon is represented leaning on a pillar, her right hand resting on her head. Beneath her left breast is a wound, but her pain is suggested merely by a certain lassitude in the pose. A comparison with the Doryphoros and the Diadoumenos brings out a close kinship— not only in the features and the hair (fig. 701) but above all in the general conception and the pose with the identical stance of the legs and the same fine curve of the body. Here too the chief interest of the sculptor was clearly to create a rhythmical scheme attained by counterpoise: the right leg and left arm balance each other as upright supporting members, the right arm and left leg as curving supports at rest. The resulting harmony is what we have learned was the distinguishing quality of Polykleitos' work, and what moreover is conspicuously absent in the rather straight design of the Capitoline Amazon which we have assigned to Kresilas (p. 181). The graceful chiton on the Berlin Amazon with its meticulous folds is also in line with what we are told of Polykleitos' love of high finish. The many replicas of this type of Amazon show how much admired it was.[73] The specimens in Berlin[74] and New York[75] are the best preserved (in the latter, part of the marble pillar is original).[76] The bronze statuette in Florence[77] is interesting since it is in the same material as the original probably was; but it is not carefully worked and both arms are restored.

It is possible that we possess a copy of Polykleitos' Kyniskos[78] in the so-called Westmacott athlete (fig. 703),[79] the statue of a boy placing a wreath on his head. The type is preserved in many replicas, a mark of its popularity. It shows Polykleitan affinities in the pose with one leg placed backward and sideways, in the modeling of the body with its well-developed pelvic bones, in the hair with its clinging strands. The attitude corresponds to the footmarks on the base of Kyniskos found at Olympia.[80] The inscription on this base can be dated about 450–440, and this is also the period

Kyniskos

72. For other views, cf. pp. 180 f. Those who assign the Capitoline statue to Polykleitos hold that its square build and the prominent inner vastus of the knee are characteristically Polykleitan. But surely Polykleitos might attenuate the squareness in a female statue, and the prominent inner vastus is not peculiarly Polykleitan but occurs also in other fifth-century statues. The harmonious composition of the Berlin type—which makes it worthy of winning the first prize in the competition—seems to me a stronger argument.

73. It is also noteworthy that in Hadrian's Villa only two types of Amazons were found—the Pheidian (fig. 662), and the Berlin-ex Lansdowne ones. It would be characteristic of Hadrian to choose for his villa the two by the most famous Greek sculptors: Pheidias and Polykleitos.

74. *Beschreibung der antiken Skulpturen*, no. 7.

75. Formerly in the Lansdowne Collection; cf. Richter in *M.M.A., Bulletin* (1933), pp. 2 ff.; *M.M.A., Catalogue of Greek Sculptures*, no. 37.

76. For a list of other copies, cf. Michaelis, in *J.d.I.*, I (1886), pp. 14 ff.; Anti, in *Monumenti antichi*, XXVI (1920), p. 602, note 3. Cf. also *Arch. Anz.*, 1942, col. 347, fig. 34.

77. Milani, *Il Museo archeologico di Firenze*, pl. CXXXVI, 2.

78. Cf. Pausanias VI. 4. 11: "The statue of Kyniskos, the boy boxer from Mantineia, is by Polykleitos."

79. Smith, *Catalogue of Greek Sculpture in the British Museum*, 3, no. 1754.

80. Loewy, *Inschriften*, no. 50, gives a facsimile.

Other Works

in which the Westmacott athlete must stylistically be placed. So that the evidence, while not at all conclusive,[81] favors the identification.

Polykleitos' gifts of exquisite finish and harmonious composition naturally marked him out as a sculptor of athletes, and we know of a number of Olympic victors whom he portrayed—Aristion of Epidauros,[82] Thersilochos of Korkyra,[83] Antipatros of Miletos,[84] Pythokles of Elis,[85] and Xenokles of Mainalos,[86] mostly young boys victorious in boxing and wrestling. We can form some idea of the winning grace and finish which doubtless were the chief characteristics of these statues from the Idolino in Florence[87] (figs. 47, 48), a copy of a late fifth-century work of this type, and from the standing Diskobolos (ca. 450–440 B.C.) which is preserved in several Roman copies—in the Vatican[88] and elsewhere,[89] among them a particularly engaging bronze statuette in the Louvre[90] (fig. 46).

The other works attributed to Polykleitos by Pliny[91] are also unfortunately mere names: a man scraping himself, a nude figure hurling a javelin, two boys playing with knucklebones, "considered by many to be the most faultless work of sculpture," a Hermes, a Herakles, a captain putting on his armor, and a portrait of Artemon,[92] called the Man in the Litter. We also hear of two bronze Kanephoroi, "not large in size . . . , of maidenly aspect and garb, who with uplifted arms were carrying on their heads certain sacred objects according to the custom of Athenian girls,"[93] and an Aphrodite at Amyklai.[94]

Most of these works, if not all, were probably of bronze, since Polykleitos is included in Pliny's[95] chapter on *Statuaria*, "bronze sculpture," and that material doubtless suited his highly finished style best. Also his novel compositions with extended and raised arms would be more successful in bronze, which needed no supports. But like other Greek sculptors Polykleitos must have been manysided and eager to try his hand in different mediums. We know that his Hera at Argos was of gold and ivory, and there is no reason to doubt his authorship of the Zeus Meilichios at Argos[96] and the group of Apollo, Leto, and Artemis on Mount Lykone[97] purely because they were

81. There are of course other "Polykleitan" figures with feet placed like the Kyniskos.

82. Pausanias VI. 13. 6; Loewy, op. cit., 92; Grenfell and Hunt, *The Oxyrhynchus Papyri*, II, p. 94, line 16.

83. Pausanias VI. 13. 6. 84. Pausanias VI. 2. 6.

85. Pausanias VI. 7. 10; Loewy, op. cit., 91; Grenfell and Hunt, op. cit., II, p. 90, l. 14.

86. Pausanias VI. 9. 2; Loewy, op. cit., 90.

87. Amelung, *Antiken in Florenz*, no. 268. For a replica of the head cf. Kaschnitz-Weinberg, *Sculture del Magazzino del Vaticano*, no. 60, pl. XIX. 88. Helbig-Speier, *Führer*⁴, I, no. 117.

89. For a list of replicas cf. Lippold, *Handbuch*, p. 164, note 3.

90. No. 183. 91. *N.H.* XXXIV. 55.

92. An engineer employed by Perikles at the siege of Samos, 440 B.C.; being lame he was carried about in a litter.

93. Cicero, *In Verrem* IV. 3. 5, and Symmachos, *Epist.* 1. 23.

94. Pausanias III. 18. 7. 95. Pliny, *N.H.* XXXIV. 55.

96. Pausanias II. 20. 1. 97. Pausanias II. 24. 5.

of marble.[98] We are also told by Pliny that he contributed to the development of embossed metalwork[99] (see p. 176).

While Pheidias consummated the idealistic trend in Greek sculpture and became its chief exponent, Polykleitos perfected the athletic conception—manly, harmonious, reverent. He did not rise to the same heights of conception as Pheidias, but he attained perfection in the task he had set himself. In the words of Quintilian,[100] "he made the human form more beautiful than it is but he failed to convey the majesty (*auctoritatem*) of the gods." And his virile creations had an abiding influence on the art of his country.

Followers of Polykleitos

OF Polykleitos' immediate followers we know little.[101] A few names have been handed down, such as Patrokles[102] and his sons Naukydes,[103] Daidalos,[104] and the younger Polykleitos.[105] Pliny and Pausanias[106] list some of their works. The subjects of most of them appear to have been figures of athletes, as we should expect from followers of Polykleitos; but we also hear occasionally of statues of deities and of larger groups, for instance, the bronze monument of gods and Spartan heroes dedicated by the Spartans after Aigospotamoi (404 B.C.). No identifications with extant statues or reliefs are, however, possible; except the little Hebe standing beside Polykleitos' Hera, which appears on Argive coins[107] of the second century A.D. (fig. 702). According to Pausanias[108] this statue was of ivory and gold and was the work of Naukydes. She is an attractive little figure in a belted chiton, with right arm lowered, the left extended toward the Hera. The quiet lines of the drapery are in keeping with the simple pose. She is evidently conceived as a subsidiary figure so as not to detract from the interest of the chief composition.

To form some idea of the larger groups of this school we may study the sculptural remains of the Heraion of Argos (fragments of the metopes and the pediments[109]). Here we find figures, often in violent action, in which the types of faces (cf. fig. 174)

98. Cf. Stuart Jones, *Select Passages*, nn. on pp. 165, 166.

99. *N.H.* XXXIV. 56; Richter, in *A.J.A.*, XLV (1941), pp. 377 ff. 100. *Inst. orat.* 12. 10. 7.

101. For a full discussion of the available evidence, cf. Johnson, *Lysippos*, pp. 4 ff.

102. Pliny, *N.H.* XXXIV. 50. 91; Pausanias X. 9. 10.

103. Loewy, *Inschriften*, nos. 86, 87; Naukydes must have been the eldest, for he made two statues of Cheimon (Pausanias VI. 9. 3), who won a victory in 448 B.C. (Grenfell and Hunt, op. cit., II, 95, 28). On Naukydes cf. Lippold, op. cit., p. 199; Conticello, in *Enc. Arte Antica*, V (1963), pp. 362 ff., s.v. "Naukydes."

104. Loewy, op. cit., no. 88.

105. Pausanias II. 22. 7 and VI. 6. 2. For a discussion of the troublesome question as to which works should be ascribed to the younger Polykleitos instead of to his more famous predecessor, cf. Johnson, op. cit., pp. 22 ff.

106. Cf. Overbeck, *Schriftquellen*, nos. 986 ff.

107. Imhoof-Blumer and Gardner, *Numismatic Commentary*, pl. I, no. XV, p. 34; Lacroix, *Reproductions de statues sur les monnaies*, p. 258, pl. XXI, 13. 108. II. 17. 5.

109. National Museum, Athens, nos. 1561–83, 3500. Papaspiridi, *Guide*, pp. 73 ff.; S. Karouzou, *Cat.*, pp. 58 f.; Waldstein, *Argive Heraeum*, I, pls. XXX ff.; Eichler, *Oest. Jahresh.*, 1919, pp. 15 ff.

and the rendering of the drapery show marked Attic influence. Evidently not even the self-contained Peloponnesians could remain untouched by the achievements of Pheidias and his followers.

The wealth of artistic talent in Greece at this period can be gauged by the large number of distinguished artists whom we know only by name or perhaps by the mention of some of their works.[110] That, for instance, one Telephanes of Phokis should have been put on a footing of equality with Polykleitos, Myron, and Pythagoras,[111] and that we know nothing further of him except that his Larisa, his portrait of Spintharos and his Apollo evoked admiration,[112] make us realize the extent of our loss.[113]

110. Cf. Overbeck, op. cit., nos. 844–850 (Kolotes), 853–869 (Thrasymedes, Theokosmos, Praxias, Androsthenes, Lykios, Styppax), 897–928 (Demetrios, Pyrrhos, Sokrates the philosopher, Nikeratos, Pyromachos, Deinomenes, Kleiton), 1020–1041 (Apellas, Nikodamos, Kleoitas and Aristokles, Kallikles, Sostratos, Patrokles).

111. Pliny, *N.H.* xxxiv. 68. 112. Ibid.

113. It is also significant that most of the sculptors who worked on the frieze of the Erechtheion and whose names are cited in the building inscription are not known to us from any other source (cf. Caskey, in Paton et al., *The Erechtheum*, p. 415).

CHAPTER 4

FOURTH CENTURY B.C.

Kephisodotos

WITH Kephisodotos[1] we pass to the next great period in the history of Greek art, the fourth century B.C. There were two sculptors by the name of Kephisodotos, both Athenians, one placed by Pliny[2] in the 102d Olympiad or 372 B.C., the other in the 121st Olympiad or 296 B.C. Since the latter was a son of Praxiteles, it is possible that the older one was Praxiteles' father or perhaps his elder brother; for the same name runs in families in alternate or, more rarely, in successive generations. It is the elder Kephisodotos that here concerns us. Pliny's date is borne out by Plutarch's[3] statement that he was the brother-in-law of Phokion (402–317).

ORIGIN AND
DATE

Kephisodotos is known to us by copies of one of his works, "Peace bearing the child Wealth in her arms," which he is said to have made for the Athenians.[4] This group stood on the Areopagos[5] and was erected probably soon after Timotheos' victory over the Spartans (375), when we know that a cult of Eirene was introduced at Athens.[6] It has been identified with groups corresponding to Pausanias' description which appear on Roman coins of Athens[7] (fig. 706), on Panathenaic amphoras dated in the archonship of Kallimedes (360/359 B.C.),[7a] and in several marble replicas. Of the latter the best preserved is in Munich[8] (fig. 704); another replica, headless and armless but of good workmanship, is in New York[9] (fig. 705); two others, considerably restored, in the Museo Torlonia;[10] and children from two other replicas, both with heads un-

WORKS
Eirene

1. On Kephisodotos the Elder cf. Lippold, *Handbuch*, pp. 223 ff., and the references there cited; Mustilli, in *Enc. Arte Antica*, IV, 1961, pp. 342 ff., s.v. Kephisodotos (1), and the references there cited.
2. *N.H.* XXXIV. 50. 3. *Phokion* 19.
4. Pausanias IX. 16. 1. Cf. Rizzo, *Prassitele*, pp. 4 ff. 5. Pausanias I. 8. 2.
6. Cornelios Nepos, *Timotheos* 2. 2: "So great was the joy of the Athenians at this victory that they first made public altars to Eirene and ordained a feast for the goddess." It should be remembered, however, that Aristophanes, *Peace*, 1020, speaks of an altar to Peace as early as 421 B.C. On the date of the introduction of the cult of Eirene cf. now Nilsson, "Kultische Personifikationen," in his *Opuscula Selecta*, III (1960), p. 239 and n. 22 (a reference I owe to M. J. Milne).
7. Imhoof-Blumer and Gardner, *Numismatic Commentary*, pl. DD, nos. IX–X; Lacroix, *Reproductions de statues sur les monnaies*, pp. 296 f., pl. XXVI, 8.
7a. P. D. Themelis, in *Archailogika Analekta ex Athenon*, II, 1969, pp. 415 ff., figs. 4, 5.
8. Furtwängler, *Beschreibung der Glyptothek*, no. 219.
9. *M.M.A. Catalogue of Greek Sculptures*, no. 98.
10. *Museo Torlonia di sculture antiche*, nos. 240, 290, pls. LXI, LXXIII.

broken, are in Athens[11] and Dresden[12] (figs. 707, 708). The relief on the coins gives the complete composition. A woman wearing a voluminous peplos is standing, scepter in hand, holding a child and a cornucopia. The conception of Wealth in the arms of Peace is in line with the more analytical temper of the fourth century as compared with the fifth. The intimate personal relation between the woman and the child, suggested by the inclination of her head toward him, the tender expression in her face, and the playful attitude of the child, are likewise signs of the new age. Kephisodotos is indeed the true precursor of Praxiteles. We need only compare Praxiteles' Hermes (fig. 711) with this group of Eirene to note how much the later sculptor learned from his predecessor. And it is not only in a new intimacy and gentleness that Kephisodotos heralds a new style, but also in the rendering of the drapery. This has sometimes been interpreted as a reversion to an earlier treatment,[13] and in the general scheme it certainly is so. But its resemblance to fifth-century models is only superficial. In the development of the rendering of drapery which we have sketched above (cf. pp. 61 ff.) the Eirene takes its natural place in the fourth century. For, though the garment is massive and the folds have a general downward tendency, there is not the simplicity of the middle of the fifth century; the folds are more complicated and there is more variety in direction. Nor is there the transparency of the later fifth-century drapery, but rather the denseness and naturalism characteristic of the fourth. We may compare the rendering with that on a figure of the Ephesos drum (fig. 328) dated about 355–330 and especially with the record reliefs of Korkyra (375–374 B.C.) and of Athens (362–361).[14]

Other Works Besides the Eirene we are told that Kephisodotos made "a remarkable statue of Athena in the harbor of Athens, and an altar in the temple of Zeus the Saviour,"[15] a group of Muses,[16] a Hermes caring for the infant Dionysos,[17] and an orator with uplifted arm.[18] Of these we know nothing further, except perhaps of the Hermes which has been tentatively identified with representations on coins[19] (cf. fig. 709) and with fragmentary statues in Madrid, Rome, and Athens,[20]—based on an engraving of a statue now lost (fig. 710). It is an interesting precursor of Praxiteles' group (cf. fig. 711). We can recognize in Kephisodotos a worthy precursor of Praxiteles, suggesting in many ways the chief directions in which fourth-century sculpture was to travel, without as yet achieving the consummate grace of the later productions.

11. National Museum, no. 175; Papaspiridi, *Guide*, pp. 77 f., and S. Karouzou, *Catalogue*, pp. 157 ff.

12. Herrmann, *Antike Originalbildwerke zu Dresden*, 1925, no. 107.

13. Furtwängler (*Masterpieces*, p. 296) would even assign political reasons for it, but later he recognized its essentially fourth-century quality; cf. his *Originalstatuen in Venedig*, p. 308.

14. Cf. Binnebössel, *Studien zu den attischen Urkundenreliefs*, nos. 34, 37 (= National Museum, Athens, nos. 1467, 1481). And cf. torsos in Venice (Furtwängler, *Originalstatuen in Venedig*, pl. v [our fig. 346] and pl. vii, 3).

15. Pliny, *N.H.* xxxiv. 74. 16. Pausanias ix. 30. 1.

17. Pliny, *N.H.* xxxiv. 87. 18. Ibid.

19. Rizzo, *Prassitele*, p. 9; Lacroix, *Reproductions de statues sur les monnaies*, p. 298, pl. xxvii, 5, 6.

20. Cf. Rizzo, op. cit., pp. 7 ff.

Praxiteles[21]

ORIGIN AND
DATE

ON a rectangular base from Leuktra which once supported a portrait statue is the inscription, "Praxiteles the Athenian made it."[22] Its date is about 330 B.C. Pliny[23] assigns Praxiteles to the 104th Olympiad (364). These are the only definite dates we have except the doubtful statement of Vitruvius[24] that Praxiteles was employed on the Mausoleum (soon after 351) and of Strabo[25] that he made an altar for the temple of Artemis at Ephesos after the fire of 356. His career perhaps extended from about 370 to 330.

WORKS
Hermes

With Praxiteles we are in the happy position of being able to judge his style by an original statue. On May 8, 1877, there was found in the Heraion at Olympia a marble Hermes[26] (figs. 178, 483, 711, 712), which was immediately identified as a work by Praxiteles from the casual but precious words of Pausanias:[27] "In later times other offerings were dedicated in the Heraion. Amongst these was a Hermes of marble bearing the infant Dionysos, the work of Praxiteles." This is the only original statue by a known Greek sculptor of the first rank which has survived.[28] It was by no means Praxiteles' masterpiece; except for Pausanias, ancient writers pass it over in silence. But to us it is a revolution. In beauty and finish of modeling it so far surpasses the Roman copies by which we mostly have to form our conceptions of Greek artists that it supplies us with a new standard, and helps us to transform in our imagination the other works which have survived only in inferior replicas. The condition is fortunately good. Only the right forearm and the two legs below the knee are missing (one sandaled foot is preserved [fig. 714]); and both arms of the child.

The composition of the Hermes is foreshadowed by the Eirene and perhaps the Hermes of Kephisodotos (p. 198, figs. 704, 710) but is softened and more gracious. Young Hermes in an easy, relaxed attitude turns to the child Dionysos whom he supports on his left arm; the child is stretching out its arm for the bunch of grapes he held in his right hand. Though the hand in the Olympia statue is missing, this feature is supplied by adaptations on Pompeian paintings (cf. e.g. the example from the Casa del Naviglio, Pompeii; fig. 714).[29] The intimate note in the conception, the relaxed

21. On Praxiteles cf. Rizzo, *Prassitele*; Lippold, *Handbuch*, pp. 234 ff. and the references there cited; Becatti, in *Enc. Arte Antica*, VI (1965), pp. 423 ff., s.v. Prassitele, and the references there cited.

22. For signatures by Praxiteles cf. Loewy, *Inschriften*, nos. 76, 76a, 488–489. Two possible other ones have recently been found on the Agora (Shear, *Hesperia*, 1937, p. 341; 1938, pp. 329 f.).

23. *N.H.* xxxiv. 50. 24. VII. *Praef.* 13.

25. xiv. 641. 26. Treu, *Olympia*, III, pls. XLIX–LIII.

27. v. 17. 3.

28. Carpenter, Casson, Blümel and others have thought that the Hermes was either a Roman copy, or by a later Praxiteles. For such views cf. *A.J.A.*, xxxv (1931), pp. 249 ff.; *Blümel, Hermes eines Praxiteles* (1948); to which now add Sheila Adam, *The Technique of Greek Sculpture* (1968), pp. 124 ff., and Carpenter, *A.J.A.*, 73, 1969, pp. 465 ff. The pro-original views—technical and stylistic—were argued at length by Dinsmoor, V. Muller, and myself in *A.J.A.*, 1931.

29. There are no exact replicas of the Hermes, but adaptations are not uncommon; cf. Pottier, in *Festschrift für O. Benndorf*, 1898, pp. 81 ff.; Rizzo, *Prassitele*, pp. 72 f.

attitude of the figure with its lovely curve, the gentle, dreamy expression of the face, the infinitely variegated and yet not sharply contrasted modeling, all help to create an impression of sensuous loveliness; and we delight in its exquisite appeal. Nevertheless we feel that the horizon has changed. We are in a more personal, less lofty atmosphere; what we have gained in grace we have lost in majesty. And this is a sign of the times. Just as Myron and Pheidias and Polykleitos represented the fifth-century outlook and embodied its conceptions, so Praxiteles reflects the fourth-century spirit and creates an art characteristic of it. Thus the art of Praxiteles with its tenderness and charm sums up for us at its best the new outlook in Greece, in which the old impersonal views have given place to a more individualistic, analytical relation.

Aphrodite of Knidos
The most famous work of Praxiteles was the Aphrodite of Knidos.[30] Pliny[31] gives an eloquent account of her popularity:

> The Aphrodite, to see which many have sailed to Knidos, is the finest statue not only by Praxiteles but in the whole world. He had made and was offering for sale two figures of Aphrodite, one whose form was draped, and which was therefore preferred by the people of Kos, to whom the choice of either figure was offered at the same price, as the more chaste and severe, while the other which they rejected was bought by the Knidians, and became immeasurably more celebrated. King Nikomedes[32] wished to buy it from the Knidians, and offered to discharge the whole debt[33] of the city, which was enormous; but they preferred to undergo the worst, and justly so, for by that statue Praxiteles made Knidos famous. The shrine which contains it is quite open, so that the image, made, as is believed, under the direct inspiration of the goddess, can be seen from all sides; and from all sides it is equally admired. There are in Knidos other statues by artists of the first rank . . . and there is no greater testimony to the Aphrodite of Praxiteles than the fact that amongst all these it is the only one thought worthy of mention.

Lucian was evidently a great admirer of the statue. He calls it the most beautiful of Praxiteles' works[34] and borrows its head for his Panthea.[35] "The hair and forehead and the finely penciled eyebrows he will allow her to keep as Praxiteles made them, and in the melting gaze of the eyes with their bright and joyous expression he will also preserve the spirit of Praxiteles." He further describes her as nude, with one hand held in front of her, and as standing in the midst of her shrine "with a smile playing gently over her parted lips."[36] The material was Parian marble.[37] Phryne and Kratine are said to have served as models (by Athenaios[38] and Clement of Alexandria,[39] re-

30. Cf. Overbeck, *Schriftquellen*, 1228 ff. The *Anthology* is full of verses singing her praises; cf. Overbeck, op. cit., nos. 1236 ff.

31. *N.H.* xxxvi. 20.

32. Nikomedes of Bithynia, 278–50 b.c.

33. Due to the forced contribution levied by Sulla in 84 b.c.

34. *Eikones* 4.

35. Ibid., 6.

36. Ἔρωτες, 13.

37. Ibid.

38. xiii. 590 f.

39. *Protrept.* 53.

spectively). Fortunately we are not dependent on mere descriptions of this celebrated statue; from reproductions of her on Roman coins of Knidos[40] (fig. 719) it has been possible to identify a number of Roman copies.[41] The best known are in the Vatican[42] (figs. 715, 717), Brussels[43] (fig. 716) and Munich.[44]

The goddess is seen standing in a graceful pose, one hand held in front of her, the other grasping her drapery, which she is letting fall on a water jar. The nude body and the variegated folds of the drapery create an effective contrast, just as they do in the Hermes. The attitude is evidently studied from all sides, for it is equally charming from every view, having been intended as we know for an open shrine. The best replicas of the head are those in the Kaufmann Collection[45] (fig. 718), and in Toulouse.[46] Roman copies though they be, we can appreciate in them the points specially admired by Lucian—the soft, wavy hair with the triangular forehead, and the melting gaze of the eyes. If to this gentle, harmonious creation we can supply in our imagination the beauty and finish of the modeling of the Hermes, we may understand the great attraction of the original.

The Aphrodite of Knidos made a deep impression on contemporary art, and its influence was felt for many generations. A nude Aphrodite henceforth becomes a favorite subject and more often than not something in the pose and expression harks back to the great prototype. Just as the Pheidian Zeus created for all subsequent time the Greek conception of the chief of the gods, so the Praxitelean Aphrodite was henceforth used consciously or unconsciously as a model for the goddess of love.

Another work of Praxiteles has been definitely identified in extant copies from a specific description of it by Pliny:[47] "[Praxiteles] also represented Apollo as a boy with an arrow watching a lizard as it creeps up with intent to slay it close at hand; this is known as the σαυροκτόνος or Lizard-Slayer." Since it is listed with the bronze works of Praxiteles, the original must have been of that material. Reproductions of

Apollo Sauroktonos

40. Gardner, *Types of Greek Coins*, pl. xv, 21; Lacroix, *Reproductions de statues sur les monnaies*, pp. 311 ff., pl. 32, 9.

41. For a list of full-sized copies, cf. Furtwängler, *Masterpieces*, p. 322, n. 3; Michaelis, in *J.H.S.* (1887), pp. 332 ff. Rizzo, op. cit., pp. 48 ff. Rizzo distinguishes two types—one, a direct copy of the Knidian Aphrodite (preserved, for instance, in a statue in the Museo delle Terme and in one of the statues in the Vatican), the other perhaps a variant by a later artist (preserved in the well-known statue in the Vatican and the heads from Tralles and in Toulouse). The second is differentiated from the first by its slenderer body, the fringe on the drapery, and the larger size of the hydria. The fact, however, that the original was presumably not available in a direct cast might account for variations in the copies.

42. Helbig-Speier, *Führer*[4], I, no. 207; Kaschnitz-Weinberg, *Sculture del Magazzino del Museo Vaticano*, nos. 256, 257.

43. Now with head, found in Copenhagen; cf. Blinkenberg, in *Illustrated London News*, Jan. 21, 1928, p. 83.

44. Furtwängler, *Beschreibung der Glyptothek*, no. 258. Cf. now also the replica found in the Villa Adriana at Tivoli (Aurigemma, *Villa Adriana*, 1961, pp. 44 ff., pl. II)—showing once again Hadrian's appreciation of famous Greek statues and his wish to have copies of them in his villa (cf. my p. 193, note 73). Moreover, recently the temple in which the statue stood has been found at Knidos—as announced by Professor Iris Love at the Dec. 1969 meeting of the Archaeological Institute of America in San Francisco.

45. Rizzo, op. cit., pls. 87 f. 46. Ibid., pls. 85 f.

47. *N.H.* xxxiv. 70. Cf. also Martial xiv. 172.

it occur on coins of Nikopolis (fig. 720) and Philippopolis[48] and in several Roman replicas,[49] the most notable of which are the marble statues in the Louvre[50] and the Vatican[51] (fig. 723) and a bronze statue in the Villa Albani[52] (fig. 722). The young Apollo is engaged in one of the sports of the boys of that time—and one that has survived to this day in southern Europe—but the action is merely a motive for a singularly graceful pose in which the sinuous "Praxitelean curve" is beautifully utilized. But how far we have traveled from the Apollo on the Olympia pediment (cf. fig. 419)! The gods have descended from high Olympos and have become charming, serene human beings.

The god Eros with his youthful, feminine charm would naturally be a subject which would appeal to Praxiteles, and we hear of several such statues by him. Two became *Eros of* world-famous—the Eros of Thespiai and that of Parion in Mysia. The former was *Thespiai* considered by Praxiteles himself as one of his masterpieces;[53] he gave it to Phryne who dedicated it in her native town.[54] No copies of it have been definitely identified though some have thought that it may survive in a fragmentary, headless statue from the Palatine in the Louvre and in a torso in the Museum of Parma.[55] In the stance and the position of the arms they resemble the satyr pouring wine (figs. 729–31), which we know was an approximately contemporary work; but the absence of the head *Eros of* makes an attribution difficult. Of the Eros of Parion,[56] we gain a faint picture by the *Parion* little reproductions of it on Roman coins of Parion[57] (fig. 721). He is standing in an easy attitude, his wings spread out, his mantle hanging from his left shoulder, his head turned to his left, his long hair gathered in a knot, a small herm at his side. The curve of the body is similar to that of the Sauroktonos, the weight also on the right leg; only the action of the arms is different. This conception of Eros as a charming boy impressed itself on the imagination of the people and became the starting point of the numerous representations of him in fourth-century and Hellenistic art. An Eros similar to the Sauroktonos, but with lowered right arm—of which replicas are in Naples and New York—may go back to another Eros by Praxiteles.[58]

48. Pick, *Die antiken Münzen Nordgriechenlands*, 1, 1, p. 362, no. 1288, pl. xiv, 34; Rizzo, op. cit., pl. 62; Lacroix, op. cit., pp. 306 ff., pl. xxvii, 7, 8.

49. For a list of replicas, cf. Overbeck, *Griech. Kunstmythologie*, v, pp. 235 f.; Klein, *Praxiteles*, pp. 104 ff.; Rizzo, op. cit., pp. 39 ff.

50. Klein, op. cit., p. 109, fig. 14; Rizzo, op. cit., pl. lx.

51. Amelung, *Die Skulpturen des vaticanischen Museums*, ii, no. 264; Helbig-Speier, *Führer*⁴, i, no. 125. The restorations include the left side of the face, the right eye, the right forearm, the right leg from the middle of the thigh, the left leg from the knee down, part of the trunk with the upper part of the lizard, the plinth.

52. Rizzo, *Prassitele*, pl. lxi; Helbig-Speier, *Führer*⁴, iii, no. x.

53. Pausanias i. 20. 2.

54. It became the chief attraction of that city (Cicero, *In Verr.* iv. 2.4; 60.35; Strabo ix. 410). Cf. Overbeck, *Schriftquellen*, nos. 1249 ff.

55. Cf. Rizzo, op. cit., pp. 20 ff., pl. 27 (Louvre), pl. 28 (Parma).

56. Pliny, *N.H.* xxxvi. 23.

57. Imhoof-Blumer, *Monnaies grecques*, p. 256; Lacroix, op. cit., pp. 315 f., pl. xxviii, 1–4.

58. Cf. Rizzo, op. cit., pls. 65–67; Richter, *M.M.A. Catalogue of Greek Sculptures*, no. 107.

Pausanias[59] mentions an Artemis in a temple at Antikyra "the work of Praxiteles; *Artemis of* it holds a torch in the right hand and a quiver hangs from the shoulder; beside it on *Antikyra* the left is a dog; and it is taller than the tallest woman." Figures of Artemis exactly answering this description—with torch, quiver, and dog—occur on coins of Antikyra[60] (fig. 724). The goddess is stepping lightly forward, an attractive, dainty figure in her short chiton as she sets out ready for the chase. The great goddess Artemis too has been transformed into a charming girl. Whether the statue was by the famous Praxiteles or by a later artist is uncertain; but that the figure resembles Hellenistic representations is seen by the close resemblance to it of the Artemis of Versailles in the Louvre.[61] The conception and the pose are similar; only the attitude of the arms has been changed.

Still another work by Praxiteles is known to us from coin types. Pausanias[62] de- *Leto and* scribes it as follows: "[At Argos] the temple of Leto is not far from the trophy; the *Chloris* image is the work of Praxiteles, and the figure of the maiden standing by the goddess they call Chloris, . . . the daughter of Niobe." A group of a woman and a little maiden clearly copied from this work occurs on Roman coins of Argos[63] (fig. 725). Leto is clothed in an ample chiton, her right hand raised to her shoulder, the left extended over Chloris. It is a quiet composition with much of the stateliness of the preceding period still apparent; so we may surmise that this was an early work of the artist.

An inscription on a headless herm in the Vatican reads: "Eubouleus by Praxiteles."[64] A bust of a youth from Eleusis[65] (fig. 551) was identified as Eubouleus, since a dedicatory inscription to Eubouleus was found at Eleusis in the same locality and at the same time as the bust. A certain resemblance of the latter to the Hermes of Praxiteles (cf. fig. 712) and the delicacy of the modeling were even thought to suggest that it was an original work by that artist.[66] Recently, however, it has been thought that the bust from Eleusis is not an original Greek work, but an especially fine Roman copy, and the theory has been advanced that it represents not Eubouleus but Alexander the Great.[67] Since several replicas exist,[68] the original must in any case have been an important work—but whether Alexander or Eubouleus remains to be seen. Personally I hesitate to accept the identification as Alexander, for the important characteristic of his portraits, viz. the upward-looking, wide-open eyes are lacking. So one must await further evidence.

59. x. 37. 1.

60. Imhoof-Blumer and Gardner, *Numismatic Commentary*, pl. Y, no. xvii, pp. 124 f.; Lacroix, op. cit., pp. 309 f.

61. Brunn-Bruckmann, *Denkmäler*, pl. 420. 62. ii. 21. 8.

63. Imhoof-Blumer and Gardner, op. cit., pl. K, nos. xxxvi–xxxviii, p. 38; Lacroix, op. cit., pp. 303 f., pl. XXVII, 2–4. 64. Helbig-Speier, *Führer*⁴, i, no. 75.

65. National Museum, Athens, no. 181. Philos, in *Eph. arch.* (1886), p. 257, pl. x; Papaspiridi, *Guide*, pp. 50 f., and S. Karouzou, *Cat.*, pp. 168 f.; Mingazzini, in *Enc. Arte Antica*, iii (1960), p. 513, s.v. Eubuleo.

66. Cf. especially Furtwängler, *Masterpieces*, pp. 330ff. (where divergent opinions are also listed); Rizzo, op. cit., pp. 104 ff. 67. Cf. E. Harrison, in *Hesperia*, xxix, 1960, pp. 382 ff.

68. Cf. the list given by E. Harrison, op. cit., pp. 382 f., which includes a specially interesting example, unfinished, with measuring points preserved, found in the Agora.

Mantineia
Base

When Pausanias[69] was at Mantineia he saw there a temple of Leto and her children. He tells us that "Praxiteles made their statues in the third generation after Alkamenes. On the base which supports them are represented the Muses[70] and Marsyas playing the flute." Three slabs from this base were found at Mantineia in 1887 and are now in the National Museum in Athens[71] (figs. 726–28). On one is a stately Apollo with his Phrygian slave and Marsyas vigorously playing the flutes; on each of the others are three Muses, charming examples of fourth-century draped figures. It is clear that the Tanagra statuettes of the period were inspired from just such lovely creations. Since the base supported three statues—Leto, Apollo, and Artemis—at least two reliefs must have occupied the long side. The remaining three Muses were, therefore, probably carved on another plaque now lost. Pausanias does not say that the base was the work of Praxiteles, only the statues. To insure a harmonious ensemble he may well have designed the composition, and the dainty charm of the figures is in line with the spirit of his work. Compared, however, with the Hermes, the execution is perfunctory, and there is no need of assuming that Praxiteles actually carried out the work.

Aphrodite
Pseliumene

Pliny[72] and Tatian[73] mention an Aphrodite *pseliumene*, "with a bracelet," by Praxiteles. Perhaps it is reproduced in a bronze statuette in London (fig. 53).

Artemis
Brauronia

Pausanias[74] states that the cult statue in the sanctuary of Artemis Brauronia on the Akropolis of Athens was the work of Praxiteles. Mention is made of this marble statue for the first time in an inscription dated 346–345 B.C. The Artemis of Gabii in the Louvre[75] (fig. 733) has been tentatively identified as a copy of Praxiteles' work, for the figure evidently reproduces a masterpiece of Praxiteles; moreover she is represented as fastening her garment, and we know that garments and other objects of adornment were offered to Artemis Brauronia as an ancient rite.

Satyr

Pausanias[76] speaks of a satyr that stood in the Street of Tripods "of which Praxiteles is said to have been extremely proud" and of which the following story was current:

> They say that once when Phryne asked for the most beautiful of his works, he lover-like promised to give her it, but would not tell which he thought the most beautiful. So a servant of Phryne ran in declaring that Praxiteles' studio had caught fire, and that most, but not all, of his works had perished. Praxiteles at once ran for the door, protesting that all his labor was lost if the flames had reached the Satyr and Eros. But Phryne bade him stay and be of good cheer, telling him that he had suffered no loss, but had only been entrapped into saying which were the most beautiful of his works.

This statue, Pausanias continues, was represented in the act of offering a cup. It is possible that the Satyr pouring wine, of which many copies are preserved (cf. figs.

69. VIII. 9. 1. 70. Pausanias' text reads Μοῦσα, clearly a mistake for Μοῦσαι.
71. Nos. 215–17. Rizzo, op. cit., pp. 86 ff.; Papaspiridi, *Guide*, pp. 69 ff., and S. Karouzou, *Cat.*, pp. 167 f.
72. XXXIV. 69. 73. *Contra Graecos*, 56, p. 122.
74. I. 23. 7. 75. Rizzo, op. cit., pp. 63 ff., pls. 94–98.
76. I. 20. 1.

729–31), the best perhaps in Dresden and Palermo, reproduces Praxiteles' statue.[77] It has his gentleness and restraint, the composition and style are Praxitelean of an early period, before he reached his maturity, and this would presumably be the time of the anecdote of Phryne.

Pliny[78] speaks of a statue by Praxiteles as "the celebrated Satyr, called by the Greeks 'the world-famed' [περιβόητον]" and lists it among the bronze works of the artist. A satyr in a relaxed pose represented leaning against a pillar occurs in so many replicas[79] that it clearly goes back to a famous original. One of the best copies is in the Torlonia Museum,[80] another is in the Capitoline Museum[81] (fig. 56), and a fragment of exceptionally good workmanship is in the Louvre.[82] The conjecture is tempting that we have here a reproduction of Praxiteles' work.[83] But there is no specific description of Praxiteles' satyr to help us, so the identification is not certain. If the original was by Praxiteles it was probably one of his later works; for the picturesque composition, the almost exaggerated curve of the body, with the foot of the flexed leg placed behind that of the supporting leg, and the personal element in the conception—a mingling of human and animal qualities—are different from the serene and detached Praxitelean creations. This very picturesqueness, which heralds the Hellenistic period, made the statue an appropriate garden figure and may account for its popularity in Roman times.

The other works attributed to Praxiteles by ancient writers[84] include many deities, nymphs, maenads, and caryatids, a gilded portrait of Phryne at Delphi, and such subjects as Persuasion and Consolation,[85] a Weeping Matron, and a Rejoicing Harlot,[86] in which the more analytical temper of the period and the tendency to represent human emotions would find scope. Athletes or warriors—the stock subject of the former period—are rare. And naturally so. An artist who "with consummate art informed his marble figures with the passions of the soul"[87] would select for himself subtler themes than victorious athletes.

Pliny[88] in his account of Praxiteles makes the statement: "His works may be seen in Athens in the Kerameikos." May this be interpreted to mean that Praxiteles had many orders for tombstones for the cemetery in the Kerameikos? Perhaps. We know definitely of one memorial he made of a soldier standing by his horse.[89] And certainly a reflection of his style is apparent in many of the gentle farewell scenes of the Athenian stelai.

The genius of Praxiteles may be compared with that of Raphael. Their works are STYLE

77. Cf. Rizzo, op. cit., pp. 17 ff., pls. XIX ff.; Picard, *Manuel*, III, pp. 415 ff. 78. *N.H.* XXXIV. 69.

79. Cf. Benndorf u. Schoene, *Die Bildwerke des lateranischen Museums*, p. 91, and Furtwängler, *Masterpieces*, p. 329, n. 5. 80. Rizzo, op. cit., pls. XLVIII–LI.

81. Rizzo, op. cit., pls. LIII–LV; Helbig-Speier, op. cit., II, no. 1429. 82. Rizzo, op. cit., pl. LII.

83. That Praxiteles' περιβόητος may have been part of a group (Pliny, *N.H.* XXXIV. 69) is not necessarily an argument against the identification, for evidently only the satyr became so famous and must therefore have been a composition complete in itself.

84. Cf. Overbeck, *Schriftquellen*, nos. 1193 ff. 85. Pausanias I. 43. 6.

86. Pliny, *N.H.* XXXIV. 70. 87. Diod. *Fragm.* 26.

88. *N.H.* XXXVI. 20. 89. Pausanias I. 2. 3.

imbued with a serene and sober grace, and appeal by their very radiance and loveliness. The majesty of Pheidias and Masaccio have indeed gone, but the grandeur of the old conceptions is still evident in the purity and restraint of the new creations. Though we have few works which can be directly associated with Praxiteles, his influence on contemporary art was so great that we see his spirit reflected in many other works. Such charming creations as the Leconfield Aphrodite,[90] and the Aphrodite of Arles[91] (fig. 732) must owe their inspiration directly to his work; and works like the Marathon boy[92] (figs. 49–51) and the Aberdeen Herakles,[93] being original fourth-century works, show us the high standard of workmanship attained in products of this style. Moreover Praxiteles' influence was long felt. The head from Chios in Boston[94] (fig. 182) bears his imprint, and the so-called Alexandrian style stems directly from him.

The Elder and the Younger Praxiteles

THERE appears to have been an elder Praxiteles; for certain works attributed to a sculptor by that name must be dated in the fifth century B.C. Pausanias[95] refers to statues of Demeter and her daughter and Iacchos standing by the Dipylon Gate of Athens "and on the wall is an inscription in the Attic alphabet stating that they are the work of Praxiteles." The Attic alphabet was superseded by the Ionic one in 403. Pausanias also assigns to Praxiteles a group of Rhea and Kronos "at the entrance of the temple of Hera at Plataia"[96] which was erected in 427–426, and "pediment sculptures made for the Thebans representing most of the Twelve Labours of Herakles."[97] Such subjects appear unusual for the fourth-century Praxiteles. If there was this elder Praxiteles it may be he who supplied the chariot for Kalamis' group (cf. p. 159).

It has been claimed that there was a younger Praxiteles, a nephew of the famous sculptor, and that some of the works assigned to the latter by ancient writers were by this later artist, e.g. the Artemis of Antikyra (fig. 724). A signature of a second-century Praxiteles was found at Pergamon.[98] The name is not uncommon.

The Sons of Praxiteles

Two sons of Praxiteles, Kephisodotos and Timarchos,[99] gained some eminence as sculptors. Pliny[100] says that Kephisodotos was "the heir of his father's talent" and that "much praise has been bestowed on his famous group of interlaced figures at

90. Rizzo, op. cit., pls. CVIII, CIX, CX.

91. Rizzo, pp. 24 ff., pls. XXXIV–XXXVII. There are replicas, for instance in Rome and Athens.

92. Rizzo, pl. 69; Papaspiridi, *Guide*, pp. 216 ff., no. 15118.

93. Rizzo, pl. CXI. Furtwängler, op. cit., pl. XVIII, pp. 346 f., thought it an original by Praxiteles.

94. Caskey, *Catalogue*, no. 29.

95. I. 2. 4. 96. IX. 2. 7.

97. IX. 11. 6. 98. Loewy, *Inschriften*, pp. 115 f.

99. Cf. Lippold, *Handbuch*, p. 299, and the references there cited; Mustilli, in *Enc. Arte Antica*, IV, 1961, pp. 344 f., s.v. Kephisodotos (2), and the references there cited; Moreno, in *Enc. Arte Antica*, VII, 1966, p. 858, s.v. Timarchos.

100. *N.H.* XXXVI. 24.

Pergamon where the pressure of the fingers seems to be exerted on flesh rather than marble." We also hear of a number of other works by him and Timarchos, chiefly deities and portraits.[101] A statue of a seated Zeus at Megalopolis[102] may be reproduced on badly preserved Roman coins of Megalopolis.[103] Several statue bases with their names have been found, dating from the late fourth and early third century,[104] one of these of a portrait of Menander (342–291) in the theater in Athens.[105] The busts generally identified as Menander,[106] may reproduce this work. But the safest way to visualize the style of these two sculptors is by the fragments from the sculptures which decorated the altar of Kos,[107] said by Herondas[108] to be by the sons of Praxiteles. They consist of a girl's head (figs. 734, 735), the lower half of a draped female figure (fig. 736), a fragment of a girl's head, the hand of a child, and the foot of a woman. They teach us that the sons carried on their father's traditions and created charming, delicate works, the immediate precursors of the somewhat effeminate renderings of the Hellenistic age.

Skopas

THE other great sculptor of this period was Skopas of Paros.[1] Pliny[2] couples him with Polykleitos as having worked (*floruit*) in the 90th Olympiad (420 B.C.), but this must be a mistake; for we know that he worked on the Mausoleum of Halikarnassos soon after 351, on the new temple of Athena Alea at Tegea some time after the destruction of the old building in 394,[3] and on the temple of Artemis at Ephesos which was begun immediately after the fire which burned down the older structure in 356, but was not yet completed in 334.[4] His activity therefore falls, like that of Praxiteles, wholly within the fourth century. Moreover, elsewhere Pliny[5] himself mentions Skopas as a rival of Praxiteles and of Kephisodotos the Younger (the son of Praxiteles); and the names of Praxiteles and Skopas are often coupled by other writers.[6]

With Skopas we are in the lamentable position of having no work which can be

ORIGIN AND DATE

WORKS

101. Overbeck, *Schriftquellen*, nos. 1331 ff.; Bieber, in *J.d.I.*, XXXVIII–IX, 1923–1924, pp. 264 f.
102. Pausanias, VIII. 30. 10.
103. Imhoof-Blumer and Gardner, *Numismatic Commentary*, pl. V, no. 1.
104. Loewy, *Inschriften*, nos. 108–112.
105. Ibid., no. 108; Pausanias I. 21. 1; Richter, *The Portraits of the Greeks*, II, figs. 1519, 1520.
106. Bernoulli, *Griechische Ikonographie*, II, p. 113; Richter, op. cit., pp. 224 ff.
107. Herzog, *Oest. Jahresh.*, VI, 1903, pp. 218 ff.; Bieber, in *J.d.I.*, XXXVIII–XXXIX (1923–24), 242 ff., figs. 1–3, pls. VI, VII, 1. 108. *Mimes* IV. 1 ff.
1. On Skopas cf. Lippold, *Handbuch*, pp. 249 ff., and the references there cited; Arias, in *Enc. Arte Antica*, 7 (1966), pp. 364 ff., s.v. "Skopas," and the references there cited. He was perhaps the son of Aristandros of Paros, who worked on the memorial of Aigospotamoi (405 B.C.).
2. *N.H.* XXXIV. 49.
3. The new building was probably not begun until after 386 B.C., which marks the end of the Corinthian war, during which Tegea was allied to Sparta. For a dating to ca. 370–55 B.C., cf. p. 209.
4. "Besides, Artemidoros says that Alexander promised to defray the expense of its [the Artemision's] restoration, both what had been and what would be incurred, on condition that the work should be attributed to him in an inscription, but the Ephesians refused to accede to this" (Strabo XIV. 1. 22).
5. *N.H.* XXXVI. 25.
6. Cf., e.g., Martial IV. 39. 1; *Carm. Priap.* 9. 2; Apollinaris, *Sidon. Carm.* XXIII. 503.

safely attributed to him, and so our study of his style must be based on conjecture. There are preserved, however, fragments of sculptures of the buildings on which we know he was engaged, and since stylistically these bear some resemblance to one another we have to build our structure on this uncertain foundation.

Sculptures of the Temple of Athena Alea

Pausanias'[7] account of the temple of Athena Alea is long, but not explicit regarding the authorship of the sculptures:

> The old temple of Athena Alea at Tegea was built by Aleos; in later times the Tegeans caused a large and remarkable temple to be erected to the goddess. The previous building was suddenly attacked by fire and destroyed in the archonship of Diophantos at Athens and the second year of the 96th Olympiad (395 B.C.). The temple which is standing at the present day is far superior to the other temples in the Peloponnese in size and magnificence. . . . I was told that the architect was Skopas of Paros, who was the sculptor of many statues in different parts of Greece proper and also in Ionia and Karia. In the front pediment is represented the chase of the Kalydonian boar . . . [then follow the names of the participants, including Atalante, Meleager, Theseus, etc.]. The sculptures of the back pediment represent the battle of Telephos against Achilles in the plain of the Kaïkos. The ancient image of Athena Alea and the tusks of the Kalydonian boar were carried off by the Roman Emperor Augustus. . . . The image . . . stands in Rome . . . made wholly of ivory, the work of Endoios. . . . The present image at Tegea was brought from the township of Manthyrenses. . . . On one side of her stands Asklepios, on the other Hygieia, made of Pentelic marble, works of Skopas the Parian.

From this description we know only that Skopas was the architect of the temple and that he made the two statues which stood on each side of the temple image of Athena Alea; not that he worked on the pediment figures, though it is quite possible that he did so. The fragments of these pediments[8] which have been preserved show an individuality of style which presupposes a distinguished artist. The most important are several battered male heads[9] (cf. figs. 737–40), part of a boar, and a female draped body[10] (fig. 743). In the male heads particularly, the square form, the deep-sunken eyes, and the marked projection of the lower part of the forehead are suggestive of force and emotion. We may surmise that they belong to the group of the hunt of the Kalydonian boar, and that their expressions are evoked by the stress of battle. The drapery of the Atalante, though not so soft and transparent as that of the Epidauros figures, has not yet the denseness and realistic quality of the works of the middle of the fourth century, such as the Maussollos and the Artemisia (fig. 330) and the figures

7. VIII. 45. 4; 46. 1. 8. Dugas, *Le Sanctuaire d'Aléa Athéna à Tégée*, pls. XCVI–CXII.

9. In the National Museum, Athens, nos. 178–80. Papaspiridi, *Guide*, p. 49, and S. Karouzou, *Cat.*, pp. 163 f.

10. Some have doubted that this figure belonged to the pediments (cf. Thiersch, in *J.d.I.*, XXVIII (1913, pp. 270–71). The head, once thought to belong to the Atalante, was not part of the temple sculptures; cf. Dugas, op. cit., pls. CXIII ff., pp. 117 ff.

of the Ephesian drum (figs. 345, 751). We may, therefore, place the Tegea sculptures midway between the two, that is, about 370–355.[11]

We know both from Pliny[12] and Vitruvius[13] that Skopas worked on the sculptures of the Mausoleum. Pliny gives an explicit account:

The Mausoleum

> The rivals and contemporaries of Skopas were Bryaxis, Timotheos, and Leochares, who must be treated in a group since they were jointly employed on the sculptures of the Mausoleum. This building is the tomb erected by Artemisia, his widow, for Maussollos, prince of Karia, who died in the second year of the 107th Olympiad [351]. That this work is among the Seven Wonders is due mainly to the above-named artists. . . . The sculptures on the east side are by Skopas, those of the north by Bryaxis, those of the south by Timotheos, and those of the west by Leochares. The Queen died before the building was complete,[14] but the artists did not abandon the work until it was finished, considering that it would redound to their own glory, and be a standing proof of their genius; and to this day they vie with one another in their handiwork. They were joined by a fifth artist. For above the colonnade is a pyramid equal to the lower structure in height, with a flight of twenty-four steps tapering to a point. On the apex stands a four-horse chariot in marble, the work of Pythis. This addition completes the building, which rises to a height of one hundred and forty feet.

The chief sculptural remains of this Mausoleum are now in the British Museum.[15] They consist of three friezes, the statues of Maussollos and Artemisia (fig. 330), and statues of lions and other figures, among them a fine equestrian statue. Of the widest frieze, representing the battle of the Greeks and Amazons, there are extant seventeen slabs; they are in more or less good preservation and rank among the most important

11. Such a time agrees well with the dating of the temple on architectural grounds: "scarcely before 370–360 B.C." (Schede, *Antikes Traufleisten*, p. 46); about 370 B.C. (Reisch, *Oest. Jahresh.*, 1906, p. 215, note 41); about 365 B.C. (Weickert, *Das lesbische Kymation*, p. 71); about 355 B.C. (Dinsmoor, *Architecture*, p. 220). Dugas' 360–330 B.C. (op. cit., p. 128) would seem somewhat late.

A stele was found at Tegea in the court of a private house near the temple of Athena Alea inscribed

ΙΕΤΣ

ΑΔΑ ΙΔΡΙΕΤΣ

(*I.G.*, v, 2, 89; Foucart, in *Mon. Piot*, XVIII, 1910, p. 146; A. H. Smith, *J.H.S.*, XXXVI (1916), p. 65; now in the British Museum.) Ada and Idreus were the sister and brother of Maussollos and Artemisia and began their reign in 351 B.C.; Idreus died in 344. The stela is therefore dated 351–344 B.C. The occurrence of these names at Tegea presupposes relations between Tegea and Karia, perhaps to be accounted for by the fact that Skopas was at work in both places and took workmen from one to the other. But since the name of the dedicator of the stele is missing we cannot know whether he was a Karian who perhaps went with Skopas to work on the Tegean temple after the Mausoleum, or a Tegean who had accompanied Skopas to Karia after the Tegean work was finished and then returned to his native home. Therefore this stele cannot help us in dating the Tegea temple either before or after the Mausoleum, even if we connect the incident with Skopas, which is of course a mere supposition. Cf. also the statue base found at Delphi with the names Ada and Idreus (*B.C.H.* XXIII (1899), p. 384, no. 631). 12. *N.H.* XXXVI. 30.

13. VII. *Praef.* 13. 14. Two years after the death of Maussolos.

15. Smith, *Cat. of Greek Sculptures*, II, nos. 1000 ff. On the building and the various sculptures cf. now the fundamental study by Riemann, in *R.E.*, XXIV (1963), s.v. "Pytheos," cols. 371 ff. A publication of the sculptures by Ashmole and Strong is in preparation.

examples we have of fourth-century sculpture. Is it possible to assign any portion of it to Skopas? The majority of the slabs were found not on the Mausoleum site but in the neighboring castle of Saint Peter, built by the Knights of Saint John in the fifteenth century largely out of the Mausoleum stones; therefore all trace of where they belonged on the building has been lost. But during Sir Charles Newton's excavations four slabs (nos. 1013–16) were found "lying in a row along the eastern margin";[16] that is, on the side of the building said to have been decorated by Skopas. Three slabs of these form a continuous composition and stand out among all the rest by their fine quality (figs. 744–46). The impetuous force of each figure, the delicate workmanship, and the rhythmical composition indicate the hand of a master sculptor. The bold poses —the Amazon sitting backward on her galloping horse, the collapsing Amazon, the crouching warrior—and the harmonious composition also indicate the hand of a great artist. The assignment of these sculptures to Skopas is therefore tempting and has been quite generally made.[17] And stylistically they bear out what have been provisionally supposed to be the characteristics of Skopas' style—originality, force, and emotion, conveyed not only in the attitudes but in the somewhat deep-set eyes and mobile mouths. Moreover since the style of some of the charioteers of one of the smaller friezes[18] is markedly similar (cf. fig. 747), these too have been ascribed to Skopas.

Temple of Artemis at Ephesos The connection of Skopas with the extant sculptures of the temple of Artemis at Ephesos is problematical. Our only information on the subject is supplied by Pliny.[19] "The length of the whole temple is four hundred and twenty-five feet and the breadth two hundred and twenty-five feet.[20] It contains one hundred and twenty-seven columns, each furnished by a king and sixty feet in height; of these thirty-six are decorated with reliefs, one by Skopas."[21] Only three of the thirty-six decorated columns have survived in any degree of preservation and it is of course not likely that among them should be the work of Skopas. There are nevertheless certain considerations which enable us at least tentatively to associate the best-preserved column with Skopas. The reliefs of this drum[22] (fig. 751), generally interpreted as Alkestis being led to the upper world by Hermes,[23] stand out as the finest of the extant remains, so superior in artistic quality that this may well be due to their execution by a great artist. Moreover, the Thanatos and the Hermes with their deep-set eyes and expressive faces resemble in style the figures on the slabs of the Mausoleum frieze attributed to Skopas (cf. figs. 749, 750); and the modeling of the nude male bodies with its soft transitions and yet clear demarcation of the salient muscles is not unlike. We may compare es-

16. Newton, in *Halicarnassus*, II, 1, p. 100.

17. Cf. Wolters and Sieveking, in *J.d.I.*, XXIV (1909), pp. 171 ff.; also the fragment 1025.

18. Smith, op. cit., II, no. 1036. 19. *N.H.* XXXIV. 95.

20. It ranked as one of the seven wonders of the world.

21. Some skeptical authorities would emend *una a Scopa* to read *imo scapo*, "on the lowest drum"; but it is the reading of the best manuscripts.

22. Smith, op. cit., II, no. 1206. 23. For other interpretations, cf. Smith, op. cit.

pecially the Ephesos Hermes with the Mausoleum warrior who has fallen on one knee (fig. 748); even the rendering of the hair with its curling, disordered strands is remarkably similar. In any event the attribution of this drum to Skopas is within the range of possibilities.

Other Works

Apart from these architectural sculptures there is little that we can assign to Skopas with any confidence. Pausanias[24] saw in the precinct of Aphrodite at Elis "a bronze figure of the goddess seated on a bronze goat . . . called Aphrodite Pandemos" and states that it was the work of Skopas. On

Aphrodite Pandemos

FIG. X. Aphrodite Pandemos, on a coin (from a drawing, enlarged) *British Museum, London*

Roman coins of Elis[25] occurs a fine figure answering this description, but unfortunately very badly preserved (fig. X). This creation by Skopas may have inspired works like the mirror relief in the Louvre[26] and the sardonyx cameo in Naples.[27] Strabo[28] mentions a temple of Apollo Smintheus at Chryse (Alexandria Troas) "and the symbol which preserves the derivation of his name, i.e., the mouse, lies at the foot of the statue; they are the work of Skopas of Paros." Eustathius[29] refers to the same sanctuary and adds "the symbol that lies at the foot of the statue, the mouse, is the work of Skopas." It used to be thought that Skopas

Apollo Smintheus

made both cult image and mouse and that this statue was reproduced on coins of Chryse (fig. 742).[30] It has now, however, been argued that only the mouse was by Skopas and that it was added to an older image.[31]

Pliny[32] lists as one of Skopas' works "the Apollo of the Palatine"[33] and Propertius[34] gives rhetorical descriptions of two (?) figures: "Fairer than Phoebus himself seems to me this marble figure as it sings its song to the silent lyre. . . . The Pythian god himself is standing between his mother and his sister,[35] making music, clothed in a long garment." A group of Apollo, Leto, and Artemis which occurs on a marble base

24. VI. 25. 1.

25. Imhoof-Blumer and Gardner, *Numismatic Comm.*, pl. P, no. XXIV, pp. 72–73; Lacroix, *Reproductions de statues sur les monnaies*, pp. 316 f., pl. XXVIII, 5.

26. Collignon, in *Monuments Piot* I, 1894, pp. 144 f., pl. XX.

27. Furtwängler, *Antike Gemmen*, pl. LVII, 22; Richter, *Engraved Gems*, II, no. 146.

28. XIII. 604. 29. *Ad. Iliadem* 30. 16.

30. The theory was first advanced by Furtwängler, in Roscher's *Lexicon* I. 466. The difficulty is that a raven appears on these coins, not a mouse.

31. Cf. V. R. Grace, in *J.H.S.*, LII, 1932, pp. 228 ff.; Cf. also Lacroix, op. cit., p. 318.

32. *N.H.* XXXVI. 25.

33. Taken there from Rhamnous. 34. II. 31.

35. The Leto and Artemis were by the younger Kephisodotos and Timotheos respectively. On the group cf. Rizzo, *La base di Augusto*, pp. 51 ff.

in Sorrento[36] has been thought to reproduce the second work seen by Propertius; and several statues of Apollo playing the lyre have inevitably been associated with Skopas' work[37] (cf. e.g. fig. 752). They can only be somewhat free imitations; for they differ in the positions of the legs and the arrangement of the folds. It is specially tempting to see at least the influence of a statue by Skopas in the inspired lyre player which occurs on coins of Nero (fig. 741[38]). The swaying attitude and forward movement are just what we should expect in Skopas' creations; but the pose does not correspond with the Apollo of the Sorrento base, and we know nothing further regarding the other Skopaic Apollo.

Pliny[39] enumerates several works concerning which it was uncertain whether Skopas or Praxiteles made them: "a group of Niobe's children meeting their death"; "a Janus" (probably a double-faced bust of Hermes); "Eros holding a thunderbolt," said to be in the likeness of Alkibiades. It has been thought that we have copies of "Niobe's children" in the statues of Niobe and her sons and daughters in the Uffizi[40] and elsewhere. From what we know of the two sculptors Skopas would be the more likely author of the originals, at least if we ascribe to him the Tegea heads. The Florence statues, particularly the Niobe, with the rather square head and deep-set eyes, are more in accord with the Tegea heads than with the radiant Hermes and Knidian Aphrodite. But of course a vague attribution in Roman times to two outstanding Greek sculptors may be due merely to a desire for big names. Moreover the attitudes, with head, trunk, and limbs in contrasting planes, are in the scheme introduced by Lysippos, and some of the heads resemble that of the Apoxyomenos. The originals could therefore hardly date before the late fourth century. As a matter of fact, recently the group has been thought to belong to the "late Hellenistic-classicizing art of the later first century B.C."[41] So we have three centuries of assignments.[42]

This sums up what we actually know of Skopas' work; and we must admit it is little indeed. Ancient writers of course mention many other statues and groups by him,[43] made for shrines both in Greece and in Asia Minor. And there have naturally been

36. Wolters-Springer, *Handbuch der Kunstgeschichte*[12], fig. 617; Picard, *Manuel*, III, p. 302, fig. 140.

37. Deonna, *Catalogue des sculptures antiques au Musée d'art et d'histoire en Genève*, no. 61; H. Marwitz, *Antike Plastik*, VI, 1967, pp. 47 f., pls. 28 f., figs. 31 f.

38. Robertson, *Roman Imperial Coins in the Hunter Coin Cabinet* I (1962), pl. 22, no. 75.

39. *N.H.* XXXVI. 28.

40. Amelung, *Führer durch die Antiken*, nos. 175 ff.; Picard, *Manuel*, III, pp. 750 ff. For a recent attractive suggestion regarding the original composition cf. Mingazzini, *Boll. d'Arte*, 1967, pp. 10 ff.

41. Cf. Weber, in *J.d.I.*, LXXV (1960), pp. 112 ff.; von Steuben, in Helbig-Speier, *Führer*⁴, II, no. 1783; Schuchhardt, in *Gnomon, 40* (1968), p. 408.

42. Cf. Mansuelli, in *Enc. Arte Antica*, V (1963), pp. 517 ff., s.v. Niobe e Niobidi.

43. Cf. Overbeck, *Schriftquellen*, nos. 1151 ff.; a Hekate at Argos, an Asklepios and Hygieia, a Herakles at Sikyon, two Eumenides in Attica (of Parian marble and "not of terrifying aspect," i.e. in the beautifying style of the period), an Apollo at Rhamnous, a Hestia, Kanephoroi, a herm of Hermes, a maenad, Eros, Himeros, and Pothos at Megara, Athena Pronaia at Thebes, Artemis Eukleia, Aphrodite and Pothos in Samothrake, Leto and Ortygia in Ephesos, Ares and Aphrodite both at Pergamon, a large group of Poseidon, Thetis, Achilles, Nereids, and Tritons in Bithynia, a Dionysos and an Athena at Knidos.

numerous attempts to recognize in extant statues copies of such works. Thus the Ares Ludovisi[44] has been associated with the "colossal seated figure of Ares" ascribed to Skopas by Pliny;[45] the Maenad in Dresden[46] (fig. 756) with the frenzied Maenad mentioned by Kallistratos;[47] the Herakles formerly in the Lansdowne Collection[48] (fig. 754) with the statue seen by Pausanias[49] in Sikyon; the Apollo with a goose, preserved in many replicas (cf. fig. 752), with the Pothos mentioned by Pausanias.[50] Moreover, many fine figures and heads with deep-set eyes and swelling foreheads—such as the Meleagers in the Fogg Museum in Cambridge, Massachusetts, and in the Villa Medici[51] (fig. 755), and the head from a relief in New York[52] (fig. 179)—have been set down as "Skopasian" works. But these are only guesses based on general stylistic considerations.

Faint though our picture is we nevertheless feel in Skopas the contact of a great personality, and one that apparently had a deep influence on the history of Greek art. For just as Praxiteles' subtle, graceful figures were imitated by many later generations, so some of Skopas' vehement creations opened the way for the emotional sculpture of the Hellenistic age.

Timotheos

TIMOTHEOS[53] took part in two great monuments of the fourth century of which remains are extant—the temple of Asklepios at Epidauros[54] (first quarter of the fourth cen-

DATE
WORKS

*Temple of
Asklepios at
Epidauros*

44. Furtwängler, *Masterpieces*, p. 304; Collignon, *Histoire de la Sculpture grecque*, II, fig. 124, p. 247.

45. *N.H.* XXXVI. 25.

46. Neugebauer, *Studien über Skopas*, pls. III and IV, pp. 62 ff.

47. Statius, 2; cf. also *Anthol. Gr.* III. 57. 3 and I. 74. 75.

48. Wolters-Springer, *Handbuch der Kunstgeschichte*[12], fig. 611, p. 329.

49. II. 10. 1.

50. I. 43. 6. For this identification cf. Furtwängler, "Der Pothos des Skopas," in *Sitzungsberichte der Münchner Akademie der Wissenschaften* (philos.-philolog.-hist. Cl., 1901), pp. 703 ff. and *Antike Gemmen*, text to pl. XLIII, 52, made out a good case, which was widely accepted, cf. e.g. Bulle, in *J.d.I.*, LVI (1941), 121 ff.; Lippold, *Handbuch*, p. 252. Recently, however, it has been questioned, on the grounds that the style with its strong torsion pointed to a later period than that of the fourth-century Skopas; and that, therefore, it may have been a work of "Skopas Minor," a sculptor attested for the first century B.C.; cf. Mingazzini, in *Arti figurative*, II (1946), p. 137; von Steuben, in Helbig-Speier, *Führer*[4], II, no. 1644; Schuchhardt, in *Gnomon*, 1968, p. 405. Personally—following Furtwängler's reconstruction, i.e. with wings and leaning on a thyrsos—I find no difficulty in seeing in these statues Roman copies of a work of the later fourth century B.C., quite possibly of Skopas' Pothos in Samothrace. The stance seems to be a development of Praxiteles' Apollo Sauroktonos, and the deep-set eyes in some of the replicas conform with what we provisionally know of Skopas' style. Moreover, the large number of replicas points to a famous original, whereas "Skopas Minor" did not rank with the outstanding Greek sculptors. Cf. also my pp. 243 ff., concerning the art of the first century B.C. My fig. 754 shows the statue found in Rome in 1940; cf. Helbig-Speier, *Führer*[4], II, no. 1644.

51. Chase, *Greek and Roman Sculptures in American Collections*, figs. 97, 101; Furtwängler, op. cit., p. 304, n. 3.

52. Richter, *M.M.A. Cat. of Greek Sculptures*, no. 118.

53. On Timotheos cf. Lippold, *Handbuch*, pp. 220 ff., and the references there cited; Borrelli, in *Enc. Arte Antica*, VII, 1966, pp. 862 f., s.v. Timotheos, and the references there cited.

54. Cf. Cavvadias, *Fouilles d'Epidaure*; Defrasse and Lechat, *Epidaure*. The sculptures are now in the National Museum, Athens, nos. 136–74. Papaspiridi, *Guide*, pp. 60 ff., and S. Karouzou, *Cat.*, pp. 99 ff.

tury B.C.) and the Mausoleum of Halikarnassos[55] (ca. 350, cf. pp. 216 f.). On the first he must have worked during his youth, on the other in his later years. His share in the sculptures at Epidauros is attested by the building inscription recording the various contracts,[56] in which his name appears with those of several collaborators. The lines referring to Timotheos read: (line 36) Τιμόθεος εἵλετο[57] τύπος[58] ἐργάσα[σ]θα καὶ παρέχεν[59] ⊟ ⊟ ⊟ ⊟ ⊟ ⊟ ⊟ ⊟ ἔνγυος Πυθοκλῆς (Timotheos contracted to make and furnish "typoi" for 900 drachmas; his security was Pythokles); (line 90) Τιμόθεος ἐλ[ετο ἀκρω]τ[ήρ]ια ἐπὶ τὸν ἄτε[ρ]ον αἰετὸν [X] X ⊟·⊟ = = ἔνγυος Πυθ[οκλῆς] (Timotheos contracted to furnish akroteria on one of the pediments for 2240 drachmas; his security was Pythokles).

The akroteria for the other pediment were contracted for by one Theo . . . (Theotimos or more probably Theon): (line 97) Θέω[. . . ἔλετο ἀκρωτήρια ἐπὶ] τὸν ἄτερον αἰετὸν XX ⊟ ⊟ [⊟] [=] = , ἔνγυος Θεοξενίδα[ς] (Theon contracted to furnish akroteria for the other pediment for 2340 [or 2420] drachmas. His security was Theoxenidas).

The meaning of the word τύποι in line 36 is important. It used to be interpreted by archaeologists[60] as signifying models, and so Timotheos was supposed to have furnished the original models of the pediments of the temple or possibly of the whole sculptural decoration, and to have thus been the chief sculptor of the temple. But though the word τύπος occurs in Plato in the figurative sense of "the original type" or pattern, when the word is used in connection with sculpture its meaning is regularly slab or relief.[61] In fact τύπος never occurs in extant literature with the meaning of concrete model in the field of art. The legitimate word for model in this connection is παράδειγμα[62] and it occurs in that sense in this very inscription (line 303): Ἑκτορίδᾳ παρδειχματος λεοντο[κ]εφαλᾶν ἐνκαύσιος —::: (To Hektoridas for the painting of a model of the lion heads, sixteen drachmas). The view that τύποι are reliefs, not models, is reinforced by the fact that recent researches have shown that the pediment sculptures can be adequately accounted for in the building inscription. If as Ebert[63] and Vallois[64] ingeniously propose we take κερκίς to mean half a gable (and this

55. Smith, *Catalogue of Greek Sculpture in the British Museum*, II, pp. 65 ff.

56. Cf. Cavvadias, op. cit., no. 241, pp. 78 ff.; *I.G.*, IV (Argolid), no. 1484.

57. For εἵλετο. 58. For τύπους.

59. For παρέχειν.

60. First by Foucart, in *B.C.H.*, XIV (1890), pp. 589 ff., and then generally accepted until questioned by Ebert, *Die Fachausdrücke des griechischen Bauhandwerks*, 1 (Würzburger dissertation, 1910), p. 34; and by Vallois, in *B.C.H.*, XXXVI (1912), pp. 219 ff. For recent views, cf. Lippold, in *J.d.I.* (1925), pp. 206 ff., and Neugebauer, in *J.d.I.* (1926), pp. 82 ff. (both for τύπος as "model"); and Richter, in *A.J.A.*, XXXI (1927), pp. 80 ff., and von Blumenthal, in *Hermes*, 63, XIII (1928), pp. 391–414 (both for τύπος as "relief").

61. Cf. the many references cited by Lippold, op. cit.; also Richter, loc. cit., and von Blumenthal, loc. cit.

62. Lippold, op. cit., claims that παράδειγμα is merely a model or pattern to serve for a series of copies, as would be the case with waterspouts, architectural ornaments, etc. But it is used by Herodotos v. 62 for the model of a temple. Cf. Richter, loc. cit. 63. *Die Fachausdrücke des griechische Bauhandwerks*, 1, 34.

64. *B.C.H.* XXXVI (1912), pp. 226 ff. Vallois does not refer to Ebert's publication, so that he must have made the discovery independently.

seems justified since the word is applied to various wedge-shaped objects[65]) and connect line 89: ['E]κτορί[δ]ας ἕλετο κερκίδα τοῦ αἰετοῦ ἐργάσασθαι Χ Η Η Η Η Η —(Hektoridas contracted to work one wing of the pediment for 1610 drachmas) with line 111 (an entry made in the following year) Ἐκτορίδ[α] ἐναιετίων τᾶς ἀτέρας κερκιδος Χ Η Η Η (To Hektoridas for the other wing of the pediment sculptures 1400 drachmas) we obtain a total disbursement to this sculptor for one whole pediment—worked and paid for in two successive years—of 3010 drachmas. And this is the identical sum paid to the sculptor of the other pediment (whose name is lost): line 98 [τῷ δεῖνι ἐναι] ε[τ]ίων ἐ[ς] τὸν ἅτερον αἰετὸν [Χ]ΧΧ—, ἔγγυος Θεοξενί[δας] (To . . . for the sculptures of the other pediment 3010 drachmas. His security was Theoxenidas). The argument therefore, which has been advanced, that the sums paid for the pediment are insufficient and that consequently we must fill up a gap in the inscription and ascribe these pediments to several names—who worked under the supervision of and from the models of Timotheos[66]—falls to the ground. If three splendid akroteria carefully finished on every side cost 2240 drachmas, 3010 drachmas is not too little for a compact pediment group which was seen only from one side and need therefore not be worked throughout. As a matter of fact the execution of the pediment figures (cf. figs. 763–66[67]) is perfunctory compared to that of the akroteria (figs. 757–60), and the finest of the extant fragments of these pediment sculptures (fig. 763[68]) is so carelessly worked at the back that the left leg does not even properly connect with the body (fig. 764), a rare feature in Greek art.

To sum up: as the sculptors of the Epidauros temple we have Hektoridas and an artist whose name is lost, for the two pediments; Timotheos and Theo . . . , for the two sets of akroteria; Timotheos, for reliefs of unknown purpose (see below). Timotheos then emerges as one of the four sculptors at work on the temple, and not necessarily the most important of them, since he receives less pay for his akroteria than Theo . . . did for his!

Several of the six akroteria of the temple have survived. They consist of two Nereids (or Aurai) on horseback[69] (figs. 757, 758; nos. 156, 157), a Nike holding a bird[70] (fig. 760), and the upper part of another Nike[71] (fig. 759). The two Nereids were found close to the western end of the temple,[72] so that their association with the western pediment is assured. The Nike with the bird was found built into a wall between the temple and the rotunda of Polykleitos,[73] that is, not far from the western

65. E.g. the rod used in weaving which had a triangular end, cf. Blümner, *Gewerbe und Künste*, 1, 146, fig. 18; a wedge-shaped division of the seats in a theater (Alexis, Γυναικοκ 1).

66. Cf. e.g. Wolters and Sieveking, in *J.d.I.*, 24 (1909), 188.

67. National Museum, Athens, nos. 136, 138, 146 (146 not certainly from the pediments). Papaspiridi, *Guide*, p. 60; S. Karouzou, *Catalogue*, pp. 101 f. 68. National Museum, Athens, no. 136.

69. National Museum, Athens, nos. 156, 157. Papaspiridi, *Guide*, p. 61, and S. Karouzou, *Catalogue*, pp. 99 f.

70. National Museum, Athens, no. 155. Papaspiridi, *Guide*, p. 61, and S. Karouzou, *Cat.*, p. 100.

71. National Museum, Athens, no. 162.

72. Cavvadias, *Fouilles d'Epidaure*, p. 21: "tout près du côté occidental du temple."

73. Ibid., p. 20.

end; she may therefore have been the central akroterion of the west pediment. The upper part of a Nike with wings came to light northeast of the temple[74] (near a base which Cavvadias erroneously thought belonged to it). Its identification as an akroterion of the temple was suggested by Furtwängler.[75] Recently still another torso has been identified as having belonged to an akroterion of this temple.[76] In style these figures are markedly similar. They have in common the delicate, transparent drapery with sharply cut, finely worked folds, very different from the more coarsely worked and denser drapery of the pediment figures. So whether Timotheos was the sculptor of the Nereids and the Nike with the bird from the west pediment or of the fragment of a Nike probably from the east pediment, his style was apparently characterized by this transparent rendering of drapery—which connects him with late fifth-century accomplishments.

We stated that besides the akroteria Timotheos made certain reliefs for which he received nine hundred drachmas (pp. 214 f.). Now there were found on the temple site two reliefs representing a seated male figure[77] (figs. 761, 762), of the same delicate workmanship as the akroteria and with similar transparent drapery. They cannot be sculptured metopes as Svoronos[78] once thought, for the measurements do not after all correspond,[79] and the composition of the reliefs with the legs protruding from the background is inappropriate for a metope; moreover, the use of the word τύπος for metope has no parallel. What purpose they actually served we do not know, but their affinity with the style of the akroteria as against that of.the pediment figures makes it at least possible that they were the work of Timotheos.

Mausoleum Timotheos is mentioned by Pliny[80] as one of the sculptors of the Mausoleum of Halikarnassos, along with Skopas, Bryaxis, and Leochares. We have seen that in the case of Skopas it has been possible to assign to him—with much probability—certain portions of the friezes (cf. p. 210). Is this feasible also with Timotheos? The attempt has been made. Wolters and Sieveking[81] see his hand in the slabs nos. 1006, 1007, 1008, 1010, 1011, 1012, 1016, 1017[82] (cf. figs. 767–69)—for they have similar, somewhat stereotyped figures not always successfully composed, as well as the same type of stocky, muscular horse, with short, thick head, conspicuous folds on the neck, and a tail very broad at the root. The characteristics, however, are not so clearly

74. Ibid., p. 118, fig. 19.

75. *Sitzungsberichte der Münchner Akademie*, philos.-philolog.-hist. Cl., 1908, p. 445.

76. Cf. Yalouris, *Arch. Delt.*, xxii, pp. 25 ff., and Megaw in *Hellenic Society Archaeological Reports* (1967–68), p. 9, fig. 12. In addition Yalouris has identified a number of fragments as belonging to the other akroteria.

77. National Museum, Athens, nos. 173, 174. Papaspiridi, *Guide*, p. 62, and S. Karouzou, *Catalogue*, p. 103. For recent views regarding these reliefs cf. B. S. Ridgway, in *A.J.A.*, lxx (1966), pp. 217 ff. But see S. Karouzou, loc. cit.

78. *Das Athener Nationalmuseum*, i, pp. 152 f.

79. Neugebauer, *J.d.I.*, xli (1926), 83 f.

80. *N.H.* xxxvi. 30.

81. Cf. *J.d.I.*, xxiv (1909), pp. 181, 185. Pfuhl, *J.d.I.*, xliii (1928), pp. 46 f., would assign only 1006, 1010, 1016, 1017.

82. Smith, *Catalogue of Greek Sculpture in the British Museum*, ii, pp. 99 ff.

marked as in the case of Skopas; and even if we admit that these slabs form a homogeneous group, we have no evidence by which we can assign it to Timotheos. We know only that he was at work on the south side, but only one of the slabs was found on the temple site (no. 1016) and that was on the east. In style they are certainly different from the akroteria of Epidauros.

We hear also of single statues by Timotheos—an Artemis[83] later shown in the temple of Apollo on the Palatine, an Asklepios[84] in Troezen, athletes, etc.[85] But no trace of them has survived. The safest criterion by which to judge the style of Timotheos is therefore the akroteria of the Epidauros temple. For either the three fine figures (figs. 757, 758, 760) or one not dissimilar fragment (fig. 759) should be by his hand. Several statues have accordingly been ascribed to Timotheos on account of their general stylistic resemblance to the Epidauros akroteria,[86] the most important being the Leda in the Villa Albani[87] and a female torso in Copenhagen.[88] But we must remember in such assignments that Timotheos' associate, Theo . . . , had evidently a markedly similar style.

Other Works

Bryaxis

BRYAXIS,[89] an Athenian,[90] was as we have seen (p. 209) at work on the Mausoleum about 350 B.C. An inscription on a sculptured base with the name of Bryaxis as the sculptor may be dated about the middle of the fourth century. We know furthermore[91] that he made a portrait of Seleukos (Nikator) who became king of Syria in 312; but the portrait may have been done before Seleukos became king, for Bryaxis would have been rather old in 312, if he was an eminent sculptor in 350.

ORIGIN AND DATE

The signed sculptured base referred to is our chief landmark for the study of Bryaxis. It is a square block found in Athens in 1891, evidently intended for the support of a votive offering. It is decorated on three sides with a horseman approaching a tripod[92] (fig. 770), and on the fourth is an inscription recording that Demainetos, Demeas, and Demosthenes—a father and two sons—were victorious in cavalry engagement (ἀνθιππασία) and that Bryaxis made the monument (fig. 771). The base was presumably at least designed by the same sculptor as the monument. Precious as this original monument is, the reliefs of the horsemen are so sketchy that they can

WORKS
Sculptured Base

83. Pliny, *N.H.* XXXVI. 32. 84. Pausanias II. 32. 4.

85. Pliny, *N.H.* XXXIV. 91..

86. Cf. Amelung, in *Ausonia*, III (1908), pp. 91 ff.; Arndt, in Brunn-Bruckmann, *Denkmäler*, text to pl. 648.

87. Brunn-Bruckmann, *Denkmäler*, pl. 648. 88. Ibid., pl. 665.

89. On Bryaxis cf. Lippold, *Handbuch*, pp. 257 ff., and the references there cited; Borrelli, in *Enc. Arte Antica*, II, 1959, pp. 196 ff., s.v. Bryaxis, and the references there cited; also Adriani, "Alla ricerca di Briasside," in *Memorie Acc. Lincei*, X (1948), pp. 434 ff. (with bibliography).

90. Clement of Alexandria, *Protrept.*, IV. 47. 91. Cf. Pliny, *N.H.* XXXIV. 73.

92. National Museum, Athens, no. 1733. Cf. Kavvadias, in *Eph. arch.*, 1883, pls. 6, 7, pp. 39 ff.; Svoronos, *Athener Nationalmuseum*, I, pls. XXVI, XXVII, pp. 163 ff.; Papaspiridi, *Guide*, pp. 71 f., and S. Karouzou, *Cat.*, pp. 159 f.

give us only a limited picture of Bryaxis. We obtain from them the impression of an able but rather conventional person of delicate perception and with a fine sense of composition, for the spacing of the horsemen with the tripods is very pleasing.

In the vicinity of this base (that is, fifty meters from it) was found the statue of a (wingless) Nike[93] (figs. 772, 773) which was once identified as the statue originally erected on it. But the execution is too summary for a single commemorative statue, more adapted to a decorative figure placed at a great height like an akroterion;[94] and the oblique direction of its forward movement does not compose well with the rectangular base.[95] Furthermore the style of the drapery, with its finely composed, sharply cut folds and the low girding, is that of the fifth rather than of the middle of the fourth century[96] (cf. figs. 774, 775). The tunics of the horsemen on the base, on the other hand, are in the familiar fourth-century style, comparable to that of the Mausoleum frieze.

Mausoleum Is it possible to use the reliefs on the base as a criterion by which to recognize part of the Mausoleum frieze as the work of Bryaxis? The attempt has been made,[97] based chiefly on a comparison of the types of horses. The thick-set build, with muscular body, triangular neck (wide at the base and narrow at the head), short head, and tail consisting of continuous long hairs, which appear on the inscribed base, occur again on the slabs, British Museum, nos. 1009, 1019[98] (figs. 776, 777) of the Mausoleum frieze; and these have accordingly been attributed to Bryaxis. If the assignment is correct, and it is at least ingenious, we have here works of a very different character from the quiet horsemen of Athens—impetuous fighting scenes with galloping and rearing horses, rapidly advancing figures and fallen bodies, the medley of the battle, boldly and yet harmoniously composed. The spirit of the two products is different indeed, but they have in common a fine feeling for design.

Apollo The rhetorician Libanios[99] describes in glowing terms a statue of Apollo by Bryaxis
Kitharoidos at Daphne near Antioch: "Imagination brings before my eyes that form, the bowl, the lyre, the tunic reaching to the feet, the delicacy of the neck in the marble, the girdle about the bosom, which holds the golden tunic together, so that some parts fit closely and others hang loose. He seemed as one that sang." We know from Cedrenus[100] that the statue was by Bryaxis; and it appears to be represented on coins of

93. National Museum, Athens, no. 1732. Svoronos, op. cit., pl. xxvii; Kavvadias, op. cit., pls. 4, 5; Papaspiridi, *Guide*, p. 72, and S. Karouzou, *Cat.*, p. 41.

94. S. Karouzou, *Catalogue*, p. 41, suggests that it may have belonged to the temple of Ares.

95. This is the case even if we imagine an intermediate column (cf. Kavvadias, in *Eph. arch.*, pl. facing p. 47). In the Paionios Nike this problem was ably solved by a triangular pyramidal base.

96. Cf. my comparisons in the earlier editions of this book, on p. 282, when the Nike was still thought to belong to the base.

97. Cf. Wolters and Sieveking, in *J.d.I.*, xxiv (1909), p. 184. Pfuhl, in *J.d.I.*, xliii (1928), pp. 48 f. assigns to Bryaxis slabs 1019, 1020, 1021, 1018, which are given by Wolters and Sieveking to Leochares (see p. 283, note 207). 98. Smith, *Catalogue of Greek Sculpture*, ii, pp. 102 f., 109.

99. *Orat.* 61. 100. *Hist. Comp.* 306 B.

Antiochos Epiphanes[101] (figs. 778, 779). It is a dignified composition harking back to earlier prototypes; quite what we might expect from this artist.

A Sarapis cited by Clement of Alexandria[102] had been identified with a type surviving in many Roman copies and adaptations, including a statue in Alexandria[103] and two busts in the Vatican.[104] But this identification was questioned e.g. by Adriani;[105] he pointed out that the only record we have of a Sarapis by Bryaxis is that cited by Clement of Alexandria, who says that this Sarapis was not by the Athenian Bryaxis but by another Bryaxis. But Clement of Alexandria adds that the Bryaxis by him cited belongs to the early Egyptian period of the legendary king Sesostris. It still seems possible to think that the Bryaxis of the fourth century was the originator of the type surviving in many later works[106] (including engraved gems, showing Sarapis in his temple, cf. fig. 780[107]). That there are many variations may be explained by the difficulty of copying a colossal statue. At all events, the many copies of this type point to an original by a famous sculptor, and the style suggests the second half of the fourth century B.C. when we know that Bryaxis was active. One hopes that clinching evidence will appear.[107a]

Of other works by Bryaxis mentioned by ancient writers[108] we know only the names. *Other Works* We hear of statues of various deities, including five colossal figures in Rhodes,[109] a Dionysos,[110] a Pasiphae,[111] and the portrait of Seleukos mentioned above. All these, except the Sarapis and an Asklepios and Hygieia,[112] were made for Asia Minor. The Bryaxis whose name on a base (opus Bryaxide[113]) must belong to a later period.

Thrasymedes

THE sculptor of the statue which stood inside the temple of Asklepios at Epidauros was Thrasymedes of Paros.[1] Pausanias[2] gives a detailed description of it: "[At Epidauros] the image of Asklepios is smaller by one half than the Olympian Zeus at Athens, and is made of ivory and gold; the inscription states that it is the work of Thrasymedes the son of Arignotos of Paros. The god is seated upon a throne and holds

101. Babelon, *Les Rois de Syrie*, p. 71, pl. XII, 12; Lacroix, *Reproductions de statues*, p. 320, pl. 28, 7.

102. *Protrept.*, IV. 48 (quoting Athenodoros). 103. Cf. Lippold, *Handbuch*, p. 258, pl. 93, 3.

104. Von Steuben, in Helbig-Speier, *Führer*⁴, I, nos. 44, 171.

105. *Atti dell'Accademia Nazionale dei Lincei*, CCCXLV, 1948, pp. 438 ff., and *Repertorio d'Arte dell' Egitto greco-romano*, II, pp. 40 ff., nos. 154 ff.

106. Cf. Lippold, op. cit., pp. 258 f.; von Steuben, loc. cit.; Borelli, in *Enc. Arte Antica*, VII, 1966, s.v. Sarapide, pp. 204 ff., and the references there cited.

107. Walters, *Catalogue of Bronzes in the British Museum*, no. 1773; Richter, *Engraved Gems*, II, no. 198.

107a. For recent opinions cf., besides Adriani and von Steuben, loc. cit., esp. Castiglione, in *Bull. Mus. Hongrois des Beaux Arts*, XII, 1958, pp. 17 ff.; Jucker, in *Genava*, N.S. VIII, 1960, pp. 113 ff., and in *Schweizer Münzblätter*, XIX, 1969, pp. 78 ff.; Th. Kraus, in *J.d.I.*, LXXV, 1960, pp. 88 ff.; Charbonneaux, in *Mon. Piot*, LII, fasc. 2, 1962, pp. 15 ff.

108. Cf. Overbeck, *Schriftquellen*, nos. 1316 ff. 109. Pliny, *N.H.* XXXIV. 42.

110. Pliny, *N.H.* XXXVI. 22. 111. Tatian, *Contra Graecos*, 54. 117 (ed. Worth).

112. Pausanias, I. 40. 6. Made for Megara. 113. *I.G.B.*, 492.

1. On Thrasymedes cf. Lippold, *Handbuch*, pp. 230 f., and the references there cited; Moreno, in *Enc. Arte Antica*, VII, 1966, pp. 838 f., s.v. Thrasymedes, and the references there cited. 2. II. 27. 2.

a staff in one hand, while he extends the other above the serpent's head. A dog is also represented lying at his feet. On the throne are represented in relief the exploits of Argive heroes, viz., the contest of Bellerophon with the Chimaira, and Perseus, who has decapitated Medusa." A seated Asklepios with staff, serpent, and dog which appears on the coinage of Epidauros (fig. 781) doubtless reproduces this temple statue.[3] It is a dignified figure in early fourth-century style, a not unworthy successor of the chryselephantine statues by Pheidias and Polykleitos. Even from the small coin reliefs we get the impression of the magnanimity and gentleness of the great god of healing. The statue was probably made after the temple was completed; at least it is not mentioned in the building inscription (cf. p. 214); but it cannot be much later, for the transparent drapery (which we noted also in the akroteria of the temple, cf. p. 216) still harks back to late fifth-century models. So we may date the original about 375 B.C.[4]

The temple statue was not the only work which Thrasymedes made for the temple of Asklepios. The building inscription (line 45) tells us that he "contracted to execute the roof above and the inner doorway, as well as that between the columns, for 9800 drachmas. His securities were Pythokles, Theopheides, and Agemon." In line 65 of the same inscription we learn that 3070 drachmas worth of ivory were furnished for this door, and the gold nails mentioned in line 65 were doubtless for the same purpose. Thrasymedes' knowledge in working ivory and other precious materials must have given him these commissions. A dedicatory inscription to Apollo and Asklepios with a signature of Thrasymedes was found near the stadium.[5]

Leochares[6]

ORIGIN AND DATE

PLINY[7] places Leochares along with Kephisodotos in the 102d Olympiad (ca. 372 B.C.). Plato[8] in a letter dated about 366 B.C. refers to Leochares as "an excellent young craftsman." As many as seven inscriptions with Leochares as the name of the sculptor have been found in Athens,[9] and these are all datable in the middle and second half of the fourth century. Pausanias[10] tells us that he made chryselephantine

WORKS

statues of Philip of Macedon and his family (his parents, his wife, and his son, Alexander the Great) for the Philippeion at Olympia, and he collaborated with Lysippos in a lion hunt of Alexander (Alexander was born in 355). We also know from Plutarch[11] that he made a bronze portrait of Isokrates (436–338). Like most Greek artists of this period he obtained important commissions in Asia Minor, where large

3. Cf. Imhoof-Blumer and Gardner, *Numismatic Comm.*, pl. L, nos. III–V; Lacroix, *Reproductions de statues sur les monnaies*, p. 301, pl. XXVI, 127.

4. In later times the statue was attributed to Pheidias; cf. Athenagoras, *Legatio pro Christianis* 14.

5. Kavvadias, in *Eph. arch.*, 1885 p. 50; *I.G.*, IV², 198.

6. On Leochares cf. Lippold, *Handbuch*, pp. 268 ff., and the references there cited; Arias, in *Enc. Arte Antica*, IV, 1961, pp. 565 f., s.v. Leochares, and the references there cited.

7. *N.H.* XXXIV. 50. 8. *Epistles* XIII (perhaps spurious).

9. Loewy, *Inschriften*, nos. 77–83. 10. V. 20. 9.

11. *Vitae X orat.*, Isokrates 838 D. Cf. my *Portraits of the Greeks*, II, p. 209.

artistic undertakings were now more frequent than in Greece proper. Thus he was one of the four sculptors of the Mausoleum of Halikarnassos (soon after 351), the western side of which was assigned to him for decoration. His chief period of activity therefore seems to have been the middle and the third quarter of the fourth century. Though his origin is nowhere directly stated, the fact that so many inscriptions with his name were found in Athens suggests that he was an Athenian, in any event active in Athens during a considerable period.

Since part of the sculptural decoration of the Mausoleum of Halikarnassos has survived, the question naturally comes up whether it is possible to assign any of it to Leochares. Sieveking and Wolters[12] in their attempt to apportion the largest frieze between the four sculptors[13] have assigned to Leochares the slabs, British Museum,[14] 1020, 1021, and 1018 (cf. fig. 783). These reliefs show a highly individual style— markedly long figures in strongly oblique postures, constantly crossing one another, and restless, waving drapery. They are certainly by one hand, and it is tempting to think it was that of Leochares; for after Skopas he seems to have been the most distinguished of the four sculptors[15] and these slabs are next to those assigned to Skopas the ablest and most original work.[16]

The Mausoleum Frieze[12]

Pliny[17] describes one of Leochares' works as follows: "Leochares represented the eagle which feels what a treasure it is stealing in Ganymede, and to whom it is bearing him, and using its talons gently, though the boy's garment protects him." A group of Ganymede and the eagle extant in various replicas, of which the best is in the Vatican[18] (fig. 786), has naturally been associated with Leochares' work; for it corresponds in a general way to Pliny's rather vague description; that is, the eagle's claws are laid on Ganymede's garment. The beautiful bronze mirror in Berlin[19] may give us another suggestion of Leochares' work, for it is at least a Greek original (fig. 782); here too the claws of the eagle are placed over the boy's garment. Another work by Leochares which has been tentatively identified is the portrait of Isokrates at Eleusis, cited in Pseudo Plutarch,[20] and of which a Roman copy may have survived in a head in the Villa Albani.[21]

Other Works

We hear of several other works by Leochares,[22] such as a "famous Zeus the thunderer," afterward on the Capitol, "a work of unequalled excellence";[23] a colossal

12. *J.d.I.*, XXIV (1909), pp 171 ff. 13. Cf. pp. 210, 216 f., 218.
14. Smith, *Cat.*, II, pp. 109 ff.
15. Vitruvius II. 8. 11 speaks of "nobili manu Leocharis," the equivalent of famous.
16. Pfuhl, *J.d.I.*, XXIV (1928), pp. 48 f., would assign these same slabs to Bryaxis and nos. 1007–1009, 1011, 1012 to Leochares; but the stormy movement of 1020, 1021, 1018 has nothing in common with the horseman on the base, our only criterion for Bryaxis' style (cf. pp. 217 f.).
17. *N.H.* XXXIV. 79. Cf. also Tatian, *c. Graec.*, 56; Martial, I. 7.
18. Helbig-Speier, *Führer*⁴, I, no. 528. The restorations include the head and wings of the eagle; the right forearm, left arm, and both legs from the knee down of Ganymede, and the upper part of the dog.
19. Cf. Furtwängler, *Collection Sabouroff*, II, pl. 147. 20. *Vitae decem oratorum, Isokrates*, 27.
21. Cf. my *Portraits of the Greeks*, II, p. 209, no. 1, figs. 1346, 1347.
22. Cf. Overbeck, *Schriftquellen*, nos. 1303 ff. 23. Pliny, *N.H.* XXXIV. 79.

statue of Ares[24] of wood with marble head, hands, and feet ($\dot{\alpha}\kappa\rho\dot{o}\lambda\iota\theta o\nu$); a series of portraits executed together with the sculptor Sthennis;[25] chryselephantine statues of Philip of Macedon, his son Alexander, and his father Amyntas in the Philippeion at Olympia;[26] etc. But of none of these have copies been satisfactorily identified in extant sculptures. Because of a certain resemblance to the Vatican Ganymede the original of the Apollo Belvedere (fig. 784) has been ascribed to Leochares. With such uncertain evidence we must admit that Leochares still remains a shadowy figure.

Euphranor

EUPHRANOR,[27] perhaps of Corinth, but later an Athenian, is placed by Pliny[28] in the 104th Olympiad (ca. 364 B.C.). Pliny gives a list of his works, and says that he "far outshone his rivals"; also that he was a distinguished painter as well as a sculptor, and wrote books on symmetry and color. Among his statues cited by ancient writers[29] was a Bonus Eventus, a Paris, Leto with her children, Apollo and Artemis, an Apollo Patroos, and Philip and Alexander on chariots—so he must have been active a considerable time. Various suggestions have been made connecting extant works with these sculptures; for instance the Bonus Eventus with a figure that appears in Roman marble copies, as well as on Roman coins and gems,[30] but they are more or less hypothetical—except one. In 1907 there was found, near the temple of Apollo Patroos in the Athenian agora,[31] just where Pausanias[32] cites it, an imposing, headless statue, which has been recognized as the original cult statue of Apollo Patroos by Euphranor[33] (fig. 785). He is represented as Apollo *kitharoidos* wearing a voluminous peplos and mantle, with the folds deeply carved and rhythmically composed. The statue was first exhibited in the National Museum,[34] but now occupies a prominent place in the Stoa of Attalos, i.e. near where it stood in antiquity.

Silanion

SILANION[35] is dated by Pliny[36] in the 113th Olympiad (ca. 328 B.C.). Pausanias, Plutarch, Cicero, Pliny, Diogenes Laertios, and others[37] mention various sculptures by him, among them statues of Achilles, Theseus, the dying Iokaste, Sappho, Korinna,

24. Vitruvius II. 8. 11.

25. Cf. Loewy, *Inschriften*, no. 83. 26. Pausanias V. 20. 10.

27. Cf. Furtwängler, *Masterpieces*, p. 408; Helbig-Speier, *Führer*⁴, I, no. 226.

27a. On Euphranor cf. Lippold, *Handbuch*, pp. 260 f., and the references there cited; Bendinelli and Squarciapino, in *Enc. Arte Antica*, III, 1960, pp. 531 ff., s.v. Euphranor, and the references there cited; H. A. Thompson, "The Apollo Patroos of Euphranor," in the *Volumes in Memory of Oikonomos*, III (1953–54), pp. 30 ff. 28. *N.H.* XXXIV. 77; XXXV. 128, 129.

29. Cf. Overbeck, *Schriftquellen*, nos. 1798–1806. 30. Cf. e.g. Furtwängler, *Antike Gemmen*, pl. XLIV, 9 ff.

31. Stais, in *Delt. arch.*, II, 1916, parartema, p. 80, fig. 4. 32. I. 3. 3.

33. H. A. Thompson, op. cit. 34. No. 3573, Papaspiridi, *Guide*, p. 82.

35. On Silanion cf. Lippold, *Handbuch*, pp. 272 ff., and the references there cited; Moreno, in *Enc. Arte Antica*, VII, 1966, pp. 288 ff., s.v. Silanion, and the references there cited.

36. *N.H.* XXXIV. 51. 37. Cf. Overbeck, *Schriftquellen*, nos. 1351–63.

Plato, the sculptor Apollodoros, and the athlete Satyros. A few identifications with extant sculptures have been attempted; for instance the statue of Plato, mentioned by Diogenes Laertios[38] as having been dedicated by the Persian Mithradates in the Athenian agora, has been thought to have survived in a series of extant heads;[39] his Korinna in the statuette from Compiègne;[40] his portrait of Satyros[41] in the bronze head of a boxer found at Olympia[42] (fig. 787). But unfortunately we know nothing of Silanion's style to make these attributions certain; only that he is said to have written on symmetry and proportion.[43]

Sthennis

STHENNIS,[44] son of Herodoros, of Olynthos, was active from the time of Alexander to about 287–281 B.C. He is placed by Pliny[45] in the 113th Olympiad (ca. 328 B.C.). Among the works attributed to him are statues of deities; weeping, praying, and sacrificing women (presumably in mythological representations); athletes; and several portraits,[46] including a group worked in conjunction with Leochares (q.v.). No reliable identifications have so far been possible, but it is interesting to note that he belonged to a circle of artists who were active in the field of portraiture at the time when this art assumed special importance.

Eukleides of Athens

ACCORDING to Pausanias,[47] Eukleides[48] made statues of deities for Achaean cities, among them a seated Zeus for Aigeira. Of the latter the head (fig. 788) and left arm have been found,[49] and the whole figure is represented on coins of Aigeira of the Roman period[50] (fig. 789). On historical and artistic grounds Eukleides has been dated in the later fourth, the third, and the second century B.C.

38. III. 25. 39. Cf. Schefold, *Bildnisse*, p. 74; my *Portraits of the Greeks*, II, pp. 164 ff.

40. Richter, op. cit., p. 144. It should be noted that a type of head known in a number of examples and once thought to represent Sappho (cf. E. Schmidt, in *J.d.I.*, XLVII (1932), pp. 263 ff., XLIX (1934), pp. 200 f.) has now been shown to represent Hygeia; cf. my *Portraits of the Greeks*, I, p. 72.

41. Athens, National Museum, no. 6439. Papaspiridi, *Guide*, p. 194 f., and S. Karouzou, *Cat.*, pp. 177 f.; my *Portraits of the Greeks*, II, pp. 245 f.

42. For other suggested identifications cf. Lippold, *Handbuch*, pp. 272 ff.

43. Vitruvius, VII, praef. 14.

44. On Sthennis cf. Lippold, op. cit., p. 303, and the references there cited; Mingazzini, in *Enc. Arte Antica*, VII (1966), p. 499, s.v. Sthennis, and the references there cited.

45. *N.H.* XXXIV. 5. 46. Cf. Overbeck, *Schriftquellen*, nos. 1343–49.

47. VII. 25. 9; VII. 26. 4.

48. On Eukleides cf. Lippold, *Handbuch*, p. 274, and the references there cited; Marzani, in *Enc. Arte Antica*, III, 1960, p. 524, s.v. "Eukleides," and the references there cited; Bieber, *Sculpture of the Hellenistic Age*², pp. 158 f.

49. Athens, National Museum, no. 3377. Papaspiridi, *Guide*, p. 66, and S. Karouzou, *Cat.*, pp. 190 f., pl. 69.

50. *B.M.C.*, Peloponnesos, p. 17, no. 5, pl. IV, 10; Lacroix, *Reproductions de statues sur les monnaies*, p. 322, pl. XXVIII, 8.

Aristodemos

OF Aristodemos[51] we hear that he made a portrait of Seleukos and of Aesop, as well as athletes and chariots.[52] Moreover, a number of his signatures on bases have survived.[53] His Seleukos has been tentatively identified with the bronze head from Herculaneum in Naples;[54] but since Lysippos is also said to have made a portrait of Seleukos, the attribution is of course doubtful.

Demetrios

A PORTRAIT sculptor[55] placed in the first half of the fourth century by two inscriptions found on the Akropolis.[56]

Others

THE many other sculptors cited by Pliny (*N.H.* xxxiv. 76 ff.) as being active in this period, and of whom we know only the names make us realize the extent of our loss and the precariousness of making attributions to those relatively few sculptors, some of whose works have survived.

Lysippos

ORIGIN AND DATE

LYSIPPOS[57] of Sikyon is placed by Pliny[58] in the 113th Olympiad (328 B.C.), a natural date to select, for we know that he was especially active during Alexander the Great's reign (336–323). But he evidently began his career early, for an inscription found at Delphi[59] shows that he was already working soon after 370 B.C. And an inscription at Olympia[60] records that one Troilos was victorious with horses, and Pausanias[61] states that these victories were gained in the 102d Olympiad (372–368) and that Lysippos made the statue. The statue need not have been erected immediately after the victory, and the character of the inscription suggests that it was not set up till considerably later.[62] Pliny[63] tells us that Lysippos made numerous portraits of Alexander beginning with his boyhood (Alexander was born in 355). An inscription on a block found at Thebes associates Lysippos with a statue of Koreidas, winner in the pankration for boys in the Pythian games, datable about 342 or later.[64] Two statue bases

51. On Aristodemos cf. Lippold, *Handbuch*, p. 304, and the references there cited; Orlandini, in *Enc. Arte Antica*, I, 1958, p. 646, s.v. Aristodemos, and the references there cited.
52. Pliny, *N.H.* xxxiv. 86; Tatian, *C. graec.*, p. 36, 7. 53. Cf. *I.G.*, II–III², 3851, 2840/41, 4275.
54. Ruesch, *Guida*, no. 890; my *Portraits of the Greeks*, figs. 1857 f.
55. Cf. Pliny, *N.H.* xxxiv. 76, and Lucian, *Philops.* 18; Lippold, *Handbuch*, p. 226, and the references there cited. 56. Loewy, *Inschriften*, nos. 62, 63.
57. On Lysippos cf. Johnson, *Lysippos* (1927); Lippold, *Handbuch*, pp. 276 ff., and the references there cited; A. Giuliano and Ferri, in *Enc. Arte Antica*, IV, 1961, pp. 654 ff., s.v. "Lisippo," and the references there cited; Sjöquist, *Lysippos* (1967); Marcadé, *Signatures*, I, pp. 66 ff.
58. *N.H.* xxxiv. 63.
59. Cf. Bousquet, *Rev. arch.*, 1939, pp. 125 ff.; Wilhelm, *Oest. Jahr.*, xxxiii, 1941, pp. 33 ff.
60. Loewy, *Inschriften*, no. 94. 61. vi. 1. 4.
62. The evidence is summarized by Johnson, *Lysippos*, pp. 60 ff. 63. *N.H.* xxxiv. 63.
64. Cf. Johnson, op. cit., pp. 62 ff.

found at Corinth and inscribed Λύσιππος ἐπόησε can be roughly dated about 325.[65] And still another statue base from Thermos bears his signature together with a later dedicatory inscription.[66] Athenaios[67] mentions Lysippos as a friend of Kassandros when he founded Kassandreia in the 116th Olympiad (316). A lost inscription mentioned as early as the fifteenth century[68] reads Σέλευκος βασιλεύς Λύσιππος ἐποίει (Seleukos assumed the royal title in 312). Pausanias[69] says that he made a statue at Olympia of Poulydamas victorious in the pankration in the 93d Olympiad (408); if this information is correct, the statue must have been much later than the event it celebrated. Lysippos, therefore, must have been active a long time, from about 368 to the last decade of the century; and he is indeed referred to as "an old man" in the *Anthology*.[70]

Lysippos, we are told, was extraordinarily prolific, more so than any other artist.[71] WORKS
The number of his works is said to have been fifteen hundred,[72] "all of such artistic value that each would have sufficed by itself to make him famous. The number became known after his death, when his heir broke open his strongbox, since it had been his custom to set aside a piece of gold from the price of each statue." Unfortunately not a single one of these many sculptures has been preserved, and—what is more amazing —we have not even a perfectly certain reproduction of one, though a few can be so identified with considerable probability.

One of Lysippos' most famous works was "a youth scraping himself which M. *Youth* Agrippa dedicated in front of his baths."[73] Its great beauty is attested by the anecdote *Scraping* that the Emperor Tiberius conceived a "wonderful passion" for it and removed it to *Himself* his private chamber but had to restore it to its former location on account of the displeasure of the Roman populace. A reproduction of this statue has long been recognized in the Apoxyomenos in the Vatican[74] (figs. 791, 794, 795), for it seemed to bear out in a striking way the characteristics of Lysippos summed up by Pliny:[75]

> He is said to have done much to advance the art of sculpture in bronze by his careful treatment of the hair, and by making the head smaller and the body more slender and firmly knit [corpora graciliora siccioraque] than earlier sculptors, thus imparting to his figures an appearance of greater height. There is·no Latin name for the "canon of proportions" [symmetria] which he carefully observed, exchanging the squarely-built figure of the older artists for a new and untried system. He was in the habit of saying that they had represented men as they were, while he represented them as they appeared to the eye.

The Vatican Apoxyomenos with its slim body, long legs, small head, and carefully modeled hair certainly corresponds, in a general way at least, to Pliny's description.

65. Powell, *A.J.A.*, VII, 1903, pp. 29–32.
66. Sotiriades, *Delt. Arch.*, I, 1915, pp. 55 ff.; Johnson, op. cit., p. 64. 67. XI. 784.
68. Loewy, op. cit., no. 487. 69. VI. 5. 1.
70. Agathas, A 22. 71. Pliny, *N.H.* XXXIV. 61.
72. Pliny, *N.H.* XXXIV. 37. 73. Pliny, *N.H.* XXXIV. 62.
74. Helbig-Speier, *Führer*⁴, I, no. 254. 75. *N.H.* XXXIV. 65.

It is obviously a conscious departure from the squarely built figures of Polykleitos and is drier, more firmly knit than the soft Praxitelean statues. So the identification seems probable. But we can obtain no real conception of the beauty of the original from this indifferent marble copy. We miss altogether the "extreme delicacy of the work even in the smallest details," which we are told[76] was Lysippos' "most individual feature." And the lifelike quality which the original doubtless had is lost. All we can get is a general picture of Lysippos' new scheme of proportions.

Agias During the excavations at Delphi there was brought to light a series of statues dedicated about 344–334 by one Daochos, of Thessaly, representing earlier members of his family.[77] The inscriptions on the base of the dedication give the names of the individuals and their accomplishments. One of the statues is of Agias (figs. 790, 792, 793), winner in the pankration in the middle of the fifth century B.C. It is the best preserved and finest of the set and has the further interest that a copy of its dedicatory inscription has been found in Thessaly (one portion in Pharsalos, the native town of Agias)—in which Lysippos is mentioned as the sculptor.[78] The Thessalian statue has not survived, so that we do not know what it was like. It was presumably of bronze, for that was the favorite material of Lysippos. Tempting though it be to regard the Agias of Delphi as a marble copy executed by Lysippos' assistants with the help of the original mold of the bronze statue, this is only a hypothesis. As a matter of fact exact copies were not current in this period. Moreover the Apoxyomenos corresponds more closely to the little we know definitely of Lysippos' style (his new scheme of proportions with a slimmer body and with trunk, head, and limbs placed in slightly contrasting planes, as well as his carefully worked hair) than the Agias, who is distinctly squarer and more frontal and whose hair shows less care in execution. And that the Agias is the finer statue of the two is merely owing to the fact that it happens to be a Greek original, while the Apoxyomenos is not. The only possibility that remains is that the Agias was an early work, whereas the Apoxyomenos was produced later.

Herakles The original of the colossal statue of Herakles Farnese in Naples,[79] signed by Glykon as copyist[80] (fig. 801), must have been an important work, to judge by the number of extant copies. One of these, in the Palazzo Pitti in Florence, has an inscription giving the name of Lysippos as artist,[81] but both the inscription and even the statue are now considered to be not ancient.[82] The original work may have been the statue mentioned by ancient writers as having stood in the marketplace of Sikyon. The smaller replica in the Uffizi, Florence,[83] in which the muscles are less prominent

76. Pliny, *N.H.* xxxiv. 65.

77. Cf. Poulsen, *Delphi*, pp. 265 ff.; *Fouilles de Delphes*, iv, pls. lxiii ff.; P. de La Coste-Messelière, *Delphes* (1957), pls. 180–89.

78. Preuner, *Ein delphisches Weihgeschenk*, pp. 20, 24.

79. Ruesch, *Guida*, no. 280; Johnson, *Lysippos*, pp. 197 ff. 80. Loewy, *Inschriften*, no. 345.

81. Amelung, *Führer durch die Antiken*, no. 186; Loewy, *Inschriften*, no. 506; Marcadé, *Signatures*, i, no. 70. "Found on the Palatine between 1540 and 1574."

82. So M. Guarducci, who has lately examined the piece with other archaeologists, has reported to me.

83. Amelung, op. cit., no. 40.

than in the Farnese Herakles, may reproduce the original more faithfully. A well-preserved bronze statuette of this type is in the Louvre[84] (fig. 802) and another has recently been found at Sulmona[85] (figs. 803, 804), both of the Roman period. The fame of the original is also attested by the fact that at Kalydon there was found a free copy of this type dating from the second century B.C., when only well-known master-pieces were apparently copied (cf. fig. 644).

Martial[86] gives us an unusually detailed description of what must have been a very *Epitrapezios* popular work by Lysippos—a statuette of Herakles less than a foot in height, used as a table decoration and therefore called Herakles Epitrapezios: "He who sits here tempering the hardness of the rock with the outstretched lion's skin, a mighty god imprisoned in the tiny bronze, and gazes with upturned eyes at the stars which once he bore, whose left hand is hot with the club, and his right with the wine-cup, enjoys no upstart fame, nor is his fame that of a Roman chisel. 'Tis a famous work and offering of Lysippos which thou seest." Statius[87] likewise gives it extravagant praise: "In how small a space what illusion of great size. What skill of hand, what deft crafts-man's cunning to fashion equally well ornaments of a table and to conceive in his mind the great colossi. . . . The mild face, as though rejoicing from the heart, invites to the feast; this hand grasps his brother's drowsy cup, the other is mindful of his club; a rough seat supports him, a rock covered with the Nemean lion's skin." It is said to have belonged successively to Alexander, Hannibal, Sulla, and Novius Vin-dex.[88] There are numerous statuettes of Herakles, Roman reproductions, correspond-ing more or less to Martial's description,[89] since the hero rests on a rock on which is a lion's skin, and holds a club in his left hand (fig. 807[90]). The right hand is preserved in a bronze figure in the Naples Museum[91] (fig. 808) and on a coin of Amastris of the time of Caracalla (fig. 806) which shows the same composition. Recently there was discovered at Alba Fucens an over life-size marble statue of this type[92] (fig. 809). This may suggest that the original by Lysippos was also colossal and that the small popular versions are due to the use of this figure in Roman times as a table decoration; for it would be more in line with what is known of Lysippos, who was famous for his grandiose compositions (cf. infra). The Alba Fucens statue, to judge by its style, appears to be a Hellenistic rather than a Roman replica—perhaps, therefore, of the second century B.C. when free reproductions of famous masterpieces were in vogue (cf. p. 244). And this would account for certain variations, such as the reversed action of the arms.

84. De Ridder, *Cat. des bronzes*, I, no. 652.

85. Cianfarani, *Santuari nel Samnio*, pp. 32 f., pl. 7; La Regina, in *Enc. Arte Antica*, VII, 1966, s.v. Sul-mona, p. 556, fig. 661. Now in the Museo Archeologico of Chieti. 86. IX. 44.

87. *Silv.* IV. 6. 88. Statius, *Silv.*, IV. 6.

89. Cf. Weiszäcker, in *J.d.I.*, IV (1889), pp. 109 ff.; Johnson, op. cit., pp. 100 ff.; De Vischer, *Herakles Epi-trapezius*, pp. 59 ff. (reprinted from *L'Antiquité classique*, 30 [1961], pp. 67 ff.).

90. Smith, *Catalogue of Greek Sculpture in the British Museum*, III, no. 1725.

91. R. Paribeni, *Not. d. Scavi*, 1902, pp. 572 ff.

92. Cf. De Vischer, op. cit.; Richter, in *Revue belge de philologie et histoire*, XLI, 1963, pp. 137 ff.

Both the Herakles Farnese and the Herakles Epitrapezios are highly realistic, and we know that Lysippos prided himself on his realism. For instance, Pliny[93] tells the following story: "Duris asserts that Lysippos of Sikyon had no master, but originally worked as a bronze-caster, and was inspired to attempt higher things by an answer of Eupompos. That artist, when asked which of his predecessors he followed pointed to a crowd of men, and replied that Nature herself and no artist was the true model." And Propertius[94] says that "the glory of Lysippos is to make his statues full of life." Moreover Niketas'[95] description of Lysippos' colossal bronze Herakles at Tarentum certainly suggests a realistic rendering: "His breast and shoulders were broad, his hair thick, his buttocks fat, and his arms brawny." This applies also to the colossal Herakles from Alba Fucens.

Poulydamas

Pausanias[96] tells us that Lysippos made a statue of Poulydamas at Olympia and that some of his remarkable feats (which he enumerates) are represented on the base. A portion of this pedestal with the reliefs referred to has been found and is now in the museum at Olympia[97] (cf. fig. 810). The reliefs represent Poulydamas in combat with a lion, seated on a dead lion, and lifting a man in the air before the Persian king. Did Lysippos execute the base as well as the statue and have we here an original work by his hand? The question would be more important if the reliefs were better preserved; but they are sadly mutilated and at best are only slight works, so that they help little in our estimate of Lysippos' style, except to bear out the evidence of the Apoxyomenos regarding his slim proportions.

Zeus

A bronze Zeus, the work of Lysippos, is described by Pausanias[98] as standing in the marketplace at Sikyon. On a bronze coin of Sikyon of the time of Caracalla is a long-legged Zeus standing in a pose not unlike that of the Apoxyomenos, only reversed;[99] at least the curve described by the body is similar; so that the figure on the coin might well represent the Lysippian statue. Unfortunately it too is badly preserved, and can teach us little beyond Lysippos' preference for a slender build.

Portrait of Alexander

Lysippos was a successful portraitist. In fact Alexander the Great would let no one else portray him in bronze. So, at least, Plutarch[100] tells us:

When Lysippos first made a portrait of Alexander with his countenance uplifted to heaven, just as Alexander was wont to gaze with his neck gently inclined to one side, someone wrote the following not inappropriate epigram: "The man of bronze is as one that looks on Zeus and will address him thus: 'O Zeus, I place earth beneath my feet, do thou rule Olympos.'" For this reason Alexander gave

93. *N.H.* xxxiv. 61. 94. iii. 7. 9.
95. *Chon. de Sign. Constant.* 5. 96. vi. 5. 1 ff.
97. Treu, *Olympia*, iii, pl. lv, 1–3, pp. 209 ff. 98. ii. 9. 6.
99. Imhoof-Blumer and Gardner, *Numismatic Commentary*, p. 29, no. 6, pl. H, no. x; *B.M.C.*, Peloponnese, p. 55, no. 243.
100. *Alex.* ii. 2. Cf. also Pliny, *N.H.* vii. 125: "[Alex.] edixit ne quis ipsum alius quam Apelles pingeret quam Pyrgoteles scalperet quam Lysippos ex aere duceret."

orders that Lysippos only should make portraits of him, since Lysippos only, as it would seem, truly revealed his nature in bronze, and portrayed his courage in visible form, while others in their anxiety to reproduce the bend of the neck and the melting look of the eyes failed to preserve his masculine and leonine aspect.

We know from Pliny's[101] statement that Lysippos made numerous portraits of Alexander, and it is of course natural to look among the several extant heads for copies of some of these. But so popular a figure as Alexander was doubtless often portrayed even after Lysippos' death; for instance, by Lysippos' own son, Euthykrates.[102] The head in the British Museum[103] (fig. 797) shows perhaps best the "melting gaze and the leonine aspect." The Azara bust[104] (fig. 796) has certain stylistic affinities with the Apoxyomenos. The bust from the Guimet Museum[105] (fig. 798) is a particularly fine conception and of excellent workmanship; though its identity with Alexander has been doubted.[106] But closest perhaps to a Lysippian original are the heads on some of the coins[107] (fig. 799), which though small in scale have at least the advantage of being practically contemporary Greek work.[108]

Since we know from an inscription (see p. 225) that Lysippos made a portrait of king Seleukos, and a bronze bust in Naples[109] has been identified with Seleukos Nikator (356–281) by comparison with the coin types, it has been suggested that this bust is a copy of the work by Lysippos.[110] But as we know that portraits of Seleukos were also made by other sculptors, including Bryaxis (cf. p. 217) and Aristodemos (cf. p. 224), we have not enough evidence for a definite assignment.

Portrait of Seleukos

According to Diogenes Laertios[111] "the Athenians . . . honored Sokrates with a bronze statue, the work by Lysippos, which they put in the Pompeion." This portrait has been reliably identified with a head preserved in about thirty Roman copies,[112] as well as in a statue drawn by Preisler[113] in 1733; and by the help of the latter a mutilated marble statue in Copenhagen has been reconstructed.[114]

Portrait of Sokrates

Another field in which Lysippos evidently distinguished himself was that of large dedicatory groups of figures in violent action. For instance Plutarch[115] tells us that "Krateros erected a memorial of a hunt at Delphi. He caused figures of bronze to be

Large Compositions

101. *N.H.* xxxiv. 63. 102. Pliny, *N.H.* xxxiv. 66.

103. Smith, *Catalogue of Greek Sculpture*, iii, no. 1857; Bieber, *Portraits of Alexander*, fig. 46.

104. Bernoulli, *Darstellungen Alexanders des Grossen*, pl. 1, p. 21. Much restored.

105. Reinach, in *Gazette des Beaux-Arts*, xxvii (1902, 1), p. 158. 106. Bernoulli, p. 87.

107. Cf. e.g. Franke and Hirmer, *Die griechische Münze* (1964), pl. 176.

108. On portraits of Alexander cf. e.g. Gebauer, "Alexanderbildnis und Alexandertypus," in *Ath. Mitt.*, LXIII–LIV (1938–39), pp. 1 ff.; Bieber, "The Portraits of Alexander the Great," in *Proceedings of the American Philosophical Society*, 93 (5) (1949), 373 ff., and *Alexander the Great in Greek and Roman Art* (1964).

109. Ruesch, *Guida*, p. 221, no. 890.

110. Wolters, in *Röm. Mitt.*, iv, 1889, pp. 39 f.; cf. also Johnson, *Lysippos*, p. 230.

111. II. 43. 112. Cf. Richter, *The Portraits of the Greeks, 1*, pp. 112 ff.

113. *Statuae antiquae*, pl. 31.

114. Richter, op. cit., p. 116, and in *Hommages Marcel Renard* (1969), pp. 279 ff.

115. *Alexander* 40.

made, representing the lion, the dogs, the king in combat with the lion, and himself coming to the rescue; some of these were made by Lysippos, the rest by Leochares." Again Arrian:[116] "Of the Macedonians there fell about twenty-five of the king's guard in the first onslaught. Bronze portraits of these stood at Dion, made by Lysippos by order of Alexander." And Pliny[117] lists among Lysippos' works "Alexander's hunt," "four-horse chariots of several kinds," and a "troop of Alexander's horse in which he introduced portraits of his friends which displayed a marvelous likeness." None of these bold creations in which Lysippos showed himself as a great composer, a portraitist, and an animal sculptor have of course been preserved; but we may form perhaps some conception of their general effect by the splendid battle scenes and lion hunt on the Alexander sarcophagus in Istanbul[118] (fig. 800), dated in the late fourth century.

Other Works Many other works of Lysippos are known to us either by the mere mention or by lengthy descriptions of ancient writers.[119] These include deities (among them a colossal Zeus over forty cubits in height, at Tarentum[120]), heroes, athletes, portraits (among them Aisopos and the seven Wise Men[121] and Sokrates), and animals (e.g. a slain lion and a free horse). We may quote as an unusual composition an allegorical statue of Kairos (Opportunity) described in the *Anthology:*[122]

> Who and whence was thy sculptor? From Sikyon. His name? Lysippos. And who art thou? Occasion, the all-subduer. Why dost thou tread on tiptoe? I am ever running. Why hast thou wings two-natured on thy feet? I fleet on the wings of the wind. Why dost thou bear a razor in thy right hand? To show men that I am keener than the keenest edge. And thy hair, why grows it in front? For him that meets me to seize, by Zeus. And why is the back of thy head bald? Because none may clutch me from behind, howsoe'er he desire it, when once my winged feet have darted past him. Why did the sculptor fashion thee? For thy sake, stranger, and set me up for a warning in the entry.

But neither this nor any of the other works has been satisfactorily identified among the store at our disposal.[123]

ATTRIBUTIONS On the other hand, there have been numerous attributions to Lysippos of extant statues based on our slim knowledge of his style; for instance, the Herculaneum

116. *Anabasis* I. 16. 7.
117. *N.H.* XXXIV. 64.
118. Mendel, *Cat. des sculptures*, no. 68.
119. Cf. Overbeck, *Schriftquellen*, nos. 1451 ff., and Johnson, *Lysippos*, pp. 274 ff.
120. Pliny, *N.H.* XXXIV. 40. Cf. also Overbeck, *Schriftquellen*, nos. 1464–67.
121. *Agath. Gr.* IV. 16. 35.
122. *Anth. Palat.*, Append., II. 49. 13 (66).
123. Though Kairos occasionally appears on extant reliefs; cf. e.g. Montanari, *Enc. Arte Antica*, IV, 1961, p. 290, fig. 343 (in the Museo Archeologico, Turin); Friedrichs-Wolters, *Gipsabgüsse*, nos. 1897, 1898, and Abramić, *Oest Jahr*, XXVI, 1930, pp. 1 ff. (in Split and in Athens), the figure does not tally sufficiently with the description of Lysippos' work for a certain identification.

Hermes[124] (fig. 77), the praying boy in Berlin[125] (fig. 59), the Eros with the bow[126] (fig. 806), the satyr and infant Dionysos,[127] and the athlete fixing his sandal.[128] They are all possible ascriptions, for the affinities with the Apoxyomenos are undeniable; but they are not material on which we can build with certainty.

Using only the actual evidence before us we obtain a picture of a highly original sculptor who by his new system of proportions, his realism, and the grandiose scale of his compositions initiated a new age. He put the finishing touch to the naturalism of the fourth century. Praxiteles and Skopas besides their qualities of grace and emotion had inherited much of the grandeur of the preceding century. Lysippos consciously went to nature as the prime master and thus began a school with a new outlook, which was carried on and developed during the Hellenistic age and from which much of the later sculpture was derived. During the two succeeding centuries the path was followed which he pointed out—of lifelike realism and of manifold subjects. The horizon was enlarged, the idealism of former times has waned.

The School of Lysippos[129]

LYSIPPOS had many relatives and pupils who followed in his footsteps and some of them attained independent fame. Of his brother Lysistratos Pliny[130] tells us that he was "the first artist who took plaster casts of the human face from the original and introduced the practice of working over a wax model taken from the plaster. [Hominis autem imaginem gypso e facie ipsa primus omnium expressit ceraque in eam formam gypsi infusa emendare instituit.] He also instituted the practice of rendering portraits 'with lifelike' precision, while previous artists had striven to make them as beautiful as possible. He also discovered how to take casts of statues. [Idem et de signis effigies exprimere invenit.]"[131] Naturally such inventions all tended in the direction of realism, which was indeed the taste and requirement of the age.

LYSISTRATOS

Pausanias[132] tells us that "Eutychides of Sikyon,[133] a pupil of Lysippos, made a statue of Fortune for the Syrians who live on the Orontes, at whose hands it receives great honor"; and John Malalas[134] gives the additional information that the figure was seated "above the river Orontes." By the help of these descriptions and the figures

EUTYCHIDES

124. Comparetti and di Petra, *La Villa ercolanese*, pl. XIII, 2; Lippold, *Handbuch*, pl. 102, 1.

125. Berlin, *Beschreibung der antiken Skulpturen*, no. 2.

126. Johnson, *Lysippos*, pp. 104 ff.; Lippold, op. cit., p. 278, pl. 100, 4. To the long list of copies cited by Johnson can now be added a fragmentary one found at Ephesos, with a well-preserved head, cf. Eichler, *Anzeiger, philog.-hist. Kl., Oest. Akad. d. Wiss.*, 1967, 2, p. 20, pl. II, 1, 2.

127. Johnson, op. cit., pp. 185 f.; Lippold, op. cit., pl. 101, 2.

128. Johnson, op. cit., pp. 185 f.; Lippold, op. cit., pl. 100, 2.

129. On the school of Lysippos cf. Overbeck, *Schriftquellen*, nos. 1516–56; Lippold, op. cit., pp. 294 ff., and the references there cited. 130. *N.H.* XXXV. 153.

131. Cf. p. 231. 132. VI. 2. 6.

133. On Eutychides cf. Lippold, *Handbuch*, p. 296, and the references there cited; Cressedi, in *Enc. Arte Antica*, III, 1960, pp. 554 f., s.v. "Eutychides," and the references there cited.

134. *Chronogr.* XI. 276.

of the Tyche of Antioch which appear on Syrian coins of Tigranes[135] (fig. 813) it has been possible to recognize copies of the group in many extant marble statues (cf. e.g. fig. 811[136]) and in several bronze and silver statuettes in various museums (fig. 812[137]), as well as on coins and gems.[138] A woman is represented seated on a rock, her foot resting on the shoulder of a youth, who is seen emerging from the ground. It is a dignified conception of a city goddess, pictorially treated, in the taste of this late period. Eutychides also made a figure of the river Eurotas "more liquid than water."[139]

CHARES

Chares, another pupil of Lysippos,[140] achieved fame by his bronze statue at Rhodes, one of the seven wonders of the world. There are many references to it in antiquity,[141] and Pliny[142] gives us a graphic account:

> The greatest marvel of all, however, was the colossal figure of the Sun at Rhodes, made by Chares of Lindos, a pupil of Lysippos. This figure was seventy cubits in height and after standing fifty-six years was overthrown by an earthquake; but even as it lies prostrate it is a marvel. Few men can embrace its thumb, its fingers are larger than most statues, there are huge yawning caverns where the limbs have been broken, and within them may be seen great masses of rock, by whose weight the artist gave it a firm footing when he erected it. The story runs that twelve years were occupied in its construction, for which the artist received 1,300 talents.

Since the earthquake took place about 224 B.C., the date of the erection of the Colossus is about 280.

EUTHYKRATES AND TEISIKRATES

Pliny[143] informs us that Lysippos had three sons: "Boedas, Laippus, and Euthycrates," all celebrated artists, "the last preeminent, although he copied the harmony rather than the elegance of his father." Among the sculptures executed by Euthykrates are cited Alexander hunting, four-horse chariots, Trophonios at his oracular shrine, and a group of Muses (Thespiades). And of his pupil Teisikrates we are told that many of his works could not be distinguished from those by Lysippos. Though none of these sculptures have so far been identified, their subjects help us to visualize their variety and the grandiose compositions that Lysippos had initiated and which were evidently continued by his successors.

135. *B.M.C.*, XIV, pl. XXVII, 6. 136. In the Vatican Museum. Helbig-Speier, *Führer*⁴, I, no. 548.

137. *M.M.A. Cat. of Bronzes*, no. 259.

138. Cf. the extensive references assembled by Dohrn in his *Tyche von Antiochia* (1960)—to which can now be added a few others on engraved gems; cf. Richter, *Engraved Gems*, II, nos. 219–21.

139. Pliny, *N.H.* XXXIV. 78, and *Anth. Pal.* IX. 709.

140. On Chares cf. Lippold, *Handbuch*, p. 297, and the references there cited; Amorelli, in *Enc. Arte Antica*, II, 1959, s.v. Chares, pp. 534 f. 141. Cf. Overbeck, *Schriftquellen*, nos. 1539–54.

142. *N.H.* XXXIV. 41. 143. *N.H.* XXXIV. 66.

CHAPTER 5

THIRD AND SECOND CENTURIES B.C.

According to Pliny,[1] there were no outstanding Greek sculptors after the 121st Olympiad, i.e. after 296–293 B.C.: "A period of stagnation followed and again a revival in the 156th Olympiad (156–153 B.C.), the age of Antaios, Kallistratos, Polykles of Athens, Kallixenos, Pythokles, Pythias, and Timokles, artists of merit, but still far below those already mentioned." Of none of these late artists do we know much more than the name. There are, however, extant a few fine pieces of the third and the earlier second century B.C., and of some of these we happen to know the authors through inscriptions or the specific descriptions by Roman writers. And they militate against Pliny's pessimistic statement.

Polyeuktos of Athens[2] was known for his portrait of Demosthenes, of which the following anecdote is told[3]: "[Demosthenes] asked for a tablet and wrote the elegiac couplet, which the Athenians afterwards inscribed upon his portrait. It runs as follows: 'Hadst thou, Demosthenes, had might as strong as thy resolve, the war-god of Macedon had never ruled the Greeks.' The portrait stands near the enclosure and the altar of the twelve gods, and is the work of Polyeuktos." Plutarch[4] moreover tells us that the statue had "clasped hands." Two statues—in the Vatican[5] and Copenhagen[6] (cf. fig. 815)—and almost fifty heads[7] have been identified as reproductions of Polyeuktos' original. The hands are missing in the Vatican copy; but they are preserved in another (otherwise very fragmentary) replica found in the gardens of the Palazzo Barberini,[8] and are there folded. The hands of the marble replica in the Ny Carlsberg Glyptotek in Copenhagen, represented as holding a scroll, formerly thought to be ancient, have been shown to be modern restorations.[9] Thus the very item in Plutarch's description which formerly stood in the way of the identification has now made it a certain one. It can be dated about 280 B.C., forty years after Demosthenes' death in 322,[10] and shows us a splendid characterization of this great, morose Athenian.

POLYEUKTOS

1. *N.H.* xxxiv. 52: "cessavit deinde ars, ac rursus Olympiade CLVI revixit." Many explanations of this statement have been given, none certain.

2. On Polyeuktos cf. Lippold, *Handbuch*, pp. 302 f., and the references there cited; Arias, in *Enc. Arte Antica*, iii (1960), pp. 76 f., s.v. Demosthenes, and the references there cited.

3. Pseudo Plutarch, *Vitae decem oratorum* 847A. Against Crome's suggestion that Polyeuktos may be a mistake for Polykles (*Arch. Anz.* 1942, cols. 47 f.) cf. Dinsmoor, *Archons of Athens*, 1931, pp. 90 ff., 123 ff.; Pritchett and Meritt, *Chronology of Hellenistic Athens*, pp. 27 ff.

4. *Demosthenes* 31. 5. Helbig-Speier, *Führer*[4], i, no. 431.

6. F. Poulsen, *Cat. of the Ny-Carlberg Glyptotek*, no. 436a.

7. Richter, *The Portraits of the Greeks*, ii, pp. 216 ff. 8. Ibid., p. 216, fig. 406.

9. A cast of the folded hands has now been added. Cf. my fig. 815.

10. In the archonship of Gorgias, cf. Pseudo Plutarch, *Vitae decem oratorum* 847D.

DOIDALSES OF
BITHYNIA

A statue of Aphrodite washing herself by Doidalses[11] (formerly read Daedalus) is mentioned by Pliny,[12] and a cult statue of Zeus Stratios in Nikomedeia (founded in 264 B.C.) is assigned to the same sculptor by Arrian.[13] The former has been recognized in a crouching Aphrodite preserved on coins[14] (fig. 823) and in many marble copies (cf. figs. 142, 822), the latter in a Zeus that appears on Bithynian coins from Prusias I (238?–183) to Nikodemos III[15] (fig. 824), as well as perhaps in a marble statuette found in Rhodes.[16] We may accordingly date Doidalses in the third century B.C.

ARCHELAOS OF
PRIENE

A relief in the British Museum[17] representing the Apotheosis of Homer, arranged in four superimposed tiers, is signed: "Archelaos, the son of Apollonios, of Priene, made it" (fig. 828). Nothing further is known of this Archelaos,[18] but from the style of the relief and a resemblance of the figure of Chronos to Ptolemy IV (221–205 B.C.), he may perhaps be dated in the late third century B.C.

SCULPTORS
ACTIVE IN
PERGAMON

The great activity at Pergamon during the reigns of Attalos I (241–197 B.C.) and Eumenes II (197–159 B.C.) is referred to by Pliny[19] as follows: "The battles of Attalos and Eumenes with the Gauls were represented by a group of artists—Isigonos, Phyromachos, Stratonikos, and Antigonos." On the pedestals of Attalos' monument, found at Pergamon, several names of sculptors are preserved: [Isig or Antig]onos, Xenokrates, Myron, and Praxiteles.[20] Phyromachos, Stratonikos, and Antigonos are known from other sources.[21] The occasional addition of their ethnics shows that they were by no means all Pergamene but came from various parts of Greece, including Athens. The famous dying Gaul (fig. 130), the Gaul killing himself and his wife (fig. 114), the head of a dying Persian (fig. 234) and other marble sculptures have been recognized as copies of the bronze statues that formed part of Attalos' dedication. We have not enough evidence, however, for assigning any of these sculptures to the specific artists whose names happen to have survived.

Of Attalos' dedication of statues on the Athenian Akropolis—likewise to celebrate his victories over the Gauls—only Roman copies have been preserved, with no names of artists. Ampelius[22] refers to a great altar of marble at Pergamon, forty feet in height, with huge sculptures representing the battle of the giants (cf. figs. 830, 836, 837). It must have been erected by Eumenes II after 180 B.C. to celebrate his victory over

11. On Doidalses cf. Lippold, op. cit., pp. 319 f., and the references there cited; Laurenzi, in *Enc. Arte Antica*, III (1960), pp. 155 ff., s.v. "Doidalses," and the references there cited.

12. *N.H.* XXXV. 35. 13. In Eustathius, *ad Dionys. Perieg.* 793.

14. *B.M.C.*, "Pontus," 37–39. 15. Ibid.

16. Laurenzi, in *Annuario*, XXIV–XXVI (1946–48), 169, fig. 2.

17. Smith, *Catalogue of Greek Sculpture*, 3, no. 2191.

18. Cf. Lippold, *Handbuch*, p. 373, and the references there cited; Guerrini, in *Enc. Arte Antica*, I, 1958, p. 543, s.v. "Archelaos," and the references there cited; Bieber, *The Sculpture of the Hellenistic Age*² (1961), pp. 127 ff.

19. XXXIV. 84. On these Pergamene sculptures cf. Lippold, op. cit., pp. 341 ff., 353 ff., and the references there cited. 20. Loewy, *Inschriften*, no. 154.

21. Overbeck, *Schriftquellen*, nos. 1998–2005. 22. *Lib. Mem.* VIII. 14.

the Gauls, for on a fragment of the dedicatory inscription found during the excavations his name appears.[23] Ampelius does not mention the sculptor's or sculptors' names. Faint traces of some artists' signatures, however, remain alongside some of the figures on this altar, which was discovered during the German excavations of 1878 and subsequent years: e.g. [Pa]lamneus, [Pel]oreus, Molodr . . . , [Men]ekratous. It has been computed that there were about forty signatures, the frieze having evidently been divided up into small portions. The survival of some of these ethnics again shows that these sculptors came from a number of different cities. Presumably, one leading sculptor made the design; but his name is not known.[24]

According to Pliny,[25] the Athenian Nikeratos[26] made, among other things, a group of Asklepios and Hygeia, and one of Alkibiades with his mother Demarate. Tatianus[27] mentions portraits by him of Glaukippe and Telesilla. The inscriptional evidence connects him with Pergamon and Delos.[28] A base inscribed with his signature, found at Delos, was once thought to belong to a statue of a warrior; but the dimensions were found not to fit.[29] Though we have no extant work that can be attributed to Nikeratos, his Pergamene connection makes it likely that he was active around 200 B.C., and that his works were in the style of the Attalid dedications.

NIKERATOS

We have heterogeneous evidence regarding a sculptor or sculptors named Boethos.[30] Pliny tells us that "though Boethos is more famous for his work in silver, he is the artist of the boy strangling a goose with all his might."[31] The group has been recognized in the boy strangling a goose preserved in several copies—in Munich (fig. 820), the Capitoline Museum, the Louvre,[32] and elsewhere. The original has been thought by some[33] to be referred to in Herondas' Mimes (4.31): Πρὸς Μοιρέων, τὴν χηνα- λώπεκ' ὡς τὸ παιδίον πνίγει, and therefore datable in the early third century B.C.; but the goose in the copies is too large to be a fox goose. Other authorities,[34] therefore, have identified Herondas' group with one also preserved in a number of copies, in which the bird is small and is pressed upon by the child with its hand. A bronze

BOETHOS

23. Cf. Fraenkel, Inschriften von Pergamon, p. 54, no. 69.

24. Cf. Schuchhardt, Die Meister des grossen Frieses von Pergamon (1925). Thimme, "The Masters of the Pergamon Gigantomachy," A.J.A., L, 1946, pp. 345 ff.; Kähler, Der Grosse Fries von Pergamon (1948).

25. N.H. XXXIV. 80 and 88.

26. On Nikeratos cf. Lippold, Handbuch, p. 320, and the references there cited; Conticello, in Enc. Arte Antica, V, 1963, p. 475, s.v. "Nikeratos," and the references there cited.

27. Contra Graecos, 53, p. 115, and 52, p. 114 (ed. Worth).

28. Loewy, Inschriften, nos. 118, 147, 496; Fraenkel, Inschriften von Pergamon, no. 132.

29. National Museum, Athens, no. 247. Papaspiridi, Guide, pp. 97 f., and S. Karouzou, Cat., pp. 170 f.

30. On Boethos cf. Lippold, op. cit., pp. 328 f., and the references there cited; Laurenzi, in Enc. Arte Antica, II, 1959, pp. 118 ff., s.v. "Boethos" (1) and (2), and the references there cited.

31. N.H. XXXIV. 84: Boethi quamquam argento melioris infans vi summa anserem strangulat. The reading vi summa is uncertain, for the word after infans is mutilated; amplexando, ex aere, sex annis, sex anno, eximia, eximie have been suggested as alternative readings.

32. Furtwängler, Beschreibung der Glyptothek, no. 268; Helbig-Speier, Führer⁴, II, no. 1410. Catalogue sommaire des marbres antiques, no. 40, p. 3.

33. Picard, Rev. arch., 1947, pp. 217 ff.

34. Cf. Herzog, Oest. Jahrsh. VI, 1903, pp. 215 ff., and his edition of Herondas' Mimes, pp. 201 f., pl. IX.

winged youth crowning himself (fig. 827), leaning perhaps on a herm of Dionysos (fig. 821), which is inscribed Βοηθὸς Καλχηδόνιος ἐποίει (Boethos of Chalkedon made it) was found in the sea near Mahdia in Tunis.[35] Pausanias[36] states that Boethos made a gilt figure of a nude seated boy and that he came from Karchedon (probably Chalkedon). A statue of Asklepios as a child is ascribed to Boethos in two epigrams.[37] Moreover, a Boethos was famous for his embossed metalware[38] and we hear of *lecti Boethiaci.*[39] There are two inscribed bases, one from Lindos, bearing the name of Boethos, son of Athanaion of Kalchadon, which can be dated about 155–150 B.C.,[40] and one from Delos of a statue of Antiochos IV (175–164 B.C.), signed by Boethos, son of Athanaion.[41] Lastly Boethos' signature appears on a cameo engraved with the representation of an emaciated Philoktetes in Hellenistic style.[42]

To judge by this evidence, it is quite possible, as some have thought,[43] that the same Boethos, active in the first half of the second century B.C., made all these works, for Pliny expressly says that he was a sculptor as well as a metal worker and the mention of him immediately after the Pergamene artists suggests that he belonged to the second century B.C. On the other hand, since Boethos was a common name, there is no valid reason why there should not have been two or more artists responsible for the works above cited. And certainly the youth from the Mahdia shipwreck and the boy strangling a goose have little in common stylistically.

The famous group in the Vatican[44] of Laokoon and his sons attacked by two mighty serpents (fig. 831) is described by Pliny[45] as follows: "The Laokoon which stands in the house of the Emperor Titus, a work to be preferred to all that the arts of painting and sculpture have produced. Out of one block of stone the consummate artists Hagesander, Polydorus, and Athenodorus of Rhodes fashioned Laokoon, his sons, and snakes marvelously entwined about them." The group was discovered in A.D. 1506 and has ever since evoked admiration. Michelangelo considered it the greatest work of sculpture ever produced, and Lessing made it the theme for a treatise on the principles of art. Though we today with our enlarged knowledge of Greek sculpture would hardly concur with these opinions, we must admit that it is a magnificent creation,

ATHANODOROS,
HAGESANDROS, AND
POLYDOROS, OF
RHODES

35. Merlin and Poinssot, *Mon. Piot*, XVII, 1909, pp. 42 ff.; W. Fuchs, *Der Schiffsfund von Mahdia* (1963), pp. 12 ff., no. 1. 36. v. 17. 4.

37. *Anthol. Palat. Append*, 55, 56; Loewy, *Inschriften*, no. 535.

38. Pliny, *N.H.* xxx. 155. 39. Porphyry, *ad. Hor. ep.*, I. 5. 1.

40. Kinch, *Bull. de l'Acad. de Copenhague*, 1904, p. 74; Hiller von Gaertringen, in *Arch. Anz.* 1904, pp. 212 f. 41. Loewy, *Inschriften*, no. 210.

42. Furtwängler, *Antike Gemmen*, pl. LVII, 3.

43. E.g. Robert, in *R.E.*, III, 1, 1897, s.v. "Boethos," cols. 604–06.

44. Amelung, *Die Skulpturen des Vatikanischen Museums*, p. 181, no. 74; Helbig-Speier, *Führer*[4], I, no. 219; Magi, "Il Ripristino del Laocoonte," *Memorie della Pont. Acc. Rom. di Arch.*, serie III, vol. IX (1960), 7 ff., and Laocoonte a Cortona, in *Rendiconti della Pont. Acc. Romana di Arch.*, XL, 1967–68, pp. 275 ff.; Aström, *Studies in Mediterranean Archaeology* (forthcoming).

45. *N.H.* XXXVI. 37. The group is really constructed of six blocks, but the joints are so carefully concealed that even Michelangelo detected only three.

superbly modeled. And its recent reconstruction,[46] which makes the composition more compact and unified, greatly adds to its effectiveness.

The date to be assigned to the group has been much discussed, some authorities favoring the first half of the second century B.C., others the middle of the first century B.C. or even later.[47] The earlier date was thought to be indicated by the baroque style of the group, i.e. by the contortions and by the realistic expression of agony, which relate it to the figures on the frieze of the Pergamon altar; the later date was suggested by the fact that several signatures by an Athanodoros, son of Hagesandros, datable in the first century B.C., have come to light in Italy and elsewhere,[48] and so were associated with inscriptions found in Rhodes in which these same names appear—among them one on a base with the signature: Ἀθανόδωρος Ἀγεσάνδρου Ῥόδιος ἐποίη[σεν], datable 42 B.C.;[49] the other citing the two brothers Athanodoros and Hagesandros as priests of Athena Lindia in 22 and 21 B.C.[50] From these inscriptions it was thought that this Hagesandros and this Athanodoros were the same as those cited by Pliny as the sculptors of the Laokoon (cf. supra), and that they were made priests in recognition of the excellence of this group.[51] These ingenious arguments in favor of a first-century date, were, however, countered by the facts that (1) the names Hagesandros and Athanodoros occur in Rhodian inscriptions again and again from the third to the first centuries, and so were evidently common[52]; and (2) that the inscription citing Athanodoros and Hagesandros as priests of Athena Lindia makes no mention of their having been competent sculptors.

Helpful new evidence has now come from the excavations at Sperlonga (cf. infra), where an inscription was found with a signature by the same three sculptors cited by Pliny as having made the Laokoon, but with their fathers mentioned: "Athanodoros, son of Hagesandros, and Hagesandros, son of Paionios, and Polydoros, son of Polydoros, Rhodians, made it."[53] These three sculptors, therefore, had different fathers from those conjectured for them, and so the whole hypothesis that connected them with the first-century inscriptions falls to the ground. Moreover, together with the inscription there were found at Sperlonga marble sculptures (figs. 832, 833) in the same

46. Cf. Magi, "Il Ripristino del Laocoonte" (above cited); cf. also Caffarelli, "Note sul restauro del Laocoonte," in *Archeologia classica*, I (1949), pl. 17, and Treu's reconstruction in the Albertinum, Dresden, in *Die Antike*, IX (1933), p. 57, fig. 1.

47. For recent discussions cf. Richter, *Three Critical Periods in Greek Sculpture* (1951), pp. 66 ff.; S. Howard, *A.J.A.*, LIII (1959), pp. 365 ff.; and especially Magi, "Il Ripristino del Laocoonte" (1960), and the references there cited.

48. Cf. Loewy, *Inschriften*, nos. 480, 520, 203, 479, 446, 302; Richter, op. cit., p. 67.

49. *Syll.*³, 765; *Inscr. Lind.* 347.

50. *I.G.*, XII, 1857. On these inscriptions cf. now Fraser, in *Eranos*, LI (1953), p. 42, n. 10, and pp. 45 ff. (summary on p. 47) (with some corrections in my quotations of them in Richter, op. cit., pp. 67 f.).

51. Cf. Blinkenberg, in *Röm. Mitt.*, XLII (1927), pp. 177 ff.

52. Cf. Hiller von Gaertringen, *I.G.*, XII, fasc. 1; Jacopi, in *Clara Rhodos*, II (1932); Richter, op. cit., pp. 67 f.

53. Jacopi, *Archeologia classica*, X, 1958, pp. 160 f.

baroque style as the Laokoon, and so presumably to be associated with that inscrip-
tion (cf. infra). The stylistic date for the Laokoon near the Pergamene frieze, that is,
in the second quarter of the second century B.C., seems now indicated.[54] This is im-
portant for our understanding of the art of the first century B.C. (cf. pp. 243 ff.).

Among the sculptures discovered at Sperlonga, in a grotto called "l'antro di
Tiberio,"[55] was found the inscription above mentioned with the signature of the same
three sculptors cited by Pliny as having made the Laokoon, and with the same addi-
tional information that they were Rhodians. The inscription is on a small marble
block, 40 by 18 cm. and 2.4 cm. in thickness, and has been dated in Imperial times,
i.e. the first century A.D.[56] It, therefore, evidently is a Roman copy of the signature on
the original base, which was left in Rhodes, as was customary with imported statues.
The sculptures were taken, the heavy bases were left behind.

As we have said, the sculptures which were connected with this inscription consist
of large, fragmentary marble statues, markedly similar in style to the Laokoon. The
work on their reconstruction and identification is still in progress.[57] For this difficult

54. It seems to me that the Laokoon, with its developed baroque style, belongs to this third group of Per-
gamene sculptures, that is, to those on the frieze of the great altar (cf. figs. 830, 836, 837, dated in the second
quarter of the second century B.C.) ; rather than to the first group, that is, the dying Gaul and the Gaul killing
himself and his wife (cf. figs. 114, 130, dated in the last quarter of the third century B.C.) ; or to the second
group, that is, the dedications on the Akropolis of Athens (cf. fig. 127, dated in the first quarter of the second
century B.C.) where the baroque style is more restrained.

55. Jacopi, *L'Antro di Tiberio a Sperlonga* and *L'Antro di Tiberio e il Museo Archeologico di Sperlonga*. On
these sculptures see now especially:

L'Orange, "Odysseen i Marmor," in *Kunst og Kultur*, 47 (1964), pp. 193 ff., with English summary on pp.
227 f.; "Osservazioni sui ritrovamenti di Sperlonga," in *Acta Instituti Romani Norvegiae*, II (1965), pp. 261 ff.;
"Sperlonga again," ibid., IV, 1969, pp. 25 f.

Andreae, "Beobachtungen im Museum von Sperlonga," in *Röm. Mitt.*, 71 (1964), pp. 238 ff.; *Gnomon, 39*
(1967), 84 ff.; *Bild der Wissenschaft*, 1969, pp. 457 ff.; *Gnomon*, 1969, pp. 811 ff.; *Antike Plastik* (forth-
coming).

Lauter, "Der Odysseus der Polyphemgruppe von Sperlonga," in *Röm. Mitt.*, LXXVIII (1965), pp. 226 ff.

Sichtermann, "Das veröffentliche Sperlonga," in *Gymnasium* (1966), pp. 220 ff.

Säflund, *Fynden i Tiberiusgrottan*, Stockholm, 1966; "Das Faustinusepigramm von Sperlonga," in *Opuscula
Romana, Institutum Romanum Regni Sueciae*, VII (1) (1967), pp. 9 ff.; "Sulla ricostruzione dei gruppi di
Polifemo e di Scilla a Sperlonga," in *Opuscula Romana*, VII (2) (1967), pp. 25 ff.

Hermann, "Sperlonga Notes," in *Acta Instituti Romani Norvegiae*, IV (1969), pp. 27 ff.

Conticello, "Problemi di Sperlonga," in *Colloqui del Sodalizio* (1969). "The one-eyed giant of Sperlonga," in
Apollo, March 1969, pp. 188 ff. (On p. 193 he points out that the marble used in these Sperlonga sculptures is
of the same Rhodian variety, i.e. the famous *lithos lartios*, as those in the frieze of the Pergamon altar; *Archae-
ology*, XXII, 1969, pp. 204 ff.; "Die Skulpturen von Sperlonga," in *Antike Plastik* (forthcoming).

I want to acknowledge the great help given me by Professor L'Orange in assembling these references and in
writing my necessarily short account. And I also want to thank Mr. Conticello, Mr. Andreae, and Mr. Scichilone
for helpful discussions.

56. Cf. Guarducci, in Magi, *Mem. Pont. Acc.*, IX, 1960, pp. 39 f., where after giving the evidence for this
dating, she concludes: "Tutto considerato, dunque, sarei incline ad attribuire l'epigrafe di Sperlonga all'età
imperiale, giudicandola opera di uno scalpellino non molto abile che si fosse proposto d'imitare una grafia più
antica." This assignment is also indicated by the fact that the names of the artists cited are those of the original
creators, not of the copyists—who regularly signed their copies without any mention of their source; cf. Richter,
Three Critical Periods in Greek Sculpture, pp. 45 ff.

57. It is being carried out with great skill by the present director of the Museum, Dr. Baldo Conticello, who
has generously allowed access to the heterogeneous material to his many interested colleagues. It is indeed only
by combined efforts that we may ultimately arrive at definite solutions of the many problems involved.

task a second inscription, in Latin hexameters, found in the same grotto as the sculptures, has proved helpful.[58] In it a certain Faustinus (now assigned to the third or fourth century A.D.) refers to several magnificent sculptured groups which would have evoked the admiration of the divine poet of Mantua (i.e. Vergil)—one the blinding of Polyphemos by Odysseus and his companions, another the killing by Scylla of Odysseus' companions, and a third the foundering of Odysseus' ship. Remains of these groups have been identified, and the composition of the first has been made possible by a representation on a sarcophagus in Catania.[59]

In addition, there apparently were two other groups, also representing Homeric heroes: one of Menelaos carrying the body of Patroklos (like the Pasquino group), the other the rape of the palladion by Diomedes and Odysseus, of which the palladion and the hand holding it has been definitely identified.[60] Further finds may clarify many moot points.

These large sculptured groups evidently occupied the various sections and surroundings of the grotto, and, according to the inscription, were installed there by Faustinus. The freshness of the modeling points to original Greek workmanship, and the style suggests the time of the Laokoon and of the frieze of the Pergamon altar (cf. figs. 830, 831, 832, 833), that is, the second quarter of the second century B.C. How and when they were brought from Rhodes to Sperlonga is not certain—perhaps in the time of Tiberius, who is known to have spent some time in Rhodes, or later. That Roman copies of some of the figures exist[61] shows their appreciation in Roman times. For us these sculptures constitute an important enlargement of our knowledge of late Hellenistic art, and, like the Pergamene frieze, give us a realization of its amazing vitality.

Related to these sculptures from Sperlonga are also several in high relief found long ago in another grotto, the so-called Ninfeo Bergantino on the Alban lake below Castelgandolfo.[62] Included is a splendid figure of a recumbent Polyphemos (fig. 842),

58. Cf. Krarup, in *Analecta Romana Instituti Danici*, III (1965), pp. 73 ff., and IV (1967), pp. 89 ff.; in *Gymnasium*, 74 (1967), pp. 485 f.; in *Acta Instituti Romani Norvegiae*, IV, 1969, pp. 19 ff.

59. Robert, *Antike Sarkophagreliefs*, II, 147; Andreae, locc. cit.; Säflund, locc. cit.

60. Andreae, in *Gnomon*, XXXIX (1967), p. 84, suggests that a head (cf. Säflund, *Fynden i Tiberiusgrottan*, figs. 16, 17) belongs to a Diomedes in this group. In this connection it may be interesting to remember that in the many representations of the rape of the Palladion on engraved gems of the Roman period—evidently reproducing Greek originals of the Hellenistic period (cf. e.g. Cades, Collection of Impressions of Gems, in the German Arch. Inst., Rome, nos. 164 ff., and my *Engraved Gems*, II, nos. 308 ff.)—it is regularly Diomedes, not Odysseus, who is shown holding the palladion.

61. Cf. Andreae, in *Gnomon*, XXXIX, 1967, p. 83, in *Bild der Wissenschaft*, 1969, pp. 457 ff., and in *Antike Plastik* (forthcoming). The fact that some of these Roman copies were found in Hadrian's villa at Tivoli also points to the importance of the Greek originals, for Hadrian's interest in *famous* Greek works is well known. Thus in the same villa were found copies of two of the Ephesian Amazons, of the Aphrodite of Knidos, and of the Karyatids of the Erechtheion.

62. Cf. Lugli, in *Bull. Arch. Com.*, 1913, pp. 89 ff., as well as his articles in subsequent volumes of this Bullettino, and in *Arte in Europa, Scritti in onore di Edoardo Arsla*, 1966, pp. 47 ff.; Balland, Une transposition de la grotte de Tibère à Sperlonga: le Ninfeo Bergantino de Castelgandolfo, in *Mélanges d' Archéologie et d'Histoire*, 79, 1967, pp. 421 ff.; Magi, "Il Polifemo di Castel Gandolfo," in *Rendiconti dell'Acc. Pontif.*, XLI, 1968–69, pp. 69 ff. I owe the photograph for my fig. 842 and permission to reproduce it to the great kindness of Professor Magi.

stylistically related to the Polyphemos of Sperlonga, but in a different pose and so evidently part of a different composition. It too—as far as one can judge in the present condition of the surface—should be a Greek original of the time of the Pergamene altar.

For convenient comparison I have assembled in figures 834–846 illustrations of the head of Laokoon[63] (fig. 834), three heads from Sperlonga[64] (figs. 835, 838–40), several heads of the frieze of the Pergamene altar[65] (figs. 836, 837, 841, 843), as well as of the Polyphemos from Castelgandolfo[65a] (fig. 842); also of the heads of the two centaurs in the Capitoline Museum[66] (figs. 844, 845), and of the hanging Marsyas in the Conservatori Museum[67] (fig. 846), the last three Roman copies of originals in the same baroque style as the others. The close stylistic resemblance of these heads is instructive. Fortunately those of the Pergamene altar are dated by external evidence to the second quarter of the second century B.C., and so should supply an approximate date also for the other sculptures.

APOLLONIOS
AND TAURISKOS
OF TRALLES

The Farnese bull in Naples[68] (figs. 836, 849), a group that represents the punishment of Dirke by Amphion and Zethos, was found in A.D. 1456 in the Baths of Caracalla. It has been identified with a group mentioned by Pliny:[69] "Asinius Pollio . . . resolved that his gallery should be an object of general interest. In it stand . . . Zethos, Amphion, Dirke, the bull, the rope—all made of one block of marble and transported from Rhodes, the work of Apollonios and Tauriskos [of Tralles]." To appreciate the appearance of the original bronze work, of which the Naples marble group is a Roman copy, we must deduct in our imagination the figure of Antiope standing at the back and some of the subsidiary figures evidently added by the copyist. The group then becomes a compact, pyramidal composition, a technical tour de force, more worthy of our admiration. An adaptation of this group—without the subsidiary figures and designed for its new purpose—appears on a gem in Aquileia[70] (fig. 850).

DAMOPHON

We have the following account by Pausanias[71] of the sculptures of the temple at Lykosoura by Damophon of Messenia,[72] fragments of which were found in 1889:[73]

> The sanctuary of Despoina is four stades distant from Akakesion. The images of the goddesses themselves, Despoina and Demeter, and the throne whereon they are seated, and the footstool beneath their feet, are all of one block. . . .

63. Cf. pp. 236 f. 64. Cf. pp. 237 ff.

65. Cf. pp. 234 f. 65a. Cf. pp. 239 f.

66. Cf. Helbig-Speier, *Führer*⁴, II, no. 1398. 67. Cf. Helbig-Speier, *Führer*⁴, II, no. 1587.

68. Ruesch, *Guida*, no. 260; Lippold, *Handbuch*, pp. 83, 383 f., and the references there cited; Amorelli, in *Enc. Arte Antica*, I (1958), pp. 485 f., s.v. Apollonios (4) and the references there cited.

69. *N.H.* XXXVI. 34.

70. Vollenweider, in *Encyclopedia of World Art*, 6 (1962), 58, pl. 3 (middle); Chiesa, *Gemme del Museo Nazionale di Aquileia*, no. 750; Richter, *Engraved Gems*, II, no. 333. 71. VIII. 37. 1.

72. On Damophon cf. Lippold, *Handbuch*, pp. 350 f., and the references there cited; Mustilli, in *Enc. Arte Antica*, 2 (1959), 999 f., s.v. "Damophon," and the references there cited.

73. Cavvadias, *Fouilles de Lycosoura*; Dickins, in *B.S.A.*, XII, 1905–06, pp. 109 ff.

Each of the images is about equal in size to that of the Great Mother at Athens; they also are the work of Damophon. Demeter bears a torch in her right hand, while she has laid the left on Despoina; Despoina bears a scepter and "cista," as it is called, in her lap; with one hand—the right—she holds the "cista." On each side of the throne is a figure; beside Demeter stands Artemis, clad in a deerskin, with a quiver on her shoulder; in one hand she holds a torch, in the other two snakes; beside Artemis lies a bitch, like those used in hunting. Close to the image of Despoina stands Anytos, attired as a warrior in full armor; the attendants of the temple say that Despoina was reared by Anytos, and that he is of the number of the Titans, as they are called. The legends of the Kouretes, who are represented beneath the images, and of the Korybantes, who are wrought in relief on the base, I omit, although I know them.

The extant fragments consist of the heads of Demeter (figs. 818, 819), Artemis (fig. 817), and Anytos (fig. 816), and a richly decorated piece of garment.[74] They clearly reflect various styles—the Demeter and Artemis classical ones, the Anytos Hellenistic. The date of Damophon is established by inscriptions for the first half of the second century B.C.[75] Damophon is mentioned by Pausanias[76] as the sculptor of other works—chiefly deities—and called the "only Messenian sculptor of repute"; he also is said to have repaired Pheidias' Zeus at Olympia.[77]

Signatures of the Athenian sculptor Euboulides[78] occur on several bases found in Athens, sometimes as co-worker of Eucheir, at other times as the son of Eucheir.[79] These inscriptions can be dated in the third and the second century B.C. respectively. The two names are also mentioned by ancient writers. According to Pliny,[80] Euboulides won fame with the statue of a man *digitis computans,* "counting on his fingers," and Cicero[81] mentions the statue of a seated Chrysippos in the Kerameikos *porrecta manu,* "with extended hand." It seems probable that these two descriptions apply to the same statue, especially as Sidonius Apollinaris[82] refers to Chrysippos as *digitis propter numerorum indicia constrictis,* "with fingers pressed to indicate numbers." It seems also likely that we may have copies of this statue preserved in a headless seated figure in the Louvre and in a number of heads and busts (cf. fig. 247);[83] for a head of this type appears on coins of Soloi,[84] the native city of Chrysippos, and

74. National Museum, Athens, nos. 1734–37. Papaspiridi, *Guide,* pp. 67 f., and S. Karouzou, *Catalogue,* pp. 172 f.

75. Dickins, in *B.S.A.,* XII (1905–06), pp. 109 ff., XIII, pl. XII, and XVII, pp. 80 ff., and *Hellenistic Sculpture,* p. 60.

76. Pausanias, IV. 31. 6, 7, 10; VII. 23. 5–7; VIII. 31. 1–3; IV. 31. 66. Overbeck, *Schriftquellen,* nos. 1537–64.

77. Pausanias, IV. 31. 6.

78. On Euboulides cf. Lippold, *Handbuch,* p. 328, and the references there cited; and on the several artists by that name cf. Cressedi, in *Enc. Arte Antica,* III, 1960, pp. 512 f.

79. Loewy, *Inschriften,* nos. 223 ff. 80. *N.H.* XXXIV. 88.

81. *De Fin.,* I. 11. 39. 82. *Epist.* IX. 9. 14.

83. On the portraits of Chrysippos cf. now my *Portraits of the Greeks,* II, pp. 191 ff., figs. 1111–46, and the references there cited. 84. *Ibid.,* fig. 1197.

a headless herm in Athens inscribed with the name Chrysippos[85] has drapery similar to that preserved on some of the heads and busts. To the headless statue in the Louvre has now been added a cast of the head in London and the result seems convincing[86] (cf. fig. 826).

Pausanias[87] mentions statues of Athena, Zeus, Memory, the Muses, and Apollo, "the work and offering of Euboulides" as being "in the house of Poulytion." Fragments of statues including a head of Athena (fig. 825) and a fragmentary female figure, perhaps a Nike,[88] as well as an inscription [Εὐβουλίδης Εὔ]χειρος Κρωπίδης ἐποίησεν (. . . , the son of Eucheir of Kropia made it) datable around 130 B.C., have been found in the locality mentioned by Pausanias.[89]

From this evidence it has been computed that there were two sculptors named Euboulides, one who made the statue of Chrysippos around 200 B.C., and another, perhaps his grandson, who lived after the middle of the second century and made the group of statues found in Athens.

DIONYSIOS, POLYKLES, AND TIMARCHIDES

Another family of sculptors active in Athens during the second century B.C., in which the names Dionysios, Polykles, and Timarchides[90] recur, is known from inscriptions and ancient writers.[91] The only definite attribution to a preserved work that can be made is that of the statue of a Roman magistrate named Gaios Ophellios found at Delos (fig. 829), the pedestal of which bears the signature "Dionysios, the son of Timarchides, and Timarchides, the son of Polykles, Athenians, made it."[92] The head, which was evidently a portrait, is lost, but the figure is in the same stance as the Hermes of Praxiteles. We learn from Pausanias[93] that Timokles and Timarchides of Athens made a copy of the shield of Pheidias' Athena Parthenos for a cult statue of Athena at Elateia.

85. Ibid., p. 192, fig. 1146, no. 16. 86. Ibid., p. 193, fig. 1144, no. 17.
87. I. 215.
88. National Museum, Athens, nos. 233, 234. Papaspiridi, *Guide*, pp. 103 f., and S. Karouzou, *Cat.*, p. 234.
89. Loewy, *Inschriften*, no. 228.
90. On these artists cf. Lippold, op. cit., pp. 365–67, and the references there cited; Moreno, in *Enc. Arte Antica*, VII (1966), pp. 857 f., s.v. Timarchides (2), and the references there cited.
91. Cf. Overbeck, *Schriftquellen*, nos. 2208–13; Loewy, op. cit., no. 242.
92. Homolle, *B.C.H.*, V, 1881, p. 390, pl. XII; Michalowski, *Délos*, XIII, p. 21, fig. 13.
93. X. 34. 7.

CHAPTER 6

FIRST CENTURY B.C.

The first century B.C. marks the beginning of a new era in Greek art. We have seen that already in the second century there was a tendency on the part of some artists to hark back to former creations (cf. supra). And there are also sculptures which, though they cannot be associated with any specific artist, are datable in the second century and can be recognized as reproductions of earlier famous creations; for instance, the Athena Parthenos (fig. 644) and a fifth-century Hera or Demeter found at Pergamon,[1] and a Scopaic Meleager and a Lysippian Herakles found at Kalydon.[2] These copies, however, are free reproductions, and so show many variations from the originals. Presently, however, there appear in Italy and elsewhere a host of exact copies of Greek works of all periods. To explain this change we must turn to the contemporary history.

During the second century B.C., when the Roman armies successively subjugated the Hellenistic Greek kingdoms there took place the well known large-scale transfer of Greek works of art from Greek public places and sanctuaries in Asia Minor, the Islands, Greece, and South Italy to Roman public buildings and private houses.[3] The plundering began with the conquest of Syracuse in 211 B.C. by Marcellus[4] and continued throughout the second century. The various conquerors brought their plunder back in triumph to Rome. Thus, L. Scipio in 190 B.C. brought 134 statues as well as large quantities of embossed metalware and coins from Asia Minor.[5] M. Fulvius Nobilior in 187 transported 285 bronze and 230 marble statues from Ambracia.[6] In the triumphal procession of L. Aemilius Paullus in 167 B.C. 250 cartloads of statues, paintings, and embossed vases took part.[7] L. Mummius, after his conquest of Corinth in 146, "filled all Rome with sculptures."[8] In 133 B.C. Attalos III of Pergamon willed his kingdom to Rome,[9] and his vast collections of art, gathered from all parts of Greece, soon found their way to Italy.

1. Winter, in *Altertümer von Pergamon*, VII, pp. 33 ff., nos. 23, 24, pl. 8.

2. Dyggve, F. Poulsen, and Rhomaios, *Das Heroön von Kalydon*, p. 369, figs. 91–93 (Meleager), and p. 363, figs. 79, 80 (Herakles, Farnese type).

3. Cf. on this subject especially F. Poulsen, "Die Römer der republikanischen Zeit und ihre Stellung zur Kunst," in *Die Antike*, XIII (1937), pp. 125 ff.; Vessberg, *Studien zur Kunstgeschichte der römischen Republik*, and in *Encyclopedia of World Art*, VII (1963), s.v. Hellenistic-Roman Art, cols. 393 ff.; Rizzo, "I Romani e l'arte greca," in *L'Urbe, 10* (1947), pp. 3 ff.; Jucker, *Vom Verhältnis der Römer zur bildenden Kunst der Griechen*, 1950, pp. 46 ff.; Richter, *Three Critical Periods in Greek Sculpture* (1951), pp. 37 ff.; Becatti, *Arte e gusto negli scrittori latini* (1951). 4. Plutarch, *Marcellus* 21; Livy, *Annales* XXV, 40, 1–3.

5. Livy XXXVII. 59. 6. Livy, XXXIX. 5; Polybios, XXXII. 13; Pliny, *N.H.* XXXVII. 5.

7. Plutarch, *Aemilius Paulus* 32. 8. Strabo, VIII. 281.

9. Cf. Wilcken, in *R.E.*, II (2), col. 2176, and the references there cited.

These works of art, which were to be seen all over Italy, exercised a profound influence on the Roman people. They became enamored of Greek art,[10] and their interest coincided with increasing personal wealth. Soon private collectors vied with each other in the acquisition of Greek works of art, especially of statues. Some were legitimately purchased, others were appropriated by officials in conquered territories. Then, after Rome had more or less terminated her conquests in Greek lands, a more responsible attitude toward her new empire took the place of the former looting. The invectives of Cicero against Verres (ca. 70 B.C.), and the latter's subsequent conviction show the new official attitude—though some looting, especially by private individuals persisted.[11]

During this comparative dearth of supplies, however, the Roman public continued to desire to possess Greek sculptures, which they so much admired. To meet this persistent demand there now arose a large-scale manufacture of copies[12]—of exact copies that could even pass as originals,[13] produced with the so-called pointing machine.

After this historical picture let us examine the literary evidence that seems to bear on this subject.

PASITELES[14]
AND
HIS SCHOOL

Pliny[15] mentions Pasiteles a number of times. He says that he was a contemporary of Pompey (106–48 B.C.) and of M. T. Varro (116–27 B.C.), that he came from Magna Graecia to Rome, that he wrote five books on celebrated works of art, and that he never executed a work without first making a model of it (cf. infra). He also mentions several of Pasiteles' statues, including a chryselephantine Zeus for the temple of Metellus, and a lion modeled from life. It would seem, therefore, that Pasiteles was an able sculptor, who studied from life but also had antiquarian interests. His five books on celebrated works of art were doubtless eagerly read by an interested public.

Pliny's somewhat confused and laconic statements (he was an author, not a practicing artist, and lived A.D. 23–79, that is, a considerable time after Pasiteles) nevertheless throw an interesting light on what evidently happened. The most important passage (XXXV. 156) reads: "Pasiteles, qui plasticen matrem caelaturae et statuariae

10. We may recall Cato Censorius' strictures.

11. Revealing in this respect are also the contents of the ship wrecked off Antikythera, which included both original Greek sculptures and Roman copies of famous Greek originals; e.g. the fourth-century bronze statue (Svoronos, *Athener Nationalmuseum*, pl. I), and a Hellenistic portrait head (Svoronos, op. cit., pl. II), as well as replicas of the Lysippian Herakles Farnese (Ibid., pl. XI, 1) and perhaps of the Knidian Aphrodite by Praxiteles (Ibid., pl. XVI, 2 [only part of the back with a possible few fragments belonging to it are preserved]). The date of the shipwreck has now been computed to have been early in the second quarter of the first century B.C.; cf. Edwards, *A.J.A.*, LXIV, 1960, pp. 183 f. On private looting, such as digging for "treasures" in Greek cemeteries, cf. Payne, *Necrocorinthia*, pp. 348 ff. (a reference I owe to T. Dohrn); also Jucker, op. cit., p. 80.

12. Cf. e.g. Furtwängler, *Statuenkopien im Altertum*, 1896; Lippold, *Kopien und Umbildungen griechischer Statuen* (1923); Richter, *The Portraits of the Greeks* (1965), I, pp. 24 ff., and in *A.J.A.*, 74, 1970 (forthcoming).

13. Cf. e.g. Lucian, *Philospeudes*, where statues of the Tyrannicides, of Myron's Diskobolos, and of Polykleitos' Diadoumenos, set up in a private house, are apparently referred to as the originals, at least without mention that they are copies. On "false antiques" cf. also Martial. XII. 69.

14. On Pasiteles cf. Lippold, *Handbuch*, p. 386, and the references there cited; Wedeking, in *Enc. Arte Antica*, V, 1963, p. 984, s.v. "Pasiteles," and the references there cited.

15. *N.H.* XXXIII. 130, 156; XXXV. 156; XXXVI. 35, 39, 40.

scalpturaeque [sculpturaeque?], dixit et, cum esset in omnibus iis summus, nihil unquam fecit antequam finxit." This has been translated (in the Loeb edition and elsewhere): "Pasiteles, who said that modelling was the mother of chasing and of bronze statuary and sculpture, and who, although he was eminent in all these arts, never made anything before he had made a clay model." Clay models, however, were used by Greek sculptors for a long time before Pasiteles (cf. p. 243), and so were nothing extraordinary; nor does *finxit* and *plastice* necessarily imply clay models; for *fingere* means to form or fashion and *plastice* is derived from the Greek πλαστική and πλάσσω, meaning "form" or "mold." Pliny's statement may, therefore, rather be interpreted as indicating the making of a plaster model, molded from an original, for use with the pointing machine. For in this process the basic requirement actually is to make a cast of a statue to act as a "model," on which a series of points can be marked, to be then transferred to the block of marble which is to become the statue.[16] The plaster cast can, therefore, be called the "mother" of the finished piece of sculpture.

Accordingly, Pasiteles may be the initiator of the making of exact copies by the pointing machine, or at least one of the initiators, for the process in its perfected form will have taken some time to evolve. This hypothesis gains likelihood from the fact that Pasiteles was active at the very time that exact copies begin to appear.

Furthermore, although none of Pasiteles' works has so far been recognized, we know products of his school.[17] A statue of a youth in the Villa Albani[18] is inscribed "Stephanos, pupil of Pasiteles made it"[19] (fig. 851), and a group of a youth and woman in the Museo Nazionale delle Terme[20] is inscribed "Menelaos, pupil of Stephanos, made it"[21] (fig. 853). Stephanos' youth—in the style of about 470 B.C.— appears again in a torso in Berlin,[22] as well as in two groups, in Naples[23] and in the Louvre;[24] and there is a replica of the group by Menelaos in the Torlonia Collection.[25] It is clear that both Stephanos and Menelaos practiced the art of copying current in their time.

We have particulars about another sculptor of this time which further help to clarify our problem. A certain Arkesilaos[26] is mentioned by Pliny[27] as a friend of

ARKESILAOS

16. On the pointing machine cf. now Richter, *Ancient Italy* (1955), pp. 105 ff.; in *Röm. Mitt.*, 69 (1962), 52 ff.; in *Studi in onore di Luisa Banti* (1965), pp. 289 ff.; *Portraits of the Greeks*, 1, 24 ff. It is of course important to remember that in the ancient process fewer "subsidiary points" were taken than is customary nowadays, so that slight variations often occur in the various copies.

17. On the Pasiteleans cf. especially Hauser, *Neuattische Reliefs*, pp. 182 ff.; Lippold, *Handbuch*, p. 386, and the references there cited; Borda, *La scuola di Pasitele*; Morena, in *Enc. Arte Antica*, VII, 1966, pp. 494 f., s.v. "Stephanos," and the references there cited; Cressedi, in *Enc. Arte Antica*, II, 1959, p. 871, s.v. Cossutius Menelaos, and the references there cited.

18. Helbig, *Führer*³, II, no. 1846; Helbig-Speier, *Führer*⁴, IV (in preparation).

19. Loewy, *Inschriften*, no. 374. 20. Helbig-Speier, *Führer*⁴, III, no. 2352.

21. Loewy, *Inschriften*, no. 375. 22. *Beschreibung der Skulpturen*, no. 509.

23. Ruesch, *Guida*, no. 110. 24. Collignon, *Histoire de la sculpture*, II, p. 663, fig. 348.

25. Arndt, *Einzelaufnahmen*, no. 1153 (where other replicas are cited).

26. On Arkesilaos cf. Lippold, *Handbuch*, p. 386, and the references there cited; Amorelli, in *Enc. Arte Antica*, I (1958), p. 902, s.v. Arkesilaos (37), and the references there cited.

27. *N.H.* XXXV. 155 f.; XXXVI. 41. 33 (there spelled Arkesilas).

Lucius Lucullus (ca. 110–56 B.C.), and as a sculptor. Among his works are cited a statue of Felicitas (ordered by Lucullus but never finished since both died before its completion); an unfinished cult statue for the temple of Venus Genetrix[28] in the Forum of Caesar dedicated in 46 B.C.; a lioness with Erotes playing round her; and centaurs carrying nymphs. Pliny furthermore says that Arkesilaos' "proplasmata" "used to sell among artists for more than the finished products of others," and that he made a plaster model (*exemplar a gypso*) of a krater for which he was paid as much as one talent. The word "proplasmata" harks back to Pasiteles' *plastice*, which we have seen may apply to a plaster model and this possibility is now strengthened by the remark that his plaster krater was costly, for this can be explained by the fact that from it many reproductions could be made and sold.

If these surmises are correct, Pliny's random remarks would further indicate that in the late second or early part of the first century B.C. the pointing process was invented. Naturally, especially at first, the artists who practiced it might produce some original works, but evidently the great demand was for reproductions, and they seem to have fetched high prices.

It is also significant that at this very time Italy began to use marble extensively, importing it first from Greek lands (during the first half of the second century B.C.), and presently developed her own supply in the Carrara quarries (during the second half of the first century B.C.).[29]

THE COPYISTS:
[ANT]IOCHOS,
APOLLONIOS
SON OF
ARCHIAS,
DIOGENES,
GLYKON,
MENOPHANTOS,
APOLLONIOS
SON OF
NESTOR,
ARISTEAS AND
PAPIAS OF
APHRODISIAS,
AGASIAS
SON OF
DOSITHEOS

The mechanical copying, initiated perhaps by Pasiteles and his school, was continued for several centuries. The Greek artists who made these copies for Roman patrons throughout the empire occasionally signed their works, so we know some of their names.[30] [Ant]iochos, for instance, signed the copy of Pheidias' Athena Parthenos in the Terme Museum[31] (fig. 852); Apollonios, son of Archias, a bust taken from Polykleitos' Doryphoros[32] (fig. 693); Diogenes a copy of the Herakles Epitrapezios by Lysippos;[33] Glykon a Herakles of the Farnese type, i.e. another Lysippian statue[34] (fig. 801); Menophantos an Aphrodite "from the Troad,"[35] a variant of

28. A figure represented on coins of Sabina, the wife of Hadrian, which is inscribed Venus Genetrix and which is evidently copied from a fifth-century statue preserved in marble copies, was thought to reproduce Arkesilaos' statue. But the same inscription appears on Roman coins with different statues, so the identification is uncertain.

29. I learned this important fact during Ward Perkins' Jerome Lectures, given in Rome in March 1969, to be published under the title, *Men, Materials, Methods and Aspects of Roman Architecture and Sculpture*.

30. On these later artists cf. e.g. Lippold, *Handbuch*, pp. 380 ff.; Richter, *Three Critical Periods in Greek Sculpture* (1951); the pertinent articles in *Enc. Arte Antica*; Loewy, *Inschriften*, under the various names.

31. Helbig-Speier, *Führer*[4], III, no. 2328; Loewy, no. 342.

32. Ruesch, *Guida*, no. 854; Loewy, no. 144.

33. In the British Museum. Smith, *Catalogue of Greek Sculpture*, III, no. 1726; Loewy, no. 361. Of limestone, found at Nineveh.

34. In Naples. Ruesch, *Guida*, no. 280; Loewy, no. 345. "Of Athens."

35. In the Museo Nazionale delle Terme, inv. no. 75674. Lippold, *Handbuch*, p. 307, n. 6; Helbig-Speier, *Führer*[4], III, no. 2236; Cressedi, in *Enc. Arte Antica*, IV (1961), p. 1026, s.v. Menophantos, fig. 1216 (head alien).

the Capitoline Venus; Apollonios, son of Nestor, the Belvedere torso[36] (fig. 848);
Aristeas and Papias of Aphrodisias the two centaurs in the Capitoline Museum[37] (figs.
844, 845); Agias, son of Dositheos, the Borghese warrior in the Louvre[38] (fig. 113)
—the last three evidently copies of late Hellenistic originals.

It is evident, therefore, that Greek works of all periods—fifth century, fourth cen-
tury, and Hellenistic (rarely archaic)—appealed to the Romans and had to be re-
produced in copies.[39] And it is also probable that these sculptures were executed by
Greek artists who had come from their impoverished homelands to prosperous Italy
where work was plentiful. It is moreover a curious and perhaps revealing phenomenon
that these copyists of the Roman period regularly sign their reproductions of earlier
works with their own names without any acknowledgment of the original source.
(Menophantos who at least gave the location of the original statue, is an exception;
and so would be the inscription ἔργον Λυσίππου on a statue of the Herakles Farnese
type in the Palazzo Pitti in Florence if it were genuine (cf. p. 226), not a signature but
"une sorte d'étiquette indiquant une copie d'oeuvre célèbre.") Perhaps the fact that
these copies had sometimes to pass as originals[40] was a contributory cause. The great
majority were of course not signed, and varied considerably in executions.

Besides straight copies we have many adaptations of former creations, in which
elements—generally in relief and on a reduced scale—are taken from different
sources and periods, and combined to form new ensembles. We know the names of
several of these often tasteful adapters, for they too occasionally signed their works—
Sosibios, who inscribed his name on a marble altar in the Louvre,[41] Salpion, whose
name appears on a marble krater in Naples,[42] and Pontios, who signed a marble
rhyton in the Conservatori Museum in Rome.[43] All three call themselves Athenians.

SOSIBIOS,
SALPION, AND
PONTIOS

We also know some of the names of the Greek artists who made the Roman por-
traits, for here again a few signatures have survived. The names of Kleomenes,
Philathenaios, Hegias, Dionysios, Sosikles, Zenon, Zenas, Antonianos are preserved
on portraits of Romans ranging from the first century B.C. to the second century A.D.[44]

GREEK
SCULPTORS
OF ROMAN
PORTRAITS

36. Helbig-Speier, *Führer*⁴, I, no. 265; Loewy, no. 343. "Of Athens." The inscription "Apollonios, son of
Nestor the Athenian made it," thought to appear on the bronze boxer in the Terme Museum (fig. 847, cf.
Carpenter, in *Memoirs of the American Academy in Rome*, VI (1927), pp. 133 ff.) has now been shown to con-
sist merely of scratches (cf. M. Guarducci, *Annuario*, XXXVII–XXXVIII, N.S., XXI–XXII [1959–60], pp. 361 ff.). A
figure on a Roman coin of Lacedaemon has been thought to reproduce the same composition (cf. Rossbach,
Arch-Anz., 1920, col. 57, and my fig. 814).

37. Helbig-Speier, *Führer*⁴, II, no. 1398; Loewy, no. 369.

38. Brunn-Bruckmann, *Denkmäler*, pl. 75; Loewy, no. 292. "Of Ephesos."

39. For this reason the term "classicizing" often applied to the sculpture of this period seems to me mis-
leading. Cf. on this question my *Three Critical Periods in Greek Sculpture*, pp. 37 ff., and my article "Was
Roman Art of the First Century B.C. and A.D. Classicizing?" in *J.R.S.* (1958), pp. 10 ff. 40. Cf. p. 244, n. 13.

41. Loewy, *Inschriften*, no. 340; Hauser, *Die neuattischen Reliefs*, p. 6, no. 1; Collignon, *Histoire de la
sculpture grecque*, II, pp. 647 f., fig. 339. 42. Loewy, no. 338; Hauser, op. cit., p. 6, no. 1.

43. Loewy, op. cit., no. 339; Helbig-Speier, *Führer*⁴, II, no. 1594.

44. Loewy, op. cit., no. 344; Treu, *Olympia*, III, pp. 244, 256, pls. LX, 1, LXIII; Ugolini, *Rendiconti, Pont. Acc.
Rom. Arch.*, XI, 1935, p. 92; Loewy, op. cit., nos. 366, 383a and b; Squarciapino, *La Scuola di Afrodisia*, pp.
29 ff.; and Richter, *Three Critical Periods in Greek Sculpture*, pp. 54 f.

Other Greek artists signed portraits of Romans on engraved gems—Agathangelos, for instance, Epitynchanos, Herophilos, Apollonios, Euodos.[45] These realistic Roman portraits are the direct descendants of the late Hellenistic products; only the "sitters" are now no longer mostly Greek philosophers, poets, and intellectuals, but practical men of affairs—officials, generals, and emperors; so the physiognomies are different.

With these last names of Greeks who worked for Romans throughout the Roman empire our history of Greek sculpture closes. Whatever we may think of the quality of the copyists' work and their lack of originality, we owe to them, as we have said, much of our knowledge of Greek sculpture; for the greater part of it has been preserved only in these copies and adaptations. Moreover, by their portraits, sarcophagi, and the Roman historical reliefs—which were doubtless also primarily at first made by Greeks—they initiated Roman art with new subjects and new spatial concepts. A new era was inaugurated.

45. Furtwängler, *Antike Gemmen*, pl. xlvii, 40, pl. xlvii, 8, vol. iii, p. 319, fig. 162; Vollenweider, *Steinschneidekunst und ihre Künstler in spätrepublikanischer und Augusteischer Zeit* (1966), passim; Richter, *Engraved Gems*, ii, nos. 634, 674, 675, 641, 676.

CHAPTER 7

CHAPTER 7

TENTATIVE CHRONOLOGY OF
OUTSTANDING GREEK SCULPTURES

The sculptures marked with an asterisk are Roman copies of lost Greek originals.

Period	Monument	External Evidence
ca. 660–650 B.C.	Statue dedicated by Nikandre (fig. 277) Fragment of a kouros from Delos (fig. 16).	Opening up of Egypt to the Greeks early in the reign of Psammetichos I (660–609 B.C.); cf. Herodotos II, 154.
	Statuette from Dreros (fig. 15)	Comparison with a terracotta mourner on a Protoattic vase, from the Kerameikos (Kübler, in *Arch. Anz.* 1933, col. 268 f.), and with the late Protocorinthian pot in the Louvre (Payne, *Necrocorinthia*, pl. I, 8–11).
ca. 630	Sculptures from Prinias (fig. 364) Reliefs from Mycenae (Karo, *Greek Personality in Archaic Sculpture*, p. 99, pl. 7) Draped woman once in Auxerre (fig. 276)	Comparison with heads on early Corinthian vases (Payne, *Necrocorinthia*, pp. 23 f.).
ca. 615–590	Sounion, Dipylon, and New York kouroi (figs. 18, 20, 144)	Comparison with plastic heads on early Corinthian pottery and with figures on early Athenian vases, e.g. the Nessos amphora (cf. Payne, op. cit., pl. 47, nos. 7–9; Richter, *Kouroi*[3], pp. 38 f.).
ca. 600	Head of Hera found near the Heraion at Olympia (fig. 147)	Comparison with heads on middle Corinthian pottery.
ca. 600–590	Kleobis and Biton by [Poly]medes of Argos, in Delphi (figs. 19, 151, 154).	Anatomically the statues are related to the Sounion kouroi, though they are somewhat more developed.
ca. 600–580	Pediment from the temple of Artemis at Corfu (figs. 66, 81, 101, 116, 150, 401) Head of sphinx from Kalydon (Dyggve, *Das Laphrion*, figs. 191–93)	
ca. 600–575	Seated statue from Didyma (fig. 67)	

Period	*Monument*	*External Evidence*
ca. 575–560	Standing maiden from Attica in Berlin (figs. 148, 149, 279, 281)	Anatomically the statue is more developed than the Sounion group of kouroi. Comparison with figures on the François vase. Cf. Richter, *Korai*, pp. 37 f.
	Headless maiden from the Akropolis, no. 593	Anatomically related to the Berlin maiden.
	Calf Bearer dedicated by [Rh]ombos (figs. 5, 6)	Cf. Richter, *Kouroi*³, pp. 76 f.
	The Naxian sphinx at Delphi	
	Metopes of the "Sikyonian" Treasury at Delphi (figs. 383, 433)	
ca. 570–550	Statue dedicated to Hera by Cheramyes, in the Louvre (Buschor, *Altsamische Standbilder*, figs. 86–89)	Cf. Richter, *Korai*, pp. 44 f.
	Statues by Geneleos (Buschor, op. cit., figs. 90 ff.)	
	Poros pediment of "Bluebeard" and Triton from the Akropolis (figs. 405, 406)	
	Metopes of the Heraion on the river Silaris	
	The Tenea and Volomandra kouroi (figs. 22, 24, 156)	Cf. Richter, *Kouroi*³, pp. 76 ff.
	Statue of Chares from Didyma (fig. 278)	
ca. 560–550	Introduction pediment from the Akropolis (fig. 407)	
ca. 550	Winged Nike from Delos (fig. 82)	
ca. 555–540	The kouros from Melos (fig. 21)	Cf. Richter, *Kouroi*³, pp. 93 ff.
ca. 555–530	Parts of the sculptured drums of the temple of Artemis at Ephesos	Most of the columns of this temple are said by Herodotos (I.92) to have been offered by Kroisos, who reigned ca. 560–547). Part of the dedicatory inscription on the astragal of a sculptured drum has been preserved, but it cannot be definitely associated with any of the sculptures. The building of the temple must have lasted some time (cf. pp. 210 f.).
ca. 540	Metopes of temple C at Selinus (fig. 434)	The simple scheme of stacked folds on these figures occurs on black-figured vases of the third quarter of the sixth century, e.g. on a late kylix by Lydos in New York; cf. Richter, in *A.J.A.*, L, 1946, pp. 17 f.
	Maiden no. 679 in the Akropolis Museum (figs. 152, 284)	
	Gravestone of a brother and sister, in New York (fig. 459)	Cf. Richter, *The Archaic Gravestones of Attica*, no. 37.
ca. 550–525	Reliefs of the temple at Assos (fig. 432)	

Period	Monument	External Evidence
	The Munich and Anavysos kouroi (figs. 22, 23)	Cf. Richter, *Kouroi*³, pp. 114 ff.
ca. 530–510	The maidens nos. 670–75, 680, 682–84 in the Akropolis Museum (cf. figs. 153, 159, 285, 286)	Cf. Richter, *Korai*, pp. 68 ff.
Shortly before 525	Pediment and frieze of the Siphnian Treasury at Delphi (figs. 102, 131, 409, 451, 452, 526)	Herodotos III.57 speaks of an adverse oracle which was pronounced against the Siphnians while they were building their Treasury at Delphi and which was fulfilled in a Samian attack dated 524 (cf. Richter, *Korai*, p. 63).
ca. 530–500	Athena probably by Endoios (fig. 69)	Inscriptions date Endoios in the last third of the sixth century (cf. Raubitschek, in *A.J.A.*, XLVI [1942], pp. 245 ff., and *Dedications*, pp. 491 ff.).
ca. 520	Marble pediment from a Peisistratid temple (figs. 119, 412)	Compare vases by Oltos (Langlotz, *Zeitbestimmung*, p. 34).
ca. 520–510	Pediment of the Treasury of the Megarians at Olympia (fig. 410)	
ca. 510	Stele of Aristion by Aristokles (fig. 460)	Cf. Richter, *The Archaic Gravestones of Attica*, no. 67.
ca. 513–500	Pediments of the temple of Apollo at Delphi (figs. 408, 411, 413, 414)	According to Herodotos V.62 and Aristotle, *Politeia* 19. 3, the temple (which took the place of an earlier structure burned in 548) was begun after the battle of Leipsydrion (513). Hipparchos died 514–513. After the fall of Hippias (510) the Alkmaionids built the east front of the temple in magnificent style (Schol. Pindar, *Pyth.* 7. 9). Cf. Richter, *Korai*, pp. 63 f.
ca. 510–500	West pediment of the temple of Apollo Daphnephoros at Eretria (figs. 295, 298)	
	The Ptoon 20 and Strangford kouroi (figs. 32, 33)	Cf. Richter, *Kouroi*³, pp. 129 ff.
	Metopes of the Treasury of the Athenians at Delphi (figs. 132, 436, 437, 438a and b)	Cf. Richter, *Korai*, pp. 64 ff.
	Frieze of mounting charioteer (fig. 289) and Hermes (fig. 290)	Compare the vases of Leagros period and early Panaitios period (Langlotz, *Zeitbestimmung*, p. 87).
	Statue base with cat-and-dog fight and ballplayers in Athens (figs. 297, 508)	Compare vases by Euthymides and Phintias.
	Metopes of the later Heraion on the river Silaris	
	Bronze krater from Vix (cf. fig. 368)	

Period	*Monument*	*External Evidence*
ca. 500–490	"Harpy tomb" (figs. 511, 512)	Compare the Theseus cup by the Panaitios painter in the Louvre and vases at the turn of the century.
	Stele by Alxenor (fig. 461)	The inscription is dated at the turn of the century (Loewy, *Inschriften*, no. 7; *I.G.*, XII. 5, no. 1426).
ca. 499–494	Head of Athena on a stater issued during the Ionian Revolt, perhaps by Priene	Cf. Baldwin, *The Electrum Coinage of Lampsakos*, pp. 26 ff., pl. 2.
ca. 500–480	Pediments of the temple of Aphaia at Aigina (figs. 108, 120, 121, 194, 415, 416, 564)	Architecturally the temple is "the most perfectly developed of the late archaic temples" in Greece proper (Dinsmoor).
Soon after 490	The statue no. 690 in the Akropolis Museum (Raubitschek, in *A.J.A.* [1940], pp. 53 ff.)	Dedicated after the battle of Marathon.
490–480	Sparta warrior (fig. 109) The heads of Maidens nos. 696 and 643 in the Akropolis Museum Moulded head on a vase by the Brygos painter	Cf. Richter and Hall, *Red-figured Athenian Vases in the Metropolitan Museum*, no. 43.
	Euthydikos maiden (fig. 168) Blond boy (fig. 177) Horse (fig. 365)	Found on the Akropolis in the Persian debris with colors well preserved. Cf. Richter, *Korai*, pp. 98 f., and *Kouroi³*, p. 191.
ca. 480	Running maiden from Eleusis (fig. 92) Seated goddess in Berlin (figs. 70, 170)	
	Reliefs with dedicatory inscription to Apollo and the nymphs, from Thasos, in the Louvre (fig. 492)	The inscription has been dated ca. 490–480 (*I.G.*, XII, 8, no. 358), "see *I.G.* XII, 8, no. 390—another inscription from Thasos dated on historical grounds 494–492, which shows considerably less developed forms of letters; so that we may choose the lower limit of 490–480 for our date of the Louvre relief and even go some few years below it" (M. N. Tod).
	Bronze statuette of a diskobolos in New York (figs. 35, 36)	
479–478	The Demareteion of Syracuse (fig. 169)	Struck in commemoration of the victory of Gelon of Syracuse over Carthage at Himera (480).
ca. 470–450	Bronze statuette of a horse in Olympia (fig. 371) Three-sided reliefs in Rome and Boston (figs. 513–18, 191–93, 197, 304)	Cf. Kunze, in III. *Olympia Bericht* (1941), pp. 133 ff.

Period	*Monument*	*External Evidence*
	Bronze statue of Poseidon from Cape Artemision (figs. 106, 107) Terracotta group of Zeus and Ganymede in Olympia (fig. 110)	
477–476	*Group of Tyrannicides by Kritios and Nesiotes (figs. 602–04, 606–15)	Erected in the archonship of Adeimantos (477–476).
476–461	Coin of Aetna (Katane) (fig. 10)	Dated by the history of the city of Aetna (Head, *Historia Numorum*², [1911], p. 131).
ca. 475–460	Metopes of temple E at Selinus (figs. 440–443, 195)	
ca. 470	Charioteer of Delphi (figs. 171, 299)	The inscription on the base seems to indicate that the group was dedicated by Polyzalos of Syracuse (ca. 478–474) in celebration of a victory.
ca. 465–457	Pediments and metopes of the temple of Zeus at Olympia (figs. 2, 71, 122, 123, 140, 141, 172, 196, 199, 210, 336, 360, 380, 417–20, 444)	According to Pausanias (v. 10. 2), the Eleans built the temple out of the booty obtained in the conquest of Pisa and her vassal states (probably ca. 470). Pausanias (v. 10. 4) also records that the Lacedaemonians placed a golden shield on the apex of the eastern pediment of the temple after the battle of Tanagra in 457. The temple must then have been practically complete.
ca. 460–450	"Mourning Athena" in the Akropolis Museum (fig. 216) Stele of a girl with casket in Berlin (fig. 463) *"Omphalos Apollo" (figs. 40, 41) *Herculaneum dancers (cf. figs. 274, 536)	Cf. Richter, *Kouroi*³, no. 197.
ca. 450	Frieze of the temple of the Ilissos (figs. 93, 454) *Diskobolos by Myron (figs. 616 ff.) *Group of Athena and Marsyas by Myron (figs. 198, 621–31)	
ca. 450–440	*Doryphoros by Polykleitos (figs. 690–94) Stele of girl with pigeons in New York (figs. 215, 462) Metopes of the Hephaisteion (fig. 448) Niobids in Rome and Copenhagen (figs. 4, 97, 125, 206)	The temple was begun ca. 449 B.C. (Dinsmoor, *Hesperia*, Supplement v, p. 153).

Period	Monument	External Evidence
	"Athena Lemnia" attributed to Pheidias (fig. 654–56)	
ca. 447–443	Metopes of the Parthenon (figs. 138, 200, 445, 447)	The building of the Parthenon was begun in 447 in the archonship of Timarchides.
442–438	Frieze of the Parthenon (figs. 262, 305, 381, 525, 527, 528)	The frieze must have been complete by 438, for, after that, work was confined to the pediment sculptures.
ca. 440	*Amazons by Pheidias, Polykleitos, Kresilas, Phradmon, and Kydon	
ca. 440–430	*Perikles by Kresilas (figs. 667, 668)	After the death of Kimon (449) Perikles was the leading citizen in Athens until his death in 429.
ca. 447–439	*The chryselephantine statue of Athena Parthenos by Pheidias (figs. 633, 636–45)	According to the building inscription of the temple gold and ivory were sold in 439–438 and 437–436 in large quantities, apparently the surplus material remaining after the completion of the statue. Eusebios, *Chron.*, dates the statue in the 85th Olympiad (440–436). It must, of course, have been a number of years in the making.
	*Reliefs found in the sea off Peiraieus, copied from the figures on the shield of the Athena Parthenos (Schrader, in *Corolla L. Curtius*, pp. 81 ff.)	
438–432	Pediments of the Parthenon (figs. 74–76, 96, 126, 306, 374, 421–23, 539, 666)	According to the building inscription the marble for the pediments was brought to the workshops in 439–438 and the work begun the following year. For 434–433 there is an entry of the yearly wage given to the sculptors (Dinsmoor, in *A.J.A.*, xxv [1921], pp. 243, 244).
ca. 440–430	Eleusinian relief (fig. 520)	
ca. 435–430	*The chryselephantine statue of Zeus at Olympia by Pheidias (figs. 647, 649) *Diadoumenos by Polykleitos (figs. 695–97)	See pp. 171 ff.
ca. 427–424	Frieze of the temple of Athena Nike (figs. 311, 313)	The temple of Athena was planned before the adjoining Propylaia but was built subsequently ca. 427–424 (Dinsmoor, in *A.J.A.*, xxv [1921], pp. 185 f.).
ca. 425–420	Nike by Paionios (figs. 682, 684–87)	The inscription on the base records that it was dedicated by the Messenians and Naupaktians to Zeus with a tithe of the

Period	Monument	External Evidence
		spoils taken from their enemies. The campaign referred to is probably that of Sphakteria, 425 (see pp. 186 f.).
ca. 420	Frieze and metopes of the temple of Apollo Epikourios at Phigaleia (figs. 111, 207–09, 211–14, 314–17)	Pausanias VIII. 41. 5 records that the temple was built by Iktinos, the architect of the Parthenon, and dedicated to Apollo "the Succorer" "for the help he gave in time of plague . . . at the time of the war between the Peloponnesians and Athenians." The most probable time, at least of its completion, is during the Peace of Nikias, which began in 421 (see p. 106).
	Statue of Nemesis at Rhamnous by Agorakritos (figs. 678, 679) and reliefs from the base (cf. figs. 680, 774)	The temple at Rhamnous belongs architecturally to ca. 436, but the reliefs may be later, ca. 421 B.C. (Dinsmoor, *Architecture*, 1950, pp. 182 f.).
	Sculptures of the Argive Heraion (cf. fig. 174) including *the statue of Hera by Polykleitos represented on Roman coins of Argos (fig. 699)	The old temple was burned in 423 and the new building started forthwith (Thucydides IV. 133; Pausanias II. 17. 3).
	"Record" relief from Eleusis (*Ath. Mitt.*, XIX, 1894, pl. 7)	Dated by the inscription 420.
ca. 421–413	The karyatids of the Erechtheion (fig. 541)	The Erechtheion was probably begun in ca. 421 (Peace of Nikias); subsequently work was stopped and not resumed till 409. The karyatids must belong to the earlier period, for in the report made by a commission in 409 on the state of the building "the ceiling blocks over the maidens" are mentioned.
ca. 413–400	Dekadrachms of Syracuse with female head and quadriga signed by Kimon and Euainetos (Head, *Historia Numorum*[2], p. 176; Gallatin, *Syracusan Dekadrachms*).	Issued after the Athenian defeat of 413.
ca. 420–410	Reliefs from the Gjölbaschi monument (cf. figs. 343, 455, 456, 555)	
ca. 412–410	Head of Apollo on tetradrachms of Chalcidic League	Cf. D. M. Robinson and Clement, *Olynthus*, IX, p. 21, no. 18, pl. IV.
ca. 410	Reliefs from the "balustrade" of the temple of Athena Nike (figs. 543, 545)	Built probably during the temporary successes of Athens in the last stages of the Peloponnesian War, 411–407.
410–409	"Record" relief in the Louvre (fig. 323)	Dated by the inscription in the archonship of Glaukippos.

Period	Monument	External Evidence
412–397	Portraits of the satraps Pharnabazus, and Tissaphernes on coins (Regling, *Die antike Münze als Kunstwerk*, pl. xix, 424, 425)	Cf. E. S. G. Robinson, in *Num. Chron.* (1948), pp. 48 ff., and *British Mus. Quarterly*, 15 (1952), 50 f.; Schwabacher, "Satrapenbildnisse," in *Charites*, pp. 27 ff.
409–406	Frieze of the Erechtheion (figs. 312, 775)	The building inscription of the Erechtheion dated 408–407 records payments made to sculptors for carving figures of the frieze.
ca. 400	The Nereid monument (figs. 318–20, 506, 529, 531)	
ca. 400	The Hegeso relief (fig. 466)	The earliest gravestones of this part of the Kerameikos are about contemporary with the stele of Dexileos (Brückner, *Der Friedhof am Eridanos*, pp. 24, 194); the Hegeso grave, however, may of course have existed before the building of the family monument and later been included in it.
	"Record" relief in Athens (Svoronos, *Das Athener Nationalmuseum*, pl. cciii)	Dated by the inscription 400–399.
ca. 394	Stele of Dexileos (fig. 225)	The inscription records that he fell in the battle of Corinth, 394.
ca. 400–375	Sculptures of the temple of Asklepios at Epidauros (figs. 757–66)	The building inscription of the temple is dated in the first quarter of the fourth century.
ca. 383–379	Head of Apollo on tetradrachms of Chalcidic League	Cf. D. M. Robinson and Clement, *Olynthus*, ix, p. 53, no. 77, pl. xi.
375–374	Relief of the treaty between Athens and Kerkyra (Dumont, *B.C.H.*, ii [1878], pl. 12)	Dated by the inscription in the archonship of Hippodamas.
ca. 375–370	*Eirene and Ploutos by Kephisodotos (figs. 537, 704–08)	Erected probably soon after Timotheos' victory over the Spartans in 375 (see p. 197).
ca. 370–350	Pediments of the temple of Athena Alea at Tegea (figs. 737–40, 743)	Pausanias viii. 45. 4 relates that "a previous building was . . . destroyed in the . . . second year of the 96th Olympiad" (395). How much later the present temple was erected is a moot question; see p. 208.
	*"Dresden Satyr," perhaps an early work of Praxiteles (figs. 729–31)	
ca. 367–353	Coins issued by Maussollos with seated Zeus and head of Apollo facing	Cf. Head, *Historia Numorum*², p. 629.
355–354	"Record relief" in Palermo (Diepolder, *Attische Grabreliefs*, fig. 10)	Dated by the inscription.

Period	Monument	External Evidence
ca. 355–352	Head of Apollo on tetradrachms of Chalcidic League	Cf. D. M. Robinson and Clement, *Olynthus*, IX, p. 81, no. 133, pl. XVII.
ca. 355–330	Sculptures of the temple of Artemis at Ephesos (figs. 345, 750, 751)	The temple was built immediately after the fire which burned down the earlier structure in 356, but had not yet been completed in 334; see p. 210.
ca. 350	Sarcophagus of "Mourning Women" from Sidon (fig. 332)	
	Demeter of Knidos (fig. 331)	
	The Mantineia base (figs. 726–28)	See p. 204.
	*Aphrodite of Knidos by Praxiteles (figs. 715–19)	
	Hermes and the infant Dionysos by Praxiteles (figs. 178, 711–14)	
	Stele of Korallion (Conze, *Attische Grabreliefs*, no. 411, pl. 98)	Dated from the history of the graves in the Kerameikos and the history of Herakleia on the Pontos (Brückner, *Der Friedhof am Eridanos*, pp. 64 ff., 68 ff.).
	The sculptures of the Mausoleum (figs. 219, 240, 330, 744–49, 767–69, 776, 777, 783)	See Pliny, *N.H.* XXXVI. 30, and my pp. 209 f.
ca. 350–325	*The Sauroktonos by Praxiteles (figs. 620, 622, 623)	
	"Marathon Boy" (figs. 49–51, 180, 181)	
347–346	"Record" relief honoring three princes of the Bosphorus (Diepolder, op. cit., fig. 11)	Dated by the inscription.
346	Staters of Delphi with head of Demeter and seated Apollo (Head and Hill, *Guide to the Principal Coins of the Greeks in the British Museum*, pl. 23, no. 30)	Probably issued on the occasion of the reassembling of the Amphictyonic Council at the close of the Phocian War (346 B.C.).
ca. 344–334	Agias (figs. 790, 792, 793)	Dedicated by Daochos II, tetrarch of the Thessalians, ca. 344–334.
340–330	*Sophokles in the Lateran (fig. 264)	Probably a copy of the bronze statue of Sophokles set up in the theatre in Athens on the motion of Lykourgos between 340 and 330.
	*Portrait of Euripides (fig. 241)	Probably erected at the same time as the statue of Sophokles. Cf. my *Portraits of the Greeks*, I, p. 139.
336–323	Coins of Alexander the Great (cf. fig. 799)	Alexander reigned 336–323.

Period	Monument	External Evidence
335–334	Choregic monument of Lysikrates (fig. 530)	The inscription on the architrave records that it was erected for a victory by Lysikrates in the archonship of Euainetos (335–334).
ca. 340–320	Dog in the Kerameikos (Collignon, *Statues funéraires*, p. 240, fig. 158)	In the same family plot as that crowned by the dog was the grave of Lysimmachides of Acharnai, perhaps the archon of 339–338 (Brückner, op. cit., p. 84).
ca. 330–315	The late Attic gravestones (Diepolder, *Attische Grabreliefs*, pls. 46–54)	The antiluxury decree of Demetrios of Phaleron (ca. 317–315) put an end to sculptured gravestones in Attica for a considerable time.
ca. 329	Votive relief with Artemis and Asklepios (*Ny Carlsberg Glyptotek, Billedtavler*, no. 231)	Dated by the inscription.
ca. 325–300	"Alexander sarcophagus" from Sidon (figs. 184, 428, 429, 800) *Apoxyomenos of Lysippos (figs. 791, 794, 795)	Dated in the last quarter of the fourth century from its resemblance to portraits of Demetrios Polyorketes on coins.
321–317	"Record" relief in Athens (Speier, in *Röm. Mitt.*, 47 [1932], pl. 29, no. 1)	Dated by the inscription in the archonships of Kephisodoros (323–322) and Archippos (318–317).
304–285	Portrait of Ptolemy I, king of Egypt, on coins. (Head and Hill, op. cit., pl. 28, no. 20	Ptolemy I, Soter, reigned 304–285 B.C. On his sculptured portraits cf. my *Portraits of the Greeks*, III, p. 260.
306–280	Portrait of Seleukos I, king of Syria (fig. 253), on coins	Head and Hill, op. cit., pp. 49 f.
ca. 200–180	Nike of Samothrake (fig. 100)	The statue used to be dated ca. 300 B.C. on account of its resemblance to the Nike on coins issued by Demetrios Poliorketes in commemoration of his victory over Ptolemy at Salamis, Cyprus, in 306 (cf. Newell, *The Coinages of Demetrius Poliorcetes*, pp. 32, 33). Later it was thought more probable that the statue commemorated the victory of the battle of Cos (ca. 258). Recently a date in the early second century was suggested (Thiersch, *Göttinger Nachrichten*; 1931, p. 368; Charbonneaux, *Hesperia*, XXI, 1952, pp. 44 ff.).
After 300	*Tyche of Antioch by Eutychides (figs. 811–13)	Antioch was founded in 300.
295–294	"Record" relief in Athens (Süsserott, *Griechische Plastik*, pl. 44, no. 1)	Dated by the inscription.
280–279	*Demosthenes by Polyeuktos (fig. 815)	Demosthenes died 322. The statue was dedicated about forty years after his death

Period	Monument	External Evidence
		in 280–279, in the archonship of Gorgias (cf. p. 233).
	Bronze portrait statuette in New York (figs. 245, 246, 258)	Resembles portraits of Epikouros who died 280.
ca. 300–250	Themis of Chairestratos (fig. 348)	The dedicatory inscription on the base is dated in the first half of the third century.
ca. 200–100	Aphrodite of Melos (fig. 574)	The base with an inscribed signature dated ca. 100 B.C. (now lost), does not certainly belong to the statue (cf. Loewy, *Inschriften*, no. 298).
ca. 240–200	*The Dying Gaul and the Gaul and his wife (figs. 114, 186)	Probably copies from a bronze group dedicated by Attalos I of Pergamon (241–197) to celebrate his victories over the Gauls.
ca. 200	*Chrysippos, perhaps by Euboulides I (cf. figs. 247, 826)	Lived ca. 280–206.
	*Statues, two-thirds life-size, of Gauls, Amazons, Persians, giants (cf. fig. 127)	The bronze originals were probably set up by Attalos I of Pergamon on the Akropolis in Athens on the occasion of his visit there in 200.
	Sleeping satyr in Munich (fig. 228)	
ca. 190–160	Portrait of Eukratides, king of Baktria and India (fig. 251)	Dates of reign, ca. 190–160.
ca. 197–159	Altar of Zeus and Athena at Pergamon (cf. figs. 185, 351, 352, 836, 837, 841, 843)	Built probably by Eumenes II, who reigned 197–159 (cf. Kähler, *Der grosse Fries von Pergamon*, p. 195, n. 114).
ca. 200–150	Sculptures of the Temple of Despoina at Lykosoura by Damophon (figs. 816–19)	Inscriptions with the name of Damophon found in the temple are datable in the first half of the second century (Dickins, *B.S.A.*, 12, 1905–1906, pp. 130–36).
ca. 150–125	Bronze portrait head from Delos (fig. 257)	Delos never recovered after the sack of 88 and the pirates' raid of 69 B.C.
ca. 170–150	Laokoon by Hagesandros, Polydoros, and Athanodoros of Rhodes (figs. 831, 834)	The group resembles the sculptures of the Pergamon altar ca. 197–159 B.C.
	Some heads and torsos found at Sperlonga (figs. 832, 833, 835, 838–40)	With them has been associated an inscription with signatures of the same three sculptors who made the Laokoon (cf. pp. 237 f.). Stylistically they resemble the Laokoon and the Pergamon altar.
	The Polyphemos found in a grotto at Castelgandolfo (fig. 842)	Stylistically related to the Sperlonga sculptures. Cf. Magi, *Rendiconti dell Acc. Pont. Rom.*, XLI, 1968–69, pp. 69 ff.
	*Belvedere Torso (fig. 835), signed by Apollōnios of Athens, evidently as copyist (see p. 247)	The style is that of the Pergamene altar, but the inscription is datable in the first century B.C.

Period	*Monument*	*External Evidence*
	*Two centaurs signed by Aristeas and Papias of Aphrodisias (figs. 844, 845)	
	*The Hanging Marsyas (fig. 846)	
	*Borghese Warrior (fig. 113), signed by Agasias of Ephesos	
	*"Hellenistic Prince" (fig. 62)	
	*Farnese Bull by Apollonios and Tauriskos of Tralles (fig. 849)	
	Portraits of Homer and Pseudo-Seneca (figs. 255, 256)	Cf. my *Portraits of the Greeks, 1,* pp. 50 ff., 58 ff.
ca. 130	Head of Athena and other fragments, perhaps by Euboulides II (fig. 825)	Found in Athens in a locality mentioned by Pausanias (I. 215) not far from an inscription, with the signature of Euboulides, datable around 130 B.C.
	Statue of Gaios Ophellios from Delos signed by Dionysios and Timarchides (fig. 829)	
ca. 65–35	*Statues signed by Stephanos, pupil of Pasiteles, and Menelaos, pupil of Stephanos (figs. 851, 853)	Pasiteles was a contemporary of Pompey. 106–48 B.C.

SELECTED BIBLIOGRAPHY

See also the references cited in the footnotes of the text and the bibliography on technique on p. 114, note 1.

Adam, S., *The Technique of Greek Sculpture*, 1966.

Adriani, A., *Sculture monumentali del Museo Greco-Romano di Alessandria*, 1946.

———, *Testimonianze e momenti di scultura alessandrina*, 1948.

———, "Hellenistic Art," in *Encyclopedia of World Art*, VII (1963), cols. 311–46.

———, *Repertorio d'arte dell'Egitto greco-romano*, 1–3, 1961–69.

Alscher, L., *Griechische Plastik*, 1–4, 1954–61.

Amelung, W., *Führer durch die Antiken in Florenz*, 1897.

———, *Die Sculpturen des vaticanischen Museums*, 1903–08 (later continued by G. Lippold).

Anderson, J. K., *Ancient Greek Horsemanship*, 1961.

Arias, P., *Mirone*, 1940.

———, *Skopas*, 1952.

Arndt, P., *La Glyptothèque Ny Carlsberg*, 1912.

Arndt, P., W. Amelung, and G. Lippold, *Photographische Einzelaufnahmen antiker Sculpturen*, 1893–1941.

Ashmole, B., *A Catalogue of the Ancient Marbles at Ince Blundell Hall*, 1929.

———, "Archaic Art," in *Encyclopedia of World Art*, 1 (1959), cols. 578–623.

———, *Late Archaic and Early Classical Greek Sculpture in Sicily and South Italy*, 1934.

Ashmole, B., and N. Yalouris, *Olympia, The Sculptures of the Temple of Zeus*, 1967.

Aurigemma, S., *Le Terme di Diocleziano e il Museo Nazionale Romano*, 1946.

Bacon, F. H., et al., *Investigations at Assos*, 1902–21.

Bakalakis, G., *Ellenika Amphiglypha*, 1946.

Beazley, J. D., *The Lewes House Collection of Ancient Gems*, 1920.

Beazley, J. D., and B. Ashmole, *Greek Sculpture and Painting to the End of the Hellenistic Period*, 1932; new ed. 1966.

Becatti, G., *Attikà, Saggio sulla scultura attica dell'Ellenismo*, 1940.

———, *Problemi fidiaci*, 1951.

———, *Arte e gusto negli scrittori latini*, 1951.

———, Le grandi epoche dell'arte, in *L'età classica*, 1965.

Benndorf, F. A. O., *Die Metopen von Selinunt*, 1873.

———, *Das Heroön von Gjölbaschi-Trysa*, 1891, 1893, 1895.

Bernoulli, J. J., *Aphrodite*, 1873.

———, *Griechische Ikonographie mit Ausschluss Alexanders und der Diadochen*, 1901.

Bianchi Bandinelli, R., *Policleto*, 1938.

———, *Storicità dell'arte classica*, 2d ed. 1950.

———, Greca arte, in *Enciclopedia dell'arte antica*, III (1960), pp. 1005–55.

Bieber, M., *Die antiken Skulpturen und Bronzen des kgl. Museum Fridericianum in Cassel*, 1915.

———, *Die Denkmäler zum Theaterwesen im Altertum*, 1920.

———, *Griechische Kleidung*, 1928.

———, *Entwicklungsgeschichte der griechischen Tracht*, 1934; 2d ed. (with T. Eckstein) 1967.

———, *The History of the Greek and Roman Theatre*, 1939.

———, "The Portraits of Alexander the Great," in *Proceedings of the American Philosophical Society*, 93 (1949), 373 ff.

———, *The Sculpture of the Hellenistic Age*, 1954; 2d ed. 1960.

Bieber, M., *Alexander the Great in Greek and Roman Art*, 1964.

———, *Laocoon*, 2d ed. 1967.

Bielefeld, E., *Amazonomachia*, 1951.

Biesantz, H., *Die thesalischen Grabreliefs*, 1965.

Binnebössel, R. D., *Studien zu den attischen Urkundenreliefs*, 1932.

Blanco, A., *Museo del Prado, Catalogo de la Escultura*, 1957.

Blinkenberg, C. S., *Knidia*, 1933.

Bloesch, H., *Antike Kunst in der Schweiz*, 1943.

Blümel, C., *Katalog der Sammlung antiker Skulptur, 2*, pt. *1, 3, 4, 5*, Staatliche Museen, Berlin, 1928–40.

———, *Griechische Bildhauerarbeit*, 1927.

———, *Tierplastik, Bildwerke aus fünf Jahrtausenden*, 1939.

———, *Griechische Bildhauer an der Arbeit*, 1940, 4th ed. 1953; Eng. ed., *Greek Sculptors at Work*, 1955.

———, *Die archaisch griechischen Skulpturen*, Staatliche Museen, Berlin, 1963.

———, *Die klassisch griechischen Skulpturen*, Staatliche Museen, Berlin, 1966.

Blümner, H., *Technologie und Terminologie der Gewerbe und Künste bei Griechen und Römern*, vol. III, 1884.

Boardman, J., *Greek Art*, 1964.

Boardman, J. Dörig, W. Fuchs, and M. Hirmer, *The Art and Architecture of Ancient Greece* [1967].

Bocconi, S., *The Capitoline Collections*, 1948.

Boehringer, R., *Platon, Bildnisse und Nachweise*, 1935.

Bonacasa, N., *Ritratti greci e romani della Sicilia*, 1964.

Borda, M., *La Scuola di Pasitele*, 1953.

Bothmer, D. von, *Amazons in Greek Art*, 1957.

Brommer, F., *Die Giebel des Parthenon*, 1959.

———, *Die Skulpturen der Parthenongiebel*, 1963.

———, *Die Metopen des Parthenon*, 1967.

———, *Die Wahl des Augenblicks in der griechischen Kunst*, 1969.

Brunn, H., *Geschichte der griechischen Künstler*, 1853–59; 2d ed. 1889.

Brunn, H., and P. Arndt, *Griechische und römische Porträts*, from 1891.

Brunn, H., F. Bruckmann, P. Arndt, and G. Lippold, *Denkmäler griechischer und römischer Sculptur*, 1888–1950.

Budde, L., and R. Nicholls, *Catalogue of the Greek and Roman Sculptures*, Fitzwilliam Museum, 1964.

Buffalo, Albright Art Gallery, an exhibition of *Master Bronzes*, by various authors, 1937.

Bulle, H., *Geschichte der griechischen Künstler*, 1889.

———, *Der schöne Mensch, 1, Im Altertum*, 3d ed. 1922.

Burlington Fine Arts Club, *Exhibition of Ancient Greek Art*, 1904.

Buschor, E., *Altsamische Standbilder*, I–V, 1934–61.

———, *Die Plastik der Griechen*, 1936.

———, *Bildnisstufen*, 1947.

———, *Pferde des Pheidias*, 1948.

———, *Phidias der Mensch*, 1948.

———, *Das Hellenistische Bildnis*, 1949.

———, *Frühgriechische Jünglinge*, 1950.

Buschor, E., and R. Hamann, *Die Skulpturen des Zeustempels zu Olympia*, 1924.

Buttlar, H. von, *Griechische Köpfe*, 1948.

Calza, R., *Museo Ostiense*, 1947; new ed. (with M. Squarciapino) 1962.

Caputo, G., *Lo scultore del grande bassorilievo con la danza delle Menadi in Tolemaide di Cirenaica*, 1948.

Carpenter, R., *The Sculptures of the Nike Temple Parapet*, 1929.

———, "Lost Statues of the East Pediment of the Parthenon," in *Hesperia, 2* (1933), 1 ff.

———, *Greek Sculpture*, 1960.

Caskey, L. D., *Catalogue of Greek and Roman Sculpture in the Museum of Fine Arts* (Boston), 1925.

Casson, S., *Catalogue of the Acropolis Museum*, II, 1921.

———, *The Technique of Early Greek Sculpture*, 1933.

Chamoux, F., *La civilisation grecque*, 1963; German ed. 1966.

———, *Art Grec*, 1966.

Charbonneaux, J., *La sculpture grecque au Musée du Louvre*, n.d.

———, *La sculpture grecque archaïque*, 1938.

———, *La sculpture grecque classique*, 1944–45.

———, *Les bronzes grecques*, 1958.

———, *La sculpture grecque et romaine au Musée du Louvre*, 1963.

———, *Grèce archaïque*, 1968.

———, with R. Martin and F. Villard, *Grèce classique*, 1969.

Chase, G. H., *Greek and Roman Sculpture in American Collections*, 1924.

———, *Greek and Roman Antiquities, A Guide to the Classical Collection*, Museum of Fine Arts, Boston, 1950; new ed. (by C. Vermule) 1963.

Collignon, M., *Histoire de la sculpture grecque*, 1892–97.

———, *Les statues funéraires dans l'art grec*, 1911.

Conze, A. C. L., *Die attischen Grabreliefs*, 1893–1922.

Cook, R. M., "Greek Art, Eastern," in *Encyclopedia of World Art*, VII (1963), cols. 56–86.

Corbett, P. E., *The Sculptures of the Parthenon*, 1959.

Curtius, L., *Die klassische Kunst Griechenlands*, 1938.

Dawkins, R. M., et al., *The Sanctuary of Arthemis Orthia at Sparta*, 1929.

De La Coste-Messelière, P., *Au Musée de Delphes*, 1936.

———, *Delphes*, 1957.

Della Seta, A., *Il nudo nell'arte*, 1930.

Deonna, W., *Les "Apollons archaïques,"* 1909.

———, *Les statues de terre cuite dans l'antiquité*, 1908.

———, *Dédale*, 1930–31.

———, *Du miracle grec au miracle chrétien*, 1945.

De Ridder, A., and W. Déonna, *L'art en Grèce*, 1924.

Devambez, P., *Grands bronzes du Musée de Stamboul*, 1937.

———, *L'art au siècle de Periclès*, 1955.

Dickins, G., *Catalogue of the Acropolis Museum*, I, 1912.

———, *Hellenistic Sculpture*, 1920.

Diepolder, H., *Die attischen Grabreliefs des fünften und vierten Jahrhunderts v. Chr.*, 1931.

Dinsmoor, W. B., *The Architecture of Ancient Greece, An account of its Historical Development*, 1950. A new edition is in preparation.

Dohrn, T., *Attische Plastik*, 1957.

———, *Die Tyche von Antiochia*, 1960.

———, "Die Marmorstandbilder des Daochos Weihgeschenks in Delphi," in *Antike Plastik*, VIII (1968), 33 ff.

Dontas, G. S., *Eikones kathymenon*, 1960.

Dugas, C., et al., *Le sanctuaire d'Aléa Athéna à Tégée au IV siècle*, 1924.

Dunbabin, T. J., *The Western Greeks. The History of Sicily and South Italy from the Foundation of the Greek Colonies to 480 B.C.*, 1948.

Dyggve, E., *Das Laphrion. Der Tempelbezirk von Kalydon*, 1948.

Dyggve, E., F. Poulsen, and K. Rhomaios, *Das Heröon von Kalydon*, 1934.

Edgar, C. C., *Catalogue du Musée de Caire, 13*, Greek Sculpture, 1903.

Ferri, S., *Plinio il Vecchio, Storia delle arti antiche*, 1946.

Filow, B. D., *Die archaische Nekropole von Trebenischte am Ochrida-See*, 1927.

————, *Die Grabhügelnekropole bei Duvanlij in Südbulgarien*, 1934.

Franke, P. R., and M. Hirmer, *Die Griechische Münze*, 1964.

Frazer, J., *Pausanias's Description of Greece*, I–VI, 1913.

Friedländer, P., *Epigrammata. Greek Inscriptions in verse from the beginnings of the Persian Wars*, 1948.

Fröber, J., *Die Komposition der archaischen und frühklassischen Metopenbilder*, 1933.

Fuchs, W., *Die Vorbilder der neuattisches Reliefs*, 1959.

————, *Der Schiffsfund von Mahdia*, 1963.

————, *Griechische Skulptur*, 1968.

————, *Die Skulptur der Griechen*, 1969.

Furtwängler, A., *Olympia, 4, Die Bronzen*, 1890.

————, *Masterpieces of Greek Sculpture*, ed. by E. Sellers, 1895.

————, *Über Statuenkopien im Altertum*, 1896.

————, *Die antiken Gemmen*, 1900.

————, *Beschreibung der Glyptothek*, 2d ed. 1910.

Furtwängler, A., et al., *Aegina*, 1906.

Garcia y Bellido, A., *Los hallazgos griegos de Espana*, 1936.

Giglioli, G. Q., *L'arte greca*, 2 vols. 1955.

Grace, F. R., *Archaic Sculpture in Boeotia*, 1939.

Greifenhagen, A., et al., *Führer durch die Antiken-Sammlung*, Berlin, 1968.

Grinnell, I. H., *Greek Temples*, 1943.

Guarducci, M., *Epigrafia Greca*, I (1967), II (1969), III (in preparation).

————, Appendix with epigraphical notes in Richter, *The Archaic Gravestones of Attica*, 1961.

Hafner, G., *Geschichte der griechischen Kunst*, 1961.

Hampe, R., and U. Jantzen, *I. Bericht über die Ausgrabungen in Olympia*, 1937.

Hanfmann, G. M. A., *Classical Sculpture*, 1967.

Hauser, F., *Die neuattischen Reliefs*, 1889.

Hausmann, U., *Griechische Weihreliefs*, 1960.

Haynes, D. E. L., *A Historical Guide to the Sculptures of the Parthenon*, 1967.

Head, B. V., *Historia numorum*, 2d ed. 1911; 3d ed., by E. S. G. Robinson et al., in preparation.

Heberdey, R., *Altattische Porosskulptur*, 1919.

Hekler, A., *Die Bildniskunst der Griechen und Römer*, 1912.

————, *Bildnisse berühmter Griechen*, 1940; 3d ed. by H. von Heintze, 1962.

Helbig, K. F. W., *Führer durch die öffentlichen Sammlungen klassischer Altertümer in Rom*, I–II. 3d revised edition by W. Amelung, 1912–13; 4th completely revised edition, by H. Speier, with collaborators, I (1963); II (1966); III (1969); IV (in preparation).

Higgins, R. A., *Greek Terracottas*, 1967.

Hildebrand, A., *Das Problem der Form*, 1918; 10th ed. 1961.

Hill, D. K., *Catalogue of Classical Bronze Sculpture in the Walters Art Gallery*, 1949.

Hill, G. F., *Select Greek Coins*, 1927.

Homann-Wedeking, E., *Die Anfänge der griechischen Grossplastik*, 1950.

Homolle, T., ed., *Fouilles de Delphes, 4, Monuments figurés*, continued by C. Picard and P. de La Coste-Messelière, 1909–31.

Horn, R., *Stehende weibliche Gewandstatuen in der hellenistischen Plastik*, 1931.

Imhoof-Blumer, F., and P. Gardner, *Numismatic Commentary on Pausanias*, 1885–87.

Jacobsthal, P., *Die melischen Reliefs*, 1931.

Jantzen, U., *Bronzewerkstätten in Grossgriechenland und Sizilien*, 1938.

Jeffery, L. H., *The Local Scripts of Archaic Greece*, 1961.

Jenkins, R. J. H., *Dedalica*, 1936.

Jex-Blake, K., and E. Sellers, *Pliny the Elder, Chapters on the History of Art*, 1896.

Johannowsky, W., Atene, in *Enciclopedia dell'Arte antica, 1* (1958), 767–863.

Johansen, K. Friis, *The Attic Grave-Reliefs of the Classical Period*, 1961.

Johnson, F. R., *Lysippos*, 1927.

Jones, H. Stuart, *Select Passages from Ancient Writers illustrative of the History of Greek Sculpture*, 1895.

Jones, H. Stuart, ed., *A Catalogue of the Sculptures of the Museo Capitolino*, 1912.

————, *A Catalogue of the Sculptures of the Palazzo dei Conservatori*, 1926.

Kähler, H., *Das Griechische Metopenbild*, 1949.

————, *Der grosse Fries von Pergamon*, 1948.

————, *Pergamon*, 1949.

Karageorghis, V., *Sculptures from Salamis*, I (1964) ; II (1966).

Karo, G., *An Attic Cemetery*, 1943.

————, *Greek Personality in Archaic Sculpture*, 1948.

Karouzos, C., *To Mouseio tes Thebas*, 1936.

————, *Aristodikos*, 1961.

Karouzou, S., *Catalogue of the Collection of Sculpture*, National Archaeological Museum, Athens, 1968 (English tr. by H. Wace). See also under Papaspiridi.

Kaschnitz Weinberg, G., *Sculture del Magazzino del Museo Vaticano*, 1936.

Kastriotes, P., *Glypta tou Ethnikou Mouseiou*, 1908.

Katterfeld, E., *Die griechischen Metopenbilder, Archäeologische Untersuchungen*, 1911.

Kekulé von Stradonitz, R., ed., *Die antiken Terra-kotten*, 1880–1903.

————, *Die griechische Skulptur*, 3d ed. 1922.

Keller, O., *Die antike Tierwelt*, 2 vols. 1909.

Kenner, H., *Der Fries des Tempels von Bassae-Phigalia*, 1946.

Kjellberg, E., *Studien zu den attischen Reliefs del V. Jahrhunderts v. Chr.*, 1926.

Kleiner, G., *Tanagrafiguren*, 1942.

Kluge, K., and K. Lehmann-Hartleben, *Die antiken Grossbronzen*, 1927.

Klumbach, H., *Tarentiner Grabkunst*, 1937.

Krahmer, G., Stilphasen der hellenistischen Plastik, in *Röm. Mitt.*, XXXVIII–XXXIX (1923–24), pp. 138 ff.

Kunze, E., *Kretische Bronzereliefs*, 1931.

————, *Neue Meisterwerke griechischer Kunst aus Olympia*, 1948.

————, in *I.–VIII. Berichte über die Ausgrabungen in Olympia*, 1937–1967, passim.

————, *Archaische Schildbänder*, in *Olympische Forschungen* II (1950).

La Coste-Messelière, P. de, *Au Musée de Delphes*, 1936.

————, *Delphes*, 1957.

Lacroix, L., *Les Reproductions de statues sur les monnaies grecques*, 1949.

Lamb, W., *Greek and Roman Bronzes*, 1929.

Lange, L., *Die Darstellung des Menschen in der älteren griechischen Kunst*, 1899.

Langlotz, E., *Zur Zeitbestimmung der strengrotfigurigen Vasenmalerei und der gleichzeitigen Plastik*, 1920.

————, *Frühgriechische Bildhauerschulen*, 1927.

————, *Phidiasprobleme*, 1947.

————, *Die Kunst der Westgriechen*, 1963.

Langlotz, E., and W. H. Schuchhardt, *Archaische Plastik auf der Akropolis*, 1941 (see also under Schrader).

Lapalus, E., *Le fronton sculpté en Grèce des origines à la fin du IVe siècle*, 1947.

Laurenzi, L., *Ritratti greci*, 1941.

Lawrence, A. W., *Later Greek Sculpture*, 1927.

————, *Classical Sculpture*, 1929.

Lawrence, A. W., *Greek Architecture*, 1957.

Lehmann, P. W., *Statues on Coins of Southern Italy and Sicily*, 1946.

———, *The Pedimental Sculptures of the Hieron of Samothrace*, 1962.

Lippold, G., *Kopien und Umbildungen griechischer Statuen*, 1923.

———, "Die griechische Plastik," *Handbuch der Archäologie*, III, 1, 1950.

Loewy, E., *Inschriften griechischer Bildhauer*, 1885.

———, *La Scultura greca*, 1911.

Lullies, R., and M. Hirmer, *Griechische Plastik*, 1956; Eng. ed. 1957.

Magi, F., "Il ripristino del Laocoonte," *Mem. Pont. Acc. Rom.*, IX, I, 1960.

———, Laocoonte a Cortona, in *Rendiconti Pont. Acc. Rom.*, 1960.

———, La grotta di Castel Gandolfo, in *Rend. Pont. Acc. Rom.*, 1969.

Mansuelli, G. A., *Galleria degli Uffizi, Le Sculture*, I, 1958; II, 1961.

Marcadé, J., *Recueil des signatures de sculpteurs grecs*, 1, 1953; 2, 1957.

Markman, S. D., *The Horse in Greek Art*, 1943.

Matz, F., *Geschichte der griechischen Kunst*, 1, 1949–50.

Mendel, G., *Catalogue des sculptures aux Musées impériaux ottomans*, 1912–14.

Michaelis, A., *Ancient Marbles in Great Britain*, 1882.

Michalowski, C., "Les portraits hellénistiques et romains," *Exploration archéologique de Délos*, fasc. 13, 1932.

Mitten, D., and S. Doehringer, *Master Bronzes from the Classical World*, 1967.

Möbius, H., *Die Ornamente der griechischen Grabstelen*, 1929.

Mollard-Besques, S., *Les Terres-cuites grecques*, 1963.

Müller, V., *Frühe Plastik in Griechenland und Vorderasien*, 1929.

Mustilli, D., *Il Museo Mussolini*, 1939.

Napoli, M. *Civiltà della Magna Goecia*, 1969.

Neugebauer, K. A., *Antike Bronzestatuetten*, 1921.

Nicholls, R. See under Budde.

Orlandini, P., *Calamide*, 1950.

Overbeck, J. A., *Die antiken Schriftquellen zur Geschichte der bildenden Künste bei den Griechen*, 1868.

Papaspiridi, S., *Guide du Musée National* (Athens), 1927 (see also under S. Karouzou).

Paribeni, E., *Museo Nazionale Romano. Sculture greche del V. secolo*, 1953.

———, *Catalogo delle sculture di Cirene*, 1959.

Paton, J. M., ed., et al., *The Erechtheum*, 1927.

Payne, H. G., *Necrocorinthia*, 1931.

Payne, H. G., et al., *Perachora*, I, 1940, II, 1962.

Payne, H. G., and G. M. Young, *Archaic Marble Sculpture from the Acropolis*, 1936.

Perrot, G., and C. Chipiez, *Histoire de l'art dans l'antiquité*, 1–10, 1882–1914.

Pfuhl, E., *Die Anfänge der griechischen Bildniskunst*, 1927.

Picard, C., *Manuel d'archéologie grecque, La Sculpture*, I–V, 1935–66.

Poulsen, F., *Delphi*, 1920.

———, *Greek and Roman Portraits in English Country Houses*, trans. G. C. Richards, 1923.

———, *Den tidlig graeske Kunst*, 1940.

———, *Katalog over antike Skulpturer*, Ny Carlsberg Glyptotek, 1940 (with *Billedtavler*); English edition, 1951.

Poulsen, V. H., "Der Strenge Stil," *Acta Archaeologica, 8* (1937), 1 ff.

———, *Les portraits grecs*, 1954.

Praschniker, C., *Parthenonstudien*, 1928.

Pryce, F. N., *Catalogue of Sculpture in the British Museum*, 1, pt. 1, *Prehellenic and Early Greek*, 1928.

Raubitschek, A., *Dedications from the Athenian Acropolis. A Catalogue of the inscriptions of the Sixth and Fifth Centuries B.C.*, ed. with the collaboration of L. H. Jeffery, 1949.

Regling, K. L., *Die antike Münze als Kunstwerk*, 1924.

Reinach, S., *Recueil de têtes antiques*, 1903.

————, *Répertoire de reliefs grecs et romains*, 1909–12.

————, *Répertoire de la statuaire grecque et romaine*, 1897–1931.

Reuterswärd, P., *Studien zur Polychromie der Plastik, Griechenland und Rom*, 1960.

Richer, P., *Le Nu dans l'art, 2, L'Art grec*, 1926.

Richter, G. M. A., *Animals in Greek Sculpture*, 1930.

————, *Archaic Attic Gravestones*, 1944.

————, *Archaic Greek Art Against its Historical Background*, 1949.

———— (with the cooperation of Irma A. Richter), *Kouroi, a Study of the development of the Greek Kouros*, 208 photographs by Gerard M. Young, 1942; 2d ed. 1960; 3d ed. 1970.

————, *Metropolitan Museum of Art, Catalogue of Greek Sculpture*, 1951.

————, *Three Critical Periods in Greek Sculpture*, 1954.

————, *Handbook of Greek Art*, 1959; 6th ed. 1969.

————, *The Archaic Gravestones of Attica*, with an appendix on the inscriptions by M. Guarducci, 1961.

————, *Korai, Archaic Greek Maidens*, with many illustrations from photographs by Alison Frantz, 1968.

————, *Engraved Gems, 1, Greek and Etruscan. A History of Greek Art in Miniature*, 1968.

Riemann, H., Pytheos, in Pauly-Wissowa, *R.E.*, XXIV, cols. 371–513.

Rizzo, G. E., *Prassitele*, 1932.

————, *Thiasos*, 1934.

————, *Monete greche della Sicilia*, 1945–46.

Robinson, D. M., ed., *Excavations at Olynthus*, from 1929.

Rodenwaldt, G., *Das Relief bei den Griechen*, 1923.

————, *Die Kunst der Antike*, 1938.

————, *Altdorische Bildwerke in Korfu*, 1938.

————, *Korkyra, Die Bildwerke des Artemistempels, 2*, 1939–40.

Rodenwaldt, G., and W. Hege, *Olympia*, 1936.

Rohde, E., *Griechische Terrakottafiguren*, 1969.

Rostovtzeff, M. I., *The Social and Economic History of the Hellenistic World*, 1941.

Ruesch, A., et al., *Guida illustrata del Museo Nazionale di Napoli*, n.d.

Rumpf, A., *Griechische und römische Kunst*, 1931.

————, *Stilphasen der spätantiken Kunst*, 1955.

Salis, A. von, *Die Kunst der Griechen*, 1919.

Schede, M., *Meisterwerke der türkischen Museen zu Konstantinopel*, 1928.

Schefold, K., *Die Bildnisse der antiken Dichter, Redner, und Denker*, 1943.

————, *Meisterwerke griechischer Kunst*, 1960.

————, *Klassisches Griechenland*, 1959.

————, *Frühgriechische Sagenbilder*, 1962.

————, et. al., "Die Griechen und ihre Nachbarn," in *Propyläen Kunstgeschichte, 1*, 1967.

Scichilone, G., Grecia, Architettura e urbanistica, in *Dizionario Enciclopedico di Architettura e Urbanistica*, III, 1969, pp. 16–39.

Schmidt, E., *Archaistische Kunst in Griechenland und Rom*, 1922.

Schober, A., *Der Fries des Hekateions von Lagina*, 1933.

————, *Die Kunst von Pergamon*, 1951.

Schuchhardt, W.-H., *Archaische Giebelkompositionen*, 1940.

————, *Die Epochen der griechischen Plastik*, 1959.

Schuchhardt, W.-H., *Griechische Kunst*, 1968.

Schrader, H., with E. Langlotz, and W.-H. Schuchhardt, *Die archaischen Marmorbildwerke der Akropolis*, 1939.

Schweitzer, B., *Zur Kunst der Antike*, 2 vols., 1963.

Seltman, C. T., *Greek Coins*, 2d ed. 1955.

Shoe, L. T., *Profiles of Greek Mouldings*, 1936.

Sieveking, J., *Die Bronzen der Sammlung Loeb*, 1913.

Sieveking, J., and C. Weickert, *Fünfzig Meisterwerke der Glyptotek*, 1928.

Sjöquist, E., *Lysippos*, 1967.

Smith, A. H., *Catalogue of Greek Sculpture in the British Museum*, i–iii, 1892–1904.

————, *Sculptures of the Parthenon*, 1910.

Speier, H., "Zweifiguren-gruppen im v. und iv. Jahrhundert," in *Röm. Mitt.*, 47 (1932), 1 ff.

————, "Frammento di una testa di cavallo," *Rendiconti della Pontificia Accademia Romana d' Archeologia*, 23–24 (1947–48, 1948–49), 59 ff. (see also under Helbig).

Springer, A. H., *Handbuch der Kunstgeschichte, 1, Die Kunst des Altertums*, 12th ed., rev. by P. Wolters, 1923.

Squarciapino, M., *La scuola di Afrodisia*, 1943.

Süsserott, H. K., *Griechische Plastik des vierten Jahrhunderts vor Christus*, 1938.

Svoronos, J. N., *Das athener Nationalmuseum*, 1908–13.

Tarn, W. W., *Hellenistic Civilisation*, 3d ed. 1952.

Tod, M. N., and A. J. B. Wace, *Catalogue of the Sparta Museum*, 1906.

Treu, G., *Olympia, III: Die Bilwerke*, 1897.

Van Buren, E. D., *Archaic Fictile Revetments in Sicily and Magna Graecia*, 1923.

Vessberg, O., *Studien zur Kunstgeschichte der römischen Republik*, 1941.

————, "Hellenistic-Roman Art," in *Encyclopedia of World Art*, 7 (1963), cols. 393–411.

Wace, A. J. B., *An Approach to Greek Sculpture*, 1935.

Waldhauer, O., *Die antiken Sculpturen der Ermitage*, 1928–36.

Walters, H. B., *Select Bronzes*, 1915.

Webster, T. B. L., *Greek Art and Literature 530–400 B.C.*, 1939; *700–530 B.C.*, 1959.

————, *Hellenistic Poetry and Art*, 1964.

Weickert, C., *Griechische Plastik*, 1946.

Wiegand, T., et al., *Die archaische Porosarchitektur der Akropolis*, 1904.

Winter, F., *Kunstgeschichte in Bildern*, n.d. (1931?).

Wuilleumier, P., *Tarente*, 1939.

Yalouris, N., *Classical Greece*, 1960 (see also Ashmole).

Zancani Montuoro, P., and U. Zanotti-Bianco, *Heraion alla Foce del Sele, 1*, 1951; ii, 1954.

Zanotti-Bianco, U., and L. von Matt, *Grossgriechenland*, 1961.

Zschietzschmann, W., *Die hellenistische und römische Kunst*, 1939.

Zürchner, W., *Griechische Klappspiegel*, 1942.

PERIODICALS AND SERIES
(cited in the text with the customary abbreviations)

Acta Archaeologica, Copenhagen, from 1930.

American Journal of Archaeology, Concord (N.H.), and elsewhere, from 1885.

Annali dell'Instituto di Corrispondenza Archeologica, Rome, 1829–85.

Annual of the British School at Athens, London, from 1894.

Annuario della Regia Scuola Archeologica di Atene e delle Missioni italiane in Oriente, Bergamo and Rome, from 1914.

Antike, Die, Berlin, 1925–39.

269

Antike Denkmäler, Berlin, 1886–1931.

Antike Kunst, Olten and Bern, from 1958.

Antike Plastik, ed. by W.-H. Schuchhardt, Berlin, from 1962.

Archaeologisch-epigraphische Mittheilungen aus Oesterreich-Ungarn, Vienna, 1877–97.

Archaeologischer Anzeiger, see *Jahrbuch*.

Archaeologische Zeitung, Berlin, 1843–85.

Archeologia Classica, Rome, from 1949.

Archaiologika Analekta ex Athenon, Athens, from 1968.

Arkhaiologikon Deltion, Athens, from 1915.

Arti, Le, Florence, from 1938.

Athenische Mitteilungen des Deutschen Archälogischen Instituts, Athens and Berlin, from 1876.

Ausonia, Rome, 1906–21.

Berliner Museen, *Bericht aus den preussischen Kunstsammlungen: Beiblatt zum Jahrbuch der preussischen Kunstsammlungen*, Berlin, from 1880.

Bollettino d'Arte, Milan and Rome, 1907–38; from 1948.

British Museum Quarterly, London, from 1926.

Bulletin de Correspondance Hellénique, Paris, from 1877.

Bulletin des Musées de France, Paris, from 1929 (superseded by *Musées de France*).

Bulletin of the Metropolitan Museum of Art, New York, from 1905–06.

Bulletin of the Museum of Fine Arts, Boston, Boston, from 1903.

Bullettino della Commissione Archeologica Comunale di Roma, Rome, from 1872.

Bullettino dell'Istituto di Corrispondenza Archeologica, Rome, 1829–85.

Clara Rhodos, Rhodes, 1928–41.

Compte-rendu de la Commission impériale archéologique, St. Petersburg, 1860–83.

La Critica d'arte, Florence, 1935–38.

Dedalo, Milan, 1920–33.

Emporium, Rivista mensile d'arte . . . , Bergamo, from 1895.

Ephemeris arkhaiologike, Athens, from 1883.

Fondation Eugène Piot. Monuments et mémoires, Paris, from 1894.

Gnomon, Berlin, from 1925.

Hesperia, Cambridge (Mass.), from 1932.

Imperial Archaeological Commission, Report (in Russian), St. Petersburg, 1889–1906 (superseded by the *State Academy for the History of Material Culture*).

Jahrbuch des Deutschen Archäologischen Instituts, Berlin, from 1886; with the *Beiblatt, Archäologischer Anzeiger,* Berlin, from 1889.

Jahreshefte des Oesterreichischen Archäologischen Instituts, Vienna, 1898–1940 (renamed *Wiener Jahreshefte* in 1940).

Journal of Hellenic Studies, London, from 1881.

Journal of Roman Studies, London, from 1911.

Journal of the Walters Art Gallery, Baltimore, from 1938.

Le Musée, Revue d'art antique, Paris, 1904–09.

Liverpool Annals of Archaeology and Anthropology, Liverpool, from 1908.

Mélanges d'archéologie et d'histoire publiés par l'École française de Rome, Rome, from 1881.

Memoirs of the American Academy in Rome, Rome, from 1917.

Memorie della Pontificia Accademia romana di archeologia, Rome, from 1923.

Metropolitan Museum Studies, New York, 1928–36.

Metropolitan Museum Journal, New York, from 1969.

Monumenti antichi pubblicati per cura della Nazionale Accademia dei Lincei, Milan, from 1889.

Monumenti inediti pubblicati dall' Instituto di corrispondenza archeologica, Rome, and elsewhere, 1829–91.

Monuments et mémoires, see *Fondation Eugène Piot.*

Monuments grecs publiés par l'Association pour l'encouragement des études grecques en France, Paris, 1872–97.

Musées de France, from 1948 (supersedes *Bulletin des Musées de France*).

Münchener Jahrbuch der bildenden Kunst, Munich, from 1906.

The Museum Journal, Philadelphia, 1910–33.

Notizie degli scavi di antichità, Rome, from 1876.

Oxford Monographs on Classical Archaeology, ed. by J. D. Beazley, P. Jacobsthal, B. Ashmole, and M. Robertson, Oxford, from 1947.

Papers of the British School at Rome, London, from 1902.

Philologische Wochenschrift, Berlin and Leipzig, from 1881.

Praktika tes Athenais archailogikes hetaireias, Athens, 1837–50, 1857–1922, 1926–39 (in Greek).

Programm zum Winckelmannsfeste der archaeologischen Gesellschaft zu Berlin, Berlin, from 1840.

Programm zum Winckelmannsfeste der archaeologischen Gesellschaft zu Halle, Halle, 1876–1931.

Rendiconti della Pontificia Accademia romana d'archeologia, Rome, from 1923.

Revue archéologique, Paris, from 1844.

Revue des études anciennes, Bordeaux, from 1898.

Revue des études grecques, Paris, from 1888.

Römische Mitteilungen des Deutschen Archäologischen Instituts, Rome, from 1886.

State Academy for the History of Material Culture, Bulletin (in Russian), Moscow and Leningrad, from 1921 (supersedes the *Imperial Archaeological Commission*).

State Museum of Fine Arts, Monuments (in Russian), Moscow, 1912–26.

Studi e materiali, Florence, 1899–1905.

Symbolae osloenses, Oslo, from 1922.

University of California Publications in Classical Archaeology, Berkeley and Los Angeles, from 1929.

Wiener Jahreshefte, Vienna, from 1940 (supersedes *Jahreshefte des Oesterreichischen archäologischen Instituts*).

Wiener Vorlegeblätter, Vienna, 1869–91.

LEXICONS, ENCYCLOPEDIAS, ETC.*

Cary, M., et al., eds., *The Oxford Classical Dictionary*, Oxford, 1949; new ed. 1969.

Daremberg, C., E. Saglio, et al., eds., *Dictionnaire des antiquités grecques et romaines*, Paris, 1877–1919.

Enciclopedia dell'Arte Antica, Classica, Orientale, I–VII, Rome, 1958–66.

Enciclopedia italiana, 1929–37; Appendix, 1938–48.

Encyclopedia of World Art, New York, and elsewhere, from 1959; Italian ed., from 1958.

Lübke, F., *Reallexikon des klassischen Altertums*, 8th ed. by J. Geffcken and E. Ziebarth, Leipzig, 1914.

Miller, W., *Daedalus and Thespis*, 1–3, New York, 1929–32.

Roscher, W. H., *Ausführliches Lexikon der griechischen und römischen Mythologie*, Leipzig, 1884–1937.

Thieme, U., and F. Becker, *Allgemeines Lexikon der bildenden Künstler von der Antike bis zur Gegenwart*, Leipzig, 1907–50.

Wissowa, G., W. Kroll, and K. Witte, *Paulys Real-Encyclopädie der classischen Altertumswissenschaft*, Stuttgart, from 1894.

* For a full list of lexica, periodicals, etc., cf. *Enc. Arte Antica, 1* (1958), s.v. "Archeologia," pp. 561–68.

INDEX TO THE TEXT

Italic numbers indicate the most important references. For museum see names of cities where located.

INDEX TO ILLUSTRATIONS

Numbers refer to the figures at the end of the book; letters, to text figures.

LIST OF ILLUSTRATIONS

Unless otherwise stated the material of the sculptures is marble and the objects in the various museums were photographed by the respective museum photographers.

ILLUSTRATIONS

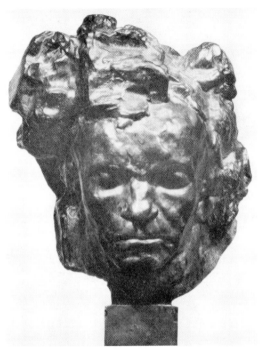

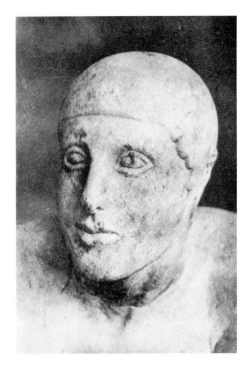

Fig. 1. Bronze head of Beethoven, by Bourdelle
Metropolitan Museum of Art
(Cf. p. 18)

Fig. 2. Head of Kladeos, from the temple
of Zeus at Olympia
Olympia Museum
(Cf. p. 18)

Fig. 3. Birth of Athena, from a hydria
Bibliothèque Nationale, Paris
(Cf. p. 26)

Fig. 4. Niobid
Museo Nazionale delle Terme, Rome
(Cf. pp. 23, 44, 66)

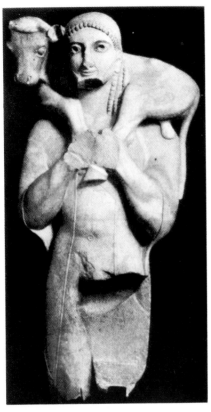 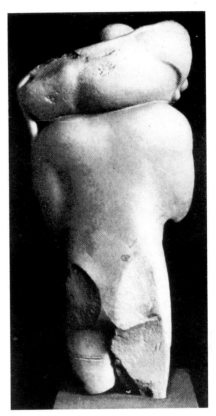

Fig. 5. Calf bearer
Akropolis Museum, Athens
(Cf. pp. 22, 23, 147)

Fig. 6. Back of Fig. 5 (from a cast)
(Cf. pp. 22, 23, 147)

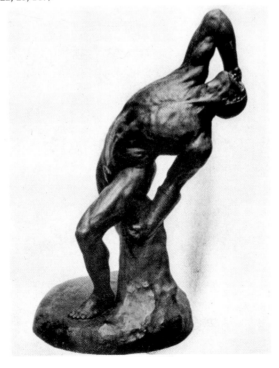

Fig. 7. Falling Gladiator, by William Rimmer
Metropolitan Museum of Art
(Cf. p. 23)

Fig. 8. Head of Acheloos
on a coin of Gela
American Numismatic Society, New York
(Cf. p. 27)

Fig. 9. Horse in a meadow
on a coin of Larisa
American Numismatic Society, New York
(Cf. p. 27)

Fig. 10. Zeus of Aetna
on a coin of Katane
Bibliothèque Royale, Brussels
(Cf. p. 27)

Fig. 11. Theseus and the Minotaur
from a red-figured plate
The Louvre, Paris
(Cf. p. 26)

Fig. 12. Odysseus and Nausikaa, from a red-figured pyxis
Museum of Fine Arts, Boston
(Cf. p. 27)

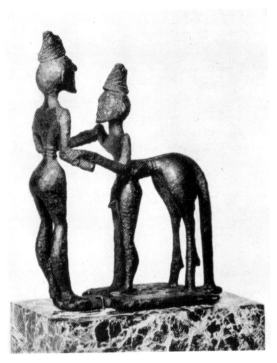

Fig. 13. Bronze group of man and centaur
Metropolitan Museum of Art
(Cf. p. 29)

Fig. 14. Anatomical Statue, by Houdon
École des Beaux Arts, Paris
(Cf. p. 30)

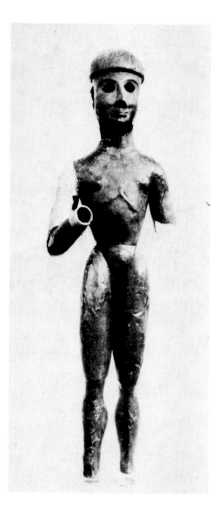

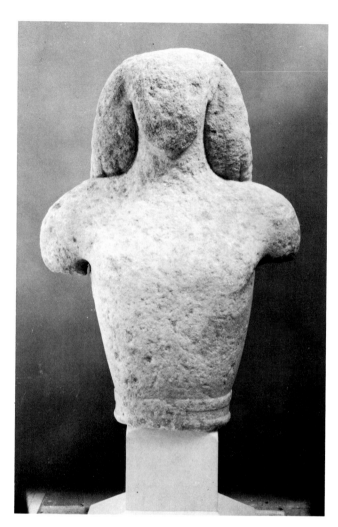

Fig. 15. Bronze statuette
from Dreros
Heraklion Museum, Crete
(Cf. pp. 30, 115)

Fig. 16. Kouros, from Delos
Museum of Delos
(Cf. p. 30)

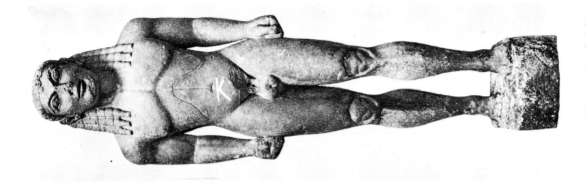

Fig. 19. Kleobis, from Delphi
Delphi Museum
(Cf. pp. 30, 151)

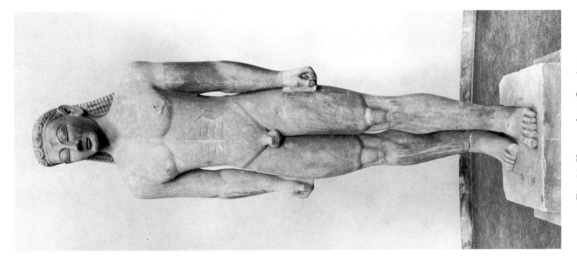

Fig. 18. Kouros, from Sounion
National Museum, Athens
(Cf. p. 30)

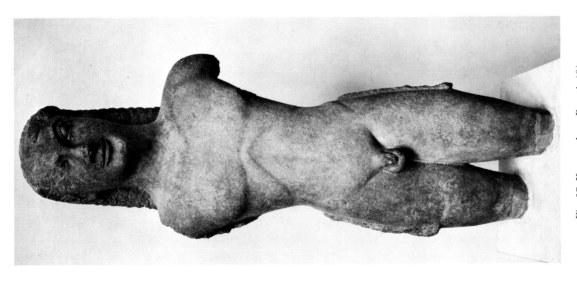

Fig. 17. Kouros, from Boeotia (?)
British Museum, London
(Cf. p. 31)

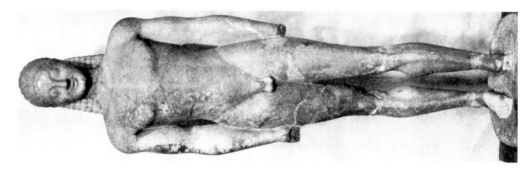

Fig. 22. Kouros, from Volomandra
National Museum, Athens
(Cf. p. 31)

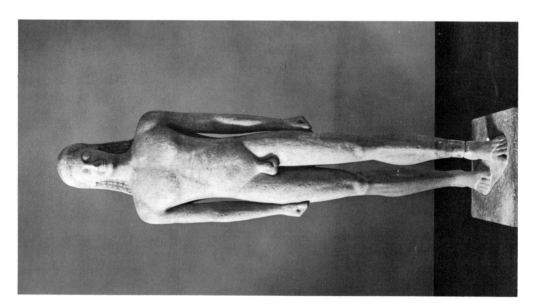

Fig. 21. Kouros, from Melos
National Museum, Athens
(Cf. p. 31)

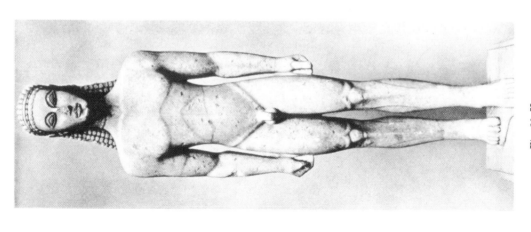

Fig. 20. Kouros
Metropolitan Museum of Art
(Cf. pp. 30, 147)

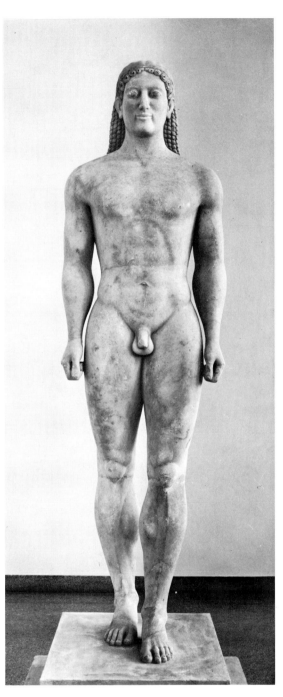 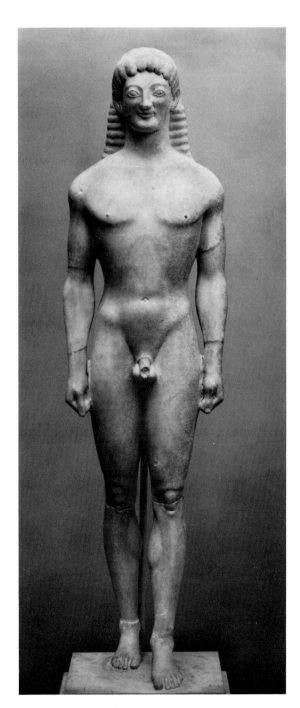

Fig. 23. Kouros, from Anavysos
National Museum, Athens
(Cf. p. 31)

Fig. 24. Apollo, from Tenea
The Glyptothek, Munich
(Cf. p. 31)

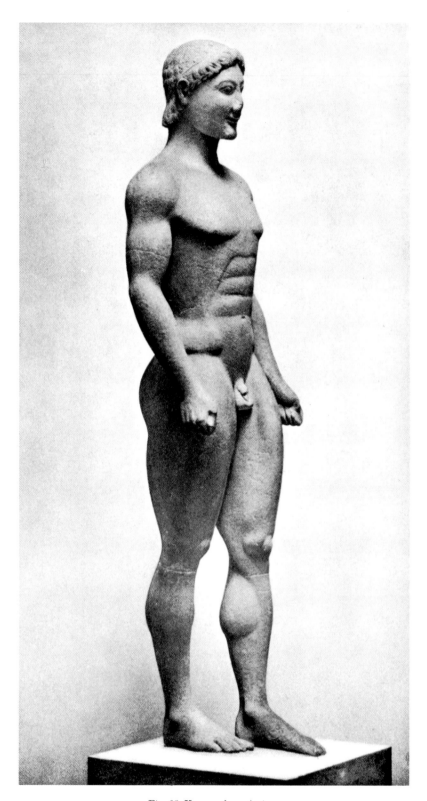

Fig. 25. Kouros, from Attica
The Glyptothek, Munich
(Cf. p. 31)

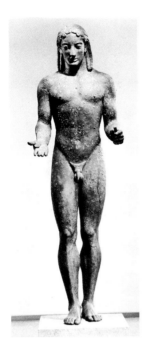

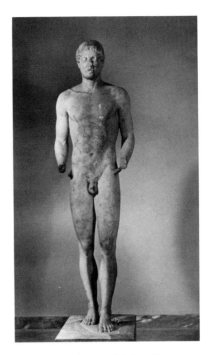

Fig. 26. Statue, from the Piraeus
National Museum, Athens
(Cf. p. 32)

Fig. 27. Statue of Aristodikos
National Museum, Athens
(Cf. p. 32)

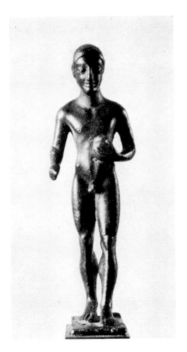

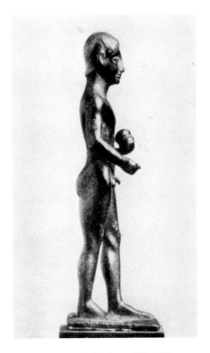

Fig. 28. Bronze statuette of
a kouros
Metropolitan Museum of Art
(Cf. p. 32)

Fig. 29. Side view of Fig. 28
(Cf. p. 32)

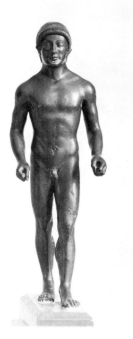

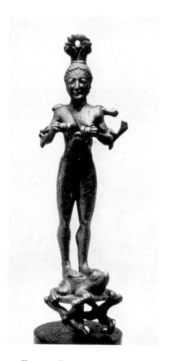

Fig. 30. Bronze statuette
from the Akropolis
National Museum, Athens
(Cf. p. 32)

Fig. 31. Bronze statuette of
a dancing girl
Metropolitan Museum of Art
(Cf. p. 32)

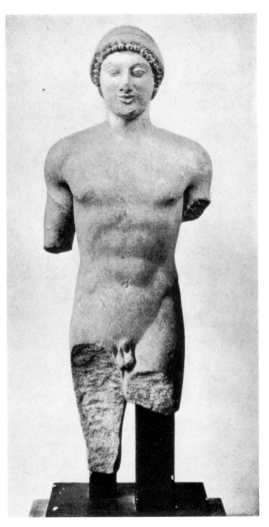

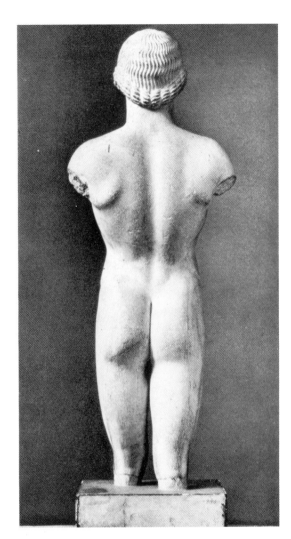

Fig. 32. Kouros, from Boeotia
National Museum, Athens
(Cf. pp. 32, 46)

Fig. 33. Back view of the Strangford kouros
British Museum, London
(Cf. p. 32)

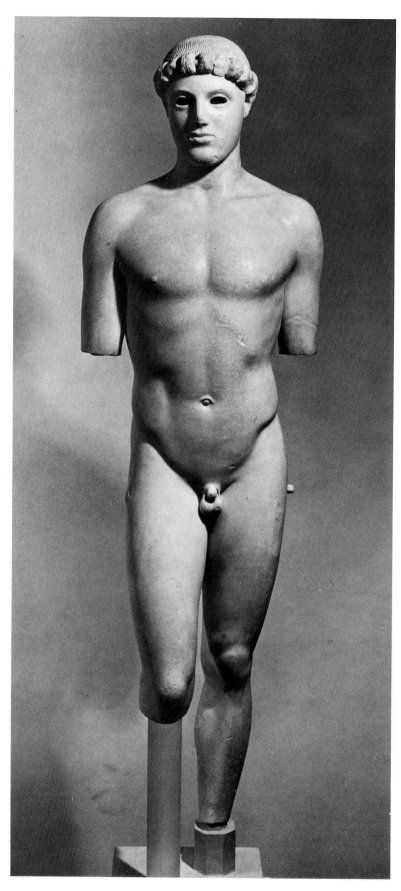

Fig. 34. Youth
Akropolis Museum, Athens
(Cf. pp. 32, 156)

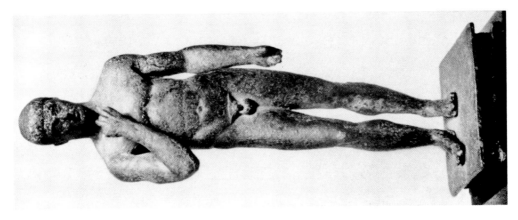

Fig. 37. Bronze statuette of a youth
Metropolitan Museum of Art
(Cf. p. 32)

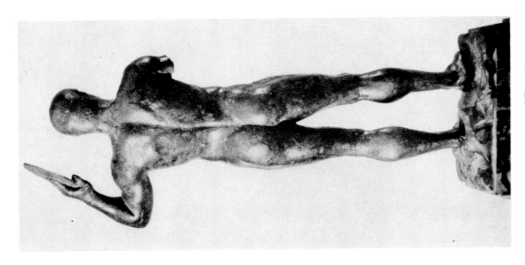

Fig. 36. Back view of Fig. 35
(Cf. p. 32)

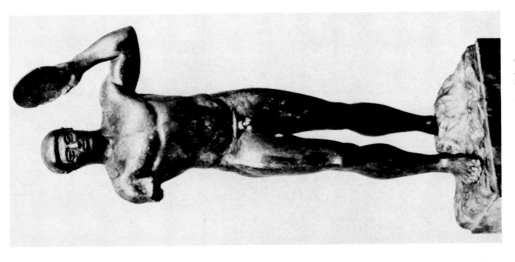

Fig. 35. Bronze statuette of a disk thrower
Metropolitan Museum of Art
(Cf. p. 32)

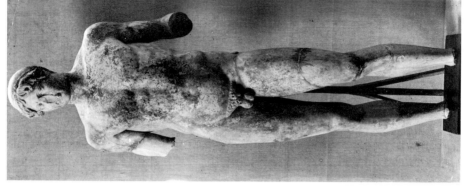

Fig. 40. "Omphalos Apollo"
from Athens
National Museum, Athens
(Cf. pp. 33, 157, 160)

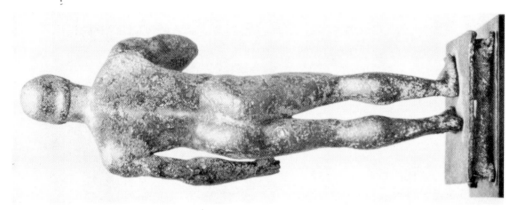

Fig. 39. Back view of Fig. 37
(Cf. p. 32)

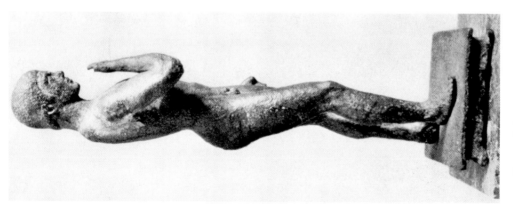

Fig. 38. Side view of Fig. 37
(Cf. p. 32)

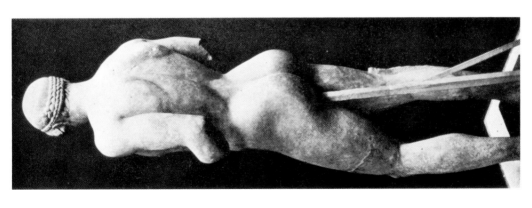

Fig. 43. Statuette of Herakles
Museum of Fine Arts, Boston
(Cf. pp. 33, 165)

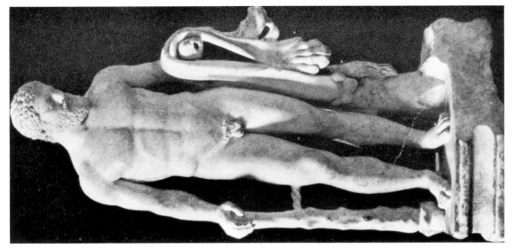

Fig. 42. "Apollo," from the Tiber
Museo Nazionale delle Terme, Rome
(Cf. pp. 33, 176)

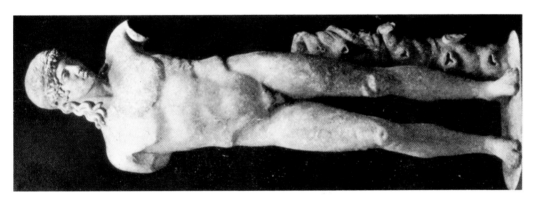

Fig. 41. Back view of Fig. 40
(Cf. pp. 33, 157, 160)

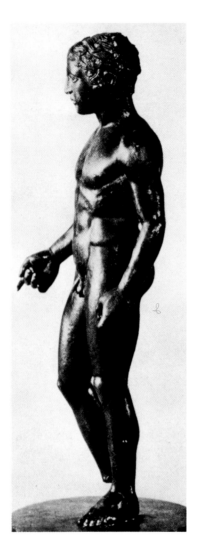

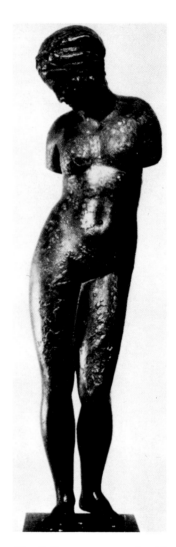

Fig. 44. Bronze statuette of a youth
Metropolitan Museum of Art
(Cf. p. 34)

Fig. 45. Bronze statuette of a girl
Museum für antike Kleinkunst, Munich
(Cf. p. 34)

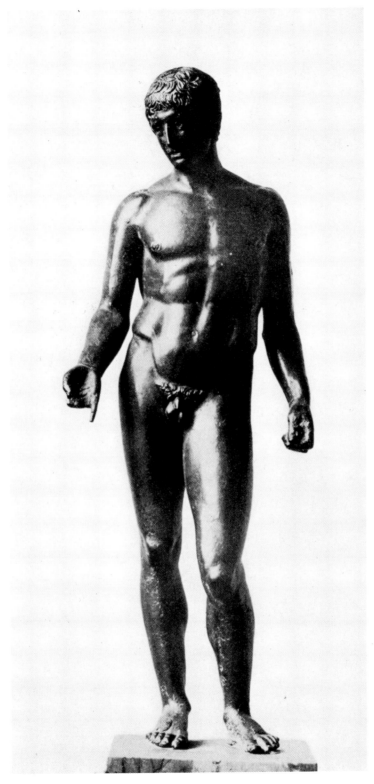

Fig. 46. Bronze statuette of a youth
The Louvre, Paris
(Cf. pp. 34, 194)

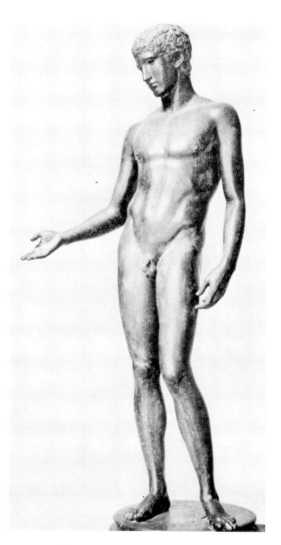 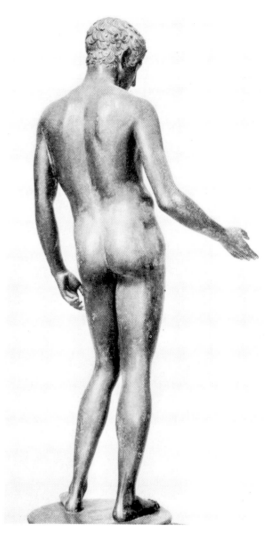

Fig. 47. Bronze statue of the Idolino
Museo Archeologico, Florence
(Cf. pp. 33f., 104)

Fig. 48. Back view of Fig. 47
(Cf. pp. 33f., 104)

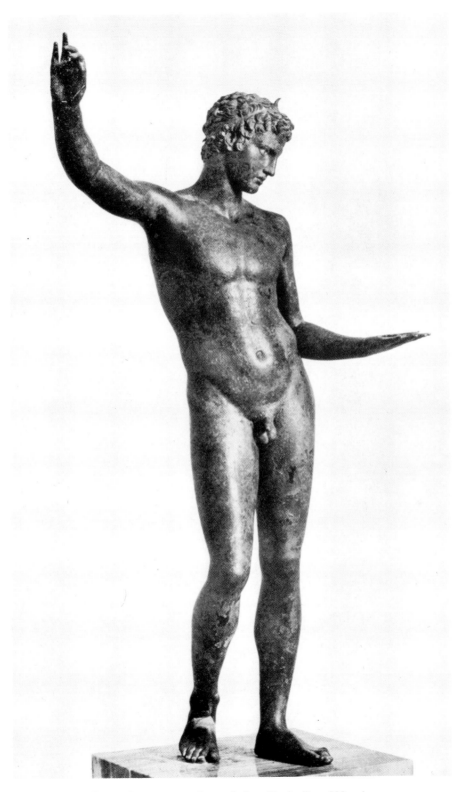

Fig. 49. Bronze statue of a youth, found in the Bay of Marathon
National Museum, Athens
(Cf. pp. 35, 206)

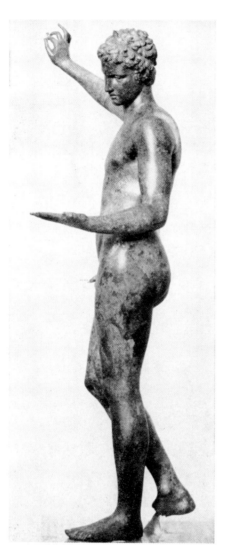

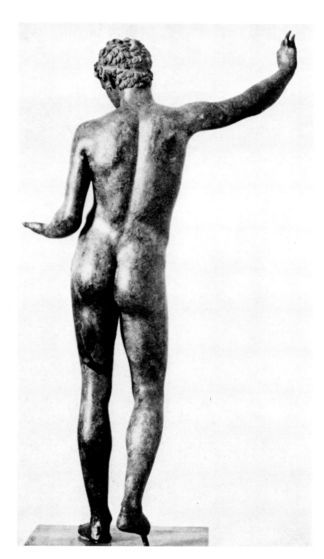

Fig. 50. Side view of Fig. 49
(Cf. pp. 35, 206)

Fig. 51. Back view of Fig. 49
(Cf. pp. 35, 206)

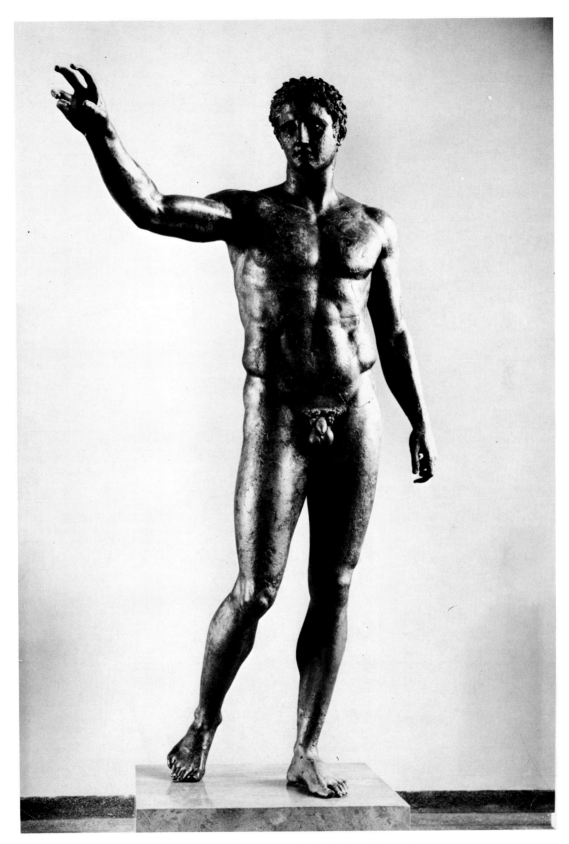

Fig. 52. Bronze statue, from the Antikythera shipwreck
National Museum, Athens
(Cf. p. 35)

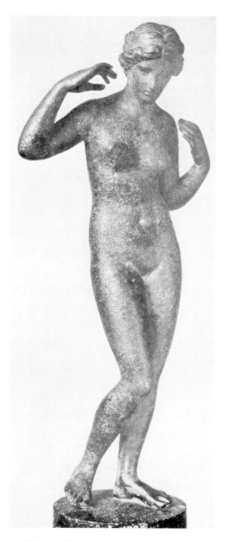

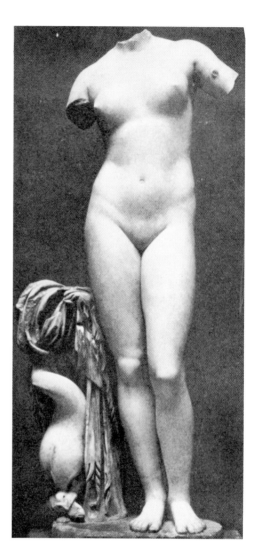

Fig. 53. Bronze statuette of Aphrodite
British Museum, London
(Cf. pp. 35, 204)

Fig. 54. Aphrodite, from Kyrene
Museo Nazionale delle Terme, Rome
(Cf. p. 35)

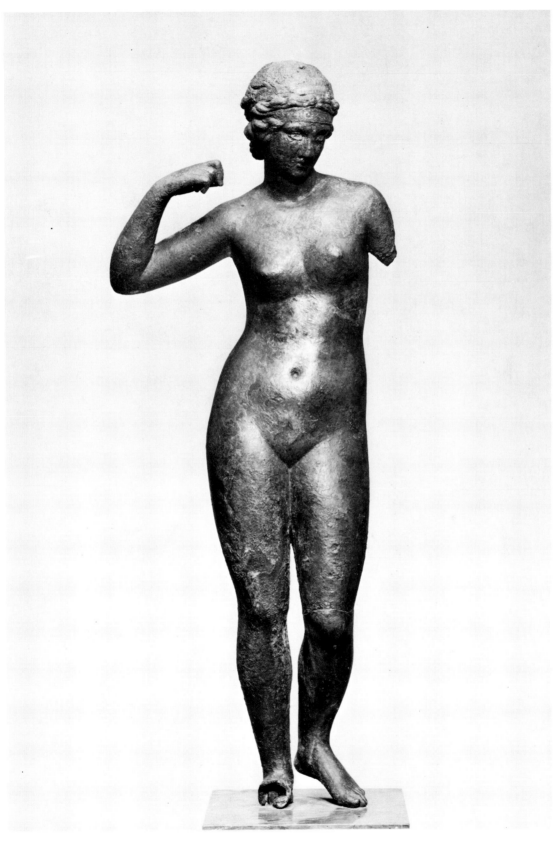

Fig. 55. Bronze statuette, from the Haviland Collection
Metropolitan Museum of Art
(Cf. p. 35)

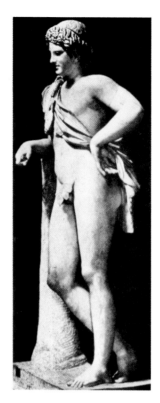

Fig. 56. Satyr
Capitoline Museum, Rome
(Cf. pp. 35, 205)

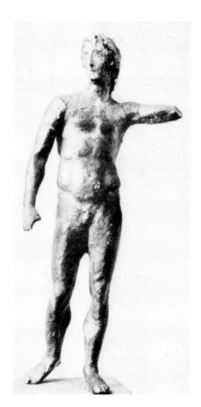

Fig. 57. Bronze statuette of Alexander
The Louvre, Paris
(Cf. p. 35)

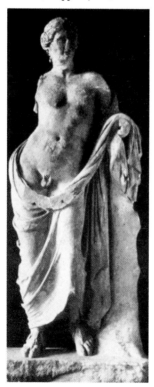

Fig. 58. Hermaphrodite
Istanbul Museum
(Cf. p. 36)

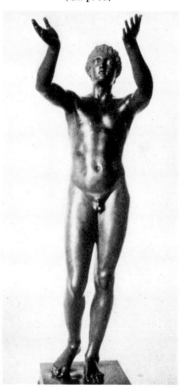

Fig. 59. Bronze statue of a praying boy
Staatliche Museen, Berlin
(Cf. pp. 35, 231)

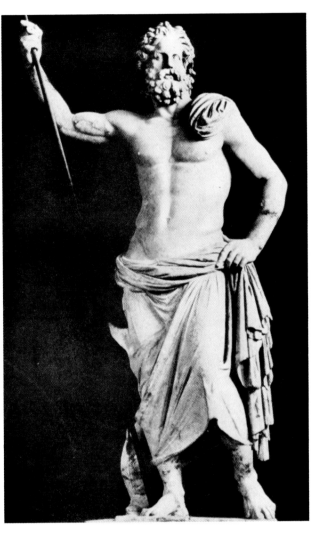

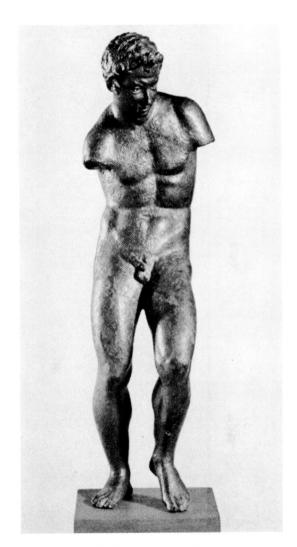

Fig. 60. Poseidon
National Museum, Athens
(Cf. p. 36)

Fig. 61. Bronze statuette of a satyr
Metropolitan Museum of Art
(Cf. p. 36)

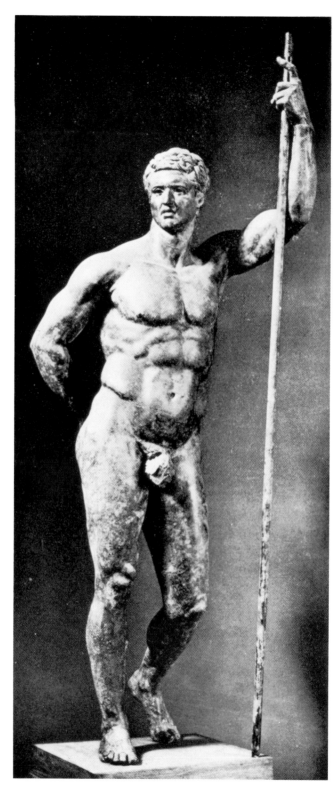

Fig. 62. Bronze statue of a "Hellenistic prince"
Museo Nazionale delle Terme, Rome
(Cf. p. 36)

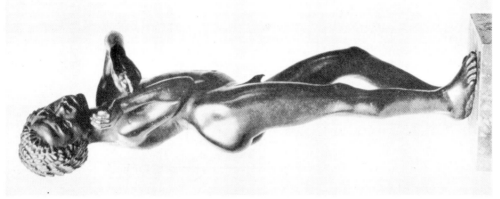

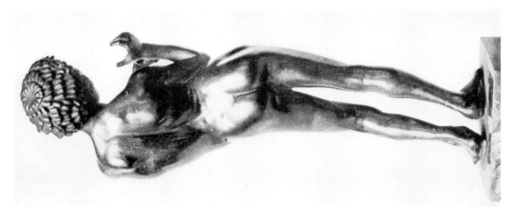

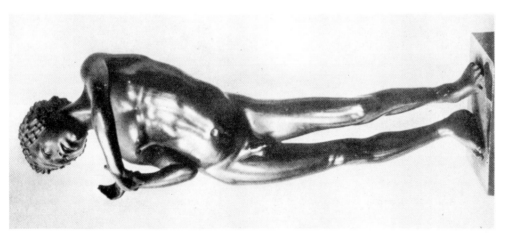

Fig. 63. Bronze statuette of a Negro musician
Bibliothèque Nationale, Paris
(Cf. pp. 36, 54)

Fig. 64. Back view of Fig. 63
(Cf. pp. 36, 54)

Fig. 65. Side view of Fig. 63
(Cf. pp. 36, 54)

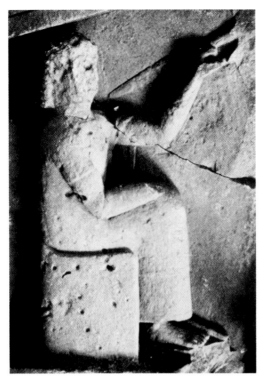

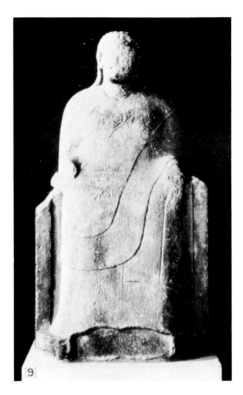

Fig. 66. Seated figure, from the western pediment
of the Corfu temple
Corfu Museum
(Cf. pp. 36, 92)

Fig. 67. Figure from Branchidai
British Museum, London
(Cf. p. 36)

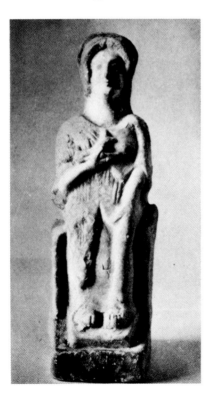

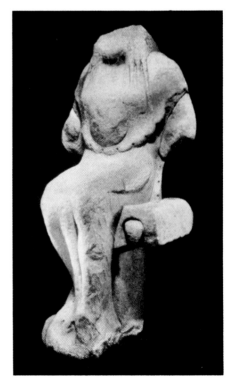

Fig. 68. Terracotta statuette
Metropolitan Museum of Art
(Cf. p. 36)

Fig. 69. Athena, perhaps by Endoios
Akropolis Museum, Athens
(Cf. pp. 36, 152)

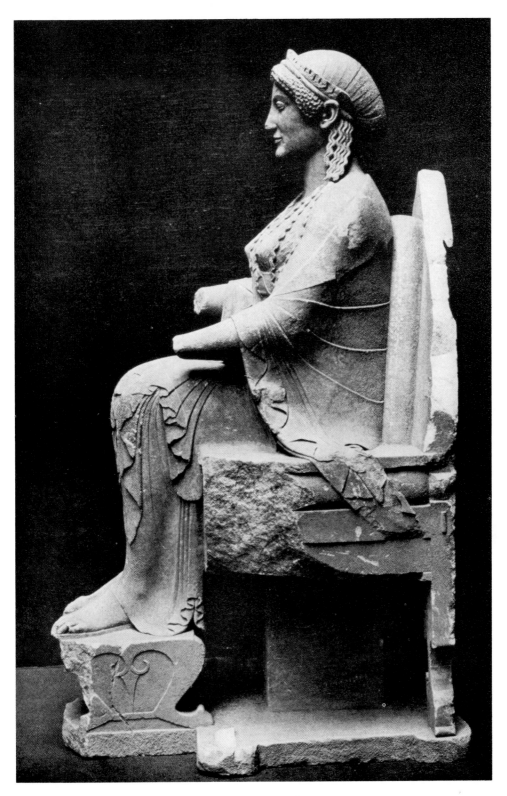

Fig. 70. Seated goddess
Staatliche Museen, Berlin
(Cf. pp. 37, 64, 127)

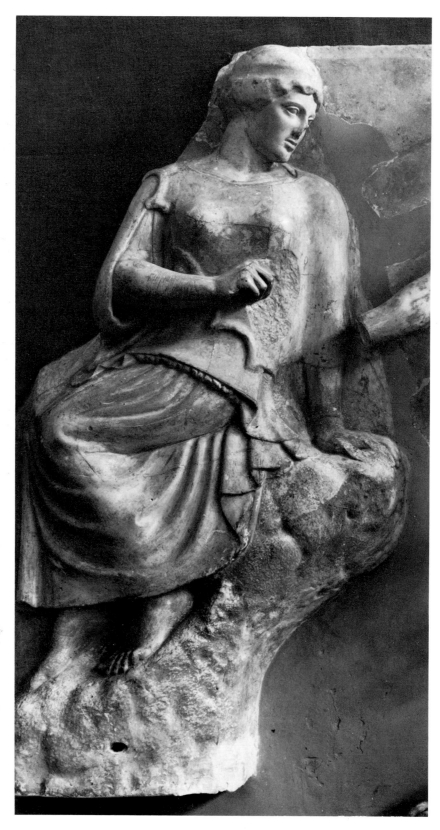

Fig. 71. Athena, from a
metope of the temple
of Zeus at Olympia
The Louvre, Paris
(Cf. p. 37)

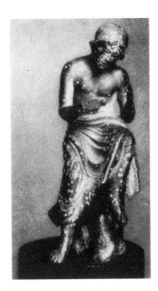

Fig. 72. Bronze statuette of
a lyre player
The Hermitage, Leningrad
(Cf. pp. 37, 172)

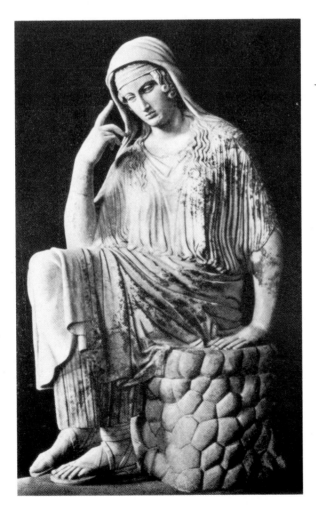

Fig. 73. "Penelope"
The Vatican, Rome
(Cf. pp. 37, 53, 160)

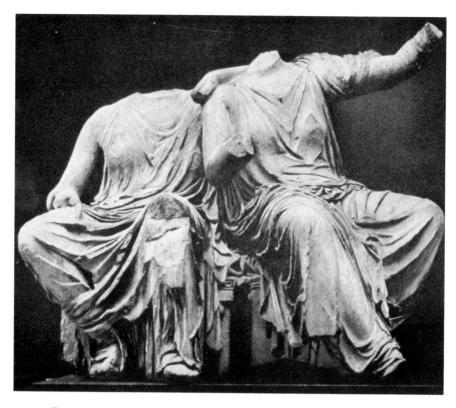

Fig. 74. Demeter and Persephone, from the eastern pediment of the Parthenon
British Museum, London
(Cf. pp. 37, 66, 178)

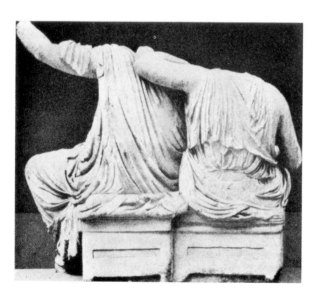

Fig. 75. Back view of Fig. 74
(Cf. pp. 37, 122, 133, 178)

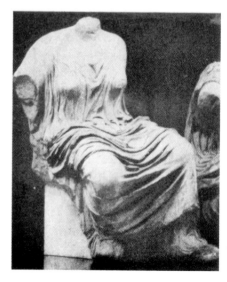

Fig. 76. One of the "Fates"
from the eastern pediment of the Parthenon
British Museum, London
(Cf. pp. 37, 178)

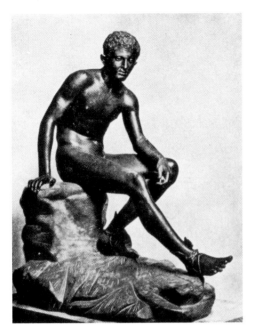

Fig. 77. Bronze statue of Hermes
Museo Nazionale, Naples
(Cf. pp. 37, 231)

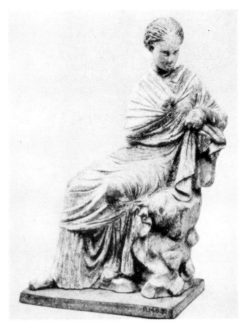

Fig. 78. Terracotta statuette
Metropolitan Museum of Art
(Cf. p. 37)

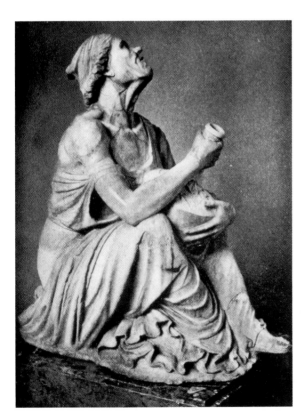

Fig. 79. Drunken woman
The Glyptothek, Munich
(Cf. pp. 37, 54)

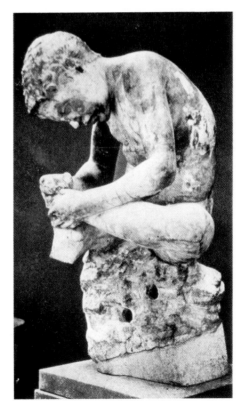

Fig. 80. Boy extracting a thorn
British Museum, London
(Cf. pp. 37, 54)

Fig. 81. Gorgon, from the western pediment at Corfu
Corfu Museum
(Cf. p. 38)

Fig. 82. Nike, from Delos
National Museum, Athens
(Cf. pp. 38, 152)

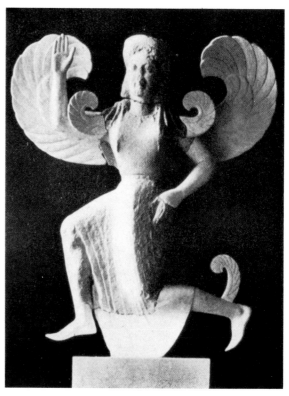

Fig. 83. Fig. 82 reconstructed (from a cast)
(Cf. pp. 38, 152)

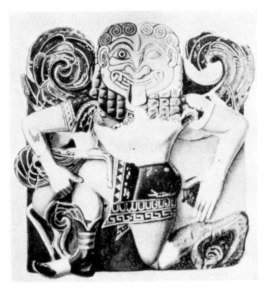

Fig. 84. Gorgon, terracotta relief
Syracuse Museum
(Cf. pp. 38, 117)

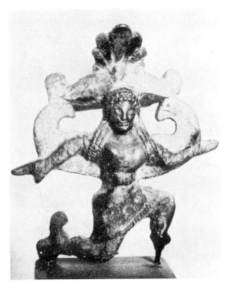

Fig. 85. Bronze statuette of Nike
National Museum, Athens
(Cf. p. 38)

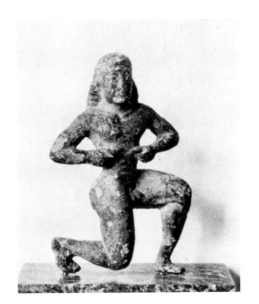

Fig. 86. Bronze statuette of a runner
Metropolitan Museum of Art
(Cf. p. 38)

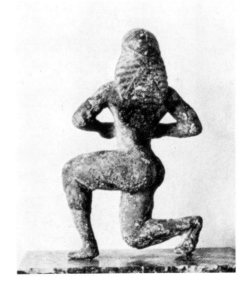

Fig. 87. Back view of Fig. 86
(Cf. p. 38)

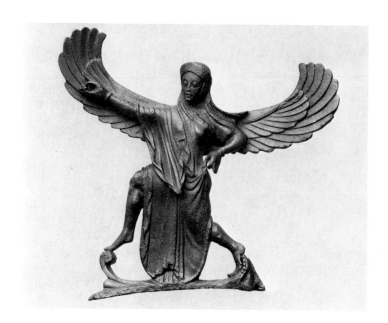

Fig. 88. Bronze statuette of Nike
British Museum, London
(Cf. p. 38)

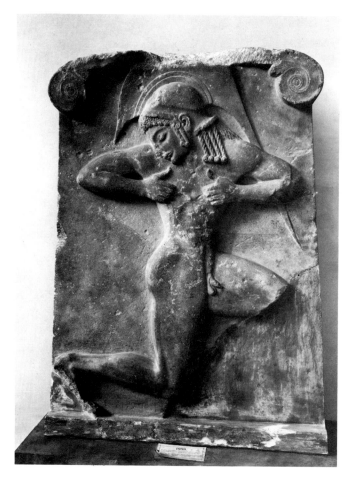

Fig. 89. Relief of a warrior
National Museum, Athens
(Cf. pp. 38, 84)

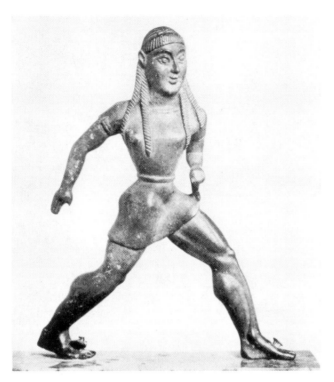

Fig. 90. Bronze statuette of a youth running
National Museum, Athens
(Cf. p. 38)

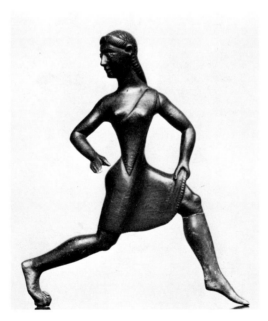

Fig. 91. Bronze statuette of a girl running
British Museum, London
(Cf. p. 38)

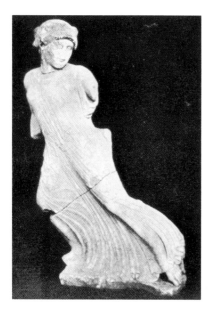

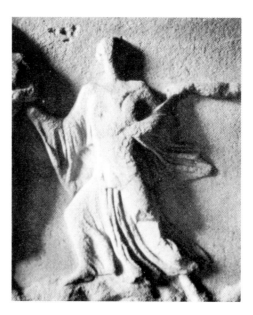

Fig. 92. Statuette of a running maiden
Eleusis Museum
(Cf. p. 38)

Fig. 93. Figure from the frieze of the
Ilissos temple
Staatliche Museen, Berlin
(Cf. p. 39)

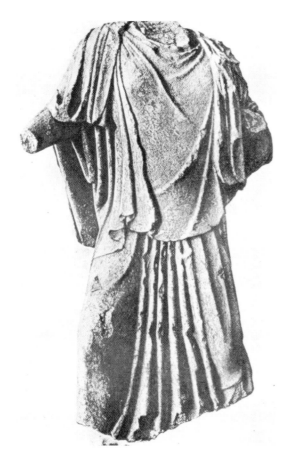

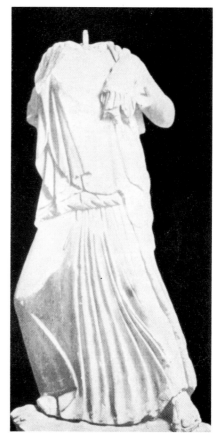

Fig. 94. Figure from Marmaria
Delphi Museum
(Cf. p. 39)

Fig. 95. Leto
Palazzo dei Conservatori, Rome
(Cf. p. 39)

Fig. 96. "Iris," from the eastern pediment of the Parthenon
British Museum, London
(Cf. pp. 39, 66, 69, 178)

Fig. 97. Niobid
Ny Carlsberg Glyptotek, Copenhagen
(Cf. p. 39)

Fig. 98. Running figure
Museum der Bildenden Künste, Budapest
(Cf. p. 39)

Fig. 99. Bronze statuette of an Eros
J. Pierpont Morgan Collection, New York
(Cf. p. 39)

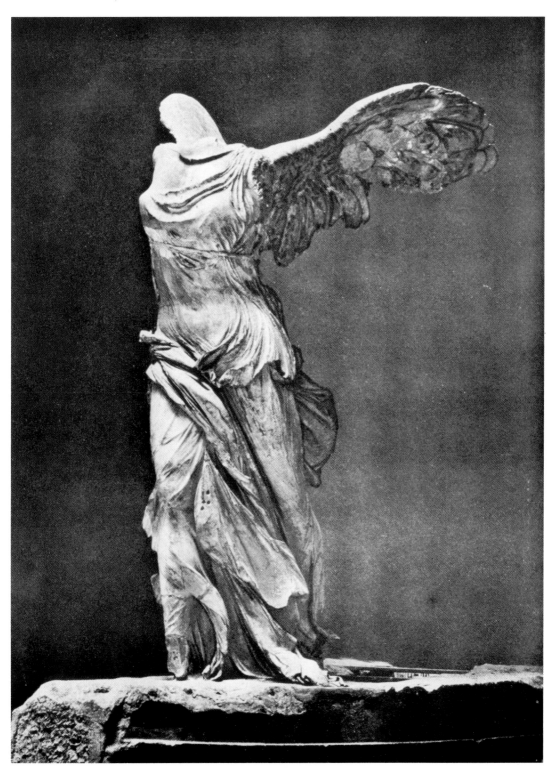

Fig. 100. Nike of Samothrake
The Louvre, Paris
(Cf. pp. 39, 71)

Fig. 101. Zeus and a giant, from the western
pediment at Corfu
Corfu Museum
(Cf. pp. 39, 43, 92)

Fig. 102. Warriors, from the frieze of the Siphnian Treasury
Delphi Museum
(Cf. p. 40)

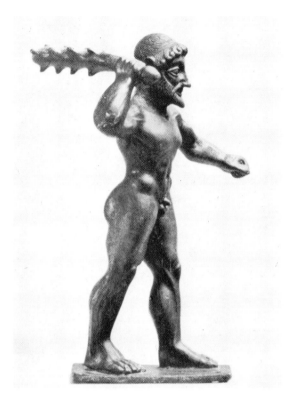

Fig. 103. Bronze statuette of Herakles
Metropolitan Museum of Art
(Cf. p. 40)

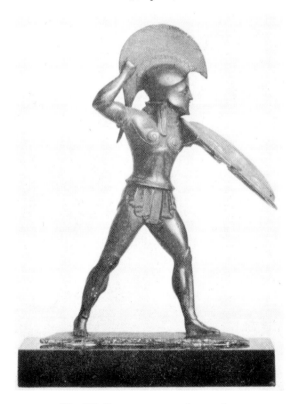

Fig. 104. Bronze statuette of a warrior
Staatliche Museen, Berlin
(Cf. p. 40)

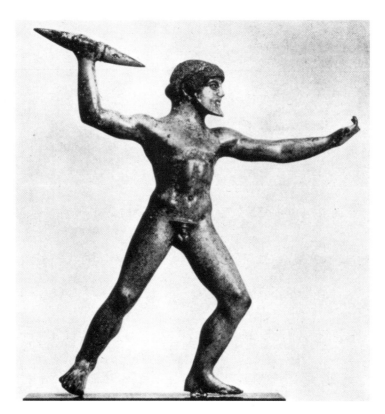

Fig. 105. Bronze statuette of Zeus
Staatliche Museen, Berlin
(Cf. p. 40)

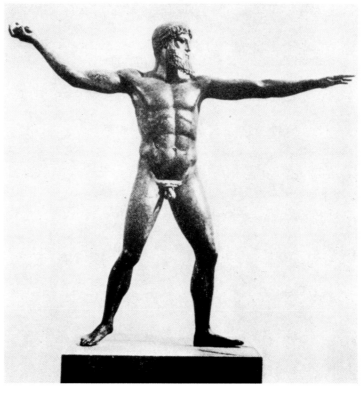

Fig. 106. Bronze statue of Poseidon
National Museum, Athens
(Cf. pp. 40, 160)

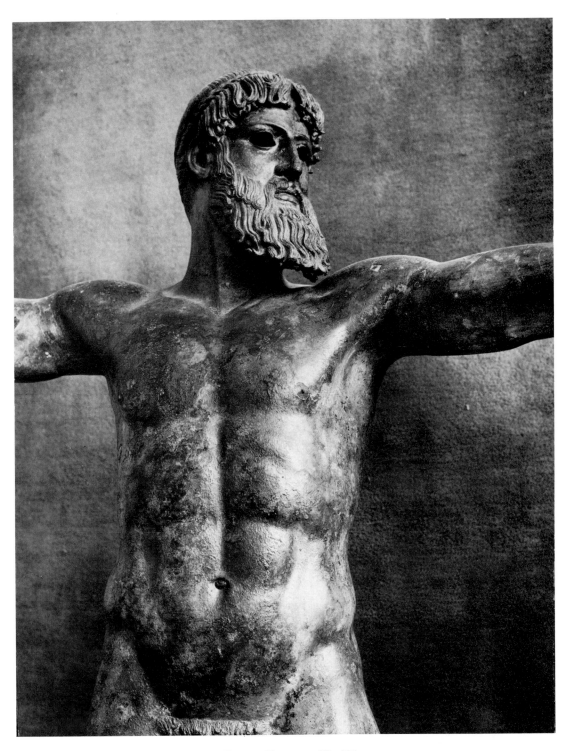

Fig. 107. Upper part Fig. 106
(Cf. pp. 40, 160)

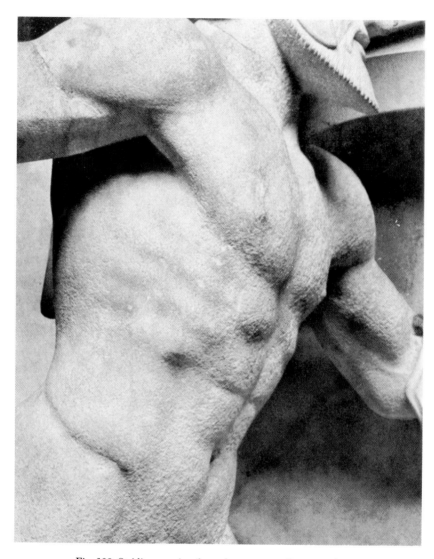

Fig. 108. Striding warrior, from the eastern pediment at Aigina
The Glyptothek, Munich
(Cf. pp. 40, 160)

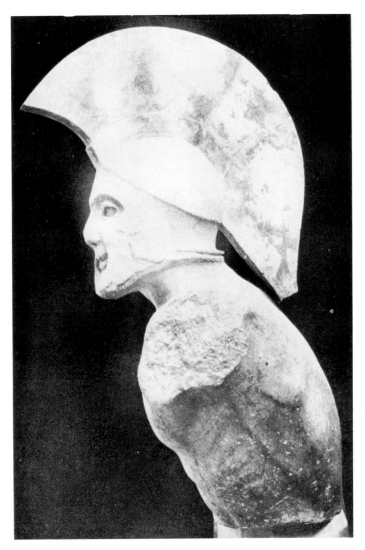

Fig. 109. Warrior, from Sparta
National Museum, Athens
(Cf. p. 40)

Fig. 110. Terracotta group
of Zeus and Ganymede
Museum of Olympia
(Cf. p. 40)

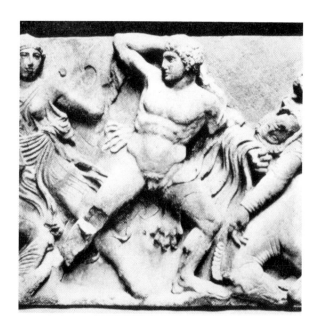

Fig. 111. Herakles, from the Phigaleia frieze
British Museum, London
(Cf. p. 41)

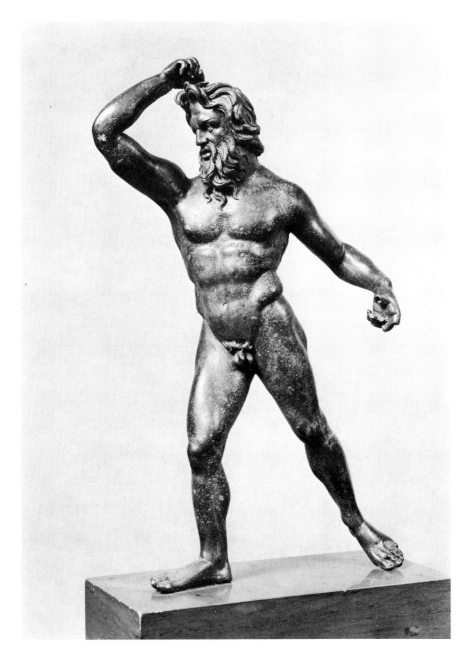

Fig. 112. Bronze statuette of Poseidon
The Louvre, Paris
(Cf. p. 41)

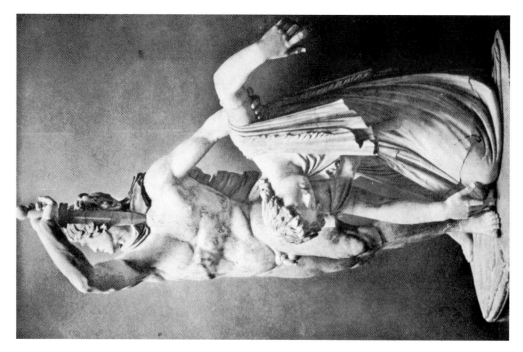

Fig. 114. Gaul and his wife
Museo Nazionale delle Terme, Rome
(Cf. pp. 41, 72, 234)

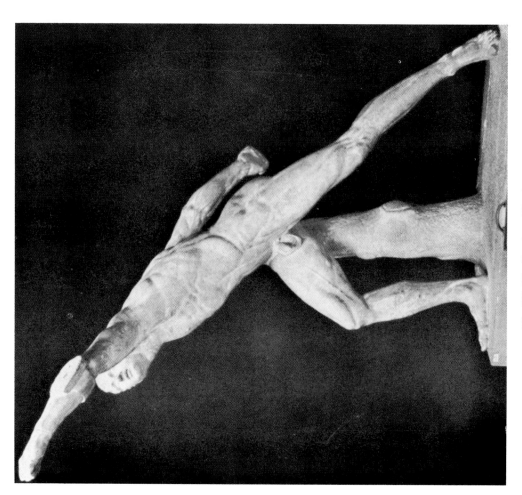

Fig. 113. The Borghese Warrior
The Louvre, Paris
(Cf. pp. 41, 247)

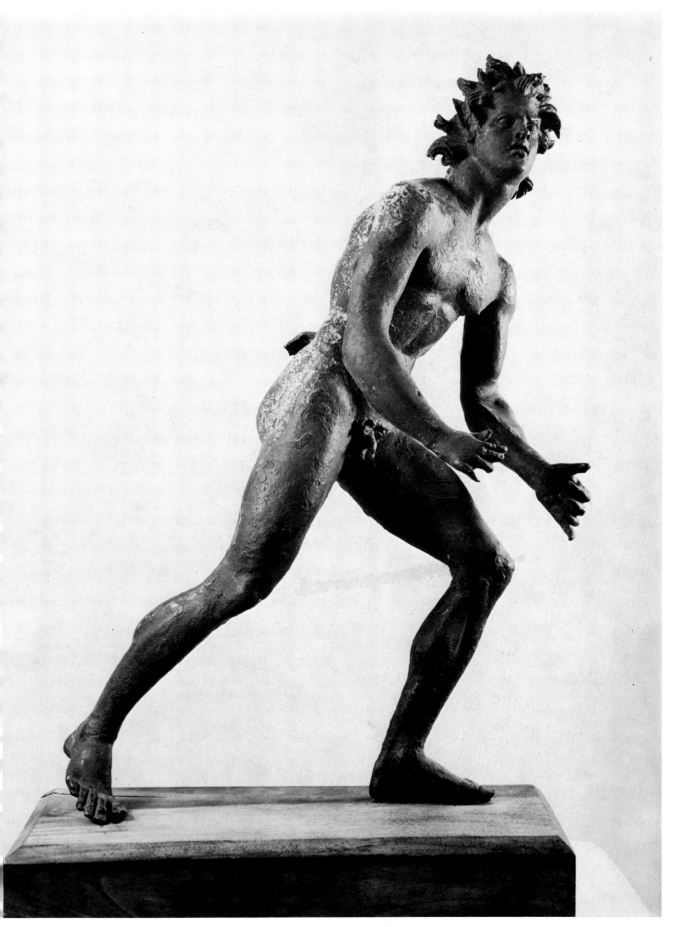

Fig. 115. Bronze statuette, from the
Mahdia shipwreck
Alaoui Museum, Tunis
(Cf. p. 41)

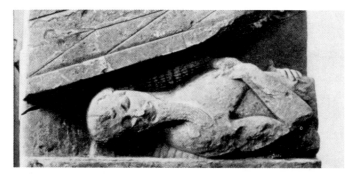

Fig. 116. Reclining figure, from the western pediment at Corfu
Corfu Museum
(Cf. pp. 41, 92)

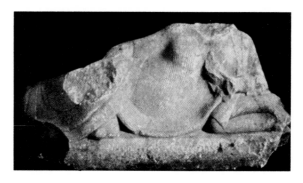

Fig. 117. Reclining figure
Vathy Museum, Samos
(Cf. p. 41)

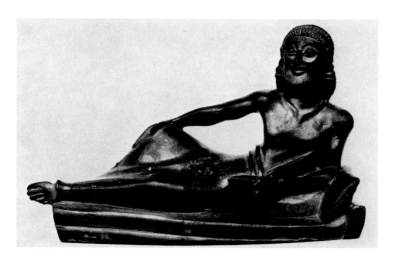

Fig. 118. Bronze statuette of a banqueter
British Museum, London
(Cf. p. 42)

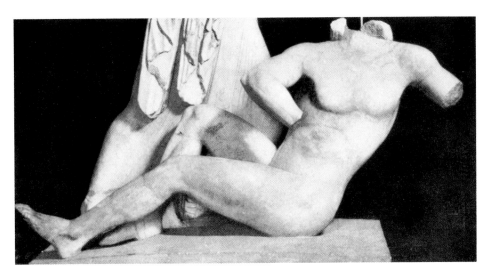

Fig. 119. Giant, from a pediment of the "Hekatompedon"
Akropolis Museum, Athens
(Cf. pp. 42, 95)

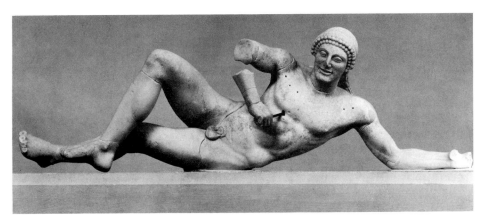

Fig. 120. Warrior, from the western pediment at Aigina
The Glyptothek, Munich
(Cf. pp. 42, 97)

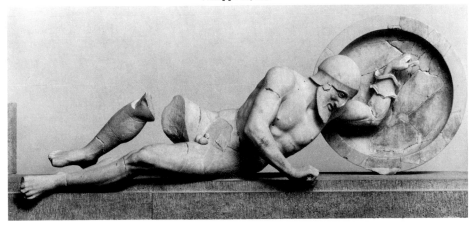

Fig. 121. Warrior, from the eastern pediment at Aigina
The Glyptothek, Munich
(Cf. pp. 42, 97)

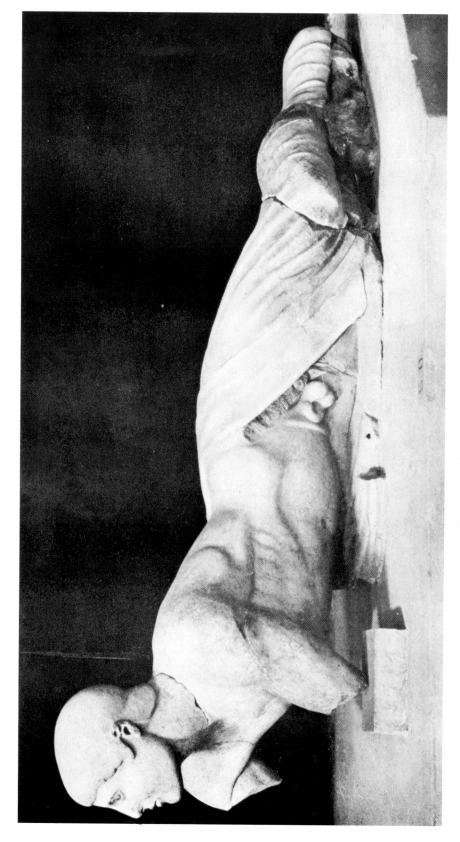

Fig. 122. "Kladeos," from the eastern pediment at Olympia
Olympia Museum
(Cf. pp. 42, 95, 98)

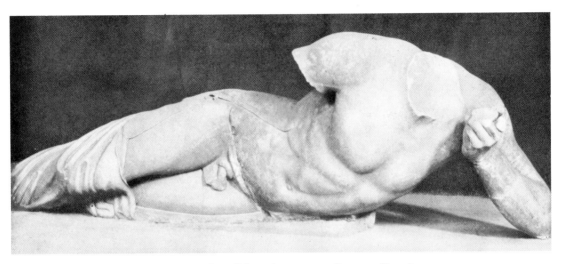

Fig. 123. "Alpheios," from the eastern pediment at Olympia
Olympia Museum
(Cf. pp. 42, 98)

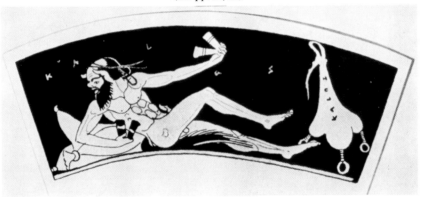

Fig. 124. Satyr, by the Brygos painter, on a kantharos
Metropolitan Museum of Art
(Cf. pp. 42, 85)

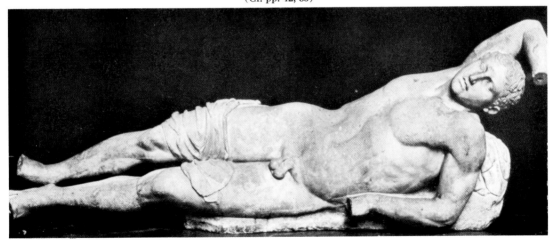

Fig. 125. Niobid
Ny Carlsberg Glyptotek, Copenhagen
(Cf. p. 42)

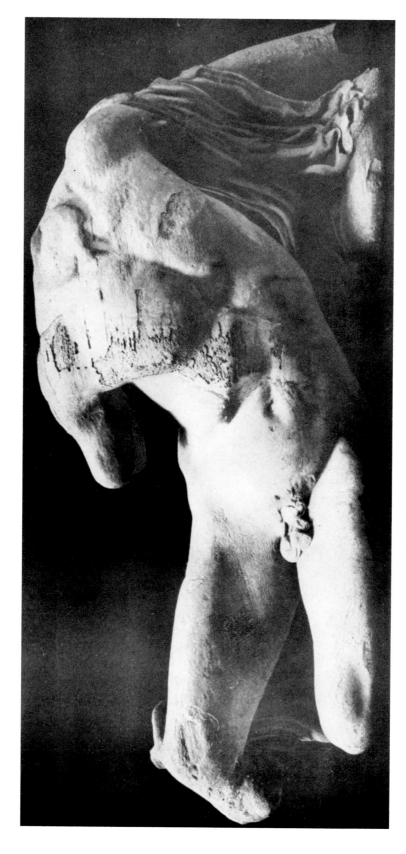

Fig. 126. "Ilissos," from the western pediment of the Parthenon
British Museum, London
(Cf. pp. 42, 95, 98, 178)

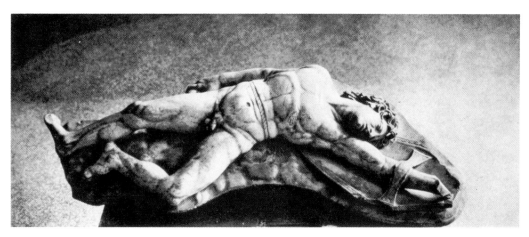

Fig. 127. Dead Gaul
Museo Archeologico, Venice
(Cf. p. 42)

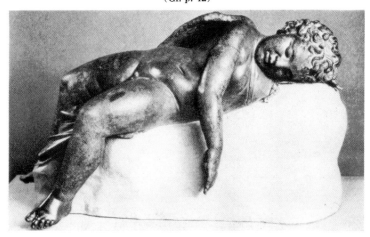

Fig. 128. Bronze statue of a sleeping Eros
Metropolitan Museum of Art
(Cf. pp. 42, 54)

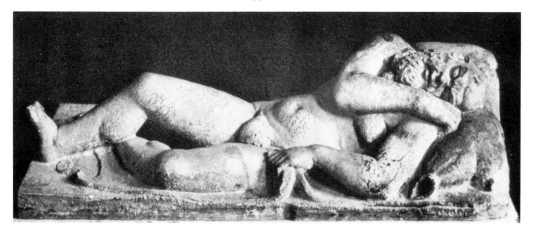

Fig. 129. Sleeping satyr
The Lateran Collection, Rome
(Cf. pp. 42, 54)

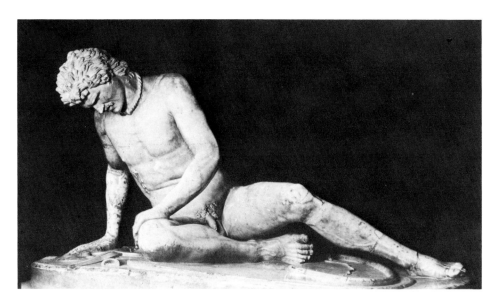

Fig. 130. Dying Gaul
Capitoline Museum, Rome
(Cf. pp. 42, 234)

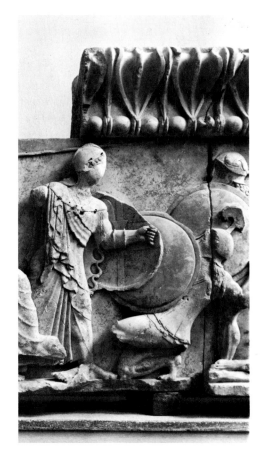

Fig. 131. Falling warrior, from the frieze of the Siphnian
Treasury
Delphi Museum
(Cf. p. 43)

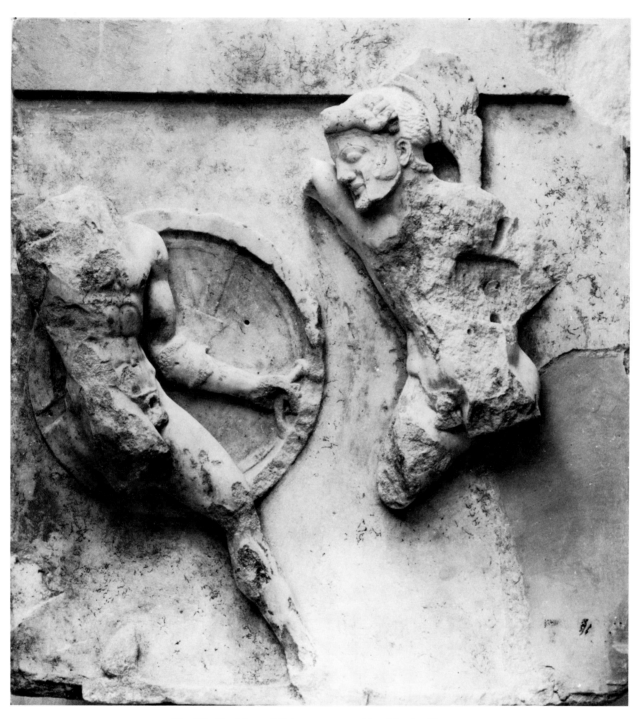

Fig. 132. Herakles and Kyknos, metope of the Athenian Treasury
Delphi Museum
(Cf. pp. 43, 102)

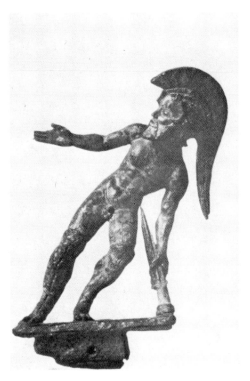

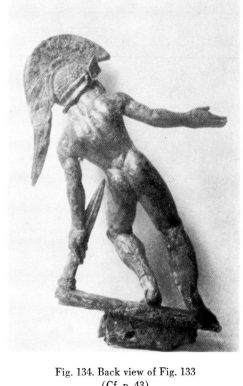

Fig. 133. Bronze statuette of Ajax
Museo Archeologico, Florence
(Cf. p. 43)

Fig. 134. Back view of Fig. 133
(Cf. p. 43)

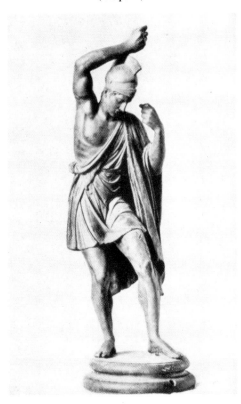

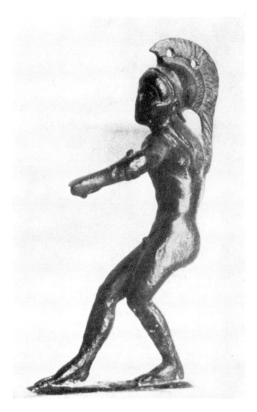

Fig. 135. Bronze statuette of a warrior
Musée Saint Germain-en-Laye
(Cf. pp. 43, 180)

Fig. 136. Bronze statuette of a falling warrior
Museo Civico, Modena
(Cf. pp. 43, 180)

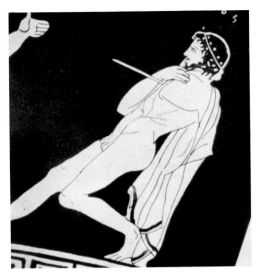

Fig. 137. Tityos, from a red-figured krater
Metropolitan Museum of Art
(Cf. pp. 43, 85)

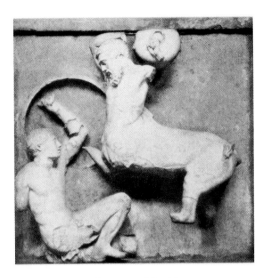

Fig. 138. Centaur and Lapith, metope
of the Parthenon
British Museum, London
(Cf. p. 44)

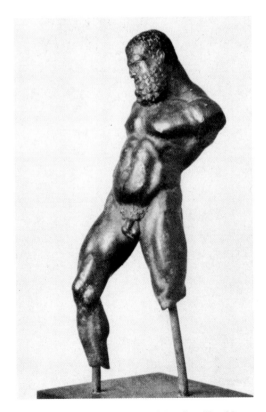

Fig. 139. Bronze statuette of drunken Herakles
Metropolitan Museum of Art
(Cf. p. 43)

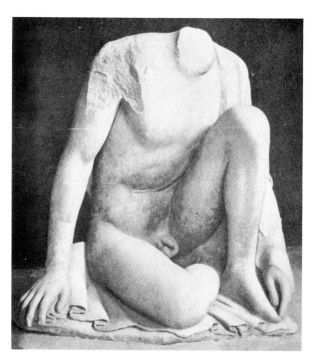

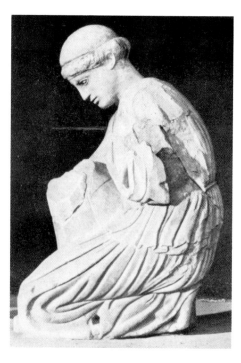

Fig. 140. Crouching figure, from the eastern
pediment at Olympia
Olympia Museum
(Cf. p. 44)

Fig. 141. Crouching figure, from the eastern
pediment at Olympia
Olympia Museum
(Cf. p. 44)

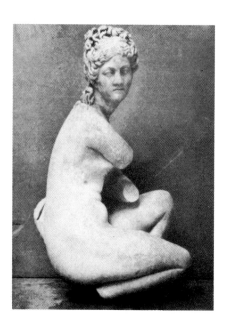

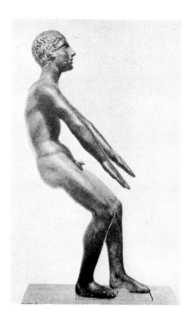

Fig. 142. Crouching Aphrodite
Ostia Museum
(Cf. pp. 44, 234)

Fig. 143. Bronze statuette of a youth
finishing a jump (?)
Metropolitan Museum of Art
(Cf. p. 44)

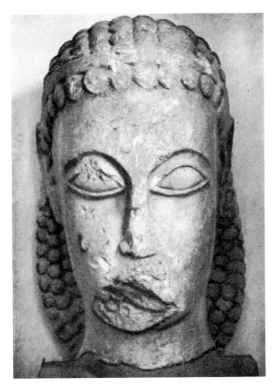

Fig. 144. Head from the Dipylon
National Museum, Athens
(Cf. p. 45)

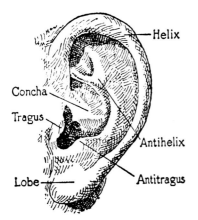

Fig. 145. Details of ear and eye
Drawn by L. F. Hall
(Cf. p. 45)

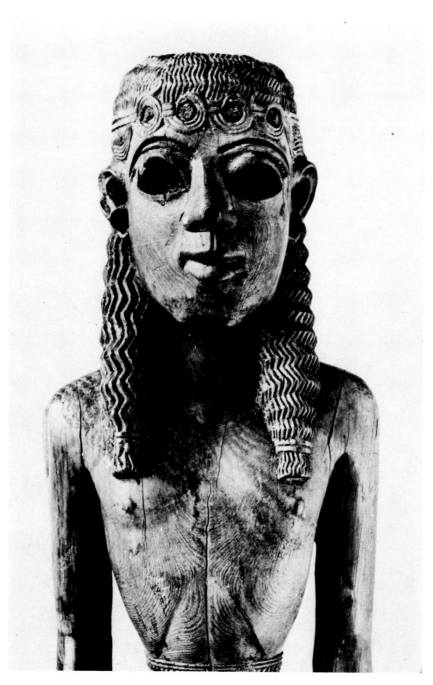

Fig. 146. Upper part of an ivory statuette
Museum of Vathy, Samos
(Cf. p. 45)

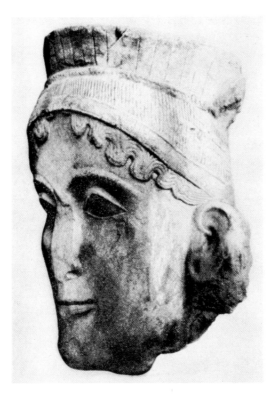

Fig. 147. Head of Hera
Olympia Museum
(Cf. p. 45)

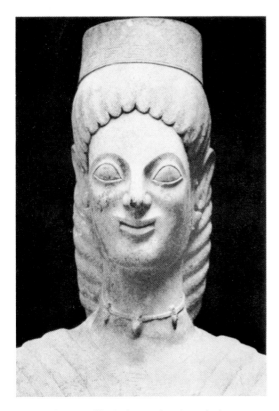

Fig. 148. Head of a maiden, from Attica
Staatliche Museen, Berlin
(Cf. pp. 45, 47)

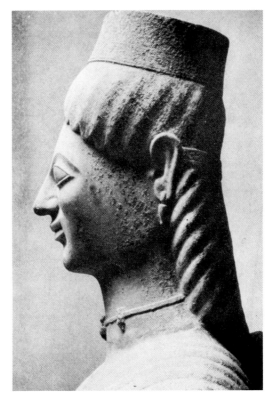

Fig. 149. Profile view of Fig. 148
(Cf. pp. 45, 47)

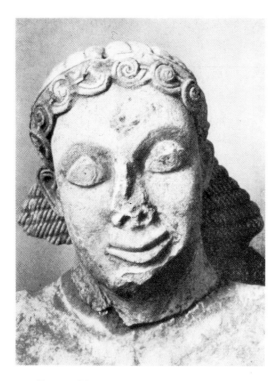

Fig. 150. Head of Chrysaor, from the western
pediment at Corfu
Corfu Museum
(Cf. p. 45)

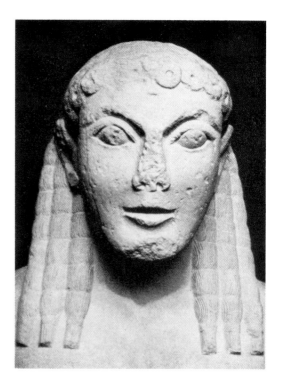

Fig. 151. Head of Kleobis (from a cast)
Delphi Museum
(Cf. p. 45)

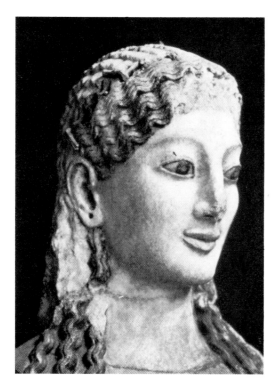

Fig. 152. Head of a maiden
No. 679, Akropolis Museum, Athens
(Cf. pp. 46, 47)

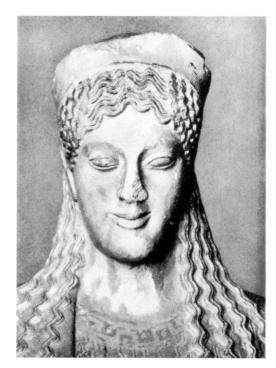

Fig. 153. Head of a maiden (from a cast)
No. 680, Akropolis Museum, Athens
(Cf. p. 47)

Fig. 154. Back of the head of
Kleobis (from a cast)
Delphi Museum
(Cf. p. 46)

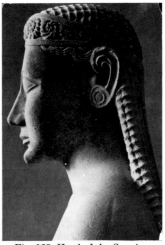

Fig. 155. Head of the Sounion
kouros
National Museum, Athens
(Cf. pp. 46, 47)

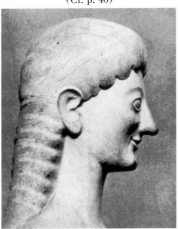

Fig. 156. Head of the kouros
from Tenea (from a cast)
The Glyptothek, Munich
(Cf. p. 47)

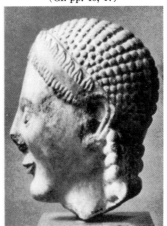

Fig. 157. Head of a kouros
from near Sounion
Metropolitan Museum of Art
(Cf. p. 46)

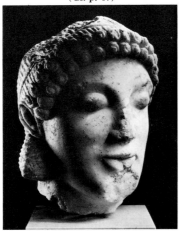

Fig. 158. Head of a kouros
William Rockhill Nelson Collection,
Kansas City
(Cf. p. 47)

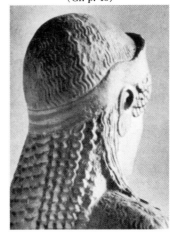

Fig. 159. Head of a maiden
(from a cast)
No. 680, Akropolis Museum, Athens
(Cf. p. 47)

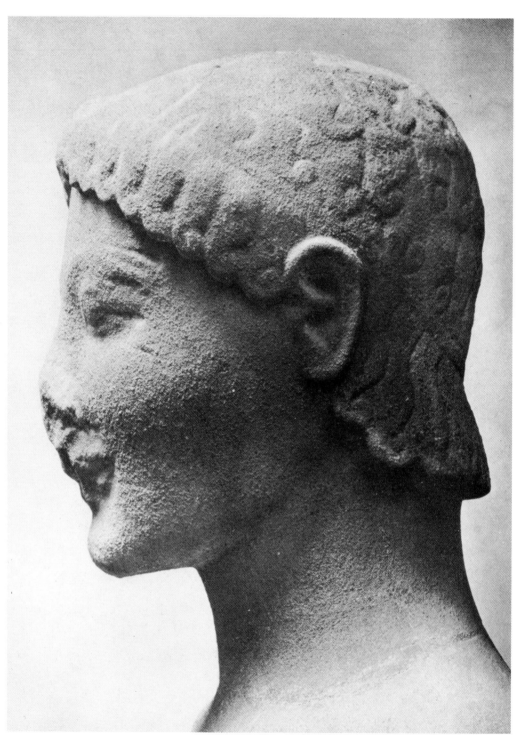

Fig. 160. Head of the kouros from Attica
The Glyptothek, Munich
(Cf. p. 47)

Fig. 161. Head of Chrysaor, from the
western pediment at Corfu
Corfu Museum
(Cf. p. 47)

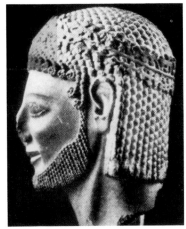

Fig. 162. "Rampin head"
The Louvre, Paris
(Cf. p. 47)

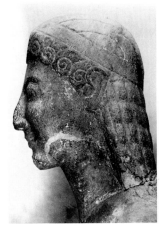

Fig. 163. Head of a kouros from Thera
National Museum, Athens
(Cf. pp. 45, 47)

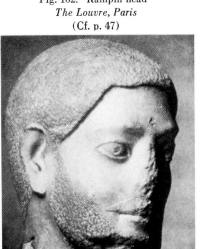

Fig. 164. Head of a man
Staatliche Museen, Berlin
(Cf. p. 47)

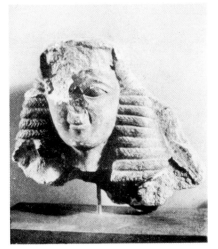

Fig. 165. Terracotta head of a woman,
antefix from a temple at Metaurum
Metropolitan Museum of Art
(Cf. p. 47)

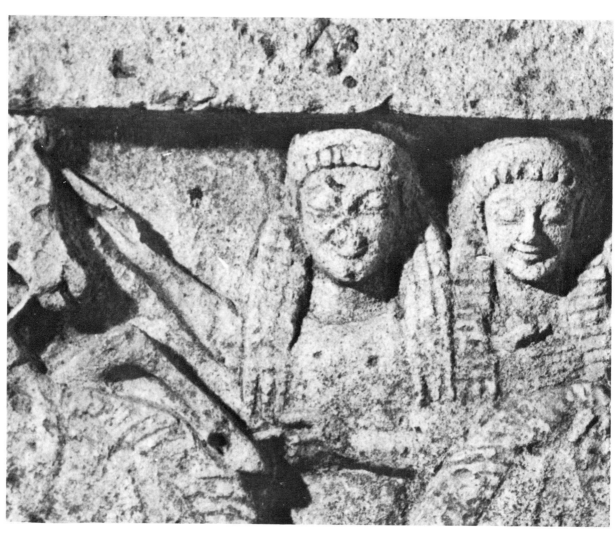

Fig. 166. Detail of a chariot group on a metope from Selinus
Palermo Museum
(Cf. p. 47)

Fig. 167. Head of a youth
Metropolitan Museum of Art
(Cf. pp. 47, 48)

Fig. 168. Head of "La Boudeuse" (from a cast)
No. 686, Akropolis Museum, Athens
(Cf. p. 48)

Fig. 169. Demareteion, from an electrotype of
a coin of Syracuse
British Museum, London
(Cf. p. 48)

Fig. 170. Head of a seated goddess
Staatliche Museen, Berlin
(Cf. p. 48)

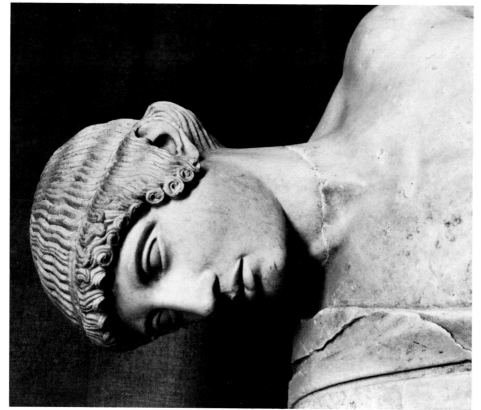

Fig. 172. Head of Apollo, from the western pediment at Olympia
Olympia Museum
(Cf. pp. 32, 48)

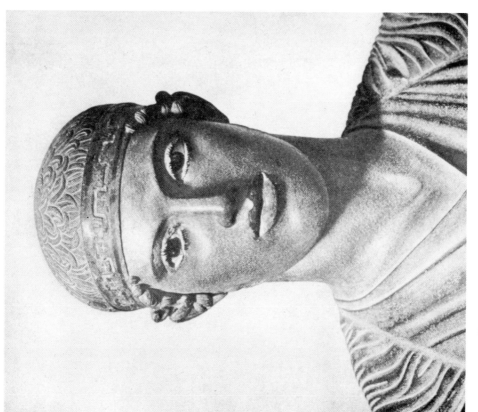

Fig. 171. Head of the bronze statue of a charioteer
Delphi Museum
(Cf. p. 48)

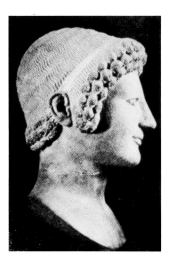 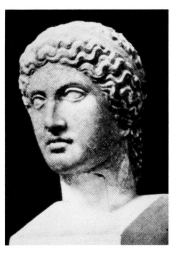 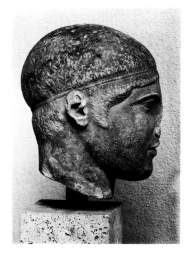

Fig. 173. Head of a youth
(from a cast)
Barracco Museum, Rome
(Cf. p. 48)

Fig. 174. Head from the Argive
Heraion
National Museum, Athens
(Cf. pp. 48, 51)

Fig. 175. Head of a youth
Museo Bresciano, Brescia
(Cf. p. 48)

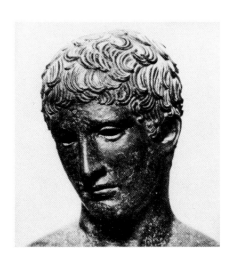 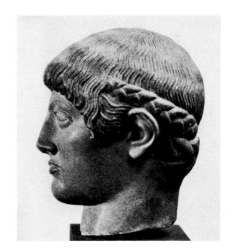

Fig. 176. Head of a bronze statue, the Idolino
Museo Archeologico, Florence
(Cf. p. 48)

Fig. 177. Head of the "blond boy"
(from a cast)
No. 689, Akropolis Museum, Athens
(Cf. p. 48)

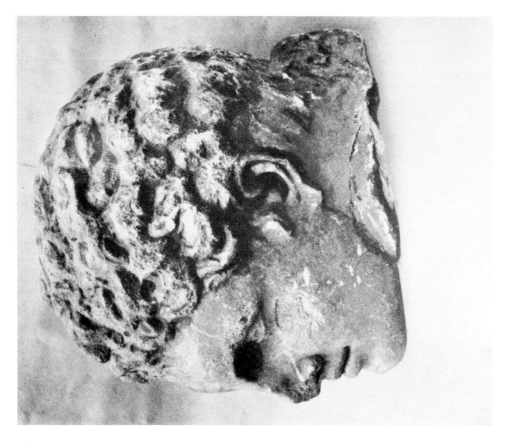

Fig. 179. Head from a relief
Metropolitan Museum of Art
(Cf. pp. 49, 213)

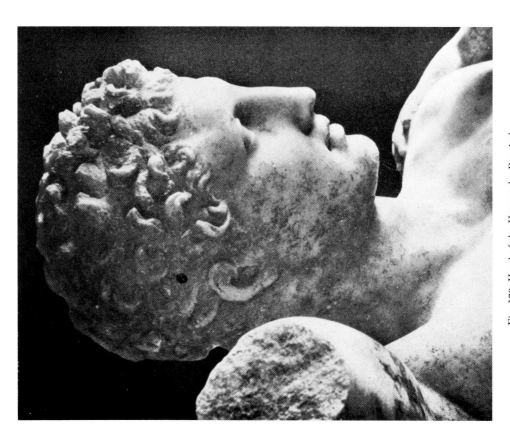

Fig. 178. Head of the Hermes by Praxiteles
Olympia Museum
(Cf. pp. 49, 53, 199)

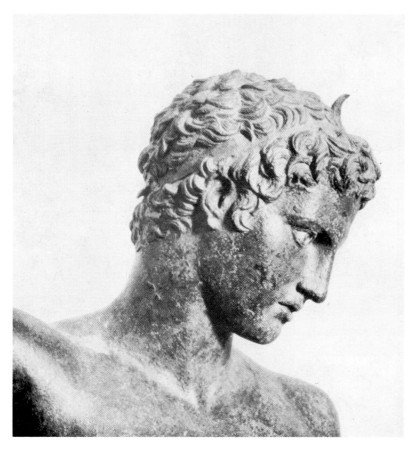

Fig. 180. Head of the bronze statue of a youth, found in the Bay of Marathon
National Museum, Athens
(Cf. p. 49)

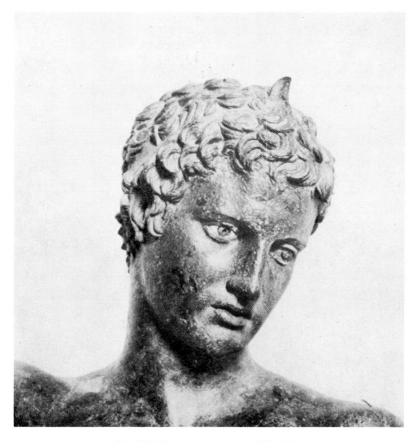

Fig. 181. Three-quarters view of Fig. 180
(Cf. p. 49)

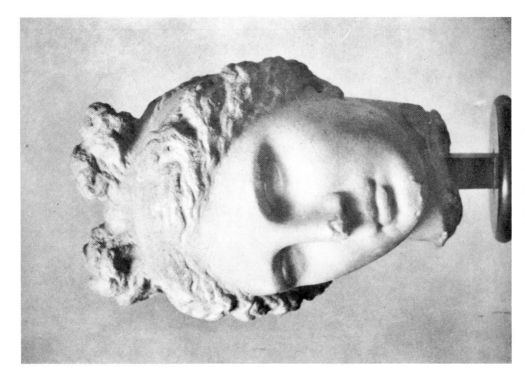

Fig. 183. The "Bartlett head"
Museum of Fine Arts, Boston
(Cf. pp. 49, 53)

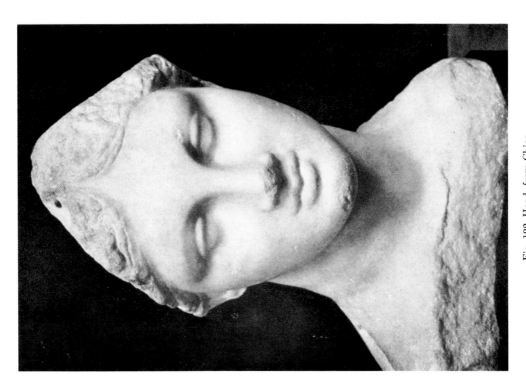

Fig. 182. Head, from Chios
Museum of Fine Arts, Boston
(Cf. pp. 49, 53, 206)

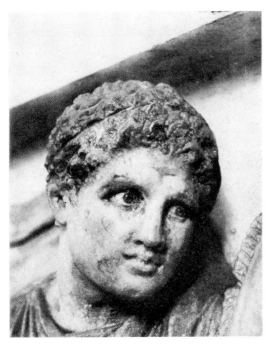

Fig. 184. Head of Alexander, from the
Alexander sarcophagus
Istanbul Museum
(Cf. p. 49)

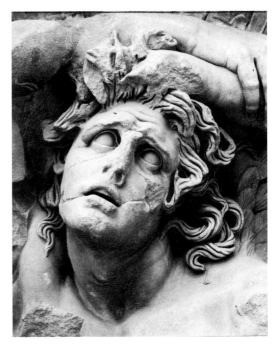

Fig. 185. Head of a giant, from the frieze of the
great altar at Pergamon
Pergamon Museum, Berlin
(Cf. p. 49)

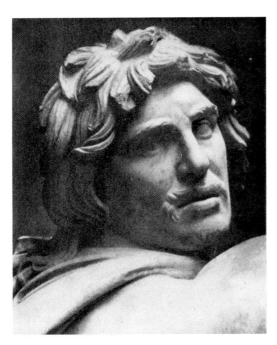

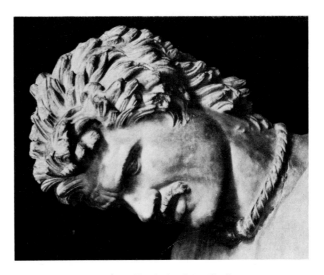

Fig. 187. Head of a dying Gaul
Capitoline Museum, Rome
(Cf. p. 49)

Fig. 186. Head of a Gaul
Museo Nazionale delle Terme, Rome
(Cf. p. 49)

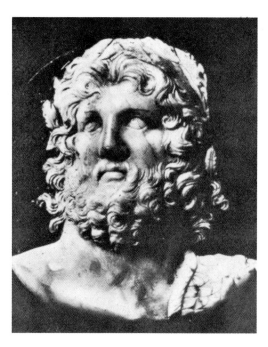

Fig. 188. Head of Zeus, on a cameo
Museo Archeologico, Venice
(Cf. p. 49)

Fig. 189. Head of Medusa
Akropolis Museum, Athens
(Cf. p. 50)

Fig. 190. Head of a giant, from a metope
of temple F at Selinus
Museo Nazionale, Palermo
(Cf. p. 50)

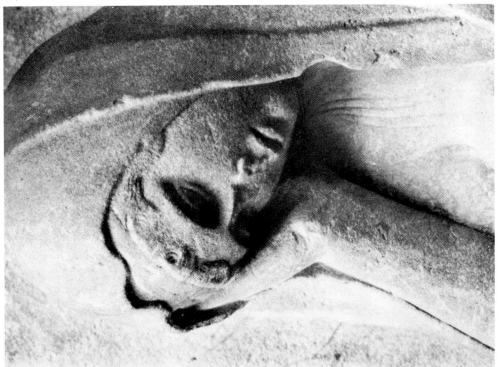

Fig. 192. Head of a mourning woman, from a relief
Museum of Fine Arts, Boston
(Cf. p. 50)

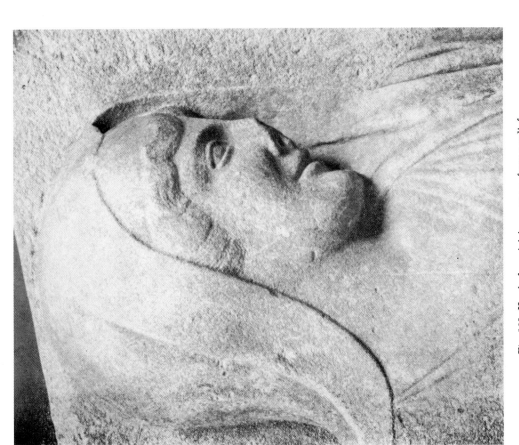

Fig. 191. Head of a rejoicing woman, from a relief
Museum of Fine Arts, Boston
(Cf. p. 50)

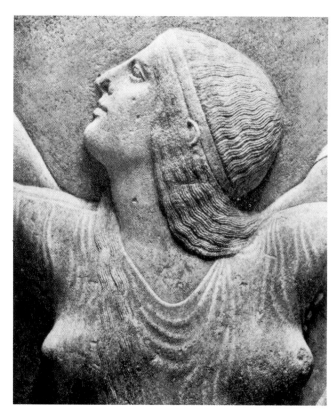

Fig. 193. Head of Aphrodite, from a relief
Museo Nazionale delle Terme, Rome
(Cf. p. 50)

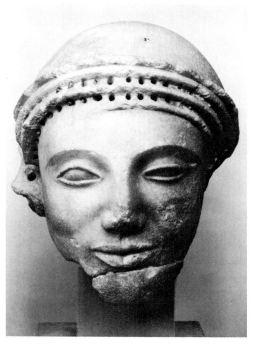

Fig. 194. Head of a dying warrior, from the
eastern pediment at Aigina
The Glyptothek, Munich
(Cf. p. 50)

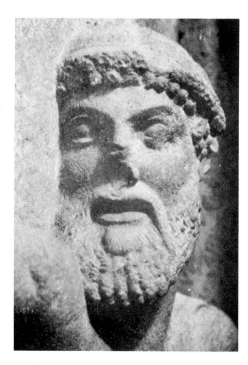

Fig. 195. Head of Zeus, from a metope of
temple E at Selinus
Museo Nazionale, Palermo
(Cf. p. 50)

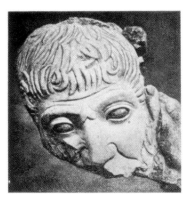

Fig. 196. Head of a centaur, from the
western pediment at Olympia
Olympia Museum
(Cf. p. 50)

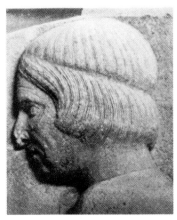

Fig. 197. Head of an old woman
from a relief
Museum of Fine Arts, Boston
(Cf. p. 51)

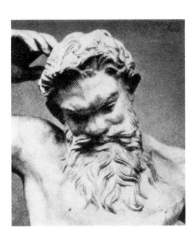

Fig. 198. Head of Marsyas
(from a cast)
British Museum, London
(Cf. p. 50)

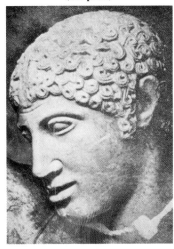

Fig. 199. Head of a Lapith, from the
western pediment at Olympia
Olympia Museum
(Cf. p. 50)

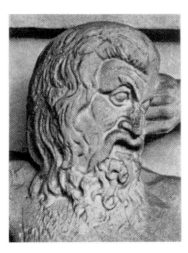

Fig. 200. Head of a centaur, from a
Parthenon metope (from a cast)
British Museum, London
(Cf. p. 52)

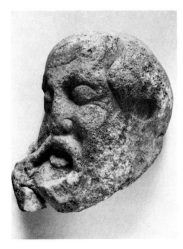

Fig. 201. Head of Eurystheus, from a metope
In situ in the Hephaisteion, Athens
(Cf. p. 52)

Fig. 202. Head of an old warrior
from a krater
Metropolitan Museum of Art
(Cf. p. 51)

Fig. 203. Old woman on a vase
Schwerin
(Cf. p. 51)

Fig. 204. Head of a statue of the type of the "Cassel Apollo"
Palazzo Vecchio, Florence
(Cf. pp. 51, 165)

Fig. 205. Head of an athlete
Metropolitan Museum of Art
(Cf. pp. 51, 181)

Fig. 206. Head of the Niobid
Museo Nazionale delle Terme, Rome
(Cf. p. 51)

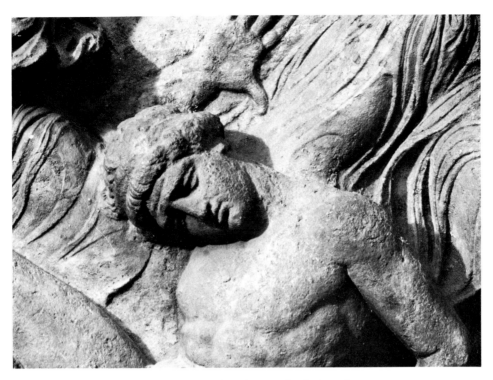

Fig. 207. Head of a collapsing Greek, from the
Phigaleia frieze
British Museum, London
(Cf. p. 51)

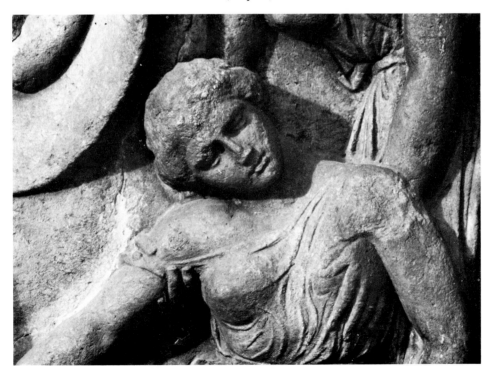

Fig. 208. Head of a dying Amazon, from the
Phigaleia frieze
British Museum, London
(Cf. p. 51)

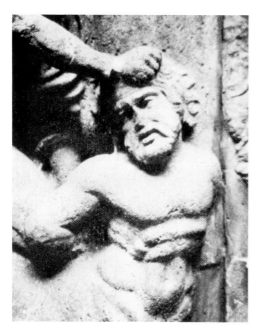

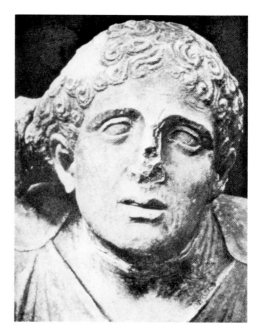

Fig. 209. Head of a centaur, from the
Phigaleia frieze
British Museum, London
(Cf. p. 52)

Fig. 210. Head of a woman, from the western
pediment at Olympia
Olympia Museum
(Cf. p. 52)

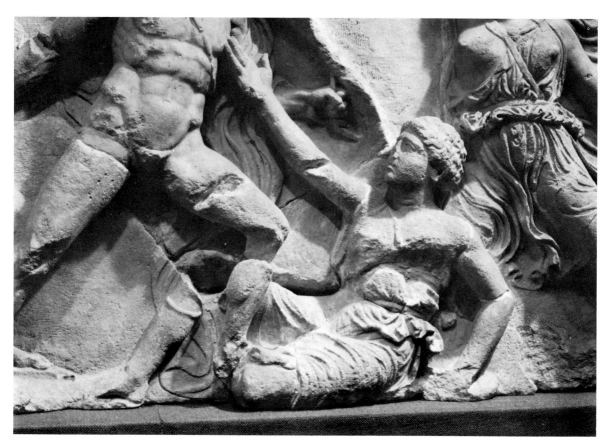

Fig. 211. Entreating Amazon, from the
Phigaleia frieze
British Museum, London
(Cf. p. 52)

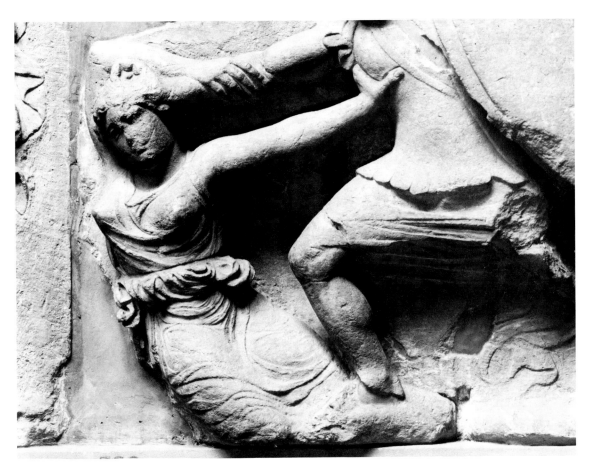

Fig. 212. Amazon defending herself, from
the Phigaleia frieze
British Museum, London
(Cf. p. 52)

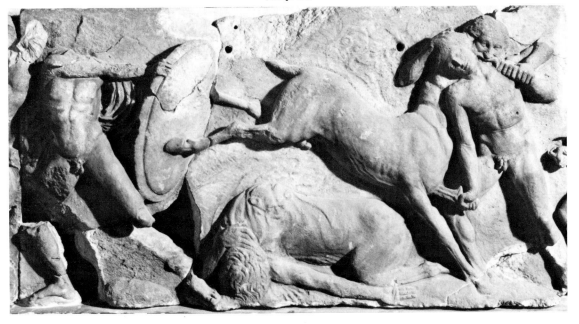

Fig. 213. Fallen centaur, from the
Phigaleia frieze
British Museum, London
(Cf. pp. 52, 87)

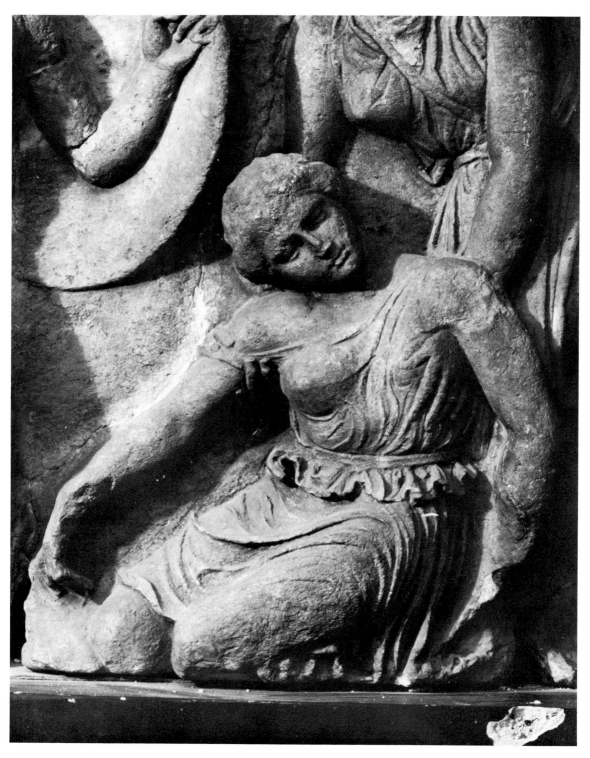

Fig. 214. Dying Amazon, from the
Phigaleia frieze
British Museum, London
(Cf. p. 52)

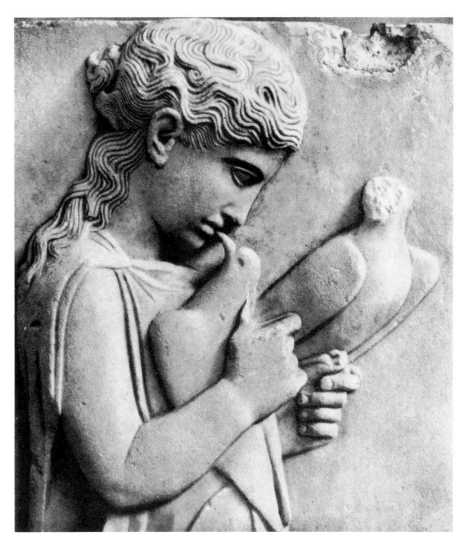

Fig. 215. Detail of a stele of a girl with pigeons
Metropolitan Museum of Art
(Cf. p. 53)

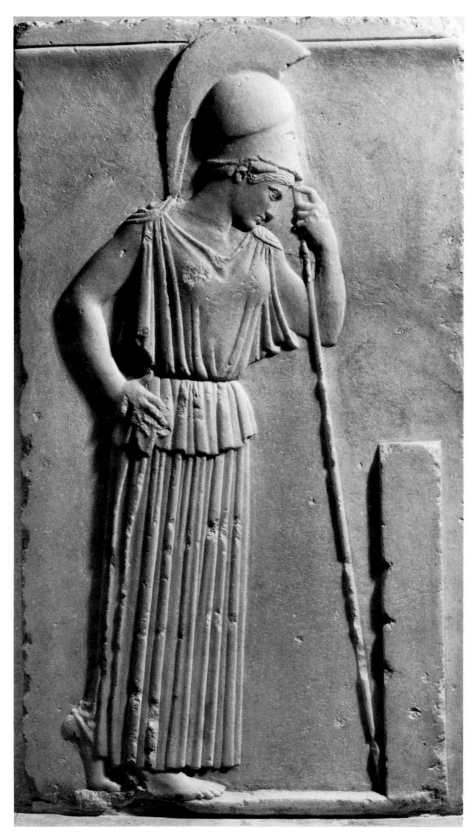

Fig. 216. "Mourning Athena"
Akropolis Museum, Athens
(Cf. pp. 52, 85, 144)

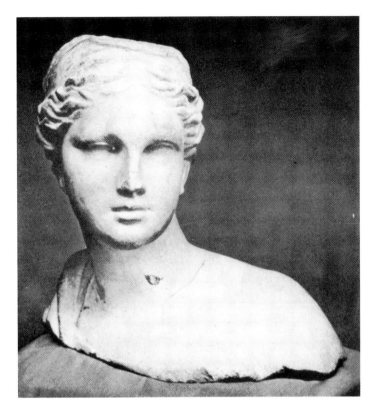

Fig. 217. Head of a girl
Museum of Toledo
(Cf. p. 53)

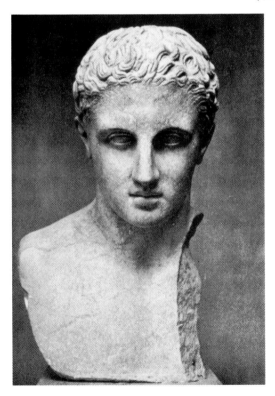

Fig. 218. Head of an athlete
Metropolitan Museum of Art
(Cf. p. 53)

Fig. 219. Head of an Amazon, from the
Mausoleum frieze
British Museum, London
(Cf. p. 53)

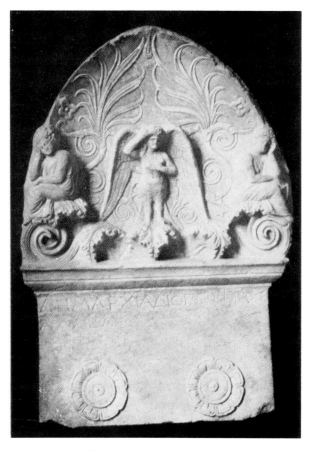

Fig. 220. Upper part of a stele
Staatliche Museen, Berlin
(Cf. p. 53)

Fig. 221. Bronze statuette of a mourning woman
Staatliche Museen, Berlin
(Cf. p. 52)

Fig. 222. Mourning woman, from Attica
Staatliche Museen, Berlin
(Cf. pp. 52f.)

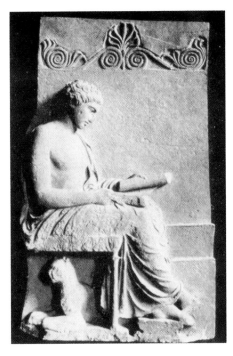

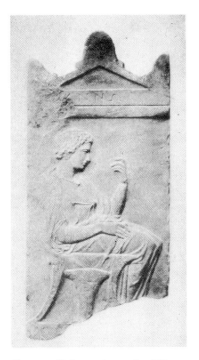

Fig. 223. Stele of a youth reading (from a cast)
Grottaferrata
(Cf. p. 54)

Fig. 224. Girl spinning, stele of Mynno
Staatliche Museen, Berlin
(Cf. p. 54)

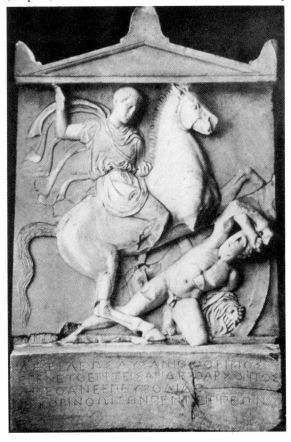

Fig. 225. Stele of Dexileos
Kerameikos Museum, Athens
(Cf. p. 54)

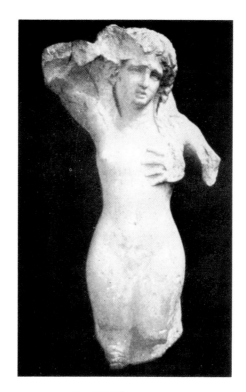

Fig. 226. Weeping siren
Museum of Fine Arts, Boston
(Cf. p. 54)

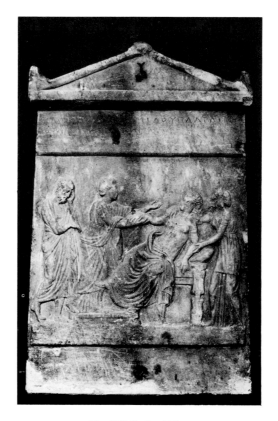

Fig. 227. Stele of Plangon
National Museum, Athens
(Cf. p. 54)

Fig. 229. Old market woman
Metropolitan Museum of Art
(Cf. pp. 54, 128)

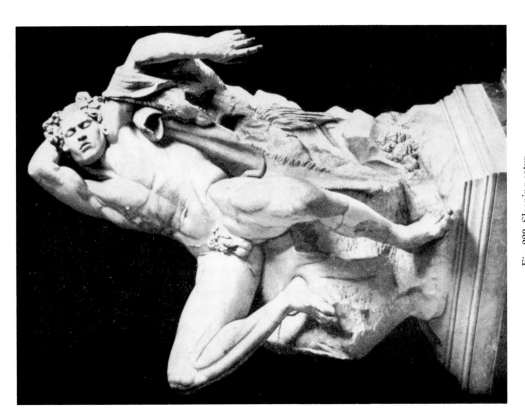

Fig. 228. Sleeping satyr
The Glyptothek, Munich
(Cf. p. 54)

Fig. 230. Terracotta statuette of a Negro boy
Ashmolean Museum, Oxford
(Cf. p. 54)

Fig. 231. Terracotta statuette of a flying Eros
Metropolitan Museum of Art
(Cf. p. 54)

Fig. 232. Terracotta statuette
of an old nurse
Metropolitan Museum of Art
(Cf. p. 54)

Fig. 233. Bronze caricature
Metropolitan Museum of Art
(Cf. p. 55)

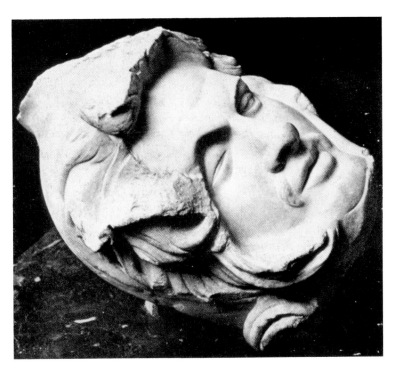

Fig. 234. Head of a dying Persian
Museo Nazionale delle Terme, Rome
(Cf. pp. 55, 234)

Fig. 235. Portrait of a man on an engraved gem signed by Dexamenos
Museum of Fine Arts, Boston
(Cf. p. 55)

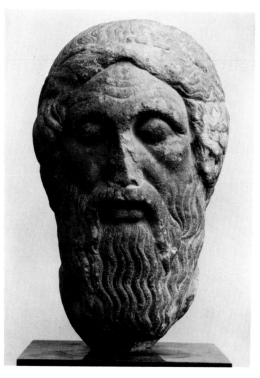

Fig. 236. Head of Homer
The Glyptothek, Munich
(Cf. p. 55)

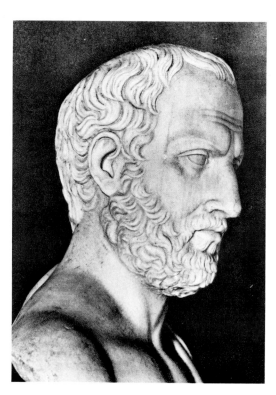

Fig. 237. Head of Thucydides
Holkham Hall
(Cf. p. 55)

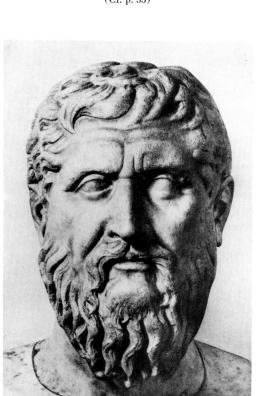

Fig. 238. Head of Plato
Holkham Hall
(Cf. p. 55)

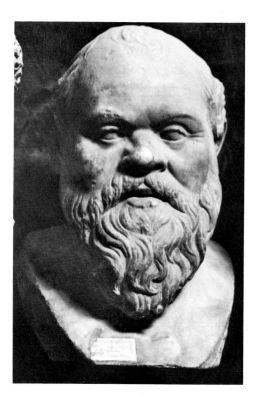

Fig. 239. Head of Sokrates, type A
National Museum, Naples
(Cf. p. 55)

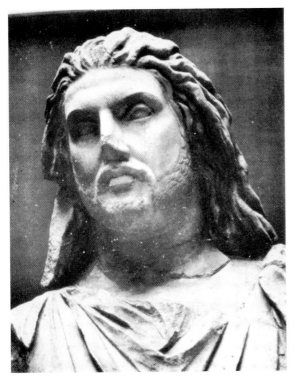

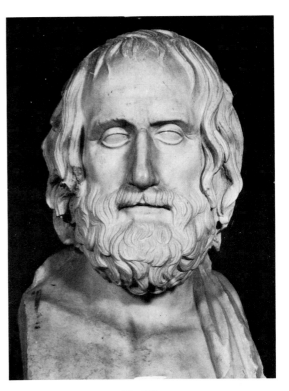

Fig. 240.
Head of Maussollos
British Museum, London
(Cf. p. 55)

Fig. 241.
Head of Euripides
The Vatican, Rome
(Cf. p. 55)

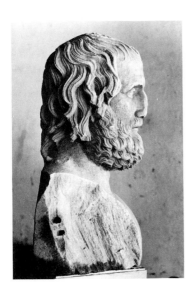

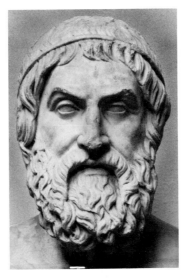

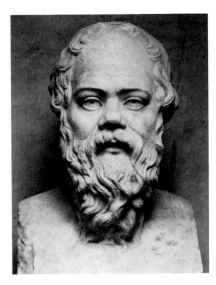

Fig. 242. Head of Euripides
Antiquario, Lucus Feroniae
(Cf. p. 55)

Fig. 243. Head of Sophokles
British Museum, London
(Cf. p. 55)

Fig. 244. Head of Sokrates, type B
The Vatican, Rome
(Cf. p. 55)

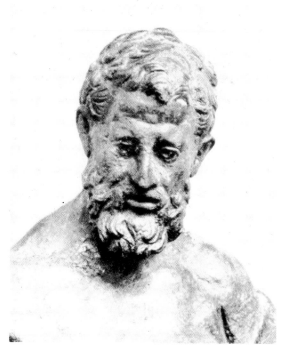

Fig. 245. Head of bronze portrait statuette
Metropolitan Museum of Art
(Cf. p. 56)

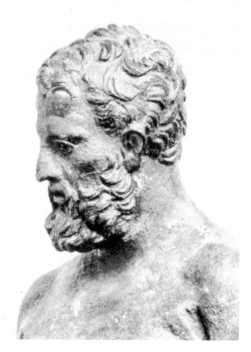

Fig. 246. Side view of Fig. 245
(Cf. p. 56)

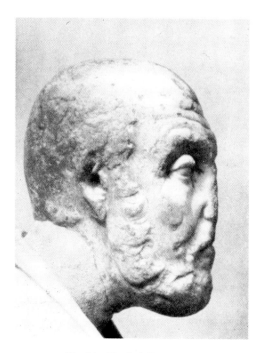

Fig. 247. Head of Chrysippos
Metropolitan Museum of Art
(Cf. p. 56)

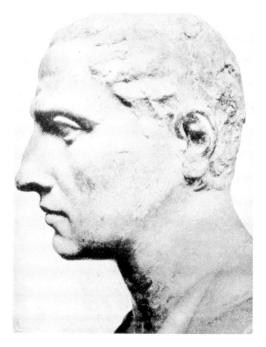

Fig. 248. Portrait head
Lord Melchett's Collection, London
(Cf. p. 56)

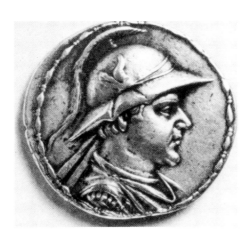

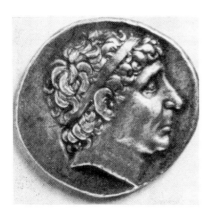

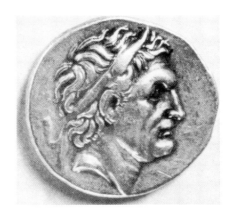

Fig. 249. Portrait of Demetrios, king of
Baktria, from a coin
American Numismatic Society, New York
(Cf. p. 56)

Fig. 250. Portrait of Philetairos, ruler of
Pergamon, from a coin
American Numismatic Society, New York
(Cf. p. 56)

Fig. 251. Portrait of Eukratides, king of Baktria and India, from a coin
American Numismatic Society, New York
(Cf. p. 56)

Fig. 252. Portrait of Antiochos I
Soter, king of Syria, from a coin
American Numismatic Society, New York
(Cf. p. 56)

Fig. 253. Portrait of Seleukos I, king
of Syria, from a coin
American Numismatic Society, New York
(Cf. p. 56)

Enlarged *c.* 1:2
(Cf. p. 56)

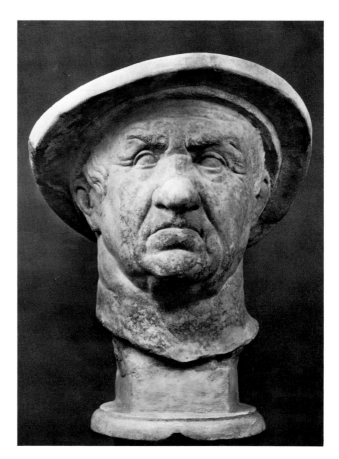

Fig. 254. Head of Euthydemos I of Baktria
Albani Collection, Rome
(Cf. p. 56)

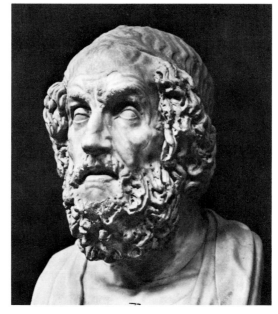

Fig. 255. Head of Homer
National Museum, Naples
(Cf. p. 56)

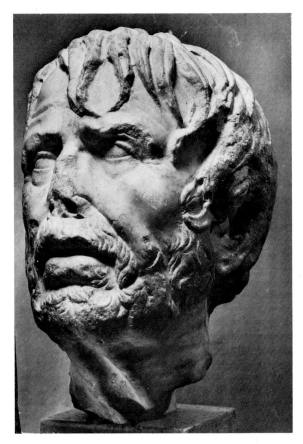

Fig. 256. Head of Pseudo Seneca
Bardo Museum, Tunis
(Cf. p. 56)

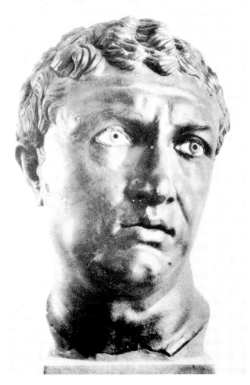

Fig. 257. Bronze portrait head
National Museum, Athens
(Cf. p. 56)

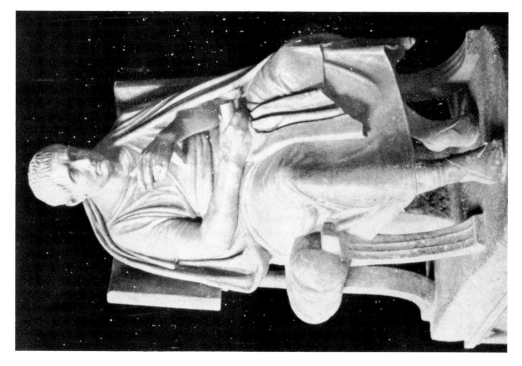

Fig. 259. Statue of Poseidippos
The Vatican, Rome
(Cf. p. 56)

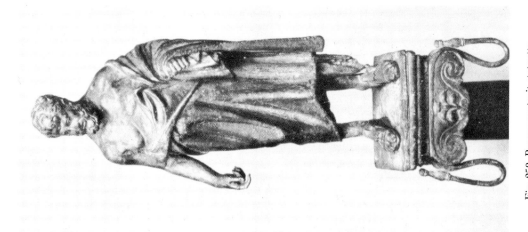

Fig. 258. Bronze portrait statuette
Metropolitan Museum of Art
(Cf. p. 56)

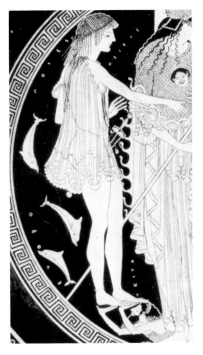

Fig. 260. Theseus, from a kylix
The Louvre, Paris
(Cf. p. 58)

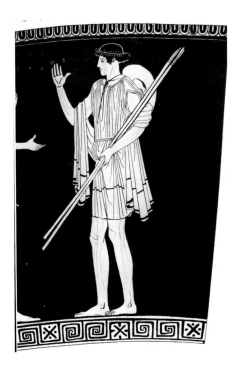

Fig. 261. Youth on a vase
Metropolitan Museum of Art
(Cf. p. 58)

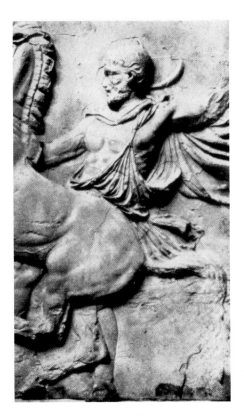

Fig. 262. Detail of the Parthenon frieze
(from a cast)
In situ in Athens
(Cf. p. 58)

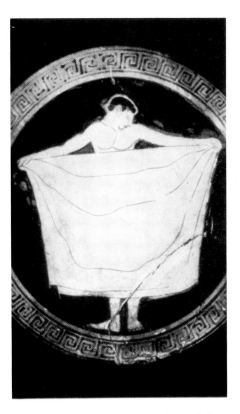

Fig. 263. Boy holding himation, from a kylix
Staatliche Museen, Berlin
(Cf. p. 58)

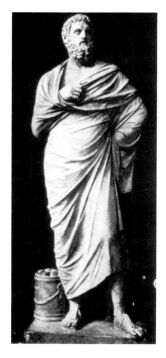

Fig. 264. Sophokles
The Lateran Collection, Rome
(Cf. pp. 56, 58, 73)

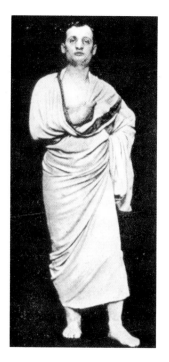

Fig. 265. Living model wearing
himation
(Cf. p. 58)

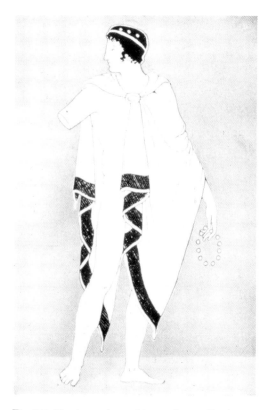

Fig. 266. Youth wearing a chlamys, from a Greek vase
(Cf. pp. 58, 59)

Fig. 267. Living model wearing a chlamys
(Cf. p. 59)

Fig. 268. Detail of a kylix
British Museum, London
(Cf. p. 59)

Fig. 269. Bronze mirror support
Museum of Fine Arts, Boston
(Cf. p. 59)

Fig. 270. Terracotta statuette
Metropolitan Museum of Art
(Cf. pp. 59, 70)

Fig. 271. Back of the Hestia
Giustiniani (from a cast)
Museo Torlonia, Rome
(Cf. p. 60)

Fig. 272. Grave relief of Myttion
Broom Hall, Dunfermline, Scotland
(Cf. p. 60)

Fig. 273. Amazon, from an oinochoe
Metropolitan Museum of Art
(Cf. p. 60)

Fig. 274. Bronze statue of a
dancing girl
Museo Nazionale, Naples
(Cf. pp. 61, 64)

Fig. 275. Living model wearing a
peplos
(Cf. p. 61)

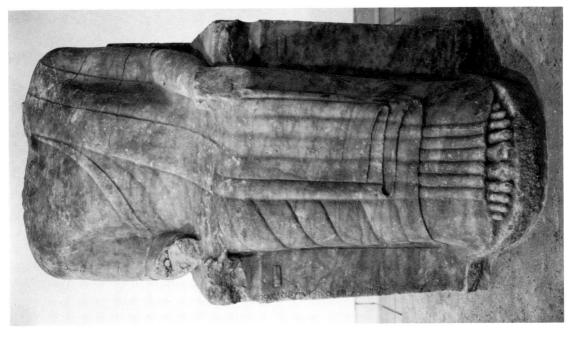

Fig. 278. Chares, from Branchidai
British Museum, London
(Cf. pp. 62, 63)

Fig. 277. Statue dedicated by
Nikandre at Delos
National Museum, Athens
(Cf. p. 61)

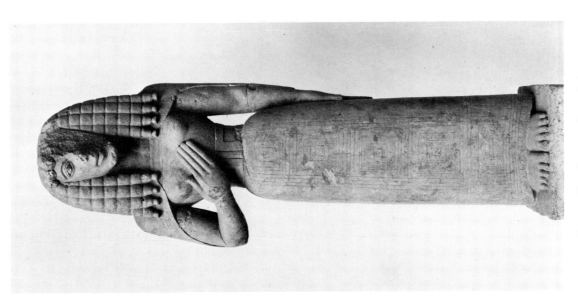

Fig. 276. Female statue, formerly in
Auxerre
The Louvre, Paris
(Cf. pp. 61, 63)

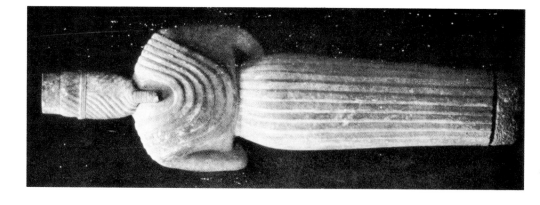

Fig. 281. Back view of Fig. 279
(Cf. pp. 62, 147)

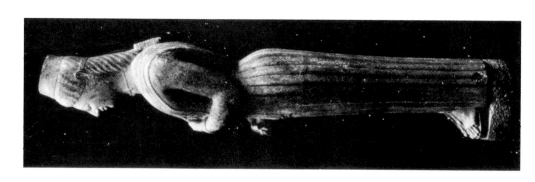

Fig. 280. Side view of Fig. 279
(Cf. pp. 62, 147)

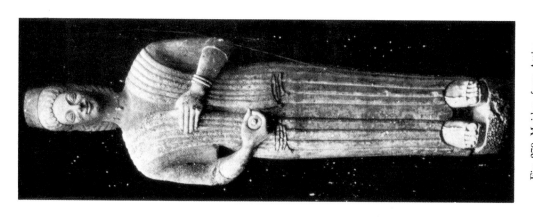

Fig. 279. Maiden, from Attica
Staatliche Museen, Berlin
(Cf. pp. 62, 147)

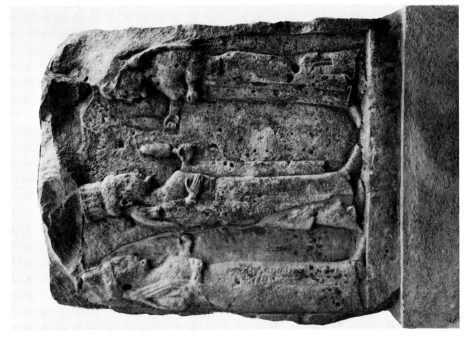

Fig. 283. Metope from Selinus
Museo Nazionale, Palermo
(Cf. p. 62)

Fig. 282. Statue of Philippe by Geneleos
Vathy Museum, Samos
(Cf. p. 62)

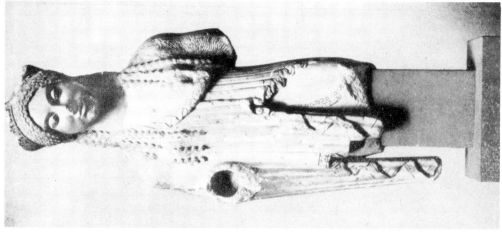

Fig. 285. Maiden (from a colored cast)
No. 680, Akropolis Museum, Athens
(Cf. pp. 60, 62, 126, 143, 147)

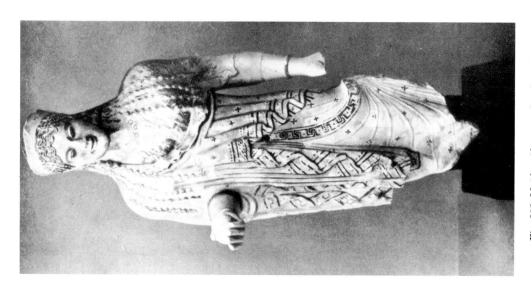

Fig. 286. Maiden (from a colored cast)
No. 674, Akropolis Museum, Athens
(Cf. pp. 60, 62, 123, 126, 143, 147)

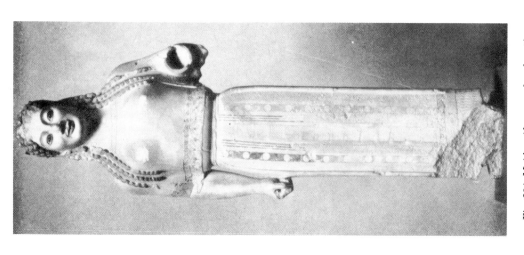

Fig. 284. Maiden (from a colored cast)
No. 679, Akropolis Museum, Athens
(Cf. pp. 123, 126, 147)

Fig. 287. Maiden, perhaps by
Antenor
Akropolis Museum, Athens
(Cf. pp. 60, 62, 124, 143, 152)

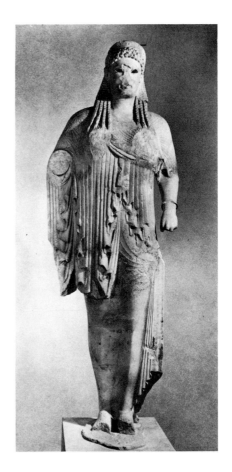

Fig. 288. Back of a maiden, from Paros
Metropolitan Museum of Art
(Cf. p. 62)

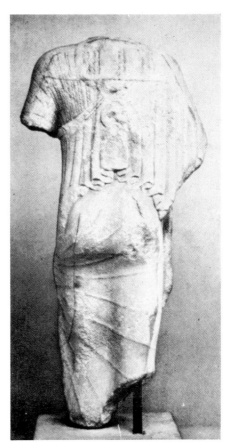

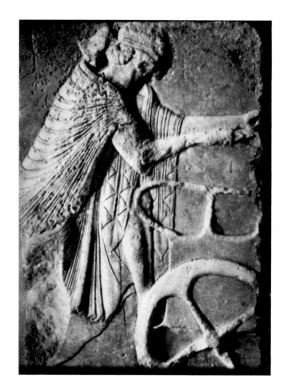

Fig. 289. Relief of a charioteer
Akropolis Museum, Athens
(Cf. pp. 62, 63, 83)

Fig. 290. Relief of Hermes
Akropolis Museum, Athens
(Cf. pp. 62f.)

Fig. 291. Detail of an amphora
Metropolitan Museum of Art
(Cf. p. 63)

Fig. 292. Detail of an oinochoe
Metropolitan Museum of Art
(Cf. p. 63)

Fig. 293. Detail of an amphora
Museum für antike Kleinkunst, Munich
(Cf. p. 63)

Fig. 294. Scene from an alabastron
British Museum, London
(Cf. p. 63)

Fig. 295. Athena, from Eretria
Chalkis Museum
(Cf. p. 64)

Fig. 296. Peleus and Thetis, from a kylix
Staatliche Museen, Berlin
(Cf. p. 64)

Fig. 297. Relief, from a statue base found in Athens
National Museum, Athens
(Cf. pp. 63, 78, 84, 127)

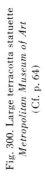

Fig. 300. Large terracotta statuette
Metropolitan Museum of Art
(Cf. p. 64)

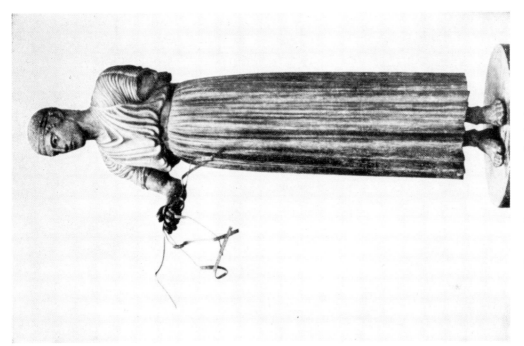

Fig. 299. Bronze statue of a charioteer
Delphi Museum
(Cf. pp. 58, 64)

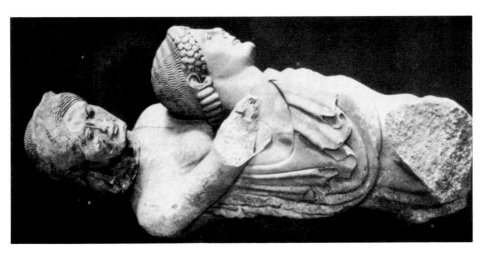

Fig. 298. Theseus and Antiope, from Eretria
Chalkis Museum
(Cf. pp. 64, 65)

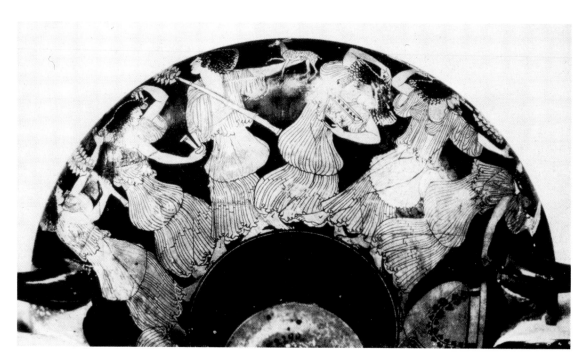

Fig. 301. Maenads, on a kylix
Staatliche Museen, Berlin
(Cf. pp. 64, 139)

Fig. 302. Detail of a kylix
Metropolitan Museum of Art
(Cf. pp. 64, 65)

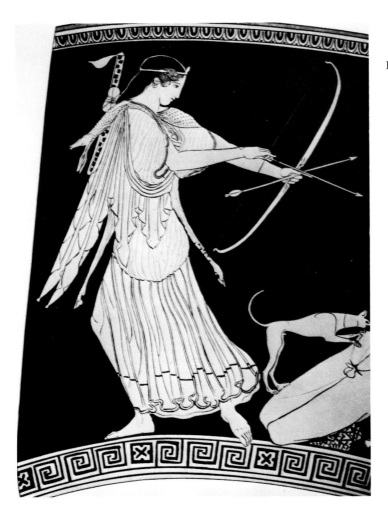

Fig. 303. Artemis and Aktaion, on a krater
Museum of Fine Arts, Boston
(Cf. p. 65)

Fig. 304. Detail from a relief
Museo Nazionale delle Terme, Rome
(Cf. p. 65)

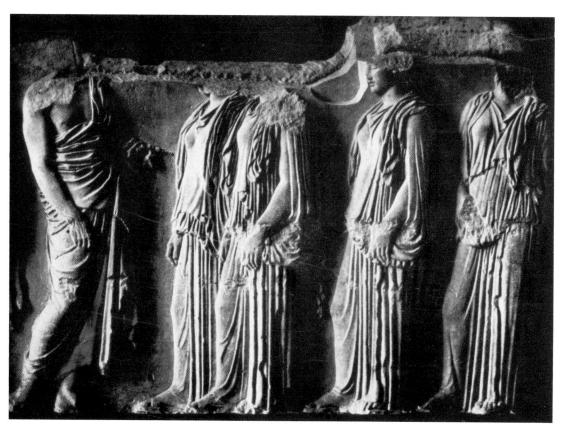

Fig. 305. Maidens marching in procession, from the Parthenon frieze
The Louvre, Paris
(Cf. pp. 65, 105, 177)

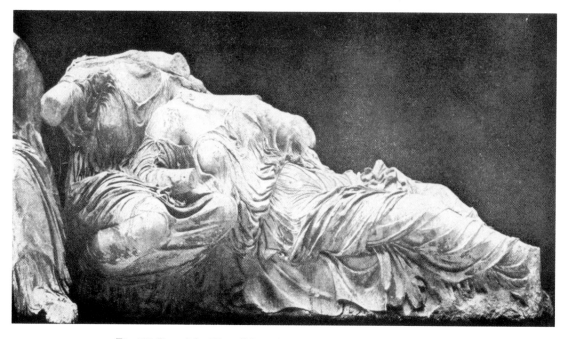

Fig. 306. Two of the "Fates," from the eastern pediment of the Parthenon
British Museum, London
(Cf. p. 66)

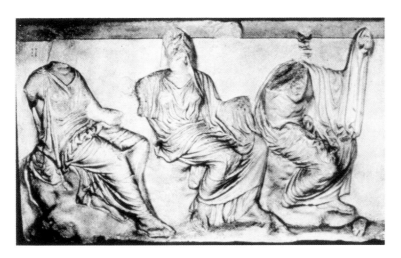

Fig. 307. Seated deities, from the frieze of the Hephaisteion (from a cast)
In situ
(Cf. pp. 66, 127)

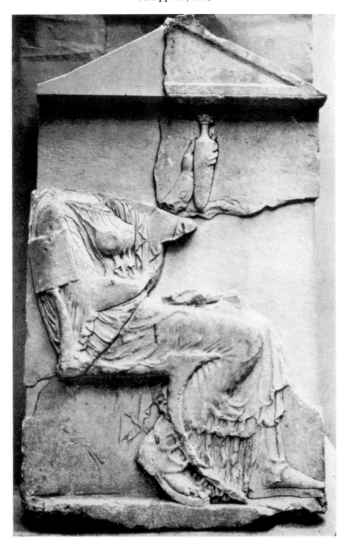

Fig. 308. Stele of a woman
Metropolitan Museum of Art
(Cf. p. 66)

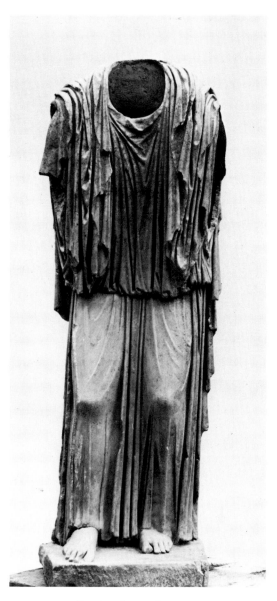

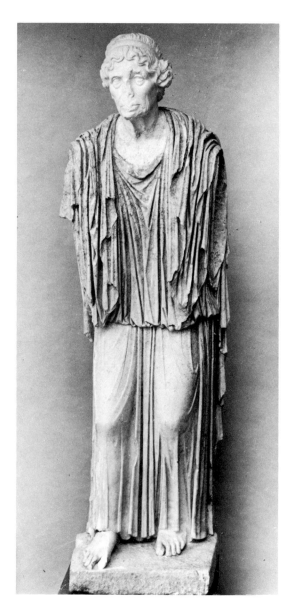

Fig. 309. Statue of a woman
Antikenmuseum, Basle
(Cf. p. 66)

Fig. 310. Fig. 309 with a cast of the head of Lysistrate inserted
(Cf. p. 66)

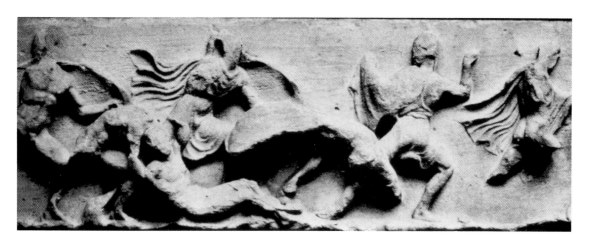

Fig. 311. Battle of the Greeks and Persians, from the frieze of the temple of Athena Nike
British Museum, London
(Cf. p. 68)

Fig. 312. Group from the frieze of the
Erechtheion
Akropolis Museum, Athens
(Cf. p. 67)

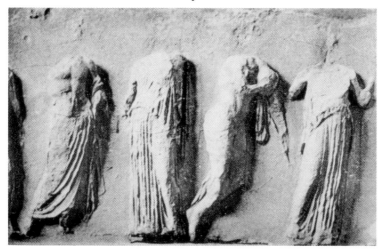

Fig. 313. Standing deities, from the frieze of the temple of Athena Nike
(from a cast)
In situ
(Cf. p. 68)

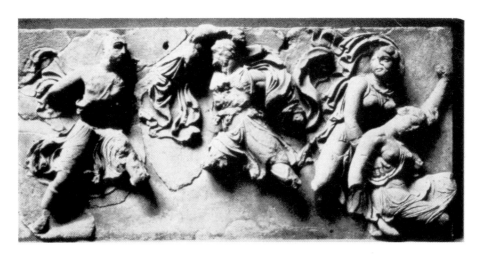

Fig. 314. Contest of Greeks and Amazons, from the Phigaleia frieze
British Museum, London
(Cf. pp. 68, 87, 106)

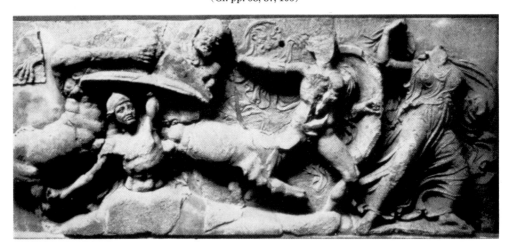

Fig. 315. Contest of centaurs and Lapiths, from the frieze shown in Fig. 314
British Museum, London
(Cf. pp. 68, 87, 106)

Fig. 316. Metope of the Phigaleia temple
British Museum, London
(Cf. pp. 68, 103)

Fig. 317. Metope of the Phigaleia temple
British Museum, London
(Cf. pp. 68, 103)

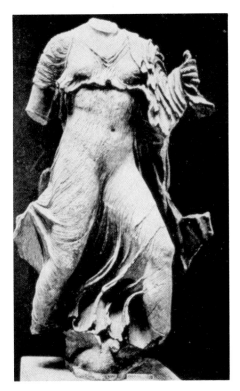

Fig. 318. Nereid from the Nereid monument
British Museum, London
(Cf. p. 69)

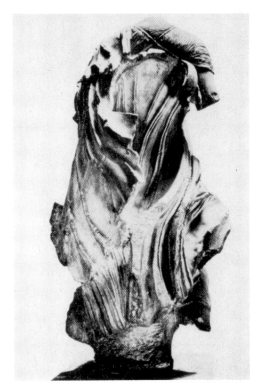

Fig. 319. Back view of Fig. 318
(Cf. p. 69)

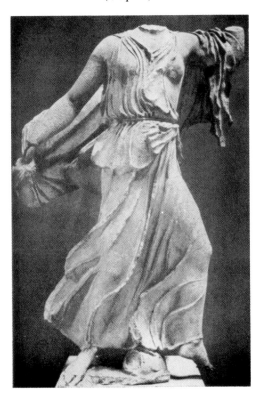

Fig. 320. Nereid from the Nereid monument
British Museum, London
(Cf. p. 69)

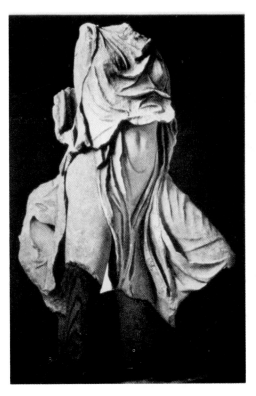

Fig. 321. "Nike," found on the Palatine
Museo Nazionale delle Terme, Rome
(Cf. p. 69)

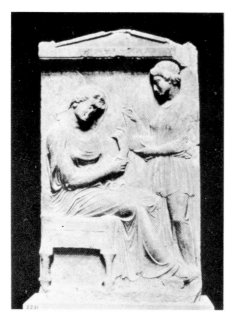

Fig. 322. Stele of Glykylla
British Museum, London
(Cf. pp. 69, 113)

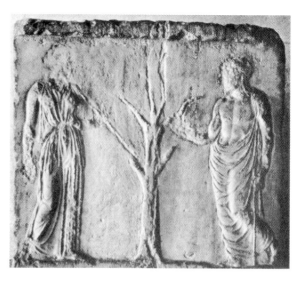

Fig. 323. "Record" relief
The Louvre, Paris
(Cf. p. 69)

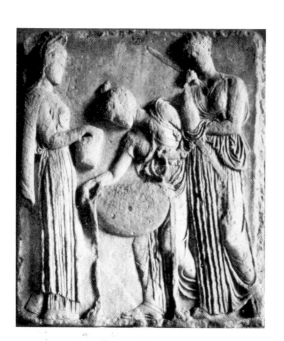

Fig. 324. Medea and the daughters of Pelias
The Lateran Collection, Rome
(Cf. p. 69)

Fig. 325. Amymone, on a lekythos
Metropolitan Museum of Art
(Cf. pp. 69, 88)

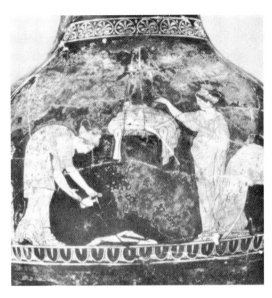

Fig. 326. Scene from an oinochoe
Metropolitan Museum of Art
(Cf. pp. 60, 69, 88)

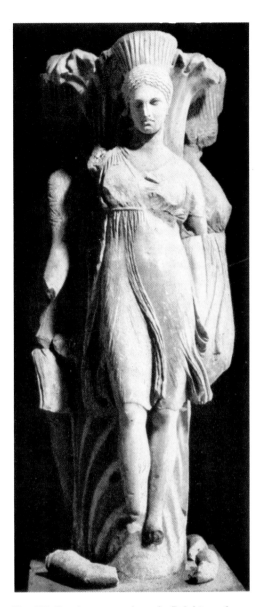

Fig. 327. Nymph, from a coin of Terina
(from a cast, enlarged)
Private Collection, Switzerland
(Cf. p. 69)

Fig. 329. Dancing women from the Delphian column
Delphi Museum
(Cf. p. 70)

Fig. 328. Aphrodite, from a silver coin of
Aphrodisias(?) (from a cast, enlarged)
British Museum, London
(Cf. p. 69)

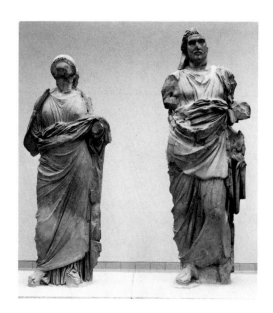

Fig. 330. Maussollos and Artemisia, from the Mausoleum
at Halikarnassos
British Museum, London
(Cf. pp. 70, 72, 208, 209)

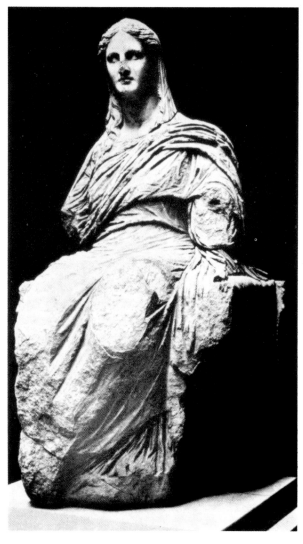

Fig. 331. Demeter, from Knidos
British Museum, London
(Cf. pp. 37, 70, 123)

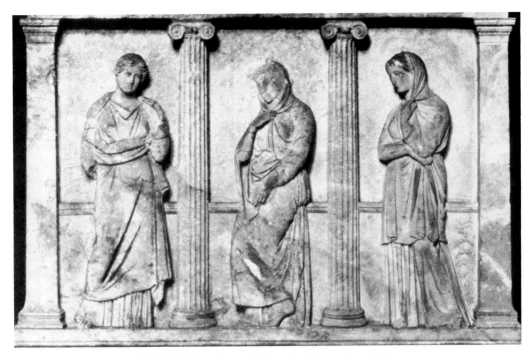

Fig. 332. Sarcophagus of Mourning Women, from Sidon
Archaeological Museum, Istanbul
(Cf. pp. 70, 106)

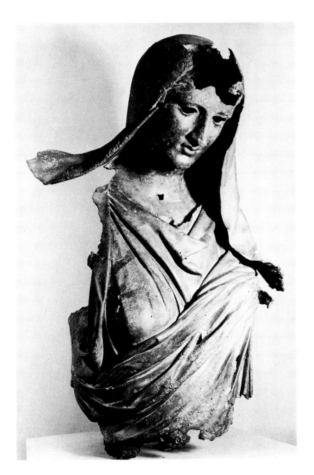

Fig. 333. Bronze statue of Demeter
Smyrna Museum
(Cf. p. 70)

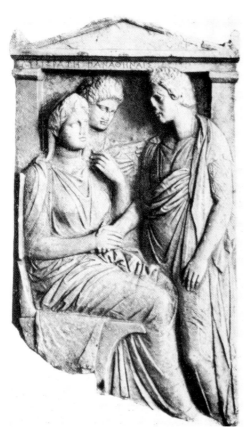

Fig. 334. Stele of Lysistrate
Metropolitan Museum of Art
(Cf. pp. 70, 88, 113)

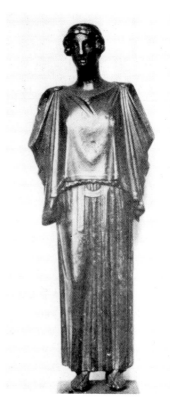

Fig. 335. Bronze statuette of a woman
Bibliothèque Nationale, Paris
(Cf. p. 71)

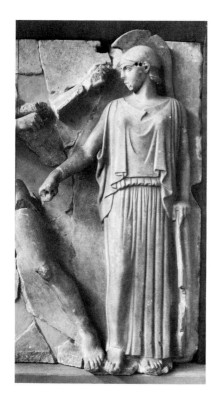

Fig. 336. Athena, from a metope of the
temple of Zeus at Olympia
Olympia Museum
(Cf. pp. 64, 70, 137)

Fig. 337. Draped woman
Ny Carlsberg Glyptotek, Copenhagen
(Cf. p. 70)

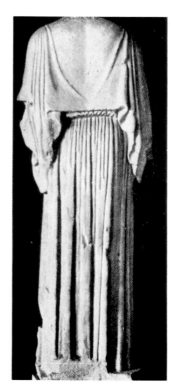

Fig. 338. Back view of Fig. 337
(Cf. p. 70)

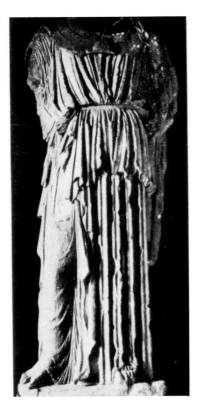

Fig. 339. "Athena Medici"
The Louvre, Paris
(Cf. p. 71)

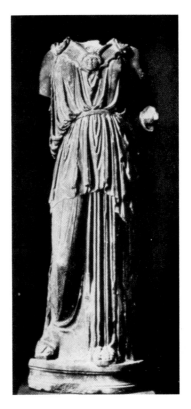

Fig. 340. Athena
Museo Archeologico, Venice
(Cf. p. 71)

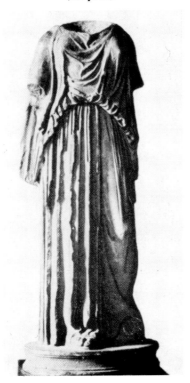

Fig. 341. Draped woman
Museo Archeologico, Venice
(Cf. p. 71)

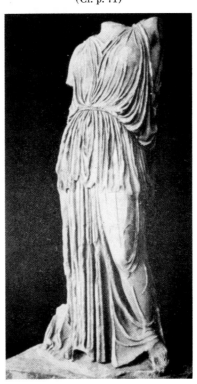

Fig. 342. Draped woman
Eleusis Museum
(Cf. p. 71)

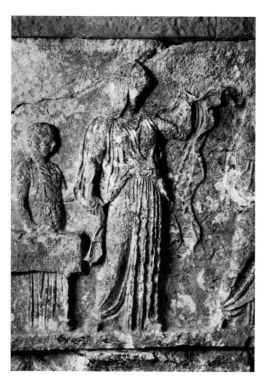

Fig. 343. Detail from the frieze of the
Heroön at Gjölbaschi
Kunsthistorisches Museum, Vienna
(Cf. p. 71)

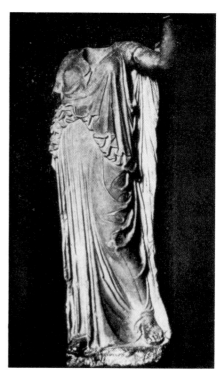

Fig. 344. Draped woman
Museo Archeologico, Venice
(Cf. p. 71)

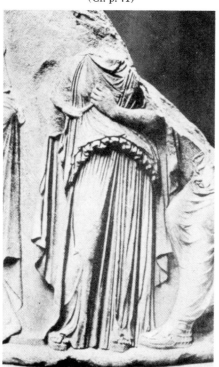

Fig. 345. Detail from the Ephesos drum
British Museum, London
(Cf. pp. 71, 209)

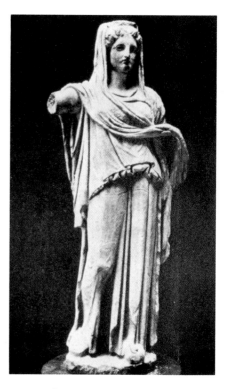

Fig. 346. Draped woman
Museo Archeologico, Venice
(Cf. pp. 71, 198, note 14)

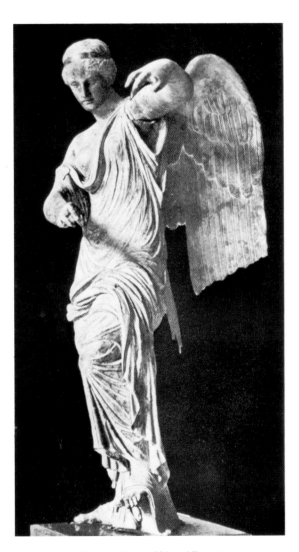

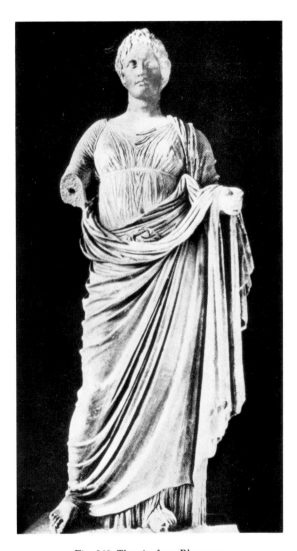

Fig. 347. Bronze Nike of Brescia
Museo Bresciano, Brescia
(Cf. p. 72)

Fig. 348. Themis, from Rhamnous
National Museum, Athens
(Cf. p. 72)

Fig. 349. Torso of a draped woman
Museum of Fine Arts, Boston
(Cf. p. 72)

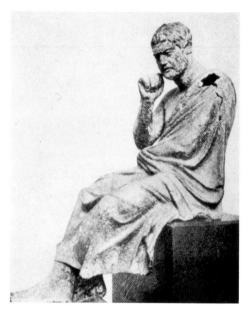

Fig. 350. Bronze portrait statue
British Museum, London
(Cf. p. 73)

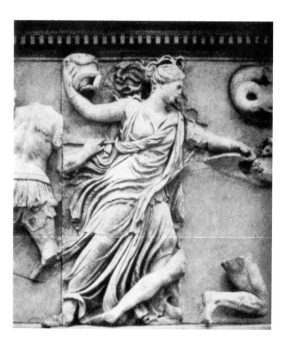

Fig. 351. Nyx, from the frieze of the great altar
of Pergamon
Pergamon Museum, Berlin
(Cf. p. 107)

Fig. 352. Eos, from the same frieze
as Fig. 351 (from a cast)
Pergamon Museum, Berlin
(Cf. pp. 72, 107)

Fig. 353. Girl from Anzio
Museo Nazionale delle Terme, Rome
(Cf. pp. 72, 123)

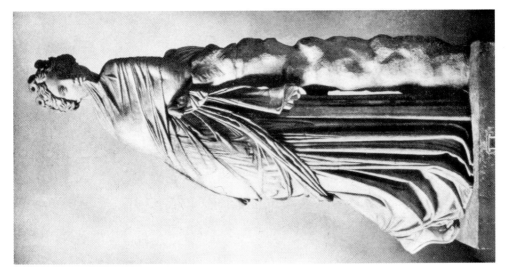

Fig. 354. Polyhymnia
Staatliche Museen, Berlin
(Cf. p. 72)

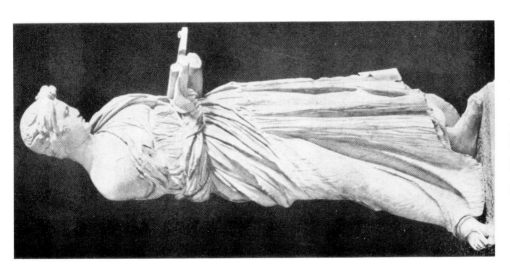

Fig. 355. Draped woman, from the Giustiniani
Collection
Metropolitan Museum of Art
(Cf. p. 72)

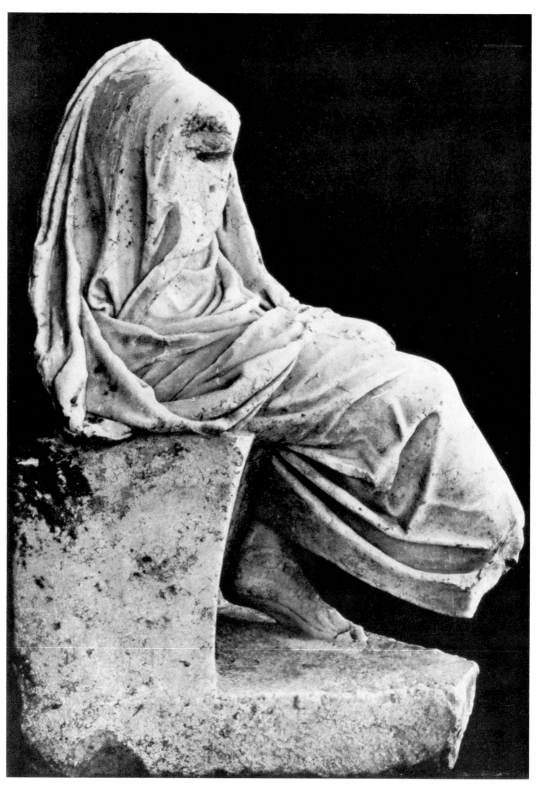

Fig. 356. Statue signed by Zeuxis
Metropolitan Museum of Art
(Cf. pp. 73, 123)

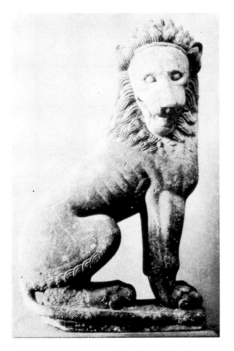

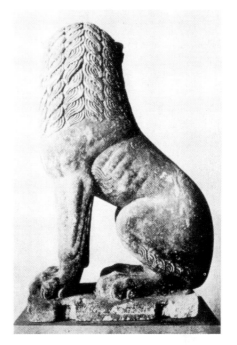

Fig. 357. Limestone lion, from Perachora
Museum of Fine Arts, Boston
(Cf. p. 74)

Fig. 358. Back view of Fig. 357
(Cf. p. 74)

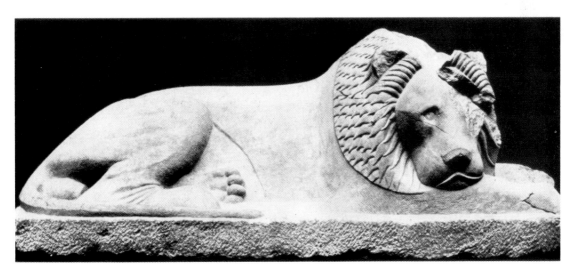

Fig. 359. Lion
Staatliche Museen, Berlin
(Cf. p. 75)

Fig. 360. Lion, from a metope of the temple of Zeus at Olympia
The Louvre, Paris
(Cf. p. 75)

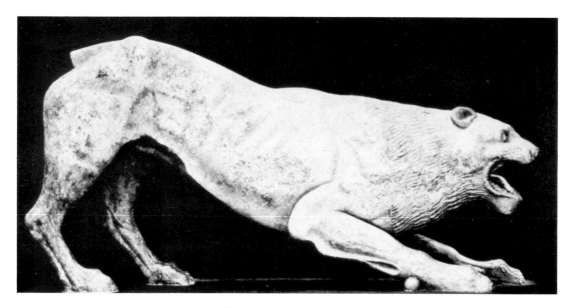

Fig. 361. Lion, from Rome
Metropolitan Museum of Art
(Cf. p. 75)

Fig. 362. Detail of Fig. 361
(Cf. p. 75)

Fig. 363. Lion, from the Mausoleum at
Halikarnassos
British Museum, London
(Cf. p. 75)

Fig. 364. Frieze of horsemen, from Prinias
Heraklion Museum, Crete
(Cf. p. 75)

Fig. 365. Horse
Akropolis Museum, Athens
(Cf. p. 76)

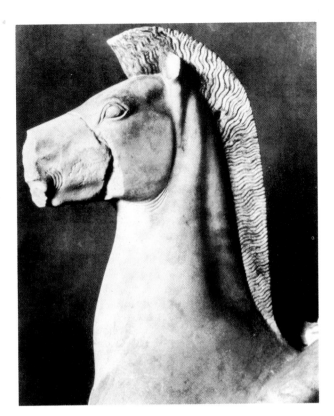

Fig. 366. Horse
Akropolis Museum, Athens
(Cf. p. 76)

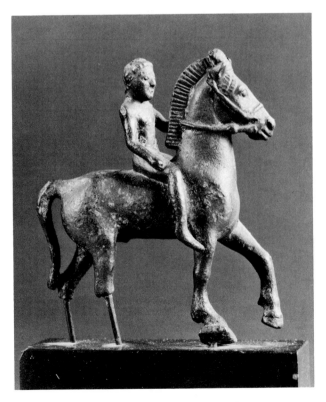

Fig. 367. Bronze statuette of a rider
The Art Museum of Princeton University
(Cf. p. 76)

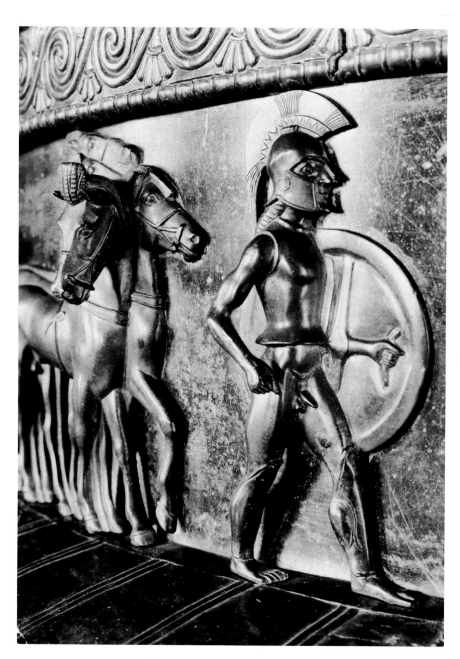

Fig. 368. Detail from a bronze krater
Museum of Châtillon
(Cf. p. 76)

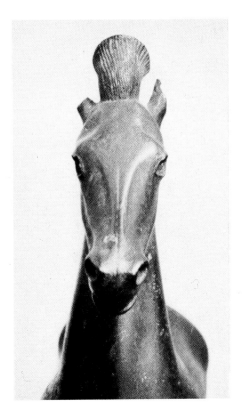

Fig. 369. Detail of Fig. 370
(Cf. pp. 76, 148)

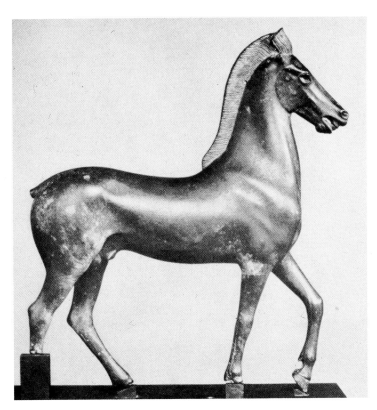

Fig. 370. Large bronze statuette of a horse
Metropolitan Museum of Art
(Cf. pp. 76, 148)

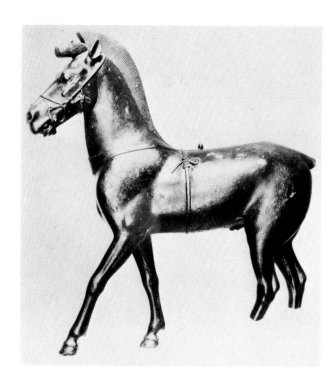

Fig. 371. Bronze statuette of a horse
Olympia Museum
(Cf. pp. 76, 160)

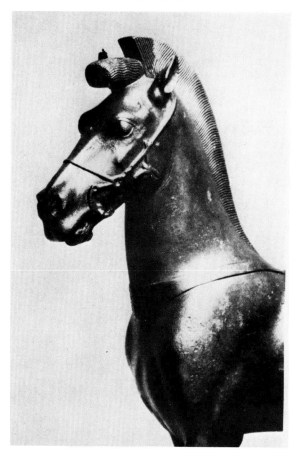

Fig. 372. Detail of Fig. 371
(Cf. pp. 76, 160)

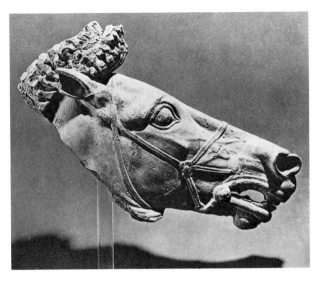

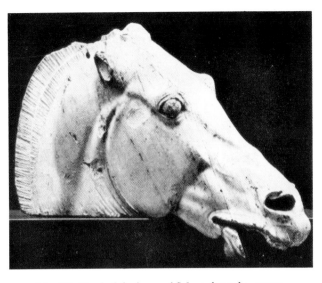

Fig. 373. Terracotta head of a horse from an akroterion
Gela Museum
(Cf. p. 76)

Fig. 374. Head of the horse of Selene, from the eastern
pediment of the Parthenon
British Museum, London
(Cf. pp. 76, 98)

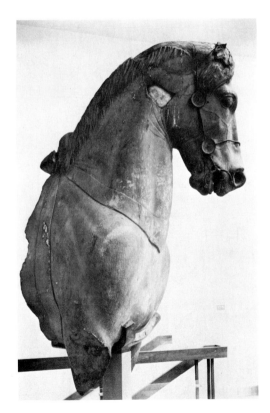

Fig. 375. Horse, from the chariot group
of the Mausoleum at Halikarnassos
British Museum, London
(Cf. p. 76)

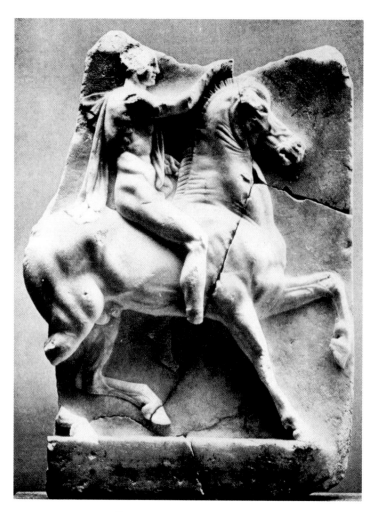

Fig. 376. Relief of a horseman
Metropolitan Museum of Art
(Cf. p. 76)

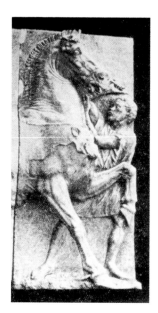

Fig. 377. Large relief of horse with Negro boy
National Museum, Athens
(Cf. p. 76)

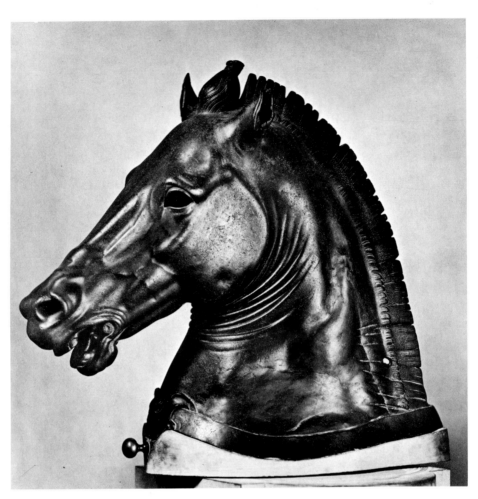

Fig. 378. Bronze head of a horse
Museo Archeologico, Florence
(Cf. p. 76)

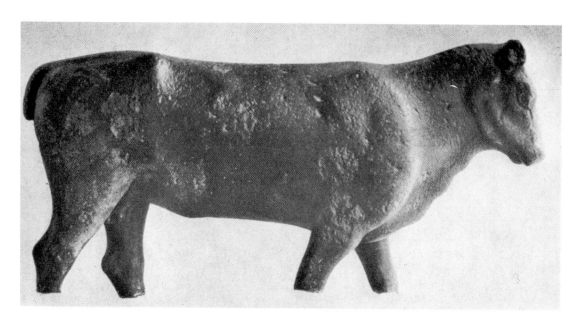

Fig. 379. Bronze statuette of a cow, from Delphi
Delphi Museum
(Cf. p. 77)

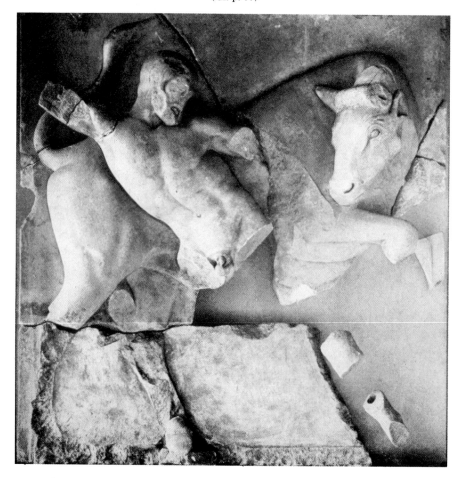

Fig. 380. Herakles and the Cretan bull, metope of the temple of Zeus at Olympia
The Louvre, Paris
(Cf. pp. 77, 103)

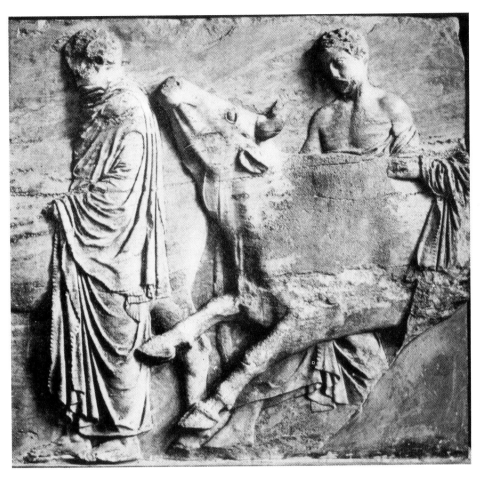

Fig. 381. Cow, from the Parthenon frieze
Akropolis Museum, Athens
(Cf. pp. 66, 77, 86, 177)

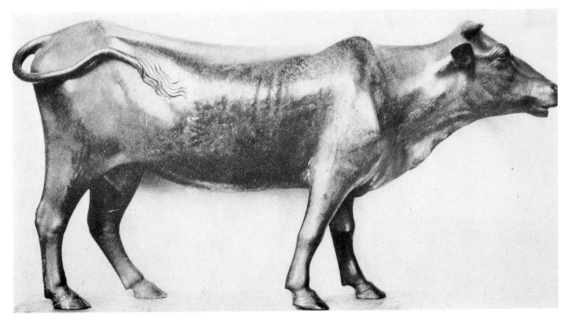

Fig. 382. Bronze statuette of a cow
Bibliothèque Nationale, Paris
(Cf. p. 77)

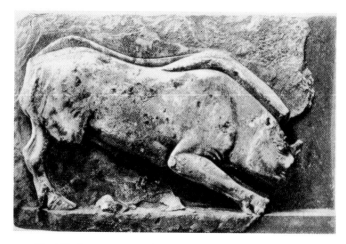

Fig. 383. Boar, metope of the "Sikyonian" Treasury at Delphi
Delphi Museum
(Cf. pp. 77, 100)

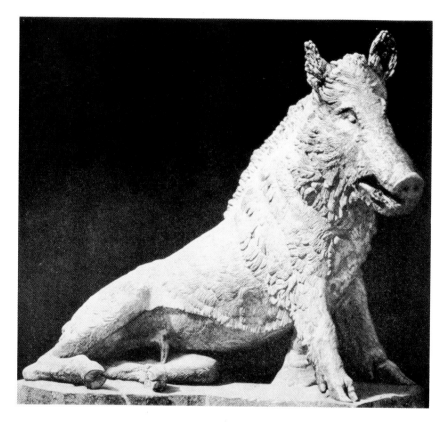

Fig. 384. Boar
Uffizi Gallery, Florence
(Cf. p. 77)

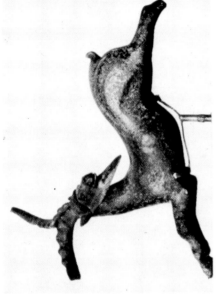

Fig. 385. Bronze statuette of a goat
British Museum, London
(Cf. p. 77)

Fig. 386. Bronze statuette of a goat
Metropolitan Museum of Art
(Cf. p. 77)

Fig. 387. Bronze statuette of a goat
Musée d'Art et d'Histoire, Geneva
(Cf. p. 78)

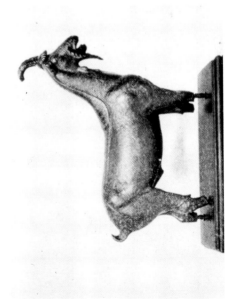

Fig. 388. Butting goats, finial of a grave stele (from a cast)
National Museum, Athens
(Cf. p. 78)

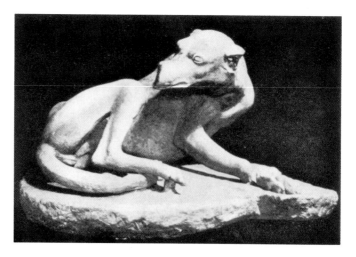

Fig. 389. Dwarf with hound, on an
engraved gem (from an impression)
Metropolitan Museum of Art
(Cf. p. 78)

Fig. 390. Dog
Barracco Museum, Rome
(Cf. p. 78)

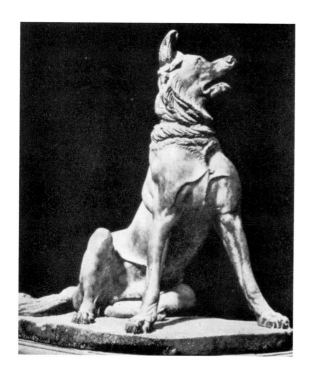

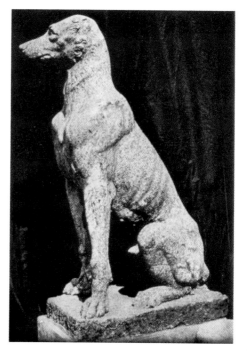

Fig. 391. "Mastiff"
Uffizi Gallery, Florence
(Cf. p. 78)

Fig. 392. Hound, of serpentine
Palazzo dei Conservatori, Rome
(Cf. p. 78)

Fig. 393. Eagle devouring a hare
on a coin of Akragas
Metropolitan Museum of Art
(Cf. p. 79)

Fig. 394. Head of an eagle, on a coin of Elis
Metropolitan Museum of Art
(Cf. p. 79)

Fig. 395. Swan preening its wings
on a coin of Klazomenai (from a cast)
British Museum, London
(Cf. p. 79)

Fig. 396. Heron, on an engraved gem
(from an impression)
Museum of Fine Arts, Boston
(Cf. p. 79)

Enlarged 1:2

Fig. 398. Crab, on a coin of Akragas
(from a cast)
British Museum, London
(Cf. p. 79)

Fig. 397. Heron, on an engraved gem by Dexamenos
Hermitage, Leningrad
(Cf. p. 79)

Fig. 399. Bee, on a coin of Ephesos
(from a cast)
Museum of Fine Arts, Boston
(Cf. p. 79)

Fig. 400. Wasp, on an engraved gem
(from an impression)
Staatliche Museen, Berlin
(Cf. p. 79)

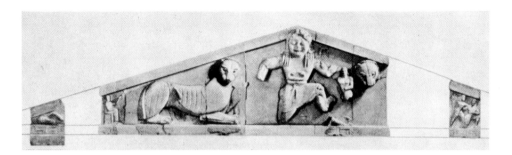

Fig. 401. The western pediment of the temple of Artemis at Corfu
Corfu Museum
(Cf. pp. 91, 105, 133)

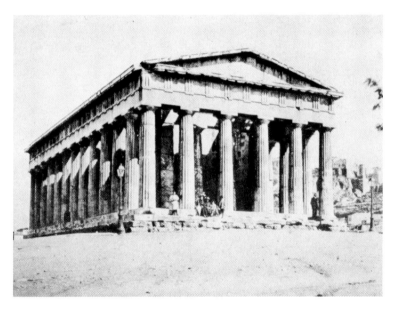

Fig. 402. The Hephaisteion in Athens
(Cf. p. 91)

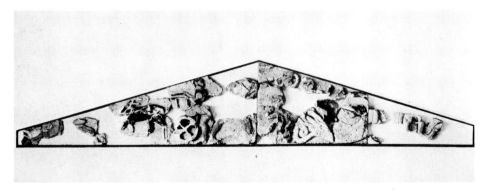

Fig. 403. Limestone pediment, contest of Herakles and the Hydra
Akropolis Museum, Athens
(Cf. pp. 94, 125, 133)

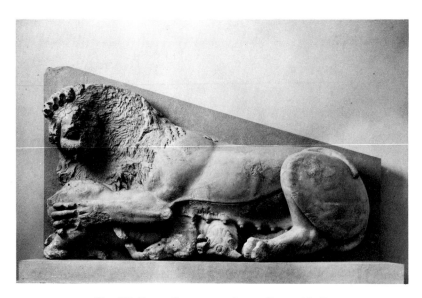

Fig. 404. From a limestone pediment, lion and bull
Akropolis Museum, Athens
(Cf. pp. 94, 125)

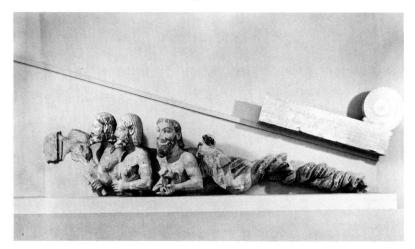

Fig. 405. Three-headed monster, from a limestone pediment
Akropolis Museum, Athens
(Cf. pp. 94, 125, 133)

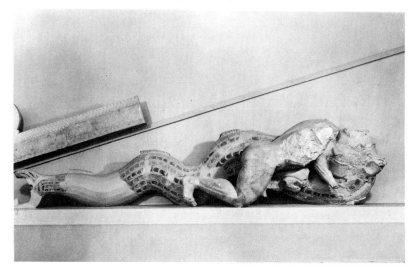

Fig. 406. Herakles and Triton, from a limestone pediment
Akropolis Museum, Athens
(Cf. pp. 94, 125)

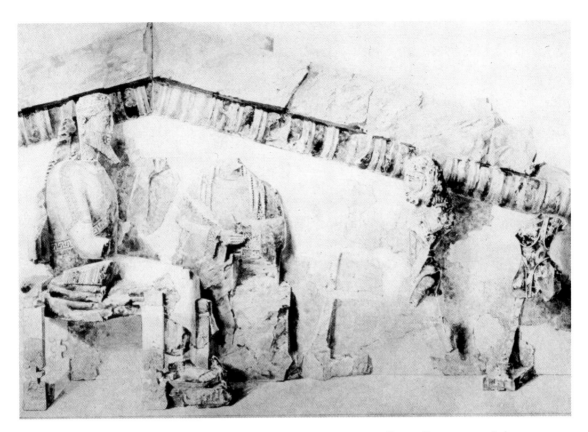

Fig. 407. Introduction of Herakles to Olympos, from a limestone pediment (from a watercolor)
Akropolis Museum, Athens
(Cf. pp. 94, 125)

Fig. 408. Eastern pediment of the temple of Apollo at Delphi
Delphi Museum
(Cf. pp. 95, 133)

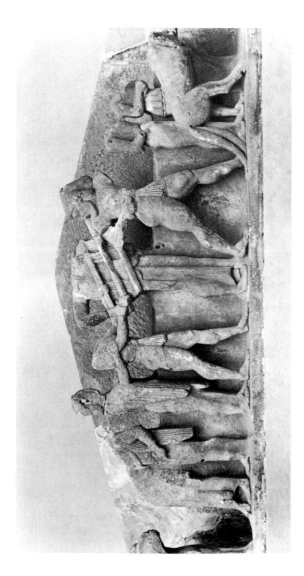

Fig. 409. Apollo and Herakles contesting for the tripod, from a pediment of the Siphnian Treasury

Delphi Museum

(Cf. pp. 40, 94, 133)

Fig. 410. Contest of gods and giants, limestone pediment of the Megarian Treasury

Olympia Museum

(Cf. pp. 44, 96)

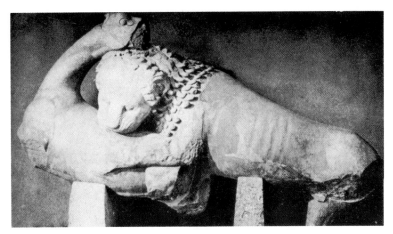

Fig. 411. Lion devouring a hind, from the eastern pediment of the
temple of Apollo at Delphi
Delphi Museum
(Cf. pp. 95, 133)

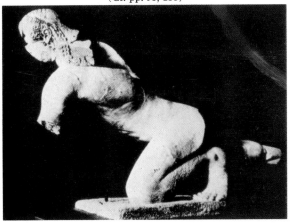

Fig. 412. Giant, from the pediment of the "Hekatompedon"
Akropolis Museum, Athens
(Cf. p. 95)

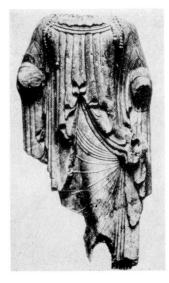

Fig. 413. Female figure, from the
eastern pediment of the temple
of Apollo at Delphi
Delphi Museum
(Cf. pp. 95, 133)

Fig. 414. Athena, from the western
pediment of the temple of Apollo
at Delphi
Delphi Museum
(Cf. pp. 95, 133)

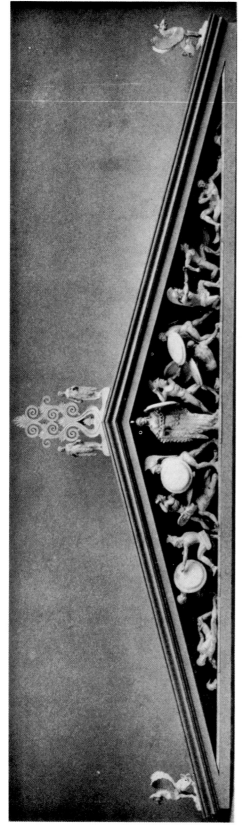

Fig. 415. Western pediment of the temple of Aphaia at Aigina, reconstruction by Furtwängler
The Glyptothek, Munich
(Cf. pp. 40, 44, 97, 127)

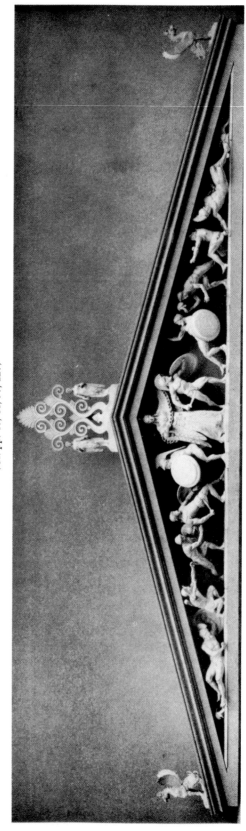

Fig. 416. Eastern pediment of the temple of Aphaia at Aigina, reconstruction by Furtwängler
(Cf. pp. 40, 43, 44, 97, 127)

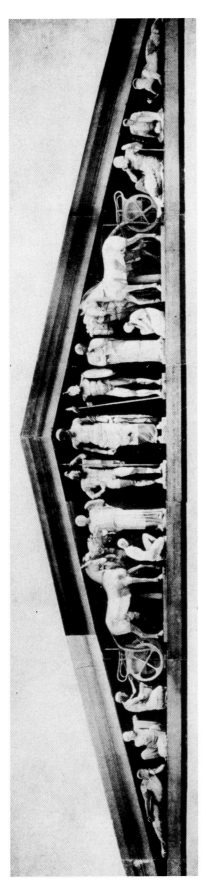

Fig. 417. Eastern pediment of the temple of Zeus at Olympia, reconstruction by Studniczka
(Cf. pp. 98, 127)

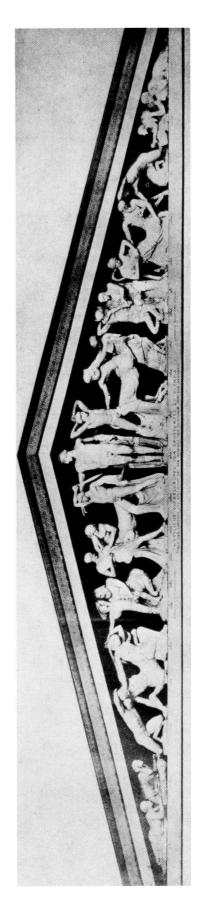

Fig. 418. Western pediment of the temple of Zeus at Olympia, reconstruction by Treu
(Cf. pp. 97, 127)

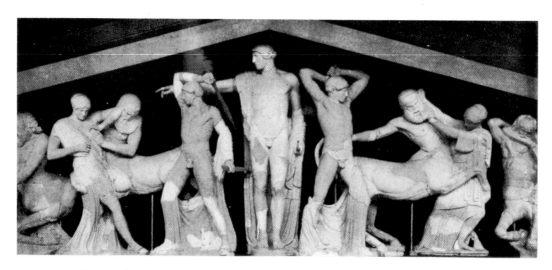

Fig. 419. Middle portion of the western pediment at Olympia, reconstruction by Treu
(Cf. pp. 32, 97, 127, 202)

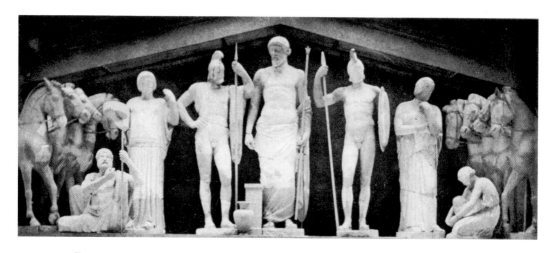

Fig. 420. Middle portion of the eastern pediment at Olympia, reconstruction by Wernicke
(Cf. pp. 98, 127, 137)

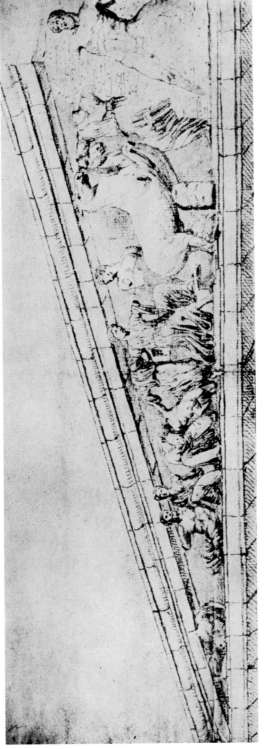

Fig. 421. Left portion of the western pediment of the Parthenon (as drawn in 1674)
(Cf. pp. 98, 178)

Fig. 422. Right portion of the western pediment of the Parthenon (as drawn in 1674)
(Cf. pp. 98, 178)

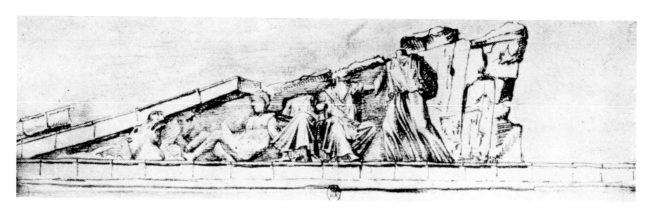

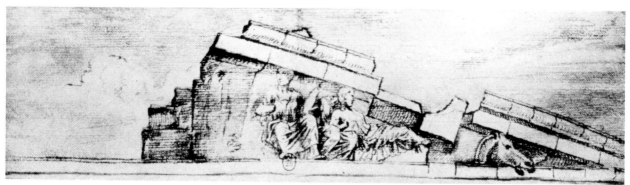

Fig. 423. Left and right ends of the eastern pediment of the Parthenon (as drawn in 1674)
(Cf. pp. 98, 178)

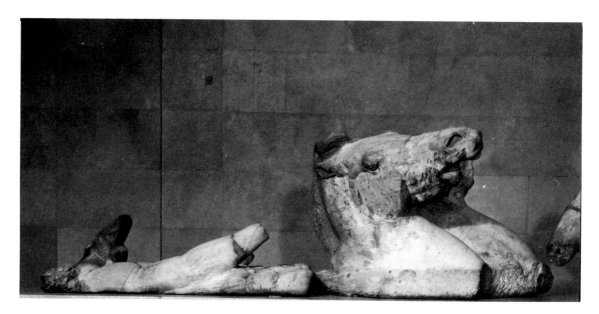

Fig. 424. Helios, from the eastern pediment of the Parthenon
British Museum, London
(Cf. p. 98)

Fig. 425. Selene, from the eastern pediment of the Parthenon
British Museum, London
(Cf. p. 98)

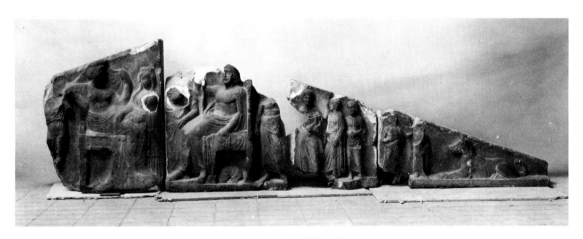

Fig. 426. Pediment of the Nereid monument
British Museum, London
(Cf. p. 99)

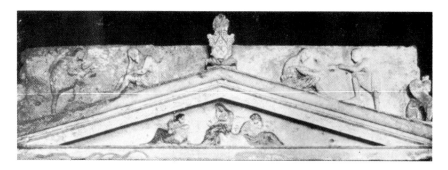

Fig. 427. Pediment of the sarcophagus of Mourning Women, from Sidon
Istanbul Museum
(Cf. p. 100)

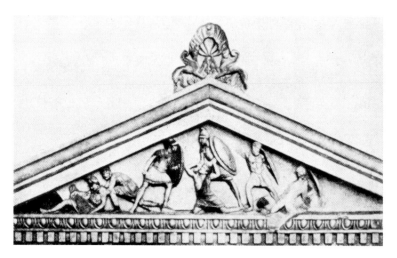

Fig. 428. Pediment of the Alexander sarcophagus
Istanbul Museum
(Cf. p. 100)

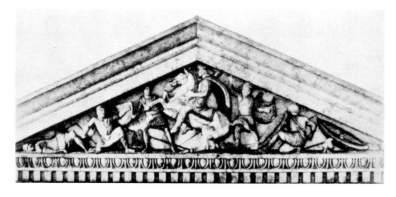

Fig. 429. Pediment of the Alexander sarcophagus
Istanbul Museum
(Cf. p. 100)

Fig. 430. Seated goddesses, from a metope of the temple
at Thermos (from a watercolor)
National Museum, Athens
(Cf. p. 100)

Fig. 431. Perseus, from a metope of the temple at
Thermos (from a watercolor)
National Museum, Athens
(Cf. p. 100)

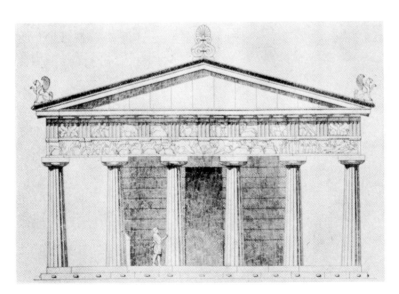

Fig. 432. Reconstruction of the east side of the temple at Assos
(Cf. pp. 100, 105)

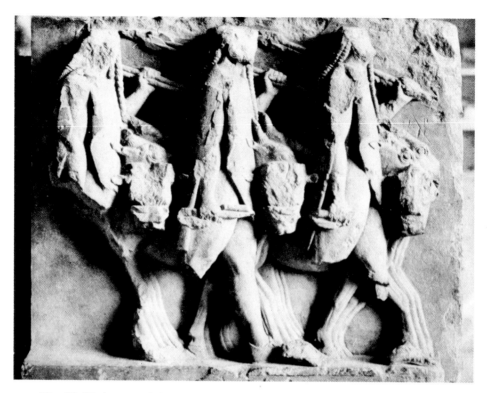

Fig. 433. Dioskouroi and the sons of Alphareos, from the "Sikyonian" Treasury at Delphi
Delphi Museum
(Cf. pp. 82, 86, 100, 126)

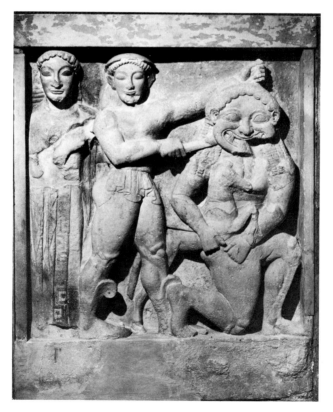

Fig. 434. Perseus cutting off the head of Medusa, from a metope of
temple C at Selinus
Museo Nazionale, Palermo
(Cf. pp. 83, 102)

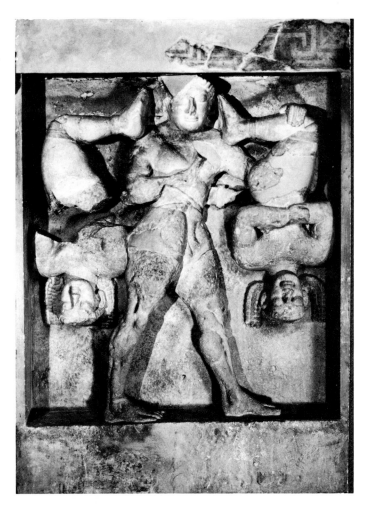

Fig. 435. Herakles and the Kerkopes, from a metope of
temple C at Selinus
Museo Nazionale, Palermo
(Cf. p. 102)

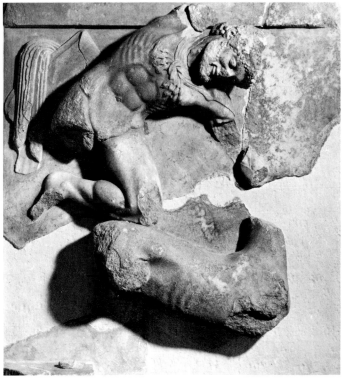

Fig. 436. Herakles and the Kerynean hind, from a
metope of the Athenian Treasury at Delphi
Delphi Museum
(Cf. p. 102)

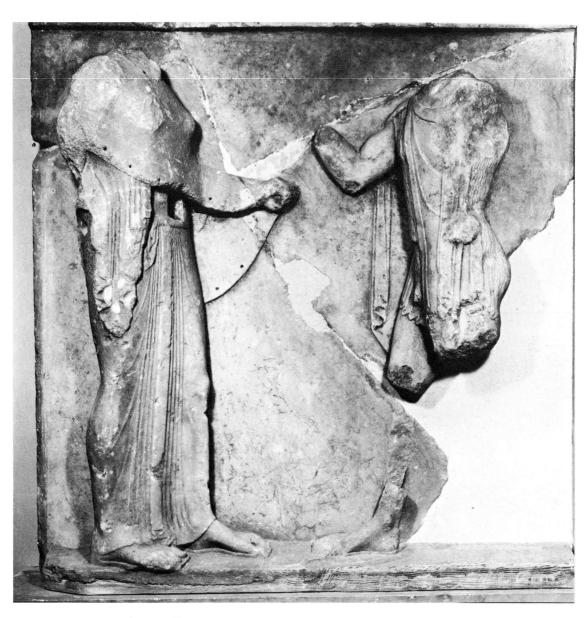

Fig. 437. Athena and Theseus, from a metope of the
Athenian Treasury
Delphi Museum
(Cf. pp. 63, 102)

Fig. 438. Theseus and the Minotaur, from a metope
of the Athenian Treasury
Delphi Museum
(Cf. pp. 63, 102)

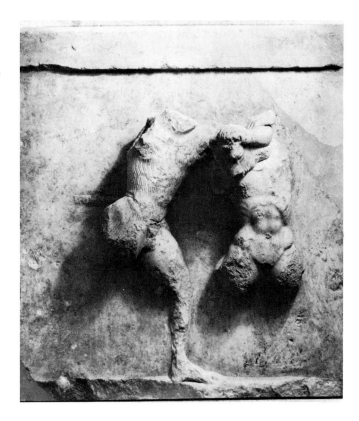

Fig. 438a. Contest of warriors, from a metope of the
Athenian Treasury
Delphi Museum
(Cf. p. 102)

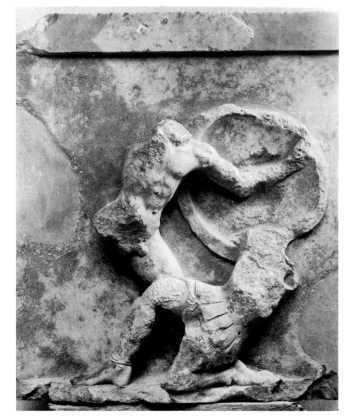

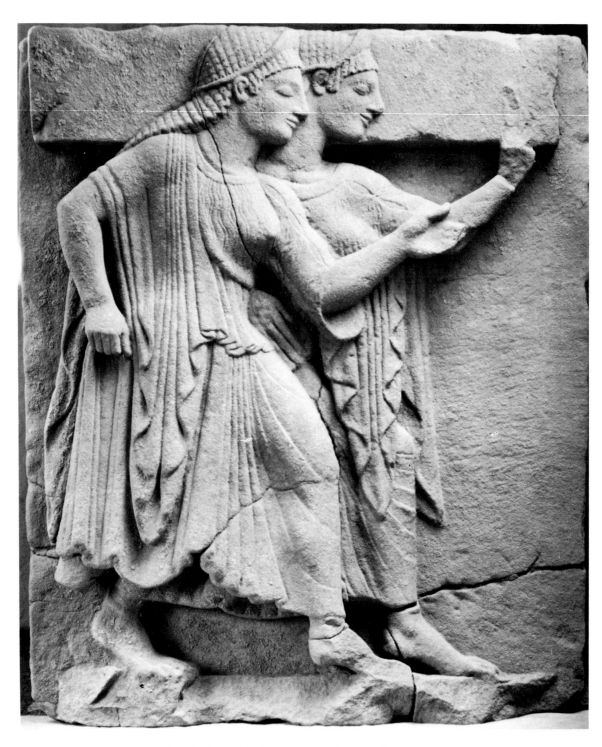

Fig. 439. Nereids(?), from a metope of the temple of Hera at
Foce del Sele, *Paestum Museum*
(Cf. p. 102)

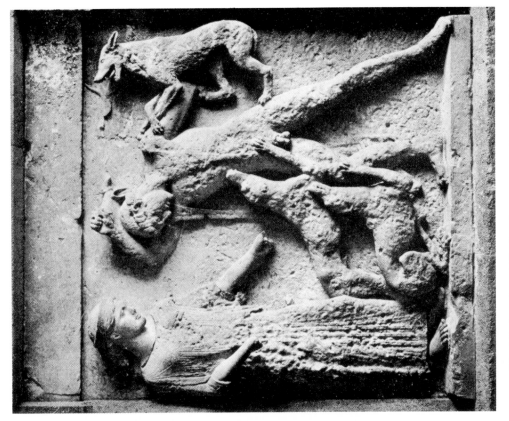

Fig. 441. Artemis and Aktaion, from a metope of temple E at Selinus
Museo Nazionale, Palermo
(Cf. p. 102)

Fig. 440. Zeus and Hera, from a metope of temple E at Selinus
Museo Nazionale, Palermo
(Cf. pp. 85, 102, 123)

Fig. 443. Athena and a giant, from a metope of temple E at Selinus
Museo Nazionale, Palermo
(Cf. pp. 43, 102)

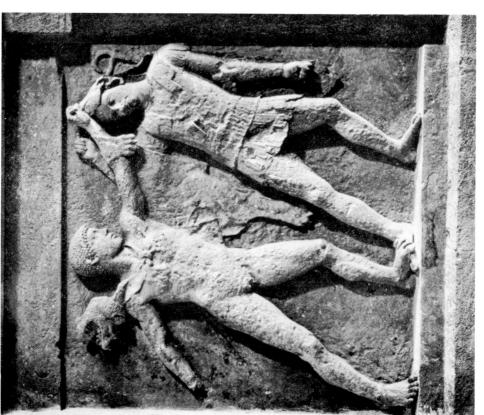

Fig. 442. Herakles and an Amazon, from a metope of temple E at Selinus
Museo Nazionale, Palermo
(Cf. pp. 40, 102)

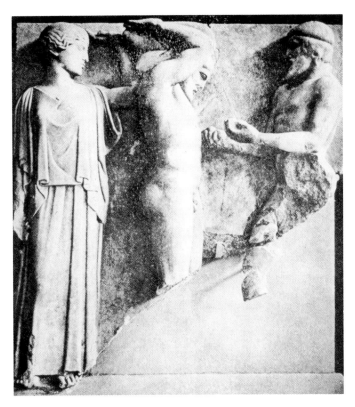

Fig. 444. Herakles and Atlas, from a metope of the
temple of Zeus at Olympia
Olympia Museum
(Cf. p. 127)

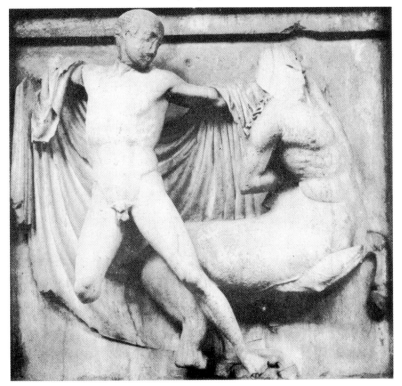

Fig. 445. Lapith and centaur, from a metope of the Parthenon
British Museum, London
(Cf. pp. 103, 177)

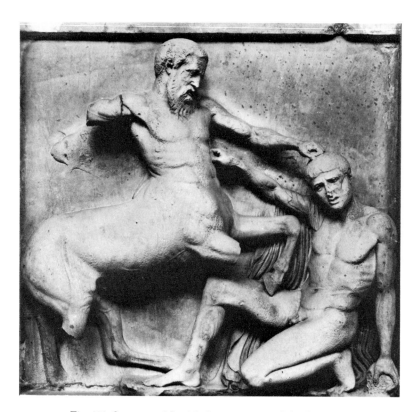

Fig. 446. Centaur and Lapith, from a metope of the Parthenon
British Museum, London
(Cf. pp. 103, 138)

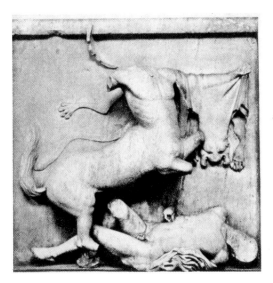

Fig. 447. Centaur and Lapith, from a metope of the Parthenon
British Museum, London
(Cf. pp. 103, 177)

Fig. 448. Theseus and Kerkyon, from a metope
of the Hephaisteion
In situ
(Cf. p. 103)

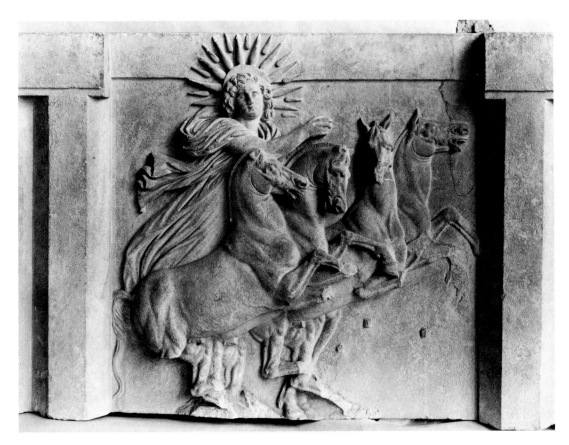

Fig. 449. Helios, on a metope from Ilion
Museum der Vorgeschichte, Berlin
(Cf. p. 105)

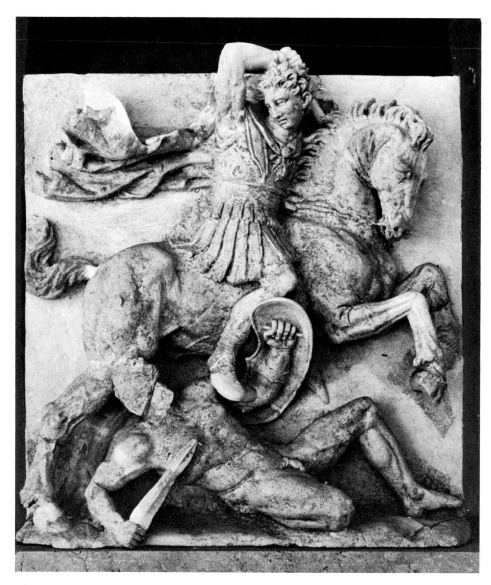

Fig. 450. Combat scene, on a metope
Taranto Museum
(Cf. p. 105)

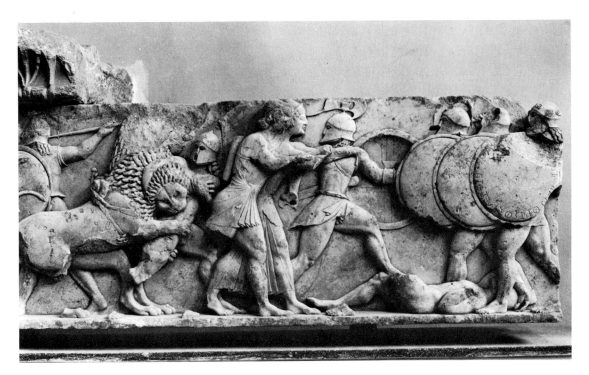

Fig. 451. Battle of the gods and giants, from the frieze of the Siphnian Treasury
Delphi Museum
(Cf. pp. 62, 83, 105, 127)

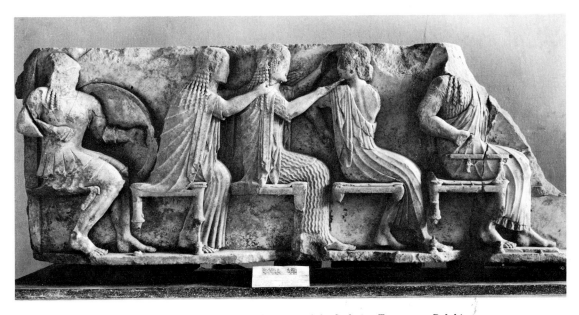

Fig. 452. Seated deities, from the frieze of the Siphnian Treasury at Delphi
Delphi Museum
(Cf. pp. 62, 105, 127)

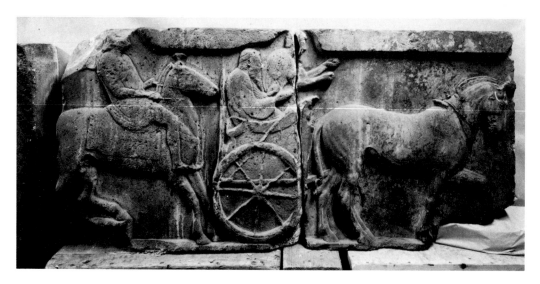

Fig. 453. Portion of a frieze from Xanthos
British Museum, London
(Cf. p. 105)

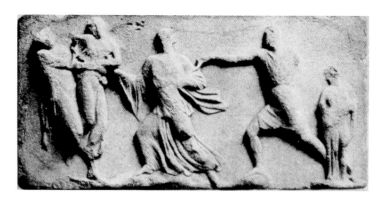

Fig. 454. Portion of the frieze of the Ilissos temple
Staatliche Museen, Berlin
(Cf. p. 105)

Fig. 455. Warriors, from the frieze of the Heroön of Gjölbaschi
Kunsthistorisches Museum, Vienna
(Cf. pp. 87, 106)

Fig. 456. Warriors, from the same frieze as Fig. 455
Kunsthistorisches Museum, Vienna
(Cf. pp. 87, 106)

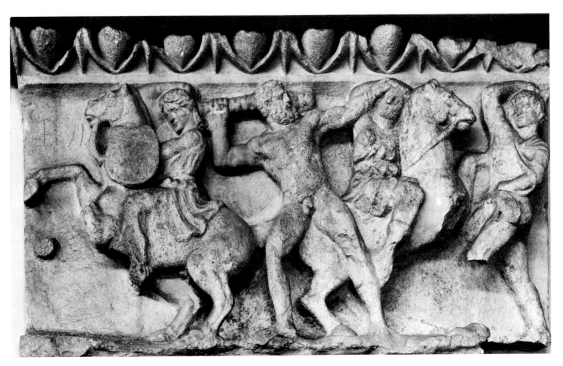

Fig. 457a. Slab from the frieze of a temple at Magnesia
Archaeological Museum, Istanbul
(Cf. p. 107)

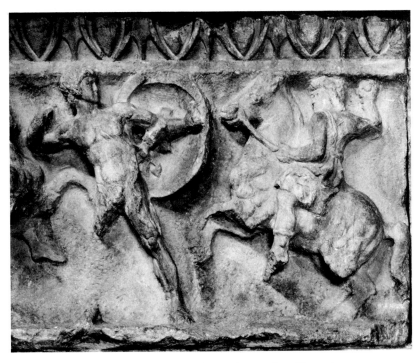

Fig. 457b. Slab from the frieze of a temple at Magnesia
Istanbul Museum
(Cf. p. 107)

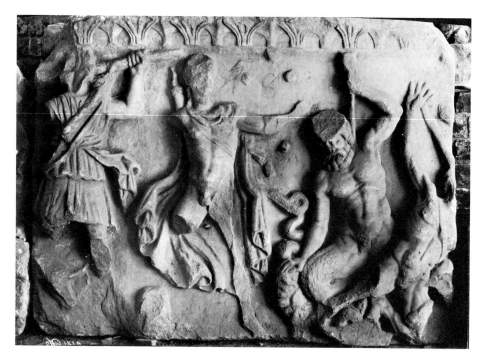

Fig. 458a. Slab from the frieze of a temple at Lagina
Istanbul Museum
(Cf. p. 107)

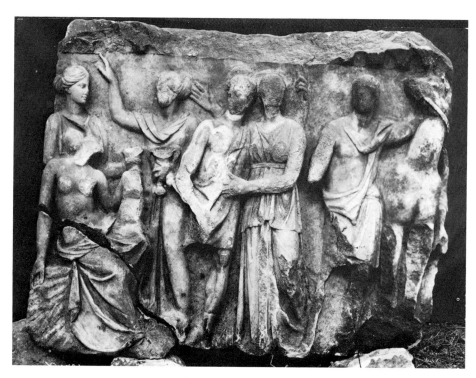

Fig. 458b. Slab from the frieze of a temple at Lagina
Istanbul Museum
(Cf. p. 107)

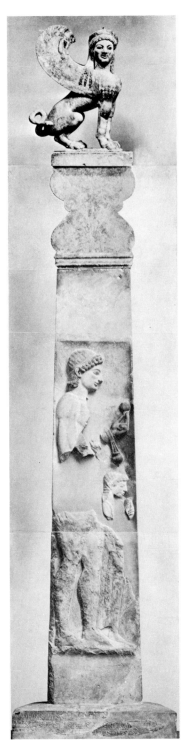

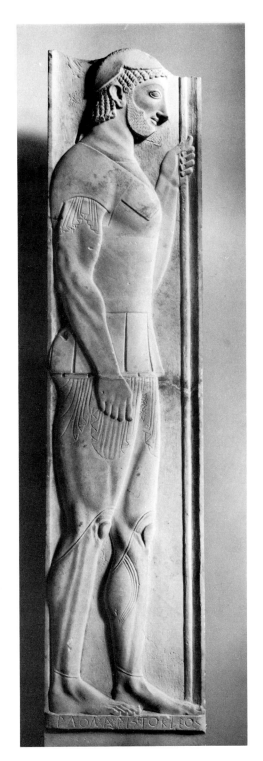

Fig. 459. Stele of a brother
and sister
Metropolitan Museum of Art
(Cf. p. 109)

Fig. 460. Stele of Aristion by
Aristokles
National Museum, Athens
(Cf. pp. 82, 83, 109, 153)

Fig. 461. Stele from Orchomenos
by Alxenor
National Museum, Athens
(Cf. pp. 84, 109, 153)

Fig. 462. Stele of a girl with pigeons
Metropolitan Museum of Art
(Cf. pp. 53, 111, 160)

Fig. 463. Stele of a girl with a casket
Staatliche Museen, Berlin
(Cf. pp. 111, 144)

Fig. 464. Stele of a father and son
National Museum, Athens
(Cf. pp. 54, 113)

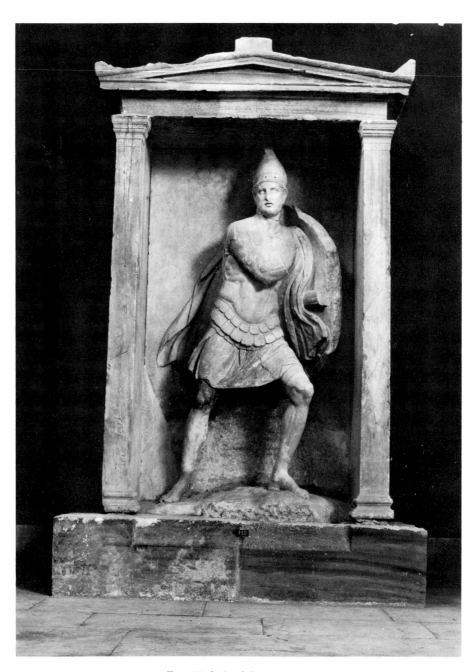

Fig. 465. Stele of Aristonautes
National Museum, Athens
(Cf. p. 113)

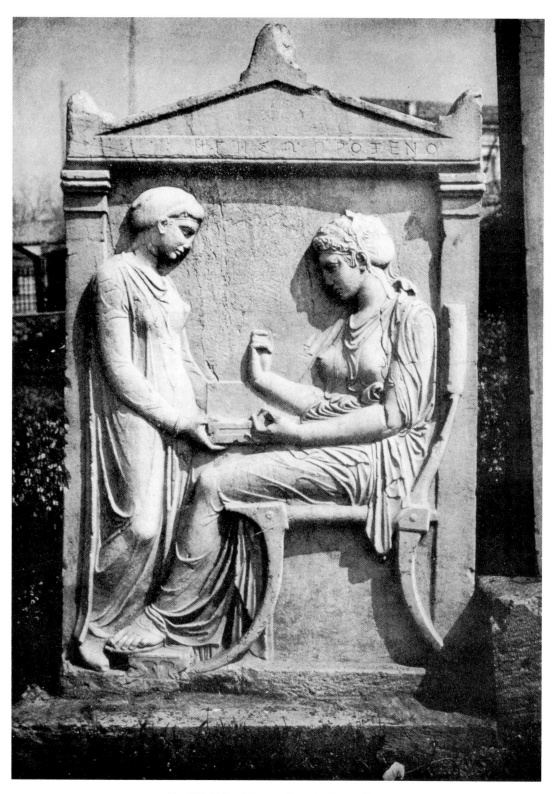

Fig. 466. Stele of Hegeso, from the Kerameikos
National Museum, Athens
(Cf. pp. 69, 81, 113)

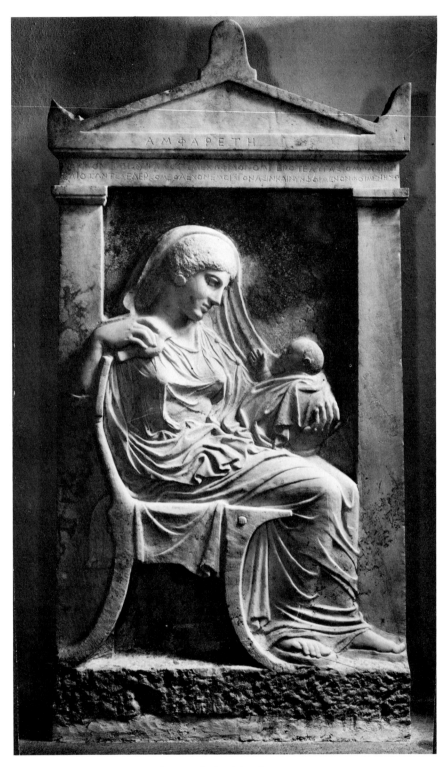

Fig. 467. Stele of Ampharete
Kerameikos Museum, Athens
(Cf. pp. 54, 69, 81, 113)

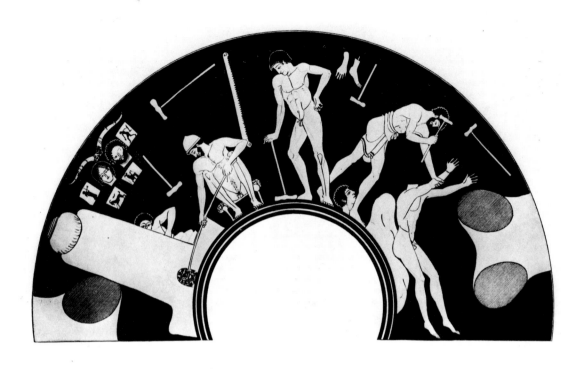

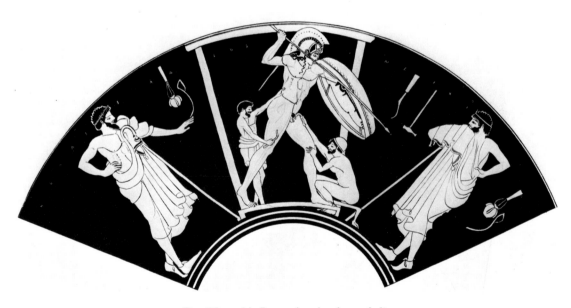

Fig. 468a and b. Bronze foundry, from a kylix
Staatliche Museen, Berlin
(Cf. p. 116)

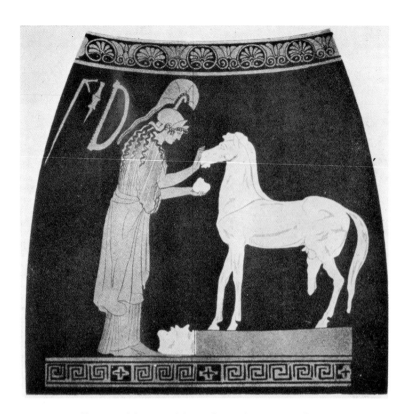

Fig. 469. Athena modeling a horse, from an oinochoe
Staatliche Museen, Berlin
(Cf. p. 119, note 38)

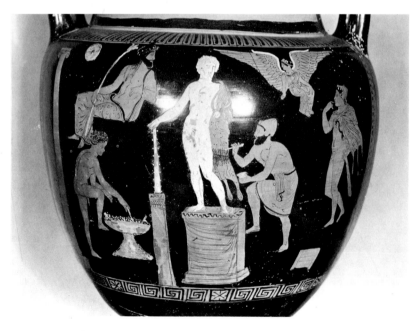

Fig. 470. Man painting a statue of Herakles, from a vase
Metropolitan Museum of Art
(p. 129)

Fig. 471. Ivory hand from Delphi
Delphi Museum
(Cf. p. 118)

Fig. 472. Ancient unfinished head
Private Collection in New York
(Cf. p. 121)

Fig. 473. Modern armature
(Cf. p. 119)

Fig. 474. Modern unfinished head, with clay model
(Cf. p. 121)

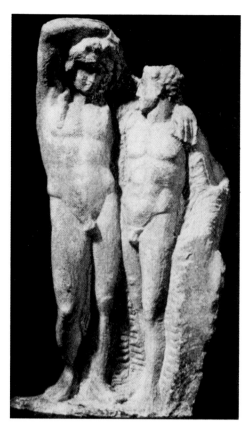

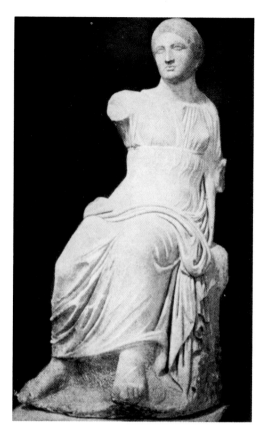

Fig. 475. Dionysos and a satyr, unfinished group
National Museum, Athens
(Cf. p. 121)

Fig. 476. Unfinished statue of a woman
National Museum, Athens
(Cf. p. 121)

Fig. 477. Backs of stelai
The Kerameikos, Athens
(Cf. p. 122)

Fig. 478. Ancient mallet and chisel, from votive relief
Metropolitan Museum of Art
(Cf. p. 121)

Fig. 479. Modern mallet and chisel
(Cf. p. 121)

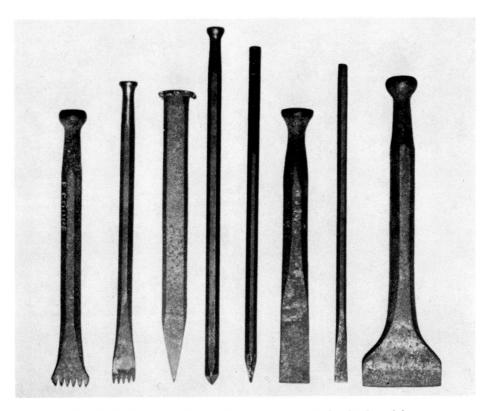

Fig. 480. Modern tools: claw chisels, punches or points, flat chisels, and drove
(Cf. p. 121)

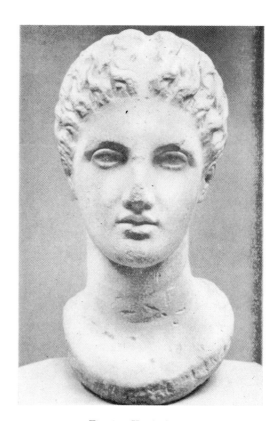

Fig. 481. Back of the Athena, from the temple of
Apollo at Eretria (from a cast)
Chalkis Museum
(Cf. pp. 122, 138)

Fig. 482. Head of a girl
Metropolitan Museum of Art
(Cf. p. 123)

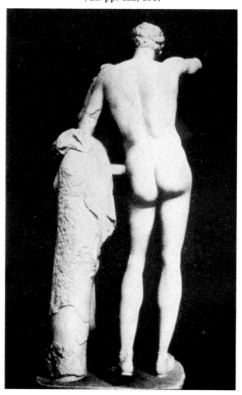

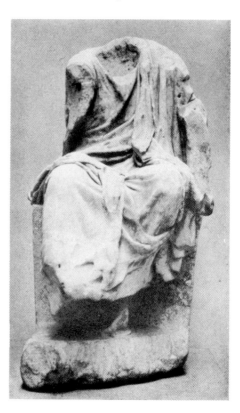

Fig. 483. Back of the Hermes by Praxiteles
(from a cast)
Olympia Museum
(Cf. pp. 122, 199)

Fig. 484. Statue signed by Zeuxis
Metropolitan Museum of Art
(Cf. p. 123)

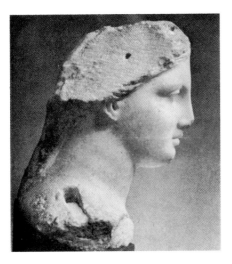

Fig. 485. Head of a girl
Museum of Fine Arts, Boston
(Cf. p. 123)

Fig. 486. Head, from a stele
Metropolitan Museum of Art
(Cf. p. 124)

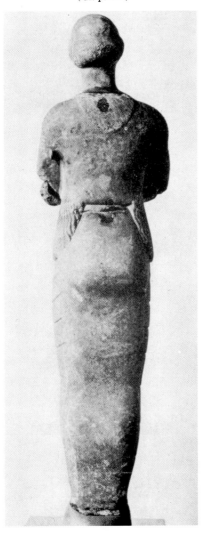

Fig. 487. Girl, from Laurion
Metropolitan Museum of Art
(Cf. p. 123)

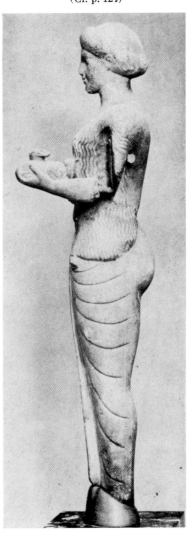

Fig. 488. Side view of Fig. 487
Metropolitan Museum of Art
(Cf. p. 123)

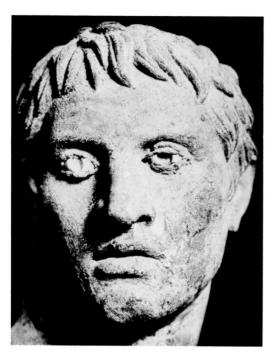

Fig. 489. Bronze head
Ny Carlsberg Glyptotek, Copenhagen
(Cf. p. 124)

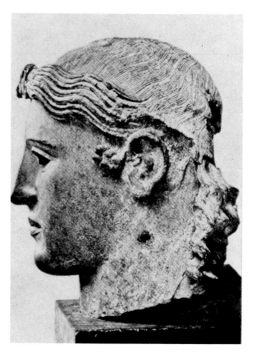

Fig. 490. The Chatsworth head
British Museum, London
(Cf. p. 124)

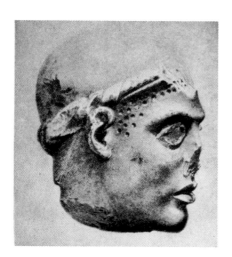

Fig. 491. Head of a youth
Akropolis Museum, Athens
(Cf. p. 124)

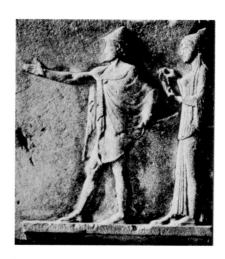

Fig. 492. Hermes and a nymph, from a relief
The Louvre, Paris
(Cf. p. 124)

Fig. 493. Reconstruction of the Paionios Nike at
Olympia (photographed at the original angle)
Olympia Museum
(Cf. p. 133)

Fig. 494. Same reconstruction photographed
level with ground
(Cf. p. 133)

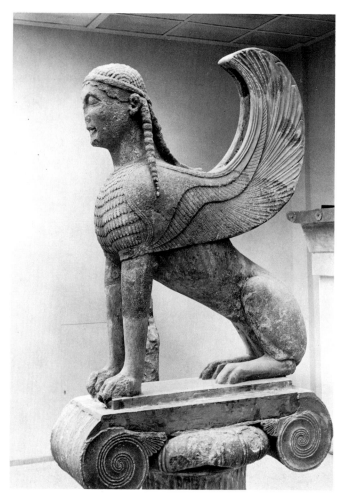

Fig. 495. The Naxian Sphinx
Delphi Museum
(Cf. pp. 127, 133)

Fig. 496. Base and plinth of a statue, from Sounion
National Museum, Athens
(Cf. p. 133)

Fig. 497. Plinth set into the capital
of the stele in Fig. 459
Metropolitan Museum of Art
(Cf. p. 133)

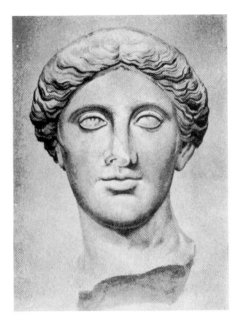

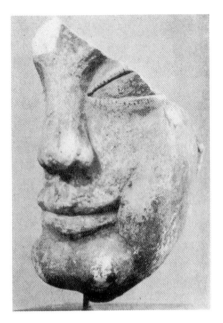

Fig. 498. Head, from the Esquiline
British Museum, London
(Cf. p. 128)

Fig. 499. Fragment of a terracotta head
Metropolitan Museum of Art
(Cf. pp. 117, 126)

Fig. 500. Votive relief
Eleusis Museum
(Cf. p. 127)

Fig. 501. Ashurbanipal and his queen feasting in a garden, limestone relief from Nineveh
British Museum, London
(Cf. p. 80)

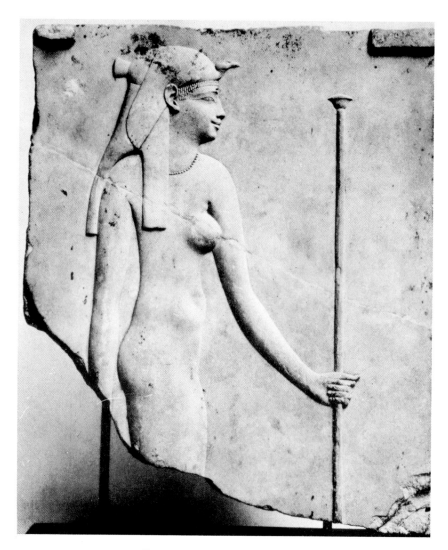

Fig. 502. Egyptian sculptor's model
Metropolitan Museum of Art
(Cf. p. 81)

Fig. 503. Warrior, relief from Naukratis
British Museum, London
(Cf. p. 81)

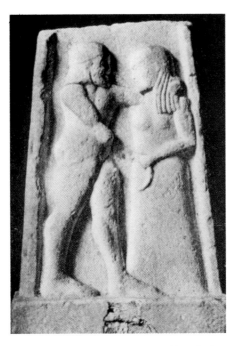

Fig. 504. Orestes and Elektra (?), relief
Sparta Museum
(Cf. p. 82)

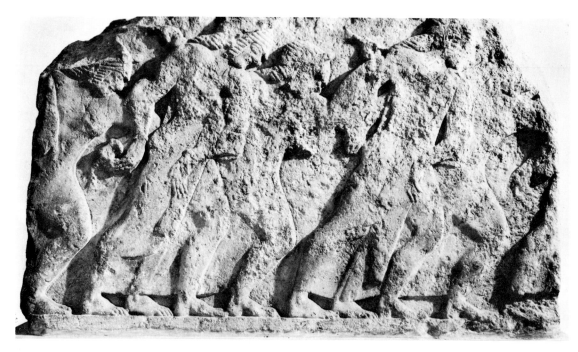

Fig. 505. Women dancing, relief, from Branchidai
British Museum, London
(Cf. p. 81)

Fig. 506. Unfinished portion of the "Fourth
Frieze" of the Nereid monument
British Museum, London
(Cf. p. 81)

Fig. 507. "Ancestor Relief," from Sparta
Staatliche Museen, Berlin
(Cf. p. 82)

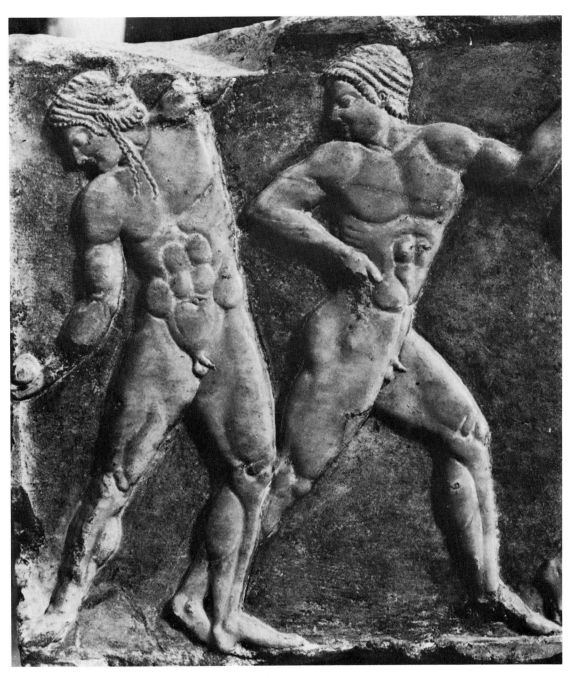

Fig. 508. Ball player, from a
statue base
National Museum, Athens
(Cf. p. 84)

Fig. 509. Detail of a grave stele
Metropolitan Museum of Art
(Cf. p. 82)

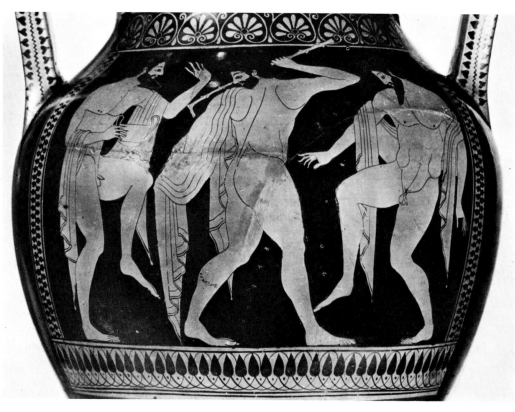

Fig. 510. Revelers on an amphora
Antikensammlung, Munich
(Cf. p. 84)

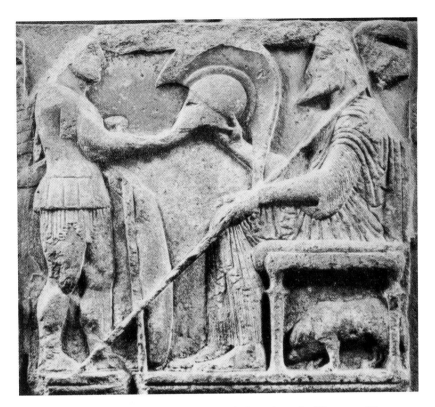

Fig. 511. Relief, deity (?) receiving a helmet, from the "Harpy tomb"
British Museum, London
(Cf. pp. 82, 83)

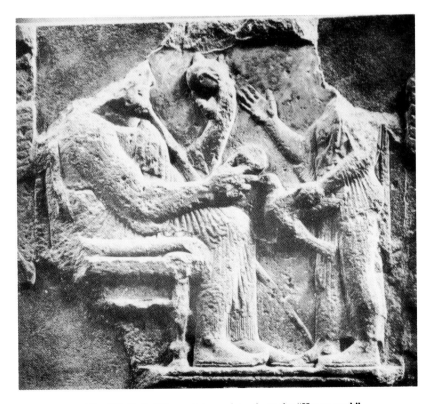

Fig. 512. Deity (?) receiving a dove, from the "Harpy tomb"
British Museum, London
(Cf. pp. 82, 83)

(Cf. p. 84)

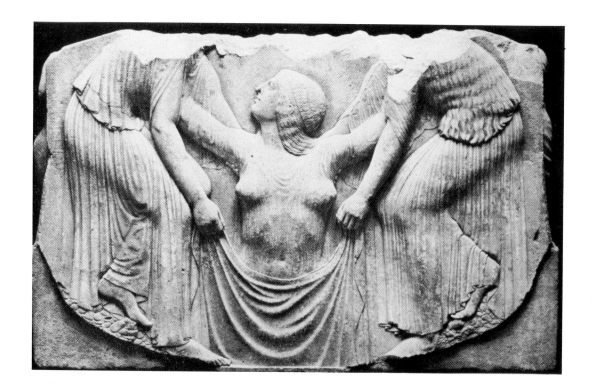

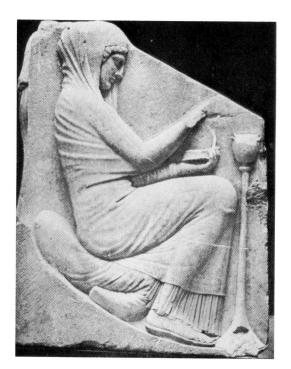
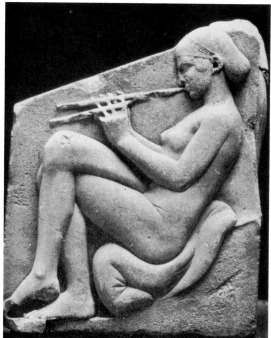

Figs. 513–15. Three-sided relief, birth of Aphrodite (?)
Museo Nazionale delle Terme, Rome
(Cf. p. 84)

(Cf. pp. 84f.)

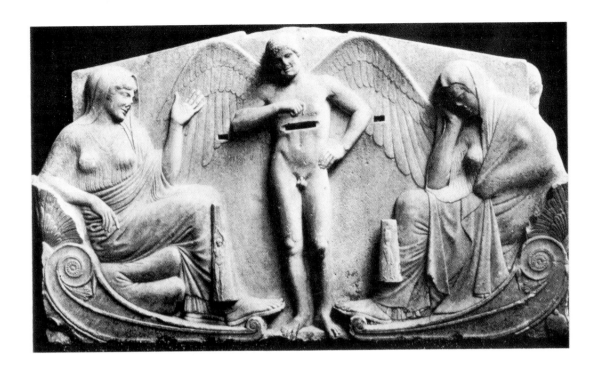

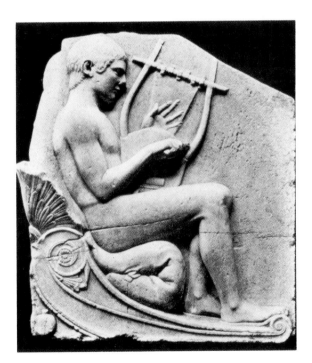
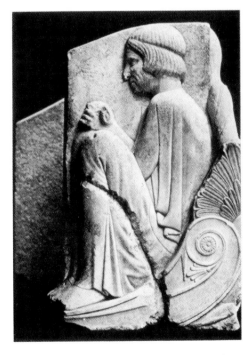

Figs. 516–18. Three-sided relief, subject uncertain
Museum of Fine Arts, Boston
(Cf. pp. 84f.)

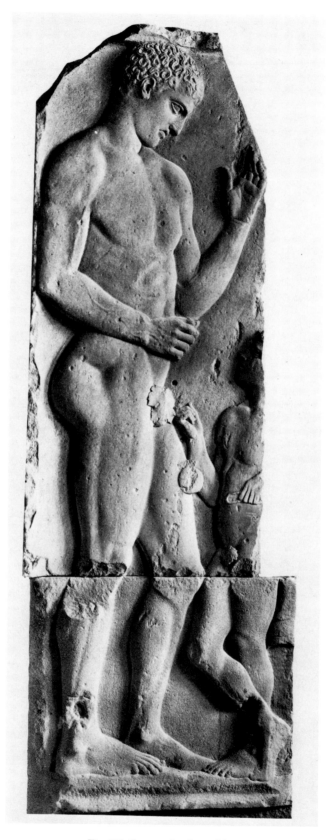

Fig. 519. Grave stele of an athlete
The Vatican, Rome
(Cf. p. 85)

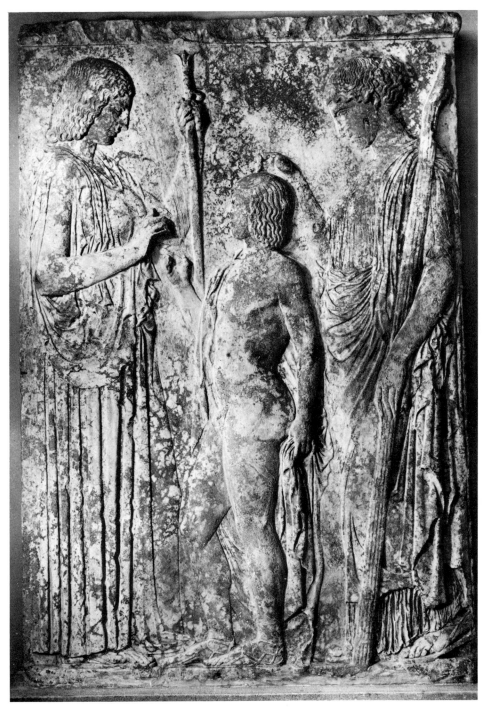

Fig. 520. Demeter, Persephone, and Triptolemos, relief from Eleusis
National Museum, Athens
(Cf. pp. 85, 139, 176)

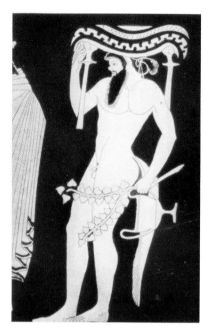

Fig. 521. Satyr, from a krater by the
Pan painter (from a drawing)
Metropolitan Museum of Art
(Cf. p. 85)

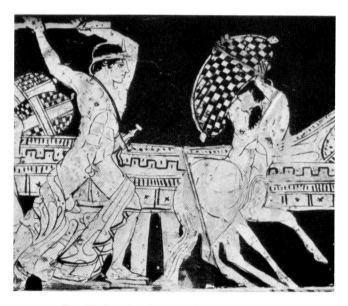

Fig. 522. Lapith and centaur, from a volute krater
Metropolitan Museum of Art
(Cf. p. 85)

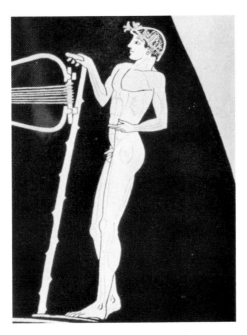

Fig. 523. Youth, from an oinochoe by the Berlin
painter (from a drawing)
Metropolitan Museum of Art
(Cf. p. 85)

Fig. 524. Satyr, from a skyphos by the Penthesileia
painter
Metropolitan Museum of Art
(Cf. p. 85)

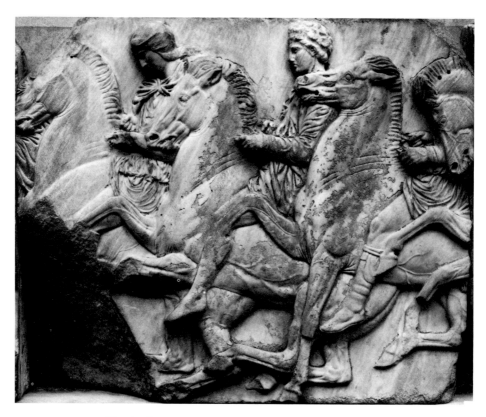

Fig. 525. Procession of horsemen, from the Parthenon frieze
British Museum, London
(Cf. pp. 76, 86, 105, 177)

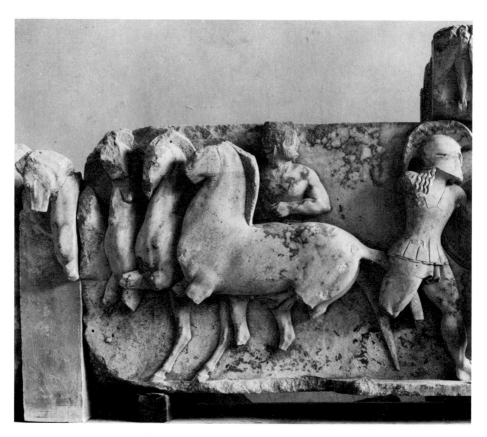

Fig. 526. Horses, from the frieze of the Siphnian Treasury
Delphi Museum
(Cf. pp. 75, 86)

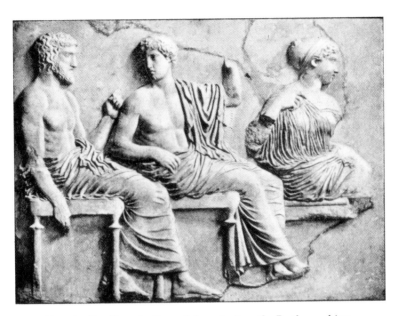

Fig. 527. Poseidon, Apollo, and Artemis, from the Parthenon frieze
Akropolis Museum, Athens
(Cf. pp. 87, 105, 177)

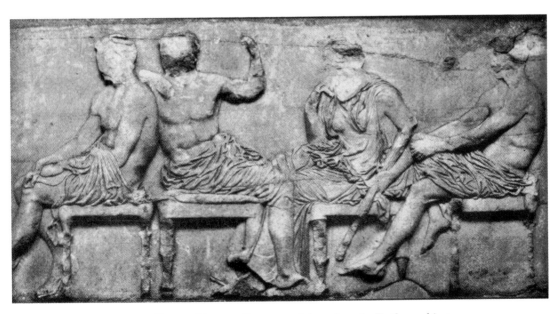

Fig. 528. Hermes, Dionysos, Demeter, and Ares, from the Parthenon frieze
British Museum, London
(Cf. pp. 87, 105, 177)

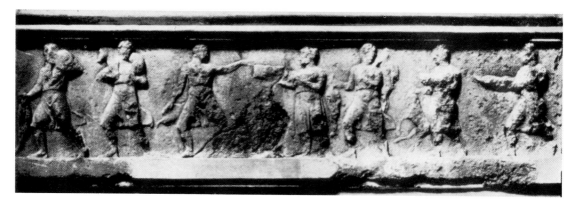

Fig. 529. Procession of tributaries, from the Nereid monument
British Museum, London
(Cf. p. 88)

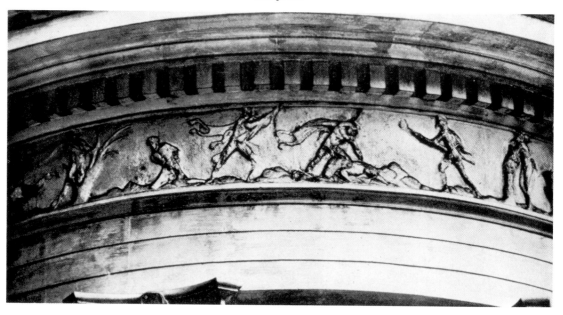

Fig. 530. Frieze from the Lysikrates monument
In situ in Athens
(Cf. pp. 88, 89, 106)

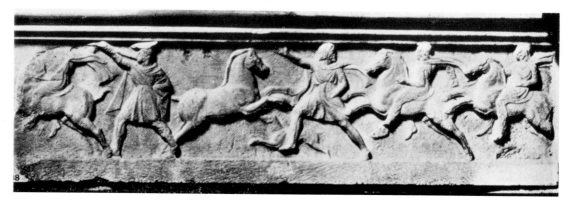

Fig. 531. Hunting scene, from the Nereid monument
British Museum, London
(Cf. p. 88)

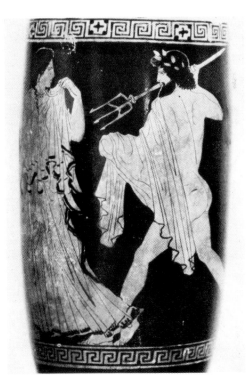

Fig. 532. Poseidon pursuing Amymone
from a lekythos
Metropolitan Museum of Art
(Cf. p. 88)

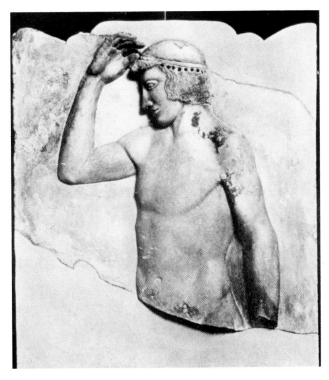

Fig. 533. Grave stele of an athlete, from Sounion
National Museum, Athens
(Cf. p. 85)

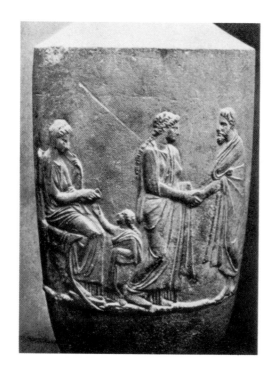

Fig. 534. Farewell scene, from a grave lekythos
Metropolitan Museum of Art
(Cf. pp. 54, 89)

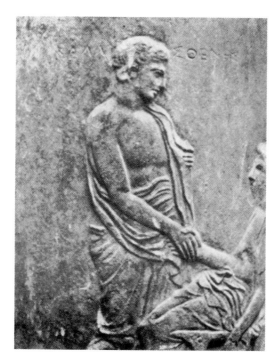

Fig. 535. Relief from a grave lekythos
Metropolitan Museum of Art
(Cf. p. 89)

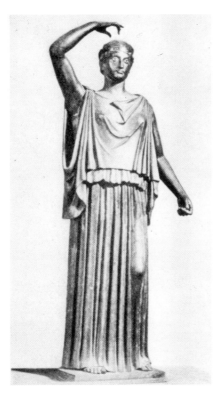

Fig. 536. Bronze statue of a dancer
from Herculaneum
Museo Nazionale, Naples
(Cf. pp. 64, 137)

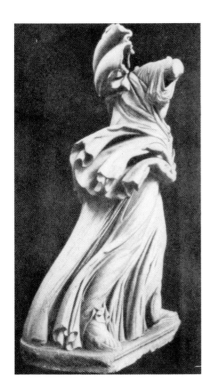

Fig. 537. The "Chiaramonti" Niobid
The Vatican, Rome
(Cf. p. 138)

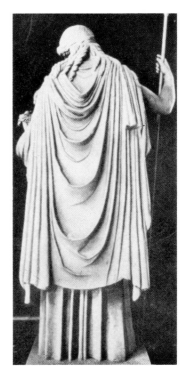

Fig. 538. Back view of the Eirene
The Glyptothek, Munich
(Cf. p. 138)

Fig. 539. Detail of one of the "Fates," from the
eastern pediment of the Parthenon (from a cast)
British Museum, London
(Cf. p. 138)

Fig. 540. "Barberini Suppliant" (from a cast)
The Louvre, Paris
(Cf. pp. 138f.)

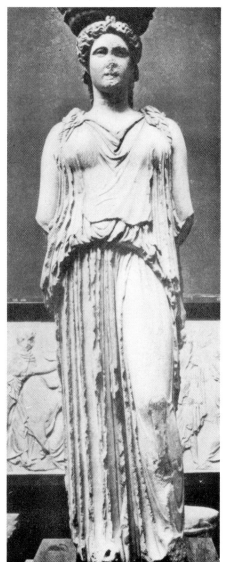

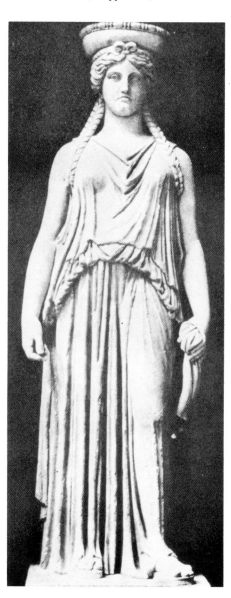

Fig. 541. Karyatid, from the Erechtheion
British Museum, London
(Cf. pp. 67, 71, 138)

Fig. 542. Roman copy of the Erechtheion
karyatid
The Vatican, Rome
(Cf. p. 138)

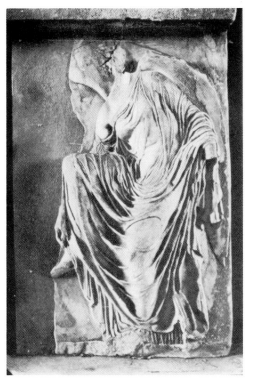

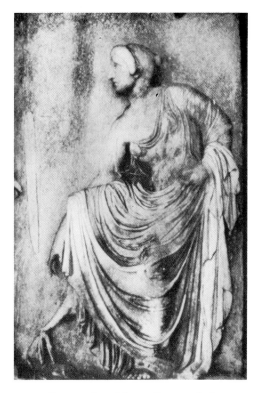

Fig. 543. Nike, from the "Balustrade" of the
Athena Nike temple
Akropolis Museum, Athens
(Cf. pp. 67, 138)

Fig. 544. Detail from a Roman relief
The Glyptothek, Munich
(Cf. p. 138)

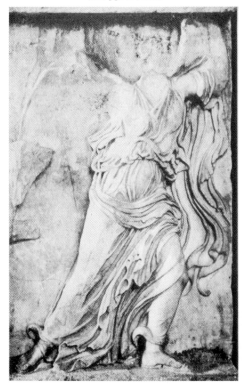

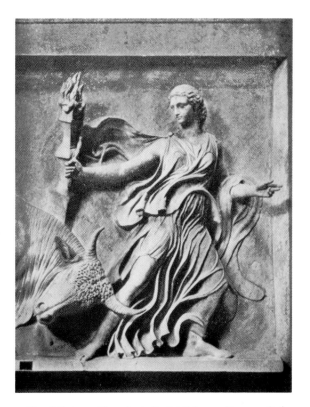

Fig. 545. Nike, from the "Balustrade" of the
Athena Nike temple
Akropolis Museum, Athens
(Cf. pp. 67, 68, 138)

Fig. 546. A sacrifice of a bull, detail from a Roman relief
The Vatican, Rome
(Cf. p. 138)

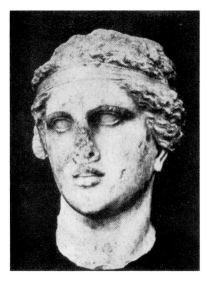

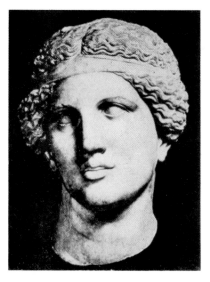

Fig. 547. Head of Ariadne (?), from the
Akropolis
National Museum, Athens
(Cf. p. 139)

Fig. 548. Roman copy of Fig. 547
Staatliche Museen, Berlin
(Cf. p. 139)

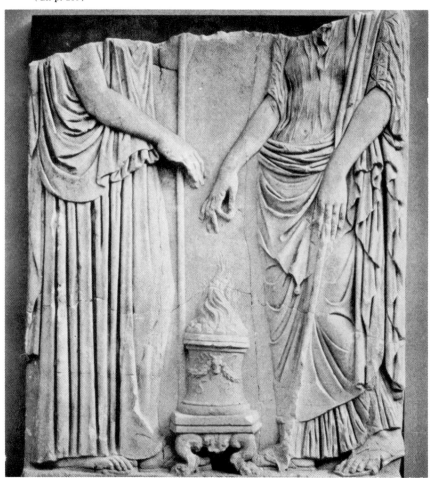

Fig. 549. Demeter and Persephone, Roman version of a relief similar to Fig. 520
Metropolitan Museum of Art
(Cf. p. 139)

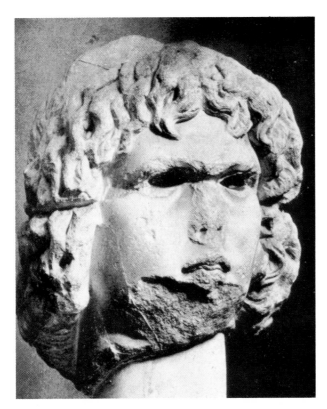

Fig. 550. Roman copy of Fig. 551 (from a cast)
National Museum, Athens
(Cf. p. 139)

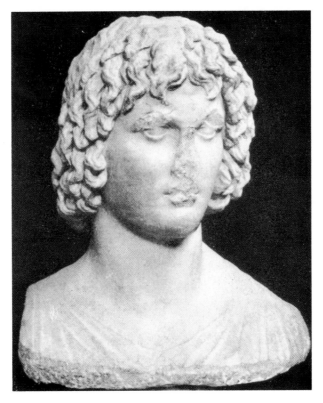

Fig. 551. Head of Eubouleus
National Museum, Athens
(Cf. pp. 139, 203)

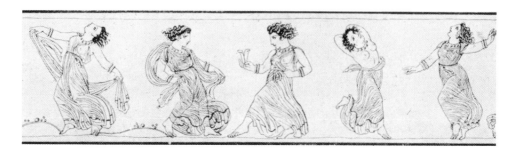

Fig. 552. Maenads, from a pyxis
National Museum, Athens
(Cf. p. 139)

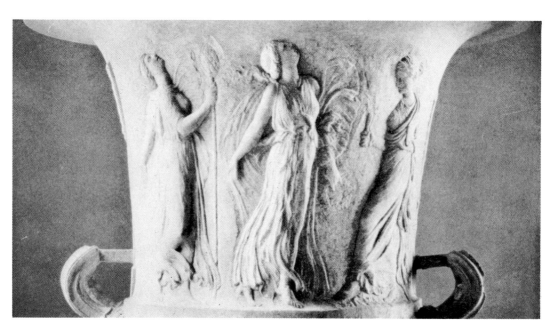

Fig. 553. Maenads, from a marble vase
Metropolitan Museum of Art
(Cf. p. 139)

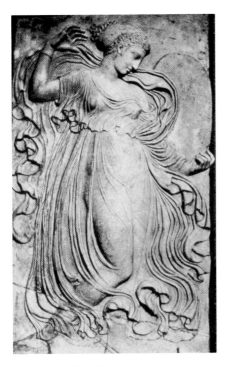

Fig. 554. Maenad
The Prado, Madrid
(Cf. pp. 139, 186)

Fig. 555. Dancers from the frieze of the Heroön
at Gjölbaschi
Kunsthistorisches Museum, Vienna
(Cf. p. 140)

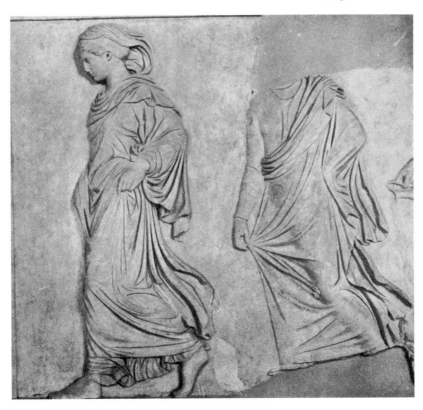

Fig. 556. Nymphs or Graces
The Vatican, Rome
(Cf. p. 140)

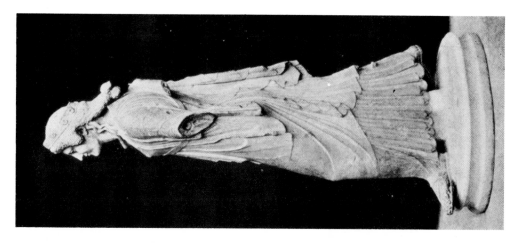

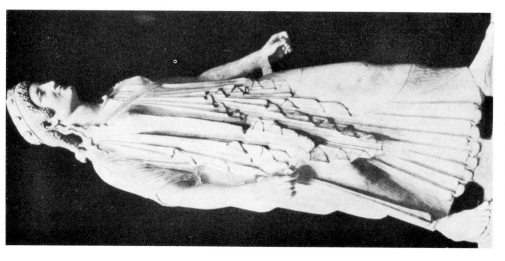

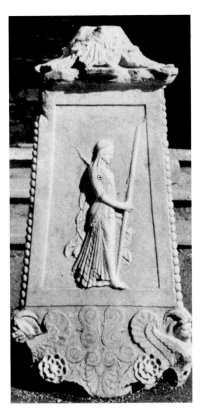

Fig. 560. Artemis, archaistic
relief
Antiquarium Comunale, Rome
(Cf. p. 140)

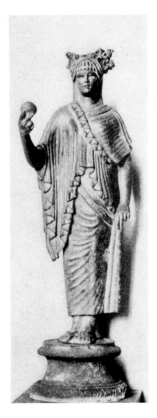

Fig. 561. Archaistic bronze
statuette
Bibliothèque Nationale, Paris
(Cf. pp. 140, 143)

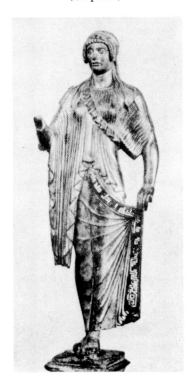

Fig. 562. Archaistic bronze statuette
British Museum, London
(Cf. pp. 140, 143)

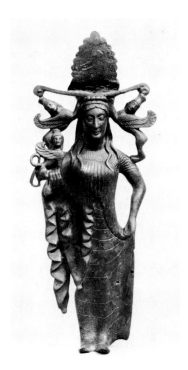

Fig. 563. Archaic bronze statuette
British Museum, London
(Cf. p. 140)

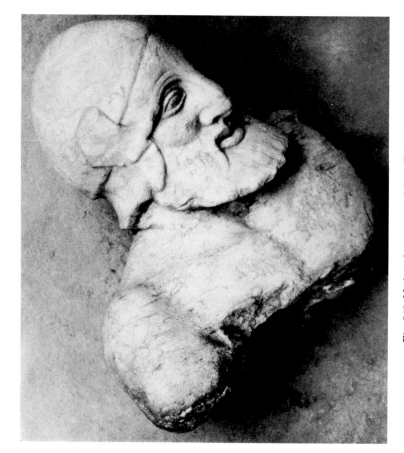

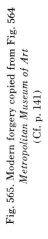

Fig. 565. Modern forgery copied from Fig. 564
Metropolitan Museum of Art
(Cf. p. 141)

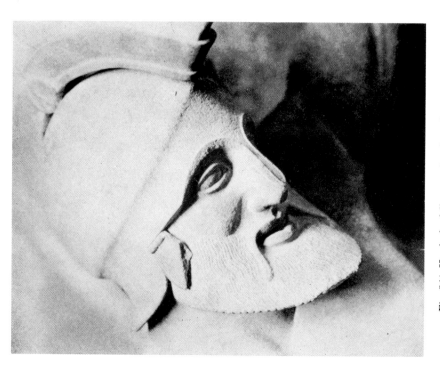

Fig. 564. Head of a fallen warrior, from the eastern
pediment at Aigina
The Glyptothek, Munich
(Cf. pp. 50, 141)

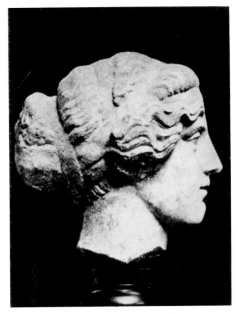
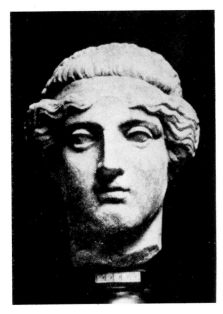

Figs. 566 and 567. Marble head of "Sappho"
Roman copy of a Greek original
Ny Carlsberg Glyptotek, Copenhagen
(Cf. p. 142)

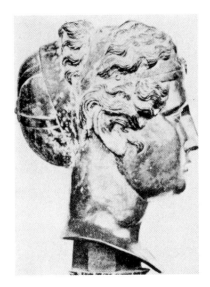
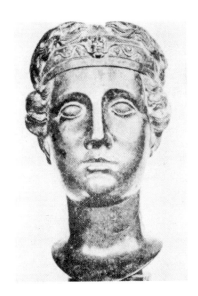

Figs. 568 and 569. Modern forgery in the style of figs. 566 and 567
(Cf. pp. 141f.)

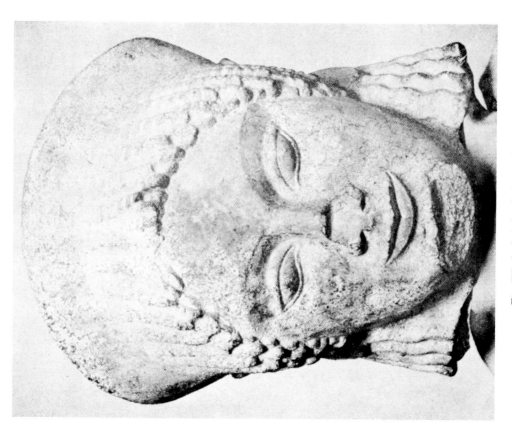

Fig. 571. Modern forgery copied from Fig. 570
(Cf. p. 142)

Fig. 570. Archaic head of a maiden
National Museum, Athens
(Cf. p. 142)

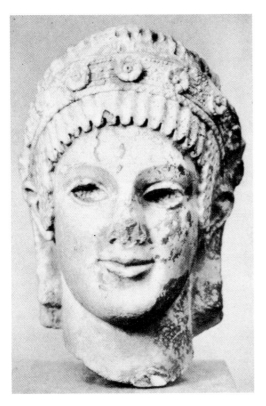

Fig. 572. Archaistic head of Athena
Metropolitan Museum of Art
(Cf. p. 142)

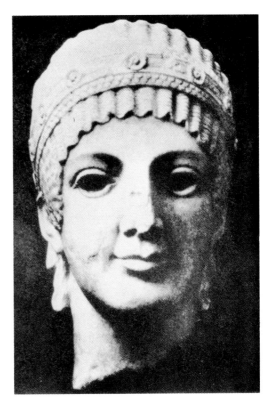

Fig. 573. Modern forgery copied from Fig. 572
(Cf. p. 142)

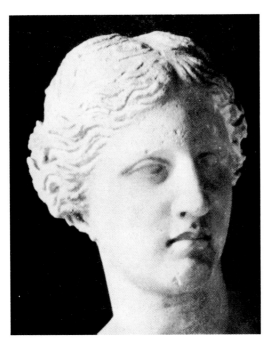

Fig. 574. Head of the Aphrodite of Melos
The Louvre, Paris
(Cf. p. 142)

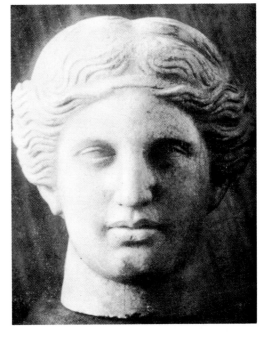

Fig. 575. Modern forgery in the style of Fig. 574
(Cf. p. 142)

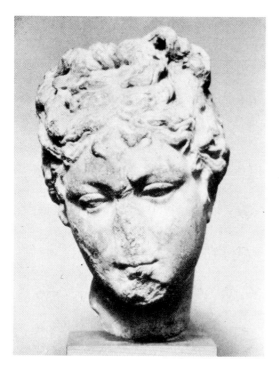

Fig. 576. Ancient head of a girl
Metropolitan Museum of Art
(Cf. p. 142)

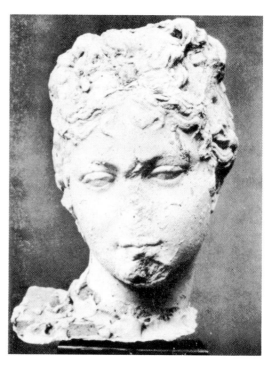

Fig. 577. Plaster cast of Fig. 576, showing puntelli
for reproduction
(Cf. p. 142)

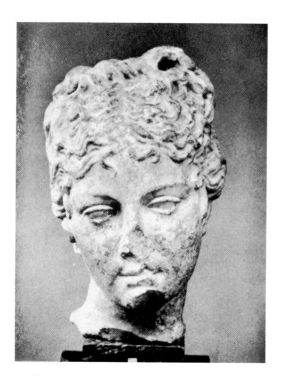

Fig. 578. Modern forgery copied from Fig. 576
with the help of the plaster cast in Fig. 577
(Cf. pp. 142f.)

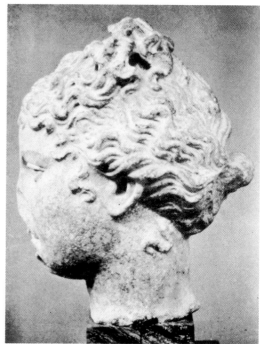

Fig. 579. Modern forgery, side view of Fig. 578
(Cf. pp. 142f.)

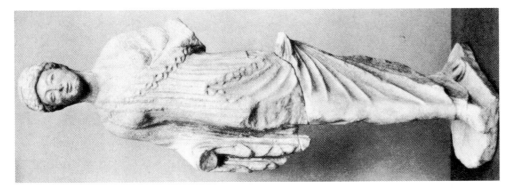

Fig. 580. Modern forgery after the
Mattei Amazon
(Cf. p. 145)

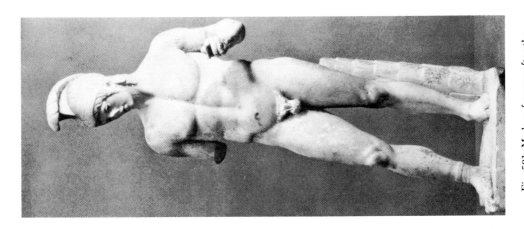

Fig. 581. Modern forgery after the
Ares Borghese
(Cf. p. 145)

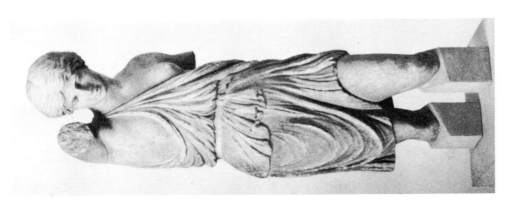

Fig. 582. Modern forgery of an
archaic maiden by Dossena
(Cf. pp. 143, 145)

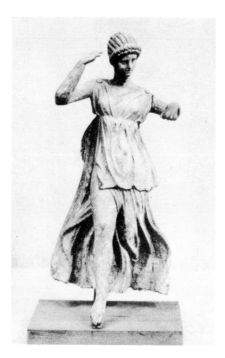

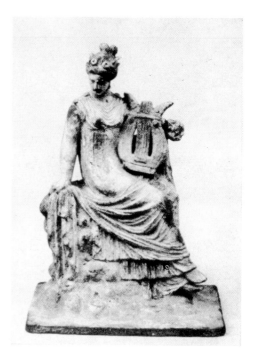

Fig. 583. Greek terracotta statuette of Nike
Metropolitan Museum of Art
(Cf. p. 143)

Fig. 584. Modern forgery of a Greek
terracotta statuette
Metropolitan Museum of Art
(Cf. p. 143)

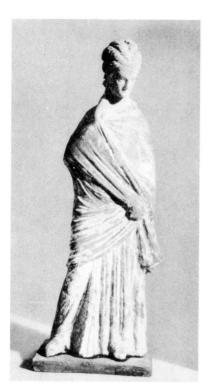

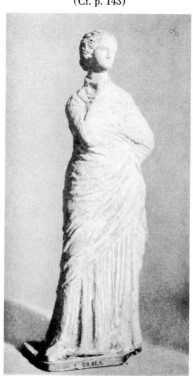

Fig. 585. Greek terracotta statuette
of a girl
Metropolitan Museum of Art
(Cf. pp. 143f.)

Fig. 586. Modern forgery of a Greek
terracotta statuette
Metropolitan Museum of Art
(Cf. pp. 143f.)

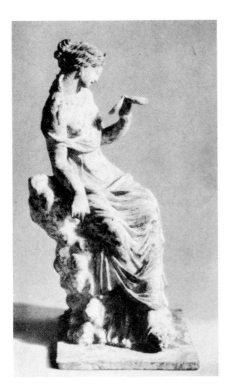

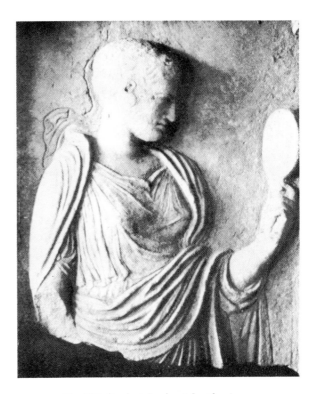

Fig. 587. Modern forgery of a Greek
terracotta statuette
Metropolitan Museum of Art
(Cf. p. 144)

Fig. 588. Greek stele of a girl with mirror
Museum of Fine Arts, Boston
(Cf. p. 144)

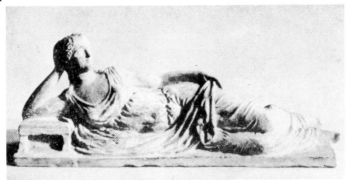

Fig. 589. Modern forgery of a Greek terracotta statuette
Metropolitan Museum of Art
(Cf. p. 144)

Fig. 590. Amymone, Greek
engraved sardonyx
Staatliche Museen, Berlin
(Cf. p. 144)

Fig. 591. Amymone, modern
engraved carnelian
Metropolitan Museum of Art
(Cf. p. 144)

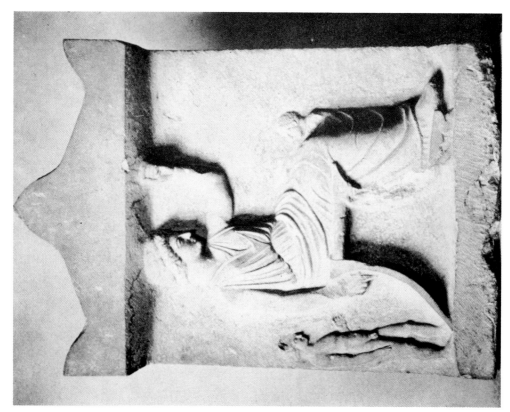

Fig. 593. Modern forgery of a Greek stele
Storerooms of the Staatliche Museen, Berlin
(Cf. p. 144)

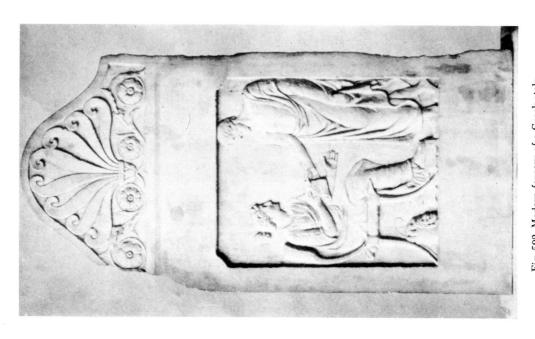

Fig. 592. Modern forgery of a Greek stele
Storerooms of the Staatliche Museen, Berlin
(Cf. p. 144)

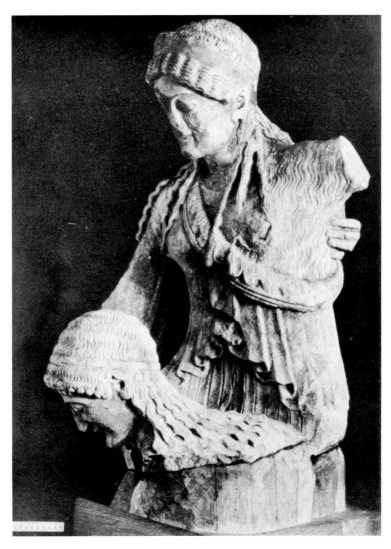

Fig. 594. Modern forgery by Dossena
(Cf. p. 145)

Figs. 595 and 596. Modern forgery by Dossena
(Cf. p. 145)

Fig. 597. Apollo, perhaps by
Kalamis, on a coin of Apollonia
(enlarged)
Staatliche Museen, Berlin
(Cf. p. 159)

Fig. 598. Hermes Kriophoros
perhaps by Kalamis, on a
Roman coin of Tanagra
(from a cast, enlarged)
British Museum, London
(Cf. p. 159)

Fig. 599. Zeus, perhaps by Ageladas
on a coin of Messene (enlarged)
British Museum, London
(Cf. p. 153)

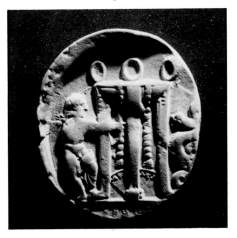

Fig. 600. Apollo killing the serpent, on a coin
of Kroton (from a cast, enlarged)
Staatliche Museen, Berlin
(Cf. p. 158)

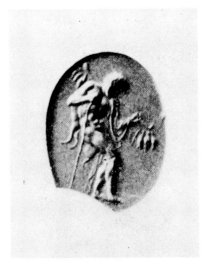

Fig. 601. Philoktetes, on
an engraved agate
(from an impression, enlarged)
The Louvre, Paris
(Cf. p. 158)

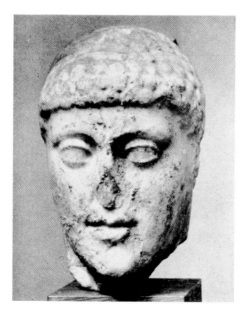

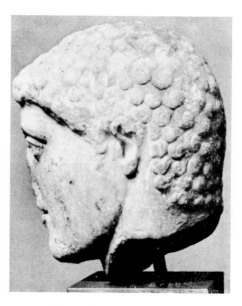

Fig. 602. Marble head of Harmodios
Metropolitan Museum of Art
(Cf. p. 155)

Fig. 603. Side view of Fig. 602
(Cf. p. 155)

Fig. 604. Tyrannicide group
on a coin of Kyzikos (enlarged)
American Numismatic Society, New York
(Cf. p. 155)

Fig. 605. Tyrannicide group
on a coin of Athens (enlarged)
British Museum, London
(Cf. p. 155)

Fig. 606. Tyrannicide group
on a fragment of a
lamp feeder
Metropolitan Museum of Art
(Cf. p. 155)

Fig. 607. Plaster
fragment of the head of
Aristogeiton
(Cf. p. 155)

Fig. 608. Tyrannicide group
shield device on a Panathe-
naic vase
British Museum, London
(Cf. p. 155)

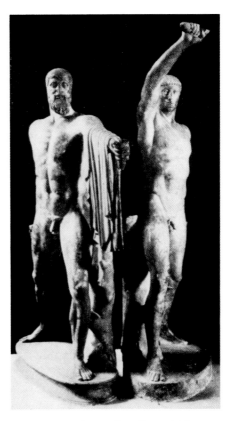

Fig. 609. Group of the Tyrannicides
Museo Nazionale, Naples
(Cf. p. 155)

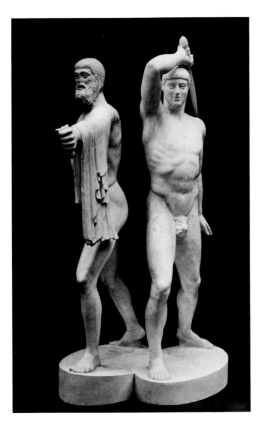

Fig. 610. Reconstructed group of the
Tyrannicides (from a cast)
Metropolitan Museum of Art
(Cf. p. 155)

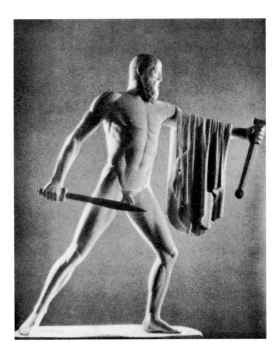

Fig. 611. Aristogeiton, Museo Nuovo, Rome,
with the cast of the head in the Vatican
(from a cast in the Museo
dei Gessi, Rome)
(Cf. pp. 64, 155)

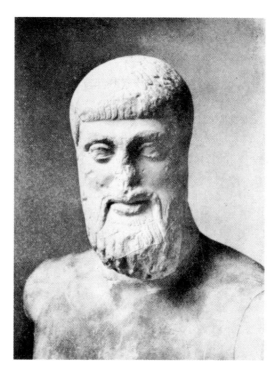

Fig. 612. Head of Aristogeiton (from a cast)
The Vatican, Rome
(Cf. p. 155)

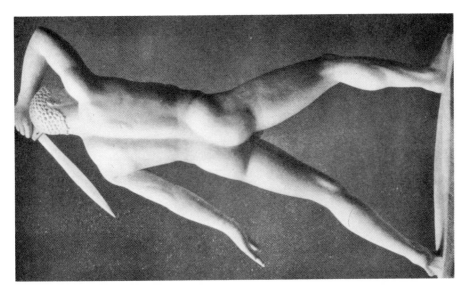

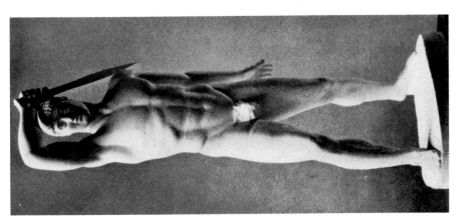

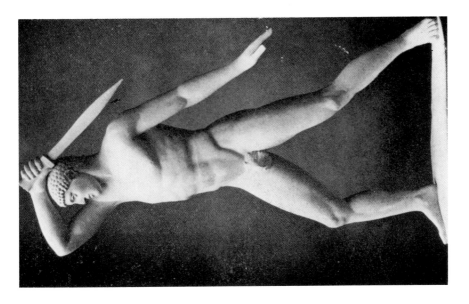

Figs. 613–15. Reconstructed cast of Harmodios
Metropolitan Museum of Art
(Cf. pp. 40, 155)

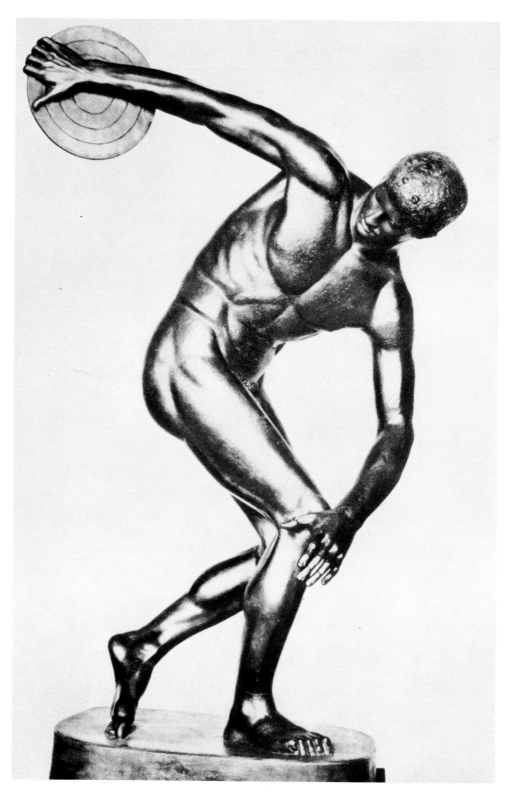

Fig. 616. Diskobolos (from a composite cast)
(Cf. pp. 44, 161)

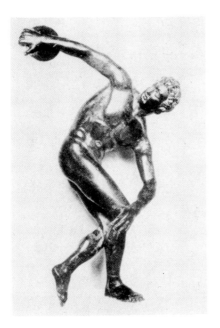

Fig. 617. Bronze statuette of a diskobolos
Museum für antike Kleinkunst, Munich
(Cf. p. 161)

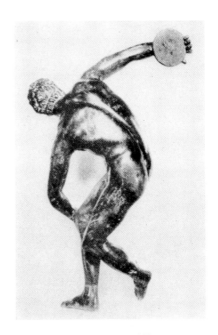

Fig. 618. Back view of Fig. 617.
(Cf. p. 161)

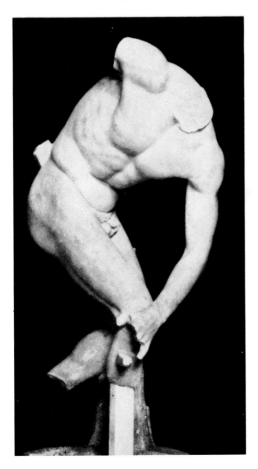

Fig. 619. Diskobolos, from Castel Porziano
Museo Nazionale delle Terme, Rome
(Cf. p. 161)

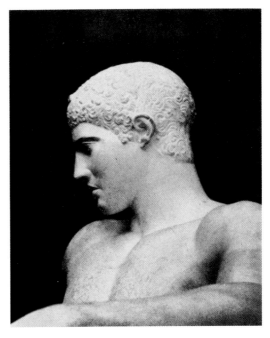

Fig. 620. Head of the diskobolos (from a cast)
(Cf. Fig. 616)
Museo Nazionale delle Terme, Rome
(Cf. p. 161)

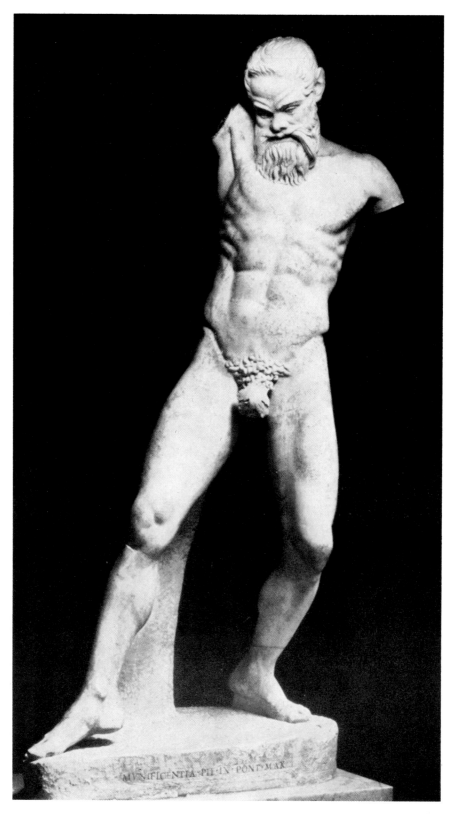

Fig. 621. Marsyas, Roman copy of a work by Myron
The Lateran Collection, Rome
(Cf. pp. 44, 162)

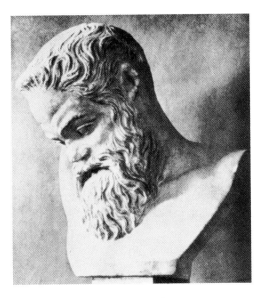

Fig. 622. Head of Marsyas
Barracco Museum, Rome
(Cf. p. 163)

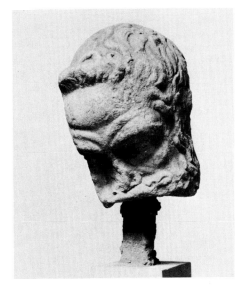

Fig. 623. Fragment of a head of Marsyas
Capitoline Museum, Rome
(Cf. p. 163)

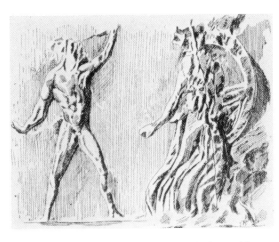

Fig. 624. Athena and Marsyas, detail of a marble
vase from Athens
National Museum, Athens
(Cf. p. 162)

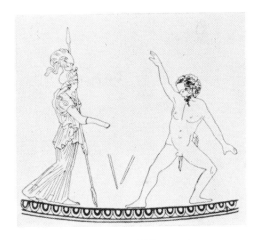

Fig. 625. Athena and Marsyas, from a
red-figured oinochoe
Staatliche Museen, Berlin
(Cf. pp. 162, 163)

Fig. 626. Athena and Marsyas, on a coin
of Athens (from a cast, enlarged)
Numismatic Museum, Athens
(Cf. p. 162)

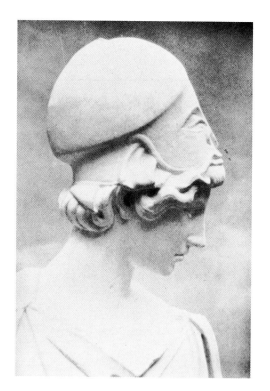 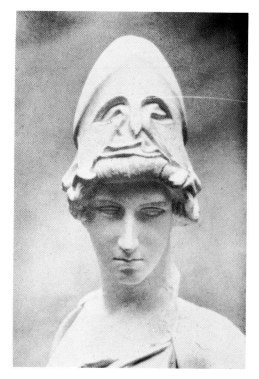

Figs. 627 and 628. Head of Fig. 629 (from a cast)
Städtliche Skulpturensammlung, Frankfurt
(Cf. p. 163)

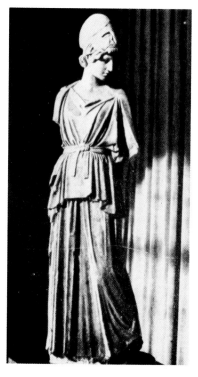 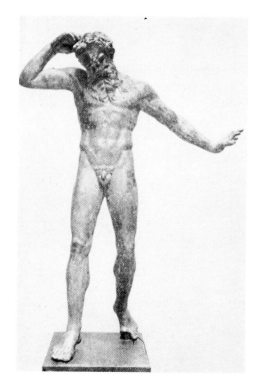

Fig. 629. Statue of Athena
Städtliche Skulpturensammlung, Frankfurt
(Cf. p. 163)

Fig. 630. Large bronze statuette of Marsyas
British Museum, London
(Cf. p. 162)

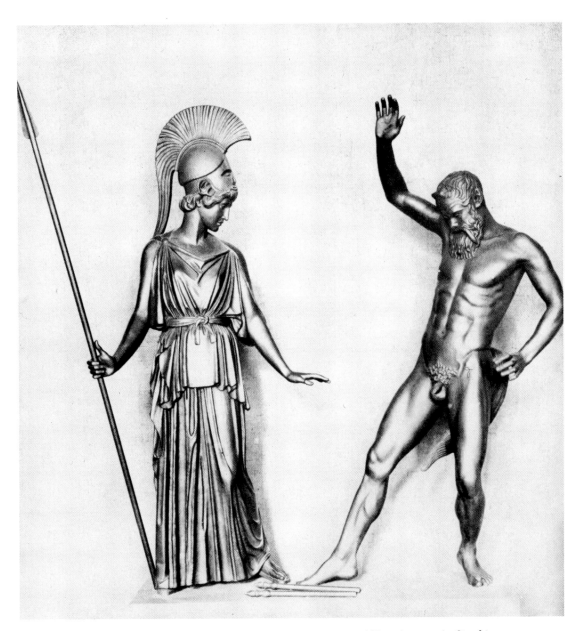

Fig. 631. Athena and Marsyas, reconstruction of Myron's group, by Sieveking
(Cf. p. 163)

Fig. 632. Athena, on a
Roman coin of Athens (from a
cast, enlarged)
British Museum, London
(Cf. p. 169)

Fig. 633. Athena Parthenos, on a
Roman coin of Athens (from a
cast, enlarged)
British Museum, London
(Cf. p. 170)

Fig. 634. Athena Parthenos,
on an engraved gem
Metropolitan Museum of Art
(Cf. p. 170)

Fig. 635. "Athena Promachos"
on the Akropolis, on a Roman
coin of Athens (from a cast)
British Museum, London
(Cf. p. 169)

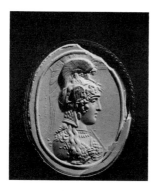

Fig. 636. Head of Athena
Parthenos, on an engraved
gem by Aspasios
(from an impression)
Museo Nazionale delle Terme, Rome
(Cf. p. 170)

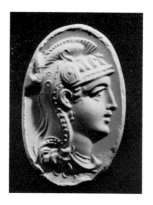

Fig. 637. Head of Athena Parthenos on a coin
(from an impression)
(Cf. p. 170)

Fig. 640. Lenormant statuette of the
Athena Parthenos
National Museum, Athens
(Cf. pp. 71, 170)

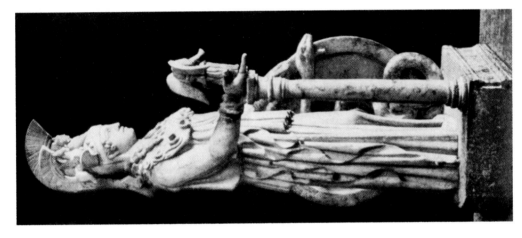

Figs. 638 and 639. Varvakeion statuette of the Athena Parthenos
National Museum, Athens
(Cf. pp. 71, 170, 174)

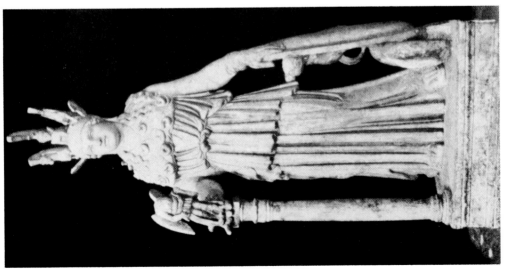

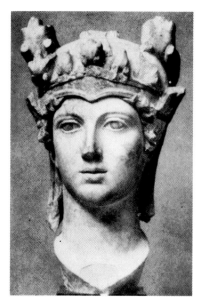

Fig. 641. Head of Athena Parthenos
Staatliche Museen, Berlin
(Cf. pp. 128, 170, 174)

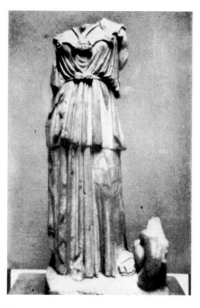

Fig. 642. Statuette of Athena Parthenos
(from a cast)
Patras Museum
(Cf. p. 170)

Fig. 643. Upper part of a statuette
of the Athena Parthenos
The Art Museum of Princeton University
(Cf. p. 170)

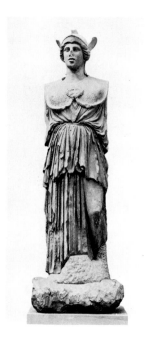

Fig. 644. Athena Parthenos, from Pergamon
Staatliche Museen, Berlin
(Cf. p. 170)

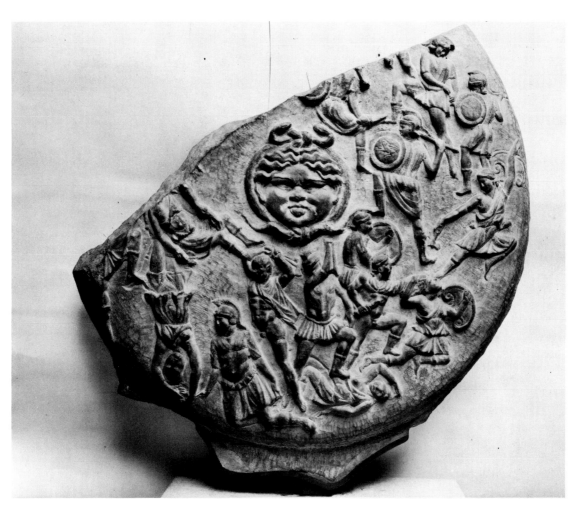

Fig. 645. The "Strangford Shield"
British Museum, London
(Cf. p. 170)

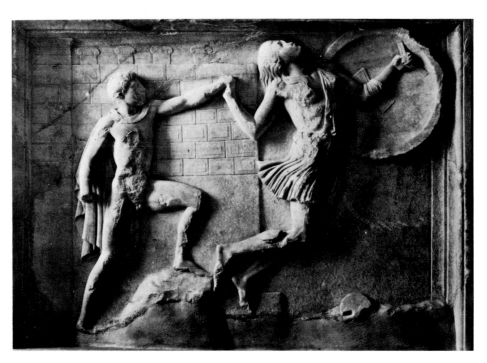

Fig. 646. Greek and Amazon
Piraeus Museum
(Cf. p. 170)

Fig. 647. Head of Zeus, on a Roman coin of Elis
(from a cast, enlarged)
Bibliothèque Nationale, Paris
(Cf. p. 172)

Fig. 648. Head of Zeus, on a Roman coin of Elis
Münzkabinett, Berlin
(Cf. p. 172)

Fig. 649. Statue of Zeus, on a Roman coin of Elis
(from a cast, enlarged)
Museo Archeologico, Florence
(Cf. p. 172)

Fig. 650. Zeus in his temple, on an engraved gem
Cabinet des Médailles, Paris
(Cf. p. 172)

Fig. 651a. Head of Zeus, on a coin of Elis (from a cast)
British Museum, London
(Cf. p. 172)

Fig. 651b. Zeus, seated, on a coin of Elis (from a cast)
British Museum, London
(Cf. p. 172)

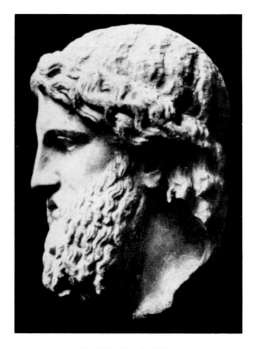

Fig. 652. Head of Zeus
Museum of Fine Arts, Boston
(Cf. p. 172)

Fig. 653. Zeus, Roman fresco from Eleusis
(Cf. p. 172)

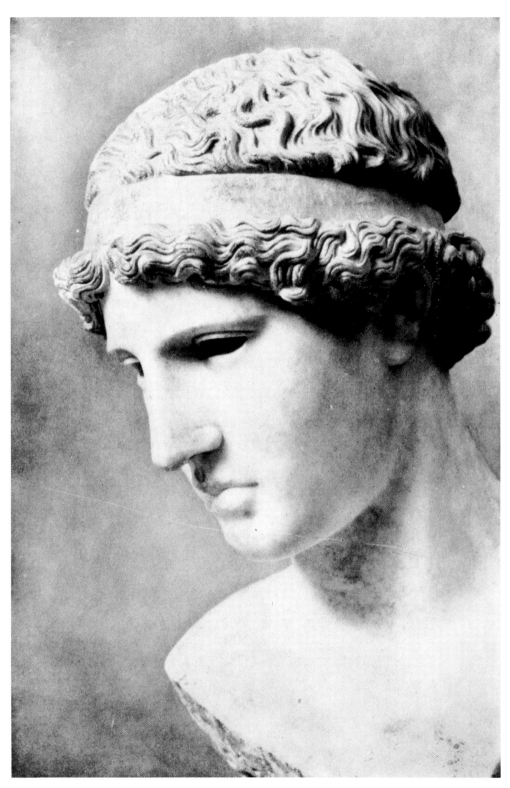

Fig. 654. Head of Athena
Museo Civico, Bologna
(Cf. pp. 51, 174)

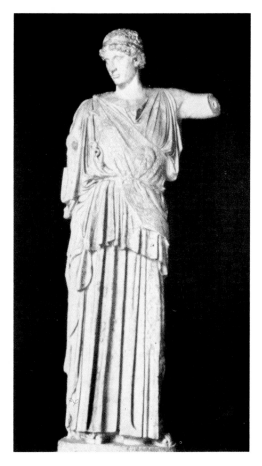 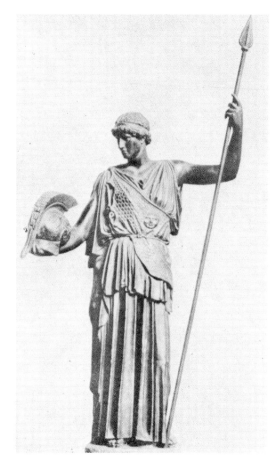

Fig. 655. Statue of Athena
The Albertinum, Dresden
(Cf. p. 174)

Fig. 656. Reconstruction of the Lemnian Athena
From a cast in the Museum der Bildenden Künste, Budapest
(Cf. p. 174)

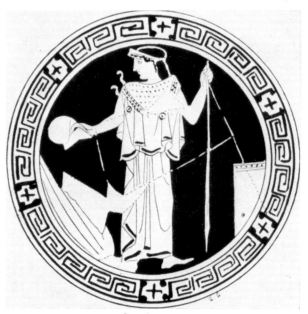

Fig. 657. Athena, on a red-figured kylix
Museo Civico, Bologna
(Cf. p. 174, note 76)

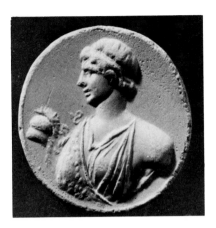

Fig. 658. Athena, on an engraved gem
British Museum, London
(Cf. p. 174)

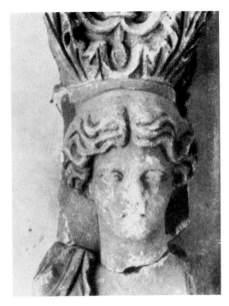

Fig. 659. Head of an Amazon
National Museum, Athens
(Cf. p. 175)

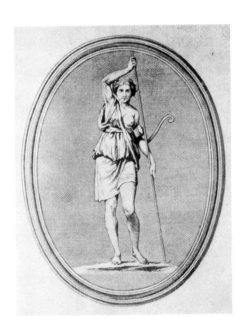

Fig. 660. Amazon, on a gem (from a drawing)
(Cf. p. 175)

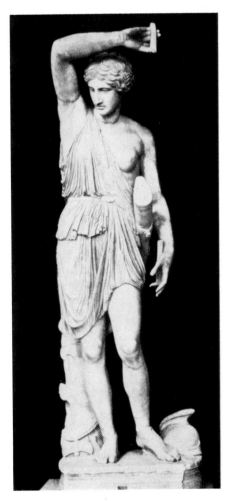

Fig. 661. Mattei Amazon
The Vatican, Rome
(Cf. pp. 175, 181)

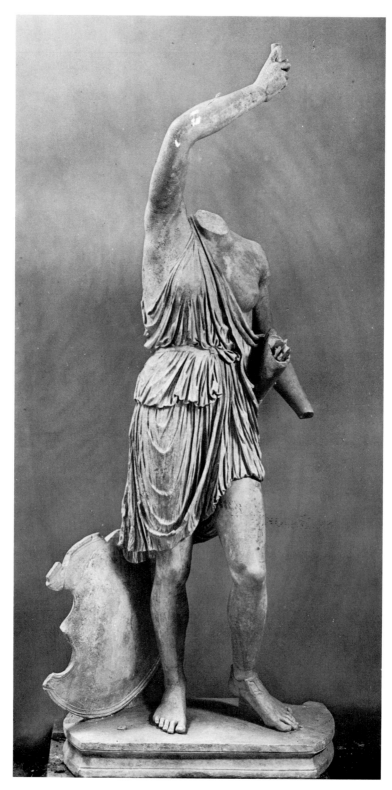

Fig. 662. Amazon
Tivoli Museum
(Cf. p. 175)

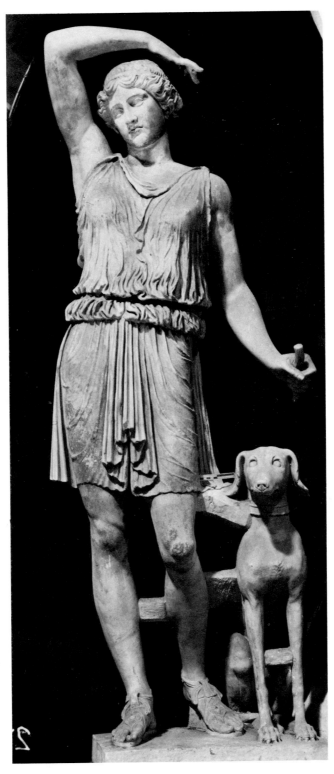

Fig. 663. Amazon
Villa Doria Pamfili, Rome
(Cf. pp. 174f.)

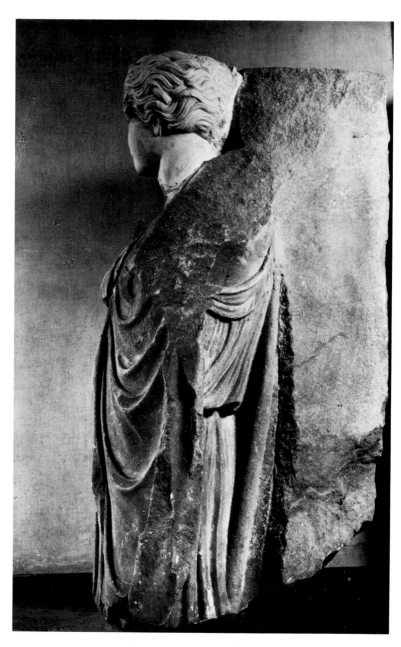

Fig. 664. Amazon from Ephesos
Kunsthistorisches Museum, Vienna
(Cf. pp. 174f.)

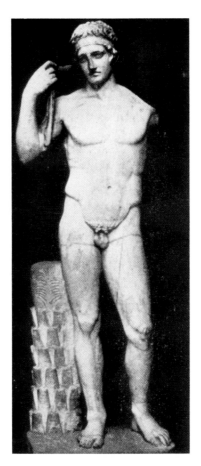

Fig. 665. Farnese Diadoumenos
British Museum, London
(Cf. p. 176)

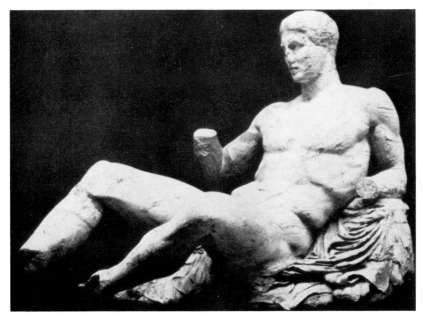

Fig. 666. "Theseus," from the eastern pediment of the Parthenon
British Museum, London
(Cf. p. 178)

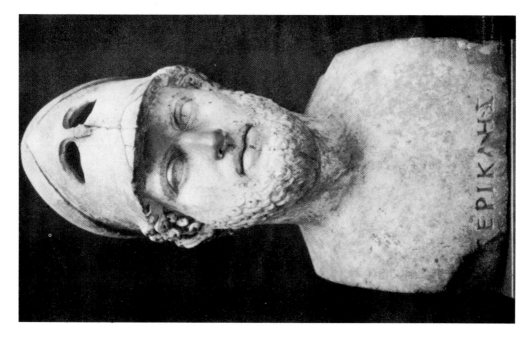

Fig. 667. Herm of Perikles
The Vatican, Rome
(Cf. pp. 179, 180)

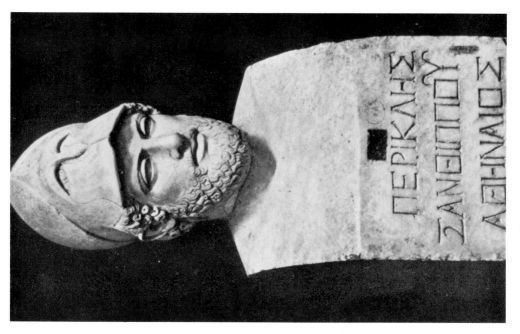

Fig. 668. Herm of Perikles
British Museum, London
(Cf. pp. 179, 180)

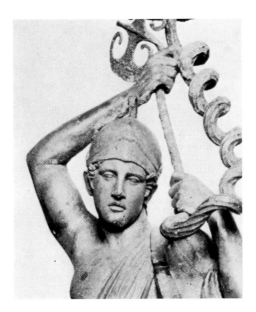

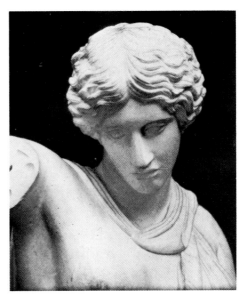

Fig. 669. Detail of a bronze statuette of a warrior
(cf. Fig. 135)
Musée St. Germain-en-Laye
(Cf. p. 180)

Fig. 670. Head of Fig. 671 (from a cast)
(Cf. p. 180)

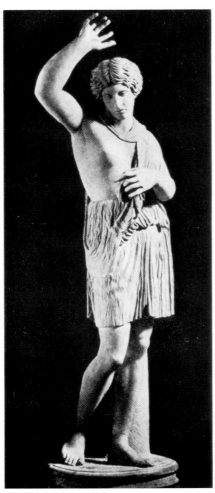

Fig. 671. Amazon
Capitoline Museum, Rome
(Cf. p. 180)

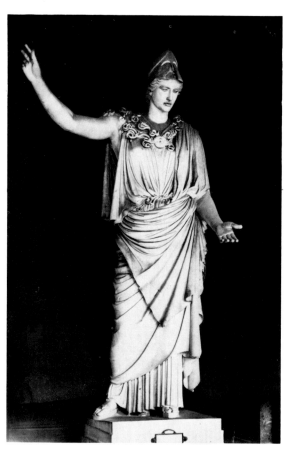

Fig. 672. Athena from Velletri
The Louvre, Paris
(Cf. p. 181)

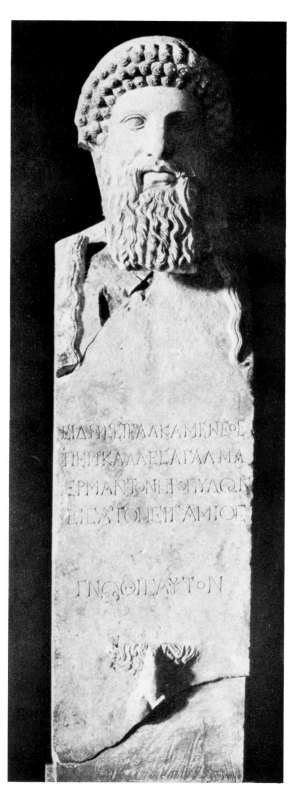

Fig. 673. Herm of Hermes Propylaios
Istanbul Museum
(Cf. p. 182)

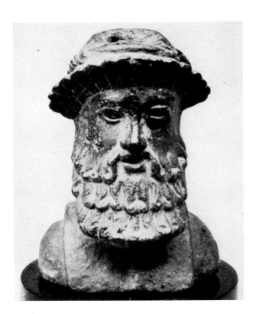

Fig. 674.
Bronze herm of Hermes Propylaios
Metropolitan Museum of Art
(Cf. p. 182)

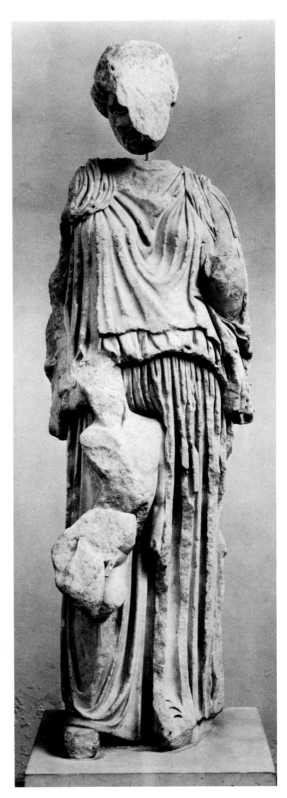

Fig. 675. Prokne and Itys
Akropolis Museum, Athens
(Cf. p. 183)

Fig. 676. Head of the Dionysos
by Alkamenes, on a coin of Athens
(from a cast, enlarged)
American Numismatic Society, New York
(Cf. p. 182)

Fig. 677. Dionysos, by Alkamenes, on a coin
of Athens (from a cast, enlarged)
Bibliothèque Nationale, Paris
(Cf. p. 182)

Fig. 679. Nemesis, on a coin of Paphos
(from a cast, enlarged)
British Museum, London
(Cf. p. 185)

Fig. 678. Head of Nemesis
by Agorakritos
British Museum, London
(Cf. p. 185)

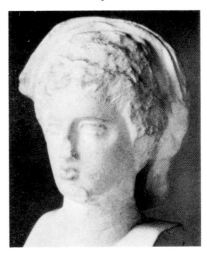

Fig. 680. Head of a woman, from the
base of the statue of Nemesis by
Agorakritos (from a cast)
National Museum, Athens
(Cf. p. 185)

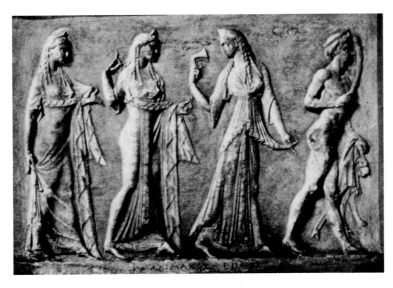

Fig. 681. Pan and the Graces
Capitoline Museum, Rome
(Cf. p. 186)

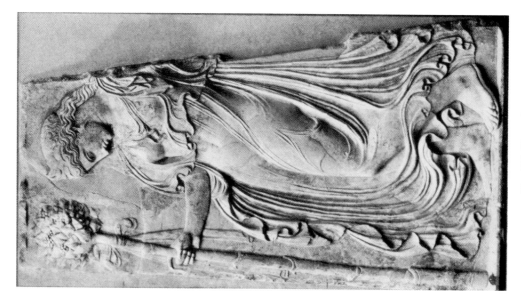

Fig. 683. Maenad
Metropolitan Museum of Art
(Cf. pp. 139, 186)

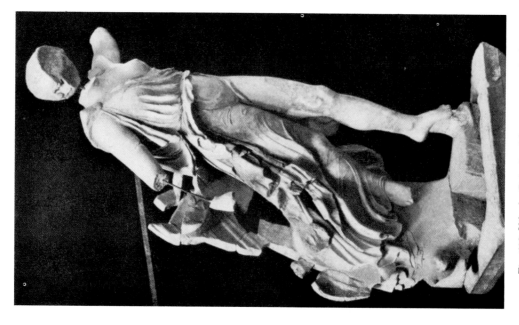

Fig. 682. Nike by Paionios (three-quarters view)
Olympia Museum
(Cf. pp. 39, 67, 138, 186f.)

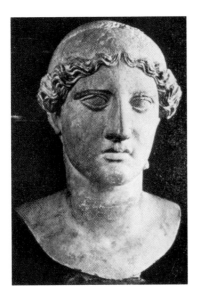 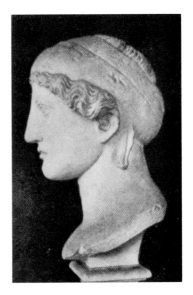

Fig. 684. The Hertz head
Palazzo Venezia, Rome
(Cf. p. 187)

Fig. 685. Profile view of Fig. 684
(from a cast)
(Cf. p. 187)

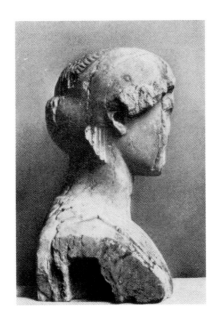

Fig. 686. Head of the same type
as that shown in Fig. 684
The Vatican, Rome
(Cf. p. 187)

Fig. 687. Fragment of the head
of the Nike by Paionios
(cf. Fig. 682)
Olympia Museum
(Cf. pp. 186f.)

Fig. 688. Artemis, by Strongy-
lion, on a coin of Megara
(from a cast, enlarged)
British Museum, London
(Cf. p. 188)

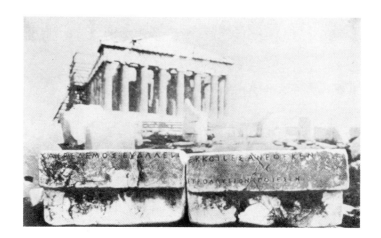

Fig. 689. Inscribed base of the bronze statue of the wooden
horse by Strongylion
On the Akropolis, Athens
(Cf. p. 188)

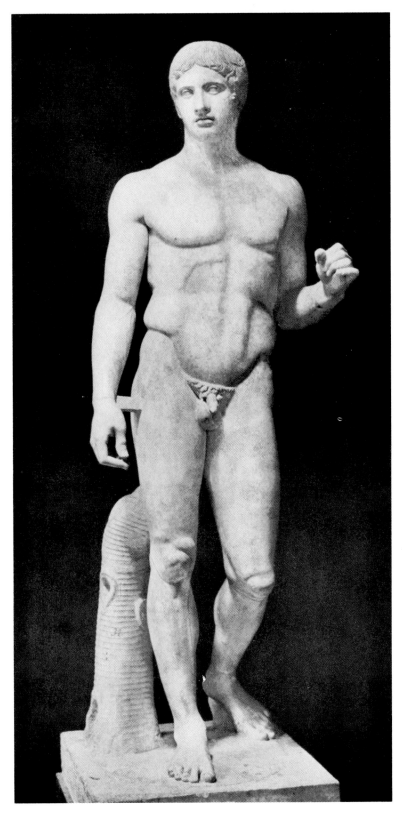

Fig. 690. Doryphoros, from Pompeii
Museo Nazionale, Naples
(Cf. pp. 33, 190)

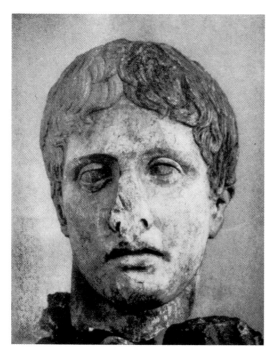

Fig. 691. Head of the Doryphoros
Corinth Museum
(Cf. p. 190)

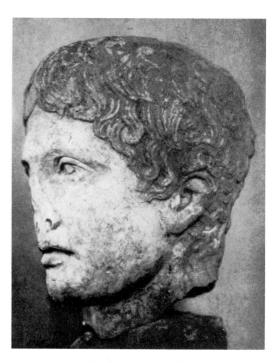

Fig. 692. Profile view of Fig. 691
(Cf. p. 190)

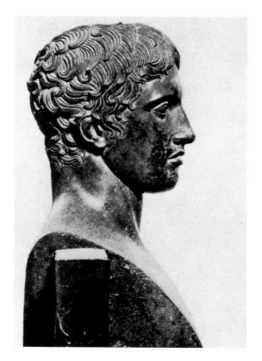

Fig. 693. Bronze herm of the Doryphoros
Museo Nazionale, Naples
(Cf. pp. 190, 246)

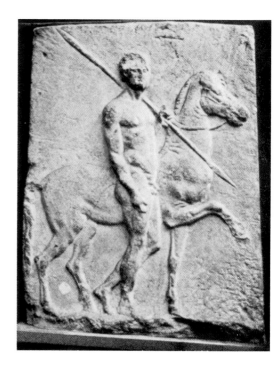

Fig. 694. Relief of the Doryphoros (from a cast)
National Museum, Athens
(Cf. p. 190)

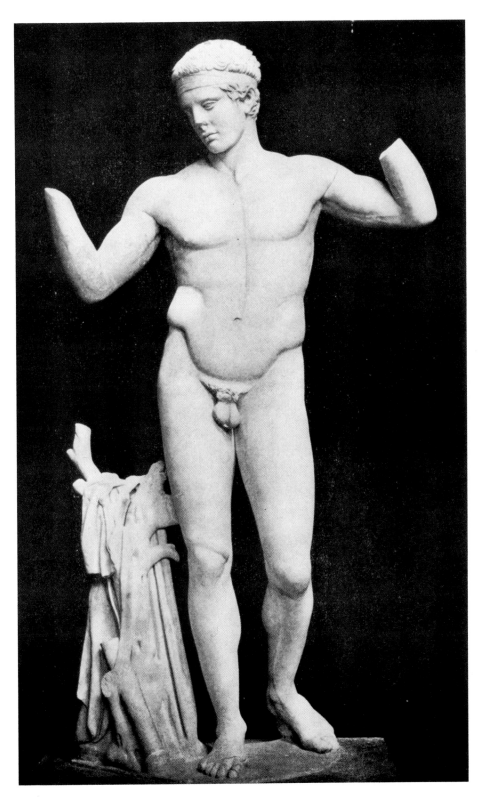

Fig. 695. Diadoumenos, from Delos
National Museum, Athens
(Cf. pp. 33, 137, 191)

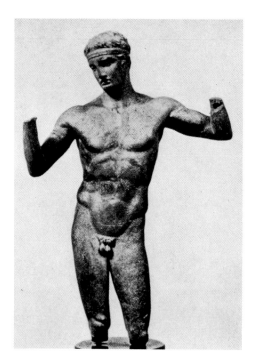

Fig. 696. Terracotta statuette of the Diadoumenos
Metropolitan Museum of Art
(Cf. p. 191)

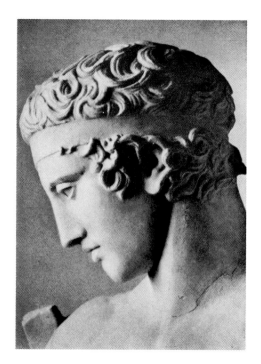

Fig. 697. Head of the Diadoumenos
Metropolitan Museum of Art
(Cf. p. 191)

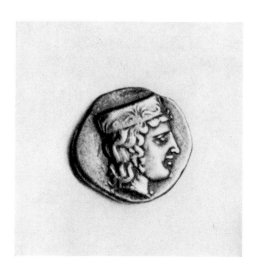

Fig. 698. Head of Hera, on a coin of Argos
(slightly enlarged)
American Numismatic Society, New York
(Cf. p. 192)

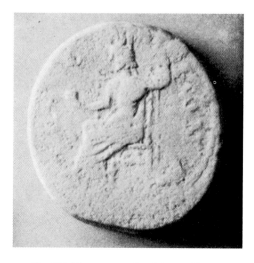

Fig. 699. Hera, on a coin of Argos (from a
cast, enlarged)
British Museum, London
(Cf. p. 192)

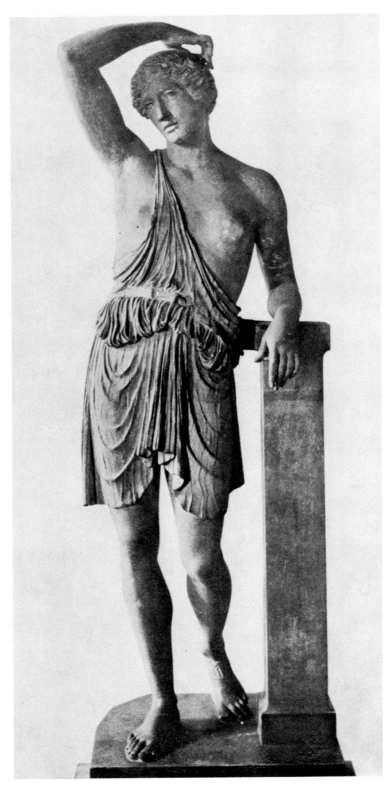

Fig. 700. Amazon, from Rome
Staatliche Museen, Berlin
(Cf. p. 193)

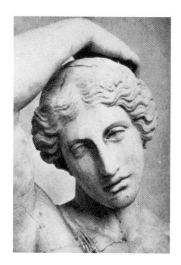

Fig. 701. Head of an Amazon
(from a cast)
Metropolitan Museum of Art
(Cf. p. 193)

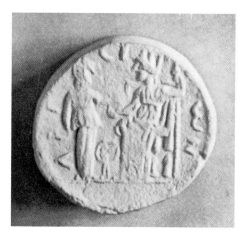

Fig. 702. Hera and Hebe, on a coin of Argos
(from a cast, enlarged)
(Cf. p. 195)

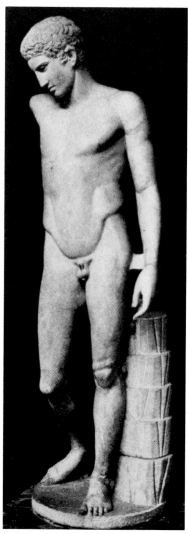

Fig. 703. "Westmacott Athlete"
British Museum, London
(Cf. p. 193)

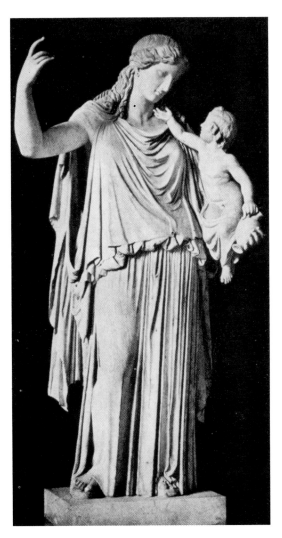

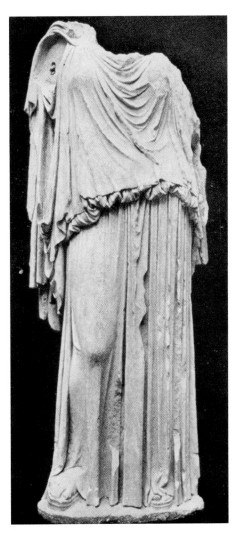

Fig. 704. Eirene and the infant Ploutos
The Glyptothek, Munich
(Cf. p. 197)

Fig. 705. Eirene
Metropolitan Museum of Art
(Cf. p. 197)

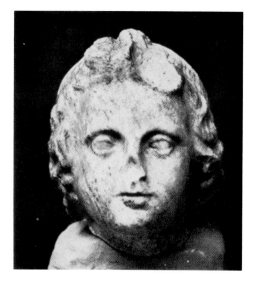

Fig. 706. Eirene and the infant Ploutos, on a coin
of Athens (from a cast, enlarged)
British Museum, London
(Cf. p. 197)

Fig. 707. Head of Fig. 708
before restorations
(Cf. p. 198)

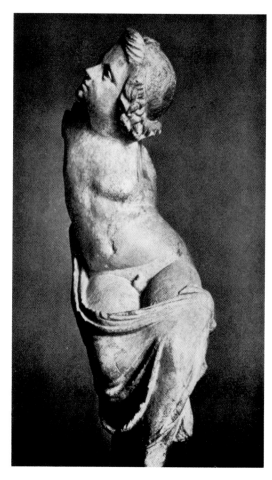

Fig. 708. Ploutos
The Albertinum, Dresden
(Cf. p. 198)

Fig. 709. Hermes and the infant Dionysos, on a Roman coin
British Museum, London
(Cf. p. 198)

Fig. 710. Hermes and the infant Dionysos, engraving of a lost statue
(Cf. p. 198)

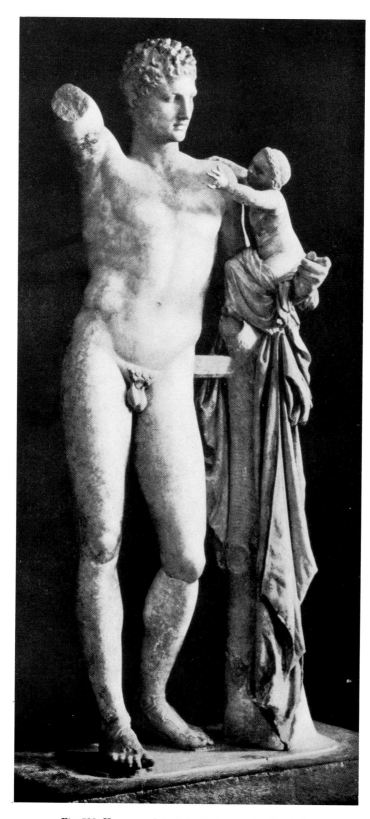

Fig. 711. Hermes and the infant Dionysos, by Praxiteles
Olympia Museum
(Cf. pp. 34f., 128, 139, 198, 199)

Fig. 713. Satyr with the infant Dionysos
From Pompeii
(Cf. p. 199)

Fig. 714. Foot of the Hermes by Praxiteles (see Fig. 711)
(Cf. p. 199)

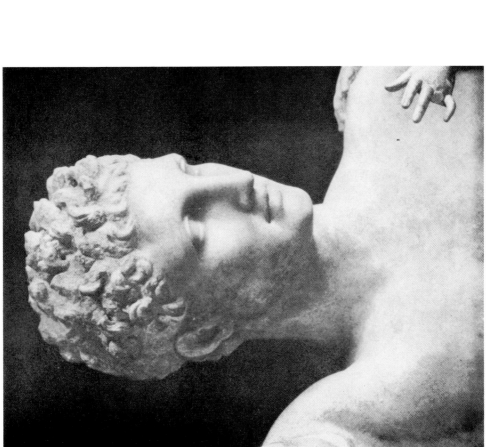

Fig. 712. Head of the Hermes by Praxiteles (see Fig. 711)
(Cf. pp. 199, 293)

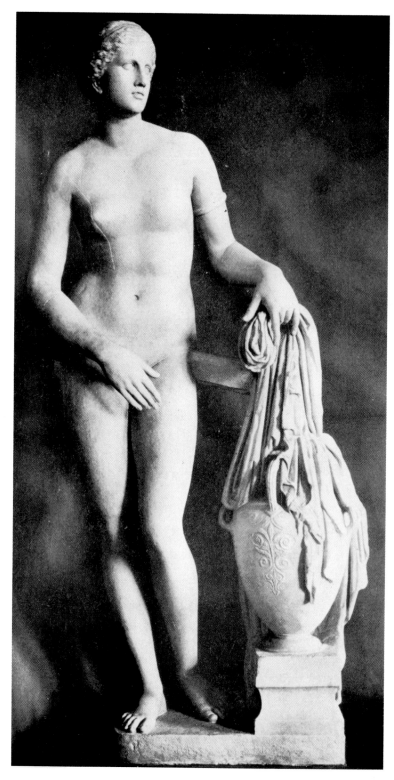

Fig. 715. Reconstruction of the Aphrodite of Knidos: body of the Vatican
figure, the Kaufmann head, and some restorations (from a cast)
(Cf. pp. 35, 201)

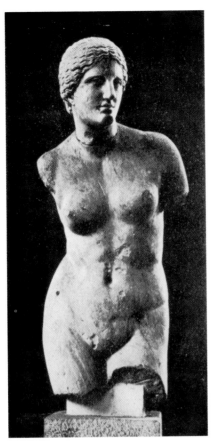

Fig. 716. Torso of Aphrodite in the
Musée Cinquantenaire, Brussels, with a
cast of the head in the Ny Carlsberg
Glyptotek, Copenhagen
(Cf. p. 201)

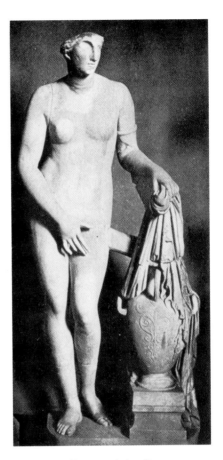

Fig. 717. Aphrodite
The Magazzini of the Vatican, Rome
(Cf. p. 201)

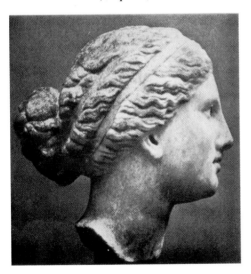

Fig. 718. Head of Aphrodite
The Kaufmann Collection, Berlin
(Cf. p. 201)

Fig. 719. Aphrodite, on a coin
of Knidos (from a cast)
Bibliothèque Nationale, Paris
(Cf. p. 201)

Fig. 720. Apollo Sauroktonos, on a coin
of Nikopolis (from a cast, enlarged)
British Museum, London
(Cf. pp. 35, 202)

Fig. 721. Eros on a Roman coin of Parion
Staatliche Museen, Berlin
(Cf. p. 202)

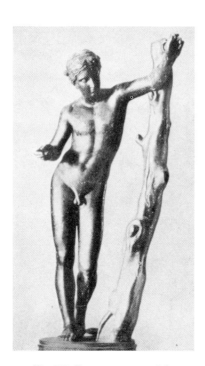

Fig. 722. Bronze statuette of the
Apollo Sauroktonos
Villa Albani, Rome
(Cf. pp. 35, 202)

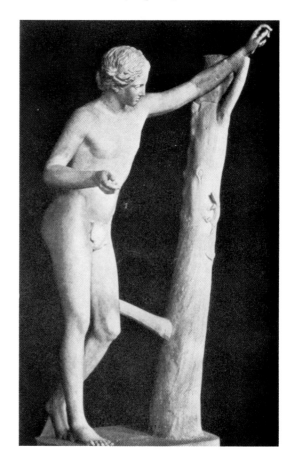

Fig. 723. Apollo Sauroktonos
The Vatican, Rome
(Cf. pp. 35, 202)

Fig. 724. Artemis, on a coin of Antikyra
(from a cast, enlarged)
Staatliche Museen, Berlin
(Cf. p. 203)

Fig. 725. Leto and Chloris, on a coin of Argos
(from a cast, enlarged)
British Museum, London
(Cf. p. 203)

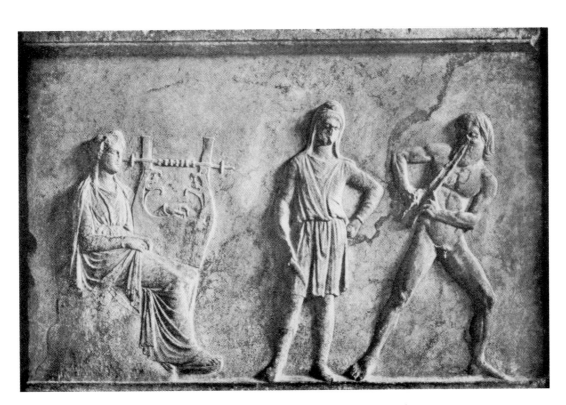

Fig. 726. Apollo and Marsyas, relief from the Mantineia base
National Museum, Athens
(Cf. p. 204)

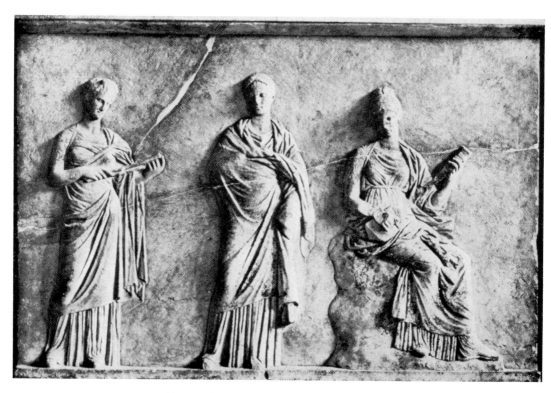

Fig. 727. Muses, relief from the Mantineia base
National Museum, Athens
(Cf. pp. 70, 204)

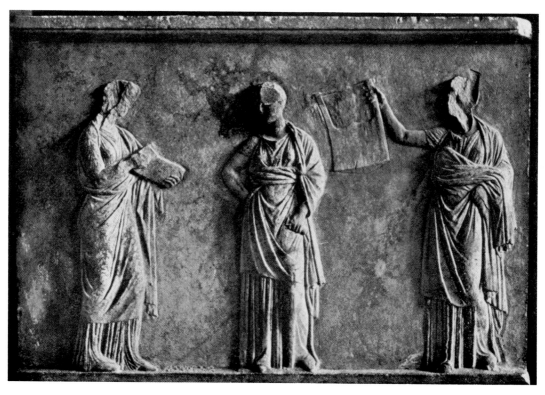

Fig. 728. Muses, relief from the Mantineia base
National Museum, Athens
(Cf. pp. 70, 204)

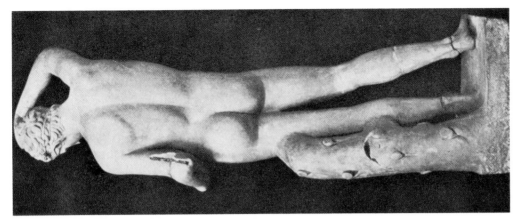

Fig. 729. Satyr
The Albertinum, Dresden
(Cf. pp. 35, 202, 204)

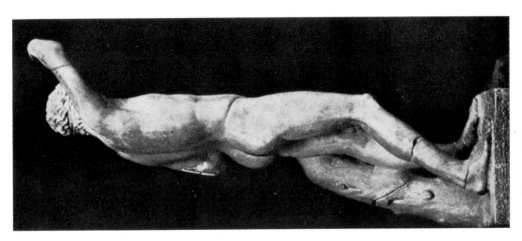

Fig. 730. Side view of Fig. 729
(Cf. pp. 35, 202, 204)

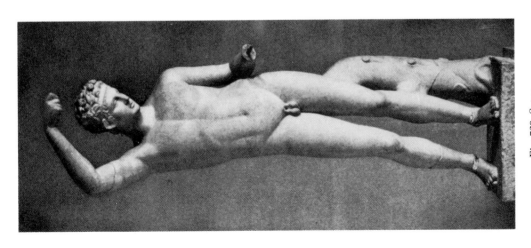

Fig. 731. Back view of Fig. 729
(Cf. pp. 35, 202, 204)

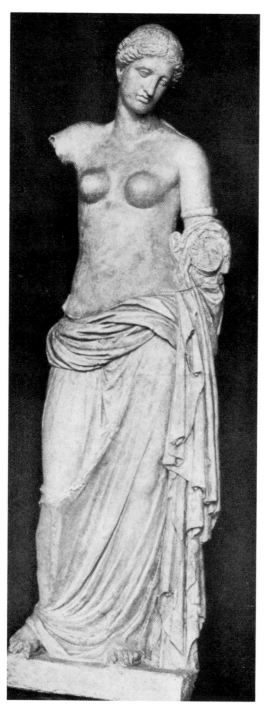 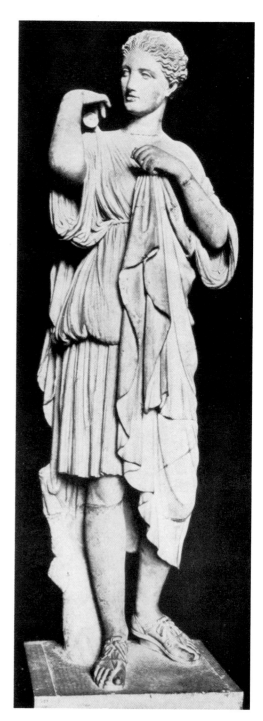

Fig. 732. Aphrodite of Arles
The Louvre, Paris
(Cf. p. 206)

Fig. 733. Artemis of Gabii
The Louvre, Paris
(Cf. p. 204)

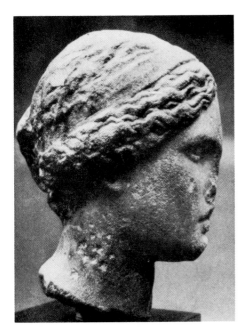

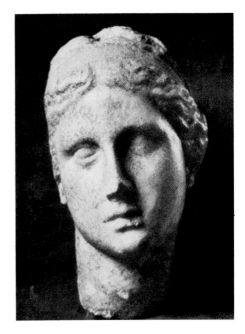

Fig. 734. Head of a girl, from the altar
of Kos (profile view)
Archaeological Museum, Istanbul
(Cf. p. 207)

Fig. 735. Front view of Fig. 734, with
restorations
(Cf. p. 207)

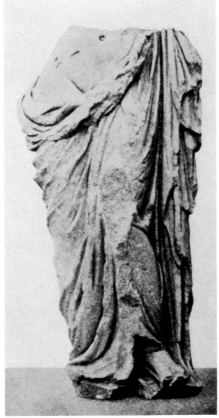

Fig. 736. Lower half of a female figure
from the altar of Kos
Archaeological Museum, Istanbul
(Cf. p. 207)

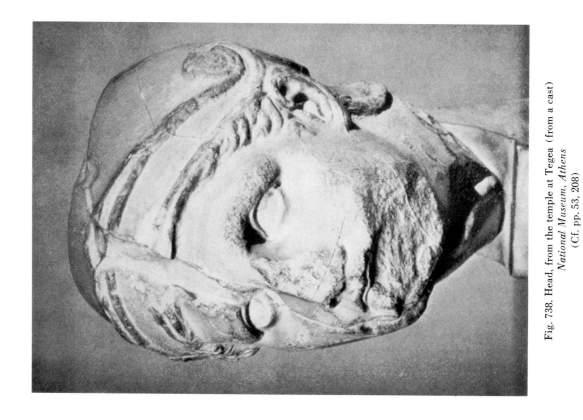

Fig. 738. Head, from the temple at Tegea (from a cast)
National Museum, Athens
(Cf. pp. 53, 208)

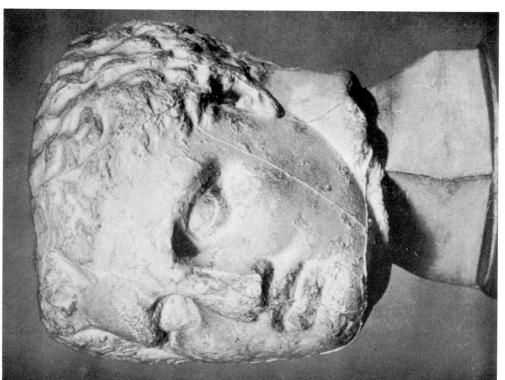

Fig. 737. Head, from the temple of Athena Alea at Tegea (from a cast)
National Museum, Athens
(Cf. pp. 53, 208)

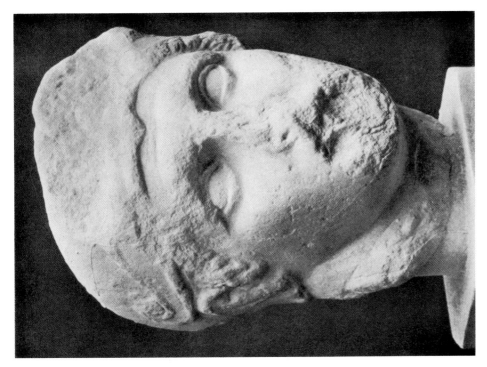

Fig. 740. Head of a warrior, from the temple at Tegea (from a cast)
Tegea Museum
(Cf. pp. 53, 208)

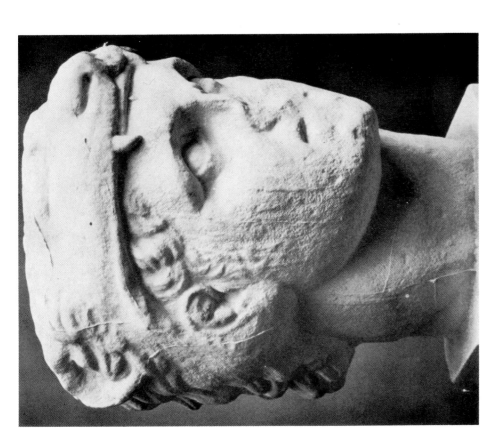

Fig. 739. Head of Herakles, from the temple at Tegea (from a cast)
Tegea Museum
(Cf. pp. 53, 208)

Fig. 741. Apollo, on a coin of Nero
(from a cast, enlarged)
British Museum, London
(Cf. p. 212)

Fig. 742. Apollo, on a coin of
Alexandria Troas (enlarged)
American Numismatic Society, New York
(Cf. p. 211)

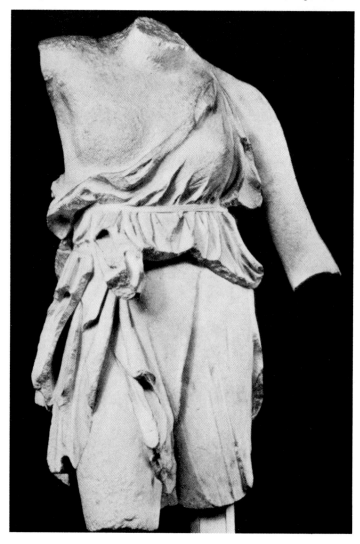

Fig. 743. Atalante, from the eastern pediment of the temple at Tegea
(from a cast)
Tegea Museum
(Cf. p. 208)

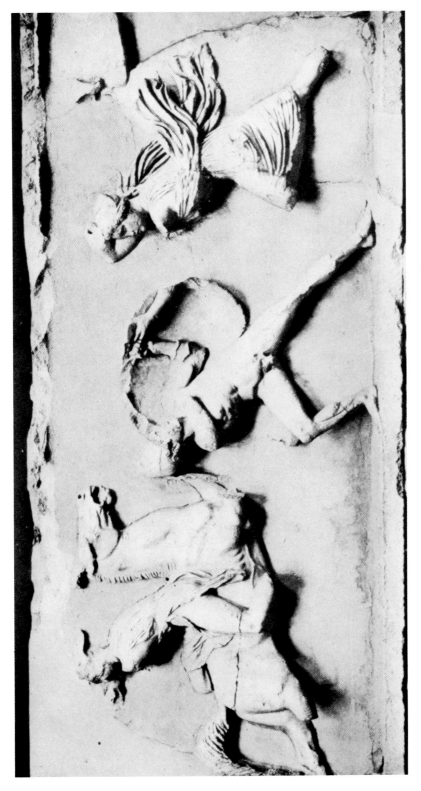

Fig. 744. Contest of Greeks and Amazons, from a frieze of the Mausoleum
British Museum, London
(Cf. pp. 76, 106, 210)

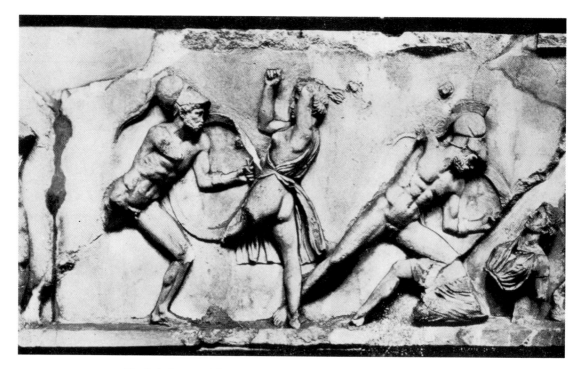

Fig. 745. Contest of Greeks and Amazons, from a frieze of the Mausoleum
British Museum, London
(Cf. pp. 41, 106, 210)

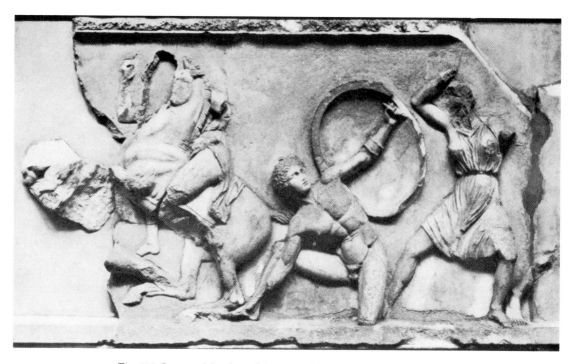

Fig. 746. Contest of Greeks and Amazons, from a frieze of the Mausoleum
British Museum, London
(Cf. p. 106, 210)

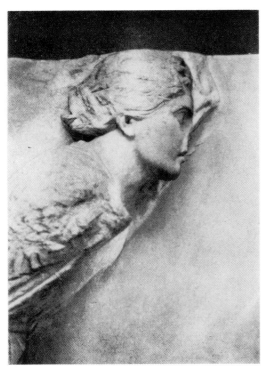

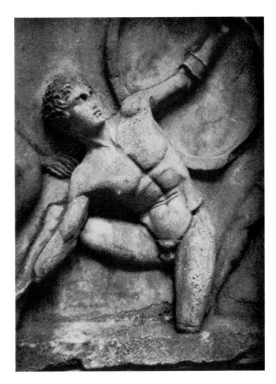

Fig. 747. Head of a charioteer, from a frieze of the
Mausoleum
British Museum, London
(Cf. p. 210)

Fig. 748. Greek warrior, detail of Fig. 746
(Cf. p. 210)

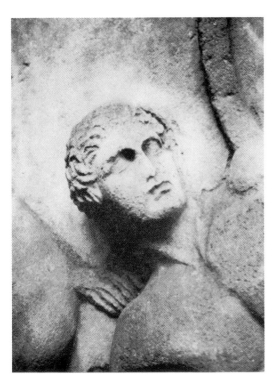

Fig. 749. Detail of head of Fig. 748
(Cf. p. 210)

Fig. 750. Head of Hermes (see Fig. 751)
(Cf. p. 210)

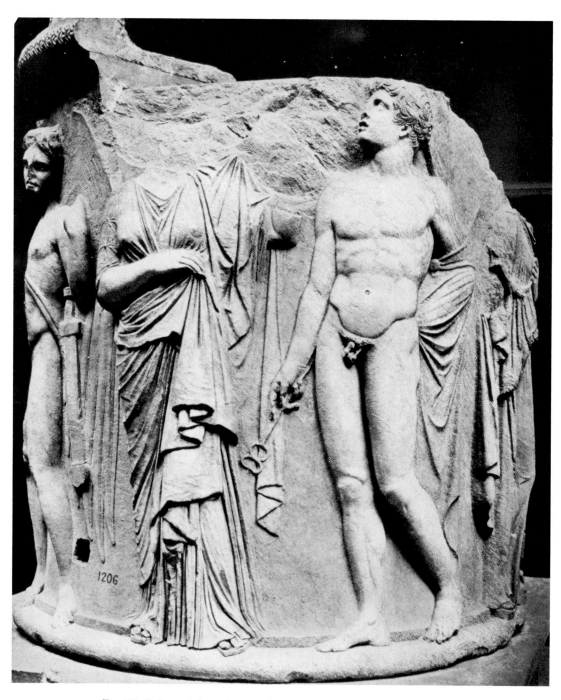

Fig. 751. Sculptured drum, from a column of the temple of Artemis at Ephesos
British Museum, London
(Cf. pp. 35, 70, 89, 198, 208, 210)

Fig. 752. Apollo
Musée d'Art et d'Histoire, Geneva
(Cf. p. 212)

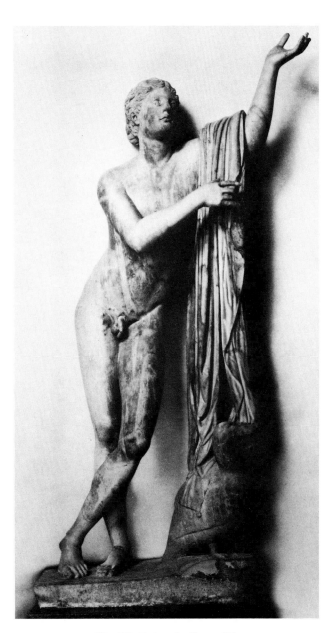

Fig. 753. Pothos, by Skopas(?)
Capitoline Museum, Rome
(Cf. p. 212)

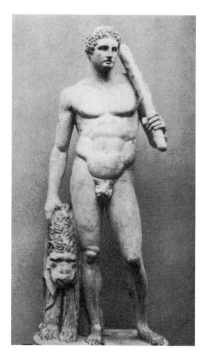

Fig. 754. Herakles (from a cast)
J. Paul Getty Museum, California
(Cf. pp. 139, 213)

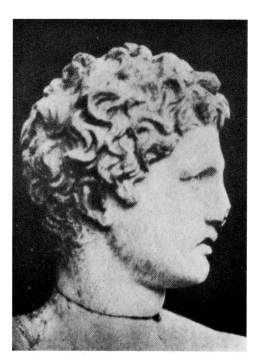

Fig. 755. Head of Meleager
The Garden of the Villa Medici, Rome
(Cf. p. 213)

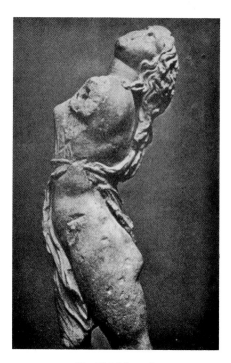

Fig. 756. Maenad
The Albertinum, Dresden
(Cf. p. 213)

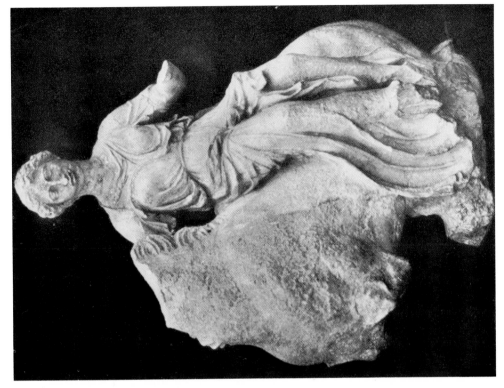
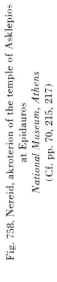

Fig. 758. Nereid, akroterion of the temple of Asklepios
at Epidauros
National Museum, Athens
(Cf. pp. 70, 215, 217)

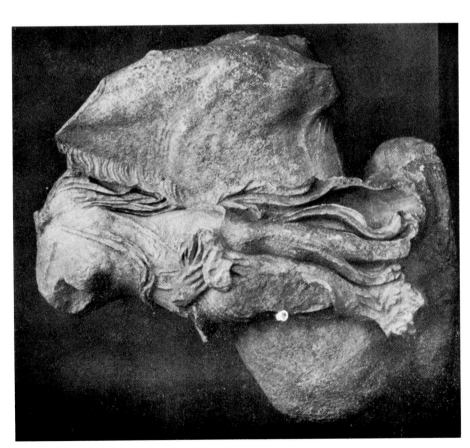

Fig. 757. Nereid, akroterion of the temple of Asklepios at Epidauros
National Museum, Athens
(Cf. pp. 215, 217)

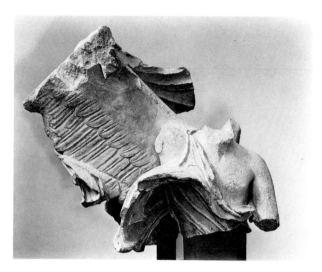

Fig. 759. Nike, akroterion(?) of the temple of Asklepios
at Epidauros
National Museum, Athens
(Cf. pp. 70, 215, 217)

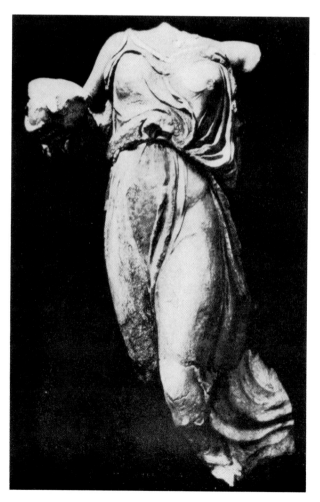

Fig. 760. Nike, akroterion of the temple of Asklepios
at Epidauros
National Museum, Athens
(Cf. pp. 39, 70, 215, 217)

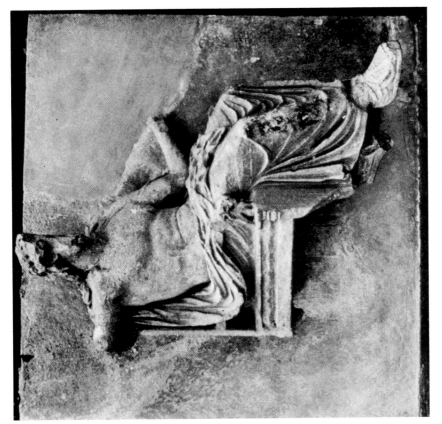

Fig. 762. Relief of Asklepios, from Epidauros
National Museum, Athens
(Cf. pp. 70, 216)

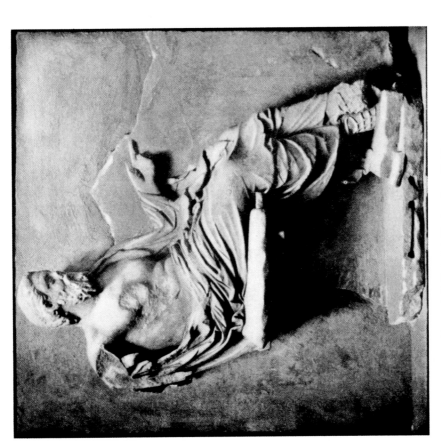

Fig. 761. Relief of Asklepios, from Epidauros
National Museum, Athens
(Cf. pp. 70, 216)

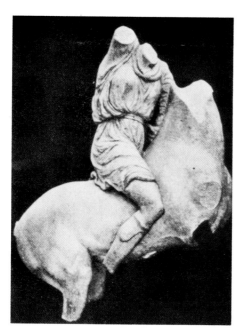

Fig. 763. Amazon, from the western pediment
at Epidauros
National Museum, Athens
(Cf. p. 215)

Fig. 764. Front view of statue shown
in Fig. 763 (from a cast)
(Cf. p. 215)

Fig. 765. Torso of an Amazon, from the pediment of the
temple at Epidauros
National Museum, Athens
(Cf. p. 215)

Fig. 766. Torso of a woman, probably from
the pediment at Epidauros
National Museum, Athens
(Cf. p. 215)

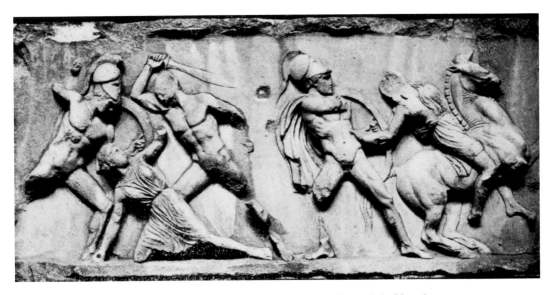

Fig. 767. Contest of Greeks and Amazons, from a frieze of the Mausoleum
British Museum, London
(Cf. pp. 76, 106, 216)

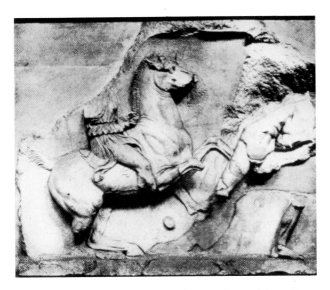

Fig. 768. Contest of Greek and Amazon, from a frieze of
the Mausoleum
British Museum, London
(Cf. pp. 76, 106, 216)

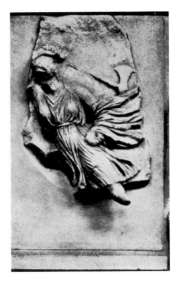

Fig. 769. Amazon, from a frieze
of the Mausoleum
British Museum, London
(Cf. p. 216)

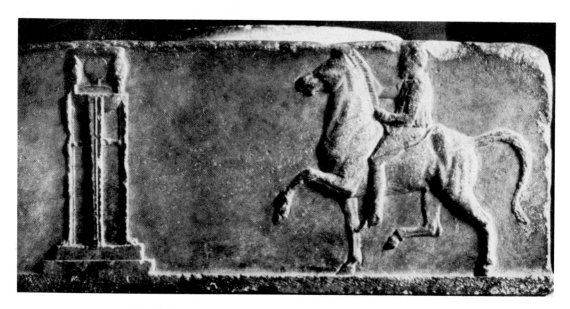

Fig. 770. Horseman approaching a tripod, base of a statue by Bryaxis
National Museum, Athens
(Cf. pp. 133, 217)

Fig. 771. Inscription on the statue base of Bryaxis (see Fig. 770)
(Cf. pp. 133, 217)

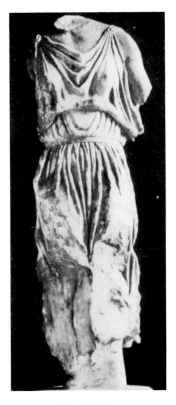

Fig. 772. Nike
National Museum, Athens
(Cf. p. 218)

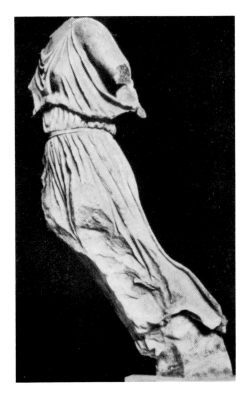

Fig. 773. Side view of Fig. 772
(Cf. p. 218)

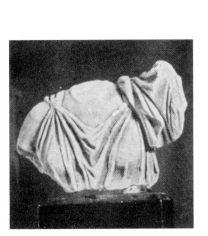

Fig. 774. Fragment of a female figure
from the base of the statue of
Nemesis at Rhamnous
National Museum, Athens
(Cf. p. 218)

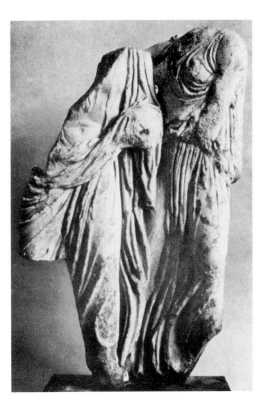

Fig. 775. Group from the frieze of the Erechtheion
Akropolis Museum, Athens
(Cf. p. 218)

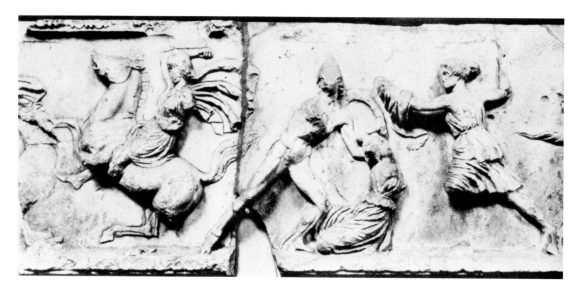

Fig. 776. Contest of Greeks and Amazons, from a frieze of the Mausoleum
British Museum, London
(Cf. pp. 76, 106, 218)

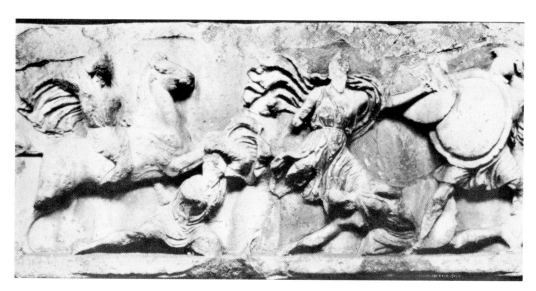

Fig. 777. Contest of Greeks and Amazons, from a frieze of the Mausoleum
British Museum, London
(Cf. pp. 106, 218)

Fig. 778. Head of Apollo, perhaps after the statue
by Bryaxis, on a coin of Antiochos IV, Epiphanes (enlarged)
American Numismatic Society, New York
(Cf. p. 219)

Fig. 779. Apollo, perhaps after a statue by
Bryaxis, on the reverse of the coin, Fig. 778
(Cf. p. 219)

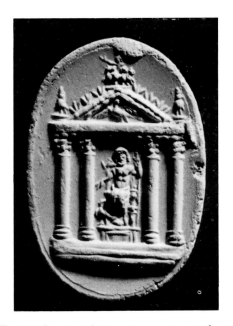

Fig. 780. Sarapis in his temple, on an engraved gem
(from an impression, enlarged)
British Museum, London
(Cf. p. 219)

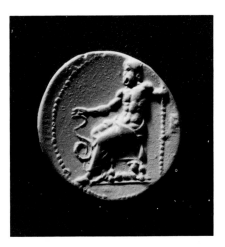

Fig. 781. Asklepios, statue by Thrasymedes
on a coin of Epidauros (from a
cast, enlarged)
Staatliche Museen, Berlin
(Cf. p. 220)

Fig. 783. Contest of Greeks and Amazons, from a frieze of the Mausoleum
British Museum, London
(Cf. pp. 106, 221)

Fig. 782. Ganymede and the eagle, on a
bronze mirror
Staatliche Museen, Berlin
(Cf. p. 221)

Fig. 785. Apollo Patroos by Euphranor
Stoa of Attalos, Athens
(Cf. p. 222)

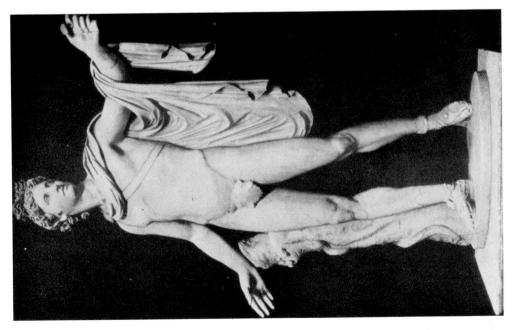

Fig. 784. Apollo Belvedere
The Vatican, Rome
(Cf. p. 222)

Fig. 787. Bronze head of a boxer
National Museum, Athens
(Cf. p. 223)

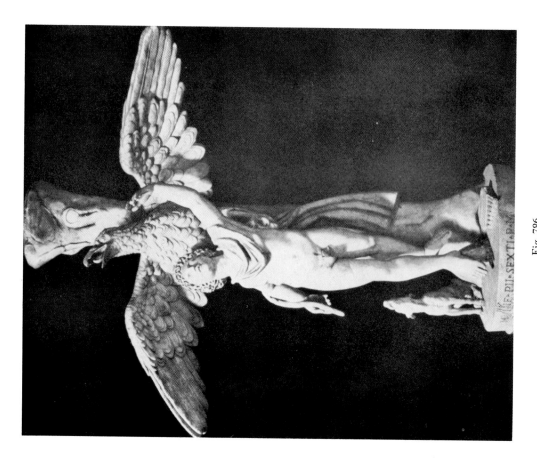

Fig. 786.
Ganymede and the eagle
The Vatican, Rome
(Cf. p. 221)

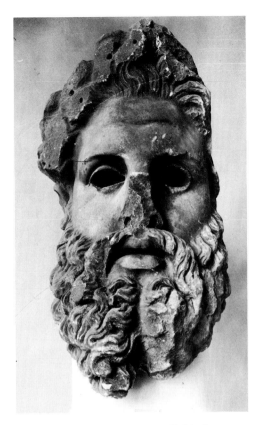

Fig. 788. Head of Zeus by Eukleides
National Museum, Athens
(Cf. p. 223)

Fig. 789. Zeus by Eukleides, on a Roman coin
British Museum, London
(Cf. p. 223)

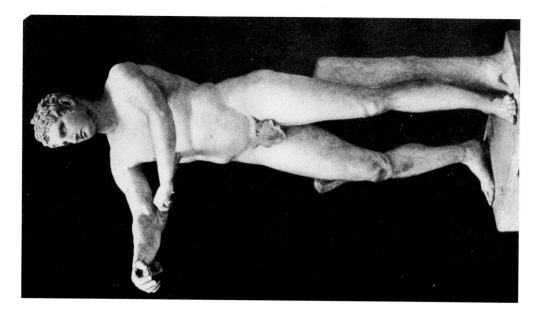

Fig. 791. Apoxyomenos
The Vatican, Rome
(Cf. pp. 35, 225)

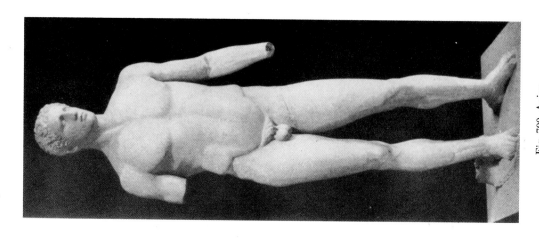

Fig. 790. Agias
Delphi Museum
(Cf. p. 226)

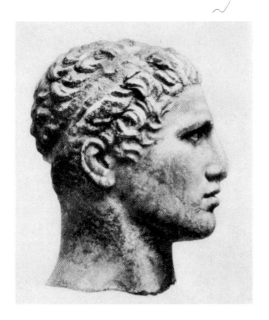

Fig. 792. Head of Agias, profile view
(see Fig. 790)
(Cf. p. 226)

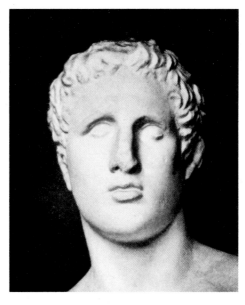

Fig. 793. Head of Agias, front view
(from a cast)
(Cf. p. 226)

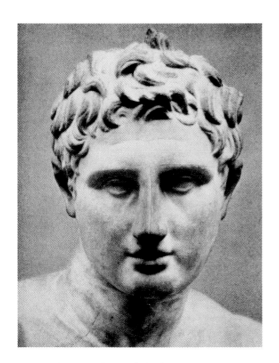

Fig. 794. Head of the Apoxyomenos
(from a cast, see Fig. 791)
(Cf. p. 225)

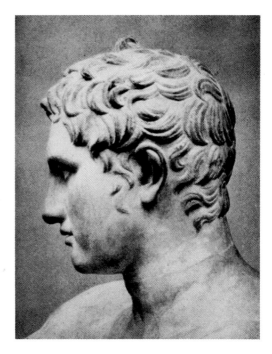

Fig. 795. Profile view of Fig. 794 (from a cast)
(Cf. p. 225)

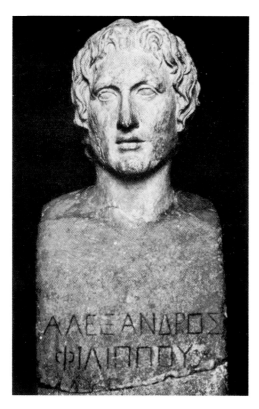

Fig. 796. Alexander the Great, the Azara bust
The Louvre, Paris
(Cf. p. 229)

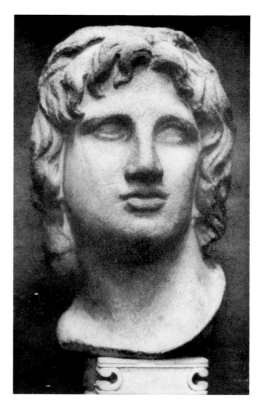

Fig. 797. Alexander the Great
British Museum, London
(Cf. p. 229)

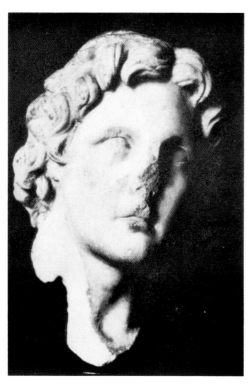

Fig. 798. Alexander (?)
From Musée Guimet, Paris
on deposit in *The Louvre*
(Cf. p. 229)

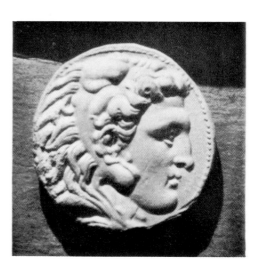

Fig. 799. Portrait of Alexander, on a coin
of Babylon (enlarged)
American Numismatic Society, New York
(Cf. p. 229)

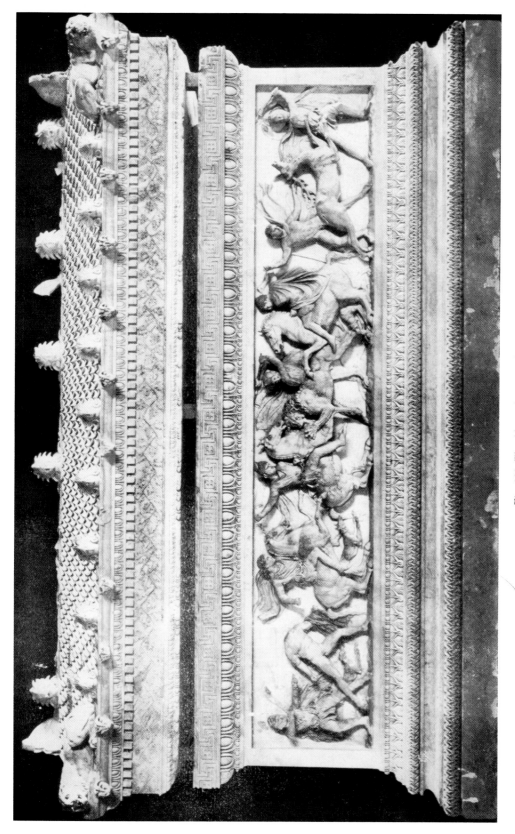

Fig. 800. The Alexander sarcophagus
Istanbul Museum
(Cf. pp. 76, 106, 230)

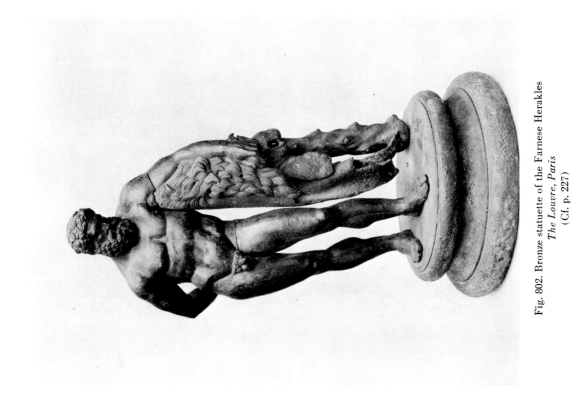

Fig. 802. Bronze statuette of the Farnese Herakles
The Louvre, Paris
(Cf. p. 227)

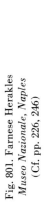

Fig. 801. Farnese Herakles
Museo Nazionale, Naples
(Cf. pp. 226, 246)

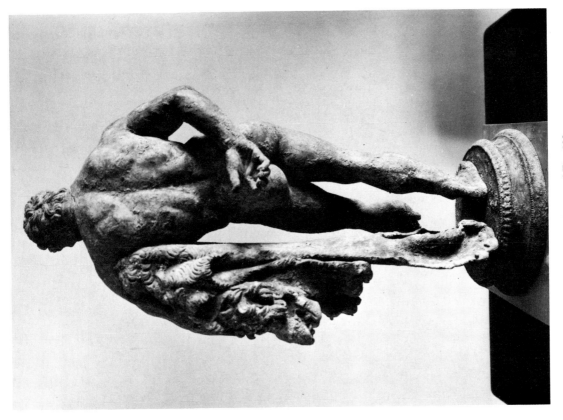

Fig. 803. Bronze statuette of the Farnese Herakles
Chieti Museum
(Cf. p. 227)

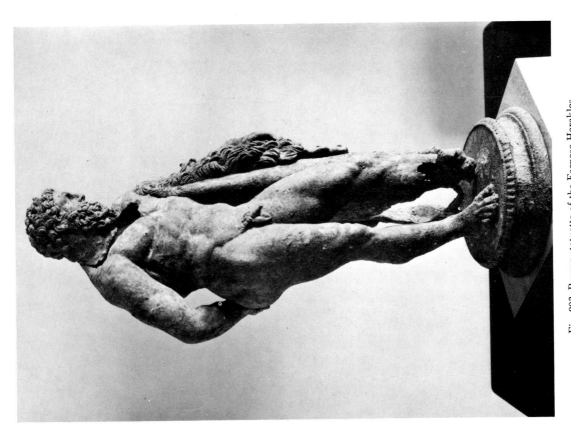

Fig. 804. Back view of Fig. 803
(Cf. p. 227)

Fig. 805. Herakles, on a coin of
Amastris (enlarged)
Museo Archeologico, Florence
(Cf. p. 227)

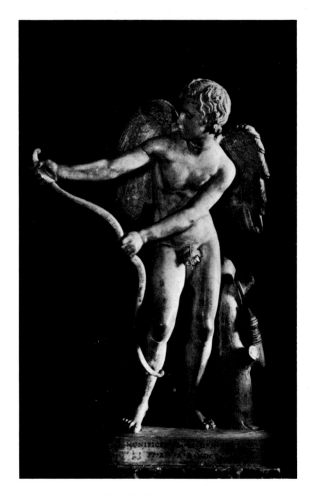

Fig. 806. Eros with bow
Capitoline Museum, Rome
(Cf. p. 231)

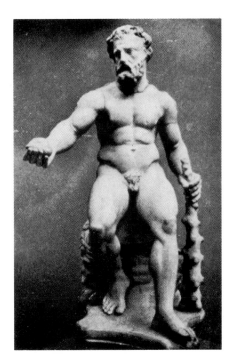

Fig. 807. Statuette of Herakles
British Museum, London
(Cf. p. 227)

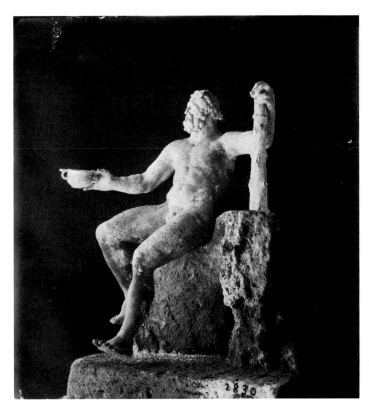

Fig. 808. Bronze statuette of Herakles
National Museum, Naples
(Cf. p. 227)

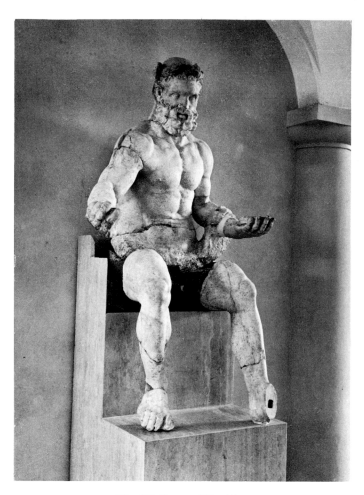

Fig. 809. Statue of Herakles
Antiquario of Alba Fucens
(Cf. p. 227)

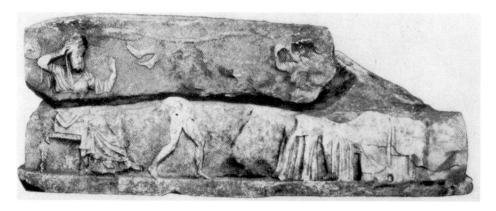

Fig. 810. Base of the statue of Poulydamas by Lysippos
Olympia Museum
(Cf. p. 228)

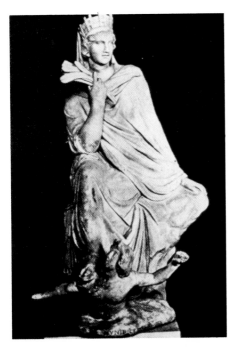

Fig. 811. Statuette of the Tyche of Antioch
The Vatican, Rome
(Cf. p. 232)

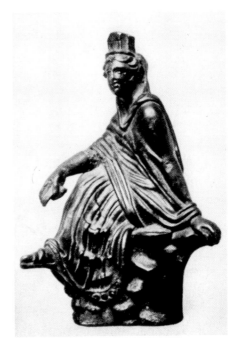

Fig. 812. Bronze statuette of the Tyche
of Antioch
Metropolitan Museum of Art
(Cf. p. 232)

Fig. 813. The Tyche of Antioch,
on a coin of Tigranes
(from a cast)
British Museum, London
(Cf. p. 232)

Fig. 814. Amykos (?), on a
coin of Lakedaimon (enlarged)
British Museum, London
(Cf. p. 247, note 36)

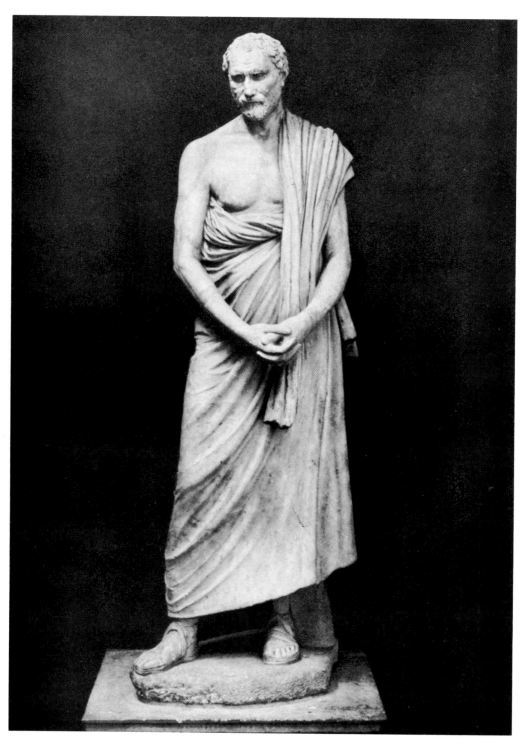

Fig. 815. Demosthenes
Ny Carlsberg Glyptotek, Copenhagen
(Cf. pp. 56, 233)

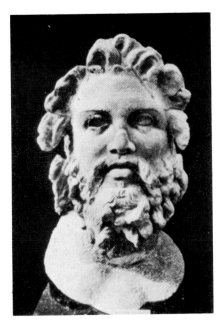

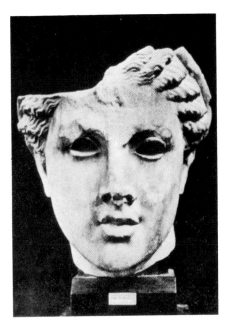

Fig. 816. Head of Anytos, from the temple
at Lykosoura
National Museum, Athens
(Cf. p. 241)

Fig. 817. Head of Artemis, from the
temple at Lykosoura
National Museum, Athens
(Cf. p. 241)

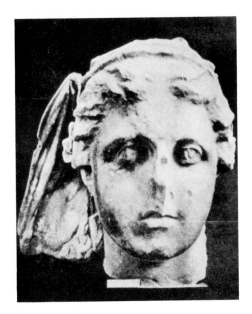

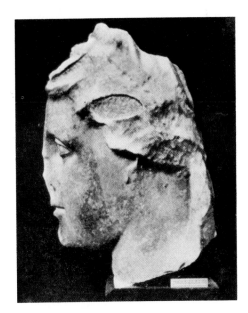

Fig. 818. Head of Demeter, from the
temple at Lykosoura
National Museum, Athens
(Cf. p. 241)

Fig. 819. Profile view of Fig. 818
(Cf. p. 241)

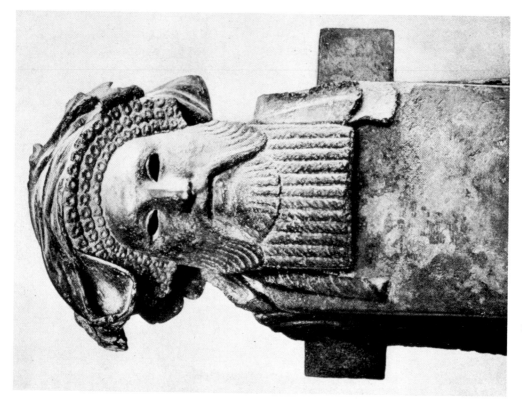

Fig. 821. Bronze herm of Dionysos, signed by Boethos
Museum of Bardo, Tunis
(Cf. p. 236)

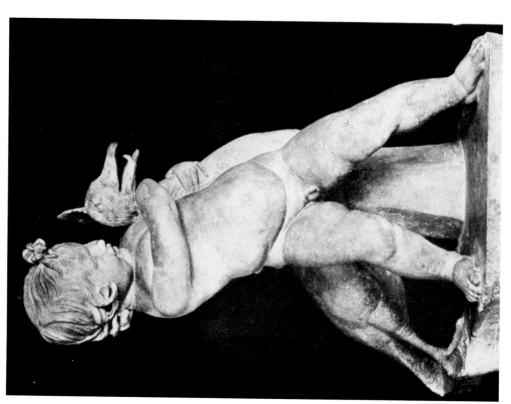

Fig. 820. Boy strangling a goose, after a work by Boethos
The Glyptothek, Munich
(Cf. p. 235)

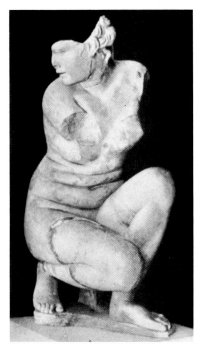

Fig. 822. Aphrodite, after a work by Doidalses
Museo Nazionale delle Terme
(Cf. p. 234)

Fig. 823. Aphrodite, by Doidalses, on a Roman coin
(Cf. p. 234)

Fig. 824. Zeus, by Doidalses, on a Roman coin
(Cf. p. 234)

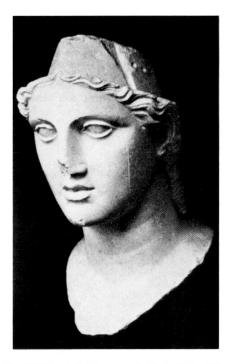

Fig. 825. Head of Athena, probably by Euboulides
National Museum, Athens
(Cf. p. 242)

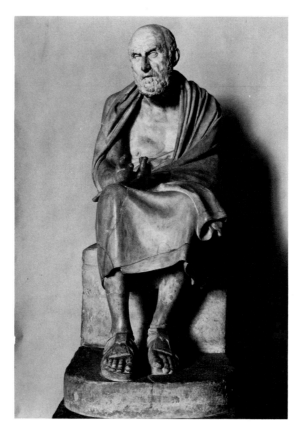

Fig. 826. Reconstructed statue of Chrysippos
The Louvre, Paris
(Cf. p. 242)

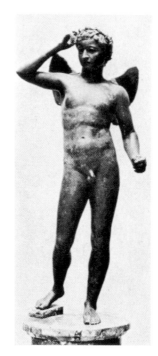

Fig. 827. Agon, perhaps by Boethos
(see Fig. 820)
Museum of Bardo, Tunis
(Cf. p. 236)

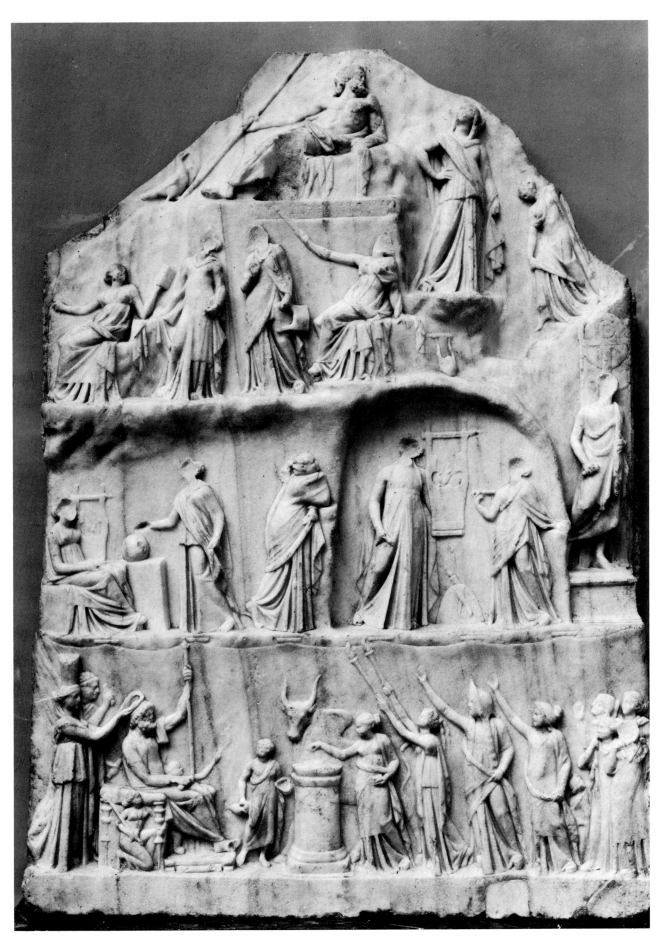

Fig. 828. Apotheosis of Homer
British Museum, London
(Cf. p. 234)

Fig. 830. Giant from the Pergamon altar
Staatliche Museen, Berlin
(Cf. p. 234)

Fig. 829. C. Ophellios, signed by Dionysios
and Timarchides
Delos Museum
(Cf. p. 242)

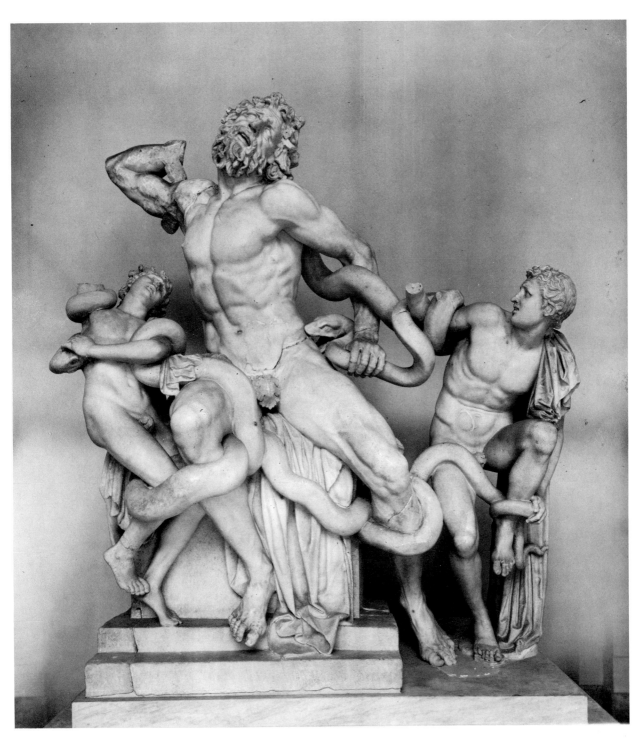

Fig. 831. Laokoon group
The Vatican, Rome
(Cf. pp. 55, 236, 239)

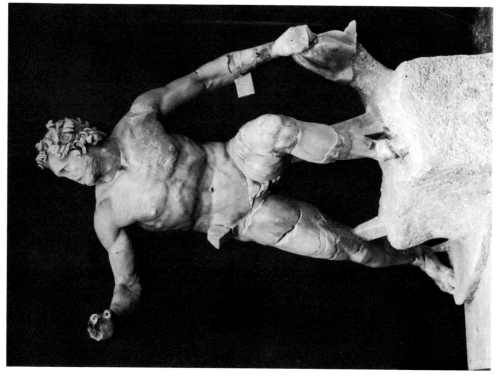

Fig. 833. Statue from Sperlonga
Sperlonga Museum
(Cf. pp. 237, 239)

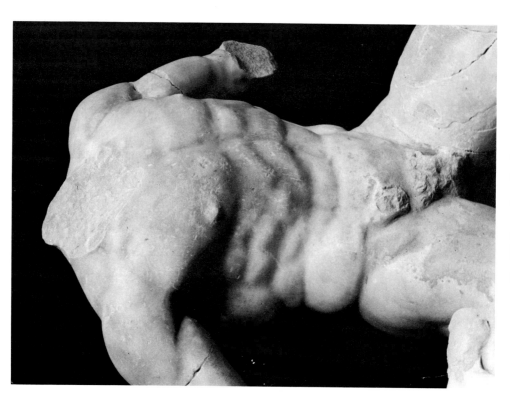

Fig. 832. Statue from Sperlonga
Sperlonga Museum
(Cf. pp. 237, 239)

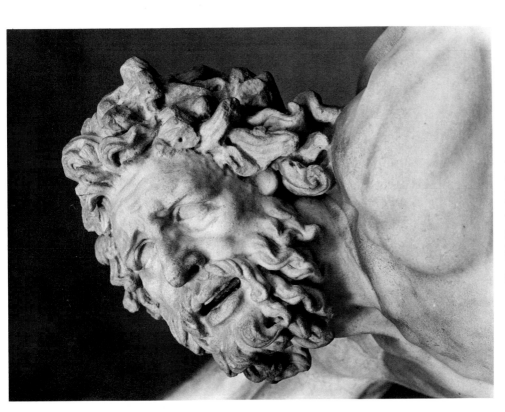

Fig. 835. Head from Sperlonga
Sperlonga Museum
(Cf. pp. 237, 239, 240)

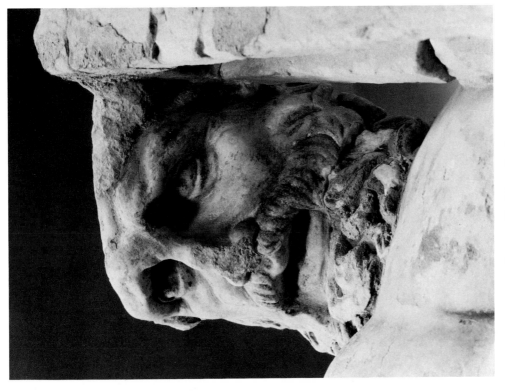

Fig. 834. Head of the Laokoon
The Vatican, Rome
(Cf. pp. 55, 236, 237, 239, 240)

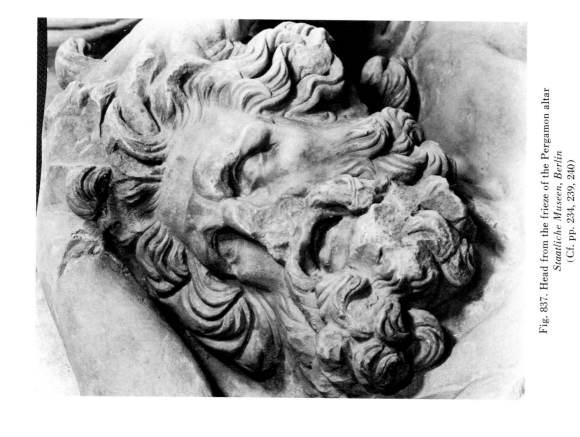

Fig. 837. Head from the frieze of the Pergamon altar
Staatliche Museen, Berlin
(Cf. pp. 234, 239, 240)

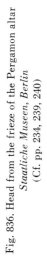

Fig. 836. Head from the frieze of the Pergamon altar
Staatliche Museen, Berlin
(Cf. pp. 234, 239, 240)

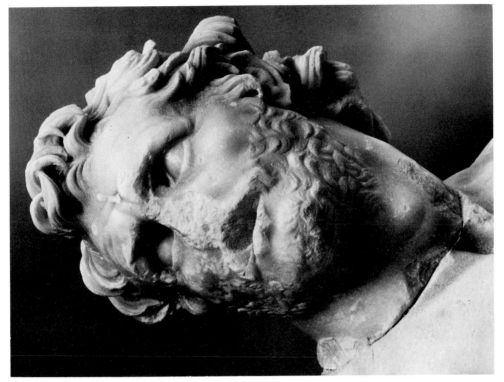

Fig. 839. Head from Sperlonga
Sperlonga Museum
(Cf. pp. 237, 239, 240)

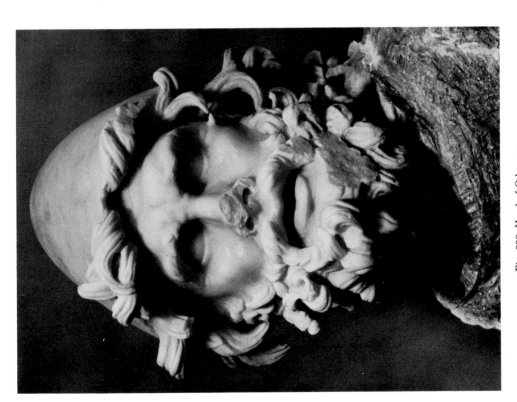

Fig. 838. Head of Odysseus
Sperlonga Museum
(Cf. pp. 237, 239, 240)

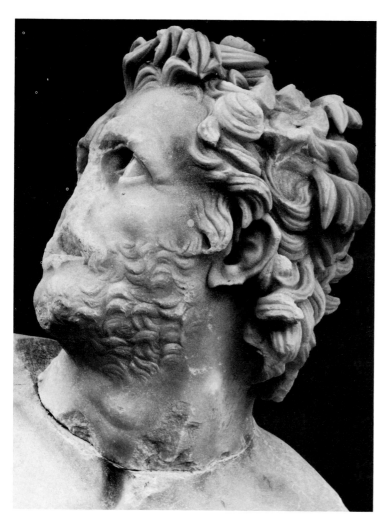

Fig. 840. Profile view of the head in Fig. 839
(Cf. pp. 237, 239, 240)

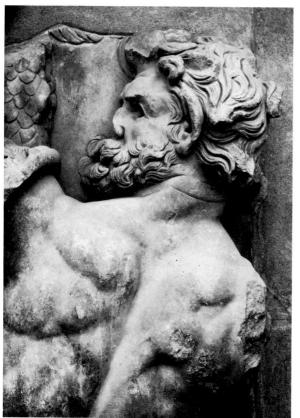

Fig. 841. Head from the frieze of the Pergamon altar
Staatliche Museen, Berlin
(Cf. pp. 234, 239, 240)

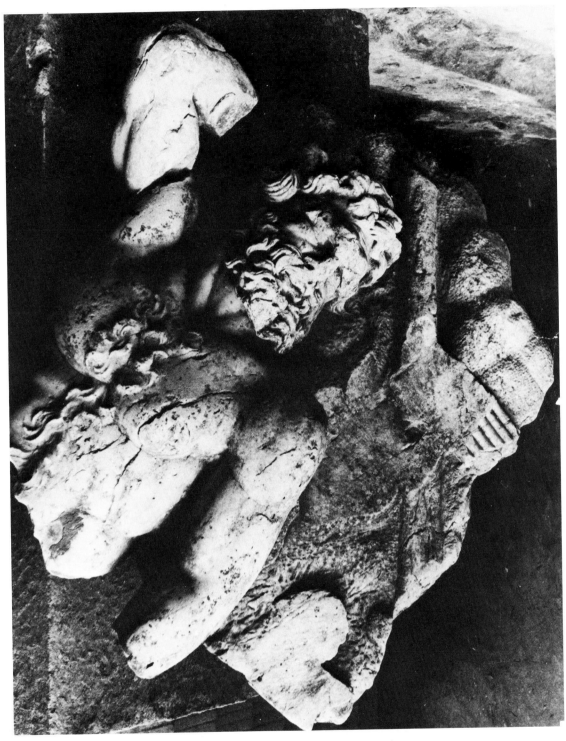

Fig. 842. Polyphemos, relief in Castelgandolfo
(Cf. pp. 239, 240)

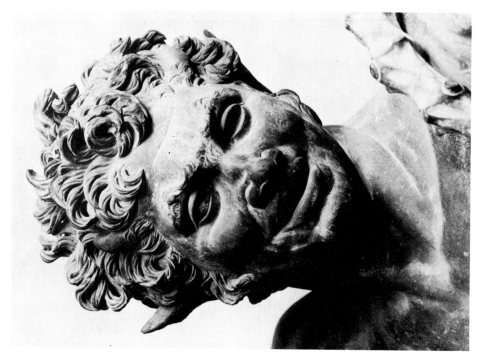

Fig. 844. Head of a centaur
Capitoline Museum, Rome
(Cf. pp. 240, 247)

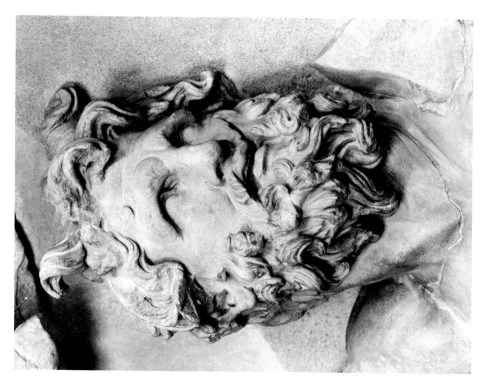

Fig. 843. Head from the frieze of the Pergamon altar
Staatliche Museen, Berlin
(Cf. pp. 234, 239, 240)

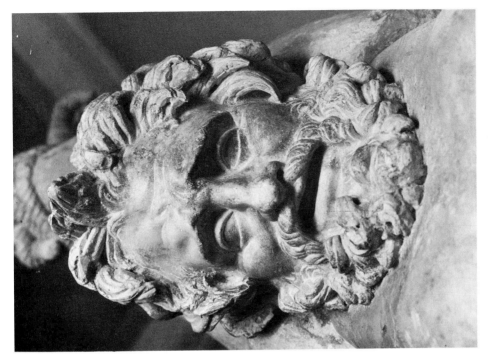

Fig. 846. Head of a hanging Marsyas
Conservatori Museum, Rome
(Cf. p. 240)

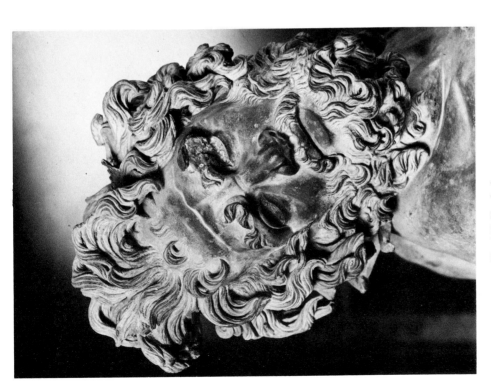

Fig. 845. Head of a centaur
Capitoline Museum, Rome
(Cf. pp. 240, 247)

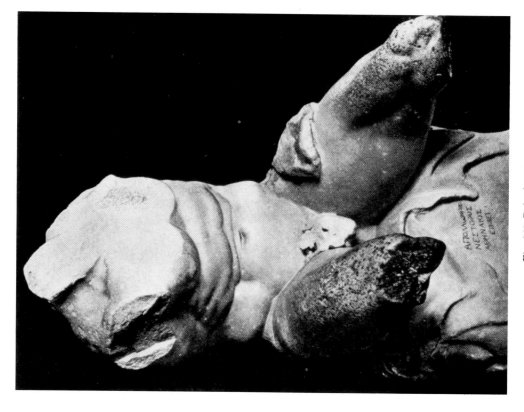

Fig. 848. Belvedere torso
The Vatican, Rome
(Cf. p. 247)

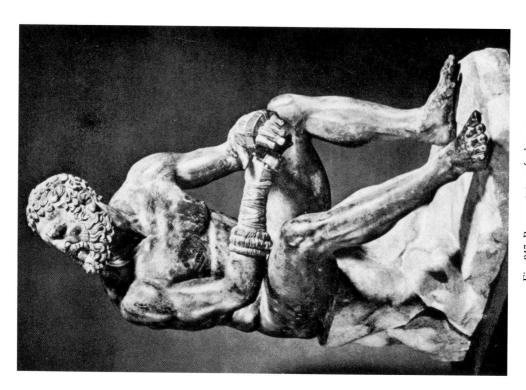

Fig. 847. Bronze statue of a boxer
Museo Nazionale delle Terme
(Cf. pp. 37, 247, note 36)

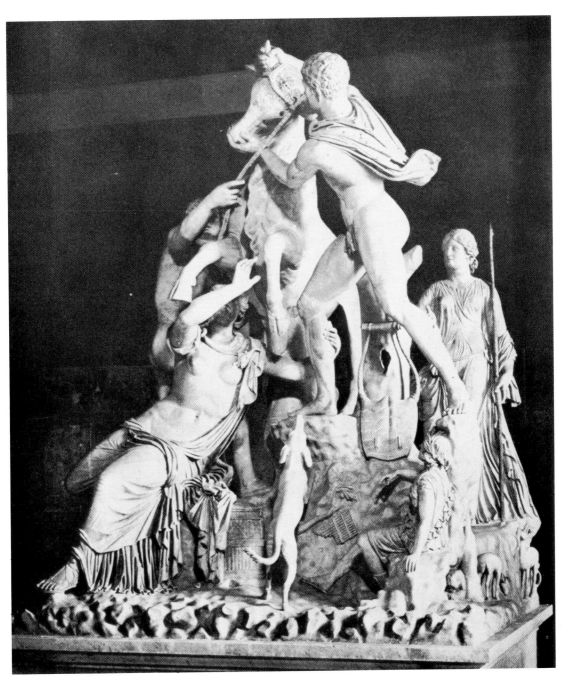

Fig. 849. Farnese bull
Museo Nazionale, Naples
(Cf. p. 240)

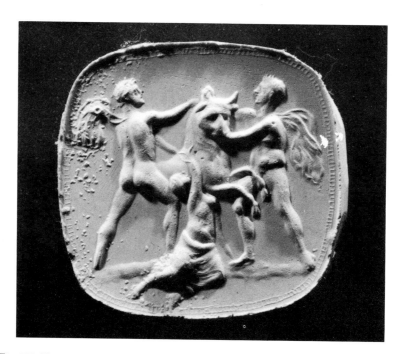

Fig. 850. The punishment of Dirke, on an engraved gem (from an impression, enlarged)
Museo Nazionale, Aquileia
(Cf. p. 240)

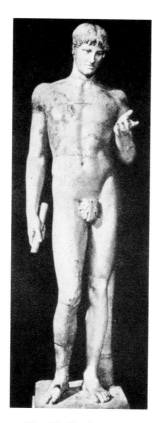

Fig. 851. Youth, signed
by Stephanos
Albani Collection, Rome
(Cf. p. 245)

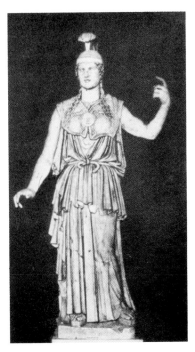

Fig. 852. Athena Parthenos (both arms are
restored), signed by Antiochos
Museo Nazionale delle Terme, Rome
(Cf. p. 246)

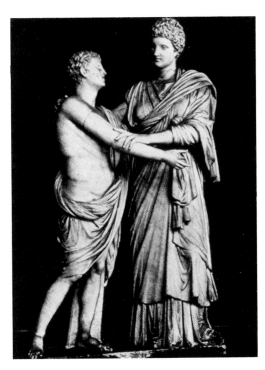

Fig. 853. Elektra and Orestes(?), signed by Menelaos
Museo Nazionale delle Terme, Rome
(Cf. p. 245)